The cultural sector receives more funding today than ever before. This book is
abou... those
artfo...

...rature,
mus... ...al arts.
It ex... ...here it
com... ...ganisa-
tions ...ibuted
thro... ...ds and
deve... ...onship
betw... ...nercial
indu...

* 'F... ...re and
 o... ...n those
 p...
* 'F... ...lic and
 p... ...pares it
 to... ...what it
 w... ...de.
* 'T... ...cultural
 se... ...nent in
 th... ...diverse
 cu...
* 'F... ...ok: the
 n... ...number
 of... ...xpendi-
 tu... ...s.

With... ...ltants,
cult... ...e most
thor...

The UK Cultural Sector
Profile and Policy Issues

Editor
Sara Selwood

Contributors

Geoffrey Brown · Michael Coupe · Claire Creaser · Anne Creigh-Tyte
Stephen Creigh-Tyte · Stuart Davies · Rachael Dunlop · Paul Dwinfour
Andy Feist · Nicholas Garnham · David Hancock · Max Hanna
Debbie Hicks · Peter Johnson · Robert King · Clare McAndrew
Kate Manton · Adriana Neligan · John O'Hagan · Tim Owen
Sara Selwood · Gareth Stiven · Peter Symon · Barry Thomas
Adele Williams

Advisers

Stephen Creigh-Tyte · Andy Feist · Nicholas Garnham · John O'Hagan
Patricia Morison · Michael Pattison

Cultural Trends

Policy Studies Institute

UNIVERSITY OF WESTMINSTER

PSI is a wholly owned subsidiary of the University of Westminster

This research was funded by the Monument Trust, one of the Sainsbury Family Charitable Trusts. Additional funding was provided by: the Heritage Lottery Fund for the financial mapping; by the John S Cohen Foundation and Trinity College, Dublin for Chapter 21; the Museums & Galleries Commission for Chapter 20; and the Department for Culture, Media and Sport for Chapter 13.

Neither the Policy Studies Institute nor the funders, advisers or editor of this report are responsible for the views or the assumptions expressed by authors or cited from other sources.

© Policy Studies Institute 2001

A CIP catalogue record for this book is available from the British Library.

ISBN 0 85374 789 X
PSI Report No. 877

Typeset by PCS Mapping & DTP, Newcastle upon Tyne
Printed by Athenaeum Press, Gateshead, Tyne and Wear

For further information contact
Policy Studies Institute, 100 Park Village East, London NW1 3SR
Tel: 020 7468 0468 Fax: 020 7468 2201 Email: pubs@psi.org.uk

Contents

Part I Policy Issues

Part II Funding

Part III The Wider Context

Contents

List of Tables and Figures

Part II Funding

Chapter 10 Funding from Central Government

Chapter 11 Urban Regeneration Programmes

Chapter 12 Funding from Institutions of Higher Education

Chapter 13 European Funding

Chapter 14 Local Authorities: New Opportunities and Reduced Capacity

Chapter 15 Taxation

Chapter 16 The National Lottery

Chapter 17 Funding from the Private Sector

Part III The Wider Context

Chapter 18 Why Does Government Fund the Cultural Sector?

Chapter 19 The Relationship Between the Subsidised and the Wider Cultural Sector

Chapter 20 Assessing the Economic Impact of the Arts

Chapter 21 Innovation and Diversity in Repertoire in Grant-aided and Commercial Theatre

Chapter 22 Art Trade and Government Policy

Chapter 23 Employment

Part IV Profile

Chapter 24 Profile of the Built Heritage

Chapter 25 Profile of the Film Industry

Chapter 26 Profile of Libraries

Chapter 27 Profile of Literature

Chapter 28 Profile of Museums and Galleries

Chapter 29 Profile of the Performing Arts

Chapter 30 Profile of Public Broadcasting

Chapter 31 Profile of the Visual Arts

Chapter 32 Survey Findings

Chapter 33 The Arts Council of England and Regional Arts Boards' Constant Sample, 1994/95–1998/99

Appendix 3

Acronyms and Abbreviations

€	Euro
A4E	Arts for Everyone
A&B	Arts & Business
ABSA	Association for Business Sponsorship of the Arts
ACE	Arts Council of England
ACGB	Arts Council of Great Britain
ACNI	Arts Council of Northern Ireland
ACT	Advanced Communication Technologies
ACW	Arts Council of Wales
AETI	Arts, Education and Training Initiative
AHRB	Arts and Humanities Research Board
AIM	Association of Independent Museums
AMC	area museum council
Aslib	Association for Information Management
BFC	British Film Commission
BFI	British Film Institute
BLDSC	British Library Document Supply Centre
BMRB	British Market Research Bureau
BSAC	British Screen Advisory Council
CAA	Cinema Advertising Association
CAVIAR	Cinema and Video Industry Audience Research
CD-I	interactive compact disk
CIPFA	Chartered Institute of Public Finance and Accountancy
CNN	Cable News Network
COSLA	Convention of Scottish Local Authorities
DCMS	Department for Culture, Media and Sport
DETR	Department of the Environment, Transport and the Regions
DfEE	Department for Education and Employment
DG	Directorate General
DNH	Department of National Heritage
DTI	Department of Trade and Industry
EA	Eastern Arts
EAGGF	European Agricultural Guidance and Guarantee Fund
EC	European Commission
ecu	European Currency Unit

EH	English Heritage
EMA	East Midlands Arts
E&HS	Environment and Heritage Service (Northern Ireland)
ERDF	European Regional Development Fund
ESF	European Social Fund
ETC	English Tourism Council
EU	European Union
FCO	Foreign and Commonwealth Office
FEFC	Further Education Funding Council
FIFG	Financial Instrument for Fisheries Guidance
FT	full-time
FTE	full-time equivalent
GAYE	Give As You Earn
GLC	Greater London Council
GLLAM	Group for Large Local Authority Museums
GNP	gross national product
GORs	Government Offices for the Regions
HCLRG	Higher Education Colleges Learning Resources Group
HEFCE	Higher Education Funding Council for England
HEI	higher education institution
HEMGC	higher education museum, gallery and collection
HLF	Heritage Lottery Fund
HoC	House of Commons
HRPA	Historic Royal Palaces Agency
HS	Historic Scotland
IFS	Interim Funding Scheme
ILO	International Labour Organization
IPPR	Institute for Public Policy Research
ITC	Independent Theatre Council
JCNAS	Joint Committee of the National Amenity Societies
LAB	London Arts Board
LFS	Labour Force Survey
LFVDA	London Film and Video Development Agency
LGIU	Local Government Information Unit
LIC	Library and Information Commission
LISU	Library and Information Statistics Unit, University of Loughborough
MGC	Museums & Galleries Commission
MTIC	Market Tracking International Consultants
NA	Northern Arts
NACF	National Art Collections Fund
NAO	National Audit Office
NCA	National Campaign for the Arts
NES	New Earnings Survey
NHMF	National Heritage Memorial Fund
NIO	Northern Ireland Office

NMG	national museums and galleries
NOF	New Opportunities Fund
NT	National Trust
NTS	National Trust for Scotland
NWA	North West Arts
ONS	Office for National Statistics
OPAC	on-line public access catalogue
PPG	planning policy guidance
PRODCOM	Products of the European Community Survey
PSA	Public Service Agreement
PT	part-time
QUEST	Quality, Efficiency and Standards Team
RAB	regional arts board
R&D	research and development
RDA	Regional Development Agencies
RICS	Royal Institution of Chartered Surveyors
ROSE	the Rest of the South East (of England)
RSC	Royal Shakespeare Company
S4C	Sianel Pedwar Cymru
SA	Southern Arts
SAC	Scottish Arts Council
SCONUL	Standing Conference of National and University Librarians
SEA	South East Arts
SHEFC	Scottish Higher Education Funding Council
SIC	Standard International Classification
SME	small- and medium-sized enterprise
SMG	Scottish Media Group
SMT	standards, measurements and testing
SO	Scottish Office
SOC	Standard Occupational Classification
SOLT	Society of London Theatre
SRB	Single Regeneration Budget
SRBCF	SRB Challenge Fund
SWET	Society of West End Theatre
TGI	Target Group Index
TMA	Theatrical Management Association
TMR	training and mobility of researchers
TSER	targeted socio-economic research
UDC	Urban Development Corporation
UK	United Kingdom
UN&M	Broadcasting United News and Media
US	United States of America
VAT	Value Added Tax
WAC	Welsh Arts Council
WO	Welsh Office
WMA	West Midlands Arts

| YHA | Yorkshire and Humberside Arts |
| YA | Yorkshire Arts |

Symbols and Conventions Used in Tables

o nil
* less than 1 per cent
** estimate not sufficiently reliable
– not available, not collected or not known
bn billion
√ yes
X no
e estimate
m million
n/a not applicable

In tables where the figures have been rounded, totals may not correspond exactly to the sum of the constituent items.

Dates including the symbol / represent a financial year (for example, 1998/99 is used to mean 1 April 1998 to 31 March 1999) unless otherwise stated.

The HM Treasury GDP deflator series, shown below, has been used throughout this book. It is based on 1998/99 as 100. The series allows us to show monetary figures at 1998/99 prices – in other words, in 'real terms'.

Year	GDP deflator at market prices
1993/94	87.440
1994/95	88.689
1995/96	91.252
1996/97	94.191
1997/98	96.840
1998/99	100.000

Source: www.hm-treasury.gov.uk/deflators/figures.htm

Acknowledgements

I would like to thank the sponsors for their support and enthusiasm for this project: in particular The Monument Trust, and also the Heritage Lottery Fund; the John S Cohen Foundation; Trinity College, Dublin; the former Museums & Galleries Commission; Resource; and the Department for Culture, Media and Sport, which provided additional support.

I am very grateful to the advisers for discussing the progress of the book and for invaluable comments on drafts: Professor Stephen Creigh-Tyte, Department for Culture, Media and Sport and Department of Economics, University of Durham; Andy Feist, Department of Arts Policy and Management, City University; Professor Nicholas Garnham, School of Communication and Creative Industries, University of Westminster; Professor John O'Hagan, Department of Economics, Trinity College, Dublin; Dr Patricia Morison, Sainsbury Family Charitable Trusts, and Michael Pattison, Sainsbury Family Charitable Trusts.

My thanks go to all the organisations in receipt of funding which responded to the survey. They are listed in the appendices. The Arts Council of England, in particular Paul Dwinfour, generously made data available. Karen McKinnon, Policy Studies Institute; Barry Jetten, Plus Four; Sara Fletcher; Freya Coffman; Alex Lucas; and Kate Halladay all contributed to the management of the survey and its analysis. I am especially grateful to all the contributors, and to the publications team at PSI: Jo O'Driscoll, publisher; Mary Daws, publications coordinator; Nina Behrman, copy editor; Brian Rooney, proofreader; Patricia Baker, indexer; Gary Haley, typesetter; and Andrew Corbett, designer. I would also like to thank Russell Southwood for his unfailing support throughout the duration of the project.

Many other people helped by providing information and advice, and peer-reviewing chapters. On a section-by-section basis, they include the following:

Policy and profile

Matthew Saunders, Ancient Monuments Society; Paul Dwinfour, Tim Eastop, Ben Heywood, Gary McKeone, Arts Council of England; Gail Kittle, Association of Independent Museums; Jonathan Davidson, Book Communications Ltd; Jo Henry and Steve Bohme, Book Marketing Ltd; Michael Quine, City University; Nick Irvine, Commercial Radio Companies Association; Diana Brown,

Department for Culture, Media and Sport. Adrian Babbidge, East Midlands Museums Service; Jean Benyon, Foundation for Sport and the Arts; Stephen Price, Group for Large Local Authority Museums; Jennifer Beever, Horniman Museums and Gardens; Damian Tambini, IPPR; Bob Kindred, Ipswich Borough Council; LISU; Holly Tebbutt, London Arts; Michael Wright, Museums Association; Kathryn Wolstencroft, Museum of Science and Industry in Manchester; Vicky Dyer, National Art Collections Fund; Andrew Robson, National Gallery; John Wrigley, National Trust; Nigel Fairhead, National Trust for Scotland; Janice Batchelor, Natural History Museum; Anne Pennington, National Museums & Galleries on Merseyside; Carole Sutton, Office for National Statistics; Stuart Davies, Resource; Helen Davis, David Fisher and Mark Smith, *Screen Digest*; Max Hanna, Sightseeing Research; Roderick Smith, Sir John Soane's Museum; Bob Jarvis, South Bank University; Andrew Brighton, Catherine Holden and Mark Mawtus, Tate.

Funding

Glyn Darbyshire-Evans, Advantage West Midlands; Michael Jubb, Arts and Humanities Research Board; James Caterer, Julia Crookenden, Tim Sweet, Pat Swell, Arts Council of England; Ivan Armstrong, Nick Livingstone, Lorraine McDowell, Arts Council of Northern Ireland; Elaine Brennan, Debbie Green, Arts Council of Wales; Ian Nelson, BFI; John Griffith, Barbara Thompson, Crystal Palace Partnership; Paul Douglas, Phillip Evoy, Chris Fisher, Chris McGuiness and Aidan Stradling, Department for Culture, Media and Sport; Ade Akinfolajimi, Jon Boland, Andy Golding and Ellen Gyampoh, Department of the Environment, Transport and the Regions; Susan Forrester, Directory of Social Change; Keith Allen, East of England Development Agency; Tony Sannia, Russell Walters, English Heritage; David Briscoe, English Partnerships; Jo Eagleson, Enterprise Ulster; Marie-Pierre Crozet, Regional Policy DG, Salvatore Pecoraro, Education and Culture DG, European Commission; Carol Comley, Film Council; Malcolm Sims, Government Office for London; Group for Large Local Authority Museums; Clare Butler-Henderson, Heritage Lottery Fund; Gillian Campbell, Highlands & Islands Enterprise; James Hervey-Bathurst, Historic Houses Association; Jonathan Drake, Kirklees Cultural Services; Barbara Bloomfield, *Lottery Monitor*; Adrienne Hedge, London Arts Board; Marc Aladenika, London Borough of Greenwich; Nina Massarik and Dave Adams, London Development Agency; Vicky Dyer, National Art Collections Fund; Tim Cosgrove, Vanessa Groves and Adam Al-Nuaimi, National Assembly for Wales; Andrew Dixon, Northern Arts; Gill Davenport, Research Support Libraries Programme; Stuart Davies, Resource; Sylvia Dow, Tanya Hutchinson, Suzie Long, Julie Crawford and Guilio Romano, Scottish Arts Council; John Stuksis, Scottish Executive; David Beards, Scottish Higher Education Funding Council; David Hancock, *Screen Digest*; Robin Morris, South West Regional Development Agency; George Cochrane, Tate; Khin Wai Chi, UNESCO; Stephen Hall and Pat Niner, Tim Schadla-Hall, University College London; University of Birmingham; Alan Wallace, Yorkshire Arts; Kate Arnold-Foster; Phyllida Shaw; Jane Weeks.

The wider context

Robert Cogo-Fawcett, Ambassador Theatre Group; Paul Dwinfour and Robert West, Arts Council of England; Michael Quine, City University; Paul Allin, Ivan Bishop and Ian Wood, Department for Culture, Media and Sport; Adrian Darnell and Peter Johnson, University of Durham; Donal Dineen, University of Limerick; Gerald Lidstone, SOLT; Eric Evans.

Afterword

Charles Landry, Comedia; Tony Bennett, Open University.

Sara Selwood, Editor
June, 2001

About the Contributors

Geoffrey Brown is Director of EUCLID, which he founded in 1993. EUCLID provides a range of European and international information and consultancy services through its offices in the UK and in Brussels. The company has been appointed by the UK Department for Culture, Media and Sport and the European Commission as the official UK Cultural Contact Point for 1999–2001, and its role includes encouraging and assisting individuals and organisations to make successful applications to EU funding programmes. EUCLID has undertaken research and evaluation projects for the European Commission, the Council of Europe, European networks, the British Council and UK arts funding bodies and local authorities.

Michael Coupe is Head of Land Use Planning and Regeneration at English Heritage, and operates as a member of the policy centre working from London. Michael is a town planner and chartered surveyor with extensive experience in local government, mainly at the strategic level. Most recently, he has been responsible for developing ideas on conservation-led regeneration, and was heavily involved in the preparation of *The Heritage Dividend*, which was launched in June 2000.

Claire Creaser is a chartered statistician who has worked at the Library and Information Statistics Unit (LISU) for over six years, compiling statistics on all types of library and information services. Her particular areas of interest include statistical benchmarking applied to both public library authorities and academic libraries, and the development and application of methodologies for comparison of performance both within and between library services. She maintains LISU's databases of individual authority/institution statistics, derived from data collected by CIPFA and SCONUL. Other interests in the public library sector include LISU's annual survey of public library services to schools and children, the relationship between social deprivation and library use, and library services for visually impaired people.

Anne Creigh-Tyte is a graduate in Economics and Anthropology from University College, London, and in Art and Design from the London Institute. She has held senior posts as a design practitioner in private industry in the United Kingdom and abroad, and various academic posts including Head of Faculty, Canberra Institute of Technology and senior research posts in various British universities.

She is currently a Research Associate of SCRIPT, the University of Edinburgh. Her particular interest is the integration of the disparate discourses of commerce and culture in theory and practice. She has authored many papers and reports including projects commissioned by the Design Council and the British Council. Anne is currently preparing for publishers a book entitled, *Pride and Predjudice: British Designer Fashion in the New Millennium.*

Stephen Creigh-Tyte has held a variety of posts within the Government Economic Service and he is currently Chief Economist at the Department for Culture, Media and Sport. He has also held various academic posts, including a secondment to the Warwick University Business School, as Acting Director for the Centre for Small- and Medium-Sized Enterprises, and Acting Director of the National Institute of Labour Studies at Flinders University, South Australia. Stephen is presently Visiting Professor in Economics in the Department of Economics and Finance at the University of Durham. He is the author of over 100 books, articles and research papers covering labour and small-business issues as well as cultural sector economics.

Stuart Davies is Director of Strategy and Planning at Resource: the Council for Museums, Archives and Libraries. His career includes: posts in local authority cultural services in Gloucester, Birmingham and Kirklees; a lectureship in strategic management at the University of Leeds Business School; and policy adviser to the Heritage Lottery Fund.

Rachael Dunlop was one of the co-authors of *Culture as Commodity?* (PSI, 1996). She was a research fellow at the Policy Studies Institute for four years, during which time she was a regular contributor to *Cultural Trends*. Now a freelance research consultant, she contributed to the research methodology for the current study, and was largely responsible for bringing together the existing data on the funding of the cultural sector. Rachael also wrote some of the appendices for this study.

Paul Dwinfour is the Data Services Officer working in the Financial and Business Services Department at the Arts Council of England and is responsible for the management and collection of financial and other statistical data across the full range of the Arts Council's work. Much of his work has been on the development and production of performance indicators. Paul previously worked for the Central Statistical Office (now the Office for National Statistics), on the production of the Retail Prices Index, and before that worked in the computer industry.

Andy Feist. After a brief spell as a historical researcher, Andy Feist joined the independent Policy Studies Institute where he specialised in cultural research. During his seven years at PSI, he became co-founder and editor of the quarterly statistical journal *Cultural Trends*. In 1992, he was appointed Senior Policy Analyst with the Arts Council of England. Since 1997, he has been undertaking research at the Home Office, but continues to keep up his research and teaching

interests in the field of arts and culture. Andy is currently an Honorary Senior Research Fellow in the Department of Arts Policy and Management, City University, London.

Nicholas Garnham is Professor of Media Studies at the University of Westminster. He has been an editor of *Media, Culture and Society* since its foundation in 1978. He is convenor of the Visual Arts and Media Panel and Member of the Research Committee and Board of the Arts and Humanities Research Board. His most recent book is *Emancipation, The Media and Modernity* (Oxford University Press, 2000).

David Hancock is Senior Analyst with *Screen Digest*, specialising in film production, distribution and exhibition. He has led and worked on many major international consulting projects and is bilingual in French and English. Previously, David was the financial administrator at the Strasbourg-based European co-production fund Eurimages and also spent three years as a media research consultant at French communications institute IDATE. David is a regular contributor to TV, radio, newspapers and the trade press regarding the film industry. He has spoken at many international conferences and film festivals and has written and edited several books, chapters and articles for publication on the global film industry.

Max Hanna, an economist and market research consultant, has a particular interest in tourist attractions and the conservation of historic buildings. Between 1975 and 1993 he worked in the research and policy departments of the English Tourist Board. In 1977 he launched *The Heritage Monitor*, in 1978, *Sightseeing in the UK*, and in 1987, *Visits to Tourist Attractions*. All these continue as annual reports. Other English Tourist Board publications include *English Cathedrals and Tourism* (1979), which was the subject of a debate in the House of Lords, and *English Churches and Visitors* (1984). For SAVE Britain's Heritage he co-authored, with Marcus Binney, *Preservation Pays* (1978) and *Preserve and Prosper* (1983).

Debbie Hicks previously worked in a regional arts board and as a senior lecturer in Arts Management at De Montfort University. She is now a freelance arts consultant specialising in literature and libraries. Her recent work includes a major contribution to *Public Libraries and the Arts, Pathways to Partnership* (Arts Council of England, 2000) and *Volunteers in Library and Information Services* (The Library and Information Commission, 2000). She is also a partner in The Reading Partnership, a national library development agency promoting public libraries and their work with readers. Debbie was part of the team that researched and published *The Next Issue, Reading Partnerships for Libraries* (1998), and *Reading the Situation, Book Reading, Buying and Borrowing in Britain* (2000), Book Marketing Ltd, the Reading Partnership.

Peter Johnson is Professor in Business Economics at the University of Durham Business School. He previously held posts at the University of Nottingham and

at University College, Cardiff. His main interests are in the economics of heritage and small business. He has published extensively on museums and other topics. In 1998, he was a guest editor (with Barry Thomas) of special issues of the prestigious *Journal of Cultural Economics* on the economics of museums. He has been awarded numerous research grants and contracts from such bodies as the Nuffield Foundation, the Economic and Social Research Council, the (then) Manpower Services Commission, DNH/DCMS and the Joseph Rowntree Foundation. He has undertaken work for the Arts Council of England, DCMS and the private sector.

Robert King was formerly a researcher at IPPR, specialising in media. His publications include *future.radio.uk* (Murroni et al., IPPR, 1998). Robert is currently training to be a history teacher.

Clare McAndrew is a part-time lecturer in economics at Trinity College, Dublin, and is completing her PhD in the economics of the arts. Her research specialises in trade in art and international art markets. She has had a number of papers accepted for publication, and is currently completing a paper on the art trade in Europe, entitled 'Cultural autonomy versus free trade in the European Union'.

Kate Manton is a freelance researcher who has worked on a variety of projects including the regional studies for *The Economic Importance of the Arts* (PSI, 1988), *Cultural Trends* and *Artstat* (Arts Council of England, 2000). Her most recent publication was *A Sound Performance: The economic value of music to the United Kingdom* (National Music Council, 1999).

Adriana Neligan is currently a graduate student at Trinity College, Dublin, working on diversity, innovation and theatres. She has also presented a conference paper on 'Public funding, diversity, innovation and theatres: an empirical analysis in relation to England' at the 11th International Conference on Cultural Economics in Minneapolis, Minnesota, in May 2000.

John O'Hagan is Associate Professor of Economics, Trinity College, Dublin. He was President of the Association for Cultural Economics International from 1998 to 2000 and is currently on the executive board of the Association. He has published widely on the economics of the arts. Publications include *The State and the Arts: An analysis of key economic policy issues in Europe and the United States* (Edward Elgar, 1998), several articles in the *Journal of Cultural Economics* on such topics as charging by museums, access to the arts and business sponsorship of the arts, and other articles in the *European Journal of Cultural Policy*, the *International Journal of Cultural Property* (forthcoming) and the *Economic and Social Review*.

Tim Owen works for Resource: the Council for Museums, Archives and Libraries, where he is responsible for liaison with central government. He was previously Head of Policy and Communications at the Library and Information

Commission. He began his career in the 1970s at Westminster Central Reference Library, moved to the City Business Library and subsequently became Principal Information Officer at the London Research Centre. Active as a journalist and trainer, Tim was for several years a feature writer for *Information World Review*, and helped form the Coalition for Public Information, a pressure group devoted to improving the quality of information for citizens.

Sara Selwood is the editor of the journal *Cultural Trends* and Quintin Hogg Research Fellow, School of Communication and Creative Industries, University of Westminster. One of the co-authors of *Culture as Commodity?* (PSI, 1996), she was previously Head of the Cultural Programme at the Policy Studies Institute, and before that worked in the subsidised visual arts sector. She has published widely on the visual arts, museums and galleries, and cultural policy as well as carrying out research for bodies as diverse as the Department for Culture, Media and Sport, Resource and the Arts Council of England and several national museums and galleries, in particular the Tate.

Gareth Stiven is a graduate of the University of Canterbury and Massey University in New Zealand. Before working as an economic assistant for the Department for Culture, Media and Sport in the UK he held a variety of government-sector economic posts in New Zealand, including for Statistics New Zealand and the Bank of New Zealand, as well as in the private sector.

Peter Symon is a Lecturer in the Centre for Urban and Regional Studies, School of Public Policy at the University of Birmingham. His research interests are the role of the cultural sector and creative industries in urban and regional development, the music industry, arts festivals and the leisure economy. He has recently carried out research work in the West Midlands, Scotland and the Netherlands.

Barry Thomas is a Reader in the University of Durham Business School. He has held posts in several other UK universities. His main interests are in labour economics, and the economics of tourism, the arts and heritage. He has written (or co-authored) several books and numerous articles in academic journals and chapters in edited books. He has been a consultant to the European Commission, the European Court of Auditors, various government departments and agencies, private-sector organisations, and has been an expert witness to Parliamentary Select Committees.

Adele Williams is working towards a PhD on the social impacts of participation in popular music, based at the Centre for Urban and Regional Studies at the University of Birmingham. Research interests include popular music, community arts, community music and the uses of arts in regeneration initiatives.

1
Introduction and Observations

Sara Selwood, University of Westminster

To have a society in which there is no government support for the arts or culture would be a very barren civilization. Of course, there are many cultural activities that can thrive and survive on their own: the popular music industry is a fine example. But there are others, which involve innovative or difficult or new or esoteric work, where public subsidy is entirely justified.

(Smith, 1998: 18)

This book is not about the state of our civilisation, so much as what arguably makes it fruitful and productive. *The UK Cultural Sector: Profile and Policy Issues* is about those arts and cultural activities which are deemed unable or unlikely to thrive or survive on their own. It covers the built heritage, film, libraries, literature, museums and galleries, the performing arts, public broadcasting and the visual arts – the various domains which fall within the remit of the Department for Culture, Media and Sport (DCMS). It describes how much subsidy those various domains receive, where it comes from, what it's intended for, how it's distributed, how organisations in receipt of it operate financially, whether the sector as a whole looks any different now from how it did before, and the relationship between those cultural activities that can thrive and survive on their own and those that can not.

In covering this territory, the book provides a picture of the sector which is drawn from several different perspectives. It includes data provided by those who provide the subsidies, and by organisations which receive them, plus analyses and interpretations from a range of professionals and commentators who work in or around the sector.

Overview: researching the cultural sector

The most complete data on the subsidised sector are provided by the funders themselves. A collation of their accounts and evidence of their grant-giving suggests that, in 1998/99:

- The sector attracted a total of £5,487 million worth of support. This includes streams of funding from the usual sources – DCMS, the Scottish, Welsh, and Northern Ireland Offices, local authorities, the National Lottery and business sponsorship – as well as other sources, usually overlooked: other government departments, charitable trusts and foundations; higher education institutions; Europe; tax forgone and funding dedicated to regeneration.
- The main funders – DCMS, the Scottish, Welsh, and Northern Ireland Offices, local authorities, the National Lottery, business sponsorship and the licence fee – provided £4,880 million in support. The BBC's licence fee alone accounted for £2,180 million. Without it, the total amount of funding to the cultural sector was £3,307 million.
- The sector appears to have been better funded in 1998/99 than in 1993/94. On the basis of the most reliable data available (those streams of income from DCMS, the Scottish, Welsh, and Northern Ireland Offices, local authorities, business sponsorship and the Lottery) its income increased by over £230 million (in real terms) from the £2,470 million it received in 1993/94 to £2,700 million in 1998/99. However, support from central and local government fell some £190 million in real terms (8 per cent).
- That difference is more than made up by the National Lottery, which provided £369 million in awards in 1998/99.
- Around a third of the sector's income (minus the licence fee) represented capital funding in 1998/99 (even though lottery capital funds would have contained some elements of 'operational revenues'). The situation in 1998/99 was, however, less extreme than it had been in previous years. In 1996/97, the year when lottery awards peaked, closer to 45 per cent of the sector's income was earmarked for capital spend.

However, relatively little is known about the workings of the sector from the perspectives of organisations in receipt of subsidy. The only regular research is that carried out by the Arts Council of England and the regional arts boards. However, their regularly funded organisations are far from being the norm. A survey carried out for this book covered a wide range of organisations – from national institutions with incomes in the millions to small volunteer-run organisations with incomes of less than £1,000. These findings provide the most comprehensive view of the sector as a whole to date. Responses to this survey suggest that:

- funding from public sources made up just over half of the respondents' income;
- the rest was generated thorough earned and unearned income and from private-sector sources;
- about half of respondents' expenditure was committed to their main activities (including their education programmes);
- spending on their main programmes outweighed spending on their education programmes by about 7:1;
- about half of respondents' administrative costs were accounted for by staff costs.

Inevitably, the organisations that we know most about are those which are the most likely to be in receipt of large public subsidies. And, whilst they may not be indicative of the sector as a whole, they nevertheless provide significant insights into what impact government and other bodies' policies and funding decisions might be having on the sector. A small group of organisations provided data about their operations in both 1993/94 and 1998/99, and several observations have been made on the basis of their reports. This group – only a tenth of the number of respondents overall – accounted for over a third of all public subsidies received, and around a third of all of respondents' income and expenditure. The evidence they provide confirms that:

- only a small number of organisations account for a large proportion of all subsidies;
- organisations have experienced reductions in their funding from both central government and local authorities; and
- there are marked changes in the way that these organisations spent their money, characterised by a shift away from spending on administration and employee costs to spending on programmes of activity. This is doubtless a response to the requirement of policy makers and funding bodies for organisations to increase access, improve their education numbers and achieve greater efficiencies – all of which have to be demonstrated by measurable outputs.

There are no statistics available on employment in the subsidised sector per se. However, the findings from the survey carried out for this book suggest that:

- the sector accounted for 198,000 permanent employees, 63,300 freelance or contract staff opportunities, and 55,440 volunteer opportunities; and
- comparisons with 1993/94 data suggest that more organisations are employing more permanent employees and becoming more reliant on volunteers.

Official sources inevitably produce bigger numbers, but they cannot distinguish between the subsidised and non-subsidised sectors. Data for spring 1999 suggest that 647,000 people had their main job in a cultural industry, cultural occupation or both. This marks a 14 per cent increase since 1995 – a rate nearly three times that of the growth in total employment.

About this book: coverage, structure and sources

Coverage

In many respects, *The UK Cultural Sector* explores much the same ground as the Policy Studies Institute's previous publication, *Culture as Commodity? The economics of the arts and built heritage in the UK* (Casey et al., 1996). It collates existing statistical and other available material on the subject, provides overviews and analyses of cultural funding and the financial operations of organisations in

receipt of funding, and presents that material in broad categories of cultural activity: the built environment (and, more specifically, the built heritage); film; libraries and literature; museums and galleries; the visual arts; the performing arts; and public broadcasting.

This book tracks changes that took place between 1993/94, the year covered by *Culture as Commodity?* (Casey et al., 1996), and 1998/99. The period covered effectively begins with the introduction of lottery funding and closes with the reorganisation of the cultural infrastructure, introduced by the DCMS to take effect from the beginning of the 1999/00 financial year. It embraces changes in thinking that run from the launch of the Arts Council of Great Britain's National Arts and Media Strategy, *A Creative Future* (1993), to the promotion of the creative industries (DCMS, 1998a)

However, *The UK Cultural Sector* also differs from its predecessor in many respects. It includes material from 25 contributors – academics, administrators, cultural economists, cultural analysts, civil servants, consultants and statisticians – representing a range of attitudes and approaches. So, it not only presents the perspectives of funding bodies and grant recipients, but those of a wide range of commentators. Their views on the subjects in hand differ, but precisely because of that they throw more light on them than is remotely customary.

This book also departs from *Culture as Commodity?* in that it places more emphasis on the context within which the subsidised cultural sector operates, and provides a greater depth of coverage on employment, funding from local authorities, regeneration sources and Europe, as well as taxes forgone. It also includes time-series data providing comparisons, where possible, between 1993/94 and 1998/99, or similar.

Structure of the book

The observations which follow this introduction set out some of the critical issues which are the focus of much of this book. The book is organised in four main parts: policies affecting the constituent elements of the cultural sector; public and private funding to the sector; the wider cultural sector, and its relationship to the subsidised sector, including employment in the cultural sector; and a detailed profile of the subsidised cultural sector. An afterword discusses some of the concepts underlying the principle of public subsidy of culture. The appendices contain lists of respondents to the survey and other investigations carried out during the course of research, plus technical information – how funding was identified and how the survey was carried out, as well as details of the different regional divisions used by various funders.

Sources and research

The basic research for this book was undertaken in much the same way as for *Culture as Commodity?*

- A review was carried out of published and unpublished documents produced since the publication of Casey et al. (1996), concerned with the financial operations of the cultural sector in the UK and policies affecting it.
- The amount of support going into the cultural sector was calculated on the basis of evidence from a range of sources, including central government, local authorities, business sponsorship and donations, trusts and charitable foundations, and Europe. Where possible, published sources are used, although occasionally references are made to unpublished data. (Appendix 1 describes how the details of such funding were collated.)
- As a matter of course, references are made to funding actually passed to organisations in the sector. However, where this was not possible, figures represent sums awarded – as in the case of data from Lottery distributors. In other instances, estimates were necessary – as, for instance, with respect to regeneration and European funding (Chapters 11 and 13).
- Organisations and individuals in receipt of subsidy during 1998/99 were identified from the annual reports and grant schedules of the sources described above. This population was sampled, and annual (audited) accounts requested. Details of income, expenditure and, where possible, employees were recorded. The processes involved are described in Appendix 2. The data assembled as a result of this exercise were combined with those gathered by the Arts Council of England and the regional arts boards through their annual survey of regularly and fixed-term funded organisations to produce the most comprehensive overview of cultural sector organisations to date.

The reference year for the research was 1998/99. In some cases, however, either 1998 or the organisations' own financial year most closely approximating to 1998/99 was used.

Observations

Whereas the previous pages and the introductions to each part of this book summarise the data presented and the various points covered, the following observations focus on some of the critical issues implied throughout *The UK Cultural Sector*. They are not only pertinent to this study, but inform our perceptions of the sector in general. Predominant among them are the shortcomings of the existing data, the difficulties of describing the subsidised cultural sector and locating it within a wider context, and the relationship between policies, subsidies and outcomes.

Constructing a financial profile of the cultural sector

Despite the quantity of data gathered in this book, constructing an overall profile of the subsidised cultural sector remains highly problematic and is subject to numerous caveats. At base, survey returns from 1,272 organisations suggested that in 1998/99 their combined turnover was £1,746 million. Of that, about 55

per cent was from public subsidies; around 30 per cent was earned; and the remainder would have come from private sources.

The amount of public funding received by those organisations represents about two-thirds of all public funds identified as having been distributed to the sector that year.[1] On the basis of the breakdown of survey organisations' income described above, a crude grossing up suggests that the funded cultural sector in general (but excluding the BBC and public libraries) may have generated as much as £1,500 million through earnings and attracted around £750 million from the private sector.

In terms of employment, a combination of data from museums and galleries, historic properties, the Arts Council of England and the regional arts boards regularly funded organisations suggests that some 65,000 people were employed in the sector in 1998/99. Adding libraries (Table 26.1) and the BBC (Chapter 30) brings this to more like 153,000. In all likelihood, the total number of people employed across the sector was higher.

Comparing the profile of the sector in 1998/99 with the 1993/94 figures is even more difficult. The overview of funding (Part II) and Chapter 23 on employment suggest that the sector received more public subsidy, employed more people and enjoyed a larger turnover than it had previously.

Thus, while the primary function of this book was to map empirically the funding of the cultural sector, it has to be said that the picture it creates is not perfect. In an ideal world, all the data needed to construct a profile of the cultural sector in the UK in 1998/99 would be accessible, robust and sufficiently consistent with previous years' data to allow historical comparisons to be made. Unfortunately, this is not how it is in practice.

Apart from the standard difficulties of producing time-series data, which are outlined in Appendix 1, some organisations are simply either more willing or more capable than others of making data available; some data are simply more reliable than other data, and some cultural and heritage activities are better covered than others (cf Part IV). Even the local authority financial data, described as from amongst the 'most reliable' sources (Chapters 10 and 14) are flawed (see Appendix 1). Some other data, such as the COSLA figures on local authorities' arts spend in Scotland, were still unavailable at the beginning of April 2001 when this book was being edited. Other data on European, regeneration and 'other' government departments' funding collected especially for Casey et al. (1996) and the present volume are, almost by definition, inconsistent. This means that comparisons cannot be made.

Data on attendances is no more satisfactory. A comparison of each of the chapters in Part IV indicates the extent of data available on the number of users and the differences in how that information is presented across the various artforms and heritage activities covered. Comparing the existing data across all those sectors is impossible, because strictly speaking, one would not be comparing like with like. The most comprehensive data set on arts attendances is the Target Group Index commissioned from BMRB (British Market Research Bureau)

1 Minus the licence fee, Foreign and Commonwealth Office funding for the World Service, tax concessions (see Tables II.1 and II.2) plus the costs of public libraries.

by the Arts Council of England. Each year data are collected from around 25,000 adults across Great Britain on the basis of questionnaires completed by 2,000 respondents each month. Summary findings based on the question 'About how often these days do you go to the following [arts events]?' were conventionally included in the Arts Council's reports under the headings 'plays', 'opera', 'ballet', 'contemporary dance', 'classical music', and 'art galleries/art exhibitions'. However, even this summary was absent from the *Annual Review 2000*. For copyright reasons it is only possible to refer to these published figures (see ACE, 2000:100) and copies of the data are only available to a highly restricted readership with the public realm. The research does not distinguish between attendances at subsidised and non-subsidised events.

More worrying, perhaps, is that the way in which data on relatively new sources of funding are being collected is not necessarily any better. There is, for example, no centrally held, consistent and definitive source of information on Lottery funding. Different sets of figures from the distributors and DCMS rarely match, as evidenced by the different totals given in Chapter 16 and Lottery figures used elsewhere in the text. Even official data has its shortcomings. The employment data, used by Creigh-Tyte and Thomas in Chapter 23, are as robust and consistent as they come – not least by comparison with industry data. But these same data are, unfortunately, insufficiently detailed to provide a picture of all the creative industries or of individual cultural sector activities. Moreover, the levels of detail available are not necessarily compatible with other official sources which would have enabled turnover or value added to be described.[2]

These kinds of difficulties have led to *The UK Cultural Sector* having two particular characteristics. One is that the profile of the sector can only be constructed piecemeal and that, consequently, comparisons can only be made with care. The other is that, given the amount of time it takes for data to be collected, processed and collated, the financial profile of the sector necessarily lags behind the development of policy. This book, consequently, tends to retrospectively contextualise data within a more advanced policy framework.

The wider context

However much the subsidised sector developed in the five years from 1993/94 to 1998/99, it remains dwarfed by the creative industries, which are reported to generate revenues of around £104 billion and employ some one million people (DCMS, 2001b).

DCMS defines the creative industries as 'those industries which have their origin in individual creativity, skill and talent and which have a potential for wealth and job creation through the generation and exploitation of intellectual property' (DCMS,1998a; 2001b). It recognises that the creative industries have 'a close economic relationship with tourism, hospitality, museums and galleries, heritage and sport', although some (the art and antiques market, crafts, film and video, music, the performing arts, television and radio) are more closely associ-

2 Personal correspondence with Paul Allin, Statistics Unit, DCMS.

ated with the subsidised sector than others. What DCMS refers to as the 'core activities' of the creative industries are associated with, if not central to, the concerns of the subsidised sector – the creation, production and exhibition of crafts; the production and exhibition of film and video; song writing and composition, and live performance of music, etc.

On the basis of their respective turnovers and national employment figures cited above, the subsidised cultural sector and the creative industries seem worlds apart. Spokespeople are, however, prone to blur the distinctions between the one and the other, not least in the context of advocacy (see, for example, Smith, 1998; Robinson, 1998: 8). Indeed, there is political mileage to be gained in highlighting the relationship between the two sectors. But, it is also the case that the relationship is far from easy. Since the mid-1980s the arts funding system has been threatened by the implications of the concepts of the 'cultural' and 'creative' industries. Justifications for subsidy have increasingly been couched in terms of the earning capacity and likely economic contribution of the arts (ACGB, 1988a; 1988b; Smith, 1998). However, few – if any – attempts have been made to scrutinise the nature of the dynamic between the subsidised cultural sector and the creative industries.

Despite its responsibility for leading cross-government support for the creative industries and for the stream of subsidy to the cultural sector, DCMS itself has never attempted to interrogate the relationship between the creative industries and the subsidised sector. Yet, according to the former Secretary of State for Culture, Media and Sport, one of the reasons for subsidy is precisely to support the creative industries.

> *There are, I believe, five principal reasons for state subsidy of the arts in the modern world: to ensure excellence; to protect innovation; to assist access for as many people as possible, both to create and appreciate; to help provide the seedbed for the creative economy; and to assist in the regeneration of areas of deprivation.*
>
> (Smith, 1998: 18–19)

If subsidies are regarded as providing a seedbed for the creative economy, it would be reasonable to consider tracking the precise nature of their contribution – not least, to lay secure foundations for the further development of strategic policy making and for the targeting of funding. Take employment. If, as it is often maintained, the subsidised sector provides a base for creativity and employment in the creative industries, it should be possible to track movement between the sectors. But, in practical terms, this is impossible because data on employment in the subsidised sector cannot be disaggregated from data on employment in the creative industries generally.

While chapters on the policy and profile of the film and public broadcasting (Chapters 3 and 25; Chapters 8 and 30) assume a blurring of distinctions between the subsidised sector and the creative industries, other contributions to this book have sought to analyse aspects of the relationship between the two sectors. Garnham (Chapter 34), for instance, considers the policy context within which public support for the cultural sector in general takes place; Feist (Chapter 19)

tracks points of common ground between the subsidised cultural sector and the creative industries in relation to the performing arts; and, O'Hagan and Neligan (Chapter 21) touch on the role of the subsidised cultural sector as a seedbed for the commercial theatre.

A major obstacle, if not *the* major obstacle, to quantifying the relationship between the subsidised cultural sector and the wider, creative industries is the fact that the existence of the subsidised cultural sector per se is rarely acknowledged. DCMS, which has been closely identified with the creative industries since its foundation,[3] for example, rarely refers to the subsidised cultural sector as such, preferring to allude to the more ambiguous 'cultural framework' (DCMS, 1998b) or the arts funding system (Smith, 1998). In its Green Paper, *Culture and Creativity* (DCMS, 2001), it describes the distincions between the commercial and the subsidised as 'false'. Nevertheless, it remains the case that some cultural activities are subsidised and others are not, and it is those that are subsidised which constitute the focus of this book.

Public subsidy and the cultural sector

The term, 'subsidy' is something of an anathema. 'Subsidy' effectively disappeared from the lexicon of cultural bureaucracies in the 1980s when the notion of subsidy as 'welfare' ceased being regarded as politically correct and the semantics of business and managerialism were introduced. This was when funders began to 'invest', 'sponsor' and 'support'. At about the same time the term 'audiences' was deemed too passive for people who made choices and constructed meaning, and the terms 'participants', 'customers', 'consumers' and, subsequently, 'users' came into common usage.

The question of what the subsidised cultural sector comprises is a vexed one. The working definition used in this book can be found in Appendix 1, although in order to highlight the differences between the subsidised cultural sector and the creative and commercial performing arts, Feist (Chapter 19) uses a more exclusive definition.

To some extent, the constituents of the subsidised cultural sector are likely to change with respect to funding policies. Indeed, the remit and conditions of cultural subsidies have changed over the years. As Creigh-Tyte and Stiven note in Chapter 18, 'government interventions' are ultimately directed at organisations unlikely to 'thrive' or 'survive' on their own: whilst the arts funding system may argue that it never has enough, subsidised organisations have for some time been expected to generate some degree of income as a necessary condition of funding. In England, for example, the conditions of the Arts Council's distribution of grant funding have, over the past 30 years, shifted to accommodate economic and political realities alongside the centrality of artists themselves. Indeed, the tensions which informed the Arts Council of England's recent emphasis on audiences and

3 DCMS (1997). The press release which announced the renaming of the Department of National Heritage as the Department for Culture, Media and Sport, also pronounced the establishment of the Creative Industries Taskforce.

readers (as opposed to artists and writers) in the mid-1990s are highlighted in the chapters on visual arts (Chapter 9) and literature (Chapter 27). In recent years, changes in Arts Council priorities have been manifest in its support of employment creation schemes, as in the case of its £2 million grant to Kirklees Media Centre (Robinson, 1998); interventions in areas formerly considered to be other government departments' responsibilities (as in interim funding for dance and drama students, or the New Deal); its greater emphasis on 'consumers' (making the arts accessible), and its development of strategic initiatives via schemes not necessarily open to applications.

While many subsidies from cultural funders are directed at non-cultural recipients (Appendix 1), the subsidised cultural sector itself also receives some funding (albeit a relatively small amount) from non-cultural funders which is intended to meet non-cultural objectives. Examples covered here include regeneration funds, targeted at the economic, physical and social regeneration of urban areas (Chapter 11) and funding from the European structural funds, intended to address economic imbalances in disadvantaged areas of Europe (Chapter 13). There are, of course, also tax concessions (Chapter 15) which are not conventionally counted as a form of subsidy.

Outcomes

The UK Cultural Sector identifies some £5,289 million of public sector funding as going to the cultural sector (Introduction, Part II). It also presents a detailed overview of the financial workings of the subsidised cultural sector, contextualised by policy issues. It is hardly surprising, therefore, that this book should implicitly also raise questions about the outcomes of cultural subsidies. Does cultural funding produce the results intended by funders? What difference does funding make to the sector itself or to the wider world? In short, what are the ramifications of subsidy?

By definition, the different pockets of funding covered in this book tend to have different intentions. Not all are necessarily compatible. And some funders – the DCMS, for example – are more concerned than others to assess the outcomes of their support. According to the former Secretary of State for Culture, Media and Sport:

> *This subsidy is not 'something for nothing'. We want to see measurable outcomes for the investment which is being made. From now on, there will be real partnership with obligations and responsibilities.*
>
> (DCMS, 1998b)

The Department itself and its sponsored bodies are committed to excellence; innovation; access for the many; promoting the creative industries; and assisting in the regeneration of areas of deprivation. Given that the DCMS is directly and indirectly responsible for the largest tranches of subsidy to the cultural sector, it seems reasonable to ask: to what extent are its objectives being delivered?

The degree to which the relationship between policy, funding, and the achievement of policy or strategic objectives is discernible is, as yet, unclear. Despite the instigation of DCMS's targets, funding agreements, earmarked pockets of funding (such as New Audiences or free admission to national museums and galleries) and the establishment of QUEST (the Quality, Efficiency and Standards Team), no evaluations of the extent to which grant funding is delivering policy objectives have been published in the UK beyond the quantitative measurement of certain aspects of cultural organisations' performances. Indeed, up to 1998/99, museums and galleries and the arts funding system had successfully managed to avoid performance measurement (Selwood, 2000).

Changes in cultural policy might be expected to have led to major changes in the constituency of the subsidised cultural sector. But the portfolio of DCMS-sponsored bodies is essentially static, and the core body of organisations supported by the arts funding system changes very little. This presumably reflects a desire for years of investment to ensure 'excellence'. But to what extent has the subsidised sector changed from being funding-led to being policy-led? Have those portfolios of historically sponsored bodies shifted to delivering policy rather than dictating it? Does the cultural funding system perpetuate its own client base, or can those core institutions ultimately be regarded as catalysts of change? Will the collection and analysis of performance indicators make any difference? Are the relatively large amounts of funding delivered through capital lottery projects necessarily expected to deliver relatively larger changes than the smaller amounts expected from revenue funding?

Several chapters in this book lay foundations for interrogating claims about the relationship between policy, funding and outcomes. O'Hagan and Neligan (Chapter 21), for example, consider innovation and diversity in the subsidised and commercial theatre sectors; Johnson and Thomas (Chapter 20) reflect on the substance of reports on the economic impact of the arts; the various art form chapters (Part IV) examine the extent of visits and usage. These chapters also raise questions about the relationship between policy, cultural activities and evaluations. To what extent are economic impact studies useful? Can they assess economic regeneration? Is it appropriate for economic measures to even be applied to arts venues or events intended to meet social or cultural, as opposed to economic, objectives? What are the policy implications of the finding that museum visits across the board have plateaued if not declined (Chapter 28)? Indeed, how reliable are the data that have led to these findings? Are the funding practices of the arts funding system actually encouraging the production of new work?

These are pertinent questions. DCMS's projected figures (DCMS, 2001a and Table 18.1) suggest that more will be spent on the cultural sector in the future. Given the government's insistence that subsidies carry obligations, the prospect of increased subsidy implies even more in terms of formal commitments. Whether or not the academic research agenda for the future is concerned with piecing together data which describe the scale of public subsidies to the sector, it may be the case that the DCMS, under its new Secretary of State Tessa Jowell, has to concern itself with evaluating the extent to which those subsidies are delivering their objectives.

Part I
Policy Issues

Introduction

Sara Selwood, University of Westminster

The advent of resource accounting across government will ensure that DCMS ties its expenditure to its objectives, and we will need to be assured that public money is being used appropriately to meet public objectives.

(DCMS, 1998b)

Public subsidies for the cultural sector do not exist in a vacuum. Policies theoretically influence funding decisions, which affect the kind of grants made available, which in turn shape the nature and output of subsidised organisations. As far as possible, all eight chapters in this part of the book describe those central government and other policies which impacted to varying degrees on individual artforms and heritage activities between 1993/94 and 1998/99 (see Part IV, Profile). This introduction serves as a preamble to those accounts by providing an overview of the cultural policies and strategies published at that time.

The period 1993/94 to 1998/99 is one of transition – the end of the old order and the beginning of a new. Central government's attitude to culture was previously essentially distinguished by the principle of 'arm's length' agreements and a policy vacuum. Consequently, most government direction was exercised through such bodies as the Audit Commission, the Arts Council of England, the Museums & Galleries Commission, etc. More recently, however, central government's attitude has been characterised by the publication of an unprecedented number of reviews, policy and strategy documents, and top-down monitoring of funding bodies as well as of the organisations they support.

The transition between the two periods is perhaps best exemplified by a dilemma which arts organisations, in particular, are increasingly having to face. In 1993 the arts funding system advocated the right of organisations to be funded to fulfil their own aims (ACGB, 1993) and upheld their 'right to fail'. Five years on, the Arts Council was still encouraging 'artistic risk-taking' (Robinson, 1998). But, by then the government was seriously considering how to contain the fallout and insisting on organisations' 'need to identify and manage the risks inherent in any decision to commit resource and effort into achieving their stated goal' (QUEST, 2000).

In the period leading up to the 1997 election, the Department of National Heritage (DNH) broke the mould and published several reviews, paving the way for strategic

developments instigated by the Department for Culture, Media and Sport (DCMS), particularly in the fields of museums, and libraries. These included: *Treasures in Trust* (DNH, 1996b); *A Common Wealth* which DCMS republished (Anderson, 1997;1999); and, *Reading the Future* (DNH, 1997). In much the same way, the principles of the DNH's Planning Policy Guidance 15 on the historic environment (DoE/DNH, 1994) served as the basis of the recent review on the built environment (EH, 2000). The DNH also highlighted issues around access and education – concerns which were to become central to the operations of DCMS. These were manifest in a series of reviews (DNH, 1996a; Pieda, undated; Harland et al., undated), and changes to the Lottery directions which enabled participatory schemes such as Arts for Everyone to take place (see Chapter 16). Moreover, it encouraged (even if it didn't actually exploit) the development of performance measures in the publicly funded cultural sector (Selwood, 2000).

Conceivably, the most important of all the reviews published between 1993/94 and 1998/99 was DCMS's *A New Cultural Framework* (DCMS, 1998b). This followed the Department's own *Comprehensive Spending Review* (1998a) and examined its own role as well as its structures of support for the arts, museums and galleries, libraries and archives, film, and the built heritage. Although much of what *A New Cultural Framework* proposed was not formally instigated until April 1999, many of the changes it encapsulated had already been proposed – if not by the Conservatives prior to the 1997 general election, then by Labour itself whilst still in opposition.

A New Cultural Framework had several functions: to establish a new role for DCMS, 'giving it a more strategic place in the complicated structures of cultural policy and funding'; to spell out the new terms and conditions of the relationships between the Department and its sponsored bodies, most notably in terms of 'the delivery of appropriate outputs and benefits to the public'; to streamline the Department's delivery of policies and programmes; and to raise standards of efficiency and financial management across its sectors. Ultimately, the Department's desire to play a more strategic role in cultural policy and funding determined its other initiatives.

The rationalisation of the 'cultural framework' resulted in the establishment of new single national bodies for the arts and crafts (the 'new' Arts Council – see Robinson (1998)); the built heritage (the 'new' English Heritage created by the merger of English Heritage and the Royal Commission on the Historical Monuments of England – see EH (undated)); architecture (the Commission for Architecture and the Built Environment which subsumed the Royal Fine Art Commission and the Arts Council's funding role); film (the Film Council); and, museums, galleries, libraries and archives (Resource: the Council for Museums, Archives and Libraries, which was developed as a result of the merger of the Museums & Galleries Commission and the relatively recently established Library and Information Commission).

While the Department's own objectives and measurable efficiency and effectiveness targets were articulated in its *Public Service Agreement* (DCMS,1999), *A New Cultural Framework* laid the foundations of its relationship with its sponsored bodies subsequently formalised in their funding agreements. This chain of agreements placed 'obligations' and strategic responsibilities on those organisations. Their funding allocations (like other grant programmes) were tied to the delivery of outcomes – increased outputs, improved access and efficiency, and increased private sector support – reflecting the Department's four central themes of access, excellence and innovation, education, and the creative industries. And, to ensure that the system worked, DCMS established a watchdog, QUEST (Quality, Efficiency and Standards Team), to scrutinise and improve standards of efficiency and promote quality across its sectors.

In the event, the government's surveillance of the cultural sector has extended further than either DCMS or its sponsored bodies' immediate spheres of influence. In order to improve the management of public libraries – and taking a lead from *Reading the Future* (DNH, 1997) – the Department required local authorities to submit Annual Library Plans. Moreover, the introduction of Best Value (in April 1999; see Chapter 14) has already served to highlight the performance of local authorities' statutory and non-statutory cultural services. In *A New Cultural Framework*, DCMS also described its intention to establish a stronger regional focus for its policies and programmes and to achieve a greater level of coherence between cultural activities in the regions by the establishment of strategic cultural consortia. The announcement of the delegation of clients from the Arts Council of England to the regional arts boards (leaving with the national companies, companies with a national remit and touring) was identified as part of that process, although delegation had already been in train since 1984 if not before (ACGB, 1984; Moody, 1997).

The implications of much of what was articulated in *A New Cultural Framework* were thus apparent to subsidised organisations well before DCMS's new policies came into effect, as the following chapters show.

2
The Built Environment

Michael Coupe, English Heritage

The historic environment helps to define a sense of place and provides a context for everyday life. Its appreciation and conservation fosters distinctiveness at local, regional and national level. It reflects the roots of our society and records its evolution.

(EH, 1997)

The component features of the built heritage embrace the human-made historic environment – historic buildings, ancient monuments and archaeological sites, industrial buildings and historic wrecks. However, this overview is not confined to stand-alone 'attractions' such as individual buildings, sites and monuments. Instead it embraces the whole of the public realm, including incidental open space and urban parks.

Background to policy development

Heritage and the cultural sector

Historic buildings and areas are part of the cultural sector: museums and galleries are frequently accommodated in historic buildings; visits to historic houses are a key focus for potential visitors to the UK; and the Regional Cultural Strategies, devised as a result of the Department for Culture, Media and Sport (DCMS) 'new cultural framework' (DCMS, 1998) all include a significant heritage component.

However, historic buildings are, more often than not, lived in, used commercially, and can be bought and sold on the open market. The historic environment is afforded a measure of protection on account of its cultural importance, and works to buildings and monuments are regulated by the processes and policies laid down by national and local government. In the absence of viable use, subsidy is normally required, either through grants or through some form of 'enabling' development, to keep historic buildings in good repair.

Special heritage controls

In 1990, as a result of the consolidation of the planning legislation in the Town and Country Planning Act 1990, land-use planning controls were detached from the specific controls relating to historic buildings and areas, contained in the separate Town and Country Planning (Listed Buildings and Conservation Areas) Act 1990. This legislative split was echoed in 1992 with the creation of the then Department of National Heritage (DNH), dealing with heritage and cultural matters. This left planning with the Department of the Environment (DoE). Because development affecting heritage features usually requires planning permission, as well as triggering other specialist controls (such as listed building consent, conservation area consent, and scheduled monument consent), since that time regulatory controls for the historic environment have, therefore, been divided between two government departments – now the Department of the Environment, Transport and the Regions (DETR), and the Department for Culture, Media and Sport (DCMS).

UK heritage bodies

Since 1984, responsibility for the built heritage in England has rested with the 'next steps' agency, the Historic Buildings and Monuments Commission, popularly known as English Heritage (EH). As the government's statutory adviser on all matters to do with the historic environment, EH operates at arm's length from government, but is still answerable to Parliament through ministers. Following its merger with the Royal Commission on the Historical Monuments of England in April 1999, EH for the first time became the official lead body for the historic environment in England.

By contrast, the comparable agencies for the rest of the UK – Cadw within the National Assembly for Wales; Historic Scotland, as part of the Scottish Executive; and the Environment and Heritage Service: Built Heritage, within the Department of the Environment, Northern Ireland – all still operate as part of government. They are increasingly likely to promote local variations in policy and practice as a result of the developing aspirations of the newly devolved national government institutions within the UK.

UK policy on heritage

At present, both the legal framework and the provisions for policy and procedure are broadly consistent across the whole of the UK, although there are some significant differences in practice. The earlier establishment of area-conservation grant programmes in England has not only improved conditions relative to the other home countries, but influenced the distribution of Lottery funds within the UK (see Chapter 16).

Guidance on government policies relating to the historic environment, including the application of specific Acts of Parliament covering both planning and the

special controls for heritage components (listed buildings, conservation areas and scheduled ancient monuments) is broadly compatible in all the home countries. Each country provides separate guidance – mainly through planning policy guidance notes (PPGs) in England; Circulars and Technical Advice Notes in Wales; Technical Planning Policy Guidelines, a Memorandum of Guidance in Scotland; and Planning Policy Statements in Northern Ireland.

In England, current policy guidance for archaeology dates from 1990, and PPG 16 on Archaeology and Planning, is one of the earliest PPGs still extant in its original form (DoE, 1990). Guidance on all other heritage features is contained in PPG 15, Planning and the Historic Environment (DoE/DNH, 1994). The policy framework laid down by PPG 15 includes the following points.

- The continued use of an historic building is the best guarantee of its preservation, preferably in the use for which it was originally designed. But, acceding to the idea that new uses may be acceptable, and by applying a test of financial viability, PPG 15 tacitly acknowledges that the upkeep of an historic building may involve additional costs (the so-called 'heritage burden'), to be covered by enabling development (for example, for a new and more profitable use, or perhaps by development in the grounds) or, where this is unacceptable, by an element of public subsidy.
- Deferred maintenance is usually the prime cause of dilapidation and disrepair. Consequently, planned maintenance plays an important role in pre-empting both more expensive repair work later on and last-ditch enabling development solutions which usually involve an undesirable loss of historic fabric and a diminution of the special interest of the building.
- Conservation and development are not necessarily mutually exclusive: such interests can usually be reconciled, adding value in the process.
- The historic environment has a vital role to play in creating attractive places in which to live, work and play, and to visit.
- It is recognised that environmental quality helps to promote economic prosperity by positively influencing inward investment decisions. This link underpins much of the recent advocacy of conservation-led regeneration as a key component in realising urban potential and furthering the recommendations of the Urban Task Force Report (Urban Task Force, 1999).

Each of these policy strands has financial implications On the one hand, an emphasis on planned maintenance and 'stitch in time' repairs might reduce the need for subsidy and, to that end, the PPG also specifically calls on public authorities to set an example to others through better stewardship of their own buildings. On the other hand, the notion that the historic environment acts as a catalyst for urban regeneration makes it easier to target mainstream government sources, such as the Single Regeneration Budget, to subsidise repair and enhancement works (see Chapter 11).

Through a succession of Conservative governments, there was growing acceptance of the added-value effects of conservation, and a new emphasis on environmental quality as an essential ingredient of a successful local economy (as in DoE, 1995). Set against this, however, and to some extent militating

against the ability of the heritage sector to capitalise on its role in promoting conservation-led regeneration, was the fact that the line to government lay through the DNH, rather than through the DoE. Consequently, English Heritage, unlike fellow environmental agencies, cannot rely on close links with the principal ministry most closely concerned with planning and environmental matters. As a result, there has been a gradual weakening of heritage interests within mainstream government policy. This is most notably marked by a failure to accept the 'green' credentials of the historic environment, or to appreciate its relevance to the application of sustainability principles (such as the preference for adaptive re-use of existing buildings over an unthinking resort to demolition and redevelopment).

With the new Labour government returned after the 1997 election, conservation bodies were faced with the need to re-establish the rationale for continued support of heritage policies and priorities. They sought to do this initially through their submissions to the Comprehensive Spending Review which the government had embarked upon as a means of realigning departmental expenditure plans to accord with new priorities. The outcome of this review reinforced the view that the government's 'modernising' agenda did not fit particularly well with the aspirations of the heritage sector (DCMS, 1998). It was not so much that the government was actively hostile, but rather that the historic environment appeared not to merit a particular priority in government programmes. Moreover, the renaming of DNH as DCMS seemed somewhat unpropitious, and raised fears of a resurgence of traditional criticisms of the heritage sector as élitist, backward-looking, a block on development and a cause of delay (*Independent on Sunday*, 1998).

Faced with the effects of shortfalls in government funding, since 1992 English Heritage had sought to improve its efficiency and generate more income from its own activities. It also became more strategic in the use of grant funding. Buildings were still repaired and areas upgraded, but grants were correlated more closely with need, and leverage was capitalised upon, both in terms of triggering other sources of funding and in securing improvements in the conservation services provided by local authorities.

There was also a conscious shift of emphasis within English Heritage, as in the wider heritage community throughout the UK. Attention was drawn to the outputs deriving from its various activities, which already aligned well with emerging national policy objectives (such as economic development, sustainability, urban renaissance and social inclusion), and to attune those activities even better to government priorities.

The new emphasis on making better use of existing built-up areas, as a means of achieving more sustainable patterns of development and of limiting the encroachment of development on to greenfield sites, was immediately perceived as an area in which the historic environment could, and should, play a key role. The messages of EH's report, *Conservation-led Regeneration* (EH, 1998) were echoed in the report of the Urban Task Force (1999), and its subsequent research report, *The Heritage Dividend* (EH, 1999), which was independently verified, provided the necessary evidence to back EH's assertions. This demonstrated the potency of EH's area conservation grants, operated in partnership with local

authorities, in helping to deliver key outputs aligned closely with the government's national policy objectives.

Following a recommendation from the House of Commons Select Committee on Culture, Media and Sport, DETR and DCMS asked English Heritage 'as the lead body for the historic environment' to 'consider current policies relating to the historic environment and to propose ways in which these might need to be further developed' (HoC, 1999). In setting the framework for the review, ministers affirmed the general principles of PPGs 15 and 16, but identified a number of policy areas which merited attention, including 'the scope for further streamlining the regulatory framework', the 'relationship between tourism and the historic environment' and 'the role of the historic environment in promoting regeneration and social inclusion'. The review was submitted to government in December 2000.

In the event, the Select Committee recommended that more Lottery money be spent on historic buildings, and called for a reduction from 17.5 per cent to 5 per cent in the rate of VAT applicable to refurbishments for housing purposes (HoC, 2000; see also Chapter 24). The fact that the review was jointly commissioned by DETR and DCMS, and that ministers requested an examination of 'the interaction between heritage policies and policies relating to the natural environment' (Howarth, 2000), provides a good basis for pressing for better links with DETR. Indeed, it would be surprising if this did not emerge as a key issue, given the importance of harnessing the attributes of the historic environment to 'support economic and social renewal and to involve [local communities] in creating the environment in which they choose to live and work' (EH, 2000). The review also called for the equalisation of VAT as between planned maintenance/repair and new building, a key recommendation of the Urban Task Force report which, if implemented, could eventually reduce the need for subsidy to support the historic environment. Similarly, the review picked up on the House of Commons Environment, Transport and Regional Affairs Committee's support for conservation-led regeneration and the need for English Heritage to be adequately funded for that purpose, which was contained in the Committee's report on the 'Proposed Urban White Paper' (HoC, 2000).

3
The Film Industry

David Hancock, *Screen Digest*

While the private sector is the key to expanding and sustaining a healthy and creative film industry, government policy nevertheless creates the conditions necessary for the sector to flourish. This involves taking risks and committing investment, as is happening in the UK at present. As a result of policies adopted in the second half of the 1990s, the UK film industry has now much improved on its demoralised state of the early 1990s.

During the period covered by this study, policy and systems of support for the film industry were mainly developed by the Labour government which came to power in 1997. However, previous Conservative governments, led by Margaret Thatcher and John Major, sowed the seeds for the current period of relative success for the British film industry.

Government policy for the film industry in the UK has revolved around three particular areas, as discussed below:

- Lottery funding introducing the film franchise scheme, funded by the Lottery and administered by the Arts Council and, later, the Film Council;
- encouraging large-scale film and television productions into the UK, with initiatives such as tax breaks and Film Export UK; and
- reducing the complexity of film-making bureaucracy, and re-defining the British film.

Lottery funding

The notion of using the National Lottery for an ambitious programme of public funding for the UK film industry based on the funding of film franchises was introduced by the Conservatives, and ultimately implemented by the Labour government of 1997. Industry professionals were asked to produce consortia and bid for the few franchises on offer. The aim was to build links between the different strands of the industry. The best consortia would have access to fast-track guaranteed funding for feature films over a fixed period of time. The Secretary of State for Culture, Media and Sport announced the awards at the Cannes Film

Festival in spring 1997.Three consortia shared over £90 million for a slate of projects to be produced over five years. The Lottery money represented about 20 per cent of their films' budgets, which totalled £450 million. The three winners were Pathé Productions (£33 million), The Film Consortium (£30.25 million) and DNA Film Ltd (£29 million).

Franchise bidders were obliged to include distributors in the consortia as well as other producers.The scheme was innovative in that it encouraged a vertical alignment between script, production and distribution and was intended to create vertically integrated structures over the period of the franchises, which could continue to exist as stand-alone units after the scheme ends.

The key issue for the Lottery franchise scheme remains the commercial viability of the projects funded.There are concerns about the limited commercial success of Lottery-funded films. In assuming the Arts Council of England's responsibility for film funding, the new Film Council was quick to revise guidelines and criteria for films passing through the franchise pipeline.

Eurimages

Eurimages is the pan-European co-production fund based in Strasbourg and part of the Council of Europe. Before Lottery money came on stream, Eurimages was a key source of funding for British films (on the basis of co-productions with other member states). However, the UK unexpectedly withdrew from the fund in December 1995.

Since leaving Eurimages, the UK has developed policy towards encouraging US producers to shoot and post-produce films in the UK. This has also succeeded in attracting European producers to the UK, looking for a bridgehead with the North American market – conceivably vindicating the decision to pull out of Eurimages in the first place. The European Co-Production Fund, run by British Screen, was previously the only port of call for pan-European public production funding. Although the European Co-Production Fund was wound up when British Screen was absorbed into the Film Council, the Council is seeing through the projects that were funded by ECF and has committed to at least 20 per cent of its production and development funds being invested in European production.

Tax breaks and other incentives

Tax breaks are of major concern to film industry professionals lobbying for wider government support. The fiscal environment is a strong factor in the health of the UK film industry. Tax breaks encourage local production and, equally importantly for the UK, also encourage overseas producers to bring their projects to the country. In 1998, over half the investment in the British film industry came from a few big-budget US productions (BFC, 2000). Without this expenditure, employment and turnover would be considerably less, and the industry would be operating on half capacity. In 1997, Gordon Brown, as the new Chancellor of the Exchequer, introduced a 100 per cent write-off on production and acquisition

costs for projects of less than £15 million in his first Budget. The cost to the UK Treasury in lost tax was estimated at around £30 million, but this was offset by forecasts of a £300 million improvement in the country's balance of payments from boosted film exports. Treasury figures showed that over 10,000 jobs could be created if the anticipated increase of one third in total industry investment is forthcoming. Up to 1998, this one-third increase had not been achieved and in fact overall investment actually dropped between 1997 and 1998 (Hancock, 1999). However, production investment rose by 36 per cent between 1998 and 1999 and the tax breaks were extended until 2002 in the 1999 Budget, and until 2005 in the 2001 budget.

The government also established an export agency, Film Export UK (in 1999), intended to work on issues such as credit export guarantees, international copyright and generic marketing of British film abroad. Film Export UK is administered by the trade body of film and television producers PACT (Producers' Association for Cinema and Television), and is composed of UK sales agents.

Infrastructure of the British film industry

Another long-discussed change was the merging of several public film bodies into a unified agency, known as the Film Council. This body acts as umbrella to the British Film Institute (BFI), British Screen Finance, British Film Commission and the Arts Council of England's Lottery funding operations. The idea was floated in September 1997 and was adopted as policy a year later. The body has been operational since April 2000.

A major review of the film industry was set up by the Secretary of State for Culture, Media and Sport immediately after the 1997 general election, concluding in spring 1998 with a report entitled *The Bigger Picture* produced by the Department's Film Policy Review Group (DCMS, 1998). The process involved a wide-ranging analysis of the film industry and recommended actions for the future, which included: support for development, distribution, marketing and training schemes; a redefinition of a British film; the establishment of an export agency; and calls for accurate, up-to-date and comprehensive information on the industry.

One of the report's proposals was to introduce a voluntary All Industry Fund as a way of encouraging voluntary contributions to support development, distribution, marketing and training schemes, as opposed to production. In the event, the scheme failed because some players refused to contribute and it was considered unfair to ask some to contribute when others wouldn't. However, another voluntary training fund has had more success as the lessons from the former scheme were learnt. The government launched the Skills Investment Fund in September 1999. This fund was intended to be worth £1.5 million a year, raised from voluntary contributions from film production budgets. Even though participation in the fund is notionally voluntary, access to funding through the new Film Council is dependent on contributions. The Skills Investment Fund will finance training in various technical and commercial aspects of film-making, including camera and sound work, editing and production, artwork and set design (Hancock, 1999).

From summer 1999, the definition of a British film was changed via secondary legislation to alter the Schedule of the British Films Act 1985. The object of this exercise was to simplify and standardise eligibility criteria, ultimately making it easier to invest in the UK film industry. The changes to the definition introduced the notion of 'production activity', of which 70 per cent must be undertaken in the UK. This replaces the old system of 'playing time', whereby proportions of expenditure in various areas had to match pre-ordained percentages of the total production budget. The new rules essentially mean that to qualify as British – and benefit from resulting tax breaks – a film must be made mainly in Britain. In addition, 70 per cent of overall labour costs must be spent on British, European or Commonwealth citizens.

Last but not least, the Film Policy Review Group concluded that its review was 'hampered by the shortage of accurate, up-to-date and comprehensive information on the performance of the film industry' (DCMS Film Policy Review Group, 1998). There are various organisations working on data collection and provision, in both public and private sectors, but there is no central information point for regular and accurate data on the film industry. The disparate nature of the sources creates problems with timing, methodology and coordination. In other European countries, notably France, information collection is a central part of the activities of the national film agency (the CNC, Centre National de la Cinématographie). This is an area that is being addressed by the Film Council.

4

Libraries

Tim Owen, Resource: the Council for Museums, Archives & Libraries

Evaluating library services

Public libraries have been a statutory service in England and Wales for over 35 years under the Public Libraries and Museums Act 1964, and there are equivalent measures for Northern Ireland and Scotland. Nearly 60 per cent of the population holds public library membership, and visiting the library is our fourth most popular leisure activity (LIC, 1997).

An Audit Commission examination of 1997 confirmed the immense popularity of the public library service (Audit Commission, 1997). Drawing on figures from the Library and Information Statistics Unit (LISU) at Loughborough University, it noted that the public library service had lent 460 million documents in 1995/96, and cost only £13 per person per year. However, it also drew attention to a pattern of reduced opening hours, increased staff costs, lower expenditure on books and a 19 per cent decline in borrowing over the previous decade. It concluded that libraries had to: improve their costing of services, revise purchasing practices to take advantage of the collapse of the Net Book Agreement, and invest in new technology.

All publicly funded library services, whether public, academic or national, face continuing serious financial difficulties in the context of firm government moves to develop the UK as an information society. Provision of adequate funding in the face of competing demands is a chronic problem, and expenditure on materials has tended to suffer more than spending on staff and premises, which are less easily cut back. In academia, for example, LISU figures show that the 29 English polytechnics which became universities in 1992 have seen a 17 per cent overall decline in library expenditure over 10 years, with spending on books down by 32 per cent, and on periodicals by 62 per cent. This has occurred at a time when average book prices rose by 50 per cent.

From contracting out to Lottery funding

In 1994, the Department of National Heritage (DNH) commissioned from KPMG and Capital Planning Information a study on options for contracting out public

library services (KPMG, 1995). The consultants' conclusions were stark – the service was not prepared for it, there was no natural market for alternative sources of service provision and there was little support for the process. A parallel study commissioned from Aslib, the Association for Information Management, also concluded that the vast majority of respondents wanted local councils to control and run public libraries and that there was a strong weight of opinion against any other body running them (Aslib, 1995).

In March 1997, the DNH published its own public libraries review (DNH, 1997). Prepared under a Conservative government, it nevertheless paved the way for most of the initiatives that Labour pursued since May 1997. Among the key points of this review were that all public library authorities in England should produce Annual Library Plans from April 1998, that a new challenge fund would be established in partnership with the private sector to improve public library services, and that library authorities should apply for National Lottery and EU funding wherever they could. The report also requested the Library and Information Commission (LIC, a government advisory body established in 1995) to report back by July 1997 on how public libraries could together respond to the challenge of new technology.

New service development

Investment in networking

In the event, it was to the new Labour administration that the LIC reported. Its vision of a networked public library service also encompassed staff training and creation of new content and services (LIC, 1997) and was hailed by the Secretary of State for Culture, Media and Sport as 'a defining moment in the public library service'. The government's response in April 1998 recognised the crucial role that public libraries could play in the context of parallel initiatives such as the National Grid for Learning, IT for All and the University for Industry (DCMS, 1998a). It committed the government to establishing a public library network by 2002, instructed the LIC to establish an Implementation Committee for the purpose and promised £20 million from the National Lottery New Opportunities Fund for public library staff training, and £50 million for the digitisation of education and learning materials. (A further £9 million to encourage public libraries to invest in technology has come during this period from the DCMS/ Wolfson Public Libraries Challenge Fund.)

These developments have taken place against a background of intense and continuing government interest in information policy. *Our Information Age* (COI, 1998), which set out the government's vision, has led to many more detailed policy documents from other departments and agencies. Meanwhile the LIC published its blueprint for the People's Network (LIC, 1998), and the Department for Culture, Media and Sport announced a little later that up to £200 million of additional New Opportunities Fund monies would be made available for network infrastructure investment under the Community Access to Lifelong Learning scheme (DCMS, 1998b).

Sustainable quality services

Despite all this investment, sustainability of services remains a serious issue in libraries of all kinds. The British Library experienced a 20 per cent fall in net operational expenditure between 1994 and 1999 as a result of the costs associated with its move to its acclaimed new St Pancras building. This came when the library was also having to get to grips with the deposit of digital publications (British Library, 1999). In the event, the Secretary of State announced an improvement in the Library's grant-in-aid for the next three financial years, and DCMS also said at the end of 1999 that it intended to carry out a detailed review of the British Library's role and functions.

Charging is becoming an increasingly important source of additional income. The British Library earned nearly £39 million in charges in 1998/99 out of total resources of £119 million – an 11 per cent increase in earned income over the previous year (British Library, 2000). Public libraries have seen their total income rise from £27 million in 1986/87 to £65 million a decade later – an increase from £0.75 per head to £1.10 at 1996 prices, with the most spectacular increases in audio-visual hire, lettings and photocopies, while income from fines has declined (Creaser and Scott, 1998). The KPMG study noted that there was a market for elements of the non-core public library services, and suggested that local authorities should be exhorted to explore these (KPMG, 1995). Aslib found that almost two-fifths of the people it surveyed favoured charging, although those who did favour it were tentative in their views and included a high proportion of occasional users and non-users (Aslib, 1995). The Conservative government was also tentative in its response. Making clear that it did not propose to introduce charges for either book-lending or book-reference services, it also said that it would 'monitor closely the ways in which public libraries offer non-core services that compete with the commercial sector' (DNH, 1997).

In the meantime, DCMS turned its attention to the quality of public library services. Following analysis of the first complete set of Annual Library Plans (IPF, 1999), the Secretary of State for Culture, Media and Sport asked 15 library authorities to carry out further work on their plans, and returned 6 more as unsatisfactory. DCMS has also started working with the Library Association and the Local Government Association on minimum standards for public library services. Based on guidelines originally drafted by the Association in 1995, these cover access, facilities, stock, information services, staff, marketing and evaluation (Library Association, 1995; DCMS, 2000). They should have the effect of clarifying the rather vague wording in the 1964 Act regarding public libraries' duties.

A wider cultural context: Resource

At the beginning of the twenty-first century, developments such as networking, the emphasis on lifelong learning and moves towards greater co-ordination of public services have induced DCMS to re-appraise the services delivered by the full range of cultural institutions for which it is responsible. In 1999, it announced

its intention of winding up both the LIC and the Museums & Galleries Commission, and combining their functions in an entirely new body (DCMS, 1999). Resource: The Council for Museums, Archives & Libraries finally came into being on 1 April 2000. Treating museums, libraries and archives as three domains within a single 'memory institutions' sector, Resource is charged with taking a holistic approach in its advice to government. Its goal will be the best possible exploitation for citizens of all of the intellectual capital these institutions contain, irrespective of whether that capital manifests itself in the form of publications, original documents or artefacts.

5
Literature

Debbie Hicks, Freelance Arts Consultant

Changing support for writers and readers

Literature has a well-deserved reputation as the Cinderella artform struggling for recognition in a funding system biased towards performing arts. Policy directives in the mid-1980s reduced it to rags when the Arts Council of Great Britain halved its literature budget, arguing that as the artform was sustained by the publishing industry and accessed via the school curriculum and through libraries, the need for public subsidy was marginal (ACGB, 1984).

During the 1990s, literature recovered its position within the system, even on occasion receiving an uplift in funding at the expense of other artforms.[1] Its funding share still represents only a slim slice of public subsidy (1 per cent and 4 per cent of the budgets of the Arts Councils of England and Wales respectively) but the status of the artform has started to shift due to developments in the last decade. These have included a significant redefinition of the parameters of the artform to include reading as well as writing, and an established approach to funding and art form development coming into line with the priorities of a new government. As a result, literature has positioned itself as a recognised player in terms of the national agenda for the arts.

The lack of a building-based infrastructure other than that provided by the public library service has proved a disadvantage in some funding contexts. The sector has not profited hugely from the capital lottery funding. Nor was it able to meet key priorities of the Conservative government without the high-profile buildings to argue for private-sector sponsorship and to focus on strategies for increased income generation. Literature has, however, been able to concentrate its resources at both national and regional levels on the creators and consumers of the artform – writers and readers.

The Conservative government's erosion of arts subsidy in the early 1990s affected all artforms, but literature's limited client base meant that the burden of revenue funding was less than in other areas. Therefore, enough funding flexibil-

1 Literature was one of three artforms to receive increased funding for 1993/94 from the Arts Council of England.

ity remained to focus on supporting artform development, broadening access and forging partnerships with both the private and public sector.

Early in the 1990s, the arts funding system implemented a key policy decision to develop a close working partnership with the public library service to support reading as the means of access to imaginative literature (van Riel, 1992). Grassroots work in libraries was already claiming reading as a highly creative activity involving the reader in an intimate relationship with the text and via the text with the artist (Hinton, 1990; McKearney and Baverstock, 1990). The parameters of the artform were being redefined.

Previously, the focus of literature funding had been on writers and writing, but by the early 1990s it also included readers and reading. In 1992, the Arts Council of Great Britain held a seminal conference, Reading the Future: A Place for Literature in Public Libraries. This resulted in the launching of the Arts Council's £65,000 Library Fund for the promotion of literature and reading in libraries and the cementing of a national Library Policy (van Riel, 1992). It also put reader development firmly on the map.

Active intervention to open up reader choice and build an audience for imaginative literature became a recognised form of arts development reinforced by national and regional funding within the arts funding system (as, for example, under the Arts Council Library Fund, 1992).[2] Reading was acknowledged as a popular and democratic participatory arts activity, with more people reading than visiting the cinema or theatre or museums and galleries; and libraries were similarly acknowledged as key providers of the reading experience (The Reading Partnership, 1999). The community role of libraries and the demographics of library use made the public library service a very attractive partner for the arts funding system in terms of the access agenda.[3] In working with libraries to reach readers, literature effectively became the artform of the majority rather than the minority.

This approach mirrored exactly the priorities of the Labour government elected in 1997. The focus of the new government, reflected in the renamed Department for Culture, Media and Sport, was very firmly upon access 'for the many and not the few' and on building new audiences for the arts and cultural industries. Other government priorities, including support for the artist and a holistic approach to cultural management based upon partnerships within and between the public and the private sectors, were also key features of emerging literature policy.

By 1998 and the Arts Council of England's second national public libraries conference, Reading for Life, reader development and partnership with libraries were central policies. New strategies then being explored included the creation of a nationally funded library development agency promoting libraries' work with

2 The Arts Council also funded a Research Project to Develop and Implement a Proposal for an Accredited Literature Module for Librarian Courses (Hicks, 1995) and *Shelf Talk, A hand book promoting literature in public libraries* (Stewart, undated). Most regional arts boards established library funds in 1992/93. Southern Arts' ongoing support for Well Worth Reading, a library-based scheme to support reading, started in 1987 (McKearney and Baverstock, 1990).

3 The socio-economic breakdown of people borrowing monthly comprises: AB, 16 per cent; C1, 34 per cent; C2, 23 per cent; DE 27 per cent (The Reading Partnership, 1999).

readers through the development of partnerships with the reading industry – including all sectors and agencies involved in the support of reading predominantly in the commercial sector, such as publishers and booksellers – and other sectors. At the 1998 Reading for Life conference (ACE, 1998b) it was agreed that there was a need to establish a national library development agency promoting public libraries and their work with adult readers through partnerships, projects, advocacy and policy development as a result of the findings of the 'Next Issue' research (Davidson et al., 1998). This resulted in the Arts Council funding The Reading Partnership. A major Lottery award was also announced for a national three-year scheme training librarians in reader development (ACE, 1999).

The Department for Education and Employment funded National Year of Reading in 1998/99 reinforced national policy on reader development by further raising the profile of reading in general and of imaginative literature in particular. The national funding provided gave a boost to reader development activity, levering additional resources from the arts funding system, local authorities, other funding agencies and the commercial sector.

Partnership working

In parallel to the policy focus upon reading, the arts funding system, in partnership with the local authorities, was also developing a strategic national network of literature development workers. Many of these posts were based in libraries. The role of the literature development worker was to act as a catalyst for increasing access to literary activity of all forms for creators, participants and consumers. In 1995/96, the Arts Council of England agreed to establish a part-time co-ordinator post for a formalised national network.

The changing perception of the relationship between the writer, the readership and the audience also informed an increased emphasis upon live literature during the period. In 1998/99, the Arts Council of England (ACE) reviewed live literature provision and policy in order to refocus the way in which the arts funding system delivered literature in performance, supported the artist and ensured accessibility. Particular emphasis was placed upon audience development through the encouragement of improved presentation, delivery and PR. This policy was part of a national emphasis upon touring and live arts activity as a means of bringing arts to the people, a priority firmly established by the government's announcement of new money for a one-off £5 million New Audiences programme in 1997. This has since been guaranteed for a further five years (ACE, 1998a).

Partnership working has always been important for an artform with slim resources. This policy was reinforced during the late 1990s both in the pursuit of a strengthened funding base and also in order to support the access imperative and make literature available in the widest context and to all sectors of the community.

At a national level, this has resulted in some high-profile joint working with commercial publishers to bring about the publication of books including work in translation that might not otherwise be commercially viable. Other initiatives

have included partnerships with Waterstone's and the BBC. ACE and Waterstone's, for example, jointly supported research for a survey of writers' living standards which stimulated widespread debate about the way in which literature is funded and the need for increased support for the writer (de Botton, 1998). *Write Out Loud* was a collaboration between the Arts Council of England, BBC Radio North and the regional arts boards to develop new writing for radio, which resulted in the BBC broadcasting work by selected writers. The Arts Council of England and the regional arts boards also developed a strong partnership with the Home Office to support a programme of writers' residencies in prisons.

The Labour government's priority of identifying the creative talent at the core of the cultural industries reinforced an established element of national and regional literature policy. Support for the writer both through the creation of employment opportunities and through direct financial aid has long been a central feature of literature policy. An increase in the number and value of writers' awards was made a priority during the period. The Arts Council of England used some its funding uplift in 1993/94 to increase the number of writers' bursaries from 12 to 16, and expressed its commitment to this area of funding in its 1998 annual report (see McKeone, 1998). Some of the regional arts boards (eg East Midlands Arts) similarly increased the value of writers' awards in 1994/95.

As part of this commitment to enabling creative talent and supporting access, publishing was also identified as a key strategic area. Subsidised publishing is an important platform for new and innovative work that might not be commercially viable but which nevertheless supports diversity and innovation. In 1993/94, the Arts Council of England established revised funding criteria for literary magazines, in 1995/96 it announced a marketing fund for independent presses and in 1998/99 magazine development was identified as a funding priority for the next three years. There has been a similar emphasis in the policy and spend of the other UK arts councils where publishing now accounts for at least half of their respective literature budgets and much of the strategic spending. This national lead has, to a large extent, been reflected in UK-wide support for independent publishing.

The 1990s have clearly been an important period for refocusing the artform and for the development of national literature policy.

6
Museums and Galleries

Sara Selwood, University of Westminster

The UK has no coherent museums policy. Rather than being driven by government objectives it has, until recently, largely developed in response to events or issues. While the Department for Culture, Media and Sport (DCMS) is theoretically responsible for directing and championing the interests of the sector, in practice its remit is restricted to England, and many of its policies refer only to museums directly funded by the government.

The Scottish Executive, the National Assembly for Wales and the Northern Ireland Assembly are responsible for museums policy in their respective countries. The Scottish Museums Council published a national strategy in 1999 which called for a coherent policy framework and a closer relationship between planning and funding across the sector (SMC, 1999). The Scottish Executive's National Cultural Strategy embraces museums and galleries per se (Scottish Executive, 1999). The National Assembly for Wales (2000) recently proposed appointing a Culture Secretary and establishing a consortium of Assembly-sponsored public bodies which would include the National Museums and Galleries and the Council of Museums in Wales. A review of museums policy in Northern Ireland (Wilson, 1995) led to the merger of the three government funded museums (Ulster Museum, Ulster Folk and Transport Museums and the Ulster-American Folk Park) in 1998. A review of local museums and heritage was announced in December 1999, which will include a policy framework and development strategy (Northern Ireland Department of Culture, Arts and Leisure, 1999).

Contradictory demands on museums

In the period since 1993/94, museums have been subject to various pressures, most of which also typified the previous decade. Prompted by the requirement for value for money across the public sector, museums were expected to comply with demands of managerialism, attract private finance[1] and generate their own income

1 As in the case of the Royal Armouries Museum, which opened in March 1996 and was the first arts and heritage project to be launched under the government's Private Finance Initiative.

(Audit Commission, 1991; Lord and Lord, 1997; Kawashima, 1997). They were also encouraged to market themselves, and improve visitor numbers – in short, to become more consumer-oriented (Runyard, 1994). Increased audiences meant more money, and charging was believed to encourage better service provision (Bailey et al., 1998). From 1991 museums – like other public-sector services – were also encouraged by the prospect of winning Charter Marks to provide a high quality of service to the public (National Audit Office, 1993; 1995). And, they were influenced by the kind of thinking that produced the 'new museology' to adopt a more 'humanitarian' approach, focus on their potential for social change, and achieve a visitor profile which was more representative of the general public (Vergo, 1989; Mathers, 1996; Dodd and Sandell, 1998). This change of emphasis is probably best exemplified by the Museums Association's adoption of a new definition of museums. Whereas it previously defined the museum as a process-driven institution 'that collects, documents, preserves, exhibits and interprets material evidence and associated information for the public benefit', from 1998 it recognised museums as being primarily for 'the people':

Museums enable people to explore collections for inspiration, learning and enjoyment. They are institutions that collect, safeguard and make accessible artifacts which they hold in trust for society.

There were, of course, inherent contradictions in the simultaneous desires for museums to generate income and broaden their social base, as the re-emergence of the debate about admission charges in the second half of the 1990s made clear. This was prompted by: the V&A' s decision to charge, and the prospect of the British Museum doing so; worries that museums' Lottery-capital-funded developments could be sustained only by revenues from charging; and the controversial findings of the Museums & Galleries Commission's enquiry into admission charges, which cast doubt on the assumption that charges necessarily affect visitor numbers, visitors' profile and people's propensity to visit (Bailey et al., 1998). The debate essentially revolved around the moral principle of free access, the impact of charging on visitor numbers and museums' ability to reach a wider audience – issues which were widely debated in the press and in parliament (for example, House of Lords, 1997). Protagonists included the then opposition (Labour, 1997), the Museums Association (1990) and the National Art Collections Fund (NACF, 1997), all of which opposed the nationals charging.

In the 15 months before the 1997 election, the DNH actively sought to change the climate for museums. As well as publishing various documents designed to encourage access to the cultural sector (DNH, 1996a; 1996b) and issuing new Directions for the National Lottery (Chapter 16), it dedicated two publications to museums in particular. Its report on museum education – the first of its kind – highlighted the potential for lifelong learning and a wider social role (Anderson, 1997). The Department also undertook a review of museums policy, the first since the 1930s (DNH, 1996c). Whilst not actually determining policy, *Treasures in Trust* nevertheless made various proposals. These were encapsulated in 24 recommendations and covered collection care, public participation and quality of

service, standards, education, and the use of new technologies especially in terms of increasing access. It also encouraged local authorities to convert their museums to charitable trusts.

A number of these recommendations were implemented before the election, including the granting of new powers to the Heritage Lottery Fund to enable it to support access, education and IT projects under the National Heritage Act 1997 (Chapter 24). Other recommendations were adopted by Labour, which has placed greater emphasis on increasing access and efficiency (Babbidge, 2001).

Efficiency, education and access

Since May 1997, the operations of the DCMS have been characterised by regular policy statements and announcements of funding commitments. Its museums policy is based on the same principles as its other activities – access, excellence and innovation, and education, if not the fostering of the creative industries (Selwood, 1999). By December 1998 DCMS had firmed up its policies and spending plans until 2000/01(DCMS, 1998). Although many of its initiatives came into force only at the end of 1998/99, they nevertheless informed the context within which museums were operating towards the end of the period examined here.

The single most important feature of DCMS's museums policy was, conceivably, the Secretary of State's insistence that the Department and all its sponsored bodies should further government objectives. In terms of the museum sector this involved ensuring efficiency, educational opportunities, and increasing access.

In its pursuit of efficiency, DCMS replaced the MGC and the Library and Information Commission with Resource, a strategic, national body for museums, galleries and archives, conceived on the assumption of common ground between them (DCMS, undated; Resource, 2000). To ensure that its sponsored museums deliver outcomes related to policy, the Department introduced three-year funding agreements, partly informed by its review of the efficiency and effectiveness of government-sponsored museums (DCMS, 1999a). Those museums also became subject to scrutiny by QUEST (the Quality, Efficiency and Standards Team).

Labour's drive to increase efficiency has not only affected the museums it supports directly, but the largest group of museums in the country – local authority museums. As a result of the Local Government Act 1999, their efficiency, cost and quality will come under quinquennial review carried out on the basis of national performance indicators. Although cultural services were never exempt from the various forms of managerialism applied to local authorities from the 1980s, it was not until 1998 that the Audit Commission first published draft indicators for museums (MGC, undated; Selwood, 2000).

In terms of education, DCMS republished Anderson's report and is funding: educational initiatives by the Area Museum Councils; a new ITC challenge fund to support access and lifelong learning; the 24-hour museum (www.24hour museum.org.uk). The DCMS has also established a joint scheme with the Department for Education and Employment for museum and gallery education projects (DCMS/DfEE, 2000).

Last but not least, the Department has systematically pursued the principle of widening access to museums, galleries and their collections. Following a review which began in the summer of 1997, DCMS has devised access standards (DCMS, 1999b), developed its own code of practice on access to museums and galleries, and insisted that the production of access plans becomes a future condition of its grant funding (DCMS, 1999a). It is also promoting museums as Centres for Social Change (DCMS, 2000). And, guided by the principle that institutions should 'do all they can to balance the books while maximising access', the Department has pursued the principle of free admission for the museums it sponsors.[2] However, having already provided additional funds to ensure free admission for children and pensioners, from December 2001, DCMS is planning to provide additional funding to allow its sponsored museums and galleries which currently charge to introduce free admission for all (DCMS, 2001).

2 The Scottish Office followed suit, committing an extra £213,000 to improve public access to the National Galleries of Scotland and drafting its own code of practice on access (Scottish Office, 1998).

7
The Performing Arts

Kate Manton, freelance researcher

Changing policy on funding?

The performing arts in the UK are supported by complex funding structures. England, Scotland, Wales and Northern Ireland each have a separate responsible ministry, and a separate arts council. In England, regional arts boards, funded by the Arts Council of England (ACE), have significant responsibilities in their areas. Local authorities also play a role. While some venues for the performing arts are directly run by local authorities, the majority of performing arts organisations are independent of their funding bodies and derive their incomes from a variety of public and private sources. This structure ensures that, while policy may be defined at ministerial or arts council levels, its impact on performing arts organisations will be felt mainly in terms of the level of financial support received.

The patterns of support for the performing arts in the UK were set decades ago. The large, long-established national companies, regional producing theatres, symphony orchestras, dance and opera companies continue to receive most of the limited funds available. In England, total spending on performing arts by the ACE was £118.5 million in 1998/99. Of this, the national companies, largest dance companies (English National Ballet, Northern Ballet Theatre and Rambert), major opera companies (Opera North and Welsh National Opera) and major orchestras in London and the regions, received £88.6 million, or 75 per cent (see Chapter 29). In Scotland, in the same year, the Scottish Arts Council spent £21.2 million on performing arts. Half of this sum, £10.6 million, went to three companies – Scottish Opera, Scottish Ballet and the Royal Scottish National Orchestra. A similar phenomenon can be seen at the regional level in England. For example, Yorkshire Arts Board spent £4.2 million on performing arts in 1998/99, of which £2.5 million went to the six regional producing theatres.

Various reports have been commissioned by the ACE and its predecessor, the Arts Council of Great Britain, which describe the under-funding of the arts. The ACE/BBC *Review of National Orchestral Provision* (1994) is one such example. The plight of the performing arts sector was most recently identified in the Arts Council of England's report *The Next Stage*, (2000) a preliminary report towards a national theatre policy and a response to the Boyden report (Peter Boyden

Associates, 2000) on English regional producing theatres. The under-funding of the sector in general has led, as shown above, to a concentration of funding on the larger-scale institutions, something highlighted back in 1995 (Stevenson and McIntosh, 1995). Its effect on these companies is to lead them, in turn, to concentrate on their core traditional activities, with little room for innovation. *The Next Stage* states that 'substantial additional investment' will be required in order to implement a new national policy which would, among other objectives, produce a more diverse range of work for a wider range of audiences, improve access to theatre and increase opportunities for theatre's role in education. In March 2001, ACE announced that it had secured an additional £12 million in 2002/03, rising to £25 million in 2003/04, for theatre in England. Over 190 theatre organisations will benefit from these increases; 146 will receive funding increases of over 30 per cent. The majority of funds will be applied to the core funding of building-based theatres.

New audiences and improved access

How the new policy for theatre will work in practice is as yet unknown. It is possible that changes may also be sought in other sectors of the performing arts. In 1998/99 there was an indication that the Department for Culture, Media and Sport (DCMS) might be attempting to take a more active role with the introduction of the New Audiences initiative, designed to bring the arts to a wider audience. New Audiences provided a total of £4.4 million in grants to various organisations (not all of them in the performing arts). The unusual feature of the initiative was that the extra finance provided by the DCMS was 'ring-fenced' from the ACE's other grant-in-aid. Policy suggestions put forward recently (March 2001), such as the proposed 'union' of ACE with the 10 Regional Arts Boards to create a single body, and the DCMS Green Paper proposal that 'premier arts companies' should receive guaranteed 6-year grants, providing 'long-term security and lighter touch oversight in return for clear targets for delivery', would obviously have substantial implications for the performing arts in England (DCMS, 2001).

From the mid-1990s, the policy initiative which made a real impact on performing arts organisations was the provision, via the National Lottery, of very substantial capital sums for new arts buildings and renovations to existing buildings which, in many cases, had been neglected due to lack of finance. (This is treated in more detail in Chapter 29.) The amount of finance available has, however, declined over the four years from 1995/96 to 1998/99, and changes of emphasis have occurred in the distribution policy. Initially envisaged as a mechanism for capital expenditure, Lottery funds have also been used to support stabilisation funding (provision of grants against the deficits of performing arts organisations), and revenue grants via the Arts for Everyone initiative. The National Lottery Act 1998 established NESTA (National Endowment for Science, Technology and the Arts) to 'promote talent, innovation and creativity'. With an estimated annual income of at least £10 million, its aim is to support talented individuals, including those in the performing arts.

The Labour government has since 1997 placed a great deal of emphasis on ideas of wider access to the arts, and has called for an increase in participation by the UK population in the arts from half to two-thirds over the next 10 years. The Agreement between ACE and DCMS (1997) specifies 'increasing access to high quality work by performing companies' and sets down percentage targets for attendance at performances by regularly funded companies: drama, 60 per cent; dance, 68 per cent; opera, 76 per cent. *The Next Stage* (ACE, 2000) also emphasises 'improved access to theatre'. Measures to achieve this include theatres playing a more central role in their local communities, 'theatre taking place in a greater range of space and environments' and 'theatre connecting with the way in which people, particularly young people, live their lives'. However, issues of access to the performing arts remain complex. Is it measured solely by attendance at professional events, or should it include participation? Is the present regional distribution of performing arts considered to be satisfactory or are some areas inadequately served? To what extent are high ticket prices a barrier to access, and how, in the present financial circumstances, could ticket prices be reduced?

8
Public Broadcasting

Robert King, Institute of Public Policy Research

The 1990s saw substantial changes in public service broadcasting. Increased competition from an ever-expanding group of commercial operators, coupled with the impact of new technology, placed additional strain on the public sector. At the beginning of the decade, TV broadcasting in the UK was dominated by the BBC on Channels 1 and 2, and commercial free-to-air operators, operating on Channels 3 and 4. The 1990 Broadcasting Act liberalised the broadcast sector and reorganised its regulatory structure. In doing so, it opened up the possibility of a fifth channel, but it took until 1997 for Channel 5 to be launched.

New technology and universal access

The advent of new cable and satellite services, plus the onset of digital TV, has encroached on the dominance of existing services. A key task of any government must be to reconcile two possibly conflicting policy objectives: universal access and the need to cater for all sections of society with fair and open competition; and, the desire to be at the forefront of the unfolding technological revolution.

In terms of the first of these issues: prior to the technological changes evident throughout the late 1990s, access to broadcasting was almost universal. The ever-growing market share that pay-TV has been able to command (13 per cent in 1998: *Guardian*, 1998) has led to a shift in delivery, directly affecting access. Many programmes (in particular, popular sporting events with large audiences) previously available to the viewer for free are now only available to pay-TV or subscription viewers. The cost of pay-TV for the viewer (On Digital, for example, currently costs £120 per year for a basic package) has led to some fearing the development of an excluded section of society unable to access vital services important to their quality of life.

Under the provisions of the 1996 Broadcasting Act, the then Conservative government attempted to tackle problems of access by ensuring that some popular sporting events were protected or 'listed' . This was intended to ensure that certain major events would be available to all – thus, for example, the rights to the football World Cup, or the FA Cup final, could not exclusively be negotiated by pay-TV providers.

Digital services and new funding policies

The second key issue during the 1990s has been how to prepare a smooth path for public service broadcasting in anticipation of the onset of digital TV and radio. With the government committing itself to an eventual analogue switch-off date, the 1996 Broadcasting Act safeguarded one of the six terrestrial digital TV and one of the seven digital radio multiplexes for the BBC; S4C (the Welsh Channel 4) holds a licence to run services on another.

The role of the BBC in the digital environment has come under ever-closer scrutiny. Both the government and the Corporation itself have faced a dilemma over targeting limited funding. Although receiver costs are currently relatively high, the ultimate aim must be to drive down receiver costs for the consumer.

New digital programming costs have raised the spectre of the age-old debate about how the BBC is funded, as well as prompting questions about why a publicly funded organisation should promote services that are not universally accessible. In 1997, Gavyn Davies, an economist at Goldman Sachs, was asked to review the role of the licence fee and how the corporation was to pay for the expansion to its services. He emphasised the vital importance of public service broadcasting in the digital age, and suggested that there should be a separate licence of £24 for digital subscribers, in addition to the existing charge (Davies, 1999). However, the Department for Culture, Media and Sport rejected Davies's recommendations, preferring to implement a general rise in the licence fee – albeit above the rate of inflation – much to the dismay of the Corporation, which had expected more funds to expand its digital operations. Cost-cutting measures are, consequently, expected. Other suggestions include revenue from advertising, and the possible sell-off of key BBC assets.

Public service broadcasting has also undergone a number of other significant changes during the second half of the 1990s. Self-generating funding has become increasingly important to publicly owned channels – the BBC as well as S4C. Channel 4 has also seen its programme-sales division grow. Commercial operations within the BBC now generate funds that can be channelled back into the Corporation as a whole.

BBC Worldwide was set up in 1994 to promote BBC products on a commercial basis, while operating at arm's length from the Corporation as a whole. This subsidiary has pumped over £220 million back into the BBC since its inception. In 1998/99, £50 million was channelled back for programming purposes alone.

BBC Worldwide has a range of interests, many of which are proving increasingly successful. For instance, its publishing division is now the third largest in the UK magazine sector; and it has formed a partnership with media company TCI to form Flexitech, and launch UKTV which broadcasts digitally. BBC Worldwide and BBC Resources, which is involved in the facilities market, are two of the Corporation's assets regarded as potential targets for privatisation.

The Broadcasting Act 1996 also gave S4C extensive rights to set up a commercial trading arm to supplement its publicly funded activities. S4C Masinchol, like BBC Worldwide, operates and manages the channel's digital operations and programme sales. The success of some of S4C's programmes at

the Oscars has led to an increasing awareness of its output in the lucrative overseas sales market.

Finally, in 1996, after years of lobbying, Channel 4 was at last able to rid itself of the funding formula whereby revenues received on the back of its success were pumped back to ITV. This has enabled substantial increases to its programming budget, such as an increase of 17 per cent in the year following the change. Since its inception, the funding formula had drained advertising revenue worth as much as £400 million away from the station and directed it back to ITV.

9

The Visual Arts

Sara Selwood, University of Westminster

The term 'visual arts', as used by the arts funding system, embraces a wide range of contemporary visual arts practices across a range of media. The Visual Arts Department of the Arts Council of England (ACE), which regards itself as the voice of the visual arts within the funding system (ACE, undated c), thus embraces photography, film, new technologies,[1] architecture, artists' film and video,[2] and crafts.[3] As the remit of visual arts has expanded, so the various artforms which it has come to embrace have become perceived in terms of their shared characteristics rather than their unique attributes.

With the exceptions of the crafts and architecture, the visual arts notably excludes most design-based activities associated with the 'creative industries'. The arts funding system's definition of visual arts thus essentially adheres to the modernist convention of distinguishing between fine and applied arts – a separation maintained throughout the whole of the last century.

An inferred policy

A citation in the ACE's *Visual Arts Department Plan 2000–2002* asserts that 'There really is no such thing as Art. There are only artists.' This suggests that ACE is wedded to the 'centrality of the individual artist', rather than any particular artform (ACE, undated b). This position essentially mitigates against the ACE adhering to a policy which might, in any way, appear over-determined. This may be why, unlike many other forms of activity such as dance, drama, new music, South Asian music, jazz and education (ACE, 1996c; 1996d; 1997a; 1996a; 1997b; 1996b), visual arts in the English arts funding system is almost unique in

1 Around 1996, arts funding bodies including ACE and the London Arts Board commissioned reports into the arts and new technologies to enable them to define their roles in relation to the production and promotion of such work. See Boyden Southwood (1996) and Haskell (1996).

2 The film industry is considered in Chapter 3 above.

3 Prior to April 1999, the crafts were the responsibility of the Crafts Council. Following *A New Cultural Framework* the Crafts Council became a client of the ACE (DCMS, 1998).

having no published formal policy. During the period, 1993/94 to 1998/99, the Arts Council drafted a visual arts policy for the arts funding system in England, intended as the basis of a visual arts Green Paper (ACE, undated c; see also Honey et al., 1997). But, despite references to a forthcoming policy in the *Visual Arts Department Plan, 1998–2000*, no such policy was ever published (ACE, undated a). The clearest indications of the guiding principles for visual arts in England are contained in the draft policy document and the 1998–2000 and 2000–2002 plans.

In broad terms, these documents emphasise the arts funding system's concern with the production and promotion of innovative contemporary visual arts and crafts, and the desire to create wider access and understanding across a range of practices. The stated intentions of the draft policy were to create an environment in which:

- artists are enabled to work on equal terms with other creative producers;
- a strong countrywide network of visual art spaces, agencies and organisations is created which ensures that artists had proper contracts and payments, and in which curators develop wider engagement and understanding of the visual arts; and
- the visual arts function as an essential part of the core school curriculum.

However, in the 2000–2002 plan, this vision has metamorphosed into a formal statement of aims, objectives and targets reflecting the mainstays of ACE policy – access, education and excellence – and articulated in the kind of form required by DCMS.[4]

Routes to increased funding

In practice, the main imperative for the visual arts during the second half of the 1990s has been to increase its funding. The draft policy called for an injection of £20 million – four times the value of its annual expenditure in 1996/97. The ACE Visual Arts Department's subsequent plan also spelt out the need for greater support, predicated on the basis of:

- making up for historical under-funding, particularly in terms of photography and the media, the desire to support a broader range of activities (such as the development of a National Architecture Centre), new agencies, and new devel-

4 Thus, the key tasks for visual arts under 'access' are identified as being to: secure, sustain and develop the visual arts infrastructure of key agencies and venues; develop a department-wide touring strategy; and, develop a department-wide publishing and distribution strategy. Under 'education' the department is bound to: strengthen a national network of organisations and individuals involved in visual arts education; and encourage new practice and thinking in visual arts education. And, under 'excellence', it is committed to: speak for the visual arts and influence the policy of others; champion the work of the individual artist; support new work and encourage innovation and the creative use of new technologies (ACE, undated b).

opments in artistic practice (especially support of the creative use of new technologies);

- satisfying revenue demands created by the Lottery; and
- countering threats to the status quo, as perceived in respect of: the cost of maintaining current commitments; having to provide revenue for capital-funded projects; and supporting the existing network of venues in the light of competition from a new generation of venues.

A confidential analysis of the operating environment of independent visual arts venues in England apparently confirmed the urgency of providing support for the existing network of galleries. Proposals for the Museum of Modern Art, Oxford, for example, implied a shortfall in 1998/99 over a third of the value of its ACE grant.

As in other fields, Lottery-capital-funded projects in the visual arts tend to require additional revenue support. The Ikon Gallery, in particular, was identified as needing over £250,000 in 1998/99 to meet the increased costs of running its new building, creating more access, and running its new programme (ACE, undated a).

ACE had argued the case for an extended and strengthened network of venues for contemporary art. This was largely made possible by ACE's own Lottery funding, which enabled the development of a new generation of galleries, including Tate Modern, the Baltic Flour Mill and the New Art Gallery Walsall. Yet, in the event, the Department regarded the very existence of these as a threat to the sustainability of its existing venues for which it argued the case for more funding.

To some extent, some of these problems are no longer the Visual Art Department's immediate responsibility. The process of devolving clients to the regional arts boards, which started in the late 1970s with community arts (Moody, 1997) and continued through the 1980s and 1990s, culminated in the 'greater delegation' specified by DCMS (1998).

Other aspects of the visual arts agenda between 1993/94 and 1998/99 have also been as the result of government intervention and designed to meet government objectives. The Visual Arts Department already had a considerable history of access projects,[5] but during the second half of the 1990s, two new access schemes were introduced: one was the one-off New Audiences programme, launched by the Secretary of State in April 1998, intended to deliver access for all and 'bring new art to new people';[6] the other was, of course, the Lottery (see Chapter 16).

5 The Visual Arts Department, for example, had been the first in the then Arts Council of Great Britain to appoint an education officer in 1980; had made education provision a condition of funding; had funded education posts through its 10-year development strategy (ACGB, 1984); and had also encouraged access through its National Touring Programme. The development strategy (1985/86 to 1996/97) provided almost £4.4 million in funding for 22 local authority museums and galleries, and was intended to encourage the promotion of the visual arts. It was succeeded in 1998/99 by the £120,000 regional gallery 'Sunrise Scheme'.

6 At the time of writing, the evaluation of year 1 of the New Audiences scheme was not yet available.

In many respects, Lottery funding has provided solutions to many of the ACE's dilemmas. It has extended the possibilities of the visual arts in the UK by contributing to the regional network of venues, created a plethora of public art commissions for artists and opportunities for film and video work, provided new short-term employment for professional artists, and supported the development of artist-run groups. Arts for Everyone (A4E) also transformed the profile of the visual arts, albeit temporarily, by widening the range of institutions and practices supported, embracing school and community projects, exhibitions and events, crafts and applied arts, and encouraging greater participation in the visual arts. A4E funded 969 visual arts projects between its launch in November 1996 and the end of the 1998/99 financial year. This provided £10.1 million – nearly 50 per cent more than the ACE's grant-funding of the visual arts during the same period.

Part II
Funding

Introduction

Sara Selwood, University of Westminster

This Part considers how much support goes to the cultural sector in the UK from various sources:

- public funds, channelled through central and local government, higher education, regeneration and Europe,[1] as well as tax forgone and the National Lottery;
- private funds, in particular those from charitable trusts and sponsorship.

Income generated by the sector itself, albeit through fees or the ancillary income of arts organisations, is not considered here, and nor is consumer spend. However, the amount of income which subsidised organisations earn from fees and consumers is considered in Part IV, Profile). Evidence on the scale of the voluntary workforce within the cultural sector is discussed in Chapter 23, although no attempt has been made to ascribe a value to this.

Within this part of the book, the length of individual chapters varies enormously. This is, however, not necessarily indicative of the relative importance of the amount of funding being covered, although the reverse may be true. Chapters are short for various reasons. In the case of Chapter 10, Funding from Central Government, this is because the policy context is considered elsewhere in the present volume (Part I, on policy) or because of extensive or comprehensive coverage published elsewhere (for example, ACE (2000)). Longer chapters (such as 11 on regeneration funding; 13 on European funding; 15 on tax forgone; and 16 on the National Lottery) are long precisely because of the lack of coverage elsewhere, the fact that they describe how estimates have been made, or because they explain the value of support in relation to the development of policy.

Where possible, the relationship of capital to revenue funding is considered, and the period 1993/94 to1998/99 is covered. However, this depends on the availability

1 The focus in Chapter 13 is specifically on funding from the European Commission. The only other funding from Europe comprises relatively small quantities from sources such as the Council of Europe and organisations such as trusts and foundations (Casey et al., 1996:14ff). Research for the present volume did not encompass these areas due to limited resources.

Table II.1 Overview of funding for the UK cultural sector by source, 1993/94–1998/99

£ millions

	1993/94	1994/95	1995/96	1996/97	1997/98	1998/99
Central government						
DCMS	843.183	855.805	894.713	815.944	745.332	768.055
Scottish Office	108.000	124.000	116.000	112.000	120.000	112.000
Welsh Office	31.100	47.100	50.700	44.400	43.200	44.100
Northern Ireland Office (a)	15.376	16.886	16.545	21.815	21.194	20.509
Subtotal	*997.659*	*1,043.791*	*1,077.958*	*994.159*	*929.726*	*944.664*
BBC licence fee income (b)	1,684.000	1,751.000	1,820.000	1,915.000	2,009.700	2,179.500
National Lottery						
Arts (c)	n/a	n/a	374.536	402.862	368.402	150.443
Millennium Commission	n/a	n/a	115.048	17.425	9.895	1.772
Heritage Lottery Fund	n/a	14.323	173.076	392.913	265.545	214.825
Charities Lottery Board	n/a	n/a	0.715	1.273	1.976	2.082
Subtotal	*n/a*	*14.323*	*663.375*	*814.473*	*645.818*	*369.122*
Local authorities (d)						
England	912.943	922.239	927.020	1,012.245	1,022.189	1,063.911
Scotland	119.019	176.858	135.039	166.570	157.222	120.356
Wales	36.844	39.120	41.074	40.914	42.679	51.486
Northern Ireland	23.430	21.673	18.347	18.571	28.811	19.936
Recorded subtotal	*1,092.236*	*1,159.890*	*1,121.480*	*1,238.300*	*1,250.901*	*1,255.689*
Business sponsorship (e)	69.522	82.820	74.584	89.681	107.326	130.760
Total	3,843.417	4,051.824	4,757.397	5,051.613	4,943.471	4,879.735
At real (1998/99) prices	4,395.491	4,568.575	5,213.471	5,363.159	5,104.783	4,879.735
Percentage year-on-year change	–	4	14	3	–5	–4
Minus the licence fee	2,159.417	2,300.824	2,937.397	3,136.613	2,933.771	2,700.235
At real (1998/99) prices	2,469.599	2,594.260	3,218.994	3,330.056	3,029.504	2,700.235
Percentage year-on-year change	–	5	24	3	–9	–11
Minus the licence fee and Lottery funding	2,159.417	2,286.501	2,274.022	2,322.140	2,287.953	2,311.113
At real (1998/99) prices	2,469.599	2,578.111	2,492.024	2,465.352	2,362.612	2,311.113
Percentage year-on-year change	–	4	–3	–1	–4	–1
Minus the licence fee, Lottery funding and business sponsorship	2,089.895	2,203.681	2,199.438	2,232.459	2,180.627	2,200.353
At real (1998/99) prices	2,390.090	2,484.729	2,410.290	2,370.140	2,251.783	2,200.353
Percentage year-on-year change	n/a	4	–3	–2	–5	–2

Sources

DNH, annual reports 1995–1997; DCMS, annual reports 1998–1999; Department of the Secretary of State for Scotland and the Forestry Commission, *The Government's Expenditure Plans*, various years; *The Government's Expenditure Plans: Department report by the Welsh Office*, various years; Information provided directly by other central government departments (see note (b) below); Arts Council of England, Arts Council of Wales and Heritage Lottery Fund – lottery data supplied directly; Scottish Arts Council, annual reports, various years (lottery data); Arts Council of Northern Ireland: Annual Lottery Report, various years; DCMS web site www.lottery.culture.gov.uk for Millennium Commission and Charities Lottery Board data; ABSA/Arts & Business *Business Support for the Arts/Business Investment in the Arts*, various years.

Notes

a) Figures for built heritage are included from 1996/97 onwards. Figures for previous years represent spending on arts and museums only.

b) For time series data on the Foreign & Commonwealth Office funding of the BBC World Service see Table 30.2.

c) As distributed by the Arts Councils of England, Scotland, Wales and Northern Ireland.

d) Information on expenditure by local authorities is partial. See separate local authority summary Table 14.1 for details.

e) May include some sponsorship through the government sponsored Pairing Scheme.

Table II.2 Other sources of funding to the cultural sector, 1998/99

£ million

	Actuals recorded	Estimates	Estimated total
Other central govt departments (a)	230.425		
Charities (b)	67.152		
Higher education institutions (c)	33.095		
European Commission (d)		51.816	
Tax forgone (e)		200.000	
Regeneration (f)		24.500	
Totals	330.672	276.316	606.911

Notes and sources
a) Table 10.6.
b) Chapter 17.
c) Table 12.3, excludes funding provided through the AHRB and the Higher Education Funding Councils.
d) Estimate of an 'average' year, based on Table 13.26.
e) Based upon the available figure of c. £90 million a year from heritage capital tax reliefs and £50–£100 million plus from VAT on alterations to listed buildings. There are no clear estimates of the value of concessions on charitable donations and films, and these have been excluded.
f) Chapter 11.

and comparability of data. Some chapters, such as 15 on tax forgone, focus on 1998/99, or as near as possible. Others, such as Chapter 13 on European funding, cover the period 1995–99 because this represents a particular 'round' of allocations of Structural Funds. It should be noted that 1993/94 marks a peak in early 1990s spending, and the close of the period, 1999/2000, marks an increase in funding.

Overview of funding

The cultural sector received basic support of £4,880 million in 1998/99 (Table II.1) according to the most reliable sources – those that describe funding channelled through the Department for Culture, Media and Sport (DCMS) and the then Scottish, Welsh and Northern Ireland Offices, the National Lottery, local authorities, and business sponsorship. However, of that total, £2,180 million alone (45 per cent) is accounted for by the licence fee for the BBC.

Additional funding in the region of £607 million is estimated to have been provided in 1998/99 by other sources, for which the data are far less reliable. They include central government departments, such as the Ministry of Defence, the Department for Education and Employment, the DTI, the Foreign and Commonwealth Office, the Department of the Environment, Transport and the Regions, the Department of Health and the Lord Chancellor's Department (see Chapter 10). Other contributors include charitable trusts and foundations, higher education institutions (apart from the special funding channelled through the Higher Education Funding Councils and the Arts and Humanities Research Board), European Commission, tax forgone and regeneration funding (Table II.2). As the various chapters which focus on each of these sources explain, the estimates given are consistently conservative.

In real terms, the amount of support given to the subsidised sector from the most reliable sources appears to have increased by about 11 per cent over the five years between 1993/94 and 1998/99 (see Table II.1). But, excluding the licence fee, funding increased by more like 9 per cent over that period. Excluding the licence fee and Lottery funding, it fell by about 6 per cent. Various caveats need to be applied to this calculation. Data on local authority spending are patchy, as indicated

Table II.3 Overview of funding to the cultural sector by home country, 1993/94–1998/99

£ million

	1993/94	1994/95	1995/96	1996/97	1997/98	1998/99
National/not identified by region						
National Lottery (a)	n/a	n/a	0.715	1.477	12.846	15.124
Business sponsorship	9.689	8.945	7.550	14.244	14.660	15.457
BBC licence fee income	1684.000	1751.000	1820.000	1915.000	2009.205	2179.500
Subtotal	*1693.689*	*1759.945*	*1828.565*	*1930.721*	*2037.205*	*2210.080*
England						
DCMS	843.183	855.805	894.713	815.944	745.332	768.055
National Lottery	n/a	13.904	583.579	708.067	504.270	260.708
Local authorities (b)	912.943	922.239	927.020	1012.245	1022.189	1063.911
Business sponsorship	50.218	64.109	57.731	65.879	77.569	97.327
Subtotal	*1806.344*	*1856.056*	*2463.043*	*2602.135*	*2349.361*	*2190.001*
Scotland						
Scottish Office	108.000	124.000	116.000	112.000	120.000	112.000
National Lottery	n/a	0.419	57.287	73.106	80.075	40.973
Local authorities (b)	119.019	176.858	135.039	166.570	157.222	120.336
Business sponsorship	6.678	6.533	5.688	6.283	11.325	11.874
Subtotal	*233.697*	*307.810*	*314.014*	*357.960*	*368.623*	*285.203*
Wales						
Welsh Office	31.100	47.100	50.700	44.400	43.200	44.100
National Lottery	n/a	n/a	13.397	20.215	30.049	25.231
Local authorities (b)	36.844	39.120	41.074	40.914	45.910	51.486
Business sponsorship	2.028	2.273	2.707	2.494	3.127	5.028
Subtotal	*69.972*	*88.493*	*107.848*	*108.023*	*122.286*	*125.844*
Northern Ireland						
Northern Ireland Office (c)	15.376	16.886	16.545	21.815	21.194	20.509
National Lottery	n/a	n/a	8.397	11.607	18.578	27.086
Local authorities (b)	23.430	21.673	18.347	18.571	28.811	19.936
Business sponsorship	0.910	0.960	0.908	0.781	0.645	1.075
Subtotal	*39.716*	*39.519*	*44.197*	*52.774*	*69.228*	*68.606*
Total	3843.417	4051.824	4757.398	5051.613	4946.702	4879.735

Sources

Department for National Heritage annual reports 1995–1997; Department for Culture, Media and Sport, annual reports 1998–1999; Department of the Secretary of State for Scotland and the Forestry Commission, *The Government's Expenditure plans*, various years; *The Government's Expenditure Plans: Department report by the Welsh Office*, various years; Information provided directly by other central government departments (see note (b) below); Arts Council of England, Arts Council of Wales and Heritage Lottery Fund – Lottery data supplied directly; Scottish Arts Council, annual reports, various years (lottery data); Arts Council of Northern Ireland: Annual Lottery Report, various years; Department of Culture Media and Sport web site (www.lottery.culture.gov.uk) for Millennium Commission and Charities Lottery Board data; ABSA/Arts & Business *Business Support for the Arts/Business Investment in the Arts*, various years.

Notes

a) National funding and funding from the Charities Lottery Board.

b) Information on expenditure by local authorities is partial. See separate local authority summary, Table 14.1, for details.

c) Figures for built heritage are included from 1996/97 onwards. Figures for previous years represent spending on arts and museums only.

in Chapter 14, Appendix 1, and the Arts Council of England's regent digest of statistics (ACE, 2000:15–16). Much information is unreliable or unavailable (for example, figures from the Northern Ireland Office cover the built heritage from only 1996/97 onwards).

Table II.4 Overview of funding to the cultural sector by art form and heritage activity, 1993/94–1998/99

£ million

	1993/94	1994/95	1995/96	1996/97	1997/98	1998/99	Percentage of overall funding 1993/94	1998/99
Built heritage (a)	221.20	227.47	284.26	449.89	410.92	610.89	6	12
Film (a)	30.07	30.61	44.42	64.48	52.74	40.03	1	1
Libraries & literature (a)	897.90	958.87	991.68	951.24	941.26	958.73	23	18
Museums & galleries (a)	464.11	501.35	719.94	710.68	618.26	616.40	12	12
Performing arts (a/b)	361.09	393.59	683.48	710.58	710.89	521.47	9	10
Public broadcasting (c)	1,919.70	1,994.49	2,073.01	2,163.79	2,186.89	2,418.10	49	46
Visual arts (a)	18.57	20.97	54.60	88.04	105.67	57.55	0	1
Total (d)	3,912.63	4,127.36	4,851.37	5,138.71	5,026.61	5,223.17	100	100

Sources: Tables 24.5, 25.9, 27.12, 28.2, 29.10, 30.2, 31.2.
Notes:
a) These rows show the most reliable and comparable data attributable to particular artforms and heritage activities. This includes funding from DCMS, SO, WO, NIO and the arts councils, local authorities, the National Lottery and business sponsorship. It excludes funding from 'other' government departments, charitable trusts and foundations, higher education, tax forgone, European and regeneration funding.
b) This sum excludes funding from the BBC.
c) This sum includes the Foreign and Commonwealth Office grant to the BBC for the World Service and the BBC licence-fee income.
d) The inclusion of FCO data for public broadcasting means that the total given here does not match those in other overview tables.

Funding by home country

On a country-by-country basis, in 1998/99 (again, excluding the licence fee) England received at least £2,190 million; Scotland, £285 million; Wales, £126 million; and, Northern Ireland, £69 million (Table II.3). Although the amounts increased since 1993/94, not least as a result of Lottery funding, the pattern of distribution remains largely the same. In 1993/94, England received 84 per cent of the funding which can be more or less reliably accounted for; Scotland, 11 per cent; Wales, 2 per cent; Northern Ireland, 2 per cent; and, national projects less than 1 per cent. (For a breakdown of the allocation of Lottery funds, see Table 16.3.) In 1998/99 this pattern of distribution was virtually the same, with corresponding percentages of (and including Lottery funding but excluding the licence fee) 82, 11, 5, 3 and 1 respectively.

Funding by artform and heritage activity

Tables II.4 and II.5 provide an overview of funding, based on the most consistent sources. Increases in funding from 1995/96, for built heritage, film, museums and galleries, performing arts and visual arts are largely attributable to the Lottery. Over the period 1993/94 to 1998/99, funding for built heritage nearly tripled, and funding for the visual arts more than tripled. Changes in the funding of other artform and heritage areas are far less dramatic. Libraries and literature (which are combined here) were the only activities to experience a fall in funding. The relative absence of Lottery funding also accounts for the lack of change in the funding of literature, which as a non-building-based artform did not stand to benefit from much capital funding. Public

Table II.5 Overview of funding to the cultural sector by art form and heritage activity, 1993/94–1998/99 at real (1998/99) prices

£ million

	1993/94	1994/95	1995/96	1996/97	1997/98	1998/99	Percentage change 1993/94–1998/99
Built heritage	252.971	256.476	311.506	477.635	424.328	610.890	142
% year-on-year change	n/a	1	21	53	−11	44	
Film	34.392	34.517	48.678	68.458	54.458	40.032	17
% year-on-year change	n/a	0	41	41	−20	−26	
Libraries & literature	1,026.873	1,081.165	1,086.750	1,009.909	971.973	958.733	−7
% year-on-year change	n/a	5	1	−7	−4	−1	
Museums & galleries	530.773	565.285	788.956	754.506	638.432	616.401	16
% year-on-year change	n/a	7	40	−4	−15	−3	
Performing arts	412.952	443.790	748.997	754.408	734.084	521.471	30
% year-on-year change	n/a	7	69	1	−3	−29	
Public broadcasting (a)	2,195.448	2,248.863	2,271.738	2,297.241	2,258.246	2,418.098	10
% year-on-year change	n/a	2	1	1	−2	7	
Visual arts	21.237	23.648	59.833	93.472	109.117	57.547	173
% year-on-year change	n/a	11	153	56	17	−47	

Source: Table II.4.

libraries, which are a statutory provision, and broadcasting, both fall outside the remit of the Lottery's 'good causes'.

Capital funding

The greatest change in the composition of the funding to the cultural sector has been the relationship between capital and revenue funding. In 1993/94, capital crudely accounted for around 12 per cent of the sector's total income, whereas in 1998/99 it accounted for 33 per cent (Table II.6).

By definition, capital spending was tied up in Lottery projects – if not entirely accounted for by them. Table 16.6 provides a breakdown of the value of capital revenue grants awarded by the main Lottery distributors (the Heritage Lottery Fund and the four arts councils) from 1994/95 to 1998/99.

An analysis of the grants provided by lottery capital and revenue programmes of the Arts Councils of England, Wales and Northern Ireland on an artform basis (not shown here), suggests that revenue funding essentially conforms to the general pattern

Table II.6 Overview of capital funding to the cultural sector, 1993/94–1998/99

£ million

	1993/94	1994/95	1995/96	1996/97	1997/98	1998/99
Non-Lottery sources (a)	264.12	301.75	336.83	581.270	551.28	496.99
Arts councils and HLF (b)	n/a	14.605	447.700	808.128	662.661	382.662
Millennium Commission	n/a	n/a	115.048	17.425	9.895	1.772
Total capital funding	264.12	316.36	899.58	1,406.82	1,223.84	881.42
Total funding to the sector, based on the most reliable data (c)	2,159.4	2,300.8	2,937.4	3,136.6	2,933.8	2,665.2
Percentage represented by capital funding	12.23	13.75	30.62	44.85	41.72	33.07

Notes and sources
a) Based on Table 16.1. These totals include some element from charitable trusts and foundations, which is not included in Table II.1.
b) Based on Table 16.6.
c) Based on Table II.1, minus licence fee.

of arts funding. A small number of revenue programmes cannot easily be attributed to particular art forms, such as the Arts Council of England's funding of arts education and training, cultural diversity, and marketing and publicity, and the Arts Council of Northern Ireland's funding of community arts. However, where revenue funding can be accounted for by artform, it would appear that the performing arts received around 80 per cent of the total distributed, whereas film and literature received around 5 per cent and the visual arts 10 per cent. Arts for Everyone and Stabilization funding represent the largest share of the arts councils' lottery revenue funding up to 1998/99.

10
Funding from Central Government

Rachael Dunlop, Freelance Researcher, and
Sara Selwood, University of Westminster

Several government departments support the cultural sector. The most obvious are the Department for Culture, Media and Sport (which changed its name in 1997 from the Department of National Heritage), the former Scottish and Welsh Offices (which were devolved in 1999) and the Northern Ireland Office. Figure 10.1 shows the responsibilities of the DNH in summer 1996 – a point midway through the period 1993/94–1998/99 considered here.

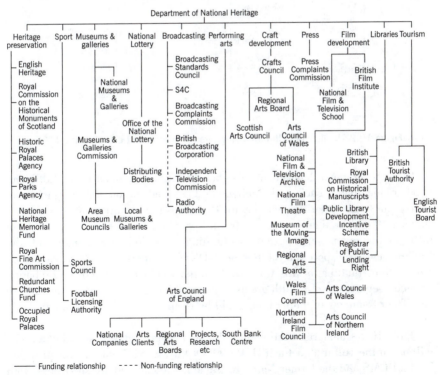

Source: Forrester, 1996.

Figure 10.1 Responsibilities of the Department of National Heritage, 1996

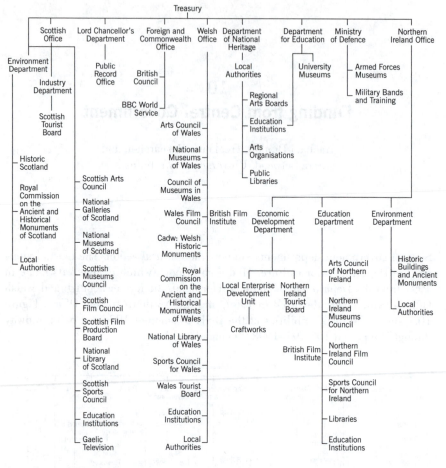

Source: Forrester, 1996.

Figure 10.2 The flow of cultural funding through government departments, 1996

Other government departments also benefit the sector, albeit in the fulfilment of other objectives – such as the delivery of higher education, military provision, support for local authorities, etc. Figure 10.2 maps these sources, as they were in summer 1996. The figure, which is drawn from Forrester (1996) is, however, not fully inclusive. Other sources of funding included: Department of the Environment, Transport and the Regions' (DETR) support of urban regeneration; Home Office funding for arts work via both the youth service and the Probation Service; Department of Health grants to national voluntary organisations; and so on. (Their financial support which could be quantified is shown below in Table 10.6.)

Table 10.1 summarises the identifiable central government spend of £1,170 million on the cultural sector in 1998/99. Of this, £944.7 million was provided by the DCMS and the former Northern Ireland, Scottish and Welsh Offices, with a further £225.6 million from other government departments

Table 10.1 Central government funding to the cultural sector, 1993/94–1998/99

£ million

	1993/94	1994/95	1995/96	1996/97	1997/98	1998/99
DNH/DCMS	843.183	855.805	894.713	815.944	745.332	768.055
Scottish Office	108.000	124.000	116.000	112.000	120.000	112.000
Welsh Office	31.100	47.100	50.700	44.400	43.200	44.100
Northern Ireland Office (a)	15.376	16.886	16.545	21.800	21.200	20.500
Total	997.659	1,043.791	1,077.958	994.144	929.732	944.655
At real (1998/99) prices	*1,140.964*	*1,176.911*	*1,181.298*	*1055.455*	*960.070*	*944.655*
Percentage year-on-year change	n/a	3	0	–11	–9	–2
Other departments	–	–	–	–	–	230.428

Sources: Tables 10.2, 10.3, 10.4, 10.5 and 10.6.

Notes
a) Includes built heritage only from 1996/97.

Department of National Heritage/Department for Culture, Media and Sport

Between 1993/94 and 1998/99, total funding for the cultural sector from the Department of National Heritage (DNH) and the Department for Culture, Media and Sport (DCMS) decreased in terms of both actual and real prices when adjusted for inflation. This support for the sector fell by £75 million at current prices – more than £196 million in real terms.

While levels of funding to S4C (the Welsh Channel 4) increased between 1993/94 and 1998/99, funding to almost all other DCMS areas of activity declined to a greater or lesser extent. The Historic Royal Palaces Agency; broadcasting; libraries; the arts, and other historic buildings, monuments and sites were also subject to decreases in expenditure (Table 10.2). Government policy towards these, and details of their funding, are considered elsewhere in more detail (see Parts I and IV in this book). However, DCMS's funding of broadcasting and media, museums and galleries, libraries and the arts was set to rise from 1999/2000 (DCMS, 1998).

Funding from the Scottish, Welsh and Northern Ireland Offices

Scottish Office

Total funding from the Scottish Office fluctuated year-on-year (Table 10.3), with the result that it stood at exactly the same level in 1998/99 as in 1996/97. However, in real terms it fell by £11.5 million between 1993/94 and 1998/99, a drop of 10 per cent. The sectors most affected included museums and galleries,

Table 10.2 Department of National Heritage and Department for Culture, Media and Sport expenditure on the culutural sector, 1993/94–1998/99

£ million

	1993/94	1994/95	1995/96	1996/97	1997/98	1998/99
Museums and galleries						
Museums and galleries (a)	209.300	216.640	219.016	212.021	205.233	203.466
Museums & Galleries Commission	8.900	9.100	9.146	9.300	9.000	8.900
Acceptance in lieu of tax	3.115	6.160	7.407	2.171	6.785	25.299
Subtotal	*221.315*	*231.900*	*235.619*	*223.492*	*221.018*	*212.366*
Arts	235.600	195.000	200.173	195.030	196.153	199.491
Libraries (b)	114.528	146.000	171.399	114.372	106.792	90.816
Media						
S4C	58.000	63.776	68.486	72.223	18.414	75.127
Assistance to films	24.340	26.144	26.422	23.590	23.593	22.880
Other broadcasting	2.000	4.818	3.920	1.971	1.971	1.971
Subtotal	*84.340*	*94.738*	*98.828*	*97.784*	*43.978*	*99.978*
Heritage						
Historic Royal Palaces Agency	6.700	9.118	4.232	6.687	7.510	3.806
Royal Parks Agency	22.800	23.949	24.701	23.171	21.871	21.065
English Heritage	100.200	104.400	109.674	107.629	105.183	102.214
RCHME	14.800	14.00	11.908	11.313	11.073	10.900
NHMF	12.000	8.700	8.805	8.005	5.000	2.000
Occupied Royal Palaces, other historic buildings	27.200	24.000	24.789	24.069	22.073	20.689
Other bodies	3.700	4.000	4.585	4.392	4.681	4.730
Subtotal	*187.400*	*188.167*	*188.694*	*185.266*	*177.391*	*165.404*
Total culture and heritage spend	843.183	855.805	894.713	815.944	745.332	768.055
At real (1998/99) prices	*964.299*	*964.951*	*980.486*	*866.265*	*769.653*	*768.055*
Percentage change year-on-year	n/a	0	2	−12	−11	0

Sources: DNH, annual reports 1995–1997; DCMS, annual reports 1998–1999.

Notes
a) Including the Royal Armouries.
b) Including Library and Information Council, Wolfson, RNIB.

funding of which rose year-on-year (except for 1995/96) but fell back in 1998/99. Historic Scotland saw year-on-year decline since 1993/94.

Welsh Office

Overall, Welsh Office funding increased between 1993/94 and 1995/96 (from £31.1 million to £50.7 million) and remained at around £44 million in the following three years. Funding to the National Library of Wales more than doubled between 1993/94 and 1995/96, but fell back to its 1993/94 level in 1996/97 (Table 10.4).

Table 10.3 Scottish Office funding for the cultural sector, 1993/94–1998/99

£ million

	1993/94	1994/95	1995/96	1996/97	1997/98	1998/99(a)
National museums and galleries	25	28	27	29	32	30
National Library	19	12	12	11	12	12
Scottish Arts Council (b)	n/a	24	24	26	27	27
Film industry and other arts	3	3	4	4	5	4
Gaelic broadcasting	10	9	9	9	11	7
Historic Scotland	51	48	40	33	33	32
Total	108	124	116	112	120	112
At real (1998/99) prices	124	140	127	119	124	112
Percentage change year-on-year	n/a	13	–9	–6	4	–10

Sources: Department of the Secretary of State for Scotland and the Forestry Commission, *The Government's Expenditure Plans*, various years, and Scottish Executive, 2000.

Notes
a) Estimated outturns.
b) Funded by the DNH before 1994/95.

Northern Ireland Office

The overall total of Northern Ireland Office spending on the cultural sector (excluding its spend on the built heritage) declined from 1994/95, although its expenditure on museums and the arts has fluctuated. Adjusted for inflation, the figures in Table 10.5 show a general downward trend from 1993/94 to 1998/99 of 7 per cent.

Table 10.4 Welsh Office funding for the cultural sector, 1993/94–1998/99

£ million

	1993/94	1994/95	1995/96	1996/97	1997/98	1998/99(a)
WAC/ACW (b)	n/a	13.700	14.200	15.500	14.500	14.300
National Museums and Galleries of Wales	14.500	12.800	12.500	12.300	12.300	12.700
National Library of Wales	6.000	8.900	12.400	6.000	6.000	6.000
Other	0.600	0.700	0.600	0.600	0.600	0.600
CADW	10.000	11.000	11.000	10.000	9.800	10.500
Total	31.100	47.100	50.700	44.400	43.200	44.100
At real (1998/99) prices	35.567	53.107	55.560	47.138	44.610	44.100
Percentage change year-on-year	n/a	49	5	–15	–5	–1

Sources: Welsh Office, *The Government's Expenditure Plans*, various years.

Notes
a) Estimated outturns.
b) Direct responsibility for the Arts Council of Wales started in 1994/95.

Table 10.5 Northern Ireland Office funding for the cultural sector, 1993/94–1998/99

£ million

	1993/94	1994/95	1995/96	1996/97	1997/98	1998/99
ACNI and other support for the arts	6.445	6.783	6.965	7.788	7.675	7.172
Museums	8.931	10.103	9.580	9.361	9.428	9.120
Total (a)	15.376	16.886	16.545	17.149	17.103	16.292
At real (1998/99) prices	*17.585*	*19.040*	*18.131*	*18.207*	*17.661*	*16.292*
Percentage change year-on-year	n/a	8	−5	0	−3	−8
Built heritage (b)	n/a	n/a	n/a	4.666	4.091	4.217

Sources: Expenditure plans and priorities, Northern Ireland: *The Government's Expenditure Plans*, various years; Environment and Heritage Service, NI, various years.

Notes
a) Approximate figures only. Exact data could not be disaggregated. These figures are given in the text of the relevant reports.
b) The Environment and Heritage Service within the DoE in Northern Ireland came into being in April 1996. Comparable data for built heritage are not available before that date.

Funding from other departments

Nearly 20 per cent of the total identified in Table 10.1 derives from government departments other than DNH/DCMS and the Scottish, Welsh and Northern Ireland Offices. Casey et al. (1996) identified the combined value of support by other government departments in 1993/94 at £168.2 million. However, the 1998/99 figure of £230.4 million is not comparable with this because the data are not consistent.

The total for 1998/99 shown in Table 10.1 is a minimum figure. Additional government funding is identified elsewhere as being channelled through regeneration funding and higher education institutions (Table II.2). Other sources of funding to the cultural sector which could not be quantified for the present volume would have been channelled largely through the Home Office (not least via the Probation Service) and the Foreign Office (for example, via the work of Panel 2000; British Council funding for the promotion of British culture overseas, and Visiting Arts support for overseas companies visiting the UK). Table 10.6 shows information available on sources which could be quantified.

Changes to the of arts funding system

In 1994 financial responsibility for the Scottish Arts Council and the Welsh Arts Council (previously sub-committees of the Arts Council of Great Britain) was transferred from the Arts Council (and ultimately from the DNH) to the Scottish and Welsh Offices respectively. The Arts Council of Great Britain was reconstituted as the Arts Council of England, and Welsh Arts Council as the Arts Council of Wales.

Although all four national arts councils are funded directly through central government departments, and their funding has already been accounted for in the

Table 10.6 Other central government funding for the cultural sector, 1998/99 (a)

£ million

	1998/99
Ministry of Defence	
Museums	11.779
Bands (b)	5.180
Music training schools (b)	3.250
Subtotal	*20.209*
Department for Education and Employment	
National Voluntary Youth Organisations	0.179
Study Support	0.140
Arts and Humanities Research Board	8.749
Subtotal	*9.068*
Specialised Research Collections in the Humanities	5.969
Scottish Higher Education Funding Council	0.700
Subtotal	*6.669*
DTI	
British Trade International (c)	0.441
Design Council (d)	6.000
Subtotal	*6.441*
Foreign and Commonwealth Office (e)	
BBC World Service	161.500
Commonwealth Institute	0.660
Subtotal	*162.160*
Department of the Environment, Transport and the Regions (f)	
London Transport Museum	1.844
Department of Health (g)	
Section 64 grants to voluntary organisations	0.139
Lord Chancellor's Department	23.898
Total	230.428

Sources:
Correspondence with the government departments and bodies concerned; Forrester and Manuel, 2000; Babbidge, 2001.

Notes
a) This does not include figures from the Home Office or MAFF, which were used in Casey et al., 1996.
The Home Office no longer publishes data on its funding of voluntary organisations; and zoos and botanical gardens have been excluded from this study.
b) From personal correspondence with MOD. Dane et al. (1999) cite a considerably higher figure (£24.6 million) but no source is given.
c) Minimum figure identifiable. Support to cultural industry companies to attend trade fairs.
d) In addition to funding from DTI, the design sector also received funding and support from Department for Education and Employment, the Treasury, Foreign and Commonwealth Office, DCMS, the Scottish Executive and the Welsh and Northern Ireland Assemblies, the No. 10 policy unit, the Parliamentary Office of Science and Technology, and the cross-Whitehall initiative, the Creative Industries Task Force. However, on the basis of personal communications with the Design Council and the DTI, it appears that no assessment has been made of the value of this.
e) Section 64 grants only. Spending on art in health is not incuded here.
f) See Table 11.2 for value of regeneration funding.
g) An additional £400,000 would have been spent on cultural exchange according to bilateral agreements. However, this has been excluded on the basis of the criteria given in Appendix 1.

Table 10.7 Arts councils' and regional arts boards' spending on the arts, 1993/94–1998/99 (a)

£ millions

	1993/94	1994/95	1995/96	1996/97	1997/98	1998/99
England						
ACGB/ACE	133.184	118.404	123.143	123.425	123.672	123.532
RABs						
Eastern	3.939	4.724	4.406	4.499	4.415	4.283
South East	2.162	2.316	2.341	2.595	3.001	3.045
North West	5.505	7.985	7.971	8.241	9.680	8.475
West Midlands	3.253	5.000	5.350	5.193	5.466	5.271
East Midlands	2.162	3.781	4.034	3.969	3.994	4.096
South West	2.573	3.886	4.559	4.619	4.935	4.944
Southern	1.830	2.877	3.149	3.147	3.086	3.448
Yorkshire & Humberside	4.326	6.200	6.614	6.453	6.498	6.732
Northern	5.657	5.773	6.497	6.644	6.701	6.817
London	8.289	11.356	11.298	11.798	11.686	11.719
Subtotal RABs	*39.720*	*53.897*	*56.221*	*57.152*	*59.463*	*58.830*
Total England	172.904	172.301	179.364	180.577	183.135	182.362
SAC	21.577	21.889	22.173	24.131	25.706	25.319
WAC/ACW	11.267	11.071	12.024	13.333	11.980	12.372
ACNI	5.335	5.931	5.982	6.344	6.178	6.371
Total	211.082	211.192	219.542	224.385	226.999	226.424
At real 1998/99 prices	241.403	238.127	240.589	238.224	234.406	226.424
Percentage year-on-year change	n/a	–1	1	–1	–2	–3

Sources:
All four arts councils' and the regional arts boards' annual reports and accounts, 1993/94–1998/99.

Notes
a) Including RAB expenditure which could not be distinguished by artform.

tables above, the following tables summarise their own spending and that of the English regional arts boards.

Table 10.7 shows the consistent decline in the amount spent on grants and guarantees by the arts councils and most of the regional arts boards since 1995/96. Moreover, over the period, the arts funding system has remained largely focused on England, which received 82 and 80 per cent of its support in 1993/94 and 1997/98 respectively (1997/98 being the most recent year for which complete data are available). Table 10.8 shows each of the arts councils' grant funding by artform.

Table 10.8 The arts councils' grants by artform, 1993/94–1998/99

£ million

	Arts council	1993/94	1994/95	1995/96	1996/97	1997/98	1998/99
Visual arts (a)	ACGB/ACE	4.454	4.730	5.087	5.056	5.161	5.148
	SAC	1.983	1.943	2.217	2.172	2.327	2.331
	WAC/ACW	1.011	0.991	1.361	1.415	1.425	1.237
	ACNI	0.808	0.836	0.856	0.806	0.573	0.712
Subtotal		*8.256*	*8.500*	*9.522*	*9.449*	*9.486*	*9.428*
Combined arts	ACGB/ACE	26.278	25.581	20.885	21.124	21.165	23.084
	SAC	2.551	2.600	2.614	2.826	2.520	2.691
	WAC/ACW	0.974	1.383	1.508	2.762	1.433	1.849
	ACNI	0.663	0.439	0.729	1.030	1.180	1.468
Subtotal		*30.466*	*30.003*	*58.736*	*27.742*	*26.298*	*29.092*
Dance	ACGB/ACE	20.969	21.623	22.410	23.286	23.162	23.236
	SAC	2.271	2.639	2.661	2.896	2.951	2.995
	WAC/ACW	0.525	0.519	0.580	0.583	0.612	0.412
	ACNI	0.094	0.153	0.196	0.166	0.074	0.135
Subtotal		*23.859*	*24.934*	*25.847*	*26.931*	*26.799*	*26.778*
Drama	ACGB/ACE	40.650	26.765	27.340	27.357	27.128	27.165
	SAC	4.288	4.717	4.656	4.585	4.741	4.460
	WAC/ACW	2.834	3.031	3.264	3.386	3.370	4.026
	ACNI	1.165	1.374	1.692	1.666	1.806	1.768
Subtotal		*48.937*	*35.888*	*36.952*	*36.994*	*37.045*	*37.419*
Music	ACGB/ACE	37.303	36.131	43.765	43.033	43.545	43.348
	SAC	8.036	8.443	8.869	9.894	11.188	11.054
	WAC/ACW	3.967	3.667	3.948	3.969	3.986	4.013
	ACNI	2.344	2.333	1.983	1.838	1.840	1.929
Subtotal		*51.650*	*50.574*	*58.565*	*58.734*	*60.559*	*60.344*
Literature	ACGB/ACE	1.489	1.467	1.554	1.565	1.427	1.551
	SAC	0.890	0.869	1.109	0.965	1.078	1.064
	WAC/ACW	0.984	0.896	0.950	1.008	0.964	0.426
	ACNI	0.261	0.320	0.256	0.286	0.238	0.340
Subtotal		*3.624*	*3.552*	*3.868*	*3.824*	*3.707*	*3.381*
Other	ACGB/ACE	2.041	2.107	2.102	2.004	2.084	0.000
	SAC	1.558	0.678	0.047	0.794	0.901	0.724
	WAC/ACW	0.972	0.583	0.412	0.210	0.191	0.409
	ACNI	0.000	0.476	0.270	0.551	0.468	0.020
Subtotal		*4.571*	*3.844*	*2.831*	*3.560*	*3.644*	*1.153*
Total grants	ACGB/ACE	133.184	118.404	123.143	123.425	123.672	123.532
and guarantees	SAC	21.577	21.890	22.173	24.131	25.706	25.319
	WAC/ACW	11.267	11.071	12.024	13.333	11.980	12.372
	ACNI	5.335	5.931	5.982	6.344	6.179	6.371
Total		171.363	157.296	163.322	167.234	167.537	167.594

Sources: ACGB/ACE, SAC, WAC/ACW and ACNI annual reports, various years.

Notes
a) This includes craft, film and video. ACE and ACNI data also include architecture.

11
Urban Regeneration Programmes

Peter Symon and Adele Williams, University of Birmingham

*Over the past three decades community based arts workers have been develop-
ing a vast body of experience and practice in creative actions geared to social
change. More recently, in the 1980s, British cities like Sheffield, Birmingham,
Manchester, Liverpool and Glasgow began to specifically explore the links
between art and urban regeneration.*

(Chelleiah, 1999: 5)

Despite a growing awareness of the role of cultural activities in urban regenera-
tion programmes (Matarasso, 1997), there is little evidence to show how much
funding actually gets spent on culture in regeneration programmes even though
regeneration spending was found to be the third most important source of UK
central government support for the cultural sector in England in 1993/94 (Casey
et al., 1996: 26). In that year, the Department of the Environment contributed
£39.3 million, or 2.3 per cent of the total estimated £1,726.9 million public and
private funding distributed to the cultural sector in the UK in that year. Only the
Department of National Heritage and the Treasury distributed more funding from
central government sources to the cultural sector in England.

This chapter looks at support delivered to cultural projects through regenera-
tion funding in England in 1998/99. It focuses on the contribution to the cultural
sector of the Single Regeneration Budget (SRB), which by the second half of the
1990s was the main form of support from central government for urban regenera-
tion in England. Although SRB funding is more usually associated with
mainstream regeneration fields such as training, employment, housing and physi-
cal infrastructure, numerous current or recent examples can be found of
arts-related projects funded through SRB programmes. These include:

- a four-year project funded by Chester City Council which uses arts-based
 projects and training activities to encourage social and economic regeneration
 in the West Chester SRB area (LGA, 2000: 9);
- an arts festival in Kilburn, north London (Garfinkel and Brindle, 2000);
- Diorama Arts Centre in the London Borough of Camden, run by a workers' co-
 operative and supported by West Euston SRB; and
- A13 Artsite, funded by East Thames Side Partnership.

The aim of the research reported in this chapter was to assess the extent to which such cultural activities were being funded in pursuit of regeneration-related objectives. The research reported here is based on new evidence about SRB spending derived from a specially commissioned survey carried out in summer 2000. The chapter is divided into three sections: recent development of regeneration funding in England[1] including a discussion of cultural expenditure under earlier programmes, such as City Challenge, and by bodies such as English Heritage, English Partnerships and Groundwork Trust; reporting the results of a survey of cultural expenditure by SRB programmes in 1998/99; and conclusions. The methods used to collect the information are outlined in Appendix 4.

Regeneration funding in England

Current approaches to the economic, physical and social regeneration of urban areas in England may be traced back to the launch, in 1968, of the Urban Programme. Urban Programme funding was allocated by the Home Office, on area-based measures of deprivation or special need. Other area-based policy initiatives followed in the 1970s, with responsibility for urban policy in England passing to the Department of the Environment in 1975.

1 Until 1996 the urban programmes co-ordinated at the Scottish Office provided competitive funding for regeneration schemes in the most deprived areas of Scotland. Four Urban Partnerships were set up by the Scottish Office in 1988 under the 'New Life for Urban Scotland' initiative, in Dundee, Edinburgh, Paisley and Glasgow. Each Partnership was designed to transform a run-down and deprived peripheral housing estate. The extent to which projects with a cultural component were funded in these Partnership areas is not known.

The urban programme was reviewed by the Scottish Office in 1996 and the partnership principle was extended further in urban regeneration. Bids were submitted for 12 Priority Partnership Areas in 1996. Again, there is no information here about the amount of cultural expenditure in these Partnership Areas, nor about how regeneration programmes have reorganised following the establishment of the Scottish Parliament and Executive in 1999.

In Wales, funding provided by the main regeneration mechanism, the Strategic Development Scheme, has, since 1997, been delegated to local authorities. It now forms part of Welsh local authorities' standard funding settlement from central government. A minimum of £365,500 capital funding and £92,200 revenue funding was passed to ten cultural projects in nine local authority areas in 1998/99 from this source. The largest awards were: a capital grant of £300,000 to Barry Railway Heritage Centre; a £40,000 capital grant for Deinlion Brass Band Centre, Gwynedd; and a £32,000 revenue grant for a libraries IT project in Newport (Gwent). These figures exclude support for small business grants and loans, provision of workshops, and support for tourism projects which might have passed to cultural organisations. The Welsh Capital Challenge, which was subsumed into the Local Regeneration Fund launched in November 1999, concentrated on funding purely economic projects. It has not funded projects of a cultural nature.

This study was not able to include information about Northern Ireland. No work appears to have been carried out to identify the sources and amounts of regeneration funding passed to the cultural sector through government agencies in Northern Ireland during 1998/99.

The geographical scope of the Urban Programme widened during the 1980s under the Conservative government (extending to 55 districts in England and Wales by 1988) (Roberts, 2000: 30), but resources were increasingly diverted towards new measures designed to encourage private-sector involvement. Cultural development – and, indeed, community involvement in general – was not a major feature of programmes in the 1980s. Most initiatives had a strong emphasis on bringing the private sector into projects designed to bring about physical redevelopment or economic development. These included: Urban Development Corporations (UDCs), designated in London Docklands and Merseyside in 1981, followed by a further ten in England and one in Wales; Enterprise Zones, 25 of which were established by the mid-1980s; the Urban Development Grant and Urban Regeneration Grant (later merged as City Grant); City Action Teams; and the Priority Estates Project (later renamed Estate Action).

In the 1990s, cultural development began to become accepted as an element, albeit a minor one, of urban regeneration programmes. A new wave of 'Challenge' initiatives, typified by a 'competitive bidding' approach to regeneration funding, was heralded in a speech by Michael Heseltine, the then Secretary of State for the Environment, in March 1991 (Oatley, 1998a: 11). A 'pilot' Challenge initiative, City Challenge, was introduced in May 1991, under which selected localities competed against each other for a limited pool of resources, with bids involving partnerships between organisations from the public, private and voluntary sectors. The confrontational approach to local authorities of the 1980s was replaced by an incentive for them to develop new approaches to regeneration based on collaboration, partnership and community involvement.

Under City Challenge, the local authorities selected were invited to bid for £37.5 million each, using funds top-sliced from the Department of the Environment's other urban programmes, in partnership with other bodies from the public, private or voluntary sectors. Eleven bids were selected in the first round (over the period 1992–1997) and a further 20 were selected in the second and final round (1993–1998) (Roberts, 2000: 31). During this period, City Challenge was the largest single element of the urban policy budget. By the time City Challenge funding ended on 31 March 1998, total grants of £1.14 billion had resulted in a total investment of about £7.58 billion. Including levered-in funds, City Challenge partnerships spent an average of £240 million in each of their areas.

City Challenge made explicit reference to cultural development as part of the regeneration strategy (Casey et al., 1996: 24). Projects with a cultural component were estimated to have been worth £5.4 million in 1993/94, including levered-in funding (Casey et al., 1996: 24). Some City Challenge cultural projects were oriented towards arts activities, for example Dance City, a project established to encourage young people in Newcastle to become involved in dance activities (Bennett, 2000: 6). Most were capital projects involving the development of new or renovated buildings, such as The Drum, a centre for black and Asian arts and culture in inner-city Birmingham. This cost £4.5 million to develop, with funding sources including City Challenge Fund, local authority, European Regional Development Fund and Arts Lottery (Symon and Verhoeff, 1999). However, most arts and cultural outputs delivered by City

Challenge tended to be marginal in relation to the scale of funding for the overall programme. The position of arts and cultural groups in the network of organisational relationships within City Challenge also tended to be marginal, as Oatley and Lambert (1998: 116) show with respect to Liverpool City Challenge.

After the 1992 general election, the Conservative government embarked on a 'root and branch' review of urban policy. This review, carried out in 1992–93, produced several far-reaching changes to the organisation of urban regeneration and its funding in England. First, a major reorganisation of the administration of regeneration programmes was brought about through the creation of ten integrated Government Offices for the Regions (GORs), including a separate one for Merseyside.

Second, an Urban Regeneration Agency was created as a kind of 'roving UDC' (Oatley, 1998a: 16), later renamed English Partnerships by the 1993 Leasehold Reform, Housing and Urban Development Act. The new quango came into full effect in April 1994 when it merged the functions of English Estates, City Grant and Derelict Land Grant. English Partnerships was intended to promote the reclamation and development of derelict, vacant and under-used land and buildings in England (Roberts, 2000: 32). It focused mainly on urban areas (especially in European Objective 1 and 2 areas, City Challenge areas, Enterprise Zones and other inner-city areas), but also on coalfield-closure areas and rural areas of severe economic need (in particular European Objective 5b areas). English Partnerships has been a partner in major area-based strategies and has also supported many SRB Challenge Fund, City Challenge and local-authority-led strategies. By 1999, a cumulative development programme of over £1 billion had been committed and was expected to lever in nearly £2.3 billion (PA Consulting Group, 1999).

English Partnerships can be seen as largely continuing the focus on property redevelopment of UDCs. It delivered support for projects mainly through the Partnership Investment Programme, but also through the Community Investment Fund, designed to realise English Partnerships' objective of enabling local communities to participate more effectively in local regeneration projects (Noon et al., 2000: 70). During 1998/99 English Partnerships approved expenditure of over £37.3 million to 27 Partnership Investment Programme and Community Investment Fund projects which were likely to have included an element of support for the cultural sector. That amount reflects the lifetime cost of the project to English Partnerships rather than expenditure falling within the 1998/99 financial year and does not include levered-in funding. Projects were located in all nine English regions and included, for example, the refurbishment of a redundant Methodist church as the Ocean multi-ethnic music venue in Hackney, East London, and the refurbishment of a large derelict building as a media centre in Leeds.

Apart from the above projects, there are likely to be a number of other English Partnerships projects which include cultural elements (for example, community centres and training projects). It is likely that some of the projects funded by the SRB, and identified in the survey reported below, include some funding levered-in to the SRB programme from English Partnerships (amounts included under the 'other public sector' heading).

The other major policy development to come out of the 1992–93 review of English urban policy moved even further towards the competitive bidding model of resource allocation with the establishment, in November 1993, of the Single Regeneration Budget. The SRB shared the same principles as City Challenge but extended them to the whole of England, along with a more flexible budget and timetable. The SRB was created by merging 20 separate programmes in England from five different government departments. The newly created GORs were charged with managing the new SRB and the other main programmes. Whilst committed central government expenditure on the 20 previously separate programmes, such as UDCs, Estate Action, City Challenge and six Housing Action Trusts (some of which, such as Castle Vale Housing Action Trust in the West Midlands, funded community arts projects), were honoured by ring-fencing the funds for these residual programmes within the SRB, all would eventually be wound down (Oatley, 1998b: 146; Loftman and Beazley, 1998: 30). All City Challenge programmes had been completed by the end of 1997/98.

The uncommitted money left after the 20 programmes were merged formed the SRB Challenge Fund (SRBCF). This Challenge Fund element of the SRB was allocated to local partnerships – usually led by a local authority or, at least initially but less so in subsequent rounds (Hall, 2000), by a Training and Enterprise Council – through an annual competitive bidding process. Bidding guidance for the Challenge Fund was introduced in April 1994. In December 1994, 201 successful first-round (SRB 1) bids were announced, which commenced during the 1995/96 financial year.

The share of the regeneration budget taken by the SRBCF increased year by year as earlier programmes wound down. Table 11.1 presents the changing pattern of regeneration spending in England from 1994/95 through 1998/99 and shows that, by 1998/99, the bulk of regeneration funding was taken by the SRB and by English Partnerships. However, the overall 'pot' of central government regeneration expenditure in England fell over the five-year period, only starting to rise in 1999/2000 when the Labour government's spending programme began to take effect.

By 1998/99, four annual rounds of competitive bidding had resulted in the allocation of SRB Challenge Funding to 676 SRB programmes of between one and seven years in duration and managed by local partnerships throughout England. A cumulative amount of £3.4 billion had been awarded to these 676 successful bids from the SRB Challenge Fund. In 1998/99, the Department of the Environment, Transport and the Regions (DETR) allocated £569 million in SRB Challenge Funding. An additional £1,631 million of other public and private-sector money was levered in to these programmes, giving a total SRB programme spend of £2,200 million for 1998/99 (unpublished data supplied by DETR).

As can be seen from Table 11.1, apart from SRBCF and English Partnerships, there were also a variety of smaller elements of regeneration funding in England in the 1990s. Some of these have contributed to the cultural sector, for example, the environmental improvement agency Groundwork Trust, which received an estimated £6.7 million from DETR in 1998/99. Groundwork has been involved, for example, in small community arts projects on housing estates in Hackney, East London and in public art provision in Hammersmith, West London.

Table 11.1 Expenditure on regeneration programmes administered by Government Offices for the Regions and other public bodies, 1994/95–1998/99

£ million

	1994/95	1995/96	1996/97	1997/98	1998/99
New Deal for Communities	n/a	n/a	0.0	0.0	0.2
Single Regeneration Budget (a)	0.0	136.4	277.5	458.8	560.9
Inner City Task Force	15.6	11.9	8.7	6.0	1.6
English Partnerships (b)	191.7	211.1	224.0	258.8	294.2
Housing Action Trusts	92.0	92.5	89.7	88.3	90.2
Estate Action	372.6	315.9	251.6	173.5	95.7
Urban Development Corporations (c)	257.7	217.4	196.1	168.8	0.0
City Challenge (d)	209.0	204.9	207.2	142.0	9.8
European Regional Development Fund	226.9	138.5	177.3	191.5	229.4
Commission for the New Towns (e)	–135.3	–126.9	–114.5	–112.2	–123.2
Groundwork	5.9	6.2	6.8	6.6	6.7
Special grants programme	1.2	1.2	1.0	0.9	1.1
Manchester city centre	0.0	0.0	0.3	1.1	5.4
Publicity and programme support	0.3	0.3	0.2	0.1	0.3
Closed programmes (f)	299.7	109.4	53.9	14.0	–1.3
Regional Development Agencies (admin. costs)	n/a	n/a	n/a	n/a	12.2
Total regeneration	1,537.3	1,318.8	1,379.8	1,398.2	1,183.2

Source: DETR, 2000.

Notes

a) On 1 April 1999 the administration of the SRB outside London transferred to the RDAs. Responsibility for the SRB in London transferred to the London Development Agency in July 2000.

b) ON 1 April, the regional role of English Partnerships outside London transferred to the regional development agencies. English Partnerships includes spending on coalfield regeneration; Greenwich Millennium site from 1996/97 to 1999/2000; and on derelict land grant up to 1998/99.

c) All UDCs had wound up by March 1998, as they completed their work. Figures include payments made by the DETR in respect of UDC liabilities after wind-up.

d) Excludes City Challenge expenditure by the Housing Corporation.

e) Disposal of assets in its ownership exceeded day-to-day operating expenditure by the Commission for the New Towns and therefore the figures appear as receipts. From April 1999 the Commission for the New Towns was combined with English Partnerships.

f) Closed programmes includes Urban Programme, Safer Cities, Business Start-up Scheme, Local Initiative Fund, Compacts, Teacher Placement Service, Education Business Partnerships, TEC Challenge, Programme Development Fund, Regional Enterprise Grant Section 11 (part A), Ethnic Minority Business Initiative, GEST 19, City Action Teams, Manchester regeneration (Olympics), Coalfield Areas Fund, Local Investment Fund, Urban Development Grant and Dearne Valley College.

Apart from DETR, bodies such as English Heritage (see Chapters 2 and 24), have local regeneration objectives and have contributed to the overall flow of funds into the arts, culture and heritage sectors through regeneration spending programmes by local partnerships. Between 1994 and 1999, English Heritage invested £36 million in 357 projects through Conservation Area Partnership and other grants schemes, including £6 million in 1998/99 (English Heritage, 1999) (Table 11.2). The share of cultural spending within that amount is not known.

To recap, by 1998/99 City Challenge partnerships were no longer in receipt of DETR funding. Apart from what were probably relatively small amounts of funding flowing into the cultural sector from Housing Action Trusts, Estate Action and Groundwork, the two main funding sources for cultural spending through

Table 11.2 Regional breakdown of English Heritage Conservation Area Partnership schemes, 1994/95–1998/99

		£ thousand
	1998/99	1994/95–1998/99
North West	1,128.2	7,179.6
North East	457.0	2,652.0
Yorkshire	593.6	4,403.2
West Midlands	309.6	2,071.7
East Midlands	605.1	3,688.6
East of England	709.3	3,664.2
South West	715.1	3,423.9
South East	282.5	3,885.5
London	1,207.7	5,056.4
Total	6,008.0	36,025.2

Source: English Heritage, 1999.

DETR were English Partnerships and the Single Regeneration Budget Challenge Fund. Given their different briefs, the latter programme is likely to have been much more significant in the cultural sector and it is to a more detailed examination of SRB funding that this chapter now turns.

Cultural expenditure by SRB programmes in 1998/99

The principal method used to estimate their contribution to the cultural sector was a survey of SRB programmes which distributed funding in 1998/99. The survey, specifically undertaken for this study, was carried out in summer 2000 in three selected regions of England: London, which received the largest SRB Challenge Funding; the Eastern region, which received the least; and the North West, which was the northern region with the largest SRBCF allocation.

Based on the survey results, a tentative estimate of cultural spending by SRB regeneration programmes in England in 1998/99 can be derived. The total SRB programme spend in England in 1998/99 was £2.2 billion (according to unpublished DETR data). The survey results indicate that the average amount spent on culture was 4.3 per cent of total SRB programme spend from all sources in 1998/99 (Table 11.3). Grossed up to the national level, the contribution of the SRB to the cultural sector in England in 1998/99 would have been £94.6 million. The national average masks quite large variations between regions: the percentage spent on culture in the North West was twice as large as that spent in London and Eastern regions.

Table 11.3 Estimated percentage of cultural expenditure by Single Regeneration Budget programmes, 1998/99

	Mean percentage	Number
London	2.8	18
Eastern	2.9	7
North West	5.9	23
All	4.3	48

Source: authors' survey.

Table 11.4 Funding sources for Single Regeneration Budget projects, 1998/99 and for programme lifetime

£ thousand

Funding source	1998/99 authors' survey		1998/99 England total		Lifetime of programmes authors' survey	
	£	percentage	£	percentage	£	percentage
SRB Challenge Fund	826.2	25.1	568,993	25.9	6,668.4	21.5
Other public spend	1,094.2	33.2	785,468	35.7	10,589.7	34.2
Private sector leverage	1,372.8	41.7	845,643	38.4	13,696.9	44.3
All	3,293.2		2,200,104		30,955.0	

Source: authors' survey, DETR unpublished data.

SRB Challenge Funding accounted for 25 per cent of the total amount spent in 1998/99 per SRB programme in the survey (Table 11.4), a very similar figure to the 26 per cent of funding contributed by SRB Challenge Funding to all SRB programmes in England in 1998/99. Basing our calculations on the distribution of funding sources in England nationally, then, the estimated total amount of SRB Challenge Funding spent on culture in England in 1998/99 was, therefore, 26 per cent of £94.6 million, or £24.6 million. The remaining SRB programme spending can be attributed to two other sources of 'levered in' funding: from other public spending (including local authority, EU and other public-sector spending – including English Partnerships); and from private-sector leverage (including private sector, voluntary sector and National Lottery – following the DETR convention of treating Lottery funding as private on the basis that it is a non-Treasury vote).

There will be a substantial amount of 'double counting' of the contribution to cultural spending from local authority, EU and National Lottery funding (reported in Chapter 16) and with English Partnerships (reported earlier in this chapter). The survey allows us to identify different sources of funding going into the SRB-programme 'pot', but once the funding is put into that pot, it all becomes 'SRB funding' and it is not possible to disaggregate different sources of funding allocated to particular projects by a local partnership. The number of projects funded in 1998/99 by SRB partnerships in the survey ranged from 1 to 95.

Thirty-one of the 66 SRB programmes responding reported at least one project funded in 1998/99 which had some cultural spending (Table 11.5). The

Table 11.5 Number of Single Regeneration Budget programmes with 'mainly' or 'partly' cultural projects by region, 1998/99

	London		Eastern		North West		Total	
	Number	Percentage	Number	Percentage	Number	Percentage	Number	Percentage
Cultural projects (a)	11	40.7	4	44.4	16	53.3	31	47.0
No cultural projects	16	59.3	5	55.6	14	46.7	35	53.0
All SRB programmes	27	100.0	9	100.0	30	100.0	66	100.0

Source: authors' survey.

Note
a) SRB programmes reporting 'mainly' and/or 'partly' cultural projects.

Table 11.6 Estimated spending on culture by Single Regeneration Budget projects involving any cultural expenditure, 1998/99 and for programme lifetime

£ thousand

	Minimum	Maximum	Mean	Number
Project cultural expenditure in 1998/99				
Mainly cultural projects	0.2	2,226.8	85.4	65
Partly cultural projects	0.3	309.2	23.4	44
Total cultural expenditure over the lifetime of the project				
Mainly cultural projects	1.0	38,900.0	894.5	60
Partly cultural projects	1.0	1188.6	101.0	44

Source: authors' survey.

proportion was highest in SRB programmes in the North West and lowest in London. These 31 SRB programmes identified 109 'cultural projects' which had been funded in 1998/99, including 65 projects which respondents considered to be 'mainly' cultural and 44 which they considered 'partly' cultural (Table 11.6). The typical SRB programme (in terms of median values) had one cultural project lasting three years out of 13 projects funded by each programme overall in 1998/99. One very large SRB 1 programme had funded 21 'mainly cultural' projects in 1998/99, out of a total SRB programme spend that year of £4.4 million.

The survey did not provide any details about the cultural projects other than their titles. Some cultural projects were short, lasting under one year. But other projects would receive funding from programmes for up to the seven years maximum for which SRB funding can last. SRB partnerships were asked to indicate, for 'mainly cultural' projects (not for 'partly cultural' projects), whether cultural, media or arts organisations (such as community arts development companies, theatre companies, community media companies, etc.) had been involved in the project. Of the 63 'mainly cultural' projects in the survey, 43 had involved a cultural, media or arts organisation, but there was little to distinguish between projects involving a cultural partner organisation and those without such a cultural partner in terms of length of the project (typically three years) or the amount spent by the project in 1998/99. However, over the lifetime of the project, projects with a cultural partner organisation tended to be projected to spend several tens of thousands of pounds more than those which had no cultural partner.

Across all 'mainly cultural' projects in the survey, the average estimated amount of cultural expenditure per project in 1998/99 was £85,400 (see Table 11.6), and £23,400 for 'partly' cultural projects. Total estimated cultural spend per project in 1998/99 varied greatly, from £200 to £2.2 million, in the case of a project involving the proposed private-sector development of a multiplex cinema in one SRB 3 programme. Estimated cultural expenditure over the lifetime of each project also varied enormously. The total (projected) lifetime cultural spend per project ranged from £1,000 to £38.9 million. The average (projected) lifetime spend on culture was £894,500 for 'mainly cultural' projects and £101,000 for 'partly cultural' projects.

Estimated spending on culture in each project was added together to give an estimated total amount spent on culture per SRB programme. The average SRB programme spent 4.3 per cent of its total income on culture in 1998/99. This average amount is inflated by a few programmes which spent very large amounts on culture (see below). Over the 66 SRB programmes in the survey, including roughly half which spent nothing on culture, the median spend on culture in 1998/99 was 0.1 per cent of overall SRB funding achieved. This indicates that the great majority of SRB programmes either involved no cultural expenditure or else involved the spending of only a few thousand pounds in 1998/99.

Four of the 66 SRB programmes in the sample accounted for 42 per cent of all estimated cultural expenditure in 1998/99. All of these four programmes spent more than an estimated £400,000 in the cultural sector in 1998/99. These four programmes were drawn from all three regions in the survey. The biggest spender on culture had an estimated £2.7 million cultural expenditure in 1998/99 and accounted for 23 per cent of the estimated total cultural expenditure in 1998/99 in the survey. Its estimated lifetime spend on culture was projected to be £40.5 million, also by far the largest in the survey. In the case of this programme's 'cultural spending', however, it was almost entirely privately funded with no SRBCF contribution.

The second biggest spender in 1998/99 (SRB 1 programme) spent an estimated £1.2 million on culture in 1998/99. These two larger SRB programmes accounted for 33 per cent of all the estimated cultural expenditure in 1998/99 in the sample.

Conclusions: apparent growth in context

The results of the survey of regeneration funding in 1998/99 in England presented in this chapter indicate a modest growth in the level of funding achieved by the cultural sector from regeneration funding since 1993/94, despite a general decline in regeneration spending over the five-year period (and which has since been reversed by the Labour government) (Hall, 1999; 2000). We estimate that urban regeneration programmes funded by the SRB in England spent around £94.6 million in the cultural sector in 1998/99. Urban regeneration spending by other bodies, including English Partnerships, English Heritage and Groundwork Trust, would have added several millions of pounds of expenditure in the cultural sector, bringing the estimated total contribution of urban regeneration programmes to the cultural sector in England in 1998/99 to a figure probably in excess of £100 million. That figure would represent an increase of a factor of around 2.5 in cash terms over the Department of the Environment contribution in 1993/94. However, there are three points which should be made about this apparent improvement in the fortunes of the cultural sector in the regeneration system.

Firstly, much of the growth in regeneration funding for culture has been due to levered-in funding from other public- and private-sector sources, including the ERDF, English Partnerships, local authorities and the National Lottery. The

estimated £24.6 million SRB Challenge Funding going to the cultural sector in 1998/99 is, however, not subject to double counting, and this contribution alone represents a significant increase on the amount contributed by City Challenge, the central government programme which had previously contributed most visibly to the cultural sector.

Secondly, compared with City Challenge and other programmes operating earlier in the 1990s, support for the cultural sector through SRB projects in 1998/99 was also likely to have been more widely geographically spread. Whereas the traditional Urban Programme targeted money at 'needy' localities, many researchers have pointed to the changed pattern under SRB where universal eligibility of local authorities in England and a consequent open market in competitive bidding between localities resulted in a much wider spread of relatively smaller amounts of money per locality.

Thirdly, consistent with the economic development (and, to some extent, physical regeneration) objectives of the earlier rounds of SRB, most bids would have tried to make themselves look attractive to central government by emphasising their purported economic and physical benefits. Cultural expenditure, then, would be likely to figure only either as part of a large-scale flagship leisure or tourism development project, or else as a very small part of training, employment, environmental and community capacity-building projects. The SRB programmes with large 'cultural' spending appeared to involve large capital investments in construction or infrastructure projects. They have been defined as falling within the 'cultural' sector, probably because they are intended to be visitor attractions. Such an interpretation would be consistent with the need for partnerships' bids to appear to be meeting the economic-development objectives of the SRB, particularly in the earlier rounds (Hall, 1999; 2000), when bidding for funds from central government. The rest of the programmes appear to have committed only very small amounts of funding to the cultural sector, as also is consistent with the above model of SRB funding in earlier rounds.

It is important to note that the survey reported in this chapter must be interpreted with caution. Apart from potential issues of 'double counting' with other sources of public money which have been mentioned above, other issues arise over: difficulties in defining the cultural sector in terms meaningful to regeneration practitioners; capturing data in a suitable form when it is not kept in that form for the purposes of monitoring regeneration programmes; and the structure of regeneration spending (particularly the distinction between projects and programmes). Moreover, this chapter focuses entirely on the position in England, due mainly to the challenges involved in constructing common data from different regeneration structures in Scotland, Wales and Northern Ireland.

The survey year 1998/99 stood at the end of an almost decade-long period of decreasing resources for urban regeneration. It also marked a change of policy by the new Labour government, which reviewed the operation of the SRB and, whilst accepting the basic principles of the old regime, has issued new guidance which addresses the criticisms of the old regime (Hall, 1999). By SRB round 6, more emphasis had been placed on social and community-development objectives, perhaps allowing more space for cultural spending to be openly included as part

of winning bids by local partnerships. Research on SRB programme expenditure after 1998/99 is required in order to find out whether the rhetoric of the Labour government and of local government promising an increased commitment to arts and culture in neighbourhood renewal and community development (Chelliah, 1999) has been matched by increased cultural spending in reality.

With the introduction of new area-based regeneration schemes, particularly the £800 million New Deal for Communities for ten-year programmes targeted on relatively small areas and administered by the Social Exclusion Unit, coupled with more emphasis on targeting resources towards needy areas, we may be seeing a return to the City Challenge geography and local scale of regeneration programmes. In these and other area-based initiatives, including the National Strategy for Neighbourhood Renewal (which the government announced in the comprehensive spending review in July 2000), Health Action Zones, Employment Zones, Education Action Zones and Sure Start, as well as the Local Government Association's 'New Commitment to Regeneration' initiative,[2] there is a potential for arts-based activities to be used for work on the government's four key indicators of health, crime, education and employment, as well as community development (Policy Action Team 10, 1999). At the time of writing, the Labour government has announced its intention to roll all funds for Regional Development Agencies into one 'pot' from April 2002, but whether this increased flexibility for these bodies will lead to more or less cultural spending will ultimately depend on how they interpret their brief from government.

2 http://www.lga.gov.uk/lga/newcommitment%5Cindex.htm

12
Funding from Institutions of Higher Education

Sara Selwood, University of Westminster

Higher education institutions (those providing education at graduate and postgraduate levels) maintain cultural facilities to: support teaching and research; enhance the quality of life for students and staff; raise the academic profile of the institution; enhance the quality of life of the wider community; and earn income for the institutions. A recent report for the Higher Education Funding Council of England describes the varying roles of higher education institutions in the provision of cultural and sports facilities to the wider public (Bennett et al., 1999). However, little consideration has been paid to the financial contribution of such institutions to the cultural sector. Given that a great many cultural facilities owned and run by higher education institutions are open to the public, this chapter sets out to consider the value of that contribution.

Seventy-three museums and galleries in higher education institutions across the UK were registered with the Museums & Galleries Commission in 1998 and were, therefore, open to the public. However, the Commission's records have no reliable financial information about these (Coles et al., 1998; Carter et al., 1999). And although LISU (the Library and Information Statistics Unit, University of Loughborough) has identified UK universities' spend on libraries (£365 million in 1998/99), it has made no calculation of the cost of extending the use of these facilities beyond those institutions' immediate populations.

The amount of funding channelled to the cultural sector through higher education institutions can been identified in two ways:

1 Through the amount spent on university museums, galleries and collections by the Higher Education Funding Councils for England and Scotland, and the Arts and Humanities Research Board (there is no equivalent scheme in Northern Ireland, and a scheme was introduced in Wales only in 1998/99).
2 Through a survey of higher education institutions' own funding of cultural venues and events, as carried out for this book.

Support by higher education funding bodies

Joint programmes

In 1994, the Joint UK Funding Councils Group (Higher Education Funding Council of England, Scottish Higher Education Funding Council, Higher Education Funding Council for Wales and the Department of Education Northern Ireland) recommended that bids should be invited for recurrent non-formula funding to support Specialised Research Collections in the Humanities (with funding split 81 per cent to England; 12 per cent, Scotland; 5 per cent, Wales; and 2 per cent, Northern Ireland). In 1994/95, £7.9 million was allocated on a non-recurring basis for conservation, cataloguing of collections and preservation. The second stage, which focused on the same areas as well as publicity and the promotion of the collections, provided £4.9 million in 1998/99 (HEFCE, 1998).

The Research Support Libraries Programme, a £30 million UK-wide initiative, was established in 1998/99. It is intended to facilitate the best arrangement for research support in UK libraries. Approximately half of its funding is to support access to major holdings libraries, effectively compensating libraries for the 'burden' imposed by visiting researchers from other UK higher education institutions. Its allocations are based on a survey of researchers carried out in 1999 (Milne and Davenport, 1999). Just over £18 million has been allocated for the two academic years 1999/2000 and 2000/2001 (HEFCE, 1999). Table 12.1 shows the start-up costs for 1998/99.

Table 12.1 Higher education funding boards' and the Arts and Humanities Research Board's funding to university museums, galleries, collections and libraries, 1998/99

£ million

Body	Funding
England	
University museums, galleries and collections (a)	8.749
Specialised Research Collections in the Humanities	4.900
Scotland	
Minor Recurrent Grant for Museums, Galleries and Collections (b)	0.700
Specialised Research Collections in the Humanities	0.919
Wales and Northern Ireland	
Specialised Research Collections in the Humanities	n/a
National	
Research Support Libraries Programme (c)	0.150
Total	15.418

Sources
HEFCE, 1998; AHRB, 2000; SHEFC, 1994; Research Support Libraries Programme (personal correspondence).

Notes
a) See Table 12.2.
b) This supports the Marischal Museum, University of Aberdeen; the Russell Collection of Early Keyboard Instruments and the University Collection of Historical Musical Instruments, University of Edinburgh; the Charles Rennie Mackintosh Building, Glasgow School of Art; the Hunterian Museum and Art Gallery, University of Glasgow; and the University Collections, University of St Andrews.
c) Start-up costs only.

England

Most university museums are funded by their parent institutions from the block grant they receive from the Higher Education Funding Councils. Their funding often comes out of the budget of the academic department with which they are most closely affiliated. However, the Higher Education Funding Council for England (HEFCE), funded by the Department for Education and Employment, also provides non-formula funding in support of a number of university museums of national importance on the condition that bona fide users from higher education have free access. HEFCE reviewed its non-formula funding of museums in 1993/94 and subsequently funded 21 higher education museums, galleries and collections (HEMGCs) in 13 higher education institutions from 1995 (HEFCE, 1993a; 1993b; 1995). These amounts increased annually to take account of inflation.[1] The amounts allocated in 1998/99 include additional sums for three institutions to allow them to take advantage of capital grants from the National Lottery (Table 12.2).

According to a survey which the Board carried out in 1999, the proportion of costs covered by this funding varies considerably – from less than 10 to over 80 per cent. Precise comparisons are difficult, because higher education institutions vary considerably in their accounting systems (AHRB, 2000).

Scotland

In Scotland, non-formula funding for museums, galleries and libraries, channelled through the Scottish Higher Education Funding Council (SHEFC), is distributed through three schemes: Minor Recurrent Grant for Museums, Galleries and Collections; Specialised Research Collections in the Humanities; and the Research Support Libraries Programme.

From 1993/94, £700,000 per annum was allocated to supporting museums, galleries and libraries, under the Minor Recurrent Grant for Museums, Galleries and Collections programme. This started with £622,000 in 1993/94. Having reviewed the scheme, SHEFC invited bids for funding in December 1994 (SHEFC, 1994). The outcome of the bidding process informed allocations in future years, and the Council announced its intention to review the grant after five years. Funding for the Minor Recurrent Grant has increased, with £822,000 being distributed under this heading in 2000/01.

Direct funding of cultural venues and events

In addition to the support provided via central government and other funding bodies, research for this book sought to assess what it cost higher education insti-

1 The funding allocations for 1995/96 were informed by a review which explicitly referred to the teaching and research activities carried out by the HEMGC within its parent institution as well as its external teaching and research functions (HEFCE circular 9/95). At the time of writing (summer 2000) Arts and Humanities Research Board (AHRB), which inherited the HEFCE's responsibility for non-formula funding for HEMGCs in 1998, was currently consulting about the future of the scheme.

Table 12.2 Non-formula funding for university museums, galleries and collections in England, 1995/96–1998/99

£ thousands

University	Museum collection	1995/96	1998/99
University of Bath	Holburne Museums and Crafts Study Centre	59	59
University of Birmingham	Barber Institute of Fine Arts	93	121
University of Cambridge	Fitzwilliam Museum/Museum of Archaeology and Anthropology	958	1,105
	Whipple Museum of the History of Science	22	(b)
University of Durham	Oriental Museum	83	84
University of East Anglia	Sainsbury Centre for Visual Arts	215	218
University of Leeds	University of Leeds Arts Collections and Gallery	23	23
University of London	Courtauld Institute Galleries	545	655
School of Oriental and African Studies	Percival David Foundation of Chinese Art/Library	252	1,082
University College London	College Art Collection	52	93
	Petrie Museum of Egyptian Archaeology	41	(c)
London Guildhall University		n/a	126 (a)
University of Manchester	Manchester Museum/Whitworth Art Gallery	1,371	1,817 (d)
Middlesex University	Silver Studio Collection	59	60
University of Newcastle upon Tyne	Museum of Antiquities	10	135
Royal Academy of Music		n/a	250 (a)
University of Oxford	Ashmolean Museum of Art and Archaeology/ Pitt Rivers Museums	2,349	2,732
	Museum of the History of Science	127	(e)
	Oxford University (Scientific Collections)	189	(e)
University of Reading	Museum of English Rural Life	186	188
Total		6,634	8,749

Sources: HEFCE 9/95; AHRB, 2000.

Notes
a) Sums specifically allocated as partnership funding for Lottery projects.
b) Funding for the Whipple Museum for 1998/99 is aggregated with that for the Fitzwilliam and the Museum of Archaeology and Anthropology.
c) Funding for the Petrie Museum for 1998/99 is aggregated with that for the College Art Collection.
d) Funding to the Whitworth Art Gallery for 1998/99 includes £250,000 allocated as partnership funding for the Lottery.
e) Funding for the Museum of the History of Science and Oxford University (Scientific Collections) for 1998/99 is aggregated with that for the Ashmolean and the Pitt Rivers.

tutions themselves to maintain cultural activities and venues open to the public in 1998/99 (including any capital spend).

Information was sought from institutes through a postal survey. They were identified through lists provided by the Committee of Vice Chancellors & Principals of the Universities of the United Kingdom; the Higher Education Funding Councils of England, Scotland and Wales; and a list of university museums on the Museum & Galleries Commission's DOMUS database. Reference was also made to those higher education institutions with cultural facilities which had responded to the survey carried out for Bennett et al (1999).

Institutions were asked about facilities open to the public, as opposed to those dedicated to internal use. These include arts venues (for example, arts centres, theatres, concert halls) cinemas, museums and galleries, archives and special library collections. Indirect provision for public benefit was also considered –

Table 12.3 Higher education institutions' funding of cultural venues, 1998/99

	£ million
Collections/visual arts	14.038
Theatre/drama	2.216
Music	1.006
Film	0.134
Built heritage	2.287
Arts centre	1.702
General arts/cultural promotion	11.689
Sponsorship	0.023
Total	33.095

Source: authors' survey.

Note: sample size: 78 institutions.

sponsorship and support of activities outside the institution. Open lectures and events taking place in teaching spaces were excluded.

A survey of the 167 institutions produced 127 returns (a 76 per cent return rate). Of those: 78 (47 per cent of the total population) provided information about the value of their direct funding of cultural facilities (see Appendix 5); 25 (15 per cent) responses were from universities with no publicly accessible cultural facilities; 17 (10 per cent) provided information about cultural facilities open to the public, without attaching figures. These included three major music colleges which declined to provide data, partly because of the 'sensitivity' of the subject, and partly because of the difficulties involved in disaggregating costs. A further seven responses were uninformative.

The data provided in Table 12.3 show the direct costs incurred by the 78 higher education institutions which provided such information. They spent some £33 million in 1998/99 on facilities open to the public – a figure based on their gross direct spend and, in the case of only 13 institutions, a full or partial overhead including some staff costs. The table, thus, represents higher education institutions' minimum spend. It follows that a comprehensive picture, including the costs of overheads and staff across the board, would indicate a considerably higher contribution.

Various caveats apply to the information provided. These pertain to overheads, staffing costs, and the costs specifically allocated to public use of the facilities.

Direct costs

It appears to have been comparatively simple for institutions to present details of their direct spending on dedicated facilities which relate to particular budgets or cost centres. Some estimated the value of their support in kind to the users of their facilities on the basis of the fees lost by waiving what might be a normal hire charge. However, calculations of costs involved in supporting such facilities, covering for example the multi-use of space in higher education institution buildings, proved more problematic. These tended to be omitted from the calculation.

Income

At one end of the scale were institutions with galleries which they described as self-funding, funded by endowments or outside grants. Since these were amongst those organisations for which detailed figures were not given, it is not clear whether the income attracted covered overheads as well as direct costs. At the other end of the scale, institutions suggested that they attracted anywhere between 6 and 34 per cent of their direct expenditure in income which they generated through admissions and catering fees. Only nine institutions gave details of such income which was used to offset direct costs. These attracted £414,296 against an outlay of £2,315,622, producing a return of 18 per cent. It is assumed that, in many cases, only negligible amounts of income are attracted.

While the object of this exercise was to find out about the cost of cultural facilities to the higher education institutions, some respondents referred to their ability to generate income. This included income from theatres and halls available for hire, and fees earned from the loans of paintings and drawings. These covered direct costs, such as lettings policies.

Overheads

Only 11 (14 per cent) of the institutions making returns specifically included overheads; two provided overheads for only some of their facilities. Overheads were specifically excluded by the majority (44, or 56 per cent) of the total respondents. The remaining 21 (27 per cent) made no mention of overheads.

Precise details of the overheads varied from institution to institution, covering such elements as premises costs, maintenance, heating, lighting, technical support, cleaning, security, communications and insurance. Moreover, overhead and utility costs might vary across the different sites of campuses of a single institution. Typically, respondents referred to the fact that their institutions supported the centre through its estates and facilities department, and that such costs, except for supplies, are met by the institution. The details of the overheads presented do not suggest a general equation which could be applied throughout.

Staff costs

The staffing structure in higher education institutions differs markedly from that in national, local authority and independent organisations. Very few facilities have dedicated or professionally qualified staff – those that work in cultural facilities tend to do so as part and parcel of their academic work. Within the context of the majority of university museums, 'collections are cared for on a part-time basis, the role frequently being combined with that of technician, postgraduate researcher, lecturer, archivist or librarian' (Weeks, 2000). Some respondents included staff costs. In many cases, respondents also experienced difficulties in estimating costs, particularly where academic and administrative costs represent a proportion of the post-holders' overall departmental responsibilities.

Costs attributable to public access

Given that in most cases institutions' cultural facilities exist to support their core educational mission, several institutes not only found it extremely difficult, but were unwilling, to disaggregate certain budgets or to apportion components attributable to services to 'the public' as separate from the services to the institution's internal users.[2] This was further complicated by the fact that the degree to which facilities described by respondents were available to the public varied considerably. At one extreme, some had cultural facilities open to the public full-time; at the other, some provided only limited access (for example, 'the closest we would go in that direction would be to access our medical books by specific request for a particular archive volume; by friends and well-wishers of the School attending student concerts or performances').

Whereas the majority did not attempt to quantify the costs of public use of particular facilities, a few attempted to do so. One institution, for example, regarded it as reasonable to assume that 25 per cent of its music centre's effort is aimed at the public rather than within the institution itself.

Costs for institutions not giving the value of their support

Most of the costs involved appear to consist of staff time and facilities' utilisation, which tend to be lost within the overhead. Moreover, there is no consistency from institution to institution. For example, one college with a small museum on one site noted that the 'costs are subsumed within the total building costs of that site'. Moreover, the curation of that museum is the responsibility of a local voluntary organisation.

Other higher education institutions which gave no indication of expenditure of income function on the basis of a mutually beneficial relationship with the public which appears to nullify their interest in calculating the direct costs. Typically, a department of music or a college specialising in the performing arts will effectively mount or host seasons of performances by students and visiting artists to which the public is invited on a regular basis – the institute provides the performers and the public provides the audience. As one college put it, 'We effectively run an arts centre which is open to the public for 35 weeks of the year – i.e. during term time.'

2 In the survey for the Research Support Libraries programme (see above), Research Surveys of Great Britain surveyed 5,000 research-active staff, postgraduate research students and post-doctoral research assistants (Milne and Davenport, 1999).

13

European Funding

Geoffrey Brown, EUCLID

A 1993 report for the European Commission (EC, the 'executive arm' of the European Union) detailed funding to the cultural sector to the community overall as being 2.5 billion ecu[1] for the period 1989–93, £1.9 billion or an average of £374 million per year (Bates and Wacker, 1993). Since 1993, the amount of EC funding to the sector has risen significantly, and millions of ecus and euros have been paid annually by the EC to the arts and heritage sectors throughout the European Union. Over the 1989–93 period, the UK accounted for about 16.5 per cent of the population of the EU, which suggests that it would have received in the region of £61.7 million per year for the cultural sector. This chapter estimates that over £50 million per year was received for the period 1995–99, based on extremely conservative estimates and excluding cultural tourism, which Bates and Wacker included.

Very little of this funding was channelled through the EC's designated cultural directorate (Audio Visual Information, Communication and Culture: DG X), or through programmes specifically devised to support cultural development. The vast majority came about as the result of successful bidding by cultural organisations and local and regional authorities for monies available under Structural Fund initiatives, primarily concerned with addressing economic imbalances in disadvantaged areas of the EU.

Such an assemblage of funding inevitably creates enormous difficulties in terms of any attempt to assess its size and impact on the cultural sector, let alone appraise its policy implications.

Structural Fund allocations to 'cultural projects' are hard to disentangle from generic categories. 'Arts', 'heritage' and 'culture' are not recognised as legitimate headings for grant allocation, data analysis and evaluation at either national or European levels. Consequently, tracing the levels and impact of European funding on cultural development requires re-evaluation by regional offices of funding recipients and projects, and/or the use of proxies, such as

1 Although the 'euro' has been the single European currency since 1999, for much of the period under consideration it was the 'ecu' (the European Currency Unit). For the sake of consistency, the ecu is, therefore, referred to throughout this chapter.

investment in tourism and visitor attractions. Data accuracy problems also arise
where there are significant time lags between budget announcements and grant
aid allocations; gaps between allocations and actual spending; and delays of
up to five or more years in project assessments and post-completion audits.

(Evans and Foorde, 2000: 55)

Despite these difficulties, this chapter aims to review EU funding to the cultural
sector in the UK between 1995 and 1999. It consists of four sections: the first
describes the methods of approach taken; the second describes the type and
value of support delivered through the Structural Funds; the third describes the
type and value of support delivered through the trans-national funds. The fourth
and final section briefly summarises the total amount of European Commission
cultural funding to the UK between 1995 and 1999.

Methods of assessing EU funding

Data sources

The data for this chapter were extremely difficult to collate, and had to be
gathered from a wide variety of sources. While some of these sources had data
that were complete, there was little commonality in how the data were kept, and
large gaps emerged where data could not be obtained.

Sources included a number of departments of the EC, covering overall alloca-
tions of Structural Funds as well as the various sections and departments which
handled the specific trans-national programmes. A number of government depart-
ments in the UK also provided information, in particular the Department for
Culture, Media and Sport and the Department of the Environment, Transport and
the Regions (although their records are neither complete nor comprehensive).
Separate departments in Scotland, Wales and Northern Ireland also contributed.
Data from these sources mainly referred to the Structural Funds, although some
government departments and other agencies had records of certain trans-national
funds specifically relevant to their areas of responsibility (for example, the
Department for Culture, Media and Sport has some records of funding through
the trans-national cultural funding programmes). In some cases, data were kept
by government departments which had administered the programmes, and in
other cases by one or more independent agencies which had administered funding
programmes on behalf of the government.

Data were also obtained from websites, CD-ROMS, complex databases and
un-categorised lists, published directories, occasional reports and journal
articles, spreadsheets and archive documents.

Data were provided by the EC in ecus/euros, the standard measure of currency
for all trans-national programmes managed from Brussels or Luxembourg, and in
pounds sterling for grants allocated from within the UK for UK recipients (for
example, via the Structural Funds). Since Structural Fund grants were all made
within the UK, tables are presented with values in pounds sterling. Schedules for
grants from the trans-national funds are in ecus, as these grants were made from

Brussels. All grants made direct from the EC are also calculated in ecus and converted.

There have been no consistent attempts by bodies in the UK cultural sector (such as the national arts councils, the regional arts boards and the area museum councils) to keep or maintain accurate figures of European funding. This is, perhaps, not surprising. With regard to trans-national funding, it would be diffi-cult since these grants are made across the whole country and, in many cases, the amounts going to a specific region may not have seemed big enough to justify any sort of monitoring. With regard to the Structural Funds, it is probably fair to say that it is only recently that the arts funding system has begun to come to terms with the vast array of EU funding programmes with a potential impact on culture, having realised that significant sums have been allocated through these channels and that they should, conceivably, try and keep track of it all.

Time frame

This chapter is based on figures for the period 1995–99, the period over which most of the EU programmes under consideration were active. This represents the last 'round' of Structural Funds, which are generally allocated over a period of five or six years. As it turned out, some of the allocations in the Structural Funds were for 1995–99, and some were split between 1994–96 and 1997–99. While the trans-national funds are allocated on an annual basis, it was felt that the allocation period of the Structural Funds provided a useful framework for examin-ing this area.

Scope

For the purposes of this chapter, culture is defined to include the performing and visual arts, literature, museums and heritage, and the audio-visual sector. Libraries have been excluded, as have the 'creative' or 'cultural' industries. There are no specific 'stand-alone' library-funding programmes as there are for culture, media, etc. although there have been specific criteria and sub-programmes for libraries from within the research and development and IT programmes, and many library projects have also benefited from grants from the generic programmes in this area. The concept of the creative industries was not common in the EU in the period under discussion, and to follow this path, while an inter-esting exercise, would have led to an attempt to extract 'cultural' funding that had been allocated through the considerable range of EU 'business support' funds. There was no indication (or previous research) to suggest that this would have been either an easy or a productive task.

Making estimates

This chapter collates and presents those data which have been made available on a funding programme-by-funding programme basis. It has been necessary to make

some assessment of how comprehensive and accurate that information might be. The total figures presented in this chapter are, necessarily, 'best estimates'.

In an ideal world, a few examples of projects would have been used in each section of the chapter to illustrate the types of projects funded. However, in some instances, examples have had to be used as a sort of 'minimum indicator' of grants in various places where no other data existed or were available.

Whereas other chapters have provided an analysis of funding on a home-country and regional basis, this is not possible for the trans-national funds, as there is no regional grouping by the EC departments which make these grants. Nor has an analysis on the basis of a split between, for example, artform or heritage activity been attempted.

Types of EU funding

From 1995 to 1999, EU funding relevant to the cultural sector came from two types of programmes – Structural Funds and trans-national (or project) funds. Until 2000, both were delivered through the 23 numbered Directorate-Generals (DGs) of the EC. Although this system has since been re-organised, and the EC's roman numbering system for the DGs abolished, this chapter still refers to them by their former numbers, as this system applied during the period under review.

Structural Funds

The Structural Funds are intended to address economic imbalances in disadvantaged areas of the European Union and to help close the gap between the advanced and less developed regions.

These are provided either directly to specific geographical locations in Member States for distribution (through the former DG XVI, which was concerned with regional policy), or to targeted organisations in the Member States (from DG V, concerned with employment) in partnership with the central administrations of Member States and their local and regional authorities. The Structural Funds consist of four separate but linked funds:

- the European Regional Development Fund (ERDF) from DG XVI
- the European Social Fund (ESF) from DG V
- the Guidance Section of the European Agricultural Guidance and Guarantee Fund (EAGGF) from DG XVI
- the Financial Instrument for Fisheries Guidance (FIFG) from DG XVI.

The Structural Funds are available through three distinct mechanisms: Regional Allocations defined through local Single Programmes (for example, Objective 1 areas); Community Initiatives; 'Innovative Actions' including Article 10 projects (via DG XVI); and, Article 6 measures (via DG V). Four strands of Structural Funding are considered here: Regional Allocations; Community Initiatives;

Employment Initiatives; and Innovative Actions. The section closes with a summary of allocations and grants to the UK from Structural Funds.

Regional Allocations

Regional Allocations are provided to regions (in some cases, large regions, or even whole countries) suffering economic difficulties. The specific allocations of monies within a particular region (within a country) are contained within a local Single Programming Document – there may, thus, be a number of these within a country. In the UK, there were Single Programming Documents for each of the Objective 1 regions and for many of the other 'Objective' regions. The Single Programming Documents are determined through a negotiation procedure involving the EC and Member States' governments. They analyse the strengths and weaknesses of regional economies within a framework of objectives for the development of the economies of Europe as a whole.

For the period 1994–99 the Structural Funds were governed by three overarching objectives:

- to promote the development and structural adjustment of regions whose development is lagging behind that of the Community as a whole (Objective 1, 1994–99), involving the European Regional Development Fund (ERDF), the European Social Fund (ESF), the European Agricultural Guidance and Guarantee Fund (EAGGF) and the Financial Instrument for Fisheries Guidance (FIFG);
- to support the economic and social conversion of areas facing structural difficulties (Objective 2, 1994–96 and 1997–99; Objective 5b, 1994–99), encompassing both ERDF and ESF funds; and
- to support the adaptation and modernisation of education, training and employment policies and systems (Objectives 3 and 4), encompassing the ESF only.

In the UK, the Objective 1 regions for 1994–99 were: Merseyside; the Highlands and Islands of Scotland; and Northern Ireland. Regions eligible for Objective 2 Structural Funds were: East London and Lee Valley; East Midlands; North West (focused on Greater Manchester, Lancashire and Cheshire); North East England; South West (focused on Plymouth); London (focused on Thanet); West Cumbria; West Midlands; Yorkshire and Humberside; East Scotland; West Scotland; industrial South Wales; and Gibraltar. And regions eligible for Objective 5b funds were: East Anglia; Lincolnshire; Midlands Uplands (parts of Derbyshire and Staffordshire); Northern Uplands (parts of East Cumbria, Lancashire, Northumberland, Co. Durham, North Yorkshire; South West England); The Marches (parts of Shropshire, and Hereford and Worcestershire); Borders; Central Scotland; Dumfries and Galloway; North and West Grampian; and rural Wales. All these areas are shown in Map 5, Appendix 3.

Table 13.1 Summary of Structural Fund allocations to the UK, 1995–99

Billions

	England	Scotland	Wales	Northern Ireland	England, Scotland and Wales	UK	Total (ecus)	Total (£)
Objective 1	850.2	320.0	n/a	1,284.5	n/a	n/a	2,454.7	1,753.4
Objective 2	3,474.6	–	–	–	n/a	n/a	3,474.6	2,481.8
Objective 5b	508.4	145.3	145.3	–	n/a	n/a	799.1	570.8
Konver	(a)	(a)	(a)	n/a	n/a	13.4	13.4	9.6
Pesca	(a)	(a)	(a)	n/a	n/a	43.1	43.1	30.8
Leader II	32.5	23.6	10.7	12.7	n/a	n/a	79.6	56.8
Rechar II	144.9	15.1	30.2	n/a	n/a	n/a	190.2	135.9
Retex	(b)	(b)	(b)	5.1	36.7	n/a	41.8	29.8
SME	48.4	12.3	2.3	6.2	n/a	n/a	69.2	49.4
Urban	82.5	15.6	6.6	19.8	n/a	n/a	124.5	89.0
Employment	(b)	(b)	(b)	12.8	134.6	n/a	147.4	105.3
Adapt	(b)	(b)	(b)	3.5	297.3	n/a	300.9	214.9
Total (ecus)	5,141.5	531.9	195.2	1,344.7	468.6	56.5	7,738.5	
Total (£)	3,672.5	380.0	139.5	960.5	334.7	40.4	5,527.5	5,527.5

Source: data supplied by EC DG Regional Policy.

Note: the conversion rate used is 1.4 ecus to £1 sterling, the average between 1995 and 1999 (Bank of England exchange rates).

(a) see UK column; (b) see England, Scotland, Wales column.

European Regional Development Fund and European Social Fund

The analysis of the Regional Allocations over the next few pages covers funding allocations from the European Regional Development Fund (ERDF). Funding from the European Social Fund (ESF) within the Regional Allocations has been more difficult to analyse. However, figures obtained from the Department for Education and Employment indicate that a total of £45.3 million was granted to tourism and cultural projects in the period 1994–99. This is around 1.25 per cent of the total ESF grants of £3,496.5 million for this period in the Regional Allocations. From a summary breakdown of this total, it can be estimated that a minimum of £15 million was allocated to the cultural sector (noting that most of this funding was probably mostly for heritage-related projects and activities). These figures include Scotland, but not Northern Ireland.

All the Structural Fund allocations to the UK are shown in Table 13.1.

Table 13.2 Total funding for cultural projects in the UK under Objective 1, 1995–99

Location	£
Merseyside	15,735,360 (a)
Highlands and Islands	7,359,358 (b)
Northern Ireland	2,057,300 (c)
Total	25,152,018

Notes and sources

a) Figures for Merseyside provided by DETR.

b) Figures from H&I Enterprise. The sum in the table is EDRF only. ESF figures are not available.

c) Figures from NI SPD (Single Programming Document) Approved Projects Database (NovEast Midlandsber 1999) excluding cultural funding via the Peace & Reconciliation Initiative programme.

Table 13.3 Summary of funding for cultural projects under Objective 2 in England, 1994/96–1997/99

Location	£
East London/Lee Valley	4,129,971
South East – Thanet	779,822
South West – Plymouth	9,430,133
West Midlands	15,743,707
East Midlands	12,721,866
Yorkshire and Humberside	42,150,705
North West – Greater Manchester, Lancashire and Cheshire	44,176,010
North West – West Cumbria	3,746,010
North East	55,694,347
England	188,572,571

Source: DETR.

Table 13.4 Available details of funding for selected cultural projects under Objective 2 in Scotland and Wales, 1995–99

	£
West of Scotland	
Dick Institute: Museum, Art Gallery, Library	261,000
Gaiety Theatre Extension and upgrading	391,000
Glasgow Gallery of Modern Art	3,382,000
Harland and Wolff Theatre conversion	244,000
Glasgow Celebration of Visual Arts 1996	771,000
Glasgow UK City of Architecture and Design, Phase 1	49,000
The House for an Art Lover (Tourist Centre)	97,000
Mayfest Marketing 1996	31,000
Mayfest Marketing Strategy, Stage 1	68,000
The Piping Centre, Phase 3	667,000
The Alexander Gibson Opera School	799,000
Subtotal	*6,760,000*
East of Scotland	
Brunton Theatre improvement	328,000
Caird Hall	391,000
Dundee City Arts Centre	1,563,000
McManus Galleries	77,000
Kirkcaldy Museum and Art Gallery	173,000
Stirling Initiative Events Programme	375,000
Subtotal	*2,907,000*
Wales	
National Centre for Literature, Swansea	1,360,000
UK Year of Literature and Writing 1995	278,000
Cultural Workspaces, Chapter, Cardiff	271,000
Coliseum Theatre, Trecynon	173,000
The Cultural Enterprise Service	125,000
Penrhys Arts and Education Employment	117,000
ISW Arts and Culture Marketing Campaign	29,000
Subtotal	*2,353,000*

Sources: Scottish Office and Welsh Office (cited by Evans et al., 1997; Evans and Foorde, 2000).

Table 13.5 Total known Objective 2 grants for cultural projects in the UK, 1995–99

Location	£
East Scotland	2,907,000
West Scotland	6,760,000
Industrial South Wales	2,353,000
Subtotal	*12,020,000*
England	188,572,571
Total	200,592,571

Source: Tables 13.3 and 13.4.

Objective 1

Table 13.2 provides an estimate of the total funding for cultural projects under Objective 1. The figures for Scotland exclude projects funded through the ESF, and there may be other gaps. Therefore, the total of £25.2 million would appear to be a conservative estimate of Objective 1 funding for the cultural sector. A rounded-up figure in the order of £26 million is likely to be more accurate.

Objective 2

Table 13.3 summarises funding for cultural projects under Objective 2 in England. These figures contain some projects that might be better classed as 'tourism' rather than 'culture' – for example, the renovation of waterfronts, or the development of visitor centres. It has not been possible to provide a totally accurate breakdown, but it is estimated, from an analysis of project titles, that at most such projects would make up no more than 25 per cent of the total allocation to cultural projects.

Figures for Scotland and Wales (Table 13.4) have been more difficult to obtain than those for England, and information is available on only a project-by-project basis.

The total Objective 2 allocations to the UK are shown in Table 13.5, with the culture grants figures based solely on the figures cited above. This total figure of £200.6 million of Objective 2 funding is likely to be an underestimate given the

Table 13.6 Summary of funding for cultural projects under Objective 5b in England, 1995–99

Location	£
South West	28,957,148
Eastern – East Anglia	4,786,287
East Midlands – Lincolnshire	2,149,074
East Midlands – Midlands Uplands (a)	984,039
Northern Uplands (b)	11,280,619
West Midlands (c)	1,089,763
England	49,246,930

Source: DETR.

Notes
a) Parts of Derbyshire and Staffordshire.
b) Parts of North Yorkshire.
c) Parts of Shropshire, and Hereford and Worcestershire.

Table 13.7 Cultural projects supported under Objective 5b in Scotland, 1995–99

	£
North East Folklore Archive	69,000
Burns Bicentenary Festival	40,000
Burns International Festival	74,000
Burns International Festival 1996	100,000
Pitlochry Festival Theatre – Multi Arts Complex	543,000
Pitlochry Festival Theatre – Marketing/Publicity Development Project	193,000
Total	1,019,000

Source: Scottish Office (cited by Evans et al., 1997; Evans and Foorde, 2000).

lack of full figures for Scotland and Wales. However, it could include an overestimate of figures for England, which include many projects that might be classified as tourism-focused. Reducing the English figure by 25 per cent and adding in a figure for the other regions based on the existing figure plus 20 per cent gives a final estimate of £156 million.

Objective 5b

Table 13.6 provides a summary of funding for cultural projects under Objective 5b in England. The total figure of £44.3 million covers a number of projects (perhaps more than for Objective 2) that might be better classed as 'tourism' rather than 'culture'. However, it has not been possible to carry out a detailed breakdown. At most, such projects would make up no more than 50 per cent of the total culture allocation.

Details of the allocation for Rural Wales are not available. However, there is some evidence of cultural projects supported in Scotland (Table 13.7), with funding of £1 million.

It can be assumed that the total figures for grants to the cultural sector in Scotland and Wales are likely to be £5 million minimum, using a conservative comparison of percentages. And, given the level of tourism projects, the total for England is more likely to be £25 million than the £49.2 million shown in Table 13.6. This suggests a total for Britain in the order of £30 million as a 'best estimate'.

Table 13.8 Funding of cultural projects under Konver in England and Wales, 1995–99

Region	£
London	874,339
South East	986,340
South West	3,567,190
West Midlands	0
East Midlands	105,000
Eastern	940,252
Yorkshire and Humberside	1,581,524
North West	755,551
Merseyside	440,000
Total	9,250,196

Source: DETR.

Community Initiatives

For the period under consideration, there were nine Community Initiatives: Interreg II; Konver; Leader II; Pesca; Rechar II; Resider II; Retex; SME; and Urban. However, no information was available on any cultural projects funded from either SME or Urban.

Interreg II

Interreg II was designed to develop cross-border co-operation to help areas situated on the internal and external borders of EU Member States and also in certain coastal areas which face difficulties due to isolation from their national economies. In the UK, this applied to Northern Ireland (except Belfast), Dyffed, Gwynedd, Kent, East Sussex (and Gibraltar). Support was given to measures intended to promote co-operation in a wide variety of fields, including business development; rural development programmes, and the improvement of infrastructure, training and employment.

Cultural projects in Kent attracted £1,536,572, and those in East Sussex, £1,616,606 – a total for England of £3,153,178. It can be assumed that the total figures for culture grants in Wales and Northern Ireland are likely to be in the region of at least a further £1 million, which would give a total for the UK in the order of £4 million as a 'best estimate'.

Konver

Konver was intended to assist areas affected by the run-down of defence-related industries and military installations. Financed measures included training for new jobs and qualifications, support for businesses (especially small- and medium-sized enterprises) and the regeneration of sites and rehabilitation of land previously used by the armed forces. Support for cultural-sector projects in England and Wales is shown in Table 13.8, with a total of £9.3 million.

These figures also contain a number of projects that might be better classed as 'tourism' rather than 'culture'. Again, at this stage, given the quality of the information available, it has not been possible to provide a more detailed breakdown of Konver funding. At most, such tourism projects would make up no more than 25 per cent of the total allocation. It can be assumed that the total figures for culture grants in Scotland, Wales and Northern Ireland are likely to be in the region of at least £0.5 million. Taking tourism-focused projects into account, this suggests an overall total for funding for cultural projects in the UK from the Konver initiative in the order of £7.5 million as a 'best estimate'.

Leader II

Leader II addressed the persistent problems affecting rural areas with weak economies. It supported: technical assistance to promote the acquisition of skills; rural innovation programmes; trans-national co-operation; and the extension of the existing Leader network for the benefit of all those concerned in rural development. The overall allocations in England are shown in Table 13.9 (with a total

Table 13.9 Funding of cultural projects under Leader II in England, 1995–99

Location	£
South West	2,736,222
West Midlands	74,967
East Midlands – Lincolnshire	268,964
East Midlands – Midlands Uplands	24,603
Eastern	338,419
Northern Uplands	451,628
Total	3,894,803

Source: DETR.

of £3.9 million), of which around 25 per cent are tourism-focused projects.

Figures for Scotland, Wales and Northern Ireland are not available. It can be assumed that the total figures for culture grants in those countries are likely to be in the region of at least £2 million, which would suggest an overall total for the UK (taking tourism-focused projects into account) in the order of £5 million.

Pesca

Pesca was concerned with the restructuring of the fisheries sector. Its object was to help the fishing industry adapt to structural changes by contributing to the economic diversification of the regions affected through the development of job-creating activities, aid for the development of productivity and access to new markets. Eligible measures included the conversion of ports to encompass new activities such as tourism and craft industries.

The figures for cultural funding in England are shown in Table 13.10 with a total of £1.8 million, including around 25 per cent of tourism-focused projects. At least two projects were supported in Wales through Pesca to the value of some £34,000. They included staff straining at Conwy Museum and Conwy Quay Maritime Museum. No other figures for this programme are available. It can only, therefore, be assumed that the overall total for the UK (taking into account tourism-focused projects) would be in the order of £2 million.

Table 13.10 Funding of cultural projects under Pesca in England, 1995–99

Location	£
Eastern	431,042
South West	1,113,351
North East	210,099
South East	30,500
Total	1,784,992

Source: DETR.

Rechar II

Rechar assisted the economic and social conversion of coal-mining areas, with priority given to environmental improvement, the promotion of new economic

Table 13.11 Funding of cultural projects under Rechar II in England and Wales, 1995–99

England	£
East Midlands	1,857,550
Yorkshire and Humberside	360,923
West Midlands	253,661
North East	986,974
Total	3,459,108

Source: DETR.

activities such as tourism and to assist human resources through training and employment measures in defined travel-to-work and other coal-mining areas in England, Scotland and Wales. Spending on cultural projects in England and Wales (including around 25 per cent on tourism-focused projects) is shown in Table 13.11, totalling £3.5 million. These are the only figures for this programme. It can consequently be assumed that the overall total spending on cultural projects (taking into account tourism-focused projects) would be around £3 million.

Resider II

Resider assisted the economic and social conversion of steel areas. Priority was given to environmental improvement in steel areas (such as the restoration of industrial buildings), the promotion of new economic activities (in particular those undertaken by small firms) such as tourism and to assisting human resources through training and employment measures. The figures for cultural spending in England and Wales (including around 25 per cent on tourism-focused projects) total some £0.6 million, as shown in Table 13.12. Since no other figures for this programme are available, it can be assumed that the overall total for the UK (taking into account tourism-focused projects) would be approximately £1 million.

Table 13.12 Funding of cultural projects under Resider II in England and Wales, 1995–99

England	£
North East	269,025
Yorkshire and Humberside	295,000
Total	564,025

Source: DETR.

Retex

Retex was intended to promote diversification in regions over-dependent on the textile and clothing industry, and to encourage the adaptation of viable enterprises from all the industrial sectors in these areas. Eligible measures included training, the rehabilitation of abandoned industrial premises and the development of less-polluting processes. The only available information is for projects supported by Retex in Wales, as shown in Table 13.13. Given the paucity of information on any other cultural projects funded under Retex, no estimate has been made of cultural grants from this fund.

Table 13.13 Selected examples of projects in Wales funded under Retex, 1995–99

	£
Retraining unemployed women from declining textile areas	39,435
Study on potential to strengthen market position of wool industry	8,532
Total	47,967

Source: Welsh European Funding Office, www.wefo.wales.gov.uk.

Employment Initiatives

The Community Initiative on Employment and Development of Human Resources

This initiative was intended to promote employment growth, mainly through the development of human resources. It was a three-strand approach targeted directly at groups facing specific difficulties in the labour market. Although examples of projects funded under 'Now', 'Horizon' and 'Youthstart' are given below, no comprehensive lists nor any specific details of funding under the Employment Initiatives are available. If the twelve projects identified below were all funded to a level of 100,000 ecu, and the UK partners took 25 per cent, this would result in a flow of 300,000 ecu, or £200,000, to the UK. This is probably an under-estimate.

- Now was aimed at women, particularly those returning to the workplace and those who had difficulty finding employment due to childcare responsibilities and costs. Examples of culture-related projects funded by this programme in which the UK was a partner included: Vocational Training for Women in Multimedia; Multimedia Operator for Cultural and Artistic Applications; A Place for Woman; Multimedia for Women in the Cultural Industries; and Trans-national Training for Women in Advanced Desktop Publishing.
- Horizon supported disabled people to overcome the challenges which they face in their integration into work and society. Examples of culture-related projects funded by this programme in which the UK was a partner included: Fingal Pottery Works; Art Access; and DATE (Disability, Art, Training and Employment).
- Youthstart supported the better integration of young people under the age of 20 into the labour market, particularly those without basic qualifications or training. Examples of culture-related projects funded by this programme in which the UK was a partner included: Training Project in World Music; Vitalia – an evaluation of 'Transition to Work' with reference to arts-based self-image work; Pact – a common curriculum for youth workers with young people in depressed areas; and Media Bridge.

Innovative Actions

Innovative Actions were specific allocations of Structural Fund monies under the direct control of the EC, and were available for the promotion of 'innovatory and

Table 13.14 Funding of cultural projects under Article 10 ERDF in the UK, 1995–99

Title	Description	£
Our City (a)	Urban cultural heritage and citizenship – multimedia development of tourist management	500,000
ECHO (a)	Exporting Cultural Heritage Overseas – maritime heritage project	325,000
COAST Heritage (a)	Historical heritage – conservation and development of cultural heritage of coastal areas	485,285
Arqueotex	European network of industrial textile heritage	599,330
Bradan	Cultural heritage to aid the local and national tourist industry	408,500
CIED	Cultural Innovation and Economic Development	400,000
Emporion	European Observatory of employment in Cultural Heritage	500,000
Econcraft	Integrated economic development of regional, local and ethnic craft heritage	498,459
IMKA	Innovative measures for employment in culture	498,465
Pleiades	Cultural itineraries in rural areas	450,000
Promise	Promoting museums through technology-based information services	600,000
Reva	European network of small archaeological towns	500,000
Total		5,765,039

Source: EC, 1998.

Note
a) Led by a UK partner.

pilot activities', which utilised various funds (ERDF, ESF, EAGGF). European Regional Development Fund (ERDF) monies, for example, were used for local and regional projects which specifically helped to develop the local heritage and establish cultural networks between regions and towns in the EU (via Article 10); ESF monies were used for training (via Article 6), as were EAGGF Guidance Section monies (via Article 8). At the time of writing (January 2001) it was not clear whether these pilot projects would continue, nor, if so, in what format.

Article 10 ERDF

Article 10 ERDF included eight areas of action and co-operation, including 'culture and heritage'. The rationale for this was that not only is culture a public activity which generates additional expenditure, but it also plays an increasingly important role in the private sector, where it has strong growth potential and where its capacity for creativity, innovation and production are a positive force in the regional and local economy. This action supported pilot projects which helped to develop the local heritage and establish cultural networks between regions and towns in the EU. Thirty-two such pilots were supported across Europe. The 12 UK projects funded through Article 10 are shown in Table 13.14.

Of the total value of the 12 projects, some 5,765,000 ecu, it can be assumed that an average of 25 per cent came to the UK. Therefore it is estimated that UK partners received approximately 1,440,000 ecus (£960,000).

Another action within Article 10 was Recite II but, as with Article 6 ESF and Article 8 EAGGF, no specific information is available on any cultural projects supported from this fund.

Table 13.15 Summary of estimates of Structural Funds to cultural projects in the UK, 1995–99

		£
Structural Funds	Objective 1	26,000,000
	Objective 2	156,000,000
	Objective 5b	30,000,000
	ESF funding	15,000,000
Subtotal		*227,000,000*
Community Initiatives	Interreg II	4,000,000
	Konver	7,500,000
	Leader II	5,000,000
	Pesca	2,000,000
	Rechar II	3,000,000
	Resider II	1,000,000
	Employment	200,000
Subtotal		*22,700,000*
Innovative Actions		960,000
Total		250,660,000

Source: previous tables and author's estimates.

Notes
a) No funds were identified for cultural projects under Retex, SME, Urban or Adapt.
b) No funds were identified for cultural projects under Recite II, Article 6 ESF or Article 8 EAGGF.

Structural Funds: summary of allocations and grants

In summary, total estimates for Structural Fund allocations to the UK cultural sector are in the region of £250.66 million (Table 13.15).

Trans-national (or project) funds

Trans-national, or project, funds are provided through a range of programmes operated by the different departments of the EC. During 1995–99, there were a great many trans-national, or project, funding programmes, administered by the various Directorate-Generals of the EC. As mentioned above, this structure of numbered DGs was replaced in mid–1999 by a new structure of DGs and 'Services' which abolished numbers and, in some cases, replaced these with abbreviations. At the beginning of each sub-section below, the relevant DG for the funding programme is listed, with the number for the DG under the old system and the abbreviation now used under the new system. The new structure also involved a few changes to the DGs, including a merger between DG X (responsible for culture and audio-visual) and DG XXII (education) to form the new DG EAC: Education and Culture.

The specific areas covered include: cultural funds; media and audio-visual; arts and education; education, training and youth; research and new technologies; environment; and tourism.

Every trans-national project includes a number of organisations from different Member States acting in partnership to undertake the project. For these projects,

Table 13.16 Overall budgets for cultural funds, 1994–99

	Million ecus	£ million
Kaleidoscope	55.85	39.89
Raphael	56.85	40.61
Ariane	15.95	11.39
Cultural co-operation with third countries	9.35	6.68
Total	138.00	98.57

Source: Evans and Foorde, 2000.

Note: the conversion rate used is 1.4 ecus to £1 sterling, the average between 1995 and 1999 (Bank of England exchange rates).

one partner acts as 'lead partner' – this is to designate both the co-ordinating responsibility that this partner will have, and also the legal responsibility, as it is with the lead partner that the EC signs the contract for the project. The lead partner therefore has ultimate responsibility for the project. Lead partners receive a larger part of grants than the other partners, and this consideration has been applied throughout in terms of the estimates made.

Cultural funds

In the period from 1994 to 1999, under DG X – Information, Communication, Culture, Audio-visual (now, DG EAC: Education and Culture), there were three main cultural funds:

- Kaleidoscope, which covered the performing and visual arts, including support for European City of Culture and European Cultural Month;
- Raphael, which covered museums and heritage; and
- Ariane, which covered books and reading, especially translation.

In addition, from 1994 to 1996, there was a budget for 'cultural co-operation with third countries' – those outside the European Union Member States. The overall budgets for these funds are summarised in Table 13.16.

In 1999, it was announced that the three main cultural funds (Kaleidoscope, Raphael and Ariane) would be merged as 'Culture 2000' to operate from 1 January 2000. In 1999, a pilot call for Culture 2000 was undertaken.

Kaleidoscope

The major priority of the Kaleidoscope programme was to encourage artistic and cultural creation through trans-national co-operation. The programme also sought to encourage the promotion of knowledge and dissemination of culture in all of the Member States of the EU. There were two categories of grants, called 'actions':

- Action 1 supported events and cultural projects carried out in partnership or through networks;
- Action 2 supported large-scale European co-operations.

A total of 28,567,720 ecus was allocated to 394 Action 1 and Action 2 projects from 1996–99 (figures for 1994–95 were not available). The UK was lead partner in 44 projects, which received a total of 1,779,595 ecus. As lead partners, UK organisations would probably have received an average of around 50 per cent of the funds for each project, or a total of 890,000 ecus (an average of 20,227 ecus per project). The UK also participated (that is, took part but not as the lead partner) in another 40 per cent of the 350 other projects funded in this period, which suggests that UK organisations were involved in a further 140 projects. Each participating partner would have received an estimated average of 10,000 ecus per project – a total of 1,400,000 ecus. Therefore, it can be estimated that UK cultural partners received 2,290,000 ecus from this programme over these four years.

The Kaleidoscope programme also supported the European City of Culture and European Cultural Month, and the European Community Youth Orchestra and European Community Baroque Orchestra (both of these orchestras contained UK players). It is impossible, however, to estimate with any accuracy the level of any grants or subsidy to such UK players.

Raphael

The main objective of the Raphael programme was to encourage co-operation between the Member States in the area of cultural heritage with a European dimension. There were three actions:

- Action 1: conservation, safeguarding and development of European cultural heritage through European co-operation;
- Action 2: co-operation in the field of exchanges of experiences and techniques applied to heritage; and
- Action 3: access, public participation and awareness of cultural heritage

A total of 47,370,095 ecus was allocated to 223 projects from 1997–99, and the UK was lead partner in 20 projects which received 4,378,713 ecus. The UK lead partners would probably have received an average of around 50 per cent of the funds for each project, or a total of 2,200,000 ecus (an average of 110,000 ecus per project) for these. The UK also participated in 32 (about 40 per cent) of the other 80 projects (but not as a lead partner). Each participating partner would have received on average an estimated 55,000 ecus, which is a total of about 4,400,000 ecus for these 32 projects. Therefore, it can be estimated that UK cultural partners received around 6,600,000 ecus from Raphael over these three years.

Ariane

Ariane was launched in 1996. Its objective was to encourage co-operation between the Member States in the field of books and reading. Support was given to promoting a wider knowledge and circulation of European literature and history among the citizens of the EU through funding for translation and support for trans-national co-operation and training projects. The programme consisted of three actions:

- Action 1: assistance for translation;
- Action 2: co-operation projects; and
- Action 3: training projects.

A total of 10,905,083 ecus was allocated to 899 projects from 1996 to 1999, and the UK was lead partner in 26 projects, which received a total of 594,753 ecus. The UK lead partners would probably have received an average of around 50 per cent, or 300,000 ecus (an average of 11,500 ecus per project). The UK also participated in 220 (about 25 per cent) of the remaining projects (but not as a lead partner). Each participating partner would have received on average an estimated 6,000 ecus, which is a total of about 1,320,000 ecus for these 220 projects. Therefore it can be estimated that UK cultural partners received 1,620,000 ecus from this programme over these four years.

Culture 2000

On 28 June 1999 the European Council adopted a single financing and programming instrument for cultural co-operation called Culture 2000, with a budget of 167,000,000 ecus over five years (2000–2004). This single integrated programme (known as a 'framework' programme) aims to provide a suitable structure to encourage, widen and deepen co-operation between European cultural operators.

The broad objectives of the programme are to:

- promote the mutual knowledge of the culture and history of the European people, thus revealing their common heritage, and encouraging cultural dialogue;
- encourage creativity, the international dissemination of culture and greater movement of artists and their creations;
- promote cultural diversity and the development of new forms of cultural expression
- promote the contribution of culture to socio-economic development;
- highlight the European importance of cultural heritage; and
- encourage European cultures in third countries, and dialogue with other countries around the world.

A total of 6,070,000 ecus was allocated to 55 projects in the pilot call in 1999, and the UK was lead partner in 5 projects. These received an estimated 550,000 ecus (based on 110,000 ecus each). The UK lead partners would probably have received around 50 per cent, or 225,000 ecus (an average of 55,000 ecus per project). For the 40 per cent of the 50 other projects funded in this period, where the UK was a partner (but not a lead partner), UK organisations would have received an estimated average of 30,000 ecus – a total of 600,000 ecus. Therefore it can be estimated that UK cultural partners received 825,000 ecus from this programme in this pilot call.

Summary

Table 13.17 summarises the calculations derived in the preceding sections and provides an estimate of total funding going to the UK from Kaleidoscope, Raphael, Ariane and the Culture 200 pilot call.

Table 13.17 Estimate of funding to the UK from the cultural funds, 1994–99

	ecus	£
Kaleidoscope	2,290,000	1,635,714
Raphael	6,600,000	4,714,286
Ariane	1,620,000	1,157,143
Culture 2000 pilot call	825,000	589,286
Total	11,335,000	8,096,429

Source:various reports from the EC and DCMS.

Note: the conversion rate used is 1.4 ecus to £1 sterling, the average between 1995 and 1999 (Bank of England exchange rates).

Other support for specific European cultural budgets

The Commission can grant support from the operating credits of the EU general budget towards the operating costs of organisations and networks deemed to be working in the European cultural interest. Two such budget 'A lines' have been adopted to this end, and these provided support to a number of organisations and networks over the period under review, culminating in support to a total of 15 cultural organisations in 1999. Amongst these was the European Opera Centre based in Manchester, which received a minimum of 800,000 ecus between 1996 and 1997. It is also likely that UK-based artists and arts organisations participated in activities funded by some of the other 'A line' beneficiaries, but it is impossible to put any figures on such support.

Media and audio-visual

Media 2, a five-year programme (1996–2000) intended to help the film, television and multimedia industries become more competitive, was first administered by DG X – Information, Communication, Culture, Audio-visual (subsequently DG EAC: Education and Culture). The programme was established in 1996 with a budget of 310 million ecus (around £206 million). Independent production and distribution companies could apply for development or distribution funding in the form of grants and interest-free loans. Financial assistance was available for training providers and organisers of markets and festivals. Individuals might also benefit from subsidised places on training courses and international markets. In January 2001, it was replaced by a new programme called Media Plus.

Table 13.18 summarises support from Media 2 to the UK in the years 1996 to 2000 in the main audio-visual areas. Other funds were made available for development of telematics and informatics, for example in library and online information systems.

Arts and education

While there is no specific DG or department with this responsibility, there have been two initiatives during the 1994–1999 period that focused on this area, so it is included here as a separate section.

Table 13.18 Summary of support from Media 2 to the UK, 1996–2000

	EU/ecus	UK/ecus	UK/£
Development	54,027,413	10,385,503	7,418,216
Distribution	99,258,651	6,260,412	4,471,723
Promotion	9,534,253	420,000	300,000
Training	38,539,338	5,512,256	3,937,326
Festivals	4,976,000	199,000	142,143
Total	206,335,655	22,777,171	16,269,408

Source: UK MediaDesk.

Note: the conversion rate used is 1.4 ecus to £1 sterling, the average between 1995 and 1999 (Bank of England exchange rates).

Arts, Education and Training Initiative

The Arts, Education and Training Initiative was originally administered by the Task Force for Human Resources, Education, Training and Youth, which subsequently became DGXXII – Education, Training and Youth and has now become DG Education and Culture (EAC). The aim of the programme was to enhance the quality and quantity of co-operation and innovation in post-secondary arts education and training. It covered six main fields: audio-visual, dance, design, fine art, music and theatre, and ran for two years: 1994/95 and 1995/96.

In the pilot year (1994/95), 44 projects were funded, with each project receiving funding of no more than 10,000 ecus. The UK participated in 16 of these projects as lead partner, therefore receiving an average of around 50 per cent of the 10,000 ecus for each project. It also participated in around 35 per cent of the remainder (that is, about 10 projects) as a partner, for which it would have received around 2,500 ecus per project. Examples of UK-led projects included 'New European Dramatists at the Royal Court Theatre', a sculpture project organised by the Scottish Sculpture Workshop and a bilingual learning pack for use in textile-design education. It is estimated that the total to UK arts bodies was approximately 105,000 ecus.

In the second year (1995/96), 60 projects were funded from a total budget of 600,000 ecus. Each project received no more than 10,000 ecus. The UK participated in 34 of these projects: 19 as lead partner, and 15 as partner. The total amount of funding given to the projects where the UK was the lead partner was 109,363 ecus, so it is estimated the UK lead partners received an average of around 50 per cent, or 55,000 ecus. UK partners participating in the other 15 projects (but not as lead partners) received 2,500 ecus per project, making a total of 37,500 ecus. This gives an overall total of 92,500 ecus. Examples of UK-led projects include the 'assessment and use of public art in art education', an international gathering of women in contemporary theatre, and a project on video in arts education in primary and secondary schools.

Overall, then, it is estimated UK projects received 197,500 ecus from these Arts, Education and Training Initiative projects.

Table 13.19 The number of projects and total budgets funded under Connect, 1999

	DG X/ecus	DG XII/ecus	Total/ecus	Total/£
Total budget	7,037,689	8,399,000	15,436,689	11,026,206
Average budget per project	227,022	139,983	169,634	121,169
Number of projects in which the UK was lead partner	2	7	9	
Number of projects in which the UK was not a lead partner	29	53	82	
Total number of projects	31	60	91	

Source: various reports from the EC.

Note: the conversion rate used is 1.4 ecus to £1 sterling, the average between 1995 and 1999 (Bank of England exchange rates).

Connect

In June 1999, the EC established a new short-term programme called Connect, to provide support for preparatory actions aimed at developing the links between the areas of culture, education and training, and in particular to look at links with research and new technologies. The programme was run by DGX – Information, Communication, Culture, Audio-visual, and DG XXII – Education and Training (and subsequently by DG EAC: Education and Culture).

The overall objectives of Connect were to:

• reduce the existing gaps between the field of culture and other fields, and to encourage innovation;
• take a more active and innovative approach to introducing culture with regard to the education and training of young people; and
• encourage continuing training for artists, performers and culture professionals.

The organisation and implementation of the programme were split between the two DGs. This involved different deadlines for proposals, different expert groups (with little apparent communication between either the administration or the expert groups for each programme), different criteria, and confusion between the applicants.

DG X's strand of Connect was based around two actions.

• Action 1: Culture and Education – support for projects aiming to introduce culture to young people in a lively and innovative way.
• Action 2: Culture and Training/Continuing Education – support for cultural operators and projects involving training and continuing education using innovative educational techniques for creative artists, performers and other cultural professionals. The use of new technologies was desirable. The training should have focused on getting young people started in their careers.

DG XXII's Connect initiative was intended to support European innovative projects which reinforce synergies and links in the areas of education, training and culture, associated with new technologies. This strand of Connect was divided into the following four areas:

- promoting European citizenship via civic and democratic education;
- better exploitation and wider dissemination of the results of community programmes and good practices with high added value;
- promoting European projects to bridge the gap between education and society; and
- organising school competitions in science, maths and invention.

Within each of the above areas, projects were allocated to sub-areas; 267 applications were received and the EC co-financed 60 of these projects. Table 13.19 outlines the number of projects and total budget funded under Connect.

The UK was lead partner for nine projects (each attracting 50 per cent of the average project budget), which brought in a total of 765,000 ecus. The UK was probably involved as a partner in 35 per cent of the other 82 projects, which would mean a total of 1,232,500 ecus (at 25 per cent of the average project income). This is an overall total estimated income to UK partners of 1,997,500 ecus.

Education, training and youth

Until 1999, these funds were administered by DG XXII – Education, Training and Youth. Since then, they have been the responsibility of DG EAC: Education and Culture.

Socrates

Socrates, which began in 1995, is a programme which encourages co-operation in the field of education. The programme aims to enhance co-operation at all levels, from nursery schools to higher education, creating opportunities for mobility and professional development while providing for trans-national collaboration on a far-reaching scale. The programme had a total budget of 543.5 million ecus for 1996–98. The original programme covered three main areas, termed 'chapters' by the EC: higher education, school education and 'horizontal' measures.

Chapter I on higher education ('Erasmus') involved two actions:

- Action 1: grants to universities for European dimension activities;
- Action 2: student mobility grants.

The majority of Erasmus funding has been for student mobility grants, which are not relevant to the present volume. However, the Erasmus Programme has also supported a number of 'thematic networks', including three in areas related to arts and culture: Thematic Network in Arts; Thematic Network in Archaeology; and Thematic Network in Tourism and Leisure Education. The UK has participated in these, although it is impossible to quantify the financial benefits accurately. It is estimated that the UK has benefited from approximately 50,000 ecus from these networks.

Chapter II on school education ('Comenius') involved three actions:

- Action 1: school partnerships for European educational projects, including teacher exchanges and visits;
- Action 2: education of children of migrant workers, occupational travellers, travellers and gypsies, and intercultural education;
- Action 3: in-service training, seminars and courses for teachers and educators.

It has not been possible to identify any culture-related Comenius projects at all, with or without UK involvement, so there is no knowledge of benefits to the UK from this source.

Chapter III on horizontal measures involved three actions:

- Action1: promotion of language learning (Lingua);
- Action 2: open and distance learning;
- Action 3: exchange of information and experience (including adult education).

The adult education programme funded many projects in the 1994–99 period. Amongst these were the following, all of which involved UK partners and the first two of which had a UK organisation as lead partner:

- Cultural Education and Action for Development;
- Enhancing Education for Disabled Adults through Expressive Arts;
- Linking Adult Education with Open Culture and Museums;
- *La Musica Nella Storia Europea.*

However, no information is available on the levels of EC grants to these projects, nor on how much of this was allocated to UK partners. It is, however, estimated that a minimum of 100,000 ecus would have been allocated to UK partners for such projects (on the basis that each project received an overall grant of at least 100,000 ecus and that the UK partners would have received 25 per cent of this, for four projects).

Leonardo da Vinci

The Leonardo da Vinci programme was initially adopted for a period of five years (1995–1999). The programme's key objective was to support the development of policies and innovative action in the field of training in the Member States. The programme was also intended to respond to the demand for new skills, as generated by the evolution of modern societies. It came at a time when the White Paper on 'Growth, Competitiveness and Employment' (1993) forcefully emphasised the crucial importance of vocational training as a key factor in combating unemployment and strengthening the competitiveness of European enterprises. The programme had a total budget of 620 million ecus for the five years.

Leonardo projects with a cultural theme in which the UK was involved as lead partner included:

- Animatics;
- CAD Across Europe;

- Design Imaging;
- Developing Vocational Mentors for the Arts and Cultural Industries;
- European Media Masters Placements;
- European Opera Centre;
- European Publishing Training Needs for the Information Society;
- European Training in Construction Conservation;
- FOOTWORK – transfer of vocational training meaasures in design;
- Integrated Multimedia Radio Journalism;
- New Life Maps;
- Product, Interior and Industrial Design;
- Skill for the Citizen – SKILLCIT;
- University of Brighton Fashion Textiles (1, 2 and 4);
- Vocational Training for Occupational Travellers (Fairground People).

Other projects in which the UK was involved (but not as lead partner) included:

- Added value of Computer Aided Architectural Design;
- Arthemis: artistic heritage multimedia information system;
- CAM training module for the furniture industry;
- Children's Television Electronic Market and Training System;
- Co-operation between Trainers to develop the arts and cultural sector;
- European Graphic and Media Education;
- Film Archives On-Line Network for the Continuing Training of Film Restorers;
- Mass Media Training for Young People;
- MOVING – multimedia and optimisation for virtual engineering and architecture;
- MULTILIGNA – design and development of multimedia training materials as new technologies in the wood and furniture industries;
- Multimedia for the Graphic, Film and Communication Industries;
- New Educational Approach to Recognition of Skills and Abilities in Sport and Cultural Training;
- New Technologies in Publishing;
- SMAB: vocational training for site managers of ancient buildings;
- Transfusion: transfer of conservation and restoration training products;
- VITA: vocational induction training for artists;
- VTTC: vocational training in traditional crafts.

Figures for one Leonardo project in which the UK was a lead partner describe the total budget as 384,902 ecus, with the EU providing 195,000 ecu. The UK lead partner received 26,955 ecus, but the three other UK partners (there were also three other partners from three other Member States) received a total of 58,245 ecus. This means that a total of 85,200 ecus went to UK partners (43.7 per cent). While it has not been possible to identify budgets for all Leonardo projects, let alone the amounts received by UK partners, an estimate for grants to UK organisations from Leonardo is based on the following assumptions. In terms of projects in which the UK was lead partner, it is assumed that: there were 20 projects (over

the whole period) in which the UK was lead partner; 200,000 ecus was provided per project, of which 40 per cent went to UK partners (based on the above example where UK partners received 43.7 per cent). This suggests a total of 1,600,000 ecus to UK partners for projects where the UK was lead partner.

In terms of estimating funding for projects in which the UK was just a partner, it has been estimated (on the basis that previous examples seem to indicate that the UK is a non-lead partner in approximately twice as many projects as the number in which it is a lead partner) that there were 40 projects (over the whole period) in which the UK was one of several partners, that 200,000 ecus was provided per project, and that 15 per cent went to each non-lead partner. (The above calculations would seem to indicate that the 60 per cent not going to the lead partner is split amongst an estimated four other partners – 15 per cent to each.) This suggests a total of 1,200,000 ecus to UK partners for projects where the UK was just a partner, and an overall total of 2,800,000 ecus to UK organisations from this programme.

Youth for Europe

The main objective of the Youth for Europe programme was to contribute to the educational and cultural progression of young people through trans-national exchanges, and by encouraging youth projects at local level and facilitating access of disadvantaged young people. Actions included:

- Action A: intra-community activities directly involving young people, including A1 Youth Exchanges and Mobility, A2 Youth Initiatives, and A3 European Voluntary Service;
- Action B: youth workers;
- Action C: co-operation between Member States' structures;
- Action D: exchanges with non-member countries; and
- Action E: information for young people and youth research.

The budget for the overall Youth for Europe was 126 million ecu for the 1995–99 period. In addition, the European Voluntary Service programme had a budget ranging from 10–15 million per year for the period 1997–99 (EC, 1997).

For Youth for Europe, the bulk of proposals funded were for youth exchanges and mobility. Particular attention was given to disadvantaged young people to access the programme's activities and positive measures were taken to achieve this goal. No projects led by the UK have been identified, although this does not mean that they do not exist, as resources did not allow a full in-depth analysis of all the project compendia. Culture-focused projects funded by this programme included that organised by the *Centre Video de Bruxelles*.

The European Voluntary Service offered young people the chance to gain experience, self-knowledge and independence. Projects were also aimed at giving a helping hand to local development whilst providing the volunteers with a successful educational experience outside schools and colleges. Volunteers from the UK have participated in projects across the EU and beyond, and EU volunteers have come to the UK to take part in similar projects. These projects covered

a multitude of areas, including arts and culture, the environment and work with youth and children. Examples of projects include: an Italian volunteer working with Haworth Art Gallery, encouraging schools' access to visual arts; and an Irish volunteer working with an artists' collective (incuding poets, sculptors and musicians) in Liverpool, helping them to raise local awareness of art and culture. It is estimated that a minimum of 50,000 ecus has been provided to UK individuals or groups for culture-related projects in the life of this programme.

Tourism

Funding for tourism projects was channelled through former DG XXIII – Enterprise Policy, Distributive Trades, Tourism and Social Economy (subsequently DG Enterprise).

The last few years have witnessed the progressive involvement of tourism in programmes supported by the EC.[2] The absence of a specific tourism budget for direct tourism activities means that DG Enterprise's Tourism Unit has not, as yet, been able to provide any funding for individual projects. However, numerous tourism initiatives have received support from other EU programmes. Sources of funding for tourism projects have included:

- the major funds for promoting regional, economic and social development in the Union (the Structural Funds);
- programmes and actions in various policy fields (for example, environment, training, research and development, promotion of cultural heritage); and
- loans from the European Investment Bank.

The first two of these have been covered in detail elsewhere in this chapter.

The single largest source of EU funding for tourism, in particular in the less prosperous regions, is from the Structural Funds (the European Regional Development Fund (ERDF), the European Social Fund (ESF) and the European Agricultural Guidance and Guarantee Fund (EAGGF)). It is widely recognised that tourism is contributing to regional development and job creation, and the total Community contribution to tourism projects over the period 1994–99 through the Structural Funds was 7.3 billion ecus.

Support for general tourism projects in the UK from the Structural Funds has not been addressed as part of this research, although support for specific cultural projects that may also have potential significance for tourism (which includes a

2 A proposal for a Council Decision on a First Multi-annual Programme to assist European Tourism ('Philoxenia' 1997–2000) based on the Green Paper (EC, 1995) and an external evaluation of the Action Plan, was adopted by the EC on 30 April 1996. A modified version was presented by the Commission in December 1996 taking into account amendments put forward by the European Parliament. However, the Council of Ministers was not able to reach a unanimous agreement on the proposed programme, and it has not therefore yet been implemented. The Commission's proposal received the favourable opinion of the other European institutions – the European Parliament, the Economic and Social Committee and the Committee of the Regions.

Table 13.20 Selected UK projects funded under Info 2000, 1996–99 (a)

	ecus	£
ARTWEB – access over the internet to a unique database of art images (b)	77,681	55,486
BMILLEN: Bimillennium of Christ	100,000	71,429
CAMP: Concentration Camps – a Nazi heritage in Europe	92,806	66,290
CHAMP (Cultural Heritage and Archaeology Multimedia Project)	100,000	71,429
Champollion: data and images related to selected Egyptian artefacts	93,291	66,636
DISCO 2000: Digital Industry Supply Chain On-line (b)	95,503	68,216
EISS: Electronic Image Safe Service	98,867	70,619
Fountain: Fountains Abbey – cultural and heritage information resource (b)	45,744	32,674
GREATCOM (great composers)	100,000	71,429
LBDH: *Les Brulures de l'Histoire*	100,000	71,429
Sophia: European Culture – a history of ideas	100,000	71,429

Source: EC database.

Notes: the conversion rate used is 1.4 ecus to £1 sterling, the average between 1995 and 1999 (Bank of England exchange rates).
a) Projects for which funding could not be identified, include:
CHAIN (Cultural Heritage and Arts Information Network), EUROPART interactive informations service for European cultural heritage, LES CROISADES interactive multimedia CD-ROM.
b) Projects with a UK lead partner.

considerable number of projects involving festivals, museums and heritage) has been covered in the section above on Structural Funds. Support from other European programmes for tourism projects that have been culture-focused has been identified elsewhere in this section.

Research and information technologies

This section brings together a number of funding programmes funded through DG XII – Science, Research and Development, and DG XIII – Information Society (subsequently, DG Research and DG Information Society). The two main programmes covered here are Info 2000 and the various programmes under the generic heading of the Fourth Framework Programme.

Info 2000

Info 2000 was intended to:

- create favourable conditions for the development of a European multimedia industry;
- stimulate demand for, and use of, multimedia;
- contribute to the professional, social and cultural development of European citizens; and
- develop the exchange of knowledge among users and providers of multimedia products and cognitive infrastructures.

Table 13.21 Selected projects with a cultural focus funded under the Telematics Applications Programme, 1994–98

	ecus	£
KAMP (Knowledge Assurance in Multi-media Publishing) (a)	2,460,000	1,757,143
MAGNETS (Museums and Galleries New Technology Study) (a)	250,000	178,571
AQUARELLE (Sharing Cultural Heritage Through Multimedia Telematics)	3,000,000	2,142,857

Source: EC database.

Notes: the conversion rate used is 1.4 ecus to £1 sterling, the average between 1995 and 1999 (Bank of England exchange rates).
a) Projects in which a UK partner was the lead partner.

The programme included an action line to support projects which serve as a catalyst for high-quality European multimedia content, including using cultural heritage assets (such as historic buildings and objects and artefacts of artistic and cultural importance) as the raw material to develop the finished multimedia product. To carry out its tasks, Info 2000 had a total budget of 65 million ecus to be spent in the 1996–99 period.

A call for proposals was launched in June 1996 to support the initial and pre-commercial phases of pan-European multimedia content developments in the domain of the European cultural heritage. The bulk of submitted projects to Info 2000 concerned the production of CD-ROMs and/or interactive CDs. Included in the call was a specific request to projects to 'exploit the cultural heritage' and to convert the heritage into commercial multimedia products to be sold on the market. Approximately 221 applications were received which related to cultural heritage. Contemporary culture was not covered by the call.

For the 1996/97 period, 80 projects were supported for the preparatory stage of six months. About half of these were then considered for funding over the period 1998–99. These projects included the production and sale of databases, software packages and especially CD-ROMs.

Table 13.20 lists the projects in which the UK was a partner. The total funding for projects in which the UK was a lead partner is 218,928 ecus, and it is estimated that a minimum of 50 per cent of this would have gone to UK partners (whether they were lead partners or participating partners) –110,000 ecus. The known total for projects where the UK was a partner is 784,964 ecus, and it is estimated that around 25 per cent of this would have gone to them – 190,000 ecus. This gives an estimated total of 300,000 ecus to the UK from this source.

Table 13.22 Selected projects supported under the ACTS (Advanced Communication Technologies) programme, 1994–98

	ecus	£
Aurora (automated restoration of original film and video archives)	1,820,000	1,300,000
Renaissance (high performance services for vocational training) (a)	2,910,000	2,078,571
Viseum (the Virtual Museum International)	2,310,000	1,650,000

Source: EC database.

Notes: the conversion rate used is 1.4 ecus to £1 sterling, the average between 1995 and 1999 (Bank of England exchange rates).
a) Projects in which a UK partner was the lead partner.

Table 13.23 Selected projects supported under the Esprit programme, 1994–98

	ecus	£
Chameleon (authoring for adaptive multimedia documents) (a)	2,100,000	1,500,000
Copysmart (implementing intellectual property rights management)	1,600,000	1,142,857
Erena (electronic areas for culture, performance, arts and entertainment)	1,700,000	1,214,286
Escape (electronic landscapes) (a)	1,950,000	1,392,857
EVA-CLUSTER (assistance to IT projects in cultural systems) (a)	147,500	105,357
GUIDE (Galleries Universal Information, Dissemination and Editing)	577,000	412,143

Source: EC database.

Notes: the conversion rate used is 1.4 ecus to £1 sterling, the average between 1995 and 1999 (Bank of England exchange rates).
a) Projects in which a UK partner was the lead partner.

The Fourth Framework Programme

This overall programme was designed to promote the competitiveness of firms and employment by supporting research and development activities in key industrial technologies, and to improve the quality of life. Specific funding programmes in the Fourth Framework which supported projects relevant to the cultural sector were: Telematics; ACTS – Advanced Communication Technologies; Esprit – information technologies; Environment; Libraries (not covered in detail in the present chapter); Standards, measurements and testing (SMT); Joule-Thermie (addressing energy efficiency); Targeted Socio-Economic Research (TSER); International Co-operation; and Training and Mobility of Researchers (TMR).

Telematics; ACTS (Advanced Communication Technologies) and ESPRIT (information technologies) each supported a number of culture-related projects, and are discussed below.

The principal aim of the Telematics programme was to facilitate access to the knowledge present in the many information resources of the EU, while also reduc-

Table 13.24 Selected projects supported under Fourth Framework programmes, 1994–98

Programme	Project title
Libraries	VAN EYCK (storing, selecting and transmitting high quality images) (a)
Impact 2	IMAGE-IN (image reporduction service for fine art, applied and decorative visual arts) (a)
Human Capital and Mobility Programme	Seismic protection of built heritage
Targeted Socio-Economic Research	Social learning in multimedia (a)
Training and Mobility of Researchers	Pigment identification: medieval manuscripts (a)
Training and Mobility of Researchers	Natural History Museum (a)
Thermie (b)	Hampton Photovoltaic Heritage Centre (a)
Standards, Measurements and Testing	Determining superficial hardness of rocks
Standards, Measurements and Testing	Micromethods for analysis of parchment
International Co-operation	Archaeology: social integration/settlement
International Co-operation	Russian early medieval towns (a)
Information Society	Infotoonment (a)
Information Society	SMILE (Students in Museums Internet Learning Environments)

Source: EC database.

Notes
a) Projects in which a UK partner was the lead partner.
b) Demonstration component of the non-nuclear RTD programme, Joule-Thermie.

Table 13.25 Summary of allocations and grants to cultural projects in the UK under the trans-national programmes, 1994–99

Programme	ecus	£
Culture (Kaleidoscope, Raphael, Ariane, Culture 2000 pilot)	11,335,000	8,096,429
A Lines'	800,000	571,429
Media	22,777,000	16,269,286
Arts and Education (AETI, Connect)	2,195,000	1,567,857
Education, Training and Youth (Erasmus, adult education, Leonardo, Socrates, European Voluntary Service)	3,000,000	2,142,857
Research and Information Technologies (Info 2000) and the Fourth Framework (TAP, ACTS, Esprit and other programmes)	7,080,000	5,057,143
Total	48,059,500	34,328,214

Source: previous tables and author's estimates.

Notes: the conversion rate used is 1.4 ecus to £1 sterling, the average between 1995 and 1999 (Bank of England exchange rates).

ing the disparities between the Member States' approaches and systems. The programme dealt with the following subjects: networks; catalogues; the efficient locating of information; digitisation of images; multimedia (CD ROM); distance learning; and standardisation and intellectual property rights. Projects with a cultural focus include those listed in Table 13.21 (although this excludes the substantial number of projects funded under this programme which had a major focus on the library sector). The UK was lead partner in the first two of these projects, and a partner in the third. It is estimated that a third of the total here (5,710,000 ecus) went to UK partners – 1,900,000 ecus.

The ACTS (Advanced Communication Technologies) programme had the aim of bringing together telecommunications, television and the media, and supporting research concentrated on a range of projects including interactive digital multimedia services aimed at developing systems combining sound, images and digital data. This programme has supported a number of projects with relevance to the cultural sector, including those listed in Table 13.22. The UK was lead partner in the second of these, and a partner in the others. It is estimated that a quarter of the total here (7,040,000 ecus) went to UK partners – 1,750,000 ecus.

The Esprit programme contributed to the development of the information infrastructure. This programme supported a number of projects with relevance to the cultural sector, including those listed in Table 13.23. The UK was lead partner in the first, fourth and fifth of these, and a partner in the others. It is estimated that a third of the total here (8,074,500 ecus) went to UK partners – 2,700,000 ecus.

Various other programmes in the areas of research and development, and of the new technologies, have supported culture-related projects: Libraries (not covered in detail this chapter); Impact 2 (a precursor to Info 2000); Standards, Measurements and Testing (SMT); Joule-Thermie (addressing energy efficiency); Targeted Socio-Economic Research (TSER); International Co-operation; Training and Mobility of Researchers (TMR); and Information Society (ISPO). Table 13.24 includes some projects relevant to the cultural sector, which were funded from these programmes and in which UK organisations were partners. It is estimated

that each of the 13 projects listed in Table 13.24 had a grant of around 100,000 ecus (noting that the Image-In project received 340,000 ecus and the Social Learning in Multimedia project received 661,000 ecus), and that a third of the total here went to UK partners – 430,000 ecus.

Trans-national programmes: summary of allocations and grants

Table 13.25 provides a summary of funding to the UK from the trans-national programmes.

Summary of all EU funding

Table 13.26 summarises income to the UK's cultural sector from EU funding over the period 1994–99. This represents over a quarter of a billion pounds over five or six years, or an average of £51.8 million per year.

Table 13.26 Summary of income to UK cultural projects from the EC, 1994–99

	ecus	£
Structural Funds	not calculated	250,660,000
Trans-national Funds	48,059,500	34,328,000
Total		284,988,000

Note: the conversion rate used is 1.4 ecus to £1 sterling, the average between 1995 and 1999 (Bank of England exchange rates).

14

Local Authorities: New Opportunities and Reduced Capacity

Stuart Davies, Resource: The Council for Museums, Archives and Libraries

The election of a new government in May 1997 brought with it a new emphasis on policies affecting the cultural sector and quality of life. 'Education', 'lifelong learning', 'access' and 'social inclusion' have given the strongest national policy direction to libraries, museums and the arts that they have ever seen. This has had the effect of opening up considerable new opportunities for these services to demonstrate their value to society through their contribution to these policy initiatives. Valued at community level, they have usually struggled to find this grassroots appreciation easily converted into adequate funding at local or national level. This chapter seeks, through a review of the key issues and financial trends between 1993/94 and 1998/99, to assess how far those opportunities have been realised within the cultural sector as funded by local authorities.

Background: key changes in the sector

Three key changes or developments can be identified as having had an important impact on libraries, museums and the arts during this period. They are: local government reorganisation; the development of statutory performance indicators; and the modernisation programme introduced after May 1997.

Firstly, local government reorganisation in England, Wales and Scotland is known to have had a number of significant local impacts on libraries, museums and the arts but no overall evaluation has been conducted. The process of reorganisation has been an extended one, beginning in 1995 and not completed until 1999. In Wales and Scotland, the former two-tier structures were replaced in April 1996 by new unitary authorities (22 in Wales and 32 in Scotland). In England, the reorganisation was the responsibility of a Local Government Commission which conducted its investigation on a county-by-county basis. Two-tier authorities (such as, shire-district and shire-county authorities) were offered the opportunity to 'bid' to become unitary authorities and the Commission assessed the viability of the arrangements. There was a heavy emphasis on public consultation and a stated desire to try and create a local-

government landscape where people could easily identify with their local authority. By April 1998, 46 new unitary authorities had been created (ACE, 2000:15).

Secondly, the use of performance indicators has always been an important part of good management and in the 1980s and early 1990s there was considerable debate about how best to apply them to public services, including libraries, museums and the arts (Jackson, 1993; Audit Commission, 1991a; 1991b; 1997; Selwood, 2000). The Local Government Act 1992, established standard performance indicators for local authority services for which local authorities were to collect data and publish in the form of performance 'league tables'. Performance indicators for libraries were agreed at the first round but none were forthcoming for museums and arts. By 1998 it was recognised that the arts and museums 'are significant areas of activity, which contribute to the quality of life of local communities' (Audit Commission, 1998: 22), but only in museums were satisfactory indicators developed.

One consequence of establishing a standard and statutory set of performance indicators in libraries and museums was increased activity in benchmarking of all kinds. Much of this was informal, typified by the creation of 'benchmarking clubs' to facilitate the exchange of ideas, experiences, data and information. Groups of local authority services with similar features began to meet regularly to find comparable bases from which to compare performance equitably. Sometimes these were on a geographical basis, but the more ambitious – such as that created by the Group for Large Local Authority Museums (GLLAM) with its 22 members – could be national in scope (Davies and Selwood, 1998: 87–88).

Thirdly, towards the end of the period reviewed here, the 1997 Labour Government introduced its Best Value initiative to local government. Based on a set of principles and the 'four Cs' (compare, consult, challenge and compete), Best Value assessments – a combination of self-assessment and inspection by the Audit Commission – are designed to test the efficiency and effectiveness of all local authority services. Although not implemented until 1999, the Best Value approach began to have an impact from the moment that the consultation paper was published in 1997 (DETR, 1997). It was also closely aligned with the development of statutory performance indicators and statutory Annul Library Plans. By 1999 it was widely believed that these changes, part of the modernisation of government programme, could have major implications for library, museum and arts services (Davies and Selwood, 1998: 83–88).

What has been the overall impact of these changes? The first point to make – and it can hardly be made too strongly – is that there is a dearth of reliable data and information on museums and arts (see Appendix 1). This makes any evaluation of the impact of change very difficult in these specific areas, and also affects broader assessments. As local authorities required (or were required to produce) more detailed data and information to substantiate the claims that are made for the value of individual services, this weakness became more and more critical in the late 1990s, constituting a serious threat to the future of services.

The impact of reorganisation of local government appears to have been very mixed. Some libraries, museums and arts services came together in unitary services for the first time and benefited from the synergies this brought. Other authorities which were split up to create new authorities found that their tax base

was denuded, making it difficult to sustain services to match previous levels. Reorganisation was often the catalyst for substantial service reviews, which led to both winners and losers.

The growth in evidence-based policy decisions, the increased role of perform-ance indicators and the appearance of Best Value seem to have had similarly mixed impacts, although it must be stressed that no substantial evaluation studies have been carried out, and such evidence as there is comes from managers' obser-vations or case study analyses. Again, there have apparently been winners and losers, but most managers seem to be agreed on one thing: that there has been a significant increase in the demands placed upon libraries, museums and arts services to provide data and information and respond to initiatives or requests which need data to inform the answers, from both inside and outside the local authority. All the services are finding that these demands challenge their capac-ity to respond. The most pessimistic managers speak of these demands seriously distracting the organisation from core work (as they perceive it).

Expenditure trends and implications

The first eight tables in this chapter summarise local government expenditure on libraries, museums and arts. Once again, information about the discretionary areas – museums and arts – fail to produce data which inspire absolute confidence. Data are collected mostly from individual local authorities by survey. The two most important surveys are those carried out by the Chartered Institute of Public Finance and Accountancy (CIPFA) and the Department of the Environment, Transport and the Regions (DETR). Both rely on the number of respondents and the accuracy and completeness of the data returned. One can, therefore, say with confidence only that the figures presented here are probably a reliable guide to general trends, and add the usual qualifying statement that local experiences may vary enormously within the general trends – something which this chapter will return to later. Tables 14.1 and 14.2 present an overview of local authority funding to the cultural sector by home country and by artform and heritage area.

Public libraries

Looking first at public libraries, it is clear from Tables 14.3 and 14.4 that while net revenue expenditure may have risen between 1993/94 and 1998/99, there has in fact, in real terms, been quite a significant reduction of nearly 7 per cent across the UK, with Scotland suffering most with a fall of over 10 per cent. The worst times appear to have been between 1995/96 and 1997/98 when actual expenditure was at a standstill and expenditure in real terms between 1994/95 and 1997/98 dropped by over 7 per cent. It was only in 1998/99 that revenue expenditure picked up significantly.

This difficult period is reflected in the research literature. A major survey in 1998 revealed that 80 per cent of responding library services had reduced opening hours in one or more of their libraries, and nearly 44 per cent had closed

Table 14.1 Local authority expenditure on the cultural sector by home country, 1993/94–1998/99

£ million

	1993/94	1994/95	1995/96	1996/97	1997/98	1998/99
England						
Arts (a)	147.300	128.600	130.600	153.100	152.400	155.700
Museums and galleries (b)	141.948	154.360	154.009	157.113	166.724	186.709
Libraries	623.695	639.279	642.411	651.724	660.808	680.471
Subtotal excluding heritage	*912.943*	*922.239*	*927.020*	*961.937*	*979.932*	*1,022.880*
Heritage (c)	–	–	–	50.308	42.257	41.031
Recorded subtotal including heritage	*912.943*	*922.239*	*927.020*	*1,012.245*	*1,022.189*	*1,063.911*
Scotland						
Arts (d)	–	50.300	–	36.600	38.000	–
Museums and galleries (e)	35.979	38.063	44.975	41.756	33.322	34.061
Heritage (f)	1.290	2.149	1.524	0.184	0.682	0.982
Libraries	81.750	86.346	88.540	88.030	85.208	85.303
Recorded subtotal	*119.019*	*176.858*	*135.039*	*166.570*	*157.222*	*120.346*
Wales						
Arts (g)	–	–	–	–	3.232	9.745
Museums and galleries	5.681	8.299	7.955	6.858	7.989	6.080
Heritage (c)	–	–	–	1.879	1.939	1.563
Libraries	31.163	30.821	33.119	32.177	32.751	34.098
Recorded subtotal	*36.844*	*39.120*	*41.074*	*40.914*	*445.911*	*51.486*
Northern Ireland						
Arts	4.093	4.001	–	–	7.846	–
Museums and galleries	1.714	–	–	–	2.553	–
Heritage	–	–	–	–	–	–
Libraries	17.623	17.672	18.347	18.71	18.412	19.936
Recorded subtotal	*23.430*	*21.673*	*18.347*	*18.571*	*28.811*	*19.936*
Recorded total	1,092.236	1,159.890	1,121.48	1,238.300	1,254.133	1,255.679
At real (1998/99) prices	*1,249.1*	*1,307.8*	*1,229.0*	*1,314.7*	*1,295.1*	*1,255.67*
Percentage year-on-year change	n/a	4.7	–6.0	7.0	–1.5	–3.0
Percentage change 1993/94–1998/99						–0.5

Sources:
ACE, Local Authority Expenditure on the Arts, Research Reports 1 (1995), 6 (1996), 17 (1998), 18 (1999); DETR annual survey of local authority expenditure on museums and galleries (data supplied directly); CIPFA *Planning and Development Statistics*, 1998 and 1999; LISU Annual Library Statistics 1999, Claire Creaser and Alison Murphy, September 1999; Public Library Statistics 1998–99 *Actuals, CIPFA, 1999. Scottish Local Government Financial Statistics*, various years, Government Statistical Service; National Assembly for Wales survey of local authority expenditure on the cultural sector; *Partnership in Practice*, The Forum for Local Government and the Arts, 1993/94 and 1994/95; ANI (1998/99 figures).

Notes
a) From the annual ACE survey of local authorities. Represents net revenue spending on the arts and includes grants from the Section 48 bodies. However, it is not clear if it includes all Section 48 grants, or only those for the arts. See Table 14.2 for breakdown of Section 48 grants.
b) Figures supplied by DETR. Represents both revenue and capital expenditure.
c) Net capital expenditure on conservation of the historic environment. Grossed estimates first published by CIPFA for 1996/97 onwards.
d) Survey not carried out every year. Represents revenue expenditure on arts and bursaries.
e) Represents both revenue and capital expenditure. Data for 1998/99 not yet available.
f) Represents net expenditure on historic houses. Data for 1998/99 not yet available.
g) Data collected by the National Assembly for Wales. Data collection only started in 1998/99 (for capital and revenue expenditure).

Table 14.2 Local authority expenditure on the cultural sector by area of activity, 1993/94–1998/99

£ million

	1993/94	1994/95	1995/96	1996/97	1997/98	1998/99
Arts						
England (a)	147.300	128.600	130.600	153.100	152.400	155.700
Scotland (b)	–	50.300	–	36.600	38.000	–
Wales (c)	–	–	–	–	3.232	9.745
Northern Ireland	4.093	4.001	–	–	7.846	–
Recorded subtotal	*151.393*	*182.901*	*130.600*	*189.700*	*201.478*	*165.445*
Museums and galleries						
England (d)	141.948	154.360	154.009	157.113	166.724	186.709
Scotland (e)	35.979	38.063	44.975	41.756	33.322	34.061
Wales	5.681	8.299	7.955	6.858	7.989	6.080
Northern Ireland	1.714	–	–	–	2.553	–
Recorded subtotal	*185.322*	*200.722*	*206.939*	*205.727*	*210.588*	*226.850*
Libraries						
England	623.695	639.279	642.411	651.724	660.808	680.471
Scotland	81.750	86.346	88.540	88.030	85.208	85.303
Wales	31.163	30.821	33.119	32.177	32.751	34.098
Northern Ireland	17.623	17.672	18.347	18.571	18.412	19.936
Recorded subtotal	*754.231*	*774.118*	*782.417*	*790.502*	*797.179*	*819.808*
Heritage						
England (f)	–	–	–	50.308	42.257	41.031
Scotland (g)	1.290	2.149	1.524	0.184	0.692	0.982
Wales	–	–	–	1.879	1.939	1.563
Northern Ireland	–	–	–	–	–	–
Recorded subtotal	*1.290*	*2.149*	*1.524*	*52.371*	*44.888*	*43.576*
Recorded total	1,092.236	1,159.890	1,121.480	1,238.300	1,254.133	1,255.679

Source: Table 14.1.

Notes

a) From the annual ACE survey of local authorities. Represents net revenue spending on the arts and includes grants from the Section 48 bodies. However, it is not clear if it includes all Section 48 grants, or only those for the arts.

Section 48 Bodies: funding for the arts 1993/94–1998/99

£ million

	1993/94	1994/95	1995/96	1996/97	1997/98	1998/99
Combined arts	1.451	1.517	1.420	1.559	1.444	1.551
Dance	0.482	0.492	0.502	0.409	0.367	0.373
Built heritage	0.014	0.014	0.014	0.014	0.016	0.014
Drama	2.058	2.076	2.138	2.168	2.078	1.992
Literature	0.002	0.002	0.006	0.002	0.002	0.005
Museum/gallery	0.522	0.526	0.601	0.597	0.593	0.590
Music	0.729	0.717	0.716	0.747	0.740	0.769
Visual arts/crafts/photo	0.309	0.316	0.312	0.307	0.269	0.267
Total	5.567	5.660	5.708	5.802	5.508	5.561

Sources: West Yorkshire Grants; Association of Great Manchester Authorities, Greater Manchester Grants Scheme, various reports, various years; London Borough Grants Committee.

b) Survey not carried out every year. Represents revenue expenditure on arts and bursaries.

c) Data collected by the National Assembly for Wales. Data collection only started in 1998/99 (for capital and revenue expenditure).

d) Figures supplied by DETR. Represents both revenue and capital expenditure.

e) Represents both revenue and capital expenditure. Data for 1998/99 not yet available.

f) Net capital expenditure on conservation of the historic environment. Grossed estimates first published by CIPFA for 1996/97 onwards.

g) Represents net expenditure on historic houses. Data for 1998/99 not yet available.

Table 14.3 Net revenue expenditure on public libraries by home country, 1993/94–1998/99

£ million

	1993/94	1994/95	1995/96	1996/97	1997/98	1998/99
England	572.9	584.8	588.0	592.7	595.3	612.0
Scotland	78.2	82.6	84.7	82.7	79.3	80.2
Wales	29.8	30.1	31.1	29.7	30.8	32.0
Northern Ireland	16.9	16.9	17.4	17.7	17.6	19.1
UK total	697.8	714.4	721.2	722.8	723.0	743.3

Source: LISU.

service points between 1986/87 and 1996/97. No fewer than 179 libraries had closed, more than two-thirds of them for financial reasons, and more than 160,000 people had lost their access to a local library, with many of them giving up completely on using this kind of community facility. The losses were not evenly distributed. Urban areas tended to suffer much more than rural areas. London boroughs, for example, had lost over 10 per cent of libraries open in 1986, while shire counties had lost fewer than 1 per cent (Proctor, 1998; Proctor et al., 1998).

Table 14.4 Net revenue expenditure on public libraries, 1993/94–1998/99, at 1998/99 prices

£ million

	1993/94	1994/95	1995/96	1996/97	1997/98	1998/99	Change % 1993/94– 1998/99
England	655.2	659.4	644.4	629.2	614.7	612.0	–6.6
Scotland	89.4	93.1	92.8	87.8	81.9	80.2	–10.3
Wales	34.1	33.9	34.1	31.5	31.8	32.0	–6.2
Northern Ireland	19.3	19.1	19.1	18.8	18.2	19.1	–0.1
UK total	798.0	805.5	790.4	767.3	746.6	743.3	–6.9

Source: Table 14.4 deflated using HM Treasury GDP deflator.

Museums and galleries

Tables 14.5 and 14.6 offer a slightly different picture for museums. Funding appears to have held up relatively well between 1993/94 and 1997/98, although the warning about the reliability of the available data (made above) should not be forgotten. Over that period, total (net revenue and capital) funding for the UK (Table 14.5) increased from £186.5 million to £210.6 million, an increase in real terms of 2 per cent (Table 14.6). Similarly, net revenue expenditure alone increased by 5 per cent, in real terms, over the same period, in stark contrast to the public library service. However, there was, apparently, a spectacular fall in net revenue expenditure for England between 1997/98 (£137.7 million) and 1998/99 (£124.4 million). Taken at face value, this would indicate a fall of more than 8 per cent in real terms between 1993/94 and 1998/99. However, there are reasons to be sceptical about the 1998/99 figure, since individual components within the total show unaccountable changes.

Table 14.5 Local authority expenditure on museums and galleries by home country, 1993/94–1998/99

£ million

	1993/94	1994/95	1995/96	1996/97	1997/98	1998/99
England (a)						
Revenue	118.481	126.824	131.242	133.648	137.673	124.385
Capital	23.467	27.536	22.767	23.465	29.051	62.324
Total	*141.948*	*154.360*	*154.009*	*157.113*	*166.724*	*186.709*
Scotland (b)						
Revenue	31.479	32.955	39.956	36.463	29.796	30.639
Capital	4.500	5.108	5.019	5.293	3.526	3.422
Total	*35.979*	*38.063*	*44.975*	*41.756*	*33.322*	*34.061*
Wales (c)						
Revenue	4.800	5.000	5.600	5.800	5.900	5.476
Capital	2.100	3.400	2.800	1.500	2.100	0.604
Total	*6.900*	*8.400*	*8.400*	*7.300*	*8.000*	*6.080*
Northern Ireland (d)						
Revenue	–	–	–	–	–	–
Capital		–	–	–	–	–
Total	*1.714*	–	–	–	*2.553*	–
Recorded total	186.5	200.8	207.4	206.2	210.6	226.9
At real (1998/99) prices	*213.3*	*226.4*	*227.3*	*218.9*	*217.5*	*226.9*

Notes and sources
a) Source: Department of the Environment.
b) Source: Scottish Local Government Financial Statistics, various years, Government Statistical Service.
c) Source: Welsh Office survey of local authority spending.
d) Source: Partnership in Practice, The Forum for Local Government and the Arts, 1993/94; Arts Council of Northern Ireland.

One of the problems in dealing with local authority data is that researchers and commentators do not necessarily distinguish carefully between net, gross, revenue net of capital borrowing repayments, revenue and capital. The results of an analysis can change significantly depending on what a researcher chooses to include or leave out.

A Department for Culture, Media and Sport review of local authority museums and galleries (DCMS, 2000), for example, bases its statistical arguments on CIPFA statistics of 'core revenue expenditure on museums and galleries by English local authorities (net of capital borrowing repayments)' (DCMS, 2000). These show that this expenditure fell in cash terms from £107 million in 1995/96 to £104 million in 1997/98 (in contradiction to the evidence presented here in the above tables). But 'since then the trend has been reversed with core expenditure rising to £109 million in 1998/99 and to £118 million in 1999/2000'. This would suggest a fall in real terms, from £117 million in 1995/96 to £109 million in 1998/99, or 7 per cent, although this was apparently largely restored by 1999/2000. The data are, therefore, sometimes contradictory and lead to unclear conclusions. Some of the detailed trends that this unsatisfactory situation may conceal are examined in more detail in the next section.

Table 14.6 Local authority revenue funding on museums and galleries 1993/94–1998/99, at 1998/99 prices

£ million

	1993/94	1994/95	1995/96	1996/97	1997/98	1998/99	Change % 1993/94– 1998/99
England	118.481	126.824	131.242	133.648	137.673	124.385	
At real (1998/99) prices	*135.500*	*142.999*	*143.824*	*141.890*	*142.164*	*124.385*	*–8*
Scotland	31.479	32.955	39.956	36.463	29.796	30.639	
At real (1998/99) prices	*36.001*	*37.158*	*43.786*	*38.712*	*30.768*	*30.639*	*–15*
Wales	4.800	5.000	5.600	5.800	5.900	5.476	
At real (1998/99) prices	*5.489*	*5.638*	*6.137*	*6.158*	*6.093*	*5.476*	*11*
Northern Ireland	–	–	–	–	–	–	
At real (1998/99) prices	–	–	–	–	–	–	–
Recorded total	154.760	164.779	176.798	175.911	173.369	160.500	12
At real (1998/99) prices	*176.990*	*185.794*	*193.747*	*186.760*	*179.026*	*160.500*	*1*

Source: Table 14.5.

Arts

Table 14.7 shows local authority expenditure on the arts in England and Wales, and suggests an overall fall in funding between 1993/94 and 1998/99, but once again there are data problems which affect the accuracy of discernible trends. These include variations in responses from authorities and the absence or presence of high-spending authorities, which can have a marked influence on the figures for any single year. Collecting accurate data about the arts from source – the local authorities themselves – is difficult because 'arts' is not always similarly defined between authorities. The mixture of 'estimates' and 'actuals' is not helpful either, casting some doubt on the accuracy of figures for both 1993/94 and 1998/99, the two crucial years for identifying trends.

Given these problems, the best one can say is that local authority revenue arts funding appears to have risen slightly in England, although not consistently – in real and cash terms – between 1994/95 and 1997/98. Arts Council of Great Britain and Arts Council of England data (Table 14.8) suggest that across the whole period (1993/94–1998/99) there may have been a drop of about 7 per cent. However, other figures also published by the Arts Council (ACE, 2000) differ from those in Table 14.8, and suggest a slight fall in real terms between 1993/94 and 1997/98.

What may be concluded from this evidence? The first point is that the evidence is considerably less clear than one would like and lends itself to being interpreted in quite different ways. However, the most pessimistic scenario across

Table 14.7 CIPFA data on local authority net expenditure on the arts in England and Wales, 1993/94–1998/99

£ million

	1993/94	1994/95	1995/96	1996/97	1997/98	1998/99
Theatres, halls, arts centres and places of public entertainment	108.394	78.679	77.423	74.650	74.697	80.959
Art galleries and museums	117.643	110.776	112.804	109.539	108.703	113.159
Other local authority activities and promotions	23.904	21.457	23.288	28.709	30.842	32.871
Subtotal	*249.941*	*210.912*	*213.515*	*512.898*	*214.242*	*226.989*
Grants						
Grants to arts funding bodies	–	–	–	–	5.324	5.914
Grants to professional arts organisations and activities	–	–	–	–	54.016	60.524
Grants to amateur arts organisations and activities	–	–	–	–	8.315	9.120
Recorded subtotal	*73.231*	*69.726*	*63.502*	*69.611*	*67.655*	*75.558*
Recorded total	323.172	280.638	277.017	282.509	281.894	302.547

Source: CIPFA leisure and recreation statistics, various years.

all three domains – libraries, museums and the arts – would suggest a fall in expenditure of 6 per cent or 7 per cent in real terms between 1993/94 and 1998/99. Because of the unreliability of the data, the next section looks at museums and galleries in a little more detail in order to articulate detailed trends, which the more general figures may conceal.

Table 14.8 Arts Council of England data on local authority arts expenditure in England, 1993/94–1998/99

£ million

	1993/94 (a)	1994/95 (b)	1995/96 (a)	1996/97 (b)	1997/98 (b)	1998/99 (a)
Net spending on venues	93.8	81.0	81.1	102.3	99.6	100.7
Arts officers and development	11.7	10.3	11.6	12.6	13.3	15.0
Net spending on promotions	4.3	5.3	5.6	4.4	4.9	5.0
RAB subscriptions	2.8	3.0	2.9	2.8	2.8	2.9
Grants to artists and arts organisations	34.7	28.7	29.1	30.9	31.8	31.9
Total net revenue spending	147.3	128.6	130.6	153.1	152.4	155.7
At real (1998/99) prices	*168.5*	*145.0*	*143.1*	*162.5*	*157.4*	*155.7*

Sources: Arts Council of England, *Local Authority Expenditure on the Arts, Research Reports 1* (1995), 6 (1996), 17 (1998), 18 (1999).

Notes
a) Estimates.
b) Actuals.

Focusing on key issues: regional museums and galleries

To illustrate some of the key issues that lie behind the data, this section examines what has happened to regional museums and galleries during the second half of the 1990s, drawing on recent assessments (Resource, 2000). Regional museums and galleries are defined as those large museums which have a pre-eminent position in their region. No accepted list of regional museums yet exists but there are unlikely to be more than two or three of these in each of the English regions, for example. They are largely self-selecting, based on size (collections, staff and multidisciplinary nature), historical importance (foundation date and collecting hinterland) and status of location (regional capital, population size and economic hinterland). They include the 'main' museums and art galleries in Aberdeen, Glasgow, Newcastle, Leeds, Manchester, Sheffield, Birmingham, Bristol and so on. Not all of these will be run by local authorities, but probably most of them will.

Not only are the data on expenditure unsatisfactory, but it is duly acknowledged that there are serious gaps in information on all the important criteria that measure the role of museums in society and their use of public funding. Although the museums' world is awash with reports on just about every aspect of their work, a 'knowledge deficit' defeats attempts at strategic thinking (Middleton, 1998: 8). This means that it is not easy to decide when even individual museums are 'in crisis' and when they are not, let alone to do so for a group such as the regional museums.

Is the current situation any worse than the situation for many decades past? A definitive assessment may not be possible, because the necessary data do not exist. However, detailed analysis of a sample of 26 large museums,[1] undertaken specifically for this chapter, and a review of sector literature suggest that a number of factors may have conspired to make life more difficult for regional museums now than for some time previously.

- It is arguable that more sharply focused policies – explicitly articulated and implemented through improved strategic management (at both government and local authority levels) – have shifted resources towards large statutory services such as education and social services, and away from discretionary services such as museums, galleries and archives.
- Continuing political pressure for restraint on local taxation, and Treasury anxieties about the public sector borrowing requirement, have effectively capped local authority expenditure.
- The most recent round of local government reorganisation set up new unitary authorities which have brought county and district services together for the first time (see pages 104–5). In the ensuing shake-up, the discretionary services have sometimes lost resources, but equally some have come out stronger than before.

1 Newcastle upon Tyne, Derby, Brighton, Portsmouth, Leeds, Bolton, Exeter, York, Sheffield, Manchester, Plymouth, Hull, Birmingham City Art Gallery, Glasgow, Bristol, Kirklees, Coventry, Norwich, Wolverhampton, Bradford, Walsall, Southampton, Swansea, Stoke-on-Trent, Leicester and Nottingham.

- Demands for museum and art gallery services from other local authority departments, community organisations and the public have grown as expectations have been fuelled by greater awareness of what museums and galleries can provide under ideal circumstances. The evidence is anecdotal or sporadic, but seems to indicate that good services stimulate increased demand.
- The move to 'cabinet government' as part of modernisation programmes has led to a disappearance of service committees, which sometimes means that museum, archive and library directors do not have the same degree of access to the more influential elected members.
- Between the 1920s and the 1970s many local authorities acquired or created suburban branch-museum and branch-library structures. By the 1990s it was clear that branch museums often led to a dilution of focus and resources, and that their geographical location (and also that of branch libraries) no longer necessarily reflected need. But equally there was local public resistance to closures.
- Expectations and demand for services from all stakeholders (including users) have grown, increasing pressure on resources and straining the capacity of museums to respond adequately.

This chapter has already suggested that it is not entirely clear whether there is a definite trend in local authority spending on museums and galleries as a whole. There is some evidence for a 7 per cent fall during the period under question, but this interpretation depends on an inexplicably sharp drop (in returned survey data) between 1997/98 and 1998/99. What seems to be agreed, however, is that the picture across the whole English local authority sector is varied. According to one report (DCMS, 2000), in real terms, London's borough museums have experienced a fall in core revenue expenditure (net of capital borrowing repayments) of around 24 per cent; metropolitan districts, a 3 per cent fall; and counties, unitary authorities and districts together, an increase of 2 per cent. Overall, the larger urban areas – where most of the regional museums are located – have suffered cutbacks in expenditure, while in the country at large there has been a slight increase.

In fact, the picture is much more mixed than the above figures suggest. Although, in total, the sample of 26 large museums saw a 2 per cent fall in net revenue expenditure over the past five years, nearly three-quarters of the sample had increased their revenue expenditure between 1995/96 and 1999/2000. Even when inflation is taken into account, this means that the worst that most have experienced is zero growth. Some have, of course, experienced severe cuts and are struggling to perform their core functions. Where any local cuts occur, they tend to affect the museum's ability to innovate and develop. Different services find themselves in difficulties at different times and for different reasons.

In addition to the considerable variations in local experience, the headline figures may of course conceal some important underlying issues and problems. The major burden of expenditure cuts has tended to fall on those parts of the budget generally regarded as 'controllable' – acquisitions, exhibitions, educational programmes and staffing costs. In other words, the impact has been greatest on the 'creative' aspects of museums. Consequences identified some years ago (Davies and O'Mara, 1997) continue to be relevant today: reduced opening hours

(Carter et al., 1999), fewer exhibitions, and a shift from specialist to generalist curatorial staff. Establishment costs may rise disproportionately, and the museum may find it impossible to maintain exhibition programmes and other professional activities at the level of previous years. Staffing levels in the sample of 26 museums have fallen by 7 per cent, and, while there are few detailed data to go on, the general consensus is that the number of specialist curatorial posts has declined, supporting the proposition that collections expertise is weakening. In many respects, changes in the nature of the museum workforce as a whole have reflected pressures on core funding and other demands. Recent ad hoc surveys have, for example, identified increases in freelance staff (Hasted, 1996) and decreases in conservation staff (Winsor, 1999).

What we can observe here is not a sudden crisis but rather the domain of regional museums and galleries changing (and responding to change) in response to progressive financial pressures and changing priorities. There have never been adequate resources to do everything, and museums have had to change priorities in response to stakeholder needs and expectations – usually without additional money. The erosion of budgets has not been a linear progression, but over a long period (probably since the 1980s) it has had the effect of gradually reducing the capacity of museums and galleries to respond to new opportunities and change.

Despite this gradual deterioration in capacity to respond, many regional museums and galleries have nevertheless continued to deliver outstanding services. The contribution that some of the larger ones have been making to the social inclusion agenda is just one example (GLLAM, 2000). But, over time, their capacity is weakening and this is reducing the ability of museums and galleries to respond both to significant new opportunities (including challenge funding) and to the major new policy agendas of the Government. Furthermore, some have relied heavily on short-term project funding to develop new initiatives.

This assessment reflects the fact that local authority museums, libraries and archives are not independent: they are part of a larger organisation, and will naturally be influenced by corporate trends and decisions. Why do some do better than others? There are many reasons. The leadership is better in some of them, directing the organisations so as to prove their value to corporate agendas while maintaining professional standards and developing services in an innovative and imaginative way. In others, the organisation may fortuitously appear central to a favoured corporate priority (for example, a 'cultural quarter' development or a tourism strategy). Sometimes, the political status of museums, archives or libraries will be raised by their ability to lever in external investment (for example, Lottery or European money).

Detailed examination of individual museum services (from the sample of 26 large museums) suggests that successful local authority museum services share three characteristics:

- governance arrangements appropriate for their core functions and their objectives;
- management and leadership which is efficient and effective; and
- a resource base adequate to meet the expectations placed upon them.

The message from this is that much more detailed research needs to be done, both to improve the statistical base for our understanding of the museums' domain and to explain identified changes.

Case study: Kirklees Museums and Galleries

The museums operated by Kirklees Metropolitan Council – a metropolitan district council in West Yorkshire created from 11 existing authorities in 1974 – offer a useful case study, embracing most of the experiences recorded in larger local authority services elsewhere. Kirklees Museums Service consists of three traditional local museums in Huddersfield (Tolson Museum), Batley (Bagshaw Museum) and Dewsbury (Dewsbury Museum), all located in municipal parks. A specialist museum (the Holmfirth Postcard Museum) had been created over the library in Holmfirth, and art galleries also existed over the libraries in Huddersfield and Bentley. The service – part of Kirklees Cultural Services – also looked after Castle Hill, a Victorian tower set on an Iron Age tallfort overlooking Huddersfield, and two important small country-house museums, the Red House (Gomersal) and Oakwell Hall (Birstall).

The service's key statistics are outlined in Table 14.9. They are based on actuals supplied by Kirklees Cultural Services. The history behind these figures is common to many local authorities in the second half of the 1990s. Key developments in Kirklees are outlined here.

- Corporate financial planning targets required cuts in each successive year until 1999/2000 when the 'gap' between expectation and budget was recognised and the budget was slightly increased (repeated in 2000/01).
- The planning targets were met by piecemeal and opportunistic reductions, largely by freezing or deleting vacant posts and salami-slicing operating budgets.
- The post of Assistant to the Head of Cultural Services specifically dedicated to museums and galleries was lost, and the most senior museum post downgraded a tier.
- In 1997/98, Holmfirth Postcard Museum was closed. In 1998/99 approval was obtained to close Dewsbury Museum and relocate some of its displays to Dewsbury Town Hall, but public and political (opposition party) protests prevented this from happening.
- Opportunistic use of special area status and Lottery funds has resulted in all venues except Tolson Museum receiving substantial investment and renewal.
- In April 1998 the venue-focused Museums Service became the Community History Service. The re-branded and effectively re-launched service placed particular emphasis on its determination to work across the venues and out in the community.
- Creative use of resources by staff has increased schools' use of capacity, while development work with local communities, especially but not exclusively ethnic minority communities, has been the major focus outside the project-funded capital developments.

Table 14.9 Actuals (out figures) for Kirklees Museums and Galleries, 1995/96–1999/2000

	1995/96	1996/97	1997/98 (a)	1998/99	1999/2000
Gross expenditure (£)	1,427,606	1,407,450	1,449,274	1,410,682	1,665,476
Net expenditure (£)	1,273,351	1,286,079	1,279,938	1,256,164	1,493,074
Staff (FTE)	48.4	50.4	48.0	44.5	42.4
Attendances	233,626	226,820	210,474	198,952	185,316

Source: Kirklees Cultural Services.

Notes
a) Holmfirth Postcard Museum closed.

- The major problems in terms of long-term planning and financial position are major building repairs and the cyclical renewal of displays. Marketing and promotion has been successfully developed, but in comparison with other leisure venues the spend on this (whether per head or as a proportion of turnover) is low.

In short, as one manager observed, 'Basically we are trying to do too much with too little.'

The overall view is that basic services are being maintained and that where development, investment and renewal occur then attendances can be maintained too. But development is entirely dependent on third-party funding, and limited development budgets at the disposal of posts is a key limitation on what can be achieved on all fronts. Increasingly, the delivery of a vibrant, high-profile service relies more and more on the resourcefulness, imagination and energy of individual members of staff, which increases pressure on them very significantly.

Conclusion

There has been considerable concern expressed about the health of local government cultural services in the second half of 1990s, both in academic circles and in the quality press (Proctor, 1998; Lister, 2000). One point agreed upon is that the data and information available for the cultural services – with the exception of public libraries – are inadequate as a reliable base for broad analysis of trends. Two facts nevertheless seem clear. Firstly, the experience of individual organisations can vary considerably from any general trend. Doing well or doing badly (however defined) is often a very localised experience, in both place and time. Secondly, while the continued substantial investment of UK local authorities in libraries, museums and the arts (exceeding £1 billion) hardly justifies speaking of a crisis, there is nevertheless sufficient evidence for a steady decrease in resources (in real terms) to cause considerable concern. Local authority cultural services are experiencing reductions in their capacity to contribute to key policy issues (such as education, lifelong learning, access and social inclusion) at the very time when that contribution would be more valued.

15
Taxation

Anne Creigh-Tyte and Barry Thomas, University of Durham

The magnitude and impact of public expenditure on the cultural sector is the dominant theme of the present volume. However, taxation concessions to the cultural sector, or more generally, represent forgone revenue which the government would otherwise have collected and used to finance public spending (on cultural or other activities). As such, these concessions provide a 'mirror image' of the direct public spending underpinning the UK's cultural sector, and need to be weighed in the balance when calculating overall public support for the sector. Unfortunately, the quantification of forgone taxes is a complex issue, even when compared to the often opaque levels of direct public spending. Moreover, the impact of tax concessions in certain key cultural areas has been the focus of considerable debate and policy development, especially by the 1997 Labour government.

In this chapter, attention is focused on these key policy areas which are, for the most part, the main areas for cultural tax concessions. The chapter begins with a discussion of indirect taxes (taxes levied on goods and services) and specifically the impact of value added tax (VAT) on the built heritage and the national museums and galleries. Direct taxes (taxes levied on income and assets) provide the focus for the next section, beginning with a discussion of the relatively well trodden ground of capital tax concessions on cultural property, before moving on to consider 'British' films. Significant recent changes in direct tax reliefs for donors to charity are then considered. The concluding section provides an overview of the value of UK tax concessions. (International taxation issues, largely involving the art trade, are discussed in Chapter 22.)

Indirect taxation issues: value added tax

Value added tax (VAT) is charged at each stage of the production and distribution chain, with the total tax falling on the final consumer. It is a tax on supply, not business profits. VAT is a broadly based indirect final consumer tax calculated by the use of fixed rates on retail price. It is limited to taxable supplies (goods and services) made by a taxable person, and, as such, VAT is levied in the same

way on both private and public sectors. Output VAT received as part of the sale of supplies must be surrendered to Customs and Excise while (recoverable input) VAT on any purchases acquired to allow the provision of business supplies may be recovered from Customs and Excise.

All 'business' activities fall within the scope of VAT, and 'business' has a wide meaning; for example, it does not need to be carried on with a view to gaining profits. VAT is a tax on individual transactions, and, in general, any activity carried out regularly on an income-producing basis will fall within the scope of VAT. Thus, for example, membership subscriptions (other than for minimal benefits) would be regarded as business activity for VAT accounting purposes. The most common non-business activities undertaken by charities obviously include free provision of charitable activity and the receipt of donations and other voluntary contributions.

The basic principle is that VAT is charged at the standard rate on all goods and services supplied by a taxable person in the course of a business, unless those goods and services are specifically exempt (or zero-rated). In the exempt case, VAT is not charged on income, but VAT on associated business expenditure remains a cost, since it cannot (normally) be reclaimed. In contrast, while no VAT is paid on zero-rated (0 per cent) income, savings can result to the organisations concerned because VAT on associated expenditure can be reclaimed – for example, income from sales of books and magazines.

Many charitable bodies have a mix of business and non-business activities, and so it is necessary to apportion VAT on expenditure in order to determine what can be reclaimed. Of course, it is also possible that a body has business activities which are both subject to VAT and exempt, necessitating yet further apportionment.

The burden of unrecoverable VAT may be reduced because of a range of specific reliefs, which allow suppliers of goods and services to certain bodies not to charge VAT in certain circumstances. These are many and varied across the economy as a whole.

Selective VAT concessions

As noted below in Chapter 18, market failure provides the underlying economic rationale for public intervention on efficiency grounds (equity concerns provide a separate distinct rationale). Such intervention can take a variety of forms including regulation but may include indirect tax policies aimed at affecting behaviour through changing the relative prices faced by final consumers. (In theory, the indirect tax imposed and hence the changes in relative prices and behaviour should reflect the degree of market failure – the positive or negative externalities or spill-over effects which the consumption of the good concerned produces. In practice, valuation is a complex (and inexact) science.) However, where indirect taxation on goods and services is simply being used to raise revenue to fund government spending, the presumption is in favour of equal tax rates across a broad base of expenditure, which do not influence relative prices and, hence, consumer behaviour.

Since 1979, successive UK governments have chosen to move the burden of taxation away from direct taxes (like income and corporation tax) and towards indirect taxes – notably VAT. Tax rates have reflected this change in emphasis with the standard rate of income tax falling from 35 per cent in 1978 to 22 per cent (and with even sharper falls in the top rate of income tax). The standard rate of VAT, which was 8 per cent when initially introduced, was almost doubled, to 15 per cent, in the first Budget of the Thatcher administration. It was subsequently raised to 17.5 per cent in the early 1990s.

These increased rates of VAT necessarily resulted in increased attention being focused on indirect taxes and the potential for exemptions and reduced rates in particular circumstances. One UK industry which has lobbied for concessional indirect tax rates over recent years is tourism, a sector sponsored by DCMS and with close connections with many cultural fields.

Tourism is a major but fragmented industry, and estimated tourism expenditure in the UK was £64 billion in 1999, of which almost £13 billion was spending by overseas residents on visits to the UK during over 25 million visits. Tourism accounts for between 3 and 4 per cent of UK GDP and about 7 per cent of employment, and is commonly regarded as a fast-growing source of employment. Nevertheless, the latest analysis of tourism employment in the 1990s indicates that the sector does not exhibit the sharp employment growth which has been almost an article of faith among development strategists (Thomas and Townsend, forthcoming).

In the late 1990s two tourism bodies commissioned studies on the economic impact of VAT and Air Passenger Duty on the UK's competitiveness. Air Passenger Duty was introduced on passenger departures in October 1994, and doubled in November 1997 (Deloitte and Touche, 1998; British Tourist Authority, 1997). The British Tourist Authority study argued that the UK levied the highest VAT rate on visitor accommodation in Western Europe (apart from Denmark) and that the UK's standard rate (17.5 per cent) was twice the European Union average (of 8.5 per cent). Such tax rates were held to undermine the UK industry's ability to compete, especially in the price-sensitive and highly mobile international in-bound tourism market.

The experience of the Irish Republic, which halved the rate of VAT on visitor accommodation and restaurant meals in the mid–1980s and experienced sharp growth in overseas visitors in the period 1986 to 1996, is cited in support of such a tax-cut policy. Indeed, Irish VAT revenues from tourism are said to have more than doubled since the late 1980s (Nevin, 1999).

Fiscal modelling of the effects of reduced UK VAT (to around the European Union average of 8 per cent) on visitor accommodation is claimed to demonstrate that reduced VAT would be more than offset by indirect fiscal gains (from increased income and corporate taxes and reduced social security payments), producing net gains for the Treasury. As with all fiscal models, such conclusions must be treated with considerable caution, especially since they rest upon a range of explicit (or implicit) assumptions. One fundamental assumption is that the prices consumers pay will fully (and immediately) reflect any tax reductions. However, theories of public finance assert that tax incidence is a function of

changes in relative prices determined by the tax structure and prevailing market forces. A tax reduction may be reflected in price falls or rises in payments to the factors of production (like wages of employees), or combinations of the two depending on competitive conditions (Musgrave, 1959: 380).

Moreover, such analyses are at best partial, with the behaviour of the rest of the economy remaining (unrealistically) unchanged. A tax reduction may indeed increase overall economic activity, at least in the short term, since, unless taxes are raised elsewhere to compensate for the reduction, the public sector's net position (reflecting the balance of revenues and expenditure) will be more expansionary (the overall public sector deficit will be higher, or the surplus smaller). Such models seldom consider whether taxes are to be raised elsewhere, and, if so, where and by what amount, and how this will influence output and employment in the sectors concerned.

On balance, arguments for selective indirect tax reductions covering certain private sector economic activities are seldom compelling on grounds of economic activity or impact. The case for selectivity in the indirect tax system must rest on specific public policy objectives; this chapter now turns to the debate on two of these areas, the built heritage and national museums and galleries.

VAT and the built heritage

Repairs to buildings have been standard-rated since the UK introduced VAT in 1973, but until 1984 alterations were zero-rated. When alterations became standard-rated under the 1984 Finance Act, zero-rating was retained for approved alterations to listed buildings by a VAT-registered builder.

Following a ruling by the European Court of Justice in 1988, zero-rating was restricted to alterations or reconstruction of 'protected buildings' used as dwellings, residential homes or for non-business charitable purposes. Alterations to other listed buildings, repairs and maintenance, alterations not needing listed-building consent and alterations to buildings in the curtilage of a listed building are all standard-rated.

The criteria which must be met in order to qualify for zero-rating are summarised in Figure 15.1. If the building contractor is not VAT-registered there is no zero-rating relief on materials used (since VAT charged to a small unregistered builder cannot be reclaimed), and if any of the subsequent questions are answered in the negative then zero-rating provisions do not apply. This is clearly a complex issue and, as a recent guide noted, 'a detailed understanding of several imprecise legal concepts must be grasped if the correct VAT liability is to be established' (Potts, 1999: 2).

Businesses may be able to recover the VAT element in refurbishment works to any listed building they own, provided it is used to provide taxable supplies, for example a lawyer's or estate agent's office. Landlords of commercial buildings may be able to recover VAT costs to listed buildings they own or lease if they 'elect to waive exemption' (Potts, 1999: section 7). Moreover, many larger historic buildings owned by the private sector are open to paying visitors and so operate

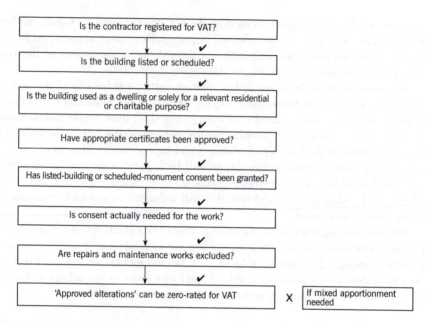

Source: adapted from Potts (1999).

Figure 15.1 VAT and historic buildings: criteria for zero-rating

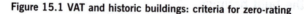

as businesses and are able to reclaim VAT on normal business expenses, including building repairs, maintenance, alterations and improvements.[1]

Nevertheless, zero-rating of certain works on listed buildings clearly provides a financial incentive to reconstruct or alter these structures (with appropriate consents, of course) rather than to repair and maintain them, and so hardly fits well with conservation objectives.[2]

In order to quantify the impact of the existing VAT arrangements on the built heritage sector, the tax group of the Joint Committee of the National Amenity Societies (JCNAS) commissioned a consultancy study. Surveys of contractors and buildings were mounted, providing information on 362 separate building projects carried out on 105 secular and ecclesiastical buildings during 1998 (JCNAS, 1999; Jenkins, 1999). The main focus of this study was to estimate the VAT paid (net of recoveries) on repairs and maintenance of listed buildings. The main findings from the survey, which are summarised in Table 15.1, indicate that on average VAT added 4.9 per cent to pre-VAT costs. Moreover, the results

1 In the 1996 Survey of Visitor Attractions, of the 585 historic properties (which answered the question) 95 per cent derived some revenue from admissions, 42 per cent from catering and 83 per cent from retailing (Hanna, 1998a: 18). Of the 2001 historic buildings and monuments regularly open to the public in England in 1998, some 44 per cent were private properties (Hanna, 1998b: 183).
2 The main zero-rated property reliefs apply to construction of new buildings and major interests in new buildings. In the case of a 'protected building', eligible 'substantial reconstruction' occurs if at least 60 per cent of the costs relate to approved alterations or the reconstructed building incorporates no more than the original building's external walls and other external features of architectural or historic interest.

Table 15.1 Incidence of VAT on repairs to listed buildings

Property type	Number of properties: projects	Total net cost excluding VAT (£000s)	Total VAT paid (£000s)	Average VAT rate (%)
Listed private home	(14:51)	405.5	66.5	16.4
Listed private home open to public	(10:15)	302.0	17.5	5.8
Cathedral	(16:83)	2,301.9	123.6	5.4
Churches, chapels etc: in use	(19:76)	1,202.9	117.9	9.8
Churches, chapels etc: disused	(1:37)	67.0	11.4	17.0
Conversion into residential use	(11:11)	857.1	40.5	4.7
Conversion into alternative commercial use	(6:8)	1,935.7	2.8	0.1
General work on property in residential/ commercial use	(15:41)	2,537.5	61.1	2.4
General work on property not in use	(6:8)	285.9	5.6	2.0
All projects, of which:		11,025.5	544.4	4.9
Secular	(64:136)	6,323.7	194.0	3.1
Ecclesiastical	(41:226)	4,701.8	350.4	7.5

Source: adapted from JCNAS (1999: Section 7, Tables D and E).

Note: for two properties with two projects the type of property was not known.

showed that projects with higher costs tended to have lower average VAT rates. This was especially true for places of worship, where on average VAT was equivalent to 7.5 per cent of pre-VAT costs (JCNAS, 1999: 17).

The JCNAS study devotes some space to a discussion of the limitations and biases in the survey. However, its conclusion, that understatement and overstatement will offset each other so that it 'may be anticipated … that the net result will therefore be a series of robust, broadly reliable estimates of the impact of VAT, (JCNAS, 1999: 26), is simply not tenable. Sampling procedures are not transparent, and overall response reflects only 105 properties from the 367,000 listed properties in England (according to JCNAS's own figures), so that there are doubts about the sample's representativeness, and clearly not all of the UK is covered. Moreover, the structure of the achieved sample does not reflect that of the population of listed buildings as a whole, especially since only 14 listed private homes were included (13 per cent of the achieved sample), although these constitute the overwhelming majority of listed properties (mainly Grade II listed).

The JCNAS study uses the English sample survey results to produce grossed-up estimates for VAT costs for the UK's listed buildings as a whole. Ecclesiastical and secular buildings are weighted separately and a 7–10 year work cycle is assumed so that repairs or alterations occur to between one seventh and one tenth of all listed buildings in a given year. This technique produces a central estimate of £5,887 million repair costs to listed buildings in 1998, on which £195 million of VAT was incurred.

Using average values of zero-rated approved alterations of £12,300 on secular properties and £27,600 on ecclesiastical properties (with work every 7 to 10 years) gives a central estimate of £586 million zero-rated work in 1998. This represents a saving of £103 million compared to the standard rate, a considerably higher figure than the estimate of about £50 million per annum made by English Heritage in the early 1990s (Creigh-Tyte and Gallimore, 1998: 35).

The JCNAS study then uses a purely accounting approach to estimate the impact on net VAT revenues of hypothetical harmonised rates on repairs and alterations. On this basis, the Joint Committee intends to lobby for a harmonised 5 per cent VAT rate involving an estimated net loss to the Exchequer of £92 million (on central estimates).

This section of the JCNAS study is one of the least satisfactory from the economist's viewpoint, since no serious transparent attempt is made to model behaviour, yet the study does make behavioural assumptions. First of all, it is assumed that VAT reductions are directly reflected in non-VAT costings, and, second, that the impact of the proposed tax harmonisation measures differs between repairs and alterations.[3]

While the JCNAS study's general quantitative conclusions cannot be readily checked against other sources, some further evidence is available regarding ecclesiastical listed buildings. Applying the survey's average VAT cost (of £10,300) on ecclesiastical repairs to 'some 20,000' listed churches yields an annual VAT cost of £24 million (central estimate with a range of from £20 to £29 million) (JCNAS, 1999: 27).[4]

The JCNAS report itself notes that the Church of England's Statistics Unit put parochial expenditure on routine maintenance of listed buildings at approximately £13.5 million (including VAT) with a further £12.4 million spent on capital projects (JCNAS, 1999:19). Moreover, according to a subsequent comprehensive published estimate, the Church of England alone paid £18 million in VAT on major church repairs (excluding routine maintenance and running costs) in 1998 (*Hansard*, 2000a). Some English Cathedrals have introduced compulsory entry fees for tourists (such as Canterbury Cathedral, which has 1.5 million visitors a year and introduced charges in 1995) but most rely on voluntary donations. The £18 million tax bill within a total cost of £123 million represents a 14.6 per cent rate, almost twice that found in the JCNAS sample.

Thus, the Church of England's estimate of the VAT cost of major repairs is not inconsistent with the higher and more widely drawn estimate for all ecclesiastical property produced in JCNAS. However, there remains uncertainty on the VAT cost of repairs across the 'listed buildings' with both ecclesiastical and secular uses.

In a further study for the Churches Main Committee, the main author of the JCNAS study estimated that the global cost of VAT on repairs and routine maintenance for all the 38 church denominations covered totalled just under £38 million in 1999 (Eckstein, 2000). Meanwhile the Historic Environment Review Steering Group strongly endorsed equalisation of VAT at 5 per cent for all building work (HERSG, 2000).

3 A harmonized 5 per cent rate applied to (currently zero-rated) alterations 'would probably have a minimal impact on the amount of work carried out' while the psychological impact of a reduction in the current (17.5 per cent) rate on repair to 10 per cent 'would be very much less than in the case of a reduction to 5 per cent' and 'would also probably result in very much less additional new expenditure on repairs' (JCNAS, 1999: 33).

4 Not all the Church of England's places of worship are listed, but some 13,000 of the 16,000 churches and 47 cathedrals in use are listed, with over one third of the Grade I listed buildings being church buildings.

In his Pre-Budget Report of November 2000, the Chancellor indicated that he proposed to explore, with the European Commission, the scope for reducing VAT on listed buildings used as places of worship. The Commission's reluctance to change VAT arrangements, prior to a general review expected in 2003, ushered in the announcement in the Budget 2001 of a new UK-wide grant scheme to help offset the VAT costs of repairs to listed buildings used as places of worship. The effect of the grant scheme will be to reduce VAT costs to 5 per cent for work undertaken from April 2001, and DCMS is consulting interested parties on the design and delivery of the new scheme.

VAT and national museums and galleries

General admission charges for national museums and galleries (NMGs) were first announced by the Heath Conservative Government in 1970 in order to raise an estimated £1 million per annum. The Museum & Galleries (Admission Charges) Act of 1972 which was implemented from January 1974 was an enabling measure, allowing NMGs to introduce admission charges (or not) as they deemed necessary.

In fact, charges were abolished in the spring of 1974 by the newly elected Labour government under Harold Wilson's premiership. However, the 1972 enabling legislation was not repealed. The successive Conservative governments elected after 1979 did not reintroduce compulsory charges to 'core' collections, but stressed that this matter was one for the individual central-government-funded museums or, more specifically, for their boards of governors/trustees. During the 1980s a number of NMGs introduced admission charges for their permanent collections, beginning with the National Maritime Museum in 1984.

Even before it was elected in May 1997, the Labour Party had placed considerable emphasis on access in cultural policy, with commitments that funding arrangements would consider the access policy of institutions in 'the widest sense' and to review admission charges at 'core' collections in NMGs (Labour Party, 1997:7; DCMS, 1997). Moreover, in 1997 the national advisory body for museums and galleries in the UK, the Museums & Galleries Commission (MGC) sponsored surveys of attitudes among museums and the general public towards admission charges.

The sample of 379 organisations drawn from the 1,692 museums on the MGC's database of registered museums (DOMUS) for 1997 included all 51 'national' DOMUS sites. Of these, 47 (92 per cent) responded, and 32 (68 per cent) levied general admission charges with reported full charges ranging from £1 to £6.95.[5] Of the 26 NMGs which provided the MGC with information on their finances, some 42 per cent reported that charges contribute at least 20 per cent of their revenue, 2 reported that one-third of income is raised from charges (or voluntary donations), 6 reported 20 to 25 per cent, 12 reported between 5 and 10 per cent,

5 The NMGs listed on DOMUS include many sites not funded by DCMS such as the museums of the armed services and Scottish, Welsh and Ulster museums. See MGC (1998, especially Chapter 6: 47–65).

and 3 less than 5 per cent (from voluntary donations only). This led MGC to conclude that 20 nationals were either fairly or heavily dependent on income from charges (MGC, 1998: 15, 34). By 1997 a (slight) minority of the (11) major DCMS-funded NMGs offered free entry while 48 per cent of all (the 1,443) registered museums which made returns to DOMUS charged admission to their 'core' collections (Creigh-Tyte and Selwood, 1998 especially Tables IV, V and VI).

DCMS's (English) NMGs formed the largest single central-government cultural expenditure vote heading during the initial years of the incoming (1997) Labour government, with a £204 million (23 per cent) share of total DCMS expenditure of £895 million in 1998/99 (DCMS, 1999a: Table A). In the same year local authorities devoted £160 million, some 11 per cent of total local authority expenditure on museums, libraries, sport and recreation as a whole, to museums and galleries (DCMS, 1999a: 191).

The Labour government's (first) Comprehensive Spending Review of December 1998 set out plans for a three-year spending programme covering the years 1999/2000 to 2001/02. These included a phased increase in spending on NMGs from £204 million in 1998/99 to £247 million in 2001/02, with detailed funding agreements with individual NMGs being announced from April 1999 onwards. Thus, the initial announcement on Comprehensive Spending Review funding allocations included a 'Museums reserve' of £1.3 million, £3.9 million and £30.3 million in 1999/00, 2000/01 and 2001/02 respectively. The Comprehensive Spending Review results across all government departments were set out in HM Treasury (1998). DCMS spending plans are discussed there in Chapter 19. DCMS (1998a) canvassed views on changes and reforms. DCMS (1998b) set out the main decisions concerning the allocation of £290 million (cumulatively) over the next three financial years, including £100 million for museums.

In order to promote economic access, unconditional guaranteed free admission for 13 million children was introduced at DCMS's 32 NMG sites from 1 April 1999. Some 23 sites which had previously charged for children abolished admission fees and the nine sites which had not charged retained free admission. As a second stage in the policy, from 1 April 2000 the free entry arrangements were extended to cover 10 million pensioners, aged over 60 years. These new funding arrangements guaranteed that 23 million people in England, out of a total population of 49.5 million, could visit NMGs free of charge. (The nine sites which were non-charging included the Tate Modern, the first new 'national' gallery in Britain for over 50 years which opened (at a cost of £134 million) in May 2000 on the basis of free admission for all. The Tate Gallery at Millbank – now Tate Britain – also retained a free entry policy.) Moreover, in April 2000 DCMS announced a 'quids in' access policy with a new standard £1.00 ticket for adults (and free admission for benefit holders and people with disabilities) for the NMGs which charge for entry. For the five principal charging NMGs with adult entry charges ranging from £5 (Victoria and Albert Museum) to £7.50 (Natural History Museum and Science Museum), the new £1.00 entry fee represents an average reduction of over 84 per cent.

Final decisions on the introduction of the new proposed adult admission charge rest with the Trustees of the individual NMGs, but the proposed funding agree-

ments were designed to compensate the museums involved for reduced admission-fee income by increasing grant-in-aid support from the DCMS (DCMS, 2000b).

Where NMGs charge for admission they can recover input VAT on this business activity. The 'non-business' activities of the non-charging museums clearly cannot allow recovery of VAT (on non-existent general admission fees) although, of course, other activities such as special exhibitions where entry fees are levied offer some limited scope for input VAT recovery. However, there is clearly a fundamental 'tension' between the elimination or minimisation of general admission charges in order to promote economic access and the potential impact of such policies on the VAT regime.

Irrecoverable VAT is a major disincentive for those museums which currently charge to remove charges, although following a VAT tribunal case Customs and Excise accepted that allowing some free admission at charging NMGs did not require detailed apportionment of input VAT, because no separate non-business activity was involved. Thus, an important element in the 'quids in' policy was the announcement that the VAT-recovery position of the charging museums would not be affected. In other words, the £1 admission charge was not merely a token charge, and substantial VAT remains recoverable on the core expenditure of these museums.

Nevertheless, Customs and Excise still appeared to have the issue of admission charges under review. Moreover, the VAT regime's impact was highlighted in the late 1990s by the success of many NMGs in obtaining significant grants from the various National Lottery Distribution Bodies to fund major capital-works projects. The key concern is that Lottery funded grants to 'good causes' are being used (in part) to fund irrecoverable VAT levied on these projects.[6]

A museum without any business activity which is zero-rated can avoid VAT on capital projects, while a business organisation can reclaim VAT. However, where a museum has some business activities it may only partly recover VAT and so faces an irrecoverable VAT bill on capital projects such as non-attributable overheads. Recent DCMS estimates of VAT reclamation on NMG Lottery-funded projects are set out in Table 15.2. Since it is not possible to produce separate data on VAT recovered on funds received from the National Lottery as compared to other funding sources, the VAT figures relate to recovery from total project costs in major charging and non-charging NMGs.

Clearly there are considerable variations in the degree to which VAT is (or is expected to be) recovered from NMG capital project costs. Some non-charging NMGs have recovered more VAT than some of those charging. However, while recovery rates for non-charging NMGs varied between 8.6 and 23.4 per cent, the two highest estimated reclaim rates are found in charging museums; the third highest reclaim rate among the charging museums (almost) equalled the highest found among the non-chargers; and non-charging NMGs recovered less than 17.5

6 For VAT purposes a (Lottery) grant is a payment of funds which enable the recipient to undertake non-business activity and for which the payee receives no supply. Grant payments are thus excluded from the VAT system, but input VAT incurred by the grant recipient on purchasing goods and services which cannot be recovered may be included as a project cost.

Table 15.2 VAT reclamation and project costs

	Grants for projects (£000) (a)	VAT recovered from project costs (£000) (b)	VAT recovered as proportion of project costs (%) (b)
Charging NMGs			
National Museum of Science and Industry	31,069	5,620	18.1
Natural History Museum	6,000	1,050	17.5
Victoria and Albert Museum	16,000	4,969	31.1
Imperial War Museum	19,124	9,000	47.1
National Maritime Museum	12,500	2,187	17.5
National Museums and Galleries on Merseyside	24,000	5,594	23.3
Non-Charging NMGs			
British Museum	45,700	8,700	19.0
Tate (c)	72,550	17,000	23.4
National Portrait Gallery	11,900	308 (d)	n/a
Wallace Collection	7,243	620	8.6

Source: *Hansard* 28 March 2000, WA67 and WA68.

Notes:
a) Acquisitions and revenue grants not included
b) Includes estimate of future VAT recovery.
c) Tate has Lottery awards for capital projects at the Tate Modern, Tate Britain and Tate Liverpool.
d) VAT recovered to date only, no estimate is available for likely future VAT recovery.

per cent of project costs (MGC, 1999).[7] On balance, the available evidence appears to support the concerns of the non-charging NMGs, in that charging NMGs are able to reclaim more VAT on their projects.

Interested parties have made various suggestions in order to ease the 'tensions'. In the autumn of 1999 the MGC suggested the introduction of a 5 per cent VAT rate on admission charges to museums (and cultural institutions) in order to promote improved access. However, a more widely advocated solution has been the possibility of adding NMGs to the bodies covered by Section 33 of the VAT Act of 1994. Section 33 allows Customs and Excise to refund input VAT chargeable to a number of bodies on their non-business activities. The institutions covered are various local and central government organisations, and the legislation is intended to avoid VAT becoming a burden on local authorities or other organisations which can raise funding from levies. Essentially, the aim is to prevent levies being used (in part) to pay VAT.

The advocates of extending Section 33 point out that the Treasury has the power to add further bodies to those specifically listed in the VAT Act 1994 (Chapter 23, Section 33: 28) and the proposal is thus simply to add central-government-sponsored NMGs (not only the DCMS-sponsored bodies, but also Armed Services Museums) to Section 33. This proposal was debated with some vigour and at some length in the House of Lords recently (*Hansard*, 2000b), especially since the Section 33 bodies are not simply local authorities (or police, river authorities, etc.), and some local-authority-sponsored museums, but also the BBC and Independent Television News.

7 This statement pre-dated both the extension of free entry to pensioners and the 'quids in' policy announcements, although not the free admission arrangements for children.

While not saying firmly or finally that there was no prospect of a change to Section 33, the government's public response to these suggestions was to stress that the NMG 'tension' arises from the nature of VAT itself – as a tax on the final consumers, either individuals or organisations which are not in business. Essentially, what matters is the net funding position of the NMGs. As with Lottery project grants, grant-in-aid levels are set bearing in mind the VAT position, which in any case is subject to negotiations with local VAT offices. This is quite reasonably a source of considerable and worrying financial uncertainty for the NMGs concerned (Dyer, 2000: 8). However, the advocates of the Section 33 option appear to assume that grant-in-aid provision would be unaffected by VAT-provision changes, such that the NMGs would gain an effective increase in net funding.

In fact, in the Budget 2001, the Chancellor announced a new initiative to allow refunds of VAT paid on purchases by UK national museums and galleries which allow free admission to the public. Like the earlier 'quids in' scheme, the new arrangements will be introduced by September 2001, although eligible non-charging museums and galleries will be able to recover the VAT they incur from April 2001 onwards. The Treasury expects the VAT refunds to cost £15 million per annum and DCMS is consulting museums and galleries on the details of the new scheme.

Direct taxation issues

Direct taxes are imposed on the incomes (or assets) of individuals and corporations. While a range of tax concessions is available, these are usually and necessarily general in nature, rather than being confined to particular sectors of the economy. However, this section considers three areas where direct tax measures are relevant to the cultural sector: cultural property, film production and incentives for charitable donations.

Capital taxation reliefs

The origins of UK heritage taxation policy date back to the introduction of Estate Duty (death duties) in the late nineteenth century, and at various times that duty, Capital Transfer Tax and (currently) Inheritance Tax have applied to gratuitous transfer of assets by individuals – including, of course, cultural assets. Capital Gains Tax applies to gains from disposal of assets (excluding principal residence) above an annual threshold level.

The major well-established tax reliefs applicable to the cultural area are: conditional exemption which defers the whole tax; private treaty sale which provides exemption; and acceptance-in-lieu of tax liabilities where tax is settled in return for the property going to a public-benefit institution (Creigh-Tyte, 1997; Creigh-Tyte and Gallimore, 1998; McAndrew and O'Hagan, 2000). These main capital taxation reliefs have remained relatively unchanged, although, especially for 1998, the emphasis on ensuring public access has been increased (Inland Revenue, 2000).

The reliefs encourage domestic retention of cultural property through encouraging donations or sales to domestic museums or providing financial incentives to retain an object rather than sell it (potentially abroad), and offer relief in exchange for public access and/or ownership by UK institutions. Encouraging museum ownership effectively retains the object within the UK since, in common with most European museums, UK institutions rarely dispose of works in their permanent collections. The value of these capital tax concessions fluctuates widely from year to year as the 'grim reaper' takes his toll.

The amount of tax forgone on sale by private treaty of heritage property is limited only by the funds available to the institutions concerned. Data on the taxes forgone are not routinely reported, but over the period 1994/95 to 1996/97 they averaged £12.9 million per annum.

Acceptance-in-lieu has involved reimbursing the Inland Revenue for the tax forgone. Until 1985 the budget allocated (to DCMS's predecessors) to fund acceptance-in-lieu was £2 million per annum. Thereafter, an agreement was reached to allow access to the Treasury's Reserve of up to £10 million a year for large and important offers. However, it was not until the Finance Act of 1998 that the requirement that DCMS reimburse the Inland Revenue was lifted.

Estimates of the annual value of acceptance-in-lieu of tax and conditional exemption provisions over the 1990s are summarised in Table 15.3. Conditional exemption typically involves the most valuable tax reliefs, averaging more than £71 million a year over the period 1990 to 1997, compared to £5 million per annum for 1990 to 1998 under acceptance-in-lieu arrangements (around half the maximum annual figure of £10 million).

Table 15.3 Tax forgone under acceptance-in-lieu and conditional exemptions, 1989/90–1998/99

£ million

	Amount of tax satisfied by acceptance-in-lieu	Tax relief due to conditional exemption
1989/90	11.5	183.4
1990/91	1.3	21.6
1991/92	3.3	44.4
1992/93	6.3	80.4
1993/94	3.1	136.8
1994/95	6.2	30.8
1995/96	7.4	42.5
1996/97	2.2	30.1
1997/98	6.8	–
1998/99	25.3	–

Source: adapted from McAndrew and O'Hagan (2000).

'British' films

Britain has a long history of government intervention in the film industry, with mixed results (Tunstall and Machin, 1999: 129–139). Thus, for example, a levy on film exhibitors (the so called 'Eady' Levy) was not abolished until the Films Act 1985. However, the 1990s saw an intensification of the debate on the means to boost activity and private investment in film production, in parallel with the increasing public-sector investments funded from the National Lottery (tickets

for which went on sale for the first time in November 1994 under an initial seven-year franchise).

In essence, film producers face a high immediate initial cost of production combined with a long pay-back period in which the film generates revenue from initial cinema release through video sales/rental and television showings. This is why tax rules on the write-off of production expenditure have been the focus of government initiatives in many OECD countries, although, of course, the detailed forms of relief and their applicability vary greatly.

By the early 1990s, there were essentially three methods under which production costs could be written off (amortised) for taxation purposes. One widespread method was to use the expected income from the film. At the end of each accounting period, income actually received and what is expected to be received over the remaining commercial life of the film can be compared, and expenditure written-off accordingly. An alternative was to treat a British film as a capital asset, and write off 25 per cent on a reducing balance basis each year.

More generous relief was introduced in Section 142 of the 1992 Finance Act under which expenditure incurred on producing or acquiring film rights can be written off in three equal annual instalments once a British film is completed. Such one-third relief encouraged some UK financial institutions to enter into sale and leaseback arrangements. Under these arrangements a producer sells a completed film to a financial institution (which is able to take the full benefits of the three-year write-off period against income). That institution then leases the film back over a 10–12-year period so that it can be exploited in order to generate revenue. These essentially re-financing arrangements can, depending on the way the arrangements are structured, generate an immediate cash sum of between 4 and 8 per cent of the film's budget to the producer, which can be used to reduce costs or to re-invest in other films.

The British Screen Advisory Council (BSAC) has lobbied hard to stress the economic and employment benefits associated with film-making and that 'market failure' in the UK film sector prevents its potential from being fully realised. To this end, BSAC commissioned the London Economics consultancy to develop a spreadsheet model capable of analysing changes in the size and structure of UK film production in response to a range of hypothetical tax policy variables. The London Economics/BSAC model also predicts employment in the industry, exports and imports of films and net revenue to HM Treasury. The model was steadily refined and updated in the second half of the 1990s, and is one of the most credible sectoral models yet developed, being far more sophisticated than that used to support the case for selective VAT reductions in the tourism sector as discussed at the beginning of this chapter.

In April 1995 the House of Commons National Heritage Select Committee reported on the film industry, and in June of that year DNH published a response to the Select Committee's report and government proposals aimed at supporting the industry (House of Commons National Heritage Committee, 1995; Department of National Heritage, 1995). Given the commonly agreed lack of investment in film and productions by general investors, the government proposed setting up an Advisory Committee on Film Finance under the chairmanship of Sir Peter Middleton,

> *to look at the obstacles to attracting private investment into the British film industry and to suggest ways that these might be overcome in order to help the industry grow*
>
> (Advisory Committee on Film Finance, 1996: 3).

The number of films produced in the UK and total investment in these films during the 1990s is summarised in Table 15.4. The volatility in UK-based film production is illustrated by the almost fourfold increase in investment in film production between 1992 and 1996 alone. However, it is important to remember that total investment is heavily influenced by a handful of 'blockbuster' productions made in the UK by major US studios. Thus, as the Middleton Committee showed, in 1995, five foreign films shot in the UK accounted for 26.5 per cent of all film-production investment in the UK, with an average budget of over £22 million against an average of just £4.24 million for wholly UK productions (which accounted for 40.3 per cent of total investment) (Advisory Committee on Film Finance, 1996: Appendix A). Co-production of various sorts accounted for the remaining one third of total investment at an average investment of £3.89 million per co-production.

The Middleton Committee produced a very valuable analysis of the industry's problems, notably that Britain's small independent producers were under-capitalised and raised money on a film-by-film basis. This gave the producers a weak negotiating position relative to distributors and prevented producers from spreading commercial risk across a number of films and developing the proven financial management and a track record of success needed to attract commercial investors. These are, in essence, arguments based primarily on the economies of scale. As such, they do not support the case for government intervention due to 'market failure' in the strict sense. They are more akin to a protectionist 'infant industry' argument, under which a domestic industry requires temporary protection from (overseas) competition until it has developed to a scale where unit costs are low enough for it to compete effectively.[8]

The central thrust of the Middleton Committee's recommendations was to improve the risk: reward ratio, and tax proposals played a key role in their suggestions (Advisory Committee on Film Finance, 1996: Chapters 4–6). Middleton noted that it was a widely held view that tax incentives had to be worth at least 10 per cent of a film's budget before they had any real impact on investment decisions. On this basis, the 4–8 per cent tax incentive available under the 1992 Finance Act's one-third relief was inadequate, and, in any case, a sale and leaseback transaction would rarely be worthwhile for a film costing less than £10 million (Advisory committee on Film Finance, 1996: 33). As noted

8 The UK production industry commanded less than 10 per cent of UK box office in the 1990s. The whole world's film industry is, of course, dominated by the US industry within which the 'majors' have an integrated distribution-led structure in which the development, production and distribution stages are carried out by individual vertically integrated companies. These companies can produce slates of costly films with the revenues of successes offsetting commercial failures and can build a library of back-catalogue rights. Nevertheless, a cynical observer of 'infant industry'-inspired protection of manufacturing from overseas competitors in the early post-war and post-colonial periods might be prompted to question whether such 'infants' ever 'grow up'.

Table 15.4 Levels of UK film production and investment, 1990–98

Year	Number of films produced (a)	Investment (£ million at 1999 prices)
1990	60	280.2
1991	59	294.1
1992	47	215.1
1993	67	260.7
1994	84	518.3
1995	78	454.7
1996	128	809.3
1997	116	599.9
1998	88	525.0

Source: Dyja (2000), Table 1: 19.

Note:
a) These films were produced either in the UK or with a UK financial involvement and include co-productions.

above, the average cost of a purely UK production was just over £4 million in 1995.

Middleton recommended that moving to a 100 per cent first-year write-off of film production costs for a limited period would have an immediate impact on the UK industry. On the basis of the London Economics/BSAC model, such an accelerated write-off might increase total annual investment by 36 per cent (almost £120 million) compared to the one-third relief 'base case'.

In its (first) July 1997 Budget, the newly elected Labour government introduced a 100 per cent write-off tax concession over one year on British films costing up to £15 million (while retaining the one-third relief system for more expensive films). As Middleton had recommended, the accelerated write-off measure was introduced on a temporary thee-year basis (to end in July 2000), although the Budgets of 1999 and 2001 extended the period to July 2005.

In May 1997 the Secretary of State for Culture announced six broad objectives for the British film industry and established a Film Policy Review Group made up of leading industry figures to draw up an action plan for the industry. In their report of March 1998 the industry members of the Group recommended extending the 100 per cent write-off by allowing 100 per cent write-off on the first £15 million of expenditure on films with budgets of over £15 million. This would encourage the production of larger films and make the UK a more attractive destination for inward investment (Film Policy Review Group, 1998: 21). The Group also recommended that the three-year life of the 100 per cent write-off should be extended (p.22). As yet, no further tax concessions have been announced. While no detailed assessment of the impact of the 1997 accelerated write-off tax concession is yet available, nearly 200 certificates of nationality were issued in the three years since the concession in order for films to qualify as British, compared to under 20 per annum in the years from 1993 to 1996.

The increased tax concession made available to 'British' films has necessarily focused attention on the criteria used. Successive advisory reports have criticised the complexity of the criteria set out in Schedule 1 of the Films Act 1985 (for example, Advisory Committee on Film Finance, 1996: chapter 7 and paragraph 7.12; Film Policy Review Group, 1998: Annex 2: 53–54). Under the revised arrangements introduced in 1999, the main qualification for a British classifica-

tion is the spending of 70 per cent of a film's budget in the UK. Film-makers are also required to spend 70 per cent of the labour costs incurred on European and Commonwealth citizens (DCMS, 1999b).

Direct taxation reliefs for donors to charity

Tax legislation defines a charity simply as 'a body of persons or trust established for charitable purposes only', and in addition to registered charities a number of specific heritage bodies are broadly entitled to exemptions, for example, the British Museum and the Natural History Museum (Taxes Act 1988: Section 507(i)). Charities themselves benefit from a range of statutory (and non-statutory) tax exemptions from income and corporation tax on investment income as well as narrower exemptions on trading income and capital gains tax. Thus, for example, where a charity carries on a trade as part of its charitable purpose, any profit will usually be exempt from tax.

In recent years, most of the policy debate and activity in the cultural field has focused upon incentives for donors to charity rather than charity taxation as such. Family Expenditure Survey data show that the share of households giving to charity fell from 34.3 per cent in 1974 to 29.7 per cent in 1996, but the average size of donations rose from £2.48 to £3.65 over the same period, more than compensating for the fall in participation and raising the overall contribution level (in real terms). See Banks and Tanner, 1997; 1998.

Moreover, as noted above, the shift in tax policy away from direct taxation and towards indirect taxes seen in the UK since the late 1970s has, necessarily, reduced the amount of basic-rate tax which charities can reclaim on donations. The drop from 35 pence in the pound in 1978 to 22 pence by 2000 has reduced the tax recoverable on a covenanted payment of £100 from 53–85p to only 28–20p. (For example, at a basic tax rate of 22 per cent, a covenanted payment of such an amount as after deduction of tax equals £1,000 involves gross payments of £1,282 (since £1,282 less tax at 22 per cent is equivalent to £1,000).)

In the mid-1990s the Arts Council of England (and English regional arts boards) commissioned a study of new and alternative mechanisms for financing the arts in the UK (ACE, 1997). At around the same time, concerns were also being expressed that the introduction of the National Lottery might reduce donations to voluntary organisations if individuals chose to buy Lottery tickets as an alternative way of supporting (Lottery-aided) 'good causes'.[9] In the first (July 1997) budget of the incoming Labour government, a consultation process on charity taxation was launched (HM Treasury, 1997).

In terms of individual donors, granting tax relief on charitable donations may be intended to boost the income of charities,[10] or simply to encourage individuals

9 Banks and Tanner (1997) found that households who play the National Lottery give less to charity than households who do not play, but there is no evidence that the Lottery has caused a decline in giving – since these households were less likely to give to charity anyway. Thus Creigh-Tyte and Farrell (1998: 19) suggest that the National Lottery has in fact been successful in gathering donations from households who would not ordinarily have donated.

to interact with charities within a wider 'giving age' social agenda. However, whatever the motive, the effect is to allow taxpayers themselves to decide which charities receive the forgone government tax revenues. Thus taxpayers can assert their individual preferences with respect to the level, type and diversity of charitable goods and services being provided.

A deed of covenant is the longest-standing method for obtaining tax relief. Provided that individuals or companies commit to a fixed donation to a charity each year for a minimum of four years, they can gain income or corporate tax relief on their donations without any upper limit. (Without such provisions, a commercial donor normally has to establish that the donation is wholly and exclusively incurred for the purposes of trade, in order for the donation to qualify as a deductible expense.) When a deed of covenant is used, the charity can claim back basic-rate tax on the gift.

Gift Aid was established in October 1990 and operates in a similar way to a covenant in that donations are made net of basic-rate tax, and the charity claims back the tax. However Gift Aid allows individuals and companies to make one-off single donations provided they exceed a minimum threshold. The original minimum donation was set at £600 but progressively reduced to £250 in March 1993, and the original upper limit of £5 million was abolished in 1991.

Payroll giving, also known as Give As You Earn (GAYE), was established in 1987. It allows authorised employers to deduct amounts from the pay of employees who nominate the charities to which their gifts go, via an approved collection agency. The GAYE operated by the Charities Aid Foundation is the largest of the payroll-giving systems, accounting for around 82 per cent of all receipts (ACE, 1997: 52). Donations are deducted before tax and so give the donor tax relief at his or her marginal rate. Initially the maximum annual contribution was set at £120 but this has been progressively raised to £1,200.

While around two-thirds of all tax-free donation are done under covenant, only about 2 per cent is arranged under GAYE schemes. The characteristics of the individuals using the various schemes differ,[11] but, although it has grown over recent years, giving to charity by standing orders and direct debits and deductions from pay is confined to around one in twenty households; in 1993–94 the shares were 4.9 and 5.7 per cent of households, respectively (Banks and Tanner, 1997: Appendix B: 38).

ACE (1997) found little difference in the fiscal incentives and tax treatment of charities in Europe, Australia and the USA. Nevertheless, the arts sector in the US received around 30 per cent of its income from private donations, sponsorship and foundations, compared to about 10 per cent in the UK. Moreover, about 90

10 In fact, the empirical evidence on the sensitivity of individual donations to tax relief in the UK is limited, and even in the US the research is far from unanimous. See Banks and Tanner (1998: Box 3.1: 9–10).

11 Banks and Tanner (1997: Table 4.1: 25–26) show that regular givers (often using covenants) are concentrated among the middle-aged, highly educated households in the upper part of the income distribution. However, Banks and Tanner (1998: 16) note that payroll-giving schemes are by contrast more popular with less-well-educated middle-earnings groups.

Table 15.5 Estimated annual donations to charity, 1996–97

Estimated total annual giving per donor	Percentage of all donors
Less than £50	35.6
£50–£100	20.8
£100–£250	21.1
£250–£400	10.7
£400–£600	4.4
More than £600	7.4

Source: Banks and Tanner (1998): 19.

per cent of donations in the USA were from individuals while in the UK the majority of voluntary income was derived from sponsorship and corporate donations (ACE, 1997: vii–viii).

As ACE (1997) noted, individuals are less likely than businesses to be willing to donate more than £250 to charity. Banks and Tanner (1998) estimated that in 1996/97 three-quarters of donors gave less than £250 to charity (Table 15.5). Thus any reduction in the Gift Aid tax limit would bring significantly more donors within its scope. Such an abolition of the £250 limit might have two potential outcomes. First, it may encourage more people to use the scheme, but second it could result in a fall in average donation size, previously guaranteed to be at least £250 (ACE, 1997: 82–83).

On balance, the ACE study concluded that 'under certain conditions, abolishing restrictions on the use of Gift Aid appears to be the most promising reform in this group of incentives [for individuals and businesses to increase donations or sponsorship]' (ACE, 1997: ix). Such a change had an 'estimated value' of £3 to £3.8 million per annum and scored highly in terms of economic distortion/impact, additionality, income distribution and political acceptance (ACE, 1997: Table 33).

In fact, while the basic legal structure of the US and UK income-tax systems is (broadly) similar, the administrative systems used in the US are very different. Individual US tax payers (and corporations) can claim itemised deductions for charitable donations against federal income tax (there is also a non-itemised threshold). However, in the UK, only self-employed and higher-rate tax payers usually file income-tax return forms. These groups account for only about one-third of UK tax payers, whereas in the US such returns are universal (Gale, 1997).

Such considerations clearly weighed heavily in the Treasury's review and the government's proposals, 'Getting Britain Giving', were announced in the Pre-Budget Report of November 1999 and developed further in the (March) Budget 2000 Statement.

The main simplifications and changes introduced from April 2000 include:

- the abolition of the £250 minimum limit for Gift Aid donations and consolidation of deed-of-covenant tax relief under the Gift Aid scheme (this means that tax can be reclaimed on any charity donations, large or small, regular or one-off, provided that there is a simple audit trail back to the donor);

- the abolition of the £1,200 per annum ceiling on payroll giving, with the government providing a 10 per cent supplement to whatever is donated for three tax years (from 2000/01 to 2002/03).
- income-tax relief for gifts of listed shares and securities by individuals or companies with capital to donate which allow relief at marginal tax rates on income or profits, as well as existing relief from capital gains tax by simplification of the rules for cash gifts by companies.

Tax reliefs are, of course, applicable to charities in all areas, but DCMS has stressed the advantages of the new arrangements for cultural charities and released a customised guide (DCMS, 2000a; CAF and ACE, 2000; Inland Revenue, 2000). The Secretary of State for Culture stressed that these arrangements 'should encourage people to give more' and 'help change the culture of giving for good [so that] it will make patrons of us all', while stressing that 'there is no question that private giving is a substitute for public funding' (Smith, 2000: 5).

The Inland Revenue sets limits on benefits a Gift Aid donor can receive before the payment ceases to be considered a donation.[12] However, free or reduced-price admission is disregarded if it is to view properties owned by heritage-preservation charities, or for a visit to a wildlife-conservation charity (Inland Revenue, 2000: paras 7.5–7.9).

It is far too early to assess the impact of these changes on charitable donations, either in general or for cultural charities in particular. In any case, as noted above, even in the US the empirical evidence on the impact of tax changes on donor behaviour is limited and unclear. However, the changes do represent a significant simplification of the previous system, and, at least for payroll-giving, now effectively recreate most of the characteristics of the 'US-style tax deductions' for individuals who are employees and corporate pensioners.

Where income-tax relief is given at the individual's marginal rate, donations by higher-rate taxpayers 'cost' them less forgone consumption. This may be especially important for arts and cultural charities. As Banks and Tanner (1998) note, survey evidence from the early 1990s indicates that donations to cultural and arts charities were (at least, at that time) confined to a small minority of donors (2.2 per cent, compared to almost 40 per cent giving to health and medicine, 19 per cent to religion and 18 per cent to general social services). However, as Table 15.6 shows, the proportion of donors to the cultural sector rose to 3.4 per cent among people in the two highest annual income bands. Thus, there are some grounds for optimism that the new tax arrangements for donors may have a differential impact on cultural and arts-sector charities. For the cultural charities, the stage is set but the drama has yet to unfold.

12 Basically, benefits cannot exceed: 25 per cent if the donation is under £100; £25 if the donation is between £101 and £1,000, and 2.5 per cent of a donation over £1,000 subject to a maximum benefit of £250. Inland Revenue estimates that in 1999–2000 over 9,000 businesses offered payroll giving to around 5 million employees.

Table 15.6 Giving to culture and arts charities by income band, 1993

Income band	Percentage of donors giving to arts and culture charities
£2,600 or less	1.5
£2,600–£4,159	2.5
£4,160–£9,099	1.0
£9,100–£19,499	3.4
£19,500 or more	3.4
All givers	2.2

Source: Banks and Tanner (1998): 11.

Conclusions

The late 1990s saw considerable controversy and policy initiatives concerning the impact of taxation (both direct and indirect) on the cultural sector. Assessing the impact and value of even well-established tax concessions is far from straightforward, and some of the most recent developments and proposals have yet to be evaluated. Nevertheless, it is clear that tax concessions provide a significant complement to direct central government spending on the UK's cultural sector.

The value of capital tax reliefs fluctuates widely from year to year, but in the 1990s it averaged about £90 million per annum (with £70 million of this due to conditional exemption reliefs). No reliable estimates are available of the value of tax concessions to charities within the cultural sector. Nor, as yet, has the actual value of direct tax concessions for 'British films' been systematically assessed. However, there are spreadsheet models available which suggest that such measures may even increase the tax revenues generated by the film industry over the medium term (as film production expands). The VAT revenue forgone on alterations to listed buildings was estimated at £50 million per annum in the early 1990s. However, the central estimate of the JCNAS study for 1998 data was £103 million. Since both figures were expressed in nominal terms, an estimate of £50–100 million for the value of the VAT concessions in the late 1990s seems reasonable.

Simple addition of the available estimates, which neglect the significant concessions available on cultural charitable donations and films, indicate forgone tax revenues approaching £200 million per annum. This represents around one fifth of total central government spending by DCMS (predominantly in England) in the late 1990s. Decisions announced in the Budget 2001 will significantly increased tax-related expenditure provisions.

However, as this chapter has sought to illustrate, one of the more important aspects of tax policies and practices has been their interaction with recent policy initiatives, for example, on reducing economic barriers to access at national museums. In the cultural sector, as elsewhere, public bodies will need to build on recent initiatives promoting 'joined-up government' if cultural policy goals are to be delivered effectively and efficiently.

16
The National Lottery

Sara Selwood, University of Westminster

By the close of the 1998/99 financial year, the National Lottery had provided nearly £3 billion for the cultural sector in the UK. This chapter considers the development of National Lottery support for the arts and built heritage up to that time. It is written in three sections: the first considers the formation of policies and programmes; the second looks at the financial impact of the Lottery, in particular the amount of funding available and how it was distributed; and the third section discusses more general issues raised by Lottery funding – questions of additionality, the sustainability of Lottery projects and the organisations responsible for them, and the economic impact of Lottery projects.

The chapter focuses on England in particular, and the two main distributors of Lottery funding to the cultural sector, the Arts Council of England (ACE) and the Heritage Lottery Fund (HLF). It does not touch on the wider issues pertaining to the economic and social impact of the Lottery as a whole – ethics, gambling, local spending and wider employment effects (Evans and White, 1996; Evans et al., 1997; White et al., 1998).

Policy, planning and programmes

In the years immediately preceding the advent of Lottery funding, relatively few new major sources of funding, in particular capital funding, had opened up to the cultural sector. Exceptions included the Foundation for Sport and the Arts[1] which

1 The Foundation, providing funding for the cultural sector as shown overleaf, is funded by the Pools Promoters Association. It supports the arts, museums and galleries throughout the UK, benefiting amateur and professional arts, and focusing on community participation and the 'grassroots' in particular. Its records do not distinguish between its capital and revenue grants, so it is unclear precisely how much capital it provided.

Foundation for Sport and the Arts: funding for the arts, 1991/92–1998/99

£ thousand

	Amounts paid	Amounts approved	Total
1991/92	3,708	8,756	12,464
1992/93	18,010	16,375	34,385
1993/94	19,814	16,548	36,372
1994/95	17,515	18,110	35,625
1995/96	17,159	16,365	33,524
1996/97	12,692	16,292	28,984
1997/98	9,225	9,445	18,670
1998/99	5,370	7,126	12,496

Source: Foundation for Sport and the Arts annual reports.

was established in 1991, and the five-year Museums and Galleries Improvement Scheme (1990/91–1995/96) funded by matching contributions of £2 million a year from the Wolfson Foundation and Family Trusts and the Department of National Heritage (DNH). Table 16.1 lists the most reliable data on capital funding available before the Lottery.[2] It suggests that in 1994/95, some £302 million was available to the sector (including funding to the built heritage). In 1995/96, Lottery capital funding provided over twice this amount (see Tables 16.4 and 16.5).

The sheer change in the scale of funding that the Lottery brought about is illustrated by the Arts Council of Great Britain and its successor ACE's previous giving. In 1993/94 its Building for the Arts scheme, which funded feasibility studies, provided £130,270 (for 53 grants, each averaging less than £2,500); and, in 1994/95, the last year of this scheme, £72,023. None of the other arts councils were providing capital funding at this time. Two years later, in 1996/97, when the largest amounts of awards were distributed, the ACE's lottery unit provided capital awards worth £358 million at an average of £468,000 each (ACE, undated).

National Lottery Act 1993

The National Lottery etc. Bill, which the Conservative government introduced in 1992, heralded major changes to the funding of the cultural sector. It was introduced by the new Department of National Heritage (DNH), and received Royal Assent in October 1993. The main provision of the National Lottery Act was to provide a major new source of funding for five 'good causes' – the arts, sport, heritage, charities and millennium celebrations. It established a framework based on three principles:

1 The proceeds of the Lottery would augment, rather than replace, public expenditure.
2 The net proceeds (determined by the total turnover and the precise percentage set aside for good causes by the selected operator after taking account of Lottery duty at 12 per cent, the prize fund, and operating costs) would be equally divided between the five 'good causes'.
3 Funding was to be distributed by independent bodies, rather than ministers. Funding to the arts and heritage would be organised by the existing arts councils and the National Heritage Memorial Fund (NHMF), which would be responsible to the Secretary of State for National Heritage. Two new bodies, which in the event also provided funding to the cultural sector – the Millennium Commission and the National Lottery Charities Board – would be established to oversee the distribution of money to celebrate the millennium and to charities and other institutions funded for charitable, benevolent and philanthropic purposes.

2 Although the ACE published a list of potential sources of partnership funding for the Lottery applicants, it gave no indication of levels of capital funding which had actually been distributed at the time (The Factary, 1994).

Table 16.1 Non-Lottery capital funding to the cultural sector, 1993/94–1998/99

£ million

	1993/94	1994/95	1995/96	1996/97	1997/98	1998/99
Museums and Galleries						
DNH/Wolfson: Museums and Galleries Improvement Fund (a)	4.000	4.000	4.000	n/a	n/a	n/a
DCMS: Assets accepted in lieu of tax	3.115	6.160	7.407	2.171	6.785	25.299
MGC: purchase grant funds	1.705	1.965	1.402	1.243	1.243	1.187
MGC: capital grants	0.415	0.401	0.372	n/a	n/a	n/a
National Art Collections Fund	1.743	2.469	2.750	1.789	2.407	2.445
National Fund for Acquisitions	0.266	0.270	0.307	0.225	0.286	0.182
English local authorities	23.467	27.536	22.767	23.465	29.051	62.324
Scottish local authorities	4.500	5.108	5.019	5.293	3.526	–
Welsh local authorities	0.875	30308	2.368	1.097	2.116	0.604
Northern Ireland local authorities	–	–	–	–	–	–
Recorded subtotal	*40.086*	*51.217*	*46.392*	*35.283*	*45.414*	*92.041*
Libraries						
Wolfson Public Libraries Improvement Scheme (a)	n/a	n/a	n/a	3.000	3.000	3.000
English local authorities	–	–	–	–	–	–
Scottish local authorities	–	–	–	–	–	–
Welsh local authorities	2.707	2.324	1.307	1.864	1.633	2.007
Northern Ireland local authorities	–	–	–	–	–	–
Recorded subtotal	*2.707*	*2.324*	*1.307*	*4.864*	*4.633*	*5.007*
Arts, museums and galleries, and heritage						
Business support for capital projects	–	13.867	4.880	15.811	18.038	33.522
Built heritage (b)	221.198	227.466	284.255	449.889	410.919	362.604
Heritage						
National Heritage Memorial Fund (c)	10.173	9.689	12.800	10.066	3.112	4.735
Arts						
ACGB/ACE	0.130	0.072	n/a	n/a	n/a	n/a
English local authorities (d)	–	–	–	70.927	57.747	–
Scottish local authorities (e)	–	6.8	–	4.5	11.3	–
Welsh local authorities	–	–	–	–	3.232	3.815
Northern Ireland local authorities	–	–	–	–	–	–
Recorded subtotal	*0.130*	*6.872*	*n/a*	*75.427*	*72.279*	*3.815*
Recorded total	264.12	301.75	336.83	581.27	551.28	496.99

Sources: ACE; DNH/DCMS annual reports; National Assembly for Wales; Scottish Executive; DETR; McAndrew and O'Hagan, 2000; Chapter 24.

Notes
a) Funded equally by the government and the Wolfson Foundation and Family Charitable Trust.
b) Taken from Table 24.5, this includes overheads and administrative costs, as opposed to grant payments. It does not include prizes and awards of higher education institution funding identified for 1998/99 only. The inclusion of this sum assumes that the vast majority of funding for the built heritage from non-Lottery sources is capital. There are, however, some exceptions. EH, for example, has funded conservation posts since 1992/93. In 1998/99 it funded 60 conservation officer posts, at an estimated cost of just over £1 million.
c) These are the amounts that the Fund provides for loans and the purchase of items across its remit: land, buildings, museums and galleries, industrial, transport and maritime, manuscripts and archives. These could not be disaggregated. A disaggregated sum for 1998/99 provided by NHMF has not been used, since it differs considerably from the published figure.
d) Arts activities and facilities including theatres, only identified separately from 1996/97.
e) Gross capital expenditure for arts facilities and equipment.

The task of the distributors was to select projects for funding from applications, and ensure that the projects were delivered as proposed and conferred the public benefit claimed for them. The government expected Lottery funding to be spread widely through the country, that the grants would benefit everyone 'irrespective of income', and that projects should be funded in response to 'the expressed needs of the general public, to create lasting assets'. However, the distributors were not licensed to create strategies for distributing funding, nor could they solicit applications.

Lottery funding was intended to provide support for what had been a capital-starved sector – constructing new buildings, improving old buildings, carrying out feasibility studies and design competitions for building projects, buying equipment including musical instruments or vehicles and commissioning public art (ACE, 1994).

The HLF was established by NHMF to distribute heritage funding. A fund of last resort, the NHMF's function is to safeguard the UK's most important heritage. It was empowered, under the National Heritage Act 1980, to give financial assistance towards the cost of acquiring, maintaining and preserving: land of aesthetic, historical or ecological significance; historic buildings; museum, gallery, library and archive collections; and industrial, transport and maritime heritage. Its funding, thus, predominantly, if not exclusively, comprised capital. The HLF, which was bound by the NHMF's remit, could: fund the construction of new buildings designed to house or enhance access to land, buildings or collections with importance to the heritage; and acquire items intended to complement collections of importance to the national heritage (HLF, 1995)

The priorities of the distributing bodies were set down in the Policy Directions issued by Secretary of State for National Heritage in June 1994. These specified that distributors should:

- consider the range of activities falling within their remit;
- fund only charitable projects benefiting the general public;
- concentrate funding on projects involving capital expenditure (in exceptional circumstances they could provide revenue funding or endowments for projects which had received capital funding but which would not otherwise be completed);
- consider the viability of projects;
- ensure that projects are supported by a significant element of partnership funding from non-Lottery sources, including support 'in kind';
- collect the information necessary to inform their decisions, and that in doing so they might consult with independent expert advisors.

It was also stated that distributing bodies should not solicit applications or fund organisations over which they have material influence. Any buildings supported by capital funds should be of the highest architectural quality and should encourage the greatest accessibility, as well as complying with the needs of people with disabilities.

Early concerns about Lottery funding of culture

Even before completing its passage through Parliament, the National Lottery etc. Bill had raised any number of issues about the distribution of funding to the cultural sector. These emerged in a context in which there were no formal needs assessments, and distributors' inability to solicit applications was used in retrospect to justify their lack of strategic approaches. As the regular coverage of the Lottery in such publications as *Arts Digest*, *Lottery Monitor* and *The National Lottery Yearbook* suggests, these issues informed debates about the Lottery, and influenced reforms to the distribution of funding. They covered: likely 'winners' and 'losers'; additionality; the implications of major injections of capital for revenue funding; and reflected some anxiety about the stability of current levels of Lottery income.

For example, it was suggested that a few high-profile, 'élitist' projects would swallow up most of the available funds and that smaller, lower-profile projects would lose out. This called into question the ethics of the arts Lottery funding being used to support capital schemes for institutions with national or international audiences and reputations, already revenue funded by the ACE – 'cash for the toffs – and the toffs' pleasure' (Tomkins, 1994). Various agencies highlighted the need for smaller organisations to receive funding, especially those in London, which was relatively less successful than other regions in attracting grants under £1 million (see, for example, Tomkins, 1994; 1996; Leisure Futures and CELTS, 1996).

Various awards made during 1995 appeared to confirm that funding was, indeed, going to élitist projects: the HLF's award of £13.25 for the Churchill Archive, and the three largest ACE grants (£78.5 million to the Royal Opera House, £30 million to Sadler's Wells, and £15.8 million to the Royal Court). Such awards were even criticised by cultural advocates, who regarded their cumulative effect as a public-relations disaster (NCA/NMC, 1996). Indeed, a survey by the Consumers' Association in September 1996 suggested that three-quarters of the public thought that too much money was being spent on a few big projects (*Which?*, 1997)

Another concern expressed was the potentially restricted nature of projects eligible for funding by the HLF in particular. Bound by the legislation that governed the NHMF's operations, the Fund could award grants only to sites or other assets in, or intended for, public or charitable ownership and of national importance. Moreover, it was subject to the criticism that by complying with the orthodoxies of its parent body and primarily funding 'listed' buildings, 'recognised' land and 'conservation areas' (FitzHerbert and Rhoades, 1997: 117) it excluded property in private ownership, education and access projects and locally important heritage.

The sustainability of Lottery capital projects was also questioned. Given organisations' lack of reserves, there was a strong likelihood that new or enhanced institutions supported by Lottery capital funding would create more pressure for revenue funding. Despite a caveat enabling Lottery distributors to provide revenue, the HLF's £1.43 million endowment to Chetham's Library, Manchester in 1995/96 and the £7 million to Baltic Flour Mill, Gateshead in 1997, were the

exceptions rather than the rule. At the time of writing (summer 2000), news stories about Lottery projects falling foul of over-optimistic predictions of visitor numbers, and their consequent failure to generate a viable level of admission revenues, were becoming increasingly familiar.

It was further queried whether Lottery funding was in fact 'additional', and not used to support activities which might otherwise be funded by government, and whether Lottery programmes were stimulating new forms of activities. Questions about additionality have dogged the history of Lottery funding, focusing on: those subsidised cultural flagships receiving Lottery funding; the fact that Lottery projects receive partnership funding, which is often channelled through government bodies (such as Single Regeneration Funding, or European Regional Development Funding); and the advent of Lottery revenue funding.

The principle of 'access for all' led to scrutiny of whether funding from the HLF and ACE in particular was gravitating towards London and the South East, rather than being equally spread throughout the UK and England respectively. The fact that the earliest, largest, ACE grants went to London-based companies reinforced such concerns. Moreover, during its first full year of operation, over 50 per cent of the ACE's funding went to London, as did 43 per cent of the HLF's. The distributors' defence rested on the location of the largest organisations and heritage assets, and their necessity to respond to individual applications as they came in (Gummer, 1996; HLF/NHMF, 1997).

By early 1996, the regional arts boards (RABs) had presented the case for better regional representation, comparing the centralisation of arts funding to regional administration of the Charities Board and the Millennium Commission's proposals (Hewitt and Dixon, 1996). The majority of the public also thought that the money should be distributed equally to all regions of the country (*Which?* 1997).

Another concern was the prospect that a large proportion of the money raised through the sale of Lottery tickets would come from those sections of the community, particularly those on low incomes, least likely to identify with or participate in the successfully funded projects (see, for example, LGIU, 1996). The fact that Lottery-capital-funded projects might well have to charge admission to generate necessary revenues was thought likely to hinder access.

Other 'losers' were identified as: charities, including those involved in medical research (although, as Evans and White (1996: 9) suggest, findings of research into the impact that the Lottery was having on the public's donations to charities varied considerably); libraries (the HLF is able to support special, historic library collections, but not public lending or current information services); and literature, which had virtually no capital requirements.

It was also feared that inequities in funding might be exacerbated by the difficulties of securing the hard commitment of funding partners, particularly in deprived areas. The potential of projects across the board to meet the partnership requirements was also in some doubt. As the Director of the then Association for British Sponsorship of the Arts (ABSA) put it, 'Where is all this extra cash going to come from?' (Colin Tweedy cited in ABSA, 1995). In the event, deprived areas attracted much European Union and Single Regeneration Bid funding which was used as partnership funding for Lottery projects (see Chapters 11 and 13). At a

more modest level, given that the equivalent costs of volunteer labour and donated goods were admissible as partnership funding, this was less of a problem for smaller projects than had been anticipated.

Resentment was expressed that certain individuals were seen to be benefiting disproportionately from the Lottery – in particular a small number of consultants and architects' practices. Artists are reported as receiving about half the minimum daily rate offered to consultants by the ACE (*Arts Digest* 30: 44). This issue was brought to the fore by Richard Rogers' practice winning nearly £1 million to carry out a feasibility study for the South Bank in 1994/95. That he was in a position to tender for work (despite going through due process), while being an ACE Council member, raised the spectre of conflict of interests, previously largely neglected in the arts funding system.

The competence of the distributors was questioned in particular: their ability to manage the thousands of applications anticipated; and the arts councils' ability to distribute film funding. The former came under the spotlight with the evaluation of the administration of the Arts for Everyone programme – especially the A4E main programme which had an approval rate of 12 per cent (Annabel Jackson Associates, 1999). With respect to the latter, the ACE's film funding eventually passed to the Film Council, and SAC's passed to Scottish Screen.

Lastly, it was feared that the percentage of Lottery proceeds received by the five good causes might be downgraded in the future. This fear was realised with the advent of a new sixth good cause, as shown in Table 16.3 below.

All of these concerns were reflected in changes to legislation and the Directions issued by the responsible government departments (the DNH, the Scottish Office, the Welsh Office and the Department of Education, Northern Ireland), as well as in the Lottery distributors' funding programmes themselves.

New Policy Directions, 1996

By January 1996, within a year of the first awards having been made, the DNH and the other responsible government bodies announced that they would be consulting the distributors about developing their remits. The possibility of various one-off revenue strands to Lottery funding was discussed, focusing on youth, talent and participation – all perceived as crucial for satisfying expectations about the 'public good'.

This consultation coincided with the publication of the government's expenditure plans in March 1996. DNH's plans showed a projected diminution of £5 million in ACE's funding from 1995/96 to 1996/97, and of £8.2 million by 1997/98 and 1999/99. The government also planned cutting NHMF's grant-in-aid, allocating £8 million in 1997/98 and £7.5 million in 1997/98 and 1998/99, against the £12 million allocated in 1993/94. The proposed cuts in the ACE's budget reinforced existing concerns about the pressures on revenue funding. As the Chair of the ACE's Lottery Board speculated, 'Within two years, we might have nearly twice as much money for capital grants from the Lottery as for revenue funding from the government' (Gummer, 1996: 29).

Arts Council of England programmes

The new Directions, which the DNH issued in April 1996, allowed the arts distributors to provide revenue funding for a wider range of organisations than before, and to fill perceived gaps in provision. This meant that voluntary and community organisations, which had never received grants from the arts councils before, were now eligible for funding. Although these schemes targeted at such recipients began a proliferation of Lottery funding programmes, they did little to answer the shortage of revenue funding exacerbated by capital grants.

The ACE, for example, designed its new revenue programme to: develop creative abilities and artistic talents and skills, particularly for young people; increase access to and participation in the arts, particularly in remote areas and areas in need of regeneration; and to enable arts organisations to gain long-term stability. It launched four new schemes, as outlined below, to run for specified periods alongside its capital programme: the Arts for Everyone (A4E), a stabilisation programme, a film programme, and funding for dance and drama students. As Table 16.2 shows, the other arts councils followed a similar model.

- The A4E main programme offered professional, voluntary and amateur groups opportunities to: create new work; develop new audiences; encourage participation in the arts and encourage young people, in particular, to participate and realise their creative potential. It offered smaller grants than conventional Lottery funding and had similarly lower partnership-funding thresholds. A4E Express was a fast-track pilot scheme aimed primarily at youth, voluntary and small professional organisations, which had previously received no funding whatsoever.
- The Stabilisation Programme (launched in September 1996) was designed to 'strengthen arts organisations creatively, managerially and financially' by putting them on a firmer financial footing. It aimed to eradicate the root causes of their instability (ACE, 1997).
- Under the film franchise schemes, three consortia – DNA Films, The Film Consortium and Pathé Pictures – were awarded a combined total of £96 million for 120 films to be made over a six-year period. Any profit made by the films was to result in a proportion of funding being returned to ACE. In April 2000, the new Film Council assumed responsibility for all DCMS film funding, including Lottery funding, with the exception of Artists' Film and Video.
- The Interim Funding Scheme (IFS) for Dance and Drama Students, co-funded by the Department for Education and Employment, was designed to help students of dance, drama and stage management pay their fees for certain accredited courses at independent colleges. Their only other option for support was though discretionary grants from their local education authorities (ACE, 1997).

Heritage Lottery Fund programmes

The new Directions allowed HLF to support the work of Building Preservation Trusts, which acquire buildings then repair and convert them to new uses and

Table 16.2 Arts Lottery programmes from 1995/96 (a)

	From 1995/96 (capital funding)		From 1996/97 (revenue funding)	1998/99 (cross-distributor funding)
ACE	Capital (equipment; building; feasibility studies)	Film Programme (films for cinema; greenlight fund; artists' film and video film franchise)	A4E (main and express) Stabilisation Interim Funding Scheme for dance, drama and stage management students	Millennium Festival Awards for All
ACNI	Capital (equipment building feasibility studies)	Film	New Work (b) Access Advancement Interim Funding Scheme	Millennium Festival
SAC	Capital (equipment; building; feasibility studies/ artists in environmental schemes; design competitions; arts in public)	Film production (short film; exploitation)	New Directions (access and participation new work; talent, skills and creative abilities) Advancement	Millennium Festival Awards for All
ACW	Capital (equipment; building; feasibility studies/artists in environmental schemes; public art)	Film	Arts for All (c) Dance and Drama awards	Millennium Festival

Sources: ACE; ACW; SAC and ACNI National Lottery Fund, annual reports, various years.

Notes
a) These breakdowns reflect the arts councils' categories as used in their annual accounts and Lottery reviews.
b) This is a capital programme.
c) For training, access and participation.

sell them on, by contributing to the shortfall between the total project cost and the estimated market value of the building after project completion. To date, the HLF has received no money back on the sale of properties.

The HLF had already launched three new programmes in January 1996 to help it achieve a regional spread of major projects over the UK and to fill gaps in the existing funding provision. These included: the Major Museum, Library and Archive Projects Assessment Programme for projects seeking grants of over £1 million; the Urban Parks Programme, which sought to reverse the decline in urban open spaces and improve the quality of life in neighbourhoods (Harding, 2000); and, in partnership with English Heritage, the Joint Scheme for Churches and other Places of Worship in England, which sought to complement existing public funds.

The operations of the HLF were, however, still limited by the restrictive clauses of the National Heritage Act 1980 which determined whom and what kind of projects it could fund. It was only when the National Heritage Act 1997

received Royal Assent, and the Secretary of State issued new Directions in 1998, that the HLF was able to extend its remit.

National Heritage Act 1997

The National Heritage Act 1997 was partly a response to the National Heritage Committee's report of 1996 and to the demands which became apparent once Lottery funding became available (HoC, 1996). It greatly increased the range of applicants and the types of project HLF might support by:

- effectively removing the concept of an eligible recipient, so, on the proviso that assistance would result in public benefit, the HLF could support such projects as comprehensive townscape schemes and national parks;
- enabling the HLF to improve access to the heritage, to support the study, understanding and enjoyment of the heritage, the maintenance and development of heritage skills, to support public exhibitions and to create records of heritage; it also extended the HLF's powers to assist IT projects and the interpretation of heritage.

The HLF launched its Revenue Grant Programme in April 1998. It addressed a range of new activities: information and communications technology, archaeology, education, information, and documentary heritage. The Museums and Galleries Access Fund (launched in July 1998) was designed to encourage: the development of new audiences, increased participation in museums, and major touring initiatives by national and other leading regional museums and galleries.

The National Lottery Act 1998

Before the 1997 election, the Conservatives were planning to introduce a sixth good cause, the Millennium Information and Communication Technology Fund (DNH, 1997). However, in July 1997 (three months after coming into office), the new Labour government set out its proposals for reforming the Lottery in a White Paper, *The People's Lottery*, which developed the proposals made in Labour's pre-election report, *The National Lottery. Initiatives and Recommendations* (Labour Party, 1996). The subsequent National Lottery Bill was introduced in 1997, and the Act received Royal Assent in July 1998. The government's intention was to enable:

The benefits of Lottery money to be more widely spread; greater confidence that money is allocated fairly across Britain and to different groups; new areas benefiting from the Lottery, particularly health, education and the environment, to help to ensure that the Lottery as a whole adds more to success and quality of life in the next millennium; Lottery money is spent according to a strategy, taking account of assessed needs; and decisions on individual grants taken closer to the grassroots.

(The People's Lottery: 3)

Amongst the changes brought about by this legislation, the following developments affected the cultural sector directly.

- A new, sixth good cause and distributor was established: the New Opportunities Fund which was created to allocate funds to support health, education and environmental initiatives.[3] Contingent upon its establishment was the reduction of funds to the other good causes and distributors from October 1997. It had previously been anticipated that the dissolution of the Millennium Commission would result in an increased share for the remaining good causes (HLF, *Lottery Update 12*, November 1998: 3).
- The National Endowment for Science, Technology and the Arts (NESTA) was established to support and promote new talent and ideas in health, education and environment. NESTA was established with a £200 million endowment, expected to produce annual income of £10 million per year. It is not a distributing body and does not receive an on-going share of the fund. NESTA's first programme, Invention and Innovation, opened for applications in November 1999.
- Decision-making was delegated to home countries and English regional offices.
- The ability to participate in joint schemes for the distribution of funding was realised in the Millennium Festival awards and Awards for All, a small-grants programme for small charities and community groups, and shared by all the distributors. The pilot was launched in Scotland, and extended to the East Midlands in September 1998 before going national in April 1999. Similar schemes in Wales and Northern Ireland are administered separately by each of the distributors (see Table 16.2).

The 1998 Act also effectively reversed certain aspects of the previous legislation by specifying the need for each distributor to consult upon and produce: a strategic plan, including a statement of the policy and financial directions issued by the Secretary of State and how it was complying with these; a statement of the estimate of the likely amount of funds available to the distributor; a statement of the distributor's assessment of the sector's needs that it has the power to deal with; and, a statement of the distributor's priorities in meeting those needs (ACE, 1999a).

While the details of the new Policy and Financial Directions issued in August 1998 differed from distributor to distributor, those issued to the NHMF (HLF, 1999) and the ACE (ACE, 1999a) stressed the government's desire to shift the distributors' previous focus 'away from big spending on bricks and buildings and concentrate on making sure more lottery money goes on people and activities' (as suggested by Hewitt and Dixon, 1996). These Directions emphasised the:

3 Launched in January 1999, its first three initiatives include: healthy living centres, out-of-school-hours activities, ITC training for teachers and school librarians. Three more initiatives announced in November 1998 included: cancer prevention, detection, treatment and care; green spaces and sustainable communities; community access to lifelong leaning (*New Links for the Lottery*, Cm 4466).

- requirement to ensure that all parts of the UK have access to funding;
- scope for reducing economic and social deprivation and the need to promote access, for people from all sections of society;
- need to ensure that their powers to solicit applications are used in connection with their strategic objectives; and
- desirability of working with other organisations, including distributors.

Other government initiatives of around the same period encouraged the social and economic directives within the cultural sector. The Coalfields Lottery conference, November 1998, highlighted the need for Lottery funding to contribute to the regeneration of areas that had fared less well in the past (DCMS, 1998), and a subsequent report highlighted ways of improving lottery funding to those areas (Gore et al., 2000). By July 1999, the DCMS reported to the Social Policy Unit on how to maximise the impact on poor neighbourhoods of government spending and policies on arts and leisure (DCMS, 1999).

Lottery funding to the cultural sector

Against the background of the issues raised in the previous section, this section considers the financial impact of the Lottery, including how much Lottery funding was made available to the cultural sector until the end of the 1998/99 financial year, and how it was distributed. More specifically, the section considers: whether the demand for funding was met; what was funded; where the funding went; and, what kind of recipients it went to. It should be said that, in many respects, there are considerable difficulties about addressing these questions, however interesting they might be, since they don't necessarily coincide with the original objectives of the Lottery.

The distributors' income

Initial predictions suggested that the Lottery would realise monies for the arts at rather less that the Government's grant in aid of £186 million per annum. Even so, the doubling of the arts budget was a matter of great consequence.
The latest predictions (Camelot) suggest that in 1996/97 £300 million will be raised for the arts.

(Hewitt and Dixon, 1996)

In the event, the success of the Lottery meant that it produced more funding for the cultural sector than even the revised predictions suggested. In 1996/97, the National Lottery Distribution Fund provided £612 million for the arts and heritage (including countryside and land). By the end of 1998/99, these two good causes had received £2.7 billion in all. The sector also benefited from funding from the Millennium Commission (particularly through its funding of major projects such as Tate Modern and its Awards for All programme) and the Charities Board. So, in purely financial terms, the Lottery has brought an enormous boon to the sector.

Table 16.3 Percentage of Lottery funds allocated by distributors, 1994/95–1998/99

Percentages

	At 31.3 1995	At 31.3 1996	At 31.3 1997	1.4.– 13.10. 1997 (a)	15.10.97– 31.3.98	1.4.98– 14.2.99 (b)	15.2.– 16.5.99	17.5.99– 30.6.99	1.7.99
Arts	20.0	20.0	20.0	20.0	16.67	16.67	5.00	16.67	16.67
of which									
ACE	16.66	16.66	16.66	16.66	13.88	13.88	4.16	13.88	13.88
SAC	1.78	1.78	1.78	1.78	1.48	1.48	0.44	1.48	1.48
ACW	1.00	1.00	1.00	1.00	0.83	0.83	0.25	0.83	0.83
ACNI	0.56	0.56	0.56	0.56	0.47	0.47	0.14	0.46	0.46
Other good causes									
NLCB	20.00	20.00	20.00	20.00	16.67	16.67	5.00	16.67	16.67
NLF	20.00	20.00	20.00	20.00	16.67	16.67	5.00	16.67	16.67
MC	20.00	20.00	20.00	20.00	20.00	20.00	20.00	20.00	20.00
Sport	20.00	20.00	20.00	20.00	16.67	16.67	5.00	16.67	16.67
NOF	n/a	n/a	n/a	n/a	13.33	13.33	60.00	13.33	13.33

Sources: National Lottery Distribution Fund Accounts, various years; DCMS.

Notes
a) The New Opportunities Fund was created in this period, and was entitled to a share of Lottery funds from 14 October 1997.
b) During 1998 the Secretary of State guaranteed the arts councils and the HLF their current share in Lottery funding up to 2001.

The percentage of Lottery funding used to support the New Opportunities Fund has meant a reduction in the share for the other good causes, which declined by 3.3 per cent (Table 16.3). When the Millennium Commission's funding is wound up, its share of funding will go to the New Opportunities Fund, which will then receive a third of the total amount allocated to good causes. This was due to take place at the end of December 2000, then postponed to August 2001.

The distributors' expenditure

Notwithstanding their income from the National Lottery Distribution Fund, the distributors' commitments and running costs determine the amount that they have to spend. As Table 16.4 shows, in the early years of the Lottery, the arts councils and the HLF, in particular, accumulated a large surplus. However from 1997/98, coinciding with the reduction in their income, the arts councils (especially ACE) and the HLF over-committed themselves. The ACE provides the most extreme example of this. According to its Strategic Plan of 1999 (ACE, 1999a), it anticipated a diminishing total spend culminating in £135 million in 2001/02 – a third of what it spent in 1996/97. It could be argued that these projected figures are to do with tamping-down demand. The amount of funding promised by Camelot is £15 billion over seven years – £5 billion more than the current licencees will have provided.

This downward trend in ACE's expenditure particularly affects its capital programme. Subtracting the £69 million currently reserved for specific projects, ACE's capital spend would average £41 million a year, less than 20 per cent of its capital expenditure in 1997/98. This reduction in ACE's funding had already taken effect before the end of the period considered in this chapter. In 1998/99

Table 16.4 Income and expenditure of Lottery distributors, 1994/95–1998/99

£ million

	1994/95	1995/96	1996/97	1997/98	1998/99	Total
Income from National Lottery Account						
ACE	48.900	255.360	262.802	297.648	241.748	1106.458
ACW	2.934	15.303	15.722	17.842	14.757	66.558
SAC	5.224	27.313	28.208	32.538	26.573	118.856
ACNI	1.644	8.590	9.055	10.361	8.919	38.569
HLF	58.691	306.065	316.953	366.274	310.962	1358.945
Subtotal	*117.393*	*612.631*	*632.740*	*724.663*	*602.959*	*2690.386*
Grants made						
ACE	n/a	229.918	344.450	455.794	57.925	1088.087
ACW	n/a	10.323	12.018	18.807	12.706	53.854
SAC	n/a	19.831	30.195	35.387	31.265	116.678
ACNI	n/a	5.187	5.084	4.652	8.940	23.863
HLF	n/a	70.906	235.516	406.556	383.324	1096.302
Subtotal	*n/a*	*336.165*	*627.263*	*921.196*	*494.160*	*2378.784*
Cost of administering Lottery grants						
ACE	1.411	6.864	14.719	22.937	21.038	66.969
ACW	0.183	0.493	0.844	1.187	1.272	3.979
SAC	0.224	0.452	1.188	1.900	1.911	5.675
ACNI	0.075	0.175	0.294	0.617	0.756	1.917
HLF	1.299	3.895	10.739	11.992	11.900	39.825
Subtotal	*3.192*	*11.879*	*27.784*	*38.633*	*36.877*	*118.365*
Accumulated funds brought forward						
ACE	0.000	47.489	66.067	–30.300	–211.383	n/a
ACW	2.751	4.487	2.860	–2.152	0.779	n/a
SAC	5.000	7.030	3.205	–4.748	–6.602	n/a
ACNI	1.567	3.228	3.677	5.091	–0.777	n/a
HLF	57.392	231.264	70.698	–52.274	–84.262	n/a
Subtotal	*66.711*	*293.498*	*140.097*	*–84.383*	*–302.254*	*n/a*

Sources: HLF, ACE, ACW, SAC and ACNI National Lottery Fund, annual reports, various years.

ACE's total grant spend was £57.9 million – less than 15 per cent of what it had spent the previous year. In the 20 months from August 1998 to March 2000, ACE only had £55 million available for new capital awards (ACE, 1998).

The main causes of this reduction in funds are commitments already made to certain projects, including: funding reserved for specific projects (South Bank Centre and the Regional Music Centre, Gateshead); funding earmarked for new schemes (the National Foundation for Youth Music; Publications, Recordings and Distribution; and National Touring Projects), as well as ACE's allocations to revenue and regional funding. The net effect is that less funding will be going to fewer major projects, and that projects which have already received feasibility awards or funding for the first phase of development may end up being refused capital funds or offered substantially lower awards than expected.

Satisfying the demand for funding

However much money was made available to the good causes, demand inevitably exceeded supply. Distributing bodies do not issue information about applicants'

Examples of success rates of all applicants to distributors of Lottery funds		
Distributor/programme	Success rate (%)	At date
ACE		
Capital programme	About 50	August 1998
Arts for Everyone Main	11	End of programme
Arts for Everyone Express	44	End of programme
Film Production	about 33	1997/98
Other Arts Councils		
ACW	72	1999
ACNI	78	1999
SAC	Figures not available	
HLF		
Capital and Revenue Programme	53	1999
Urban Parks Programme	About 11	1999
Joint Places of Worship	9	1999

Source: research by *Lottery Monitor*.

success or failure rates on a regular basis, if at all. The box above illustrates snapshots of success rates at particular times. Except for the A4E success rates, assessed at the end of the programme, the figures given cannot be taken as representative of the programmes identified as a whole.

However, to some extent, certain funding schemes, at least, responded to demand. Before the most recent Directions insisted that the distributors should consult their constituencies, the HLF had revised its original allocations for the Urban Parks programme as a result of the sheer number of applications. This programme, like A4E, was conceived to appease disquiet over the perceived élitism of certain early major capital grants, and to provide support for those parts of the country 'not overburdened with an abundance of funding'. The Urban Parks programme was initially launched in 1996 with £50 million for a three-year period. But by March 2000 it had awarded 314 grants totalling £170 million to urban parks. Of that, funding went to 48 of the most 50 deprived areas in the UK. A4E was reported to have been initially launched with £22.25 million (*Arts Digest*, 17: 40), although in the event it delivered awards worth £49.9 million.

What was funded

There are different ways to answer the question, 'what was funded?' One response is a quantitative description of the number and value of awards made by region, artform, heritage activity or scheme, another might be on the basis of the value of the partnership funding delivered. Another response might focus on less tangible effects of Lottery funding, describing, for example, the extent to which the objectives of Lottery funding were delivered – how much more access was created, and to what extent social deprivation was eradicated. In practice, however, the first approach is standard. Consequently, our understanding about 'what was funded' is determined by the nature of the data easily collated by the distributors. Thus, Table 16.5 shows funding to arts activities and heritage areas. Drama and music

received almost 50 per cent of arts funding between them, with museums and galleries receiving nearly 50 per cent of all heritage funding, and historic buildings receiving some 30 per cent. The vast majority of that heritage funding went on bricks and mortar, and within that a high percentage was spent on repair, physical improvements and extensions. The fact that these activities attracted the bulk of funding is more or less consistent from 1994/95 to 1998/99.

Given the original non-strategic nature of Lottery funding, it is not surprising that the distributors' annual reports analyse their grant-giving as illustrated in Table 16.5, rather than on the basis of effectiveness. But, as the ramifications of government policy can be seen on the priorities of the distributors, this should, logically, change. Both A4E and the HLF's Museums & Galleries Access Fund have built-in assessment requirements designed to reveal how far funded projects have succeeded in delivering the programmes' objectives. Were the same principles applied to the new ACE capital programme, this would imply a series of annual statements on: the degree to which greater access to the arts had been achieved, projects' success in reaching new audiences and participants, and the extent of cultural diversity provided.

Assessments of what has been funded are quite often based on the use of proxies – the substitution of one measure for another. One example might be the amount of Lottery funding committed to revenue awards, which can be seen as a move away from bricks and mortar to people and activities (Table 16.6). Another example might be that the analysis of funding on a local-authority basis not only demonstrates whether an equitable geographical balance of provision has been achieved, but more specifically provides a crude measure of whether funding has been distributed to areas of high deprivation. Although several of the national museums and galleries funded by DCMS and various flagship arts organisations which have received large capital grants are actually located in deprived areas (Selwood, 1997: 13–14), recent initiatives have been intended to address issues of social and economic deprivation. The HLF's capital programme, for example, is currently targeting local, neglected aspects of heritage, and the Urban Parks, Townscape Heritage and Places of Worship programmes are being refocused to help areas of social and economic deprivation. New initiatives are likely to concentrate on the coalfield areas and urban green spaces.

Other proxies include funding by grant size (Table 16.7). The size of awards, for instance, is generally considered to be indicative of the extent to which distributors are funding projects of national, regional, local and community interest. It also reflects organisational size, as well as perceptions of competencies, sustainability and, in the case of the HLF, 'heritage merit'. The HLF's decision to allocate 50 per cent of its budget to grants below £1 million, delegated to the four country committees on the basis of population, illustrates the relationship between grant size and equitable access to funding (HLF, 1999). These smaller awards include capital funding for equipment and feasibility studies, as well as revenue funding intended for access and participation projects.

According to *Lottery Monitor*, the average size of awards across the board has halved over the last six years. More than 17,000 awards were made in the first nine months of 2000, compared with 16,620 in the whole of 1999 and 4,321 in 1995,

Table 16.5 Total Lottery grants to the cultural sector by artform and heritage asset, 1994/95–1998/99

£ million

	1994/95 (a)	1995/96	1996/97	1997/98	1998/99	Total
Arts (b)						
Architecture	n/a	0.838	0.988	1.267	0.837	3.929
Broadcasting	n/a	0.738	7.130	0.123	0.000	7.991
Circus	n/a	0.206	0.956	0.241	0.208	1.612
Combined arts (c)	n/a	66.242	71.061	71.714	24.673	234.690
Dance	n/a	30.823	32.020	48.496	9.476	120.816
Drama and mime (c)	n/a	135.759	129.857	84.170	24.924	374.709
Film and video	n/a	11.749	35.044	21.290	9.753	77.835
Literature	n/a	1.244	1.948	3.373	4.112	10.677
Music	n/a	45.835	61.905	58.024	39.283	205.046
Opera/Music theatre	n/a	61.451	0.708	3.379	1.386	66.924
Visual arts and crafts (c)	n/a	25.376	61.086	73.439	24.856	184.756
Other	n/a	1.751	1.758	7.668	9.934	21.111
Subtotal	*n/a*	*382.011*	*404.461*	*373.183*	*150.443*	*1,310.097*
Heritage (d)						
Historic buildings (c)	n/a	39.973	104.583	121.738	82.175	348.469
Industrial transport and maritime (c)	0.419	16.199	65.936	23.019	19.324	124.897
Manuscripts and archives	13.254	7.844	23.175	11.691	21.836	77.800
Museums and collections (c)	0.650	216.634	215.045	114.211	93.261	639.801
Subtotal	*14.323*	*280.650*	*408.739*	*270.660*	*216.596*	*1,190.967*
Charity Lottery Board (e)	n/a	0.715	1.273	1.976	2.082	6.047
Total	14.323	663.376	814.472	645.819	369.121	2,507.111
At real (1998/99) prices	*16.150*	*726.971*	*864.703*	*666.892*	*369.121*	*n/a*
Percentage change year-on-year	n/a	4,401.480	18.950	−22.880	−44.650	*n/a*

Sources:
Arts Council of England; Scottish Arts Council annual reports, various years; Arts Council of Wales; Arts Council of Northern Ireland National Lottery Report, various years; Department for Culture, Media and Sport website (www.lottery.culture.gov.uk); Heritage Lottery Fund.

Notes
a) Only the Heritage Lottery Fund identified grants made in this year.
b) Grants made by the four arts councils and by the Millennium Commission.
c) Including Millennium Commission awards.
d) Grants made by the Heritage Lottery Fund and by the Millennium Commission.
e) Could not be separately identified by artform.

Charity Lottery Board: estimated value of grants to cultural projects, 1995/96–1998/99

	1995/96	1996/97	1997/98	1998/99	Total
Total number of awards	2,591	4,613	7,159	7,545	21908
Estimated number of awards at average of 1.2 per 100 grants	31	55	86	91	263
Estimated value of arts grants at average of £0.023 million per grant (£m)	0.715	1.273	1.976	2.082	6.047

Source: Department for Culture, Media and Sport website (www.lottery.culture.gov.uk).

Table 16.6 Capital and revenue grants awarded by the Heritage Lottery Fund and the four arts councils, 1994/95–1998/99 (a)

£ million

	1994/95 (a)	1995/96	1996/97	1997/98	1998/99	Total
HLF						
Capital grants	14.323	173.076	392.913	265.545	206.384	1,052.242
Revenue grants	n/a	n/a	n/a	n/a	8.441	8.441
Subtotal	*14.323*	*173.076*	*392.913*	*265.545*	*214.825*	*1,060.682*
ACE						
Capital grants	n/a	229.918	363.551	247.700	88.900	930.069
Revenue grants	n/a	n/a	n/a	76.100	31.400	107.500
Subtotal	*n/a*	*229.918*	*363.551*	*323.800*	*120.300*	*1,037.569*
ACW						
Capital grants	n/a	11.280	14.030	21.957	7.198	54.466
Revenue grants	n/a	n/a	0.042	4.618	7.038	11.698
Subtotal	*n/a*	*11.280*	*14.072*	*26.575*	*14.236*	*66.164*
SAC (b)						
Capital grants	0.282	24.041	24.189	29.883	12.092	90.487
Revenue grants	n/a	3.525	6.614	11.335	11.510	32.984
Subtotal	*0.282*	*27.566*	*30.803*	*41.218*	*23.602*	*123.471*
ACNI (c)						
Capital grants	n/a	5.860	6.788	4.587	8.800	26.036
Revenue grants	n/a	n/a	n/a	0.935	0.899	1.834
Subtotal	*n/a*	*5.860*	*6.788*	*5.522*	*9.699*	*27.870*
Total, of which:	14.605	447.700	808.128	662.661	382.662	2,315.756
total capital grants	14.605	444.175	801.472	569.673	323.375	2,153.300
total revenue grants	n/a	3.525	6.656	92.988	59.287	162.456

Sources: personal correspondence with HLF, ACNI, SAC, ACW; various ACE annual reports and National Lottery Reports.

Notes
a) The distinctions between capital and revenue funding projects are shown in Table 16.2, exceptions are described in the following notes.
b) Film is counted as revenue. For the purpose of this table, advancement, which SAC counts as capital and revenue, is counted as revenue.
c) Film and New Work programmes are counted as capital expenditure.

the first year of Lottery grants. Money is flowing faster too: £1.6 billion was awarded between January and October 2000, compared with less than £1 billion in 1999.

Partnership funding is not solely regarded as additional money, but as evidence of a wider interest in and support for projects. Table 16.8 shows various programmes' minimum requirements for partnership funding. Despite initial worries that it would prove difficult for smaller projects (especially those in areas of high deprivation) to find other sources of funding, it proved more of a problem for some of the larger flagship Lottery projects. Years after starting their Lottery projects (and, contrary to the funding criteria) several ACE award-winners were still struggling to find sufficient partnership funding (National Audit Office, 1999).

Table 16.9 shows the amounts of partnership funding attracted in 1998/99 by Lottery projects funded by the HLF and the arts councils. With the exception of film projects, funding from the Lottery distributors exceeds partnership funding –

Table 16.7 Heritage Lottery Fund and Arts Council of England Lottery awards by size, 1994/95–1998/99

	1994/95		1995/96		1996/97		1997/98		1998/99	
	No. of awards	% of spend	No. of awards	% of spend	No. of awards	% of spend	No. of awards	% of spend	No. of awards	% of spend
HLF										
Under £50,000	n/a	n/a	124	1	270	1	344	2	445	4
£50,000–£99,999	n/a	n/a	64	2	119	2	176	4	168	5
£100,000–£499,999	n/a	n/a	111	12	187	8	321	22	238	19
£500,000–£999,999	n/a	n/a	17	5	51	7	62	13	63	15
£1m–£10m	n/a	n/a	29	53	77	46	57	45	48	40
Over £10m	n/a	n/a	4	26	10	35	4	14	3	18
ACE										
Under £50,000	5	9	275	2	2,376	5	3,648	10	495	15
£50,000–£99,999	1	5	123	3	234	6	272	9	223	21
£100,000–£499,999	0	0	55	4	102	8	152	17	98	25
£500,000–£999,999	2	86	31	7	52	12	33	10	27	25
£1m–£10m	0	0	33	23	59	48	53	58	21	57
Over £10m	0	0	8	70	6	40	3	32	1	18

Sources: HLF and ACE.

albeit to varying degrees. The private sector contributed the largest share of partnership funding across the board (providing nearly 50 per cent), with the arts receiving the lowest proportion of funding from this source.

Where the funding went

Both the ACE and HLF were subject to criticism for their relative neglect of the regions in relation to London and the South East (not least in the annual editions of *National Lottery Yearbook*) and despite the sheer weight of cultural organisations in those areas. But, as Table 16.10 shows, the disparities between the levels of funding received in London and elsewhere have narrowed since 1995/96. This has presumably been in response to various factors: bad press; public opinion; the elimination of major flagships from the picture once they have received their Lottery funding; the advance of the government's programme of regionalisation; and the advent of schemes such as A4E. Between November 1996 and the end of the 1998/99 financial year, A4E alone provided £71.7 million of Lottery money to the regions. Nevertheless, London still received the largest share for the A4E main programme, and almost the largest share for A4E Express.

Table 16.8 Minimum partnership funding required by selected Lottery programmes, end of 1998/99

Programme	Minimum partnership funding required
Awards for All	None
ACE	
Capital (a) and revenue programmes	25% for projects over £100,000; 10% for under £100,000
Stabilisation	Not fixed
Arts for Everyone	Not fixed
Film Production	10–50% generally
NLCB	None required
HLF	
Main grants programme (a)	25% for projects over £100,000; 10% for under £100,000
Revenue grants	25% for projects over £100,000; 10% for under £100,000
Urban Parks	25% for projects over £100,000; 10% for under £100,000
Museums and Galleries Access Fund	Not fixed
Joint Places of Worship	25% for projects over £100,000; 10% for under £100,000
Millennium Commission	
Millennium Awards	10%
Millennium Festival Award for All	Not fixed
NOF	Not fixed

Source: research by *Lottery Monitor.*

Note
a) These requirements are as reported in DNH, 1996.

In terms of the distribution of ACE funding, ACE had no small-grant schemes operating in 1998, other than the pilot Awards for All in the East Midlands where four grants of less than £5,000 were made. But the funding of regional programmes developed as a result of ACE's package of various Lottery programmes centred on, and managed by, the regions (ACE, 1999a). This included small-scale capital funding (grants under £100,000); a new regional arts revenue programme (announced in May 1999, to continue 'Lottery support for many of the areas reached by A4E' (ACE, 1999b)); and small grants including Awards for All and the Year of the Artist, 1999/00. All in all, this is expected to provide an average of £26.4 million per year to the regions between 1999/2000 and 2001/02. However, this represents about the same level of funding as before: between November 1996 and the end of 1997/98, A4E Express and Rounds 1 and 2 of the main programme provided £49.9 million; and, during 1998/99, Rounds 3 and 4 of A4E main programme provided £21.6 million.

At the outset of Lottery funding, the HLF was the most centralised of all the distributors, based as it was in London with no regional representation. Despite its remit to cover the whole of the UK, its funding remained disproportionately weighted to the South East of England – a tendency that it defended on the basis of the distribution of what was narrowly defined as 'heritage assets'. Moreover, it is alleged that where its funding went to the regions it was concentrated in more advantaged local-authority areas – probably because these were the sources of

Table 16.9 Sources of partnership funding attracted by Lottery projects, 1998/99

£

Distributor	New hard commitments	Central government	Local authorities	ERDF	Other public	Private	Total partnership funding
HLF	319,438,27	15,616,013	47,502,288	4,398,871	43,137,081	104,775,720	215,429,973
ACE	140,426,46	0	19,716,385	3,297,322	51,729,471	58,725,436	133,468,614
SAC	322,666,32	0	1,716,003	2,879,110	10,081,233	15,855,954	30,532,300
ACW	13,978,58	0	904,835	1,079,409	1,171,000	15,972,344	19,127,588
ACNI	8,311,41	0	7,090,273	1,874,398	8,002,766	4,557,422	19,834,859
Total	*514,821,04*	*15,616,013*	*76,929,784*	*11,839,110*	*114,121,551*	*199,886,876*	*418,393,334*

Artform and heritage activity

Heritage

HLF	173,586,489	4,818,019	39,350,530	4,295,214	29,362,880	78,393,963	156,220,606

Museums and galleries

HLF	145,851,777	10,797,994	8,151,758	103,657	13,774,201	26,381,757	59,209,367
ACE	379,905	0	0	0	0	58,120	58,120
SAC	0	0	0	0	0	0	0
ACW	0	0	0	0	0	0	0
ACNI	20,600	0	8,000	0	0	10,000	18,000
Total	*146,252,282*	*10,797,994*	*8,159,758*	*103,657*	*13,774,201*	*26,449,877*	*59,285,487*

Arts

ACE	116,337,125	0	19,565,147	2,838,959	48,615,548	39,850,203(a)	71,020,654
SAC	29,720,466	0	1,691,003	2,879,110	9,276,233	8,405,487	22,251,833
ACW	12,697,139	0	904,835	107,949	1,000	8,410,545	10,395,789
ACNI	8,092,396	0	7,064,273	184,398	7,927,242	4,472,132	19,648,045
Total	*166,847,126*	*0*	*29,225,258*	*6,982,876*	*65,820,023*	*21,288,164*	*123,316,321*

Libraries

ACE	556,825	0	0	0	0	0	0
SAC	382,375	0	25,000	0	0	138,600	163,600
ACW	0	0	0	0	0	0	0
ACNI	75,000	0	2,000	0	0	5,500	7,500
Total	*1,014,200*	*0*	*27,000*	*0*	*0*	*144,100*	*171,100*

Film

ACE	18,360,107	0	54,461	457,363	3,023,839	18,001,312	32,594,707
SAC	2,563,482	0	0	0	805,000	7,311,867	8,116,867
ACW	1,281,443	0	0	0	1,170,000	756,179	8,731,799
ACNI	123,416	0	16,000	0	75,524	69,790	161,314
Total	*22,328,448*	*0*	*70,461*	*457,363*	*5,074,363*	*32,944,768*	*49,604,687*

Other

ACE	4,792,497	0	96,777	0	90,084	815,801	1,002,662
Total	514,821,042	15,616,013	76,929,784	11,839,110	114,121,551	160,036,673	378,543,131

Source: DCMS, distribution body management returns.

Note: a) Not entirely accounted for by the existing partnership categories.

'best applications', and conceivably the greatest possibilities of partnership funding (FitzHerbert et al., 1996: 98).

Despite setting up regional teams in 1997, it was only towards the end 1998, in response to the Culture, Media and Sport Select Committee, that the HLF established Committees for Scotland, Wales, Northern Ireland and England with

Table 16.10 Total Lottery grants to the cultural sector by home country and region, 1994/95–1998/99

£ million

	1994/95 (a)	1995/96	1996/97	1997/98	1998/99	Total
HLF and Millennium Commission funding by GOR (England)						
East	13.254	7.922	28.745	15.359	12.409	77.689
East Midlands	0.000	8.731	8.307	5.467	8.211	30.716
London	0.000	154.505	131.113	87.059	46.084	418.761
North West	0.650	46.102	54.893	22.634	34.739	159.018
North East	0.000	3.206	14.060	11.864	1.336	30.466
South East	0.000	11.390	31.713	32.740	19.748	95.591
South West	0.000	7.686	46.476	14.662	21.063	89.887
West Midlands	0.000	1.755	19.541	11.776	15.339	48.411
Yorkshire and the Humber	0.000	11.573	23.551	17.136	11.157	63.417
Subtotal GORs England	*13.904*	*252.868*	*358.399*	*218.696*	*170.087*	*1,013.955*
Arts Lottery funding by RAB (England)						
Eastern	0.000	6.883	6.120	6.906	5.179	25.088
East Midlands	0.000	13.380	13.232	10.741	2.420	39.772
London	0.000	166.594	158.651	67.925	32.028	425.198
North West	0.000	52.709	23.557	40.240	5.424	121.930
Northern	0.000	14.839	19.030	51.300	6.708	91.878
South East	0.000	4.744	14.848	6.297	19.588	45.478
South West	0.000	13.132	10.618	20.054	3.793	47.597
Southern	0.000	30.681	14.409	24.160	5.330	74.581
West Midlands	0.000	16.553	59.633	46.147	4.995	127.328
Yorkshire and Humberside	0.000	11.196	29.570	11.804	5.155	57.724
Subtotal RABs England	*0.000*	*330.711*	*349.668*	*285.574*	*90.621*	*1,056.574*
England	13.904	583.579	708.067	504.270	260.708	2,070.529
Wales	0.000	13.397	20.215	30.049	25.231	88.893
Scotland	0.419	57.287	73.106	80.075	40.973	251.861
Northern Ireland	0.000	8.397	11.607	18.578	27.086	65.668
National funding	0.000	0.000	0.204	10.870	13.041	24.115
National Lottery Charity Board (b)	n/a	0.715	1.273	1.976	2.082	6.047
Total	14.323	663.375	814.473	645.818	369.122	2,507.112
At real (1989/99) prices	*16.380*	*747.979*	*892.553*	*685.647*	*381.166*	*2,507.112*
Percentage change year-on-year	n/a	4,466.312	19.329	−23.181	−44.408	557.748

Sources: HLF, ACE, ACW, SAC and ACNI National Lottery Fund, annual reports, various years, DCMS website (www.lottery.culture.gov.uk); HLF.

Notes
a) Only the Heritage Lottery Fund identified grants made in this year.
b) Could not be separately identified by region.

powers to award grants for projects. Since April 1999, the country and the English regional committees have been able to awards grants of up to £1 million. The *2000 Corporate Plan* includes allocations per country on a per capita basis, delegated budgets to the English regions and the announcement of a contingency plan to enable the Fund to improve the position of under-performing English regions (HLF/NMHF, 2000).

Who received funding

Initially, both ACE and HLF funded organisations which already fell within the remits of the Arts Council and the NHMF – providing, as it were, more for those which already had. Having primarily supported capital projects, on a non-strategic, responsive and first-come-first-served basis, both bodies increasingly targeted their funding in accordance with the secondary legislation and Directions. These targets are ultimately determined by government objectives. And, since 1996, all the arts councils and the HLF have considerably expanded their remits to include voluntary and community organisations that had not previously received funding from either body – not least in response to questions about whose heritage is being funded (ACE, 2000b). The Arts Council of Wales is unique in having published (in annual reports) breakdowns of how its Lottery grants were distributed according to different types of groups, with professionals accounting for around 33 per cent; amateurs, around 46 per cent; community groups, 13 per cent; and educational groups, around 5 per cent. Nevertheless, these patterns of funding have been instigated without the benefit of formal needs assessments, and the distributors' preference is still for the arts and heritage establishments.

How has the Lottery affected the cultural sector overall?

The first section of this chapter examined various issues which have dogged the Lottery since the advent of funding for the original five good causes; the second section considered their development and gradual resolution. The final section considers three of the general issues raised by Lottery funding of the cultural sector: additionality, the sustainability of Lottery projects and the organisations responsible for them, and the economic impact of Lottery projects.

Additionality

Although the ACE and the HLF's Lottery revenue schemes, by definition, address perceived gaps in existing provision, it is has become increasingly unclear what might or might not constitute a breach of the principle of additionality – the idea that Lottery funding should not replace other funds. The ACE's announcement in June 1999 that it would no longer separate out its Lottery income from its DCMS grant is a case in point. Other contentious examples include the following.

- There is some ambiguity about those schemes which have taken up funding responsibilities for activities regarded as falling within the remit of local authorities, and which were intended to galvanise local government or other funding bodies into concerted action. Examples include the ACE dance and drama student programme, which filled a gap in discretionary funding and was eventually taken over by the Department for Education and Employment. The Scottish Arts Council never funded an equivalent scheme precisely because it regarded such funding as a government reponsibility.

- The HLF's Urban Parks programme was similarly conceived to address local authorities' failure to repair and maintain the park infrastructure. Its funding of new manager posts is intended to be made permanent at the end of the grant period, usually five years. This kind of situation applies to other local authority facilities. A 1996 report (KPMG, 1996) identified backlogs costed at £102 million of maintenance and repairs in museums and sport facilities (probably an underestimate) – precisely the kind of project targeted by Lottery capital funding for refurbishment and improvements.
- The Year of the Artist (1999/2000), funded by ACE Lottery funds, falls within the tradition of the 'Year of...' projects, funded throughout the 1990s under the Arts Council's Arts 2000 scheme.

Sustainability

The Lottery was never intended to remedy under-funding. It has, nevertheless, highlighted the issue of the sustainability of award-winners. Four issues pertaining to sustainability are considered here – those that impact on projects, organisations, funding bodies and local government. They include: the threat represented by Lottery projects' failure to generate a viable level of admission revenues; the fact that revenue needs inevitable follow-up injections of capital; the revenue implications of capital projects for organisations' operating costs; the cost to funding bodies bailing out projects; and, in the wider context, local authorities' tendency to shift funding towards high-profile Lottery projects at the expense of existing provision.

Firstly, there are reports of Lottery projects which have fallen foul of over-optimistic predictions of visitor numbers, resulting in organisations' failure to generate viable levels of admission revenues. Unfulfilled expectations of partnership funding and escalating project costs are also becoming increasingly common. These situations leave two options open – reduction in operations and ultimately closure (as in the case of the National Centre for Popular Music, Sheffield) or top-ups from funding bodies – as with ACE supplementary grants going to Sadler's Wells, the Royal Court Theatre, the National Glass Centre, the Cambridge Arts Theatre, Victoria Hall/ Regent Theatre, Dovecot Arts Centre, Milton Keynes Theatre, and the Royal Academy of Dramatic Art (HoC, 2000). Others falling outside the remit of the present study include the Earth Centre, Doncaster, and, of course, the Millennium Dome, Greenwich.

Secondly, an examination of the costs for the museums sector in England, in particular the operating costs of newly created museums and the occupancy costs of extensions, suggests these may be daunting. Babbidge (2001) has suggested that between the beginning of January 1995 and December 1999, HLF projects alone had created additional costs of some £29 million for UK museums.

At a time of reducing public subsidy, an expectation that museums will generate more earned income, and a static market, there is a substantial risk that many museums will find themselves over-committed. Thus, rather than remedy-

ing the problems of historic under-funding for museums, there is a risk that lottery money will be creating problems for the next generation.

(Babbidge, 2001)

Thirdly. there is the spectre of distributors having to provide supplementary grants to projects which have not gone according to plan. This is highlighted by the number of grants the Millennium Commission has made to the Dome. The same problem typifies several ACE projects. The House of Commons Public Accounts Committee (HoC, 2000), for example, found that 13 out of the 15 projects it examined had received supplementary grants – with eight alone receiving almost £20 million.

The uncertain financial health of some grant recipients, coupled with the fact that some have not yet attracted all of the funding they require from other sources, serve to highlight ACE's exposure to financial risk.

(HoC, 2000)

The Committee observed that this problem might have been avoided had the ACE enforced 'the special conditions which they attach to offers of grants before huge sums of lottery money are paid out'. Moreover, the bigger the project, the greater the risk of having to provide more money.

Lastly, research carried out in 1996 found that within English local authorities' leisure services there was a significant shift in funding allocations in response to Lottery awards. Where resources were transferred to higher-profile Lottery-funded schemes, this tended to be at the cost of reductions and cut-backs in service levels (as in staffing and opening hours) and facility maintenance, offset by increased income from charging above the rate of inflation (KMPG, 1996).

Assessing the impact of the Lottery on the sector

To date, there have been relatively few studies of how Lottery-funded cultural projects have affected local, regional or national economic and social wellbeing (Evans and White, 1996: 5) although a Millennium Commission Economic Impact Study is forthcoming.

Even though creating employment was never one of the Lottery's original objectives, the ACE has attempted to measure the effect of Lottery projects, including A4E, on employment (Evans, 1998; Johnson and Thomas, 1997; Larter, 1999). A study of employment arising from the first 1,000 arts Lottery awards in England found that less than 75 per cent of the total value of projects represented actual new spending, since Lottery monies were being matched by historic, 'in-kind' closure and other 'non-additional' expenditure. A high concentration of contracts had been won by a small number of architects, surveyors and engineering firms and Lottery assessors, who were mostly London-based. Employment arising from those first 1,000 arts Lottery awards (worth £1 billion in new spending) was estimated at between 12,500 and 17,800 full-time equivalents posts,

with the lion's share being accounted for by building, construction and related design and materials supplies. In many cases, public art commissions (an integral part of new-build awards) resulted in between 10 and 20 per cent of the total costs going to artists (although it is unclear how much constituted fees; see Chapter 31). Changes in Lottery policy are likely to have affected the employment effects of the Lottery.

The rhetoric of much capital funding is that it contributes to regeneration. Again, this was never one of the Lottery's original objectives. In that sense, the issues raised by independent assessments of cultural projects credited with spearheading urban regeneration in the early 1990s in cities suffering from the effects of industrial decline, such as Birmingham and Glasgow, might well apply to Lottery-funded capital projects. These critiques raised questions about the extent to which prestige projects have had a trickle-down effect – how they improved the economic and social positions for less-well-off residents, what kind of employment they generated, and so on (see, for example, Loftman and Nevin, 1992; Booth and Bloye, 1993). Methods of assessing the social impact of projects are probably still too crude to be used to assess the social wellbeing resulting from Lottery projects (Selwood, 2000).

In conclusion, it would appear that, while Lottery funding has been distributed to the cultural sector since 1995, and distributors are now confronting the issue of where funding is going, relatively little is known about the effect that Lottery monies are having on the sector itself, or the wider economy, or the social wellbeing of the communities it touches. Some qualitative research into the benefits to end-users is, however, underway. Given the government's concern to assess the efficiency and effectiveness of funding across the cultural sector (Selwood, 2000), it seems all the more remarkable that there still has not been 'any attempt to monitor even the programmes of one distributor for value for money, employment outcomes, usage, access, financial position, development of new programmes, etc.'(White et al., 1998: 23).

17
Funding from the Private Sector

Rachael Dunlop, freelance researcher, and
Sara Selwood, University of Westminster

This chapter considers funding to the cultural sector from two private sources:
charities and sponsorship.

Charitable trusts and foundations

The most comprehensive picture of charitable trusts' giving to the cultural sector
is provided by the Directory of Social Change's series of arts funding guides. The
2000 edition presents details of 294 trusts in England and Wales which gave to
the arts in 1997/98 (Forrester and Manuel, 2000). Of those, 246 trusts are identi-
fied as having given £69.436 million.

An analysis of charitable trusts' 1998/99 giving was undertaken for the
present volume. A list of charitable trusts was drawn up from various sources
(Forrester, 1996; Forrester and Manuel, 2000; Fitzherbert et al., 1999; CAF, 1999;
Forrester and Casson, 1998; The Factary, 1994; and Casey et al., 1996), and from
the membership of the Arts Interest Group of the Association of Charitable
Foundations. In all, 110 trusts returned annual accounts and funding schedules
for 1998/99 (see Appendix 5). Funding to projects overseas was excluded, as
were non-specific grants to religious or secular buildings (see Appendix 1).

Table 17.1 Funding of the cultural sector from charitable trusts, 1998/99

Value of giving	Number of trusts	Total value of giving (£ million)	Percentage of total value
£1 million and over	13	54.673	81.4
£500,000–£999,000	8	5.395	8.0
£250,000–£499,999	7	2.526	3.8
£100,000–£249,999	19	2.969	4.4
£50,000–£99,999	11	0.789	1.2
£10,000–£49,999	32	0.729	1.1
£9,999 and below	20	0.071	0.1
Total	110	67.152	100.0

Source: Research undertaken for this book.

The research for 1998/99 yields a total of £67.152 million going to the arts and the heritage in 1998/99. Wherever possible, this is based on actual amounts given, as opposed to amounts awarded. As Table 17.1 shows, the 13 trusts which gave £1 million or more (12 per cent of those surveyed) provided over £54 million (81 per cent of the total). By comparison, as many as 63 trusts (57 per cent) which each gave under £100,000 provided under £2 million (less than 3 per cent of the total). The median value of charitable trusts' giving was £63,677.

In an attempt to compare changes in the value of charitable trusts' funding over time, a constant sample of 53 charitable trusts (48 per cent of the 1998/99 sample) was drawn up (Appendix 5). The value of their 1998/99 giving was compared with that of 1993/94. This value declined by 53 per cent, from £46 million in 1993/94 to £24 million in 1998/99.

Sponsorship from business

Sponsorship is the payment of money by a business to an arts organisation for the purpose of promoting its business name, its products, or services. Sponsorship is part of the general promotional expenditure of a business, but can also encompass a sense of corporate or social responsibility.

<div align="right">(ABSA/DNH, undated)</div>

Both the Department of National Heritage (DNH) and the Department for Culture, Media and Sport (DCMS) actively encouraged business sponsorship in the late 1990s, not least through the government's Pairing Scheme, an incentive scheme for businesses. Sponsorship not only provides private-sector support and partnership funding, but according to Chris Smith, the former Secretary of State for Culture, Media and Sport, can be a 'powerful way' of making the arts more accessible to everyone (ABSA/DNH, undated).

Table 17.2 Constant sample of organisations' business sponsorship, 1993/94–1998/99

£ million

	1993/94	1994/95	1995/96	1996/97	1997/98	1998/99
General business support	24.0	29.0	29.6	33.3	38.0	42.3
Corporate membership	7.3	9.0	8.5	8.4	8.5	7.2
Corporate donations	3.8	4.0	3.1	4.1	4.5	5.0
Subtotal	*35.1*	*42.0*	*41.3*	*45.9*	*51.0*	*54.5*
Capital projects	0.3	6.4	2.7	14.0	11.4	24.0
Support in kind	3.8	3.8	4.1	2.9	3.4	4.5
Total	39.2	52.2	48.1	62.8	65.8	83.0
At real (1998/99) prices	*44.8*	*58.9*	*52.7*	*66.7*	*67.9*	*83.0*
Percentage year-on-year change	n/a	31.3	−10.4	26.5	1.9	22.2

Source: ABSA/Arts & Business, *Business Support for the Arts/Business Investment in the Arts*, 1993/94–1998/99.

Notes
Base: 265 organisations.

Table 17.3 Business sponsorship of capital arts and heritage projects, by English RAB and home country, 1993/94–1998/99

£ million

	1993/94	1994/95	1995/96	1996/97	1997/98	1998/99
England						
East	n/a	0.095	0.011	0.022	0.023	0.645
East Midlands	n/a	0.174	0.069	0.154	0.057	0.285
London	n/a	7.490	2.364	13.604	12.549	25.948
North West	n/a	0.246	0.230	0.307	0.296	0.264
Northern	n/a	0.219	0.211	0.132	0.380	0.281
South East	n/a	3.413	0.722	0.386	0.078	0.025
South West	n/a	0.016	0.007	0.125	0.123	0.027
Southern	n/a	0.174	0.302	0.300	0.045	1.386
West Midlands	n/a	0.118	0.484	0.284	0.287	1.357
Yorkshire and Humberside	n/a	0.822	0.003	0.037	0.529	0.570
Wales	n/a	0.033	0.171	0.173	0.018	0.335
Scotland	n/a	0.685	0.306	0.250	3.533	2.251
Northern Ireland	n/a	0.028	0	0.024	0.110	0.148
National funding and umbrella bodies	n/a	0.355	0	0.013	0	0
Total	n/a	13.867	4.880	15.811	18.038	33.522
Survey base (a)	1,104	2,049	1,172	1,518	1,298	1,646

Source: ABSA/Arts & Business, *Business Support for the Arts/Business Investment in the Arts*, 1993/94–1998/99.

Note

a) This includes organisations whose data were gathered through Pairing Scheme information.

The main source of data on business sponsorship is the annual survey of arts and heritage organisations and museums carried out by Arts & Business (formerly the Association for Business Sponsorship of the Arts (ABSA)). The following paragraphs track the results of that survey between 1993/94 and 1998/99.

The most accurate indication of trends is provided by the constant sample of organisations which have responded to every survey since 1993/94 (Table 17.2). This suggests that business support has risen consistently since 1995/96, most notably as a result of increases in capital spending and corporate donations. These increases almost certainly relate to the Lottery, 1995/96 being the first full year of Lottery funding.

Other tables drawn from the ABSA and Arts & Business's annual surveys provide an indication of minimum levels of sponsorship going into the sector. The data shown however (see Tables 17.3 to 17.6) are subject to fluctuations in the survey population, which may cause disproportionate changes – not least if a particularly large cultural organisation leaves or joins the sample. The data are not grossed up.

Between 1993/94 and 1998/99, the levels of sponsorship recorded fell only once – in 1995/96, the first full year of the distribution of Lottery funding. The £74.6 million recorded for that year was down over £8 million on the previous year (see Table 17.4). At the same time, sponsorship of capital projects also fell (Table 17.3).

Table 17.4 Business sponsorship of the arts and heritage, by English RAB home country, 1993/94–1998/99

£ million

	1993/94	1994/95	1995/96	1996/97	1997/98	1998/99
England						
East	1.002	1.323	0.950	0.972	0.836	1.957
East Midlands	0.668	0.897	0.751	0.835	1.070	1.826
London	28.954	38.844	37.806	45.774	48.812	64.459
North West	3.620	6.414	2.676	3.715	3.272	3.427
Northern	0.849	1.528	1.888	1.537	1.148	1.673
South East	5.380	6.387	3.061	3.052	2.792	3.246
South West	1.753	1.445	1.423	1.538	2.076	2.677
Southern	2.910	4.765	3.596	3.737	5.983	6.042
West Midlands	2.453	2.351	3.347	2.601	8.406	7.023
Yorkshire and Humberside	2.627	3.154	2.223	2.120	3.174	4.996
Wales	2.028	2.273	2.707	2.494	3.127	5.028
Scotland	6.678	6.533	5.688	6.283	11.325	11.874
Northern Ireland	0.910	0.960	0.908	0.781	0.645	1.075
National funding and umbrella bodies	6.244	6.451	4.550	10.674	10.750	15.457
Awards and prizes	3.445	2.494	3.000	3.550	3.910	–
Total	69.522	82.820	74.584	89.681	107.326	130.760
Survey base (a)	1,104	2,049	1,172	1,518	1,298	1,646

Source: ABSA/Arts & Business, *Business Support for the Arts/Business Investment in the Arts*, 1993/94–1998/99.

Note
a) This includes organisations whose data were gathered through Pairing Scheme information.

Table 17.5 Business sponsorship arts by artform and heritage activities, 1993/94–1998/99

£ million

	1993/94	1994/95	1995/96	1996/97	1997/98	1998/99
Arts centres	1.799	3.800	1.187	1.302	1.177	1.634
Arts festivals	6.491	7.396	8.029	8.119	10.418	9.752
Community arts	(a)	0.671	0.451	0.752	1.382	1.651
Dance	2.661	2.252	2.962	3.006	1.752	3.012
Drama/theatre	9.191	8.824	9.295	16.549	19.919	17.177
Film and video	4.732	3.469	4.249	3.847	5.875	5.399
Heritage	0.994	1.429	2.006	2.232	1.946	6.723
Literature	0.538	1.053	0.516	0.424	0.517	0.793
Museums	9.040	17.170	9.204	12.759	18.313	31.790
Music	11.907	11.674	11.051	11.095	10.870	12.336
Opera	10.690	12.568	8.144	9.708	8.055	13.036
Services	0.133	1.363	0.842	0.364	0.472	2.042
Visual arts and crafts	3.133	4.649	7.855	5.165	9.654	9.347
Other (b)	8.213	6.502	8.790	14.360	16.975	16.017
Total	69.522	82.820	74.571	89.681	107.327	130.708
Survey base (c)	1,104	2,049	1,172	1,518	1,298	1,646

Source: ABSA/Arts & Business, *Business Support for the Arts/Business Investment in the Arts*, 1993/94–1998/99.

Notes
a) Included in 'other' for this year.
b) Including local authority arts departments and awards and prizes.
c) This includes organisations whose data were gathered through Pairing Scheme information.

**Table 17.6 Business sponsorship of capital arts and heritage projects by artform,
1993/94–1998/99**

£ million

	1993/94	1994/95	1995/96	1996/97	1997/98	1998/99
Arts centres	–	0.423	0.036	0.144	0.026	0.316
Arts festivals	–	0.002	0.016	0.021	0.912	0.498
Community arts	–	0.113	0.005	0.089	0.050	0.079
Dance	–	0	0.060	1.486	0.065	0.900
Drama/theatre	–	0.413	0.758	7.946	9.100	3.988
Film and video	–	0.068	0.573	0.101	0.033	0.089
Heritage	–	0.035	0.069	0.048	0	0.121
Literature	–	0.326	0.300	0	0	0.300
Museums	–	8.444	1.255	2.643	4.361	17.991
Music	–	0.293	0.506	0.207	0.259	0.401
Opera	–	3.406	0.756	2.890	1.507	7.271
Services	–	0.103	0.103	0.104	0	0.001
Visual arts and crafts	–	0.165	0.442	0.088	0.107	1.161
Other (b)	–	0.075	0	0.043	1.619	0.406
Total	–	13.867	4.880	15.811	18.038	33.522
Survey base (c)	1,104	2,049	1,172	1,518	1,298	1,646

Source: ABSA/Arts & Business, *Business Support for the Arts/Business Investment in the Arts*, 1993/94–1998/99.

Note
a) Included in 'other' for this year.
b) Including local authority arts departments and awards and prizes.
c) This includes organisations whose data were gathered through Pairing Scheme information.

The amount of business sponsorship attracted by several regions increased by over 100 per cent between 1995/96 and 1998/99 – East Midlands, West Midlands, Yorkshire & Humberside and Scotland (see Table 17.4).

In terms of the spread of business sponsorship across a range of cultural and heritage areas (Table 17.5), music has consistently received over £10 million a year throughout the period 1993/94 to 1998/99. Community arts, heritage, museums, services, and visual arts and crafts all increased their sponsorship income by over 100 per cent. Sponsorship of drama and theatre rose substantially between 1995/96 to 1997/98, to nearly £20 million, and sponsorship of museums nearly doubled from 1997/98 to 1998/99 (from £18.3 million to £31.8 million).

All other things being equal (bearing in mind the caveats above), a proportion of this increased sponsorship income was for capital projects, and may represent partnership funding for Lottery projects. In the three years 1996/97 to 1998/99, sponsorship for capital projects more than doubled (Table 17.6). Museums have consistently received the largest share of business sponsorship capital funding, which more than tripled between 1993/94 and 1998/99.

Part III
The Wider Context

Introduction

Sara Selwood, University of Westminster

The main focus of this book is the subsidised cultural sector – that constituency of cultural organisations in the UK which received subsidy in some shape or form during 1998/99. Nevertheless, the concept of a subsidised cultural sector is far from straightforward. Most organisations in receipt of subsidy, to varying degrees, also function commercially in that they generate income through ticket sales, fees, merchandising, retail and so on, in order to stay operational. In that sense, they might more accurately be regarded as 'hybrids'. Moreover, despite the rhetoric of the 'arm's length principle', cultural organisations in receipt of public subsidy are, implicitly and increasingly, subject to a wide range of expectations about their relationship with the wider world. These expectations are probably best characterised by the government's rationale for supporting the sector – developing the intellectual and cultural life of the country, and contributing to its economy, albeit in terms of stimulating the creative industries' generation of revenues and employment or aiding regeneration in particular localities.

This part of the book considers the cultural sector within the wider political and economic context. Chapters 18 to 22 address questions about the role and relationships of the sector. Why is it that governments intervene in the cultural sector? How does the relationship between the subsidised sector and the creative industries function in any practical sense? What do economic impact studies actually reveal? How is it possible to assess whether subsidy does, in fact, create a climate in which more innovative and more diverse cultural practices take place than in the commercial sector? And, how does the government support areas of cultural activity which would not normally be regarded as subsidised – in this case, the art trade? Chapter 23 provides an overview of employment and earnings in the cultural sector, also analysing changes between 1995 and 1999.

18
Why Does Government Fund the Cultural Sector?

Stephen Creigh-Tyte, Department for Culture, Media and Sport, and University of Durham, and Gareth Stiven, Department for Culture, Media and Sport[1]

This chapter considers the rationale for government intervention in markets, and more specifically in the markets for cultural goods and services. The initial section of the chapter is devoted to a discussion of the scope for market failure in cultural markets. The measurement of market failure, and policy responses, are then discussed. The final section considers the published objectives and targets of the Department for Culture, Media and Sport (DCMS) and how these relate to the rationale for intervention based on market failure. While the discussion is primarily focused on cultural issues, it necessarily also touches on wider government intervention, especially in the final section.

The neo-classical model of economic behaviour describes an optimal allocation of resources, which assumes that rational agents (consumers, firms) act with self-interest within a 'perfect' environment. The 'self-interest' of actors is formalised as the maximisation of profits by firms and the maximisation of utility by consumers. The 'perfect' environment assumes perfect competition, where the market price cannot be affected by the actions of any of the numerous individual agents, and that everyone involved shares perfect knowledge, information and foresight. However, once these economic conditions (assumptions) fail to hold, then market forces alone cannot guarantee an optimal efficient outcome – the situation where no one person can be made better off without someone else being made worse off. Market failure in this sense provides the rationale for the government to intervene on efficiency grounds.

The arts and cultural industries are often cited as areas in which the existence of market failure is prevalent, and therefore government intervention is justified. This chapter outlines different types of market failure, their existence within DCMS sectors, and the consequent arguments and justifications for public-sector intervention. Sawers (1993), Peacock (1995; 2000) and O'Hagan (1998) provide overviews of these arguments mainly focused on the arts. However, DCMS sponsors all the main 'cultural' sectors, including museums and heritage sites for example, as well as the performing and visual arts.

1 The views expressed in this chapter are personal, and not those of the DCMS nor the University of Durham.

Market failure and reasons to intervene

Market failure can occur for a variety of reasons: when there is imperfect competition or monopoly, economies of scale, imperfect information (information asymmetry or adverse selection), or where no market equilibrium exists (in the cases of public goods, merit goods, externalities and incomplete markets). These concepts are often interrelated, and certain goods may display one, many, or all of these characteristics to lesser or greater degrees.

Externalities

Externalities ('spillover', or 'indirect' effects) occur when the activities of a firm or an individual have a spillover effect on other firms or individuals, in ways for which no compensation is paid. Imposition of costs upon the local community which are not compensated for by the firm represent a negative externality. Without this externality being addressed, we can anticipate a level of activity by the firm which is greater than the optimum which would occur if all costs were allowed for. However, within the cultural field, it is generally positive externalities that are addressed. These exist where there are incidental benefits accruing to others from a firm or individual's activities, for example, gains to social cohesion due to participation in cultural activities. In these situations, we can anticipate a sub-optimal level of activity, and in extreme cases there may be no provision at all.

This area of market failure is widely discussed in the literature. Most discussions and arguments recommending or vindicating the need for public-sector intervention revolve around some form of externality. For example, it is widely acknowledged that education confers benefits not just to the individual, but also (by making that individual more knowledgeable, better informed and more adaptable) to others as well. DCMS sectors contribute to the education or social improvement of individuals.

Clearly, attendance at the theatre, films, music, opera, and so on, enhance appreciation and understanding of literature and the performing arts. Similarly, museums and historic buildings can develop an appreciation of history. Furthermore, the arts have often been said to act as catalysts in challenging social convention, testing the barriers, and pressing society forward by breaking down stereotypes and bigotry. Likewise, the existence of a world-renowned museum, and the quality of a country's artists and musicians, may be a source of pride and positive feeling for many people within the country. These benefits are all spillover benefits from investment within the DCMS sectors. However, it is important also to recognise that some activities, such as certain broadcasts, films and 'literature', may have negative externalities through their tendency to shock or ultimately 'deprave and corrupt'. In these cases, public intervention in classification or prohibition may be required. Thus, for example, DCMS (jointly) funds and sponsors the Broadcasting Standards Commission, which acts as a forum for public concern on fairness and decency in television and radio.

No market mechanisms exist by which future generations can indicate the present level of 'heritage services' which will protect their provision tomorrow.

The preservation/conservation function of museums, galleries, libraries, etc, represents a legacy we pass to future generations. Users and non-users alike may be willing to pay today to ensure that art and culture are preserved for future generations. Thus, there are spillover benefits for tomorrow's generation from investment within the DCMS sectors by today's taxpayers.

Furthermore, public provision in preserving collections for future generations may help to accelerate the process of accretion by diverting privately owned artefacts into public care. For example, wealthy donors gain the satisfaction of making artefacts available to future generations as well as gratifying their own desire for 'immortality'. Such an immortality motive could lead donors to prefer public-authority-supported museums as recipients of their largesse on the grounds that the chances of survival of such museums are greater and they are more likely to accept conditions (such as the requirement that gifts are never sold or lent). Unless some publicly funded collections are able to accept such gifts, there may be under-provision of the resulting heritage services to the public.

Land and buildings provide instances of both positive and negative externalities. Architecture is not an artform which can be made entirely available for only private consumption. Someone passing a building cannot avoid being aware of its merits, or even its historical associations. Thus, the building affects the welfare (intentionally or otherwise) of people other than its owner, and planning regulations exist to control negative externalities.

Innovation is logically seen as a major source of progress. Experimentation, however, is costly and subject to failure. These costs and failures are generally compensated for by the ability (or prospective ability) to patent or copyright successes. This ability, however, is limited within the DCMS sectors, as it is often impossible to protect an innovative style or form. To this extent, a successful innovation within these sectors will have spillover benefits for future users of this style, but the originator may have difficulties in benefiting from the intellectual property created.

Moreover, it has been argued that human propensity for excitement may be satisfied by providing artistic outlets. Thus, government-sector intervention can perhaps be justified in areas such as promoting cultural participation by the young in order to encourage young people away from activities which have large negative externalities, or which are bad for society, such as crime (Scitovsky, 1983).

Public goods

As Samuelson (1954) pointed out, pure 'public goods' have two key distinguishing features: no one person has exclusive rights to the consumption of public goods (non-exclusivity), and the consumption of the good by one person does not affect the consumption of another (non-rivalry). Under these circumstances, it is difficult to direct a good exclusively to the person who is paying for it, or, as it is sometimes put, to avoid the 'free-rider' problem. Such 'free-riders' deprive any private provider of the appropriate level of rewards for supplying the good. In these circumstances, economic theory suggests that market provision will be less

than socially optimal, and other means of provision need to be explored. The classic example of a public good is national defence. This is non-rival, since consumption by one person will not affect the level or quality of consumption by another, and it is non-exclusive, since it is impossible to exclude specific persons from the benefits of the good, even if they refuse to pay for it (and free-ride).

While it is difficult to find examples of goods which exhibit the characteristics of pure 'public goods', 'quasi-', 'impure' or 'mixed' public goods abound. Public beaches and parks are examples of this; they are usually non-exclusive in practice, yet they are rival to the extent that (ultimately) congestion lessens their quality.

DCMS sectors sometimes display some or all of the characteristics of public goods. The public-good aspects most often associated with these sectors are actually generated by the externalities discussed above. For example, while a performance at a theatre may be of a private-good nature (it is exclusive, since tickets can be charged for at the door, and it is rival since there are a limited number of seats), the externalities discussed above (education, prestige, legacy, etc), which are generated indirectly by the performance, are generally of a public-good nature. (IRP, 1999: 202–207) provides an account of market failure and the role of broadcasting as a 'public good'.)

Merit goods

It is often argued that the arts constitute a merit good. This is a good the consumption of which is deemed intrinsically desirable. As Musgrave (1958: 57-58) pointed out, consumer sovereignty does not hold, and if consumers are unwilling to purchase adequate quantities they should be compelled or encouraged to do so. However, merit goods are mired in controversy. The economic arguments tend to overlap with some of the points made above, especially regarding imperfect information, and externalities. Other arguments are not really economic arguments at all, but simply a means of dressing policy-makers' paternalistic value judgements in economic terms.

One common argument is the inability of consumers to know what is 'best' for them. (Musgrave, 1958: 180) discusses this in the context of outdoor recreation.) It is assumed that children, for example, do not possess the capacity to make the best decisions for themselves, and so these decisions are made on their behalf by others (for example, in making education compulsory). Similarly, it is felt that people suffer from myopia, and that future consumption tends to be undervalued relative to present consumption. This is the justification behind compulsory superannuation schemes. The corollary is the concept of the merit bad (for example, alcohol, addictive drugs and various works of 'literature'), the consumption of which, it is felt, should be discouraged. These are really arguments concerning imperfect information. If consumers were made more aware of how good (or bad) something was for them, they would be more (less) inclined to consume it.

Similarly, if we believe that opera attendance is intrinsically desirable, then we should justify it with arguments surrounding the positive externalities generated by attendance, rather than by using (non-economic) value judgements.

Probably the strongest economic argument for merit goods arises in the context of paternalistic redistribution. Hochman and Rogers (1986) discussed the case where donor D derives utility from giving to recipient R. However, D derives far greater utility from a grant in kind (for example, food), than a grant in cash (which D knows that R will use for, say, alcohol). While R cannot be damaged (they can refuse the grant), their utility gain is less than it would be for a cash grant. Thus, charity involves an imposition of D's preferences regarding what D considers to be of good to R.

This argument suggests a role for government intervention in the DCMS sectors. If there exists a number of potential donors, or a significant portion of society (and hence taxpayers), which receives utility from others enjoying the arts, then the government may have a role in providing the means for making such a redistribution. This has been suggested by Fullerton (1991), who argues that a donor's utility depends on the improved access to the arts that recipients receive.

Fullerton further suggests that non-rivalry applies, since any donor's provision will benefit other like-minded potential donors at no additional cost. Likewise non-excludability applies, since a donor cannot exclude the other potential donors from the benefit. This allows classic 'free-riding' on other people's donations, and damages each individual's incentive to donate. However, government intervention can raise donors' utility by banding together potential donors and paying (via taxes) to support subsidised arts provision.

An overview of the possible elements within the overall total benefit or value which can be derived in the cultural sector is set out in Figure 18.1. Clearly not all cultural activities or assets will deliver all of these benefits, but they all need to be considered when assessing the potential total benefit or value accruing to a particular cultural activity or asset.

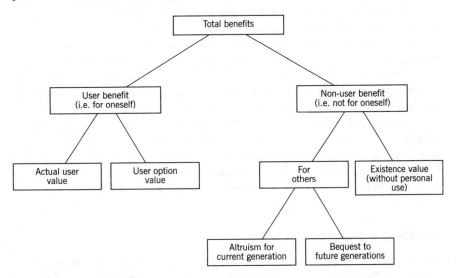

Source: adapted from Ozdemiroglu and Mourato (2001).

Figure 18.1 Elements comprising the total benefit from culture

Imperfect information

To operate efficiently, all agents in the market require full information regarding the goods being traded, although full information may be more efficient than obtaining perfect information where information is costly to obtain. To the extent that the consumer is ignorant of the choices, or quality of choices, available to them, there is a source of market failure.

A compelling argument made about the arts, for example, is that they are an acquired taste. The more familiar consumers are with them and the more knowledgeable they become about them, the greater the enjoyment and demand. In this sense, the lack of education in and information about the arts (in terms of experience) leads to an under-provision. While this can be overcome to a certain extent by advertising, Netzer (1978) argued that this solution is not available to arts enterprises as the markets for most artforms are segmented, specialised and too modest in size to make mass advertising campaigns possible, and concluded that government intervention is justifiable as a way of overcoming the lack of consumer information in these industries by giving consumers firsthand experience of them.

Adverse selection

'Adverse selection' occurs when there is an information asymmetry between participants in a transaction (for example, sellers know more about the 'quality' of a good than buyers). The classic illustrative example (Akerlof, 1970) concerns the market for used cars. In this case, distrust of a seller's protestations about the reliability and performance of a car, in a situation where the purchaser is not in a position to establish the truth, has an important effect upon the market. Potential buyers assume that all used cars have something wrong with them (are 'lemons'), and the price of all used cars (good and bad) reflects this fact.

In the cultural realm, McCain (1980) has suggested that similar effects may exist among some buyers of non-figurative art, so there is a situation of asymmetric information and adverse selection can be the consequence. Unless the individual or enterprise can be assured that the information provided is objective and unbiased, there will again be less than optimal provision – although, of course, there is the issue of who are the arbiters of the 'quality' of art, and the reliability of the judgements of the 'experts' concerned. This failure may require some form of intervention to redress the information asymmetry, in the form of either government provision of information and regulation or self-regulation by a trade body that imposes strict conditions of probity on its members.

Declining average-cost sectors

In some cases, average production costs fall as output increases. If this is the case, then the marginal cost of production (the cost of producing an additional unit of output) must always lie below the average cost. To break even, the price charged must at least cover average costs. This implies an inefficiency. Thus, for

example, the marginal cost of an extra visitor must be less than the average, so the industry is limiting supply at below efficient levels in order to break even. If price was set at marginal cost, then suppliers would lose money and be forced to close. Museums and libraries are often cited as examples of such declining-cost industries, with visitors imposing little or no marginal cost (at least up to some limit of physical capacity).

'Transferable skills' training

In a production sector composed of numerous small enterprises with high labour-turnover rates, provision of any training by single employers (except that of immediate direct use to only the individual employer concerned) is likely to be very limited. Under competition, individuals will bear the cost of 'transferable' or 'general' training of use across the industry's various small firms, but labour-market rigidities, information failures, and so on, may prevent this, leading to the need for some collective training provision, possibly involving public-sector support.

Merit goods and social equity

Government intervention may be justified on equity grounds, for example, for social or geographical access, as well as on the grounds of economic efficiency as discussed above.

If society holds the view that certain DCMS sectors constitute 'merit goods' – with people under-consuming these goods or services at prevailing prices – then public intervention or subsidy may be justified. As discussed above, in such a view consumer sovereignty does not hold, and consumers are essentially delegating some of their decision-making to government. For example, people on low incomes facing significant admission prices could have limited access on economic grounds. If society takes an egalitarian view that all people should have improved 'economic access', then government assistance may be justifiable. There may also be certain sections of society facing barriers to participation due to discrimination. There are arguments for government assistance to redress the balance through 'positive discrimination', sponsorship, or other means designed to promote the sectors or groups affected. Likewise, there may be justification for government support if society believes that certain areas of the country are unfairly represented in terms of access or opportunities.

Baumol's cost disease

In their 'classic' work, Baumol and Bowen (1965; 1966) argued that the costs of the live performing arts tend to increase relative to those of goods and services generally – a 'cost disease'. This was likely to occur because the live arts are labour intensive, and, while there is little scope for increasing (labour) productivity, earnings tend to increase in line with those elsewhere in the economy. So,

the relative cost of the performing arts would tend to rise and (other things being equal), this would imply that demand for the live performing arts would tend to decline. If considerations of social equity and merit goods demand affordable access to the arts, then ever-increasing levels of subsidy would be required.

Baumol and Bowen's conclusions have been criticised on the grounds that arts (labour) productivity has risen with increased scale of production and improved production efficiency, and that the arts-sector labour market may not have to match wage increases elsewhere in the economy to attract or retain labour. There is little empirical evidence of differential inflation rates in the performing arts compared to other sectors of the economy. And, in any case, rising real incomes among arts-sector consumers, coupled with high responsiveness of demand for leisure activities to rising incomes, may go some way to offset the supposed demand effects of rising labour costs and ticket prices. Towse (1997) reviews the issues here.

Measuring market failure

The extent of market failure, and therefore the cost of compensating for it, can be measured using a variety of methods. Most of these approaches seek to circumvent the problems of externalities and public goods by trying to ascertain the willingness of people to pay for the external benefits produced by the activity. For example, if the restoration of a local historic building was being considered, local support could be canvassed to get an idea of the value the community would place on this restoration. If this value was in excess of the cost of the restoration, this could provide grounds for the project to proceed.

Quite apart from their unmeasured and unpriced elements, the valuation of goods consumed collectively is even more problematic where they are unique, so that where they are over-used a trend may be set leading to their degradation or even destruction. Uniqueness and non-reproducibility often impart non-use or passive value in addition to any user benefits. In static terms, the total economic value of environmental or collective consumption goods is sometimes categorised as 'option' value. This reflects willingness to pay for preservation in order to retain the possibility of use in the future – for either the present generation or as a bequest value for future generations. It can also involve intrinsic or existence value, reflecting preference for the continued existence of heritage resources, for example landmarks like the Tower of London, even for those who never expect to visit and use them. Figure 18.1 above provides an overview of benefits comprising total potential benefit.

Valuation methods

Three approaches to measuring benefits – contingent valuation, hedonic pricing and travel-cost methodology – are discussed below.

Contingent valuation

The most direct approach to valuation is found in the contingent-valuation method, in which consumers are questioned on their willingness to pay (for example, for an environmental improvement), or their willingness to accept compensation (for a decline in environmental quality). Over the last decade or so this approach has developed rapidly and has been applied in urban conservation contexts.

One well-known study (Willis et al., 1993) applied contingency valuation to Durham Cathedral in the North of England (a World Heritage site). This produced willingness-to-pay estimates of £0.80 per person per visit by actual visitors, giving a valuation of £388,000 per year. Studies of the natural environment have found that non-user values account for between 35 and 75 per cent of total value. Given the view of Durham Cathedral (and Castle) afforded from the London-to-Edinburgh rail line, it seems not too fanciful to adopt an upper non-user estimate, giving a total static benefit figure of £1,522,000 per annum, against £388,000 from actual visitors alone. (Allison et al., 1996 prefer a more conservative estimate of 40 per cent). At a real discount rate of 6 per cent, the present value of Durham Cathedral is therefore £19.8 million over a 25-year period, or more than £25 million over 100 years and more. (Allison et al., 1996 provide other examples.)

Hedonic pricing

While a literature has developed on placing monetary valuations on 'non-traded' goods in the natural environment, work on DCMS sectors such as the economics of preserving historic buildings is much less common. The hedonic-pricing method aims to determine the relationship between the attributes of a good and its price, for example by comparing the value of two identical buildings, one of which is in a conservation area.

Travel-cost methodology

Using a similar indirect approach, the travel-cost methodology rests on the argument that the amount of money that visitors are prepared to spend travelling to a particular site reveals the value they put upon that site. While used in the valuation of recreational sites (especially in rural areas), this clearly has limited application in the urban context, where many people live near or inside the 'site'.

Policy responses

In all cases provision ought to be made up to the point at which the marginal social cost of the activity equates to the marginal social benefit. As noted above, in the case of a purely private good not subject to any 'market failure' effects, market forces will ensure that production and consumption will expand until the point where the additional private costs involved in producing an additional unit of output equal the additional private benefit of consuming it. At this point

marginal social costs and social benefits are also equal, and the unrestricted operation of free competitive market forces produces the optimal social outcome.

Policy approaches to externalities or spill-over effects clearly depend upon the nature of these effects (associated with the production, consumption or simply existence of goods). When attempting to promote greater production or use, subsidies or tax reliefs may be provided. Taxes or regulation may be used to curb activity.

The classic policy response to the 'public-good' market failure is public provision to which everyone contributes through taxes. Thus, national defence will be provided by government using general taxation. Mixed public goods, education services for example, are generally partially funded through taxation. Local taxes (say, council tax) can be used to fund local public goods, such as local parks.

The problem of adverse selection is normally addressed through industry self-regulation or government regulation. This is visible in the tourist sector where the government intervenes to try and ensure that credible quality standards are set within the industry. Hotels can prove their quality to prospective customers by obtaining an objective ranking.

It is generally agreed that there are information failures where the consumer is not in a position to make an informed judgement about the quality of the product or service before purchase. For domestic consumers this may present a role for government to intervene to establish credible quality standards. As the benefits of obtaining a good-quality mark accrue principally to the operator, fees are generally charged for the award of quality merits. So, this rationale for intervention does not necessarily mean that it has to be funded from public monies. However, in many countries hotels are legally required to register and obtain certification, whereas in Britain this is done on a voluntary basis.

So far as foreign consumers are concerned, governments may not be overly concerned with maximising consumer welfare. The market failure here is primarily the 'free-rider' problem in that no individual operator has a significant incentive to undertake promotion of the generic product. As a result, investment in promotion expenditure which would improve the overall profitability of the industry may not occur due to free riders. Here the government may have a potential co-ordinating role by helping to promote the generic product whilst extracting contributions from the major players in the market (for example, airlines) and by encouraging joint action by groups of smaller operators.

Levels of public funding

The theoretical arguments in support of public intervention in cultural markets are applied in many developed countries. As noted above, such intervention does not always take the form of public expenditure. Often, regulation, direct ownership/management and tax concessions to the private sector are used alongside public spending.[2] However, public-spending data are relatively transparent and comparable (although this is not to imply that such comparisons are easily made) both over time and between countries. Thus, for example, Table 18.1 summarises real arts funding from central government grant-in-aid to the Arts Council of

Great Britain and the Arts Council of England. This shows that spending doubled between the second half of the 1970s and the 1990s, although spending was broadly flat throughout the 1990s themselves. However, a further rise of over a quarter is projected in 2000/01 and 2003/04 (HM Treasury, 2000).

While real public spending on the arts has clearly grown over time, international comparisons of the UK's direct public spending on the (wider) arts and museums sector in the mid-1990s indicate relatively low levels of spending, at least prior to the National Lottery capital grants programmes of the late 1990s (Creigh-Tyte and Gallimore, 2000). As Table 18.2 shows, the UK's spending as a percentage of GDP and per head was lower than in any of the European nations considered, except for the Irish Republic. UK spending broadly matched that found in Australia as a share of GDP and per head. Only in the US was direct public spending on the arts and museum sector lower than in the UK. However, the US is, of course, a very special case where public-sector cultural funding comes predominantly from indirect sources – notably forgone tax revenues on donations to cultural charities.

Table 18.1 Central government grant-in-aid to the arts in England, 1974/75-2003/04

£ million

Five-year period	Real grant-in-aid (annual average) (a)
1974/75 to 1978/79	99.4
1979/80 to 1983/84	130.9
1984/85 to 1988/89	176.7
1989/90 to 1993/94	206.0
1994/95 to 1998/99	204.5
2000/01 to 2003/4 (b)	256.6

Source: adapted from ACGB and ACE annual reports.

Notes
a) GDP-deflator adjusted.
b) Projections to 2003/04 based on HM Treasury (2000).

The declared objectives of cultural policy

British cultural policy has, at least since the establishment of the Arts Council in the immediate postwar period, operated according to the so-called 'arm's length' principle. Under this system, certain executive, administrative, regulatory or commercial decisions are taken by non-departmental public bodies or executive agencies – collectively known as sponsored bodies – within broad guidelines and spending limits set by DCMS/DNH and its predecessors (Creigh-Tyte, 1998).

2 For an account of the various intervention methods used in the built-heritage sector – possibly the most complex range of instruments within the cultural sector to be found in the UK – see Creigh-Tyte (1997). Valuation issues in the built heritage are discussed in Creigh-Tyte and Thomas (2000) and Creigh-Tyte (2000). It must always be remembered that government intervention may itself be subject to failure, and that market failure is only a justification for intervention if market failure exceeds government failure (in the relevant policy context). There are of course other arguments used to explain government support for the arts in terms of the rent-seeking behaviour of arts and culture lobbies and government acquiescence to their demands. See, for example, Grampp (1989).

The UK Cultural Sector

Table 18.2 Direct public expenditure on the arts and museums, various countries

	Australia 1993/94	Canada 1994/95	Finland 1994	France 1993	Germany 1993	Irish Republic 1995	Nether-lands 1994	Sweden 1993/94	UK 1995/96 (a)	USA 1995
Total estimated arts spending (£ million)	289	818	300	2,181	4,586	21	466	327	967 (1,106)	970
Arts spend as percentage of final government consumption expenditure	0.82	0.93	2.1	1.31	1.79	0.43	1.47	1.02	0.65 (0.74)	0.13
Arts spend as percentage of GDP	0.14	0.21	0.47	0.26	0.36	0.07	0.21	0.29	0.14 (0.16)	0.02
Total arts spending per head (£)	16.4	29.9	59.2	37.8	56.5	5.6	30.3	37.5	16.6 (18.9)	3.8

Source: adapted from Feist et al. (1998). The original table includes numerous endnotes and caveats.

Note
a) Includes all capital spending.

However, the late 1990s saw the development of more explicit agreements on objectives and targets linked to increased levels of public spending.

The Comprehensive Spending Review announced in July 1998 set out public spending plans for 1999 to 2002 (HM Treasury, 1998a), and subsequent announcements published in December 1998 and March 1999 set out published objectives and targets across the whole range of the new Labour government's activities (HM Treasury, 1998b; 1999).

Public Service Agreements (PSAs) show how each department's spending will deliver government objectives (alongside increased efficiency and effectiveness). In turn, output and performance analyses show indicators which can be used to measure and monitor success against departmental objectives and PSA targets (HM Treasury, 1999). The Whitehall-wide adoption of resource accounting and budgeting, with its emphasis on the measuring of resources used against specified objectives, has further underlined the increasing emphasis on identified outcomes achieved for resources invested.

The overall aim of the DCMS is 'To improve the quality of life for all through cultural and sporting activities and to strengthen the creative industries.' The department will:

- work to bring quality and excellence in the fields of culture, media and sport;
- make these available to the many, not just the few;
- raise standards of cultural education and training; and
- help to develop the jobs of the future in the creative industries.'

Department for Culture, Media and Sport: objectives and targets

DCMS, in partnership with others, to work:
To increase national productivity.

OBJECTIVE 1

Create an efficient and competitive market by removing obstacles to growth and unnecessary regulation so as to promote Britain's success in the fields of Culture, Media and Sport and Tourism at home and abroad.

PSA Target 1

Facilitate and promote our competitiveness, both at home and abroad, in the creative industries.

PSA Target 2

Promotion of quality tourism development which is economically, environmentally and socially sustainable and supports the Government's employment objectives. These plans were detailed in the new Tourism Strategy published early in 1999.

PSA Target 3

Develop proposals for a future regulatory system for broadcasting which recognises market and technological developments.

PSA Target 4

Facilitate and generally promote the competitiveness of UK broadcast-related industries and in particular the early take-up of digital broadcast services.

PSA Target 5

Ensure public service broadcasters sustain quality and range of output. In particular, review the BBC licence fee and public review conclusions for consultation by July 1999.

PSA Target 6

Work with the British film industry to implement a new joint-funded strategy for the development of the industry by April 2000, as envisaged by the Film Policy Review.

OBJECTIVES 2 and 3

2 Broaden access for this and future generations to a rich and varied cultural and sporting life and to our distinctive built environment – and to harness the educational potential of DCMS funded institutions.
3 Develop the educational potential of all the nation's cultural and sporting resources; raise standards of cultural education and training; ensure an adequate skills supply for the creative industries and tourism; and encourage the take-up of educational opportunities.

PSA Target 7

Visitor numbers in major national museums to increase substantially, in line with the removal of entry charges for children in 1999–2000, for pensioners in 2000–01 and for others in 2001, if Trustees decide to remove entry charges while maintaining the quality of exhibitions.

PSA Target 8

Access to the performing arts will increase by attracting new audiences over the next two years. New companies, new work and new venues will be funded and the New Audiences Fund will continue to widen access to the arts.

PSA Target 9

Raise standards of care of collections and public access by establishing a £15 million Challenge Fund by 1999 to fund new investment in the 43 Designated Museums.

PSA Target 10

Extend social inclusiveness by increasing the involvement of identified groups in each of the sectors the Department has responsibility for.

PSA Target 11

Maintain standards and diversity of broadcasting output and ensure that content is socially inclusive, to secure wide access to broadcast material.

PSA Target 12

200,000 new educational sessions undertaken by arts organisations.

PSA Target 13

Make the most of the potential of libraries by doubling the number of Internet connections by 2000 and ensuring that at least 75 per cent of public libraries have Internet connections by 2002.

OBJECTIVES 4, 5 and 6

4 Ensure that everyone has the opportunity to achieve excellence in the areas of culture, media and sport and to develop talent, innovation and good design.
5 Maintain public support for the National Lottery and ensure that the money used for good causes supports DCMS and other national priorities.
6 Promote the role of the Department's sectors in urban and rural regeneration, in pursuing sustainability and combating social exclusion.

To agree new standards of effectiveness with DCMS funded bodies (all Objectives)

PSA Target 14

Funding of NDPBs to be conditional on quantified improvements in outputs, efficiency, access, quality promotion, income generation or private sector funding, monitored by a new independent watchdog. Targets to be announced on funding agreements March 1999.

PSA Target 15

Improve efficiency by completing the review of national museums and galleries by end July 1999 (subject to confirmation when consultants are appointed).

To streamline policy delivery mechanisms (all Objectives)

PSA Target 16

Subject to the outcome of a consultation exercise, establish new funding councils for the Performing and Visual Arts and for Film, and create a new national strategic body for museums, libraries and archives in place of existing structures and exchange existing frameworks of support for heritage, sport and tourism to achieve a long term saving of £23 million.

PSA Target 17

Establish the new Film Council by April 2000 with clear objectives to help develop film culture and a sustainable domestic film industry.

PSA Target 18

In streamlining support for the built heritage sector transfer the Department's responsibilities for operating the Heritage Grant Fund (HGF) to English Heritage by 1 April 2000 and for underwater archaeology to the same body by the same date subject to legislation.

PSA Target 19

Establish a new National Lottery Commission and transfer functions from the Director General of the Office for National Lottery to the Commission (effective from 1 April 1999).

PSA Target 20

As required by the 1998 Act distributing bodies to develop by 1 April 1999 new strategic plan for Lottery funding designed to achieve a proper balance between capital and revenue schemes and between different regions of the country.

PSA Target 21

Devolution of decision making to the regions and strengthened regional bodies where possible (for example, decisions on Lottery grants up to a certain level).

Source: DCMS (2000a).

Note: In addition to the 21 PSA programme and policy targets set out above, DCMS has objectives for increasing the productivity of its own operations, for example, the attainment of Investor in People status (DCMS, 2000b: 22–26).

The approach may be summarised as: quality, access, education and the creative economy.

DCMS's six major objectives and the related 21 PSA policy and programme targets of the 1998 Comprehensive Spending Review are summarised in the box above. By April 2000, DCMS was able to demonstrate that seven PSA targets had already been met and that the Department was on course towards 13 other targets (DCMS, 2000a: 11). The remaining target was subject to legislation for which time had yet to be found. Thus, for example, the Davies Review on BBC funding was published in August 1999 and a new funding settlement was announced in February 2000 (PSA Target 5), and the final report of the review of the efficiency of national museums was also published (PSA Target 15) (DCMS, 1999a).

DCMS's published framework clearly reflects at least some of the economic rationale for cultural-sector intervention discussed above. Objective 1 (PSA

Targets 1–6) is essentially focused on 'market failure' and explicitly on measures aimed at improving productivity in the cultural sector, the creative industries and the closely related domestic and in-bound tourism sectors.

Objectives 2 and 3 (PSA Targets 7 to 13) are both access-related objectives. The former is explicitly addressed to broadening access for both current and future generations, while the latter focuses on education, training and skills supply. At one level, access is a question of equity, although future generations necessarily suffer from 'market failure'. As noted above, education has a range of associated external benefits as well as 'merit-good' charactistics.[3]

Objective 4, the quality objective, has a clear access/opportunity focus. Objective 5 underlines the National Lottery's role as the dominant funding mechanism for DCMS sectors and other 'good causes'. Objective 6 emphasises the Department's role in regeneration,[4] sustainability and combating social exclusion (DCMS, 1999b), so that this final objective embraces both market failure and access/equity policy issues. PSA targets 14-21 focus on improving the effectiveness of DCMS-sponsored bodies and policy mechanisms in support of all six Objectives.

Clearly, the DCMS's various published objectives (and their related targets) fall within the arguments for government intervention, in terms of both equity and efficiency (or market failure), which have been advanced by economists in the cultural, regional and urban-regeneration fields. The policy statements are often couched in non-economic terms, but publication of resource accounts for DCMS (and other government departments) will aid researchers and policy analysts in assessing the allocation of public resources to policy objectives. (See DCMS, 2001: 16 for an overview of resource allocation in 1999–2000.)

3 The interfaces between creativity, culture and education and a potential National Strategy are discussed by the National Advisory Committee of Creativity and Cultural Education (NACCCE, 1999). The access and participation dimensions are emphasised in DCMS (2000a).

4 HM Treasury (1995), commonly called the EGRUP report (from Inter-departmental Evaluation Group on Regional and Urban Programmes), sets out the rationale for government regeneration policy in terms of market failures because of institutional constraints or the failure of external effects to be reflected in (property) market prices (see HM Treasury, 1995: 4). For a discussion of how to improve National Lottery funding in the coalfield areas see Gore et al, 2000.

19

The Relationship Between the Subsidised and the Wider Cultural Sector

Andy Feist, City University, London

A critical debate within contemporary cultural policy centres on the nature of the relationship between the subsidised arts sector and what might be referred to as the commercial cultural sector. Discussions tend to congregate around a number of common themes. While the exact nature of the relationships explored vary, there are essentially two points of view: one perceives the relationship to be a benign one for the subsidised sector, maintaining that the subsidised arts are in some way the beneficiary of the relationship; the other is essentially pessimistic and casts the commercial sector as a threat to the subsidised sector. Those with a benign perspective (the optimists) tend to highlight the potential spill-over benefits from the publicly funded sector to the private sector, and the potential role that the commercial cultural sector might have in democratisation of culture. The pessimists, on the other hand, highlight the potential competition that the subsidised sector faces for both resources and audiences, and the increasingly adverse 'trading' situation in which the sector finds itself.

This chapter explores that controversy. It is divided into three sections. After defining some of the boundaries around the subsidised and commercial sectors, it summarises the main arguments around the nature of the relationship between the subsidised and commercial sectors. Thirdly, it examines how the distinctions between sectors have become blurred over time, and it ponders the benefits and problems that these ambiguities have given rise to. For reasons of simplicity, this chapter focuses mostly on the performing arts.

Three cultural sectors

The subsidised sector

The subsidised cultural sector can, for the sake of argument, be defined as consisting of independent organisations that routinely derive a significant part of their revenues directly from the public purse. Defining the sector rather more narrowly than does the present volume in general (see Appendix 2), it could be

Table 19.1 Income profiles for the arts councils' regularly funded clients (a)

£ million

	ACE/RAB (b) (1999/2000)	SAC (1997/98)	ACW (c) (1997/98)	Total (%)
Arts council /RAB	183.03	18.02	10.36	211.41 (37)
Local authority and other public bodies	44.64	6.01	10.62	61.27 (11)
Earned income	221.83	14.59	16.24	252.66 (44)
Contributed income	38.07	4.29	2.48	44.84 (8)
Total	487.57	42.91	39.70	570.18 (100)

Sources: ACE, 2000a; ACW, 2000.

Notes

a) Much of this expenditure is on the performing arts. Data relate to Great Britain only.

b) Excludes Lottery capital funding. The category of contributed income does include non-capital Lottery funding.

c) Excludes Lottery funding.

argued that in Great Britain the sector is only: the 500 or so organisations in England which are regularly funded by the Arts Council and the regional arts boards; the 100 clients which are regularly supported by the Scottish Arts Council; and the broadly similar number supported by the Arts Council of Wales (ACE, 2000d; ACW, 2000). The vast majority of organisations funded by the national arts councils also receive monies from local government or other national sources, although the five national companies in England represent something of a unique sub-group of major arts organisations that receive little in the way of regular local-authority funding.[1]

On the basis of this rather narrow view of the subsidised arts sector, it is possible to use the performance-indicator data collected by the arts councils to give an overall impression of the size of the sector in Great Britain (Table 19.1). This reveals that, in revenue terms, the arts councils' main funded clients in England, Wales and Scotland have a turnover in the region of £570 million, of which 37 per cent is in the form of revenue support from the arts councils themselves. It is important to note that this is very much a minimum figure. The main omissions are arts council project-funded organisations and those organisations solely in receipt of local authority funding.

One important feature of the arts councils' revenue support is its unevenness. The support for organisations is skewed towards the performing arts – dance, drama, music – and the mixed category of combined arts (see Part IV below). For instance, in 1997/98, film, literature and visual arts organisations combined accounted for only 8.9 per cent of the total value of the turnover of all regularly funded arts organisations supported by the Arts Council of England and the regional arts boards. Similarly, in 1998/99, crafts, visual arts and literature accounted for only 13.7 per cent of all revenue support by the Scottish Arts Council. So, while the analysis in this chapter focuses on the performing arts as supported by the arts funding system, it does not necessarily reflect the totality of

1 This is partly a result of the abolition of the Greater London Council and former metropolitan counties in April 1986, which resulted in the transfer of funding responsibilities to the then Arts Council of Great Britain.

public support for any of the arts (for instance, it excludes the support by the national galleries for the contemporary visual arts).

The 'related' commercial sector

The commercial cultural sector can be sub-divided into two: one sector comprises a range of organisations and activities which share certain similarities with the 'subsidised sector' but which operate primarily on commercial grounds (the 'related' commercial sector) – for instance, the commercial West End theatre and commercial art galleries.[2] The second sector consists of the cultural industries.

Accurate accounts of the size of the 'related' commercial sector are difficult to generate. However, it is possible to come up with some plausible estimates of the value of the non-subsidised live-performance sector. Selectively updating data collected within *Artstat* (ACE, 2000b) for consumer spending on the performing arts from a variety of sources indicates a total figure in the region of £845 million. This includes admission costs to grant-aided performances, commercial theatre and music performances and voluntary-sector activity (see below).[3] Data on earned income for the subsidised sector is from Table 19.1 (£253 million). Subtracting the latter from the former provides a broad indication of the value of the 'non-subsidised' sector (£592 million).[4]

It is important to be aware of some caveats regarding the earned-income figure for the subsidised sector. First, it is based on trading rather than box-office income (and, as such, includes income from ancillary activities). Secondly, it includes some income relating to the non-performing-arts sector. It is also the case that the rather narrow definition of the subsidised sector adopted here includes only revenue clients. Finally, not all funded organisations respond to all the arts councils' requests for performance-indicator data.[5] Nevertheless, it seems reasonable to treat this as a plausible 'ball park' figure for box-office income for the subsidised sector. This means that for the performing arts, at least, it is possible to make out the general nature of the financial relationship between subsidised activity and that commercial activity which is organised on broadly similar lines.

The cultural/creative industries

Outwith the 'related commercial' sector is a vast swathe of activities dominated by the commercially driven cultural industries – music recording, film, publish-

2 For the sake of simplicity, the data cited in this section include figures on what is known about the voluntary and amateur sectors.

3 Confidence in the broad accuracy of this figure is assisted by data from the Family Expenditure Survey which suggest that household spending on admissions to theatres, concerts, circuses and amateur shows, etc. is broadly in line with estimates generated from box office surveys, etc (see ACE, 2000b: 98).

4 This figure includes consumer spending on voluntary-sector activity which is neither commercially driven nor frequently in receipt of subsidy.

5 For 1997/98 data, for example, the response rate for English funded organisations was 77 per cent, although this covered 83 per cent of the total value of ACE/RAB grants.

ing and some radio and television broadcasting. Unfortunately, there are few established definitions of exactly what constitutes the 'cultural industries' (see Chapter 34). Definitions have generally focused on mass consumption and mass production as key features of a cultural industry. In the 1980s, for instance, the UNESCO document *Cultural Industries – A challenge for the future of culture* reflected:

> *Though the term 'culture industry' (in the singular) was coined ... by Adorno and Horkheimer in ... the* Dialectic of Enlightenment, *there is still some doubt as to the type of activities it is supposed to cover (for example, photography, computer science in general, or the manufacture of all the equipment and installations used in the production and dissemination of messages: film and television cameras, radio and television receivers, photographic apparatus, record players of all kind, video tape recorders, and so on – even tourism and advertising)...*
>
> *Generally speaking, a cultural industry is held to exist when cultural goods and services are produced, reproduced, stored or distributed on industrial and commercial lines, that is to say on a large scale and in accordance with a strategy based on economic considerations rather than any concern for cultural development.*
>
> <div align="right">(Girard, 1981)</div>

Elements of this definition are helpful although one might question both the suggestion that cultural industries work only on 'commercial lines' and have little concern for 'cultural development'. While 'commercial' might describe much of the cultural industries' activities, this is clearly an over-simplification. The most glaring example of a non-commercial cultural industry is the BBC.[6] Although the BBC generates some of its income via commercial enterprise, the majority of its funding is from the licence fee. Although not funded by direct taxation, the £2.5 billion it receives via the licence fee represents de facto public expenditure, of which a not insignificant slice ends up supporting the arts, indirectly and directly. Peacock (2000) conservatively estimated that 15 per cent of this (some £375 million) might be thought of as supporting artistic performance.

Elsewhere, public-sector support for the commercial cultural industries manifests itself in a number of ways. There has, for instance, been a long history of mechanisms to support the film industry (Dickinson and Street,1985). In terms of indirect support, the abatement of VAT on the retail price of books can be seen as a substantial indirect form of support to the publishing sector (London Economics, 1997; see also Chapters 15 and 22). At a more general level, support for post-school education and training across a wide range of cultural and ancillary activities represents a substantial public-sector investment in the cultural

6 For the purposes of this chapter, we are taking the BBC as a wholly owned public corporation to be outwith both categories. There is an entirely separate debate about the relationship between a publicly funded broadcaster and the subsidised sector more generally. During the 1990s, this debate was highlighted in the BBC/ACE review of orchestral provision (BBC/ACE, 1994) and the consultation on the future of the BBC and the Arts Council's response to that exercise (ACGB, 1994).

sector as a whole, and some studies have identified this as an integral part of public support (for instance, see estimates for public spending on professional music training cited in National Music Council, 1996; Dane et al., 1999).

The difficulty of defining precisely the 'commercial' cultural industries makes any assessment of their total value problematic. One source of data is *The Creative Industries Mapping Document* (although the definition of a 'creative industry' is somewhat broader than that used to define a 'cultural industry'). The definition used in the *Mapping Document* was:

> *Those activities which have their origin in individual creativity, skill, and talent which have a potential for wealth and job creation through the genera-tion and exploitation of intellectual property.*

(DCMS, 1998)

The *Mapping Document* was one of the first outputs of the Creative Industries Task Force, established by the new DCMS in June 1997.[7] This document, essen-tially a collation of a wide range of secondary data, covers, inter alia, details on revenues, market size, balance of trade, employment, and potential for growth. These measures are presented for 13 areas designated as 'creative industries': advertising; architecture; arts and antique market; crafts; design; design fashion; film; interactive leisure software; music; performing arts; publishing; software; and, television and radio.

The aggregate figures for the creative industries are impressive. Towards the end of the 1990s it is estimated that the sector had an aggregate turnover of £57 billion, employment of one million and estimated value added of £25 billion (DCMS, 1998a). Unfortunately, within these selected industrial categories, the nature and extent of public support is rarely made explicit, despite the fact it includes sectors where direct subsidy plays an important role – for example, performing arts and music.

So, in short, what can be said about the relative size of the sectors on the basis of a brief and admittedly limited assessment of secondary data? Table 19.2 summarises the data on the three main sectors described above. The core subsidised sector has a turnover of around £570 million. The 'related' commercial sector, which undertakes similar activities to the 'subsidised core' but tends not to rely on regular subsidies, has an estimated value of £590 million. The combined value of these sectors is therefore a little under £1.2 billion. Thirdly, the wider creative industries, as defined by the *Creative Industries Mapping Document*, have a turnover of £57 billion. We can take a more restricted view of the creative indus-tries to include only those where a particularly close relationship might exist with the subsidised performing arts sector. Including only TV/radio (£6.4 billion), film (£0.9 billion) and music industries (£3.6 billion), adjusts the value of the relevant

7 The purpose of the Task Force was to provide a forum in which government could come together with senior industry figures to assess the value of the creative industries and establish what their needs were in terms of government policy, in order to maximise their economic impact. The mapping exercise was an attempt to address the absence of comprehensive official statistics on the creative industries.

Table 19.2 Performing arts in Great Britain: estimated value of the subsidised, related commercial and wider sectors

£ million

Performing arts sector	Estimated value
Subsidised activity: total turnover	570
Related commercial activity (e.g West End theatre, pop concerts, voluntary activity) (a), consumer spending	590
The wider creative industries (b)	11,000

Source: DCMS (1998)

Notes

a) A further component of cultural activity which does not fit comfortably within a subsidised–commercial dichotomy, but which needs acknowledgement, is the amateur or voluntary sector (Hutchison and Feist, 1992). Some of this activity may receive subsidy, usually through local authorities, although the most distinguishing factor is often the degree of self-funding (e.g. through personal subscriptions).

b) TV, radio, film and music industries only – see text.

creative industries around £11 billion. While we might argue about the precise relationship between these three sectors, the principal point to note here is one of relative size – the magnitude of the commercial cultural industries set alongside the commercial live-arts and publicly funded sectors.

Who benefits from the relationship between cultural sectors?

Turning to assess the range of views about the relationship between the subsidised sector and the commercial cultural sectors, the box opposite attempts to summarise briefly the main threads of the pessimists' and the optimists' arguments. Each is considered in more detail here.

The provision of product and services to the commercial sector

Chapter 21, on the relationship between the subsidised and commercial theatre, examines the specific issue of the transfer of product in this area, so it is not dwelt on here. One of the problems about trying to articulate the nature of the relationship between the subsidised and non-subsidised sectors is that it implies a degree of homogeneity. In reality, even within the relatively narrow field of the performing arts, the relationships vary from sub-sector to sub-sector. In terms of product transfer from the subsidised to the non-subsidised world, one tends to think mainly in terms of the theatre (works of drama, dance and musical theatre). However, in considering the relationship between predominantly subsidised orchestras and the non-subsidised sectors, one tends to think in terms of the provision of services for which the commercial sector pays fees.

A significant part of the activities of the main orchestras funded by the Arts Council of England is the provision of 'orchestral services' to a range of purchasers. While some of these are other public-sector producers (for example, local authorities or subsidised festivals), other activities represent transactions with the commercial sector (for example, commercial promoters, film and advertising sessions and general recording activities). Several of these services expanded

Optimistic and pessimistic views of the relationship between the subsidised and commercial sectors

A pessimistic perspective	An optimistic perspective
• *Competition argument (1): consumers* Increasingly cheaper cultural industrial goods competing against ever more expensive output of the subsidised sector. • *Competition argument (2): inputs* Low 'per session' earnings in the subsidised compared to the commercial sector make labour inflexible and concentrated around the main locations of the cultural industries.	• *Product transfers* From the subsidised sector to the commercial sector (in effect, the subsidised sector plays a critical R and D role for the non-subsidised sector), and receives essential income through copyright payments, etc. • *Services* The subsidised sector provides critical services to the commercial sector which would not be provided otherwise, and receives essential income for these services. • *Labour-market argument (1): quantity* The subsidised sector contributes to a diverse, experienced and well-stocked labour market of artists and technicians. • *Labour-market argument (2): quality* The subsidised sector provides a key training ground for younger artists and technicians to gain experience and develop their skills for eventual transfer to the commercial sector. May return to the subsidised sector on maturity, but with the enhancement of 'star' appeal. • *Contribution to democratisation of culture* Through the cultural industries in particular, as a vehicle to get the 'subsidised' arts to a socially wider and numerically larger audience.

considerably during the early 1980s with the early exploitation of the CD. The four London orchestras – traditionally active within a wide range of engagement arenas – received almost 20 per cent of total income from recordings alone in 1988/89 (Feist and Hutchison, 1990b: 25). More recently, the commercial activities of those and other orchestras have, in many cases, been hit by increased competition from abroad (and in particular from less expensive orchestras located in Eastern Europe), and the over-production of titles in the classical CD market.

The labour market arguments

A second area of interest relates specifically to the movement of labour. One characteristic of the arts labour market that has been well established is the extent to which flexible working arrangements apply in many areas. Furthermore, the move towards greater employment flexibility is considerable (see for instance O'Brien and Feist, 1995; Feist, 2000 and Chapter 23 below). Many occupations within the cultural sector are based around short contracts, self-employment, multiple and part-time job holding. With a few notable exceptions, full-time permanent employment is not a strong characteristic of cultural sector employment and the general trend appears to be towards ever higher levels of job flexibility in this area.

It is, therefore, tempting to argue that such patterns imply that individuals move from sub-sector to sub-sector within the cultural field and that the employment links between the commercial sector, subsidised sector and cultural industries are considerable. If true, this is an important feature for those arguing for enhanced cultural funding from the public purse primarily because it highlights the inter-relatedness of the cultural sector as a whole. The Arts Council document *Theatre is for All – Report of the Enquiry into Professional Theatre in England 1986*, 'The Cork Report' (ACGB, 1986), highlighted the link between the theatre sector and broadcasting through the provision of a skilled and trained labour force.[8] This embodies one of the arguments offered by conventional welfare economists for the public support of the arts, namely that the publicly-supported cultural sector provides 'spill-over effects to other producers' (see for instance Hughes, 1989; Peacock, 2000). This yields considerable high-value employment, net export earnings and wealth to the UK economy.

So what is the evidence? In research terms, rather too little is known about the way in which artists might move from subsidised to commercial sectors, and vice versa. Probably the most frequently cited examples of movement of individual artists across the commercial and subsidised sectors are actors and directors. The critical relationships here would appear to be between subsidised theatre on the one hand, and commercial theatre, film, broadcasting and TV on the other. In his 2000 lecture, the Chairman of the Arts Council of England cited the example of Sam Mendes, whose career in the subsidised theatre was a prelude to his much vaunted success in directing the film *American Beauty* (ACE, 2000c: 13). One can paint an attractive picture of the role of the subsidised sector in this context. It offers younger artists essential opportunities to develop skills and experiences, particularly in the earlier part of their careers. They contribute to a well-developed pool of artists which the commercial and cultural industrial sectors can subsequently draw upon.

A contrary view might be that while there is much employment flexibility within the cultural sector per se, this is dominated by intra-sector movements of workers, not by the movement of individuals, critically, from the subsidised to the commercial sectors.

Elsewhere in this volume, the significant discontinuity between cultural occupations and cultural industries has been highlighted (in other words, large numbers of individuals in cultural occupations work outside the cultural industries, and many in cultural industries have non-cultural occupations – see Chapter 23). Furthermore, even if there were clear 'paths of transitions' for artists, these would have to be facilitated in a way that worked within national boundaries. Providing an endless supply of talented actors and directors from the subsidised sector to work in Hollywood, as in the case of Mendes, is a great testament to the developmental role of the British subsidised theatre, but it would not seem to meet the criteria of a spill-over benefit. In spite of several studies examining in detail the careers of those working in the cultural sector (for example,

8 To this end, The Cork Report recommended the introduction of a 1 per cent levy on both the BBC and commercial broadcasters to invest in live theatre (recommendation 189). The recommendation was not acted upon.

Jackson et al., 1994), there is little in the way of detailed longitudinal studies to support or challenge the argument about the transfer of labour. This remains a critical area for future work.

The commercial cultural industries and democratisation of culture

Another relationship between the subsidised and non-subsidised sectors relates to the distribution of cultural product. It has long been recognised that the cultural industries can play a key role in the dissemination of high culture. Many of the principles that underpinned Reith's view of the BBC highlighted the almost missionary role that broadcasting could achieve by spreading an aptitude for higher things to seemingly unsuspecting listeners and eventually viewers (see, for instance, Barnard, 1989, for an excellent account of the history of the BBC in relation to music). There have, of course, been massive changes since Reith's day, and in particular a decrease in the ability of broadcasters to dictate what the public consumes, with the increase in first terrestrial, then cable and satellite channels and technological developments such as the video recorder and DVD.

Nonetheless, before the advent of multi-channel television it was still the case that consumption and understanding of the output of the subsidised arts producers was enhanced through the activities of broadcasters. McLaughlin's 1986 study for the Independent Broadcasting Authority provided an extremely useful insight into the way that television, in particular, provided audiences with information about the arts (McLaughlin, 1986). Furthermore, both the sheer size and broader socio-economic composition of the audience for broadcast drama and classical music indicated the potential of the medium to disseminate beyond the traditional heartlands of these artforms.[9] However, exactly how a combination of the advent of widespread multi-channel viewing, tougher market conditions for commercial broadcasters and a move to lighter-touch regulation have altered the democratising potential of broadcasting for the arts remains to be established.

Competition for outputs and inputs

Negative perspectives on the relationship between the subsidised sector and the cultural industries have tended to focus on the competition for both inputs and outputs. Bennett (1991) provides a useful starting point here, highlighting a particular problem about the convenience and cost of the performing arts versus the 'substitute' outputs of the cultural industries:

the personal cultural centre [is] based in the home, and it's well equipped: with TV (terrestrial and satellite), radio, video, hi-fi, and whatever else technology can produce. It's safe ... comfortable ... convenient ... cheap. Arts organisa-

9 These points were usefully highlighted in the Arts Council of Great Britain's submission to the Department of National Heritage over BBC Charter renewal (ACGB, 1994). See also Feist and Hutchison, 1990a.

tions find themselves in a double bind: they are inadequately supported by an inadequate system, and are thrown back on the market place where they encounter increasingly fierce competition from the cultural industries.

(Bennett, 1991)

Bennett touches on the increasing price differential between the costs of the outputs of the cultural industries and the cost of attendance at the live arts. The evidence for this widening gap is clear, as the performing arts – subsidised and commercial – have seen a sustained period of real-terms price increases, while the cost of the products of the cultural industries have increased at a much slower rate, remained static or in some cases even fallen (see Feist, 1997, for a summary of the data up to the mid-1990s). There is, however, substantial evidence to support the notion that price is not, by and large, a significant factor in the public's decision to attend a live arts event. The importance of the particular product first and foremost in the decision to attend, and the intrinsic difference between the product of the cultural industries and the product of live perform-ance, means that it is necessary to be cautious in assuming that they are substitutes for each other (see, for instance, Blamires, 1992 and MBI, 1991). Nevertheless, Bennett's point about the convenience and ease of consuming the products of the cultural industries, a process furthered by technology in the ten years since he made the observation, is a critical one. Furthermore, the continual expansion of consumer choice is in stark contrast to the inflexibility and constraints around consuming the performing arts through attendance at a fixed time in a fixed location.

Blurring definitions?

While we endeavour to construct sensible definitions of the subsidised and commercial sectors, in reality the boundary tends to be prone to fluidity and change (Casey et al., 1996). This partly reflects the changing way in which the public sector actually relates to the cultural sector, but also how opinion-formers might like us to view the cultural sector.

The changing role of the public sector?

The relationship between the state and the cultural sector has been influenced by the need for public policy to address issues of cultural democracy (see, for instance, Langsted, 1990). In other words, the very boundaries of what is to be subsidised have been expanded. While the notion of cultural democracy has become an important part of the pattern of cultural support overseas, some British commentators criticised the way in which what might be termed the traditional arts-policy-making bodies had tended to ignore 'new' forms of cultural produc-tion. Writing in 1986, Mulgan and Worpole noted:

Somehow the Arts Council has remained strangely impervious to newer, techno-logical art forms, and its chosen fields of activity remain those of the pre-twentieth century – drama, ballet, opera, orchestral music and the visual arts. Film has always been kept at one remove. Photography was only accepted into the canon in the late 1960s, more than a century after its innovation. Even literature has never been accepted as a legitimate part of the Council's activity.

(Mulgan and Worpole, 1986: 22)

To be fair, the pattern of funding through government during the 1980s was more complex – for example support for commercial film was largely channelled through the Department of Trade and Industry. In fifteen years, a lot has altered. The political and administrative context of arts funding in the UK has changed, for instance through the creation of the DCMS and more recently the Film Council, which has at last brought most areas of public expenditure on film under a single umbrella body. The public-funding landscape has also changed radically, through the creation of the National Lottery, which has permitted the inclusion of a somewhat more diverse range of funding to sectors outside the 'traditional' arts base. And, finally, technology has continued to be a driving force in the fields of cultural production and distribution.

And yet, while it may be the case that public funding bodies in the UK have made progress in embracing the adjacent commercial sectors, the extent to which regular revenue support from the arts councils is still focused on the performing arts has already been noted. Furthermore, while the Lottery may have provided a degree more flexibility in the support of new forms of cultural production and, in particular, allowed a more constructive relationship with the cultural industries, this is merely scratching the surface. Direct public funding for the commercial cultural industrial sectors remains tiny compared to the vast sums of commer-cially generated income. Of course, this is not to play down the contribution of the public sector in these areas and its ability to make a difference. But it would be somehow inappropriate to describe the adjacent commercial sectors as being anything but wholly commercial, with small focused enclaves of publicly supported activity.

The influence of research studies

A second important factor influencing the way in which the relationship between the subsidised and commercial cultural sectors is perceived has been the output of UK cultural research. Since the 1980s, mapping studies of the cultural sector have generally neglected the relationship between subsidised and commercial sectors. In several instances this reflected the desire of researchers and others to pay minimal attention to subsidised/commercial boundaries; their preference was to look holisti-cally at the cultural sector.

Back in the late 1980s, Myerscough's report on the economic importance of the arts in the UK used an extremely broad definition of the 'arts' sector which embraced both the commercial and subsidised sectors, with little differentiation

between the two (Myerscough et al., 1988). It encompassed the commercial art trade, book publishing and all broadcasting (areas that are not normally considered to constitute the 'arts'). Casting the net wide does indeed generate big numbers, but it can also serve to confuse rather more sensitive policy issues (Hughes, 1989). Simply put, the majority of Myerscough's £10 billion was due to high-earning commercial cultural industries; the 'arts', as more reasonably defined, and the subsidised sector in particular, accounted for perhaps just one tenth of this total.

A second study which did not touch on the subsidised/commercial dichotomy was O'Brien and Feist's (1991) special analyses of cultural sector employment from the 1991 Census of Population. The use of such data in a cultural sphere was not new (Myserscough had already used some of the findings from the 1981 Census in his 1988 study). While there are inevitable advantages to be gained from analysing Census data, there are also drawbacks. Principally, these relate to the limitations imposed by Census categories of industry and occupation in the way in which cultural employment is measured. Critically, the coding of the Census data allowed nothing to be said about the balance between subsidised versus commercial employment within the cultural sector.

Unusually, the predecessor volume to this present study, Casey et al. (1996), did refer to the relationship between employment in the subsidised sector and wider cultural sector. The study used data from the Labour Force Survey (LFS) to identify the nature of the employer within the cultural sector (for a short summary of the LFS, see Chapter 23). Among Standard Industrial Classifications categorised as 'cultural',[10] 68 per cent worked in commercial organisations, compared with 25 per cent in the public sector and 6 per cent in voluntary or other sectors. The incidence of private-sector employment was found to be highest in 'films' and 'visual, literary and performing arts' (96 per cent and 85 per cent respectively).

The most recent attempt to map the sector has, however, returned to take a holistic view of the cultural sector. The DCMS *Mapping Document* covers a range of industries, from the purely commercial (advertising) to the highly subsidised (the performing arts), although as noted above rarely in the document is explicit mention made of the relative importance of public subsidy across different sectors (DCMS, 1998).

Summary

This chapter has attempted to examine some of the issues around the relationship between the subsidised and non-subsidised cultural sectors. This remains an area of little research, poor understanding and much speculation. It has tried to examine the dimensions of the subsidised and the commercial sectors and to speculate about the way in which the sectors inter-relate. What is clear, however, is that the relationship is made up of a number of different strands, and that the subsidised and non-subsidised sectors are closer than many might be prepared to acknowl-

10 Publishing, recording, films, radio and TV, visual literary and performing arts, museums, libraries and archives.

edge. Furthermore, research itself has tended to blur the definitions between funded and commercial sectors at a time when the profile of public funding has, through the National Lottery, been subject to a degree of change.

What this overview has not attempted to address is a range of issues around the practicalities of more direct intervention by subsidy providers in the commercial sectors. Using subsidy to produce leverage within the commercial sectors represents a potentially cost-effective way of delivering public-sector aims and objectives. But, it also critically raises questions about the purpose of subsidy, the mechanisms for intervention and the means of evaluating success or failure.

20
Assessing the Economic Impact of the Arts

Peter Johnson and Barry Thomas, University of Durham

Not even the most self-professed philistine can imagine life entirely without stories, pictures, plays, poems, songs or dancing. And those stories, pictures, plays, poems, songs and dancing must first and foremost delight, fascinate, disturb, question, inspire, enchant and amuse people as human beings. They may also have relevance to economics, for example, regeneration, to health, social inclusion and so on, but only if they first have meaning to us as people.

(Robinson, 2000)

The arts play an important role in determining the quality of our lives. Our tastes in music, drama, painting and literature – to select just a few expressions of artistic activity – may differ, but, for most of us, a world devoid of the arts would be a much less enjoyable one. However, the arts sector generates significant business activity, and is also a destination for substantial public funds. For all these reasons, it is not surprising that the arts have attracted attention from economists. Scarce resources are utilised in the 'production' of the arts, and choices have to be made in their allocation both within the arts sector and between that sector and other sectors. Such choices need to be informed by a good understanding of the demand for, and supply of, artistic activities. This understanding has been growing rapidly over the past thirty or so years: see, for example, Caves (2000); Frey (2000); Frey and Pommerehne (1989); Heilbrun and Gray (1993); Throsby (1994); and, Towse (1997).

One of the most high-profile areas in which economic analysis has been applied is the calculation of the economic impact of the arts.[1] Such impact studies are often held to be of particular interest given the scale of public subsidies for the arts compared to other sectors of the economy. Some arts organisations would not continue either at all, or at their present scale, without these subsidies. Thus, if the level of public funding were to change, then the scale of the arts sector

1 The literature is very substantial. The references cited in the tables in this chapter represent only a sample of published studies. Other studies include Cwi and Moore (1977); Gazel and Schwer (1997); Myerscough (1988a,b,c,d); Port Authority of New York and New Jersey et al. (1993); Port Authority of New York and New Jersey and the Cultural Assistance Center (1983); and Vaughan (1976).

would be likely to alter. Impact studies of the arts could provide useful information on the way in which government intervention of this kind influences the allocation of resources across sectors.

This chapter reviews calculations of the economic impact of the arts – the methodologies used, the results obtained and their strengths and limitations – and explores the possibilities for developing the economic assessment of the arts in a way that more fully reflects their fundamental purpose. The chapter is structured as follows: the first section reviews some recent impact studies and outlines some key results; the second provides a critique of these studies; and the third suggests ways forward for the analysis of economic impact and proposes a much wider remit for the analysis of the economic impact of the arts.

Recent studies of economic impact

Over the years the assessment of 'economic impact' has taken on a fairly narrow meaning. The principal concern of those researchers involved has been with measuring the scale of the arts in terms of conventional economic measures, such as employment, sales, foreign earnings, and so on. Studies range from fairly straightforward mapping exercises (such as Casey et al., 1996; DCMS, 1998), in which estimates of the numbers employed in, or sales directly arising from, arts activities are provided, to rather more sophisticated analyses that seek to take account of knock-on effects in associated activities (for example, restaurants which benefit from the trade generated by the artistic activity), in the chain of suppliers (for example, stage-set manufacturers, and their suppliers) and in the wider economy as a result of the increase in consumer incomes more generally (often referred to as the 'induced' effects). These studies may also consider displacement, that is, the diversion of activity from other organisations. This may happen, for example, if subsidies to arts organisations generate more consumer expenditure on those organisations by diverting expenditure away from other organisations. In this case, from the standpoint of society as a whole, the losses of displaced activity should be deducted from any gains in the subsidised activity.[2]

The focus in this chapter is mainly on the type of study which attempts to measure all the effects. The tables provide detailed descriptions of selected key studies. Before these are considered, a number of preliminary points should be made about the selection. Firstly, they reveal a rather relaxed view of what constitutes the arts sector.[3] They include some museum studies, and the coverage of the studies that purport to deal with the arts as a whole has not been queried. The reasons for this approach are that a more rigorous definitional approach, which required consistency across all studies, would have reduced the coverage without providing compensating benefits.

2 There are several variants of the displacement concept. Employment displacement, for example, might arise where an incoming firm to an area attracts labour away from other firms.

3 This approach is consistent with the wide definition adopted in this volume which includes in the arts: the visual and performing arts, literature, film, public broadcasting, museums and galleries, archives and libraries, and the historic environment.

Table 20.1 Summary of selected economic impact studies on the arts in general

1	Short title of the study	Arts in Britain	Arts in Wales	Northern Ireland Arts
2	Reference	Myerscough (1988a)	Welsh Economy Research Unit (1998)	Myerscough (1996)
3	Source of funding/support	Commissioned and supported by the Office for Arts and Libraries, and other bodies	Commissioned by the Arts Council for Wales, and other bodies	Commissioned by Northern Ireland Economic Council
4	Main focus	'To provide an assessment of the economic contribution of the arts to the British economy' (p3)	To 'quantify, in terms of outputs and incomes and jobs, the direct and indirect impact of the arts and cultural industries in Wales' (p1)	'To provide an evaluation of the importance of the arts in Northern Ireland and to examine options for development, including ways of increasing their economic contribution.' (p1)
5	Reference organisation/activities	'Museums and galleries, theatres and concerts, creative artists, community arts, the crafts, the screen industries, broadcasting, the art trade, publishing and the music industries' (p5) Includes public and private sector, excludes amateur organisations and education in the arts	Performing arts; visual arts, craft and design; literature and publishing; media, libraries, museums and heritage; general cultural activities (p14)	Performed arts (venues, companies, promoters), museums and galleries, heritage, cultural industries (design trades, independent film and video, broadcasting, cinema, the music industry and the art trade) (p3)
6	Reference date(s)	1984/85	1996–97	1993–94 (some data for earlier years and some for 1995)
7	Reference area	UK	Wales	Northern Ireland
8	Specific measures used	Turnover, value added, employment, overseas earnings	Output, incomes, jobs	Employment, income, turnover, exports, investment, financing
9	Sources of data and methods	Extensive use of national statistics, and three detailed regional case studies for census of arts organisations and surveys of arts institutions, arts customers, and others, to estimate spending, attribution, multipliers, etc. Input–output tables possibly used (p97)	Data from surveys of institutions and use of other surveys and secondary data sources. Use of input–output model to estimate all the indirect effects.	Surveys of institutions for employment and turnover data. Use of other surveys by consultants and others for visitor expenditure, size of multipliers, etc. Secondary sources for other data, etc. Application of expenditure–employment ratios, and multiplier analysis
10	Measurement of:			
10a	Direct effects	Yes	Yes	Yes
10b	Indirect effects	Yes	Yes	Yes
10c	Induced effects	Yes	Yes	Yes
10d	Associated activity	Yes	No?	Yes
10e	Leakages	Yes	Yes	Yes, in part (see row 13 below)
10f	Displacement	Not apparent (though claims to do so, p5)	No?	No?
10g	Attribution	Yes	No?	Yes

Table 20.1 *continued*

1	Short title of the study	Arts in Britain	Arts in Wales	Northern Ireland Arts
10h	Other	Very detailed descriptive data on the scale and structure of the arts		Various descriptive measures of 'the economic scale of the cultural sector' (p127), sources of public funding, and attendance at events etc.
11	Quantitative results on employment			
11a	Measurement units	'Jobs', includes full-time and part-time (p100)	Full-time equivalents	Full-time and part-time jobs sometimes counted equally
11b	Direct employment in reference organisation/ activities	486,000 (p57)	16,134 (p35).	5,668 (p161)
11c	Additional employment	175,000 (p57).	[6,674]	[2662–3402]
11d	Gross employment	671,000 (p57) (NB 11a + 11b = 661,000)	22,808 (p39).	8,330–9,070 (p161)
11e	Ratio of 11d to 11b	[1.38]	[1.41]	1.47 – 1.6 (p161)
11f	Diverted employment	Not calculated?	Not reported	Not calculated
11g	Net employment	Not calculated	Not reported	Not calculated
12	Other results	Arts turnover = £10bn (2.5% of all spending in UK) (p61). 27% of overseas tourist spending induced by the arts (p83). Regional estimates of incremental multipliers (direct+indirect+induced effects, as proportion of direct effects): spending by arts organisations 1.11–1.20 (p100); Jobs 1.23–1.42 (p101)	Ratio of total gross output to arts gross output: 1.37 (p39). Arts output multiplier: 1.68 (p41) Arts employment multiplier: 1.74 (p41)	Details of turnover, employment, attendance etc. by sub-sector. 'Gross local income component (income impact)' of visitor spending is £7.07m out of total visitor spend of £19.63m. i.e. 36% (p123)
13	Interpretation of results	Most calculations explicit. Theoretical framework clearly evident. Occasional ambiguities, e.g. incremental multiplier does/ does not (p 97/Tables 6.4 and 6.5) include direct effects in numerator; relation of 'arts multiplier' (p104) to incremental multiplier (p101) unclear	Some calculations not presented explicitly. Explicit theoretical framework used, though associated expenditure by visitors to arts events and attractions appears not to have been calculated.	Many calculations not presented explicitly. Calculation of associated employment appears not to allow for leakages, and there may be some double counting in the direct reference activities
14	Comments	A major data-collection and compilation exercise. Discussion of prospects for the arts, and of 'less easily quantifiable aspects', e.g. means of asserting civic and national	Discusses the prospects for different subsectors.	Gives much detail of the scale of the direct reference activities, and extensive discussion of prospects for the cultural sector, including an 'examination of the

Table 20.1 *continued*

1	Short title of the study	Arts in Britain	Arts in Wales	Northern Ireland Arts
4	Main focus			wider context of the arts in terms of their role as a social amenity, and their role in the promotion of Northern Ireland' (p2)

1	Short title of the study	New York Arts	Idaho Arts
2	Reference	Alliance for the Arts (1997)	DiNoto and Merk (1993)
3	Source of funding/support	Commissioned by The Alliance for the Arts	'full co-operation and support of the Idaho Commission on the Arts,' (p42)
4	Main focus	'The impact that the arts have on the economy through employment…expenditures by cultural organisations…as a magnet for visitors.' (p1)	'the economic importance of the arts in Idaho' (p1)
5	Reference organisation/activities	Arts and Cultural Organisations. Non-profit cultural institutions: performing and visual arts, film and media, and other cultural organisations directly funded by NY State Council for the Arts, zoos, botanical gardens. Commercial theatre, art galleries and auction houses. Motion picture and television production (p4)	Non-profit arts organisations included in the National Endowment for the Arts classification scheme (p43)
6	Reference date(s)	Fiscal Year 1995 (the precise time period varied slightly with the source of data)	No date given – probably circa 1990
7	Reference area	New York State	Idaho
8	Specific measures used	Income, employment, tax revenues attributable to the cultural sector, visitor expenditure	Output, earnings, employment
9	Sources of data and methods	Data from surveys of institutions and use of numerous other surveys and secondary data sources. Aggregate expenditure patterns analysed through an input–output model to estimate the change in local final expenditure	Survey of arts organisations for their income and expenditure data. Use of input–output model
10	Measurement of:		
10a	Direct effects	Yes, but not separately	Yes
10b	Indirect effects	Yes, but not separately	Yes
10c	Induced effects	Yes, but not separately	Yes
10d	Associated activity	Yes (associated spending by cultural tourists to NY State, but not by residents) (pp19, 20)	No?

Table 20.1 *continued*

1	Short title of the study	New York Arts	Idaho Arts
10e	Leakages	Yes	Yes
10f	Displacement	No?	No?
10g	Attribution	Yes	Yes
10h	Other	Breakdown of income and expenditure for non-profit cultural organisations, attendance figs., etc.	
11	Quantitative results on employment		
11a	Measurement units	Full time equivalents	'Jobs', not clear if full-time equivalent
11b	Direct employment in reference organisation/activities		
11c	Additional employment	Not reported	Not reported
11d	Gross employment	174,000	174–271 depending on method (pp46, 50)
11e	Ratio of 11d to 11b	Not reported	Not calculated
11f	Diverted employment	Not calculated	Not reported
11g	Net employment	Not calculated	Not reported
12	Other results	$13.4bn gross output for cultural sector (p 21) – breakdown by sub-sector given. $480m returned to NY State in taxes (p22)	Total gross output from reference activity: $6.7–9.6m depending on method (pp46, 50) Multiplier (defined as change in final cash flow per $ change in arts sector final demand): output multiplier 1.3–2.1; earnings multiplier 0.42–0.82. Employment multiplier (defined as number of jobs created per $1m expenditure) 33.21–58.7 (pp46, 50)
13	Interpretation of results	Some calculations not presented explicitly. Explicit theoretical framework used	Calculations not presented explicitly. Associated direct expenditure does not appear to be counted
14	Comments	Major data-collection exercise	Difficult to discern the scale of employment and gross impact

Source: authors' analysis.

Notes
Figures in square brackets are inferred.
Blank cells mean there is nothing further to report.
Page references refer to the publication cited in row 2.

Table 20.2 Summary of selected economic impact studies about events

1	Abbreviated title of the study	New York Museums	Wexford	Theatre festivals in Ontario
2	Reference	Alliance for the Arts (1993)	O'Hagan (1992)	Mitchell (1993)
3	Source of funding/support	Internally financed	Not clear	Social Science and Humanities Research Council
4	Main focus	'the desire of the museums to investigate the impact of their major art exhibitions on the economy of the city' (p4)	'to evaluate the case for public funding … of the Wexford Opera Festival' (p61)	To describe spatial variations in expenditure patterns of visitors at performances across theatre companies, and explain these
5	Reference organisation/ activities	Four major exhibitions at the Metropolitan Museum of Art (2), the Museum of Modern Art (1), and the Solomon R. Guggenheim Museum (1)	The Opera Festival (3 weeks), Wexford, Ireland	9 small (budget < $2m in 1986) professional theatre companies
6	Reference date(s)	1992–3	1988	1989
7	Reference area	City of New York	(Mainly) the Irish economy	9 small (population<10,000) communities in southern Ontario
8	Specific measures used	Expenditure by out-of-town visitors	'International acclaim', foreign-exchange earnings	Visitors' expenditure
9	Sources of data and methods	Survey of visitors to exhibitions for data on visitor spending, attribution, etc.	Survey of festival attenders for data on visitor characteristics, and spending, etc. Use of impressionistic evidence of contribution to Irish tourism, international acclaim, etc.	Visitor expenditure from mail questionnaire to theatre-goers. Interviews with '50 merchants in each business community' (p60)
10	Measurement of:			
10a	Direct effects	Yes	Yes	Yes
10b	Indirect effects	No	None reported	Impressions only
10c	Induced effects	No	None reported	No
10d	Associated activity	Yes	None explicitly reported	Yes
10e	Leakages	No?	Yes	Not calculated?
10f	Displacement	No	No	No
10g	Attribution	Yes	Probably yes	No?
10h	Other	Visitor characteristics	Visitor characteristics	
11	Quantitative results on employment			
11a	Measurement units	Not relevant	Full-time	Not relevant
11b	Direct employment in reference organisation/ activities	Not calculated	3 (p62) (+ some services provided free of charge by the National Symphony Orchestra p61)	Not calculated?

Table 20.2 continued

1	Abbreviated title of the study	New York Museums	Wexford	Theatre festivals in Ontario
11c	Additional employment	Not calculated	Not calculated	Not calculated?
11d	Gross employment	Not calculated	Not calculated	Not calculated?
11e	Ratio of 11d to 11b	Not calculated	Not calculated	Not calculated
11f	Diverted employment	Not calculated	Not calculated	Not calculated
11g	Net employment	Not calculated	Not calculated	Not calculated
12	Other results	Total spending on 'shopping and expenses' of out-of town visitors: $368 (after allowing for visiting > 1 exhibition, and attribution). Tax revenue estimated at $36.8m (p7)	IR£330K 'conservative estimate' of foreign-exchange earnings (p65). Qualitative assessments of international acclaim	Estimated total visitor expenditure (excluding ticket costs): over $6m (p62)
13	Interpretation of results	Clear details presented. Attribution based on visitors' using a rating scale to indicate importance of exhibition in visit to the City	Calculations not shown	Calculations not given. Attribution does not seem to be taken into account
14	Comments	Limited focus on direct (including associated) expenditure by visitors to the City	Study makes very limited attempt to quantify the value of the Festival, 'it has to be a political judgement' (p65)	Very limited study of direct (including associated) expenditure

Source: authors' analysis.

Notes

Figures in square brackets are inferred.

Blank cells mean there is nothing further to report.

Page references refer to the publication cited in row 2.

Table 20.3 Summary of selected economic impact studies about organisations

1		South West England Museums	Beamish	Tate, St Ives
2	Reference	South West Museums Council (2000)	Johnson and Thomas (1992)	West Country Tourist Board (1996)
3	Source of funding/support	Commissioned by the South West Museums Council (SWMC)	Joseph Rowntree Memorial Fund	Survey sponsored by Tate Gallery and other bodies
4	Main focus	'To identify the direct and indirect contribution of the museums sector – including art galleries – to the regional economy' (p5)	'Evaluating the local economic impact, measured in employment terms, of a major tourist attraction in the North of England' (p1)	'To provide an estimate of the impact of the gallery in terms of tourism expenditure and ... additional tourist expenditure' (p21)
5	Reference organisation/activities	Registered museums in the South West and associated members of the SWMC, including administrative centres such as local-authority museum services	The North of England Open Air Museum at Beamish	The Tate Gallery, St Ives, Cornwall
6	Reference date(s)	1998	1989	1995
7	Reference area	The South West region of England	NE England (Counties of Durham, Northumberland, Cleveland, and Tyne and Wear)	Cornwall
8	Specific measures used	Output (also called total revenue, and total income), employment, GDP	Employment	Visitor spending (by day visitors + stayers)
9	Sources of data and methods	Questionnaire-based mail survey of reference organisations for basic employment and other data. 'Speculative estimates' (p 13) used for attribution factor. Use of input–output model	Data on employment and expenditure on supplies, from the reference organisation. Visitor surveys for expenditure data, attribution, displacement, etc. First-round indirect effects, multipliers from primary sources. Other data from regional and national secondary sources. Application of sales-employment ratios to expenditure data, and multiplier analysis	Visitor survey used to assess attribution, then applied to secondary data on visitor spending
10	Measurement of:			
10a	Direct effects	Yes	Yes	Yes
10b	Indirect effects	Yes	Yes	No
10c	Induced effects	Yes	Yes	No
10d	Associated activity	Yes	Yes	Yes
10e	Leakages	Yes	Yes	No
10f	Displacement	No?	Yes	No
10g	Attribution	Yes	Yes	Yes

Table 20.3 *continued*

1	Short title of the study	South West England Museums	Beamish	Tate, St Ives
10h	Other	Provision of a general database on SW museums (numbers of visits, etc.)		Details of visitor characteristics
11	Quantitative results on employment			
11a	Measurement units	Full-time equivalents	Full-time equivalents	Not relevant
11b	Direct employment in reference organisation/activities	954 (+ 317 unpaid) (p11)	156 (p60)	Not calculated
11c	Additional employment	[410]	100 (p60)	Not calculated
11d	Gross employment	1,364 (p11)	256 (p60)	Not calculated
11e	Ratio of 11d to 11b	1.43 (p24)	[1.64]	Not calculated
11f	Diverted employment	Not reported	195 (p60)	Not calculated
11g	Net employment	Not reported	61 (=24% of gross employment) (p60)	Not calculated
12	Other results	Museums' direct total income (output = revenue) =£29.1m; output multiplier: 1.74 (p25) Direct contribution of museums to GDP = £18.6m; GDP multiplier: 1.61 (p25)		'over £16m spent in Cornwall on visits whose primary reason was to visit the Tate.' (2% of 1994 total estimated spend in Cornwall by staying visitors) (p22)
13	Interpretation of results	Some calculations not presented explicitly, though explicit framework used. High degree of sub-regional and size disaggregation may require cautious interpretation. Large use of unpaid labour (25% of direct fte figure) which is not counted, though estimates of the economic contribution including unpaid labour are given	All calculations explicit. Explicit theoretical framework used	Very simple calculations only, but fit for limited scope of the study
14	Comments	Comparisons with other service sectors in the South West are presented	Narrow focus on employment. Nothing on job quality	Simple visitor study with no attempt to estimate employment of indirect and induced effects

Source: authors' analysis

Notes
Figures in square brackets are inferred.
Blank cells mean there is nothing further to report.
Page references refer to the publication cited in row 2.

211

Secondly, the range of studies included is of varying spatial coverage with different focuses. The latter requirement has determined the inclusion of studies of the economic impact of the arts in general, and of particular events and particular organisations. Some overseas studies are also included. This has been done to demonstrate that interest in the economic impact of the arts is not peculiar to the subsidised sector in the UK. Other countries also regard the issue as important. In addition, the overseas studies demonstrate that the purpose and methodological challenges faced by studies in different countries have much in common, so we can learn from them as well as from UK studies.

The purpose of the tables is to present some representative examples of the different types of impact study. The concern is not to discuss the virtues, or possible weaknesses, of particular studies, but rather to provide a basis for an overall assessment (in the next section) of the value of impact studies. Policy-makers and others might reasonably ask if the tables provide any general conclusions about the impact of the arts which can be applied to other cases. The evident diversity in the scope of the studies, and in their methods and results, makes this extremely difficult, and any attempt to transfer results requires the utmost caution.

A critique of recent studies

What are we to make of the studies in Tables 20.1–20.3? Their primary function is to provide a measure of the scale, including (to a greater or lesser degree) knock-on effects, of the activities under consideration, using conventional economic yardsticks. For lobbying purposes, there may be great virtue in being able to demonstrate the economic 'importance' of the sector, or a particular part of it. Some of these studies compare the arts with other industries for precisely this reason. The measurement of scale may also help, indirectly, in the analysis of new policy measures, by providing a scaling factor for policy evaluations based on samples or case studies. In addition, it may also perform an educative role: it is often helpful to have some feel for scale. Finally, economic impact studies may enhance our understanding of the 'micro processes' involved in (say) employment generation, and thus enable more informed judgements to be made on key issues in policy evaluation. For example, a good knowledge of the nature of knock-on effects, for example, in suppliers and/or other activities can make an important contribution to such evaluation. However, these studies suffer from a number of major drawbacks which raise fundamental questions about their value. Some of these drawbacks are set out below.[4]

1 Without similar calculations for other sectors of the economy, based on identical methodologies, it is difficult to place the arts in any kind of relative position. Even studies within the arts sector lack comparability, as the three tables show, in their coverage in terms of the reference organisation/activities, and the size of the reference area. There are also differences in definitions

4 For critical reviews of impact studies, see Hughes (1989); van Puffelen (1996); and Seaman (1986).

used. To take just one example, the 'multiplier' is defined in different ways in different studies: sometimes it is the ratio of total effects (direct plus indirect plus induced) to direct activity in the reference organisation/activities (Johnson and Thomas, 1992); sometimes it is the ratio of final to initial changes (South West Museums Council, 2000); sometimes it is the number of jobs created per unit of expenditure (DiNoto and Merk, 1993).

2 Economic impact studies give little indication of the responsiveness of the sector (or parts of it) to changes in the economic environment or in policy. 'What if' questions are not easily addressed. Simply because it can be demonstrated that a sector is 'large' in some sense, offers little insight into how such a sector would respond to different stimuli. For example, in order to assess what the effects of altering the level of public funding would be, information on marginal relationships is required – that is, the change there would be in an arts organisation in response to a unit change in public funding. In practice, there is usually information only on average relationships, such as average cost-per-job figures (total public subsidy to an organisation divided by employment). In the absence of superior information, such average cost-per-job figures are probably better than nothing and they have been used in discussions of the efficiency of public expenditure for job creation (see Myerscough, 1988a and Johnson and Thomas, 1992). It must be acknowledged, therefore, that simply measuring the scale of the activity in some period – providing a snapshot – can be of some interest.

3 The underlying questions that these studies are seeking to address are sometimes unclear. They may be intended simply as descriptive exercises, or they may be seeking to discover what difference the sector (or event, or organisation) makes. This question in turn needs further consideration. It does not really make sense to compare the existing world with one where no arts exist at all, although there may be some value in being able to estimate the effects of a marginal reduction or expansion. It should also be recognised that when it comes to particular events or organisations, the question 'What difference has this event/organisation made?' may yield an answer that varies significantly from the one that answers the question 'What difference would the closure of this event/organisation make?' An example may help to clarify the point. The setting up of a new theatre may encourage surrounding business activity (for example, restaurants). Such activity might not otherwise have occurred. However, the subsequent closure of the theatre may not cause a corresponding reduction in that activity, because the businesses concerned may seek to develop other markets. Behavioural changes of this kind are rarely taken into account (this issue is further developed in the next point).

4 There is a danger that a mechanical approach to estimating economic impact will ignore the dynamic nature of business and, indeed, arts activity. This is particularly relevant when it comes to looking at the impact of a particular event, activity or organisation. Part of such an analysis is the estimation of the extent of diversion, for instance – the extent to which visitors divert from elsewhere. Calculation of diversion usually assumes that there is no competitive response on the part of those adversely affected by the diversion. While

this may sometimes be true, it is more likely that there will be some reaction to a potential threat.

5 A key assumption behind the calculations – rarely made explicit – is that there is spare capacity in the economy. If this does not exist, then the calculation of (for example) multiplier effects, which arise from the successive rounds of expenditure out of incomes generated from the initial increase in some activity, is misguided.

6 The definition of the arts sector typically adopted in general economic impact studies is arguably very wide. The broader the definition of the arts, the more difficult it is to be precise about the impact because it is more complex to track all the possible effects of a set of diverse activities. Achieving an appropriate balance between, on the one hand, the scope of arts activities studied and, on the other hand, the completeness and accuracy of impact measures, is a matter of judgement. Some commentators feel that there is little value in very broad-ranging studies. Hughes (1989), for example, has argued that the definition adopted in the Myerscough (1988a,b,c,d) studies is too broad and 'makes little sense in economic terms'.

7 Perhaps the most fundamental issue surrounding economic impact studies is their relationship with the ultimate purpose of the arts. Economic effects in terms of, say, jobs or sales are a consequence of arts activity, and not a primary purpose of such activity. These effects may well be an important consideration, for example in the siting of a new theatre, but to over-emphasise them represents a distortion of what the arts are about. At the very least, one can argue that these studies represent an incomplete assessment of the effects of the arts (Thompson, 1998). It is perhaps ironic that by focusing on conventional economic impact studies, arts-promotion bodies may be diverting attention from the main benefits of the arts.

There is a further general point, raised by van Puffelen (1996), about the impact studies conducted so far, which raises a more subtle question about their value. It is that most have been sponsored by bodies friendly to, or with a direct interest in, the promotion of the arts. As a result, question marks hang over their objectivity and interpretation. Perhaps a cynic would not be surprised to learn that all the studies cited in the tables which have been sponsored by interested parties conclude that the arts make a 'significant' or 'substantial' or 'major' contribution to the economy, and some go on to argue the case for further expansion and more public support.

In the light of the points made above, the following paragraphs provide an assessment of what we know from the studies in the tables and what value they represent. It is clear from the tables that few generalisations are possible, given the diversity across the studies in the scope, methods and data (see point 1 listed above), though they all focus on similar economic variables (mainly employment and output, or related concepts such as turnover, local income, GDP, or value added). The studies are of interest in showing the scale of arts activity – the direct effects – and this descriptive information is often presented in rich detail. Most of them also attempt to calculate indirect and induced effects in addition to direct effects.

While the extent to which the results of a particular study can be transferred to other situations is limited, there nevertheless seems to be scope for some tentative generalisation. This is most apparent in the case of the studies which estimated employment. There was substantial agreement on the size of the indirect and induced employment associated with the direct employment. This additional employment typically seems to be, very roughly, around 50 per cent of the direct employment: all five studies which present data on the ratio of gross to direct employment (row 11e in the tables) show a ratio within the range 1.38–1.64.

There are, however, at least two respects in which the studies are of limited value from the standpoint of policy debates on subsidies to the arts. First, they are rarely able to incorporate any behavioural responses or consequences of the kinds discussed in points 2 and 4 above. In particular, with the exception of the Beamish study, none of the studies calculates displacement effects.[5] This is a major omission, because it is the net gain that is relevant in considering the effects of public subsidies. Similarly, it is important to know the extent to which arts activities which are supported by subsidies would have taken place without the subsidies – the deadweight effect – but the studies can provide little information on this. Secondly, in relation to point 7 above, there is only a weak or non-existent link between impact, as measured in the reported studies, and the real purpose of arts activities. Against the background of these comments, the next section considers potential ways forward in economic studies of the arts.

A way ahead?

Arts-promotion bodies will doubtless continue to sponsor conventional economic impact studies of the arts since they provide useful headlines and lobbying material. Is there a role for such studies outside the confines of such promotion? It is proposed that there is, provided the above limitations are addressed in a careful way. Our understanding of the interrelationships between events and organisations within the arts sector, and between this sector and other sectors, can be enhanced. In addition, some insights into the likely effects of policy can be obtained. It is particularly important however that the methodologies and calculations used are explicit and ensure comparability across studies.

Although there is arguably a place for dispassionate economic impact studies of the kind described in Tables 20.1 to 20.3, there is also a need to pursue an altogether wider research agenda on the economic effects of the arts. This agenda would focus more on the measurement and valuation of the impact of the activities of the arts sector on the enjoyment, appreciation and human capital of participants, and on those whom they influence – in other words, the cultural impact. This would be a significant departure from the typical approach of studies undertaken hitherto, such as those reported in the tables, which have

5 Some studies seem to imply that they calculate these, but there is little evidence that they have done so, and they do not seem to present the results.

attempted to quantify only the rather narrowly defined economic impact in terms of such measures as employment or local income. Some of the studies, for example Myerscough (1988a), have noted the 'less tangible influences of arts provision on social life' and the benefits of the arts as 'a source of local pride and civic identity [which] inspires new-found confidence' in communities, and adds to the vitality of cities. There has, however, been little or no attempt to measure this kind of subtle social benefit, nor individual psychic benefits.

Such research would, however, be much closer to the underlying rationale for the arts, and would provide an altogether more satisfactory basis for policy evaluation, as it would seek to capture those benefits that are not reflected in market transactions (see Hughes (1989) for a discussion of these benefits).

The research challenges in this area are formidable, but there are tried techniques available – for example, contingent valuation (Thompson, 1998)[6] – careful application of which would yield important insights into the measurement of the welfare-enhancing effects of the arts. The contingent-valuation method is one of a number of techniques which enable economic values to be estimated for a range of items which are not traded in markets. The method works by attempting to derive individuals' willingness to pay for having more arts services, or their willingness to accept compensation to forgo an increase in arts services. It is beyond the scope of the present chapter to explore the possibilities of this method for measuring the cultural impact of the arts, but it is worth noting that it is widely used and accepted in the valuation of the environment. It offers considerable promise in the case of the arts, where there are similar measurement problems. If this kind of evaluation of the impact of the arts were added to the existing types of impact study, as discussed in this chapter, there would be a real information gain which could lead to more rounded discussion of the role of the arts and public subsidy.

6 For an excellent review of contingent valuation, and other relevant techniques in the environmental field – an area in which similar issues arise – see McConnell (1985). The contingent-valuation approach is not however without its critics: see Frey (1997). Chapter 18 in the present volume includes further brief information on the method.

21

Innovation and Diversity in Repertoire in Grant-aided and Commercial Theatre

John O'Hagan and Adriana Neligan, Trinity College Dublin

Innovation and diversity are considered by many to be key to a long-term, vibrant theatre sector in England and as such are the focus of this chapter. The two concepts are also, as shall be seen, connected fundamentally to the perceived relationship between the grant-aided and commercial theatre sectors.

The first section of the chapter considers the complex issue of defining 'innovation' and 'diversity' and the possible links between these two concepts, both with each other and with new writing. The section also contains a discussion of why innovation in drama poses problems for the market, and examines the possible role for the state in this regard. The second section examines some issues that arise in relation to new writing and innovation in English drama. A new type of analysis is applied in the section, both at the level of the theatre sector as a whole and at the level of some individual theatres to attempt to throw light on this complex issue. The third section examines the Arts Council of England's policy responses to issues pertaining to the lack of new work: firstly, concerning ventures involving linkages between the grant-aided and commercial sectors; and secondly, in terms of increasing state funding and/or an emphasis on new work and innovation in English drama policy.

It should perhaps be stated at the outset that innovation and diversity are only part of the 'mission' of the grant-aided theatre sector: developing a broad popular audience and nurturing a sense of national identity are others, and often these aims conflict directly. This is an issue that will be returned to in the conclusion to this chapter.

Innovation, diversity and the role of the state

Definitions

A recent review of the literature in relation to the concepts of innovation and diversity in the arts, particularly the performing arts suggests that innovation is the introduction of something new and is usually related to creativity (Castañer,

2000). Most commentators writing on this topic in relation to the performing arts identify artistic innovation with the creation and/or introduction of new, contemporary works. Their emphasis tends to be on innovation in content, and applies to both the writing of new plays and their performance on stage. However, artistic innovation also embraces new practices or uses in both the form and content of a particular artistic medium. Thus, apart from the introduction of new or unusual works, innovation could reside in the combination of multiple art forms, the introduction of new ways of interacting with the audience, new adaptations or interpretations of old works, and new and innovative production methods (Cloake, 1997). The emphasis in this chapter is on repertoire innovation – the introduction of new work – and to a lesser extent the performance of rarely produced drama. The main reason for this is the availability of data.

Although individual playwrights create new drama, theatres play a fundamental role in introducing and presenting these works. Theatres tend to be necessary in terms of the presentation and interpretation of the work to the public. It might be argued that only the writing of the play is innovative and that the theatre merely adopts the innovation. This is obviously an oversimplification. What is the point of new work if it is never performed? Besides, producers genuinely innovate by organising and interpreting plays and/or by presenting old works in new ways. For the purposes of this paper, therefore, the writing and presentation of new plays is treated as essential to repertoire innovation in drama.

It could be argued that innovation is a relative term, at least when deciding on whether a theatre, say, is innovative or not. In the performing arts, studies usually assesses the innovativeness or otherwise of the drama repertoire of a theatre in relation to other similar theatres. At the aggregate level, the comparison would be relative to aggregate indicators for previous years.

Some commentators treat lack of diversity or non-conformity as indicators of innovation (DiMaggio and Stenberg, 1985a; 1985b; Martorella, 1977; Pierce Lamar, 2000). Their studies compare the repertoire of a performing arts institution such as an opera house or a theatre to that of all other similar institutions in the same country for a given period. As discussed below, the indices so constructed are based on the frequency in which each opera or play produced by the local opera house or theatre is performed by the rest of the population during the given period. Castañer (2000) has questioned whether these indices are an appropriate measure of repertoire innovation and risk-taking, on the basis that such indices study repertoire differences but not necessarily innovation, as the process underlying the latter is dynamic and undergoes several stages. Nonetheless, diversity measures provide indicators of innovation and are considered by many researchers to throw useful light on the issues of innovation and risk-taking.

Diversity in theatre repertoire is also of interest in itself as a measure of how the theatre sector responds to a range of preferences for drama, reflecting minority interests and ethnic differences, for example. It is also an indicator of how well the sector is doing in relation to the greatly varying aims of drama – providing a live entertainment experience; a critical reflection on society; and contributing to national cohesion, identity and prestige. Only a diverse repertoire will accommodate such varied objectives.

Innovation, repertoire and the market

Both the commercial sector and the grant-aided sector have an interest in innovation and the creation of new works. The commercial sector needs a flow of new and popular works in order to survive. In other words, the primarily entertainment function of drama cannot survive on an indefinite repetition of existing works; it needs new works to sustain it. The problem is that nobody can predict what will or will not be a commercial success – the 'nobody knows' property that attaches to a creative work like a play (Caves, 2000). There is huge uncertainty about how consumers will value a new play. It might meet with great acclaim and bring in revenue far exceeding its cost of production, or it might find few customers prepared to see it. Plays can be very expensive to produce, and high risks attach to their success.

A further factor is that there is substantial evidence to show that the length of run required to make a play commercially successful has increased considerably in the last 50 years (see, for example, Caves, 2000). This means that, more than ever, commercial theatres and producing companies need some certainty about the likely success of a play before mounting a production. A theatre or production company (whichever is incurring the cost of mounting the production, and hereafter simply referred to as theatre for convenience) nowadays incurs very high fixed costs in staging a first performance (rehearsal time, design and construction of set and lighting, advertising). However, marginal performance costs (the cost of an extra show, once fixed costs have been incurred) fall everywhere and there are potentially very large economies of scale to be had by increasing the average length of run per production (Austen-Smith, 1980). The result of this might be twofold. The commercial sector will go to considerable lengths to have new work tested before mounting a production and, all things being equal, will opt for 'safe programming' given the commercial reality outlined above.

Innovation is also required to fulfil other functions of drama (see O'Hagan, 1998, for a fuller discussion of this). Drama can contribute to the sense of a country's national identity and this in turn can lead to a greater sense of social cohesion and continuity. As Weil (1995) argues, the arts, including drama, are one of the principal means by which a society binds itself together and transmits its beliefs and standards from one generation to another. Not only can drama provide a kind of 'social glue', it also furnishes a means by which English society can identify and distinguish itself from others. Herein, perhaps, lies much of the rationale for the large public subsidy to the Royal Shakespeare Company and the Royal National Theatre. This type of benefit from drama is public in nature and will not in itself be an aim of commercial theatre. Such 'national' drama, by its nature, implies the repetition of standard works that contribute to this function. However, national identity and the issues that bind a society change over time, and so new works are also required in this genre to replenish and sustain this function of drama.

Drama also has a role to play as an agent of social disruption and change. Functioning in this capacity, drama 'may intrude rudely upon our everyday sensibility, force us to consider the most extreme possibilities of the human condition,

and prod us to think more profoundly than is comfortable about ultimate matters of life, death, and our own contingency' (Weil, 1995: 158). Many people in a democratic society, and not just those who see a given play, may benefit from this function of drama, but commercial theatres can only charge those who attend for the enjoyment of viewing the play. In a similar vein, film, TV and commercial theatre may benefit from ideas created in the grant-aided theatre sector but cannot be charged for these benefits as they are not reproducing the play per se but simply adapting and popularising a concept developed elsewhere. These non-private and non-chargeable benefits of drama, some argue, provide a strong *prima facie* case for public funding of drama that is new, challenging and innovative (O'Hagan, 1998).

Finally, it is argued that drama must also be accessible to a diverse audience if the benefits above are to be realised. In particular, to be inclusive, no minorities – ethnic, socio-economic or whatever – should feel excluded from live drama. Therefore, there tends to be an emphasis not just on new work that may prove commercially successful, or contribute to society in a broader sense, but also on new works that reflect the cultural and socio-economic diversity of present-day England. There is no reason to expect commercial theatre to take such considerations into account in choosing its repertoire. However, there is good reason to expect grant-aided theatre to do so. Indeed, by doing so it may also contribute to the other functions of drama listed above. Some argue that cultural activities that have conferred the most lasting benefits, and which have been seen in retrospect to have done most to illuminate their 'times', have more often than not served initially only minority interests (Federal Cultural Policy Review Committee, 1982).

Diversity in English theatre repertoire

Overview of the theatre sector in England

The commercial sector is dominated, at least in terms of revenue, by the West End theatres in London. The only other significant player in this respect is Apollo Leisure (UK), owner and operator of approximately 25 theatres based mostly in the northwest of England. The grant-aided sector consists largely of two components, at least in terms of public funds expended. The first consists of the national companies, the Royal Shakespeare Company (RSC) and the Royal National Theatre, as well as the Royal Court Theatre. The second is the producing sector of the English regional theatre, which consists of grant-aided theatres outside London as well as the 'local' theatres in the Greater London boroughs, for example the Lyric, Hammersmith.

The Arts Council of England (ACE) is the main state funder of the national companies, which receive about £23 million of the ACE drama budget of £30 million (Boyden, 2000b). ACE provides around £5 million to the regional producing theatres (around 70 per cent of them receive ACE funding). These theatres also receive further funding from the Regional Arts Boards (£16 million) and local authorities (£12 million), bringing their total direct state funding to £33 million.

In terms of the rest of the professional theatre sector, the Society of London Theatre (SOLT) is the employers' organisation for the approximately 50 commercial West End theatres in London, plus the national companies and the Royal Court Theatre. The Theatrical Management Association (TMA) mainly represents the grant-aided regional producing theatres but also covers some commercial theatres.

London also has numerous pub theatres, the most famous of which perhaps is the Bush, at Shepherd's Bush, which is an important home for new writing (Quine, 1998). There are also 120 touring theatres, of quite large scale, and some receive public funding.

The independent theatre sector is smaller and less formally organised than the other sectors. It includes the so-called Fringe (or, off-West-End theatre) which specialises in experimental work, and is often based in studio theatres and arts centres. Some independents receive state funding, but others receive none and are sustained on box-office income and voluntary labour. Given the lack of data, this sector is not covered in the later discussion on diversity of repertoire despite embracing work that is innovative and risk-taking with regard to repertoire. For further detail on the English theatre sector, see Feist et al. (1996), Quine (1999) and Travers (1998).

Perceived 'crisis' in English theatre repertoire

The Arts Council of Great Britain (ACGB), and its successor the Arts Council of England (ACE), have commissioned and produced numerous reports since the mid-1980s, which have drawn attention to a perceived crisis in English theatre related to the lack of innovation and risk-taking in theatre repertoire. The Cork Report stated that:

> *theatre in England is currently run on budgets which inhibit innovation and risk in the repertoire, the maintenance of permanent companies, the finest technical standards and casts of sufficient size to have diverse repertoires....*
> *...the narrowing down of the repertoires of many theatres shows that the original and desirable aims of public funding in promoting innovation, risk and diversity are slowly being submerged by practical considerations of short-term financial survival.*
>
> (Cork, 1986: 12)

The report also asserted that the wealth of British theatre is 'maintained and refreshed by the constant development of new playwriting and experiment in a variety of theatrical forms'. However, 'more and more, though, funding constraints have meant new plays must usually have limited cast requirements, if they are to be professionally presented, and that programming is tending to the safe and less adventurous' (Cork, 1986: 26).

Ten years later, the ACE policy document still maintained that:

> *drama in England is currently facing a major crisis as it struggles to survive under the weight of financial insecurity and threat of mounting debt.*
>
> *The pressure to generate earned income [is] forcing theatres to give priority to marketing and administration at the expense of the artistic programme.*
>
> (ACE, 1996: 2)

It claimed that: there had been fewer productions in 1994/95 than ten years previously; that there were much fewer home-based studio performances, with very serious consequences for experimental work and new writing; and there had been a marked increase in musicals at the expense of the 'play'.

The Boyden report of 2000 was even more pessimistic, especially in relation to regional producing theatres. It maintained that 'the capacity to build a healthy "research and development" component into programming has become financially constrained to the point of disappearance' (Boyden, 2000a: 13). It also argued that, across the creative industries, new writing is the primary process through which ideas are ordered as the basis of performance, and that:

> *financial constraints increasingly inhibit the 'traditional' commitment to new writing in studio spaces and ... regional producing theatres can only afford to commission with the intent of producing. They therefore tend to turn to the more established writers.*
>
> (Boyden, 2000a: 15)

The Boyden report was the starting point for ACE's development of a new national policy for theatre in England (ACE, 2000a). It contended that theatre had been inadequately funded since the mid-1980s and that this had:

> *produced an environment in which it has been much harder for artists and managers to take creative risks.... They have been unable to commission new work or take full advantage of new talent and the new resources offered by the 21st century.*
>
> (ACE, 2000a: 3)

It is clear then that the subsidised theatre sector believes that new writing and the innovative role of the grant-aided theatre sector are in need of serious upgrading. Is there any concrete evidence for this? This question is addressed in the rest of this section.

Data sources

Table 21.1 outlines the different types of repertory classification that are available using the different data sources provided by SOLT, TMA and ACE (Feist et al., 1996; Quine, 1999). The ACE categorisation, the first standardised classification system in the sector, has nine categories. The SOLT[1] and TMA classifications are compatible, as the twenty-eight TMA categories include the nine SOLT categories. Both the SOLT and ACE categorisations have nine

Table 21.1 Three categorisations of theatre work

Arts Council of England	Society of London Theatre (a) until 1998 (New categories from 1999)	Theatre Management Association
Postwar New work Translations Adaptations	Modern drama (*Plays*)	British drama up to 1956 Other-European drama up to 1956 Non-European drama up to 1956 British drama 1956 to 1979 Other-European drama 1956 to 1979 Non-European drama 1956 to 1979 British drama 1980 onwards Other-European drama 1980 onwards Non-European drama 1980 onwards
	Comedy (*Plays*)	Comedy
Musicals	Musicals (*Musicals*)	Modern musical Traditional musical
	Revue/variety (*Entertainment*)	Revue/variety/one-person show
	Opera/operetta (*Opera*)	Opera/operetta (excl. Gilbert & Sullivan) Gilbert & Sullivan
	Ballet/dance (*Ballet*) (*Dance*)	Dance – classical ballet Dance – contemporary Dance (folk/ethnic)
Children's	Children's shows (*Children's shows*)	Children's show Children's show (with educational context, esp. school/set-book value) Family show Pantomime
Classics Translations	Classical plays (*Plays*)	Classic British play (Classic = broad set-text status) (not Shakespeare) Classic other-European play Classic non-European play Shakespeare
Other drama Translations	Thrillers/other (*Plays*)	Thriller Other (not classifiable elsewhere)

Sources: Feist et al., 1996; Quine, 1999; Lidstone, 2000.

Note
Categories also used by the Society of West End Theatre (SWET).

categories, but SOLT includes 'opera', 'revue/variety', and 'dance', none of which is regarded as theatre by the ACE. It is difficult to integrate the ACE categorisation into the two other categorisations, as ACE does not include categories like 'comedy' or 'thriller'. While SOLT just has one category, 'modern drama', ACE distinguishes between 'postwar', 'new work' and 'adaptations'. SOLT divides drama into 'modern drama', 'comedy' and 'classical plays'.

1 This discussion refers to the classification system used by SOLT until 1998. Lidstone and Stewart-David (2000) outline the reclassified production categories used for 1999. The previous classification system has been simplified from nine to seven categories ('plays', 'musicals', 'opera', 'ballet', 'dance', 'entertainment' and 'children's shows'). Additionally, two other classification systems have been introduced. One is a classification by period of origin ('new', 'contemporary', 'modern' and 'classical'), which will allow identification of trends in new writing. The third classification will allow a more detailed analysis of current trends: 'comedy', 'Shakespeare', 'translations', 'adaptations', 'stand-up', 'thriller', 'transfer from subsidised', 'transfer from Broadway'.

The latest and most precise classification system is the TMA categorisation, which has several subdivisions. The strength of this system in relation to new work is that it distinguishes between 'British', 'other European' and 'non-European' drama, which is further divided into drama 'up to 1956', '1956 to 1979' and '1980 onwards'. Therefore, new work can be divided into three different categories (British, other European and non-European drama from 1980 onwards).

Various other questions related to 'new work' are raised by all three categorisations.

- Are new adaptations or interpretations of classical plays classified as 'classical plays' or as 'new work/modern drama'. The ACE classification is the only one using a categorisation of 'adaptation'.
- ACE data do not categorise translated new work as 'new work', but as 'translation'.
- In the case of musicals, only TMA data have a subdivision, 'modern musical'.
- The category 'other drama' in all three categorisations could also include new work.

Furthermore, there is some ambiguity around classifying modern comedies using SOLT and TMA data. The TMA has various subdivisions, whereas the relevant SOLT classifications would be 'comedy' or 'modern drama'.

While the TMA categories will be of use in the long term, given the unavailability of these data it is as yet impossible to chart trends. In marked contrast, the ACE classifications go back to 1971 and data are available in this scheme. The ACE data also relate to many of the theatres belonging to the TMA. Data on the SOLT classifications can be traced back to 1981, although some changes have been introduced. Consistent data since 1994 are readily available. Given that time-series data are available from SOLT with respect to repertoire diversity in the commercial sector, and from ACE with respect to the grant-aided sector, these categorisations are the subject of analysis in the next subsection of this chapter.

ACE provides detailed 'playlist' data for a large number of years, and these offer a rich source for repertoire analysis. Some preliminary findings are reported in the last subsection.

Diversity of repertoire in the theatre sector: Herfindahl Index

The Herfindahl Index is a measure of concentration, used widely in industrial economics. Applied to theatre repertoire (in this case the broad repertoire types provided by ACE and SOLT, as outlined in Table 21.1), the index is the sum of the squares of the percentage of productions of each drama category produced during a given period. A low index indicates high diversity, while a high index indicates more homogeneity in theatre repertory. For example, imagine that the theatre sector puts on 100 productions in a given season, with 50, 20, 20, and 10 productions of four different types. The Herfindahl Index in this case is simply the sum of the four percentages squared $(0.25 + 0.04 + 0.04 + 0.01) = 0.34$. If all of the productions were just Type 1, the index would be 1.00. The extreme opposite case

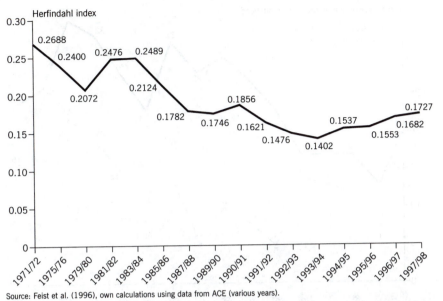

Source: Feist et al. (1996), own calculations using data from ACE (various years).

Note: Calculation of the index was based on the work classification in relation to the number of productions (not performances, as in Figure 21.3).

Figure 21.1 Diversity in grant-aided theatre: Herfindahl Index, 1971/72–1997/98

would be where there were 100 possible different types of play and each of the 100 productions in the season represented a different type of play; in this case the value of the index would be 0.01. It would be possible to have 100 or more different categories, if a given play was the unit of analysis rather than using broad play types, as here, as the unit of analysis.

In Figure 21.1 the Herfindahl Index for the grant-aided sector can be seen over the period 1971 to 1998 (some of the raw data are presented in Table 21.2). While no marked trend is evident, if anything there has been a move towards higher diversity over the period as a whole, with the value of the index declining. This of course is a crude and very general measure and is applied to data the limitations of which have already been discussed. Nonetheless, it provides cause for thought, precisely because it does not confirm the general impression conveyed in the industry that diversity is on the decline.

Figure 21.2 plots the share of new work, and new work and adaptations, as a proportion of total productions over the period in question. And, again, it supports the view that innovation, at least as measured in this way, was not on the decline. The figure shows a marked drop in the proportion of new work in total productions in the 1980s, but since then the share has risen significantly.

In Figure 21.3 the Herfindahl Index has been calculated for SOLT theatres, again in relation to the broad work classification seen in Table 21.1, for the time period 1994 to 1998. The tentative picture here is one of decreasing diversity, in line with common perceptions. However, the time period is very short and once again the data are open to question, as discussed above. Nonetheless, diversity, as measured in this way, has if anything been on the decline in SOLT theatres.

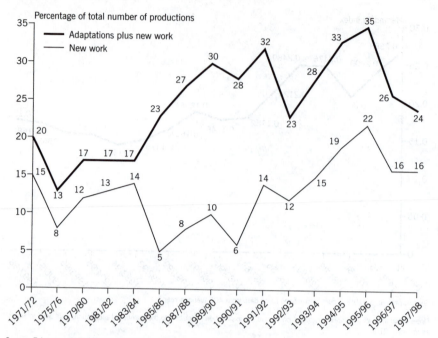

Source: Feist et al. (1996), own calculations using data from ACE (various years).

**Figure 21.2 New work and adaptations in relation to all drama productions,
1971/72–1997/98**

Diversity of repertoire in individual theatres: DiMaggio/Stenberg Conformity Indices

In the case of this measure, the theatre rather than the play or play category is the unit of analysis. For each theatre in a fixed period, a conformity index is constructed. This index is the mean number of times that all theatres in the sector produced each play produced by the given theatre in the given period. A score of

Table 21.2 Production analysis for building-based theatres, 1971/72–1997/98 (%)

	1971/72	1975/76	1981/82	1985/86	1990/91	1995/96	1997/98
Adaptions	5	5	4	18	11	13	8
Ayckbourn	1	3	6	5	4	2	1
Children's	6	7	7	6	9	14	16
Classics	18	20	14	8	10	7	9
Musicals	4	8	7	16	18	7	6
New work	15	8	13	5	12	22	16
Postwar	45	42	44	37	25	23	31
Shakespeare	6	5	5	5	4	6	8
Translations	–	–	–	–	7	6	3
Total	100	98	100	100	100	100	99

Source: Feist et al. (1996); authors' own calculations using data from ACE (various years).

Note: Based on analysis of all productions (home-based, joint, tours-in and studios, where applicable). Latest playlist 1998/99 does not categorise productions according to ACE categories.

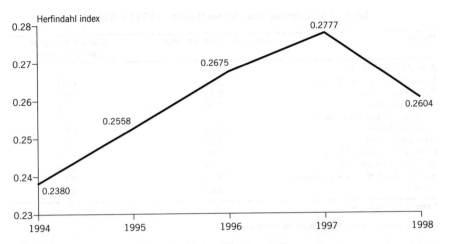

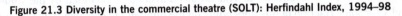

Source: Feist et al. (1996), own calculations using data from ACE (various years).

Note: Calculation of the index was based on the work classification in relation to the number of productions (not performances, as in Figure 21.3). The SOLT classification has changed for Box Office Report 1999. Therefore the result for 1999 cannot be compared with that for previous years. The Herfindahl Index for 1999 is 0.399 using the new work classifications.

Figure 21.3 Diversity in the commercial theatre (SOLT): Herfindahl Index, 1994–98

1 means that no other theatre produced any of the plays in that theatre's repertoire, implying a very low level of conformity. A score of 21 would mean that on average 20 other theatres produced each play in that theatre's repertoire, implying a much higher level of conformity.

A simplified hypothetical example, using the playwright rather than the play, illustrates the measure. Assume Theatre 1 had 40 productions during the period, based on the work of just four playwrights. Assume that the number of theatres (including the theatre in question) that produced plays by these playwrights is as shown in the box below. This indicates for example that 19 other theatres also produced plays by Shakespeare, four produced plays by Ayckbourn, and so on. The average, or conformity index, for each theatre gives some indication then of how conformist or otherwise that particular theatre has been relative to the sector as a whole.

The number of theatres could, of course, change over time, or the time period to which the measure is applied could vary. Thus, for comparative purposes, over time this average needs to be adjusted by the number of years to which the data apply and the total number of theatres operational in the period in question. Thus, if there

Plays produced by other theatres			
Theatre 1:		**Theatre 2:**	
Shakespeare	20	Miller	14
Ayckbourn	5	Bennett	11
Christie	1	Austen	15
Godber	2	Williams	20
Average	8	Average	15

Table 21.3 Conformity index for ten theatres, 1995/96–1996/97

Theatre	Average or conformity index	Adjusted average or conformity index
Almeida Theatre London	7.00	0.04
Birmingham Repertory Theatre	9.64	0.05
Bush Theatre London	2.42	0.01
Chester Gateway	7.50	0.04
Cottesloe Theatre, RNT, London	4.18	0.02
Derby Playhouse	11.92	0.06
Harrogate Theatre	9.82	0.05
Leicester Haymarket Theatre	9.00	0.05
Royal Court Theatre London	1.69	0.01
Stratford Royal Shakespeare Company	22.00	0.11
Average	8.52	0.04

Source: ACE (various years).

Note: The calculations are limited to home-based productions.

were for example 50 theatres in the comparator group and the data covered two years, then the adjusted average or conformity index in the case of Theatre 1 would be 0.08, and 0.15 for Theatre 2. This adjusted average is bounded by the values 0 and 1 (or some fraction of this depending on the number of years used). For example, if every other theatre produced plays by the same playwrights used by Theatre 1, the adjusted conformity index would be 1, whereas if no other theatre produced plays by any of the playwrights used by Theatre 1, the adjusted conformity index would be close to 0. Thus, the lower the value of this index, the less conformist would be the theatre in question.

Using ACE playlists data on the grant-aided sector, it is possible to calculate these indices in very crude form. This is done below for a sample of ten grant-aided theatres in England over the periods 1995/96–1996/97 and 1997/98–1998/99. Four theatres in London and six theatres outside London were chosen (see Table 21.3). The programming was measured for each theatre in relation to the programming of all 97 grant-aided theatres listed, by comparing the productions by playwright.

The Bush Theatre and the Royal Court Theatre are the theatres with the lowest conformity indices, while the Royal Shakespeare Company has the highest conformity indices in both periods. This is not surprising, given the remit of the RSC and the way conformity is being measured here. As the Bush Theatre and the Royal Court Theatre are known for new writing and experimental theatre, it is reassuring perhaps to see that the conformity indices appear to confirm this, at least indirectly. As may be seen (Tables 21.3 and 21.4) there is considerable variation in the adjusted index across theatres, for both periods.

It is possible to detect a small drop in conformity across the ten theatres in question over the period shown in Tables 21.3 and 21.4 (see averages). For seven of the theatres, the conformity index declined. Only in the case of one theatre did it increase. This confirms the trends seen above using the Herfindahl Index for the grant-aided sector as a whole.

There are of course huge limitations to these measures (Castañer, 2000; DiMaggio and Stenberg, 1985a). In the case of this exercise, they are applied to

Table 21.4 Conformity index for ten theatres, 1997/98–1998/99

Theatre	Average or conformity index	Adjusted average or conformity index
Almeida Theatre London	4.90	0.03
Birmingham Repertory Theatre	7.33	0.04
Bush Theatre London	1.09	0.01
Chester Gateway	6.38	0.03
Cottesloe Theatre, RNT, London	5.75	0.03
Derby Playhouse	7.92	0.04
Harrogate Theatre	6.23	0.03
Leicester Haymarket Theatre	5.08	0.03
Royal Court Theatre London	2.50	0.01
Stratford Royal Shakespeare Company	11.00	0.06
Average	5.818	0.031

Source: ACE (various years).

Note: The calculations are limited to home-based productions.

playwrights and not plays. This means that new plays by the same playwright are not being picked up; and that the emphasis is on new playwrights rather than new plays. As mentioned above, the measures are not sensitive to variation in performance style. Conventional and experimental productions of the same play are treated identically. It may be that non-conformity in terms of the selection of playwright is positively associated with non-conformity in terms of theme and style of performance – neither of which is so amenable to measurement. Many people would regard diversity of repertoire as important in its own right, as it provides an index of the ability of playwrights to have their works produced, criticised and thus entered into the dramatic literature.

Measures to increase new work in theatre repertoire

Co-operation between grant-aided and commercial sectors

Commercial and grant-aided theatre have been totally interdependent for decades.

(Mackintosh, 1995/96: 12)

What is vital … is the link between subsidised and commercial theatre.
(Lamour, cited in Tait, 2000: 14)

Problems in the grant-aided sector are of almost as much concern to the commercial sector as to the grant-aided sector itself. Because the grant-aided sector tends to be the source of innovative work, particularly new writing, in some ways it is the 'lifeblood' of the commercial theatre. Besides, the grant-aided theatre sector is conventionally regarded as the crucial production line of talent for the wider creative industry in relation to acting, writing and directing. However, the current financial situation of the grant-aided sector makes it difficult to maintain staff, with talent drifting away to the better and more regular-paying commercial

theatre, film and television industries. Furthermore, it can be difficult to entice good actors to leave London due to the better income opportunities in television. There is, of course, a two-way flow of artistic, technical and production staff, although the flow from the grant-aided sector is far stronger than vice versa (Boyden, 2000a; Cork, 1986; Quine, 1998). The commercial sector clearly recognises these links, and in 1999 SOLT commissioned a report on new writing (Cogo-Fawcett, 2000).[2]

There are three ways in which the grant-aided and commercial sectors might attempt to exploit the links between them. First, the grant-aided sector might concentrate more on new plays with a greater potential to transfer to the commercial theatre or television. Secondly, productions could be co-financed by the grant-aided and commercial sectors. Thirdly, there is the question of 'untied' funding of the grant-aided sector by the commercial sector. These three possible measures are dicussed below.

Transfers

Successful productions in the grant-aided theatre sector can, and do, transfer to the West End where they are commercially exploited. The Royal Court Theatre, the Donmar Theatre, the Hampstead Theatre, the King's Head Theatre, the Almeida and Theatre Royal Stratford East are all examples of London theatres with successful productions which transferred to the commercial West End. Theatre Royal Stratford East, which produces work primarily for its local community, has also had several productions transferred to the West End, Broadway, television and film (National Campaign for the Arts, 1998). Outside London the regional theatres in Birmingham, Leeds and Manchester have important links with the commercial sector (Cogo-Fawcett, 2000; West, 2000).

The Almeida and the Donmar have produced West End hits that have attracted Hollywood stars like Nicole Kidman and Kevin Spacey (Tait, 2000). Both theatres have attempted to exploit commercial opportunities more efficiently than other small theatres, even despite taking high risks by producing new writing. Their success, according to Thorncroft (1998), is arguably due to their imaginative, risk-taking, artistic directors (Jonathan Kent and Ian McDiarmid at the Almeida and Oscar-winning Sam Mendes at the Donmar), and in their modern and actor-friendly theatres which operate on financial tightropes.

Many writers for TV and film started their career in the grant-aided theatre sector. The Bush Theatre, a major home for new writing, and the Soho Theatre, which is devoted to finding and nurturing new playwrights, are good examples of this (Tait, 2000; West, 2000). The danger of course in targeting a possible transfer to the commercial theatre sector is that the grant-aided theatre might adopt 'commercial-style productions' and thereby neglect the other functions of grant-aided theatre (discussed above).

2 In July/August 1999 around 115 regional theatres and theatre companies were visited and this was followed later in 1999 by a symposium at which around 100 members of the entire sector attended (SOLT, TMA, the independent sector, Writers' Union and Equity) (Cogo-Fawcett, 2000).

Co-productions

Co-productions enable commercial theatre to exploit the financial subsidy of the grant-aided theatre by receiving a product which has been developed and tested in grant-aided theatre, at a reasonable cost. The grant-aided theatre sector exploits the potential contact and earning power of the commercial theatre by presenting its work to a wider audience, in the West End and nationally. Even though such co-productions involve considerable risks, many think they can be very beneficial for both theatre sectors if the interests of both are protected (ACE, 1996; Boyden, 2000a; Cork, 1986; Quine, 1998).

In practice, there are still relatively few co-productions. A danger for grant-aided theatres is that they may lose their identity and purpose by exploiting commercial production partners (ACE, 1996; Quine, 1998). Specialist management, experienced in both making deals and production control, and with a certain distance from the production, is necessary to co-produce successfully since the grant-aided theatre sector lacks the experience to deal with commercial producers. It may, therefore, be necessary for the Arts Council and the regional arts boards to establish guidelines together with the commercial theatre to support the development of such partnerships (ACE, 1996; Boyden, 2000a).

Most of the successful partnerships between grant-aided and commercial theatres have been in London. The Ambassador Theatre Group has co-operated with the Royal Court, while Associated Capital Theatres works closely with the Donmar and the Almeida, both of which offer challenging drama (Thorncroft, 1999). Ambassador, arguably the most pro-active commercial theatre for co-productions, has produced several successful co-productions with the Royal National Theatre (Cogo-Fawcett, 2000; West, 2000).

Financial contribution from commercial sector

If the commercial theatre sector and television and film companies benefit from the grant-aided theatre sector, it could be argued that they should recognise this by supporting the latter. It has been suggested that television companies should pay a certain proportion of their licence fee to a fund for the grant-aided theatre sector which would be administered by the Arts Council's drama department (Cork, 1986). Another option is to set up commercial R & D trusts to support the grant-aided theatre sector in developing innovative work. There are already several trusts in existence, but it is argued that these provide ad hoc support and not continuous long-term support. These trusts would have the potential to be R & D trusts if they received more financial support (Cogo-Fawcett, 2000; West, 2000).

The Theatre Investment Fund is one such trust. A registered charity, its aim is to ensure the long-term health of the commercial theatre by encouraging new producers and by investing in their talents. It not only finances commercial productions, but also gives advice and support. A key drawback is the limited financial contribution of the SOLT members (ACE, 1996; Cogo-Fawcett, 2000; Theatrenet, 1996). Another trust is the Mercury Workshop (formerly the Cameron Mackintosh Foundation), the only writer-based organisation. Small in size and geared towards musical production, the Mercury Workshop finances only one

production per year. The organisation runs a development programme, stages workshops and collaborative productions to nurture new work, and organises seminars, conferences and discussions aimed at furthering the cause of musical theatre (Cogo-Fawcett, 2000; Theatrenet, 2000). There is, however, no available evidence to show how effective these models are.

ACE policy measures

As suggested above, a strong case still needs to be made that a key role for improving innovation and repertoire diversity in the output of English theatres should rest with the state funding agencies. ACE's preparations for a national policy for theatre in England acknowledged the need for supporting risk and experimentation. A national policy has been confirmed and funding decisions will take effect from 2002/03, increasing the total budget for theatre to 72 per cent between 2000/01 and 2003/04 (ACE, 2001).

In developing a national theatre policy, ACE acknowledged the need to develop a culture of innovation and risk with an emphasis on support for new work. It accepted that it should 'encourage more new work, including new writing, for theatre and the wider creative industries' and encourage the production of 'culturally diverse patterns of live performance from artists and companies who represent multi-cultural Britain' (ACE, 2000a: 8). In particular, it proposed that increased funding, and/or changes in the allocation of funding, would lead to up to 200 new productions commissioned each year, new writing, new work and workshops across all scales and communities, a culturally diverse pattern of live performance and a diverse range of work more fully toured and exploited. The emphasis is, thus, clearly on diversity, in all of the dimensions discussed above.

A similar, albeit less marked, emphasis on diversity characterised ACE's previous policy (ACE, 1996). And, the short-lived Arts for Everyone (A4E) Lottery programme (launched in 1996) provided one-off revenue grants for a whole range of new creative arts projects. But the available data, based on the ACE's new-work indicator for the English grant-aided theatre sector, show no significant impact on the production of new work in drama since then (Figure 21.4). The criteria that ACE developed for its 'new-work indicator' count commissions of new work created as the result of funding and intended to be presented at some future date. To date, neither new translations nor new productions are included. The work is counted for the year in which the funding is made available, as opposed to when it is presented. Commissions made possible by project or development funding are not included in the data (Hacon et al., 2000).

In fact, the number of commissions for new work in drama and mime actually dropped between 1996/97 and 1997/98 from 287 to 220, but increased in 1998/99 to 302. The number of performances dropped over these three periods.[3]

3 These performance numbers are always taken from a constant sample of grant-aided theatre companies. Taking a constant sample of 88 organisations, performance numbers dropped from 25,055 to 21,178 between 1996/97 and 1997/98. Between 1997/98 and 1998/99 the number of performances decreased from 22,013 to 21,292, taking a constant sample of 87 organisations (Hacon et al., 1998; 2000).

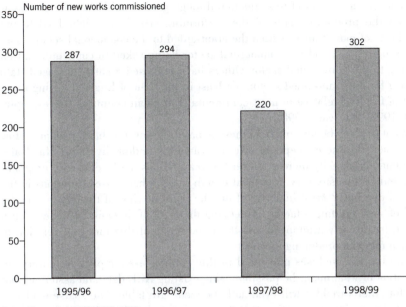

Source: Hacon et al. 1997; 1998; 2000.

Figure 21.4 New drama works commissioned, according to the ACE new-work indicator, 1995/96–1998/99

The new-work indicator is not an ideal measure of innovation, as it counts commissions created (not necessarily performed in the year) and excludes new productions and translations (Evans, 2000; Hacon et al., 1997; 1998; 2000).[4]

Conclusion

The English theatre sector is a diverse and complex network of theatres, showing a robust performance in terms of attendance and revenue statistics (Quine, 1999). But, various commentators, as well as the Arts Council itself, perceive a financial and artistic crisis in the sector which inhibits the grant-aided theatre sector in fulfilling its R & D function and forces many theatres into safe programming. This phenomenon is not limited to drama in England, but has been identified in other performing-arts sectors in other countries. For example, the following criticism was made recently of American orchestral repertoire: 'The orchestral landscape in America has been levelled to its lowest denominator by the market place, as safety in programming seems to be more important than artistry' (Ruhe, 2000).

4 In 2000, ACE was awarded an extra £25 million per annum funding for drama, starting in 2003/04 (ACE, 2000b). The increase is dependent on the theatre community and the regions coming up with imaginative and dynamic proposals which genuinely revitalise theatre in England.

Some see a way out of this situation through greater public/private co-operation on the production side of the performing arts. This might lead to the possibility of more transfers from the grant-aided to the commercial sector, more joint productions, and the commercial sector being asked to contribute untied funding to the grant-aided sector. Others have proposed greatly increased state funding for the grant-aided sector, not least in the light of England having a low level of funding relative to most continental European countries (for example, Feist, 1998; O'Hagan, 1998).

What tends to be missing from these debates, however, is hard evidence. How do we measure the concepts of safe programming and/or diversity? Has 'safe' programming actually increased over the years? Does the level of safe programming and/or diversity vary from theatre to theatre? What causes variations in the level of diversity? Most important from the point of view of this study – is the level of state funding a factor influencing the level of diversity? (Austen-Smith (1980) is an early attempt to test the importance of this factor in relation to English regional producing theatre.)

The limited analyses presented in this chapter are simply exploratory, an indication of what might be possible using existing ACE data and assuming that data for other variables will eventually be made available. The sparse evidence provided here does not confirm that the artistic vitality of English theatre (to the extent that vitality is related to diversity in the repertoire offered to the public) has been in decline over the last few decades. The evidence, in fact, points to the contrary. Much more work, however, needs to be done before firm conclusions can be reached. There is almost no quantitative analysis of what factors determine the level of conformity in programming across theatres. Available evidence for the US shows that the level of state funding makes a difference, but that other factors also count (Castañer, 2000).

Policies designed to increase diversity and experimental work may, in practice, conflict with other objectives of drama policy, such as providing training and employment to actors or providing wider access to theatre for the general public. Achieving both sets of objectives is one of the most intractable and complex tasks facing policy-makers in the cultural sector, not just in the case of publicly funded drama, but across the whole spectrum of the arts.

22

Art Trade and Government Policy

Clare McAndrew, Trinity College Dublin

Introduction

The UK is home to the largest art market in Europe, rivalled only by New York as an international centre of trade in art. Trade has flourished, not least because of the predominantly free-market ideology present in the UK since the 1980s. The British government regulates trade in art, and the measures it takes affect trade. But, its approach is liberal, and its promotes free trade in all but the most important national-heritage works. Restrictions prevent art of the national patrimony leaving the UK. However, these are applied only to a small and narrowly defined group of art objects. In anticipation of VAT changes being introduced, there have been fears that factors such as the increased costs and 'red tape' associated with regulations imposed by the European Union in the art market may slowly tip the balance of trade in art towards New York, Switzerland or elsewhere outside the EU as vendors try to avoid the higher costs of selling in London.

Policies adopted by the government directly and indirectly affect trade in art, and this chapter provides an overview of government intervention and its effects in the UK art market. The first section examines the various government measures in place in the market. It considers those measures designed to protect the British national artistic patrimony, namely export restrictions and tax incentives. These all directly or indirectly restrict the export of these art objects from the UK. However, they apply to only a very small fraction of the market. Other regulatory measures, such as VAT and Droit de Suite, that affect contemporary and other non-patrimony art sectors, are also considered. These measures affect the entire traded sector of the art market in the UK and are, consequently, of concern to art traders given the increasing pressure for harmonisation with other more restrictive EU markets. The second section describes the UK art market in terms of size, turnover and trade and considers how and to what extent the various measures outlined affect the UK art trade, and also the possible future ramifications of EU-imposed regulations. The third and final section concludes the chapter.

Intervention measures in place

Governments influence trade in art through direct trade restrictions as well as through domestic policies affecting art flows. The most important of these measures, and their application in the UK, are discussed below.

Export restrictions[1]

Export regulations are the most common form of government intervention in art markets. The Treaty of Rome guarantees free trade in all goods and services within the Single Market. However, works of art are given a special exemption under Article 36. Under this article, Member States are allowed to adopt or maintain prohibitions, restrictions, or measures of equivalent effect on the import, export or transit within the EU of national treasures having artistic, historic or archaeological value (Biondi, 1997). Each state can define their own national treasures and then adopt suitable action to protect them.

The UK has adopted one of the most lenient systems of export regulation in Europe to encourage the free trade in all but the most exceptional objects of national-patrimony art. As a general rule, an application for an export licence is required if goods are over 50 years old at the date of export and over a specific value relevant to their particular category. If an object is valued above these limits, an export licence must be sought from the Department for Culture, Media and Sport (DCMS) which consults with expert advisers to decide either to grant the licence or to recommend its refusal. In practice, expert advisers object to licence applications relating to as few as 25 to 50 objects each year out of a total of around 3,000–4,000 applications referred to them (DCMS, 1998).[2] Where they recommend refusal, the application is referred to the 'Reviewing Committee' that must judge on the basis of the same pre-specified criteria whether the licence should be granted or further steps taken to assess whether export should be restricted.

The criteria used are known as the Waverley Criteria and are designed to determine whether the object is of sufficient national importance to delay or deny export.[3] If it is decided that the object sufficiently meets the criteria, the export

1 See McAndrew and O'Hagan (2000) for a full discussion of measures to protect the British artistic patrimony, and O'Hagan and McAndrew (2001) for a discussion of the rationale for protecting the national patrimony.

2 To reduce the need for applications for specific licences being put forward for every art export, the DCMS also operates a system of 'open individual export licences' and 'open general export licences', both of which allow export of items without a licence. The latter give blanket permission for certain items, even if over 50 years, to be exported, and largely include those exported under an EU licence or for which an EU export licence is not required. In practical terms, the prime grantees of such licences are the major auction houses of Christie's and Sotheby's which can export any art objects imported less than 50 years ago without further formality.

3 The three criteria are: is the object so closely connected with the nation's history and current life that its departure would mean a misfortune for the nation?; is it of outstanding artistic and aesthetic importance?; is it of outstanding significance for the study of some particular branch of history, art or learning? (Greenfield,1995)

licence is not refused outright but a delay period is given – generally of two to six months – to allow an offer at or above the fair market price from the state, a public body or some other private domestic source to come forward. It is an important feature of UK law that the right to deny an export licence is not absolute and can only be upheld if a bona fide offer is forthcoming from a domestic collection within the specified delay period. An owner refused a licence is not obliged to sell the object at any price but only to keep it within the UK. In the past this has enabled exporters simply to wait a few years and re-apply, once values have risen to a point where no museum bid is feasible. If the delay period elapses and no offer is made, a licence must be granted. However, occasionally and in exceptional circumstances, the period of licence suspension may be extended to allow time for national public bodies to raise necessary acquisition funds. Concern does remain however in the few isolated cases such as the proposed *Three Graces* sale that, while the Waverley system works effectively in selecting appropriate national-patrimony works to protect, lack of national funds may prevent proposed export controls working satisfactorily.[4] Rights of pre-emption allow a delay period to try to raise funding, but export restriction in the UK can be used only if there are eventually funds available to buy objects considered to be national treasures. Such funds are more difficult to raise when international art prices are high.

A survey of the financial year 1993/1994 (Casey et al., 1996) found that public, EU and private funding of the 'visual arts'[5] amounted to £619 million (of which £286 million came from the Department of National Heritage (DNH)) and from this a total of £42.5 million was specifically earmarked as assistance towards the purchase and acquisition of objects by museums and galleries. Since this survey year the National Lottery has given up to 20 per cent of its net marginal annual revenue to the National Heritage Memorial Fund for distribution to national heritage concerns via the Heritage Lottery Fund (Chapter 16). Amongst other things, the Fund provides financial assistance for the acquisition, maintenance or preservation of artworks of outstanding importance to the UK national heritage. The Heritage Lottery Fund provides money directly to museums and galleries to purchase artworks of artistic and historic interest and importance on the condition that they also raise part of the funding elsewhere.

Tax incentives

The main tax breaks offered in the UK relating to the arts are discussed in Chapter 15. There are, however, specific tax incentives aimed at preserving nationally important works of art within the UK and discouraging their export abroad. These provisions mainly concern capital tax deductions for donations

4 In this particular case the sale to the Victoria and Albert Museum was secured only after a major fundraising campaign. The final funds involved a large grant from the National Heritage Memorial fund, significant donations from J P Getty II and Baron Thyssen, £0.5 million from the National Art Collections Fund and £0.1 million in smaller-scale public and private donations (Casey et al., 1996).
5 Defined in the survey as visual arts, crafts, art trade, museums and galleries and the national collections.

and bequests toward the national heritage and are intended to account for superior prices on international markets, versus those available in the UK, by providing additional fiscal incentives to retain artworks domestically. Under the Taxation of Chargeable Gains Act 1992, Inheritance Tax Act 1984 and the Finance Act of 1998 there are three forms of tax relief all aimed at protecting and preserving the national heritage but working through different channels. Provision for private treaty sales provision, acceptance-in-lieu and conditional exemptions are all discussed below.

Private treaty sale

Under the provision for private treaty sale provision, an object can be sold to certain listed institutions in Schedule 3 of the Inheritance Tax Act 1984 and the taxes due, such as capital gains tax and any previously conditionally exempt inheritance taxes, can be avoided.[6] This incentive covers a rather broad range of items as it allows freedom from tax on private treaty sale given that the object is of 'exemptible quality', and meets the relevant criteria under the Inheritance Tax Act of 1984 which are not as high a standard as the other tax exemptions to be discussed. The criteria in the Act state that the object must be of national, scientific, historic or artistic interest or historically associated with a building of outstanding historic or architectural interest and generally of good enough quality to display in a public collection. The private treaty sale dispensation is generally available only in relation to capital gains on private sales, that is, where the vendor is an individual rather than a company, and it is not available if the acquiring institution purchases at auction (Manisty, 1996).

The system is beneficial to both the purchasing institution and the seller due to the method of price determination. The acquisition price for the institution is determined by first subtracting the tax due from the normal price the item would obtain on the open market and then 25 per cent of the total tax saving is added to determine the final purchase price. This additional 25 per cent is called a 'douceur' (literally a 'sweetener'), as it sweetens the purchase price offered to the seller, and the acquiring institution also gains through an improved purchase price over that available on the open market.[7] Some problems arise in the workings of this system. First, establishing an accurate price base or market value can be difficult. Second, the extent of the douceur is flexible up to 25 per cent, and debates over its level and fixity are recurrent; for low-valued items, 25 per cent may not provide sufficient inducement to sell under private treaty sale, and for high-value items it might not be necessary to offer so much. Finally, museums may still be unable to afford the reduced purchase price and works may still be lost to higher-bidding international buyers.

6 Schedule 3 bodies cover a broad range of institutions. It is also possible to manipulate the system to enable an even broader range than that included under the Schedule (see Manisty, 1996).

7 The douceur for heritage land and buildings is only 10 per cent. For a thorough discussion of tax and other government policy in relation to the built heritage in the UK, see Creigh-Tyte (1998).

Acceptance-in-Lieu

If inheritance tax or capital transfer tax are due on an asset or estate, donations of certain works of art to the state allow taxpayers to discharge their tax debt. If approved by the Secretary of State for Culture, Media and Sport, works of art can be given in lieu of taxes on estates and properties within them due on transfer, and the object itself is also tax-exempt.

The value (V) or implicit price of the work is calculated in the same manner as for private treaty sale (V = price less tax + 25 per cent douceur), which is a relatively attractive deal for the donors as again the price may be better than that available on art markets, less taxes, and they may have the added advantage of recommending where the object is placed. Occasionally it will be allowed to remain in situ, in which case it is legally state-owned and effectively on loan. Minimum public access and conservation requirements are attached to in-situ offers of acceptance in lieu of tax (Manisty, 1997). Most commonly, however, it is actually transferred to the Inland Revenue and institutions will bid for it with the Secretary of State for National Heritage deciding to which it will be sold.

Again, the state gets to keep the work in the UK and at an acquisition price less than that on open markets. But in this case the Inland Revenue has a significant cost in that no tax is paid on the transfer of the object; in addition, a percentage of the value is offset against other estate and property taxes. Because of this, the state is more particular about what items it will accept in lieu of taxes. To be considered they must be both museum-worthy and pre-eminent in their own right or as an addition to a collection.[8] Once advice has been given by relevant experts and the then Museums & Galleries Commission (now Resource), the final decision-making is carried out by the Inland Revenue and appropriate ministers – usually those attached to the DCMS.

Until the mid-1980s, a major problem with the scheme was the ceiling (or limit) placed on what could be accepted in lieu. The Office of Arts and Libraries' budget allocated for reimbursing the Inland Revenue was kept at £2 million. This changed in July 1985 when Lord Gowrie obtained the provision for access to a 'contingency fund' for large important items taken from the Public Expenditure Reserve of up to £10 million per year. The Finance Act of 1998, however, has removed the need for the present DCMS to reimburse the Inland Revenue for the amount of tax forgone (Creigh-Tyte, 1998).

Despite early problems, this incentive now makes up a significant part of the value of the works acquired by the state. There have also been suggestions to extend and expand the incentive, such as by allowing tax credits that can be set against future tax liabilities when the value of important items, or especially collections, exceeds the tax to be satisfied.

8 Guidelines developed in classifying objects as pre-eminent are: does the object chosen have a particularly close association with our history and national life? (this includes foreign works); is the object of especial artistic or art-historic interest?; is the object of especial importance for the study of some particular form of art learning or history?; does the object have an especially close association with a particular historic setting? (Inland Revenue, 1986; Capital Taxes Office, 1999).

Conditional exemptions

Conditional exemptions, the most financially significant tax incentive, provide 'conditional exemption' from capital transfer taxes, estate duties, capital gains taxes and inheritance taxes, for those acquiring art by gift or inheritance.[9] To avail of these exemptions, certain conditions must be fulfilled.

- The work must be considered by the state to be of national artistic, historic or scientific interest. The 1998 Finance Act introduced the additional criterion that such interest should be of a pre-eminent nature, meaning that the object or group of objects concerned would make a pre-eminent addition to a national or local authority, university or independent museum (Capital Taxes Office, 1999).[10]
- It must also be deemed of sufficiently high quality to be displayed in a public collection, or be 'museum-worthy'.
- The owner must agree to keep the object permanently in the UK (unless given special permission by the Capital Taxes Office for temporary export for exhibition purposes).
- The owner must also agree to take reasonable steps to preserve and maintain the object and ensure reasonable access for the public either through allowing access in situ in private homes or through loan to a public institution for exhibition for at least 28 days of the year (subject to some leeway). Alternatively, under the 1992 legislation, details of the item and its whereabouts could be maintained at a National Art Library in the Victoria and Albert Museum or the Public Records Office where the public may consult records. The item must also be allowed to be viewed by appointment or, alternatively, be lent on request for temporary exhibition for not more than six months in a two-year period. The list of items is also available in libraries in Belfast, Cardiff and Edinburgh as well as via the Inland Revenue website. Changes introduced by the 1998 Act mean that there must be a measure of public access without prior appointment, or 'open access' under terms agreed with the Capital Taxes Office, the extent of which will vary depending on the nature and type of the asset, and its preservation and maintenance needs. The owner may charge a fee to view the work in most circumstances, provided it is in keeping with the owner's statutory obligations to provide 'reasonable access' (for instance, the charge must be 'reasonable' to the public at large).

The conditional exemption can be maintained if the work is donated to someone else and the new owner fulfils the same conditions and new pre-eminence or other criteria introduced by the 1998 Finance Act (or if the donation is to a tax-exempt collection, museum, etc.). However, if the object is sold publicly, the

9 In current conditions conditional exemption is relevant only for the latter two taxes – capital gains and inheritance taxes (although the two older exemptions are still relevant when items previously exempted in this way are sold).

10 The test used in the legislation is the same as under the acceptance-in-lieu scheme, and, again, certain objects of lesser standard may be accepted if they have a historic association with a listed building open to the public.

exemptions are revoked and full, including back, taxes are due. Owners are requested to give Resource three months' warning of intended sales, to allow UK public institutions to attempt to match the offer. Although this is not written into law, sellers can be sanctioned for non-compliance through export regulation – including placing indefinite stops on items of national importance.

VAT

In the EU, VAT on works of art is governed by the seventh VAT directive, Directive 94/5/EC, which outlines special rules concerning the taxation of second-hand goods, objects of art and antiquity and collections. It establishes the system of taxing the profit made by taxable dealers rather than the full price, that is, the difference between the selling price charged by the dealer for the good and the purchase price. This avoids double taxation: second-hand goods, including works of art, have already borne VAT when they were sold as new, therefore to apply VAT again on the full price amounts to double taxation, whereas this scheme ensures that VAT is levied only on the 'real' value added. This 'margin' scheme is available only to taxable dealers, and the rate of VAT charged is generally the standard rate applicable in each state – in other words greater than 15 per cent. In the UK, VAT is charged at the standard rate of 17.5 per cent under this scheme. The seventh VAT directive also introduced the origin principle to establish VAT rates due on the margin where the rate applicable is that of the state initiating the sale. The margin system also applies to sales by public auction such that VAT is charged on the auctioneer's fee and not on the value of the object.[11] This principle has been introduced with the seventh VAT directive which obviously places high-VAT countries at a disadvantage. Other things being equal, they should export less art, as buyers will have to pay a higher duty on purchase.

VAT rates charged on sales of works of art in the EU are shown in Table 22.1. Other states apply VAT at lower rates for works of art than the UK, most notably Germany, the third-largest market in the EU, which has 15 per cent VAT. These rates, however, are for intra-EU trade which makes up a small proportion of trade on the UK art market. For example in 1999, intra-EU imports made up only 6 per cent of imports of paintings to the UK whereas 94 per cent came from extra-EU destinations.

Table 22.1 also gives rates of VAT applicable to imports of works of art from third countries. Another important provision introduced by the seventh directive was that Member States can apply VAT at the reduced rate of at least 5 per cent. A special case was made for the UK, which was given a derogation until 6 June 1999 to apply a super-reduced rate of 2.5 per cent to imports of works of art. Prior to 1995, imports to the UK were tax-exempt and so the increase to 2.5 per cent, and more recently to 5 per cent, is considered detri-

11 According to the directive, sales between individuals are not subject to VAT nor to any formality throughout the EU, with the price paid once and for all at the place of purchase (European Commission, 1999).

Table 22.1 VAT rates due on works of art in the European Union

Member State	Import VAT (%)	VAT on margin scheme (%)
Austria	10(a)	20
Belgium	6(b)	21
Denmark	5(c)	25
Finland	22(d)	22
France	5.5	20.6
Germany	7	15
Greece	8	18
Ireland	12.5	21
Italy	10	19
Luxembourg	6	15
Netherlands	6	17.5
Portugal	17	17
Spain	7(e)	16
Sweden	12	25
UK	5	17.5

Sources: European Commission, 1999; MTIC, 2000.

Notes
a) 10% is the rate applied to imports outside the margin scheme. If imported items are sold within the scheme, 20% applies.
b) Dealers and artists' heirs are charged 6%, whereas 21% is the full rate of import VAT.
c) The taxable value of works of art and antiques is reduced on import to 20%, and then the standard rate of VAT is applied which means in practice an effective rate of 5% applies.
d) Works of art are exempt if owned by the artist.
e) For dealers only.

mental to the UK trading position, particularly in relation to the competing extra-EU markets of Switzerland and the US that effectively maintain zero VAT on imports.[12]

Those in the UK opposing the harmonised VAT directive claim that VAT, along with Droit de Suite, not only makes the EU as a whole less attractive to non-European vendors and increases costs for European collectors and institutions to buy on world markets, but that it is also largely ineffectual as a fundraising tax. Import VAT collected in the UK based on the 2.5 per cent levy rose from £6.9 million in 1996[13] to £15.4 million in 1999. One reason for the low funds raised by import VAT in the UK is the possibility for dealers to obviate some of the costs of the tax through the use of a temporary importation bond. This bond means that the work of art does not legally enter the country until the sale is actually made. Dealers may therefore avoid paying import VAT in line with UK tax law if the object is re-exported to a non-EU country within two years. The European Commission (1999) reports that the use of the temporary import arrangements in the UK increased by a factor of 13 between 1995 and 1998, and that a large majority of works sold by

12 Switzerland has an import VAT rate of 7.5 per cent for works of art. However, dealers can reclaim the full amount if they are able to show that the item has been resold and if they sold that item outside the margin scheme. According to MTIC (2000) this is what nearly all dealers elect to do, with the effect of a zero-rating import in most cases. Import VAT does not apply in the US. There are other taxes, however, placed on sales within the US, for example, New York has a sales tax of 8.5 per cent applied to the full sales value for works of art (European Commission, 1999).
13 Approximately £5.7 million was collected in 1995 but this was only for half the year following its introduction.

Table 22.2 Droit de Suite within the European Union

State	Rate	Basis	Threshold value	Collected	Type of transactions
Austria	None	n/a	n/a	n/a	n/a
Belgium	4	Sales price	>50,000 BF	Yes	Auction sales only
Denmark	5	Sales price	>2000 DKr	Yes	Auction and dealer sales
Finland	5	Sales price	>1500 FM	Yes	Auction and dealer sales
France	3	Sales price	>100 FF	Yes	Auction sales only
Germany	5	Sales price	>100 DM	Yes	Auction and dealer sales
Greece	5	Sales price	>100 Dm	No	Auction and dealer sales
Ireland	None	n/a	n/a	n/a	n/a
Italy	1–10	Margin	Varies	No	Not collected in practice
Luxembourg	3	Sales price	None	No	Not collected in practice
Netherlands	None	n/a	n/a	n/a	n/a
Portugal	6	Sales price	None	No	Auction and dealer sales
Spain	3	Sales price	>300000Pta	No	Auction and dealer sales
Sweden	5	Sales price	>1800 CS	Yes	Auction and dealer sales
UK	None	n/a	n/a	n/a	n/a

Sources: Christies, 1998; MTIC, 2000.

auction is covered by these arrangements. It should be noted, however, that there is still a cost to art dealers who use the scheme. Firstly they have to organise a bond facility with the UK authorities to the value of 5 per cent of the sum of the value of items they wish to bring into the country. Then, once the bond is fully utilised, if the dealer wishes to bring any more objects into the country under this scheme, they have to remove another item from the bond, or apply to increase the bond.

Droit de Suite

Droit de Suite, or resale royalties, are the rights of visual artists to receive a percentage of the revenue from the resale of their works in the art market.[14] In the EU, eleven of the fifteen Member States currently have this right, although it is effectively enforced in only eight. The UK, Ireland, the Netherlands and Austria do not have Droit de Suite legislation, and although Italy has had the legislation in place for over 50 years, no royalties have ever been collected. The right is typically inalienable, but transferable after the artist's death to heirs for up to 70 years. Table 22.2 summarises the current state of Droit de Suite in the EU.

For art traders the resale royalties function like a tax which they must pay to the artist, thereby lowering net proceeds to the seller while increasing the buyer's price.

14 See Schulze and McAndrew (forthcoming) and McAndrew (2000) for a comprehensive discussion of the rationale and effects of Droit de Suite.

This means that it is likely that trade will be diverted away from countries with Droit de Suite effectively enforced. This has been the main fear of those in the British art trade who have opposed the introduction of the royalty on a European-wide level. The possible trade distortion in the internal market caused by the absence of the levy in some Member States, together with the varying ways it is administered, led to the proposal to harmonise Droit de Suite within the EU. On 16 March 2000, after delays of four years primarily due to objections from the UK, the Commission formalised a proposal for the introduction of royalties on the basis of a sliding scale starting at 4 per cent for works of art over 4000 euros to 0.25 per cent on works worth over 500,000 euros or up to a maximum limit of royalties payable of 12,500 euros. It is applicable to all professional resales and can be transferred to heirs for up to 70 years after the artist's death. Directive 2000 EC on the Resale Right for the Benefit of the Author of an original work of art was put into place in 2001 and means that the UK will have to introduce royalties for living artists by 2005. The UK, Ireland, the Netherlands and Austria are allowed a ten-year derogation in implementing measures to extend benefits to artists' heirs.[15]

Impact on the UK art trade

The UK art trade

The UK is the most important art market in Europe, and the second-largest centre for trading art internationally. It is estimated that world art sales totalled nearly £6,500 million in 1998 (Art Sales Index, 2000; European Commission, 1999). The EU accounted for over 30 per cent of world sales at £2,020 million whilst the US share of international trade was 26 per cent. The UK is by far the largest market within the EU, with sales in 1998 of £1,043 million.[16] This represents 52 per cent of the EU art market and 16 per cent of the international trade in art (Figure 22.1). The UK has also been amongst the fastest-growing art markets internationally, with 91 per cent growth of sales from 1993/94 to 1998/99. This was slightly ahead of the US (which had 90 per cent growth) and nearly three times as much as any of the other major art markets (France had 9 per cent; Germany, 29 per cent; and Switzerland, 35 per cent).[17]

In 1999, exports of paintings amounted to over £637.8 million, an increase of nearly 5 per cent on the value in 1994. UK exports accounted for over 57 per cent of all paintings exported in the EU (to intra-EU and extra-EU destinations). The biggest destination markets for UK exports were the United States (69 per cent), Switzerland (18 per cent), Japan (2.5 per cent), and Germany (1.1 per cent) (Eurostat, 2000).

15 Claims to royalties from heirs account for around 90 per cent of all Droit de Suite applications (conversation with Jens Gaster, DG Internal Market, European Commission).

16 The only other significant art markets in the EU are France and Germany with sales of £654.7 million and £183.1 million respectively (32 per cent and 8 per cent of EU trade).

17 Growth rates are based on turnover figures from the Art Sales Index (2000) which quotes year-on-year sales turnover in nominal terms.

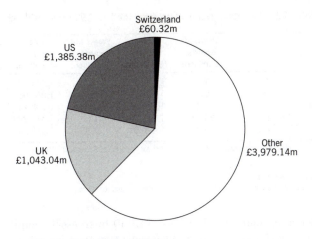

Source: Art Sales Index, 2000; European Commission, 1999.

Figure 22.1 World art market turnover (value of sales), 1998/99

The value of imports of paintings into the UK rose by 21 per cent between 1994 and 1999, to reach £652 million, representing 70 per cent of all EU imports. It is notable from Figure 22.2 that nearly all of this growth occurred in 1997/98, when imports increased by over 47 per cent following a steady decline up to 1996/97. The United States was the main source of UK imports at 68 per cent of total, followed by Switzerland (17 per cent), France (3 per cent) and Australia and Japan at under 2 per cent each.

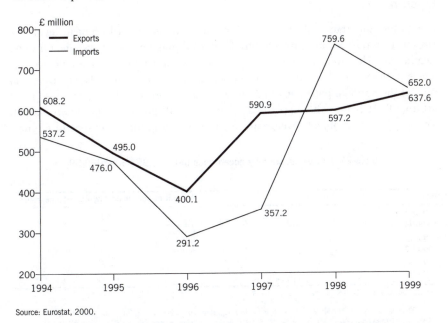

Source: Eurostat, 2000.

Figure 22.2 Value of UK imports and exports of art, 1994–99

Table 22.3 Exports of works of art from the UK, 1993/94–1997/98 (a)

Year	Licensed exports (£ million)	Unlicensed exports (£ million)	Works not exported (b) (£ million)	Total exports (£ million)	Percentage of exports unlicensed
1993/94	17.87	1,329.20	9.08	1,347.07	98.67
1994/95	9.13	1,259.93	9.37	1,269.06	99.28
1995/96	22.29	1,275.86	6.02	1,298.14	98.28
1996/97	23.32	1,289.00	1.56	1,312.28	98.22
1997/98	19.00	1,496.34	2.95	1,515.24	98.75

Source: Reviewing Committee on the Export of Works of Art, Annual Reports, 1993/94 and 1997/98.

Notes
a) The most recent data available.
b) Cases considered by the Reviewing Committee, deferred and then not granted a licence.

The art market consists of at least 11,950 businesses, employing 48,000 people. These businesses generated some £3.6 million in sales either directly through the art market or indirectly through the services sector supporting the trade. MTIC (2000) estimates that in the same year, the UK art market contributed at least £426 million to the UK's government finances – £130 million from the income tax of employees of the art trade, £193 million from company-profit taxes, £104 million from VAT on intra-EU art sales, and £30 million from import VAT on art and antiques.

Impact of regulations on the art trade

Export restrictions

Due to the importance of the art market nationally and at a European level, the UK has generally always promoted trade in art through a liberal system of trading regulations. However, there are a variety of ways in which the government intervenes in the art market, and all have a potential anti-trade bias. The measures to protect the national patrimony that are designed to prevent the export of works of art from the UK in reality apply to a relatively small proportion of the art market. The number of art objects even requiring the export-application procedure repre-

Table 22.4 Taxes satisfied by acceptance-in-lieu, 1993/94–1998/99

£ million

Year	Amount of tax satisfied by acceptance-in-lieu
1993/94	3.1
1994/95	6.2
1995/96	7.4
1996/97	2.2
1997/98	6.8
1998/99	25.3

Source: Department for Culture, Media and Sport, 1999.

Note: These figures include all cultural items accepted in lieu, e.g. stamp collection (£113,000), land (£57,920), vintage cars (£153,000), harpsichord (£10,500), racing cup (£15,400) (Reviewing Committee on the Export of Works of Art). However, paintings are by far the largest number of items in terms of quantity and value.

sents a very small percentage of the total exports of art from the UK. Table 22.3 shows that in the five-year period given, licensed exports were only a tiny fraction of total exports – less than 2 per cent of the total throughout.

Private treaty sales

Heritage tax exemptions also apply to a very specific and narrow range of items. The amounts of tax forgone in private treaty sales are not reported separately in the Inland Revenue's annual statistics. In a 1993/94 report, the National Heritage Memorial Fund reported that private treaty sales accounted for as little as £1.7 million. This could, however, be a significant under-representation of the total as only a relatively small percentage of such sales are assisted by the National Heritage Memorial Fund (Casey et al., 1996). The cost to the Exchequer from private treaty sales also fluctuates, often significantly, from year to year. For example, Creigh-Tyte (1998) reports the cost for this exemption at £2.8 million in 1994/95, and a large increase to £33.7 million in 1995/1996, but then a fall back to £2.1 million in 1996/97.

Acceptance-in-lieu

Table 22.4 shows a sample of the amounts of taxes satisfied by the acceptance-in-lieu scheme in the period 1993/94 to 1998/99, and how in practice this exemption accounts only for a very small amount in consideration of the volume of overall trade in art in the UK.

Conditional exemption

The conditional exemption is the most financially significant of the three exemptions, and, as seen in Table 22.5, can fluctuate greatly from year to year. There are often relatively few annual applications (and not all are accepted) and the considerable tightening of the qualitative criteria for acceptance of objects, and the introduction of the open-access clause in the 1998 Finance Act, also means that fewer items will be accepted and possibly fewer applications made for this exemption in the future. This could result in more sales abroad of important items that would have been exempted and hence retained prior to the introduction of the Act.

Table 22.5 Tax losses due to conditional exemptions on heritage works, 1993/94–1996/97

Year	Tax losses due to conditional exemption (£ million)	Total inheritance tax paid (£ million)	Percentage of exemptions in total
1993/94	136.8	1,333	10.3
1994/95	30.8	1,411	2.2
1995/96	42.5	1,518	2.8
1996/97	30.1	1,558	1.9

Source: Inland Revenue (various years).

Note
Figures include both conditionally exempt property and exempt transfers to national bodies.
1996/97 is the most recent data available.

Table 22.6 Year-on-year changes in the value of painting imports, 1994/95–1998/99

Year	Percentage change
1994/95	−11
1995/96	−39
1996/97	23
1997/98	113
1998/99	−14

Source: Eurostat, 2000.

VAT

VAT and Droit de Suite, by contrast, affect nearly all of the works of art traded on the British market. The full effects of the rise to 5 per cent of UK import VAT on the UK art trade remain to be seen. Import VAT was increased from zero to 2.5 per cent in 1994/1995, which coincides with the start of the decline in UK imports. The sudden growth in imports in 1998 could also be explained by the fact that this was the last year before import VAT was increased again to the EU minimum of 5 per cent. It could be possible that a significant factor in this rise was a rush by dealers and collectors to bring paintings into the country before the cost of doing so doubled. As Table 22.6 below shows, imports fell again in 1999, the first year of the introduction of 5 per cent VAT. The UK has always served as a gateway for foreign traders into other EU markets, consequently the rise in 1999 to 5 per cent could have diverted trade to centres without import VAT.

Droit de Suite

There are fears that EU harmonisation of resale royalties might not eliminate trade distortions, but only lead to different trade diversions – paintings would be traded in Zurich and New York instead of London. The extent of the diversion of trade caused by the introduction of the royalty is still a moot point. Opponents of the royalty, such as the British Art Market Federation, claim that by 2005 introduction of the royalty could lead to a loss of sales of as much as 78 per cent, or nearly £60 million per annum, and will put between 5,000 and 8,000 jobs in the art trade at risk (Browne, 2000). Others contend that the fears of the British art trade are exaggerated (European Commission, 1999). Whether and to what extent Droit de Suite diverts trade cannot be estimated, as the royalties for artists will not be in place until 2005, with a further derogation for heirs (often the main beneficiaries) until 2010.

At present, any estimates of the extent of trade diversion due to Droit de Suite are hypothetical. However, some indications can be gained from considering the

Table 22.7 Average auction sale prices, 1993/94–1999/2000

£ nominal

	1993/94	1994/95	1995/96	1996/97	1997/98	1998/99	1999/2000
UK	8,352	9,600	10,405	10,728	11,038	11,976	15,800
US	21,918	21,827	23,495	26,025	29,347	32,490	46,055
World	9,045	9,044	9,708	10,074	10,806	11,412	13,796

Source: Art Sales Index, 2000.

position of a seller faced with paying the royalty or shipping the goods to an extra-EU destination for resale. Based on estimates for a German seller sending an item to New York for sale, and including all shipping costs, that is, freight (packing and handling), insurance, customs clearance and order-processing costs, MTIC (2000) estimate that shipping the good for sale to avoid the levy would become viable only for works worth over £33,020. For items of lower value, shipping costs would outweigh the amount of Droit de Suite saved. In 1998 1,090 eligible items over this price were sold in the UK, worth some £191 million. Table 22.7 shows the average auction sales prices. While these have increased in nominal terms,[18] the average in the UK is still well below that for New York and below the threshold mentioned above. On average, works sold in the UK are priced at around 43 per cent of those sold in the US. There is a possibility that Droit de Suite and VAT regulations being introduced from the EU to the UK are diverting trade in higher priced artworks to New York. However, based on average prices, the price differential between New York and London existed well before these measures were introduced. Demand studies on art markets show that the strongest influence on demand and price of works of art is real income and wealth per capita (Frey and Pommerehne, 1989; Goetzmann, 1993). The fact that the US income per capita has been consistently higher than that of the UK may explain the price differential. In 1991, GNP per capita in the US was £16,214 whereas in the UK it was £11,380 – a difference of £4,834. By 1999 the gap had widened to nearly £7,000, with US and UK GNP per capita of £21,760 and £14,850 respectively (World Bank, 2000).

Conclusion

Government policies manifestly affect the art market both directly and indirectly. Export restrictions and certain tax incentives directly restrict exports. Tax incentives have an indirect anti-trade effect as they encourage domestic retention or placement in a museum. In the UK these regulatory measures affect only a very small proportion of works of art, yet they are crucial for protecting the most important objects of British artistic patrimony.

Droit de Suite and VAT both have an anti-trade bias in that they increase the costs of buying and selling art. Whether or not Droit de Suite and VAT will influence the international competitiveness of the UK art market in the future, it is certain that they are only some conditions of the many that influence sellers' choice of where they will trade. It is important not to overlook the fact that the art market is subject to a range of historical, political, economic and legal influences. Legal and fiscal constraints influence the trade in art directly, yet Droit de Suite is only one feature amongst many. It is important, however, that the potential effects of new EU regulations on the trade are not ignored, especially in consideration of how they might cumulatively affect the competitiveness of an art market.

18 The current price, as opposed to the real price adjusted for inflation.

23
Employment

Anne Creigh-Tyte and Barry Thomas, University of Durham

Overview and definitions

Overview

This chapter draws together the existing data to provide an overview of employment and earnings in the cultural sector and it compares data from 1995 and 1999 to show how the situation has changed. The chapter primarily refers to official data sources, namely the Labour Force Survey and the New Earnings Survey. The main characteristics of employment in the cultural sector between 1995 and 1999, as compared to overall employment, are its rate of growth and its geographical distribution.

- In spring 1999, some 647,000 people had their main job (either full- or part-time) in a cultural industry, a cultural occupation or both. This figure represents about 2.4 per cent of total employment in main jobs in 1999. Since 1995, main-job employment in culture has increased by nearly three times the rate of total employment.
- In 1999, over one third of the UK's total employment in cultural industries and cultural occupations was in Greater London. London and the rest of the South East accounted for over half of all employment in cultural industries and cultural occupations, as against less than a third of employment overall.

Within the cultural sector itself, people in cultural occupations accounted for the largest share of cultural employment. Just under one quarter of all the people employed in the cultural sector were in a cultural occupation within a cultural industry. One quarter of total employment in cultural industries can be accounted for by artistic or literary creation and so on. This applied in 1995 as well as in 1999. Taken together with the second-biggest category – radio and TV activities – the two industries accounted for about half of all cultural-industry main jobs in Spring 1999. The fastest percentage growth rates were recorded in arts facilities (over 70 per cent) and museum activities (nearly 40 per cent).

 The largest cultural-occupation grouping – artists, graphic designers, etc – accounted for just under one quarter of total employment in all the cultural

occupations. Together with the second-largest grouping – authors, writers and journalists – they accounted for about half of the total. All cultural occupations, except camera and other equipment operators, recorded employment growth between 1995 and 1999. Musicians recorded the most rapid employment growth (nearly three times the rate of cultural occupations overall).

An assessment of trends in average earnings for all full-time employees found that radio and TV activities recorded the highest average weekly earnings among the (identifiable) cultural industries in both 1995 and 1999. Their average earnings grew by almost 11 per cent between 1995 and 1999, noticeably less than industries in general. In the public sector, average earnings for (merged) library, archive and museum activities grew by over 22 per cent, although in 1999 they represented only about 85 per cent of the average for all industries.

The rest of this section defines the terms used in the chapter. The second section, on employment patterns, presents data on:

- size and geographical distribution of cultural-sector employment;
- gender and education of those working in the cultural sector;
- self-employment and employment-stability;
- unemployment;
- earnings; and
- volunteering.

The third section then considers growth and diversity of employment in the cultural sector, and a fourth section focuses on creative occupations and questions of job quality. A brief final section considers occupational changes in employment in the cultural sector.

Some definitions

Employment in the cultural sector is defined as including both those persons employed in cultural industries and those in cultural occupations. Obviously, such a definition includes people working in organisations which belong to one of the cultural industries, but who are not themselves pursuing a cultural occupation, as well as people in cultural occupations who work in organisations not based within the cultural sector.

Cultural industries are drawn from the 1992 Standard International Classification (SIC) and occupations are identified from the 1988 Standard Occupational Classification (SOC). In this chapter the 'cultural industries' are taken to consist of 13 SIC (four-digit) codes[1] and the 'cultural occupations' of 8

1 Explicitly, these SIC codes are: publishing of books (22.11); publishing of sound recordings (22.14); reproduction of sound recording (22.31); reproduction of video recording (22.32); reproduction of computer media (22.33); motion picture and video production (92.11); motion picture and video distribution (92.12); motion picture projection (92.13); radio and television activities (92.20); artistic and literary creation and interpretation (92.31); operation of arts facilities (92.32); library and archives facilities (92.51); museum activities and preservation of historic sites and buildings (92.52).

SOC (three-digit) unit codes.[2] This approach adopted here parallels that used in Casey et al. (1996), where the focus of interest was employment in 1994. The relevant SIC and SOC categories have been grouped as follows:

Publishing/reproduction/recording	SICs 22.11, 22.14, 22.31, 22.32 and 22.33
Films	SICs 92.11, 92.12, 92.13
Radio, TV activities	SIC 92.20
Artistic, literary creation etc	SIC 92.31
Arts facilities	SIC 92.32
Library, archive activities	SIC 92.51
Museum activities	SIC 92.52
Entertainment and sports managers	SOC 176
Librarians, archivists and curators	SOCs 270, 271
Authors, writers and journalists	SOC 380
Artists, graphic designers etc	SOC 381
Actors, stage managers etc	SOC 384
Musicians	SOC 385
Camera, sound etc equipment operators	SOC 386

The main data source used in this chapter is the Labour Force Survey (LFS). LFS is the largest regular private household survey in the UK. It provides coherent labour market information on the basis of definitions agreed by the International Labour Organisation of the United Nations and used by both the European Union and the Organisation for Economic Co-operation and Development (OECD).

The LFS was carried out every two years from 1973 to 1983. In 1984 the survey became annual, with results available for each spring quarter (March to May). From spring 1992 in Great Britain and winter 1994/95 in Northern Ireland, the survey moved to a continuous basis, with quarterly average results released four times a year. These continuous LFS survey data form the basis for the employment analyses presented in this chapter. Finally, from April 1998 onwards LFS results were published 12 times a year for the average of 3 consecutive months. This chapter uses these data from the continuous UK survey and concentrates on the spring quarter in order to maximise compatibility with earlier studies. The results reviewed thus cover spring 1995 and spring 1999.[2]

While LFS interviews have been undertaken during each week of the year since 1984, limitations on sample size, except for the March to May (spring)

2 In each three-month period, LFS interviews are carried out with a representative sample of 120,000 people aged 16 and over in 60,000 households, with 12,000 households in 5 'waves'. However, around one third of interviews are conducted by 'proxy' (when one member of the household answers questions on behalf of another member of the household who is not present) which can affect data quality. Like any sample survey (interviewing 1 person in 350) the LFS is subject to sampling variability. Estimates drawn from small samples have relatively wide confidence intervals (within which we can expect 19 out of 20 samples to contain the true population value) and are not published by the Office for National Statistics. A 10,000 estimate has a confidence interval of ±4,000.

quarter, meant that only data for the spring quarter were available between 1984 and 1991. From March 1992 improved sample size meant that regular quarterly results were published.[3]

The LFS counts only main and second jobs on average over a given three-month time period. In contrast the 'workforce jobs' measure of employment (previously termed 'workforce in employment') counts all jobs (on a specific date) rather than the number of people with jobs, and, as such, counts people with several jobs more than once. The employee element in the workforce-jobs measure comes from employer surveys, although LFS data are used for the self-employment estimates.[4] The divergence between estimates of employees for the LFS and employer survey since 1992 has been analysed in some detail (ONS, 1997). In essence, it appears that the LFS provides a more complete measure of total employment (as well as job characteristics), and for this reason analysis of the LFS data forms the core of this chapter.[5]

Recently the Office for National Statistics (ONS) announced that a new survey of employers will significantly improve estimates of employee jobs from April 2001. The new Annual Business Survey is expected to lead to upward revisions of 500,000 to 750,000 in the estimated number of employee jobs in the economy, which will bring these employer-based estimates more closely into line with LFS results.

Earnings levels are estimated by the LFS and the New Earnings Survey (NES). The NES is a sample survey of the earnings of employees in employment (based on pay-as-you-earn income tax records) in Great Britain which has been carried out on a constant basis since 1970. LFS earnings data for employees are derived from responses to the first and fifth LFS interviews (each household is interviewed five times at three-monthly intervals, although prior to April 1998 data on earnings were only published from the first interview). The sample sizes tend to be smaller than those for other analyses of employment data and, as a consequence, the analyses in this chapter are based on NES earnings estimates.

Employment patterns

Size and geographical distribution of cultural-sector employment

In spring 1999 some 647,000 people had their main job, either full- or part-time, in a cultural industry, a cultural occupation or both. This figure represents about 2.4 per cent of total employment in main jobs in 1999 (Table 23.1). Since 1995,

3 Laux (1998) provides a discussion of the evolution of the LFS (especially since the quarterly results were produced from March 1992 onwards), and implications of the ONS's decision to publish LFS data every month (giving averages for the last three months' data). O'Brien and Feist (1997) discuss the insights provided by LFS data for the cultural industries.

4 A useful overview of official labour market data is provided by ONS (2000). ONS (1998) provides a more detailed review of the employment data.

5 Stuttard et al. (1998) concluded that employer surveys provided more exact data on industry classification of employees, but such series are clearly less useful where self-employment is important and analyses of employment characteristics are being undertaken.

Table 23.1 Employment in the cultural sector, 1995 and 1999

Main job	1995		1999	
	Thousands	Percentage	Thousands	Percentage
Cultural industry	174	30.7	204	31.5
Cultural occupation	252	44.5	287	44.3
Both	140	24.7	156	24.1
Total	566	100.0	647	100.0

Sources: Labour Force Survey, Spring 1995 and 1999.

Notes
Employment in all sectors: 25,973,000 (1995); 27,251,000 (1999).
Cultural jobs as percentage of all main jobs: 2.2% (1995); 2.4% (1999).

main-job employment in culture has increased by 14.3 per cent (from 566,000) over a period when total employment grew by about 4.9 per cent. Employment in the cultural industries as a whole grew by 14.6 per cent over the four years to 1999, while for the larger cultural-occupations group, the corresponding growth was 13.1 per cent. People in cultural occupations accounted for the largest share of cultural employment (44.3 per cent) in 1999, with just under one quarter of all the persons in the cultural sector being in a cultural occupation within a cultural industry.

In the remainder of this chapter, the analyses compare and contrast individual cultural industries or cultural occupations, and these cultural industries and occupations as a whole, with overall trends in employment across the whole UK economy. This two-fold approach has been adopted in order to avoid any confusion arising from conflating the industrially and occupationally defined cultural-sector employment.

Table 23.2 Employment in the cultural sector, by industry and occupation, 1995 and 1999

Main job	1995		1999	
	Number	Percentage	Number	Percentage
Cultural industries				
Publishing/reproduction/recording	40,198	12.8	45,696	12.7
Films	37,648	12.0	40,085	11.1
Radio, TV activities	64,199	20.4	70,433	19.6
Artistic/literary creation, etc	77,656	24.7	92,485	25.7
Arts facilities	15,506	4.9	26,617	7.4
Library/archive activities	52,903	16.8	47,563	13.2
Museum activities	25,946	8.3	37,075	10.3
Total	314,056	100.0	359,954	100.0
Cultural occupations				
Entertainment and sports managers	47,221	12.0	56,939	12.8
Librarians/archivists and curators	25,835	6.6	32,809	7.4
Authors, writers and journalists	91,061	23.2	98,836	22.3
Artists, graphic designers, etc	99,882	25.5	109,996	24.8
Actors, stage managers, etc	57,981	14.8	68,738	15.5
Musicians	21,301	5.4	29,498	6.6
Camera, sound, etc equipment operators	48,947	12.5	46,781	10.5
Total	392,228	100.0	443,597	100.0

Sources: Labour Force Survey, Spring 1995 and 1999.

The distribution of those working in either a cultural industry or cultural occupation as their main job in 1995 and 1999 is summarised in Table 23.2. Clearly, the information on cultural industries covers both those with a cultural occupation working within a cultural industry (156,000 in 1999) and those persons simply working in a cultural industry in any capacity (204,000 in 1999).

The largest single SIC cultural industry category – artistic, literary creation, etc – accounted for about one quarter of total employment in both years. Taken together with the next most important category – radio, TV activities – these two industries account for over 45 per cent of all cultural-industry main jobs in spring 1999. All the identified cultural-industry categories, except library and archive activities (which registered a decline of 10.1 per cent), recorded increased employment levels over the four-year period considered. The fastest percentage growth rates were recorded in arts facilities (71.7 per cent growth) and museum activities (37.6 per cent expansion).

The largest cultural-occupation grouping – artists, graphic designers, etc – accounted for just under one quarter of total employment in all the cultural occupations, and, together with the second-largest grouping – authors, writers and journalists – comprised over 47 per cent of the total. All the cultural occupations, except 'camera, sound, etc. equipment operators' (whose numbers declined by 4.4 per cent), recorded employment growth between 1995 and 1999. Musicians recorded the most rapid employment growth (38.5 per cent compared to overall cultural occupation employment growth of 13.1 per cent).

In spring 1999 some 12 per cent of overall employment was in Greater London and a further 15 per cent was to be found in the Rest of the South East (ROSE) of England. Thus almost three-quarters of UK employment was outside the south east of England. The very divergent geographical distribution of employment in the cultural sector is illustrated in Table 23.3. In 1999, over one third of the UK's total employment in cultural industries and cultural occupations was in Greater London and the combined London and ROSE shares reached 54 and 52 per cent respectively.

Among the cultural industries, 'radio, TV activities' was the most concentrated, with 53 per cent of employment in Greater London in 1999. Moreover, employment concentration in London is increasing, since London's share stood at 44 per cent of UK employment as recently as spring 1995. The publishing/reproduction/recording industry had over 40 per cent of its total employment in Greater London in both 1995 and 1999. In contrast, employment in the arts facilities, library and museum activities industries is more evenly spread across the UK, with over 60 per cent of employment outside the South East in both 1995 and 1999.

Two of the cultural occupations – authors, writers and journalists, and actors, stage managers, etc – had 40 per cent or more of total employment in Greater London in spring 1999. In all but two of the seven cultural occupations, a majority of UK employment was in London and the South East region combined. In contrast, and mirroring the cultural-industries results discussed above, 60 per cent of employment in the 'entertainment and sports managers', and 'librarians, archivists and curators' categories was outside London and the South East, reflecting more closely the UK's overall employment and population distribution.

Table 23.3 Employment in the cultural sector, by region, 1995 and 1999

Per cent

Main job	1995			1999		
	Greater London	Rest of South East	Rest of UK	Greater London	Rest of South East	Rest of UK
Cultural industries						
Publishing/reproduction/recording	42.4	30.3	27.3	39.8	22.6	37.6
Films	47.3	8.9	43.8	35.1	22.1	42.9
Radio, TV activities	43.5	20.7	35.7	53.2	18.0	28.8
Artistic/literary creation, etc	33.5	22.0	44.5	36.3	17.4	46.3
Arts facilities	–	–	–	39.1		60.9
Library/archive activities	10.6	28.9	60.5	33.8		66.2
Museum activities	39.2		60.8	40.5		59.5
Total	33.9	20.8	45.3	34.9	18.6	46.5
Cultural occupations						
Entertainment and sports managers	35.5		64.5	16.2	19.1	64.8
Librarians/archivists and curators	40.7		59.3	40.2		59.8
Authors, writers and journalists	34.9	19.2	45.9	43.9	18.8	37.4
Artists, graphic designers, etc	28.1	25.4	46.5	31.8	20.5	47.7
Actors, stage managers, etc	41.3	13.9	44.8	40.8	17.3	41.9
Musicians	50.1		49.9	36.7	14.1	49.2
Camera, sound, etc equipment operators	27.0	20.8	52.2	36.6	14.8	48.6
Total	29.3	20.7	50.0	33.9	18.3	47.8
All sectors	11.8	14.3	73.9	12.1	14.5	73.3

Sources: Labour Force Survey, Spring 1995 and 1999.

Gender and education of those working in the cultural sector

In both 1995 and 1999, some 55 per cent of all employees were male. But, as shown in Table 23.4, the share of males in main jobs in the cultural industries (53 per cent) was slightly below the overall average in 1995, and above it (56 per cent) by 1999. Males are noticeably more prevalent in terms of cultural occupations, with shares of 64 and 65 per cent in 1995 and 1999 respectively. The contrast between these industrial and occupational figures suggests that many of the main jobs being held by women in the cultural industries are not in cultural occupations.

The distribution of employment by gender in individual cultural industries and occupations was fairly stable between 1995 and 1999, although the share of males grew sharply in the publishing/reproduction/recording industry, and fell almost as sharply in the 'actors, stage managers, etc' occupation over the four years.

At the detailed industrial and occupational levels, it is clear that females account for around three-quarters of employment in the 'library, archives activities' industry, as well as a clear majority of employment in museum activities. In the parallel 'librarians, archivists and curators' occupational group, more than seven jobs in every ten were held by females. This was the only cultural occupational category in which women constituted a majority of employees.

The distribution of (main-job) cultural employment across four broad age bands is summarised in Table 23.5. The patterns for both 1995 and 1999 are

Table 23.4 Employment in the cultural sector, by gender, 1995 and 1999

	Percentage men	
Main job	1995	1999
Cultural industries		
Publishing/reproduction/recording	43.9	57.8
Films	62.0	58.2
Radio, TV activities	63.7	64.2
Artistic/literary creation, etc	66.0	70.5
Arts facilities	42.3	47.8
Library/archive activities	26.4	22.8
Museum activities	45.3	44.1
Total	52.7	55.6
Cultural occupations		
Entertainment and sports managers	70.1	71.9
Librarians/archivists and curators	35.1	28.5
Authors, writers and journalists	52.4	61.8
Artists, graphic designers, etc	64.4	68.0
Actors, stage managers, etc	67.7	58.1
Musicians	75.3	83.2
Camera, sound, etc equipment operators	83.5	82.4
Total	63.8	65.2
All sectors	55.3	55.2

Sources: Labour Force Survey, Spring 1995 and 1999.

closely comparable, with the youngest age group (16 to 24 years) under-represented in both the cultural industries and (especially) the cultural occupations as a whole. In contrast, around one third of employment in both cultural occupations and industries is accounted for by persons aged 25 to 34 years, while this is only true for about one quarter of total employment. Robust analysis at the level of individual industries or occupations is difficult given the small sample sizes.[6]

In the cultural sector, as in the economy as a whole, education and qualification levels are rising over time as new entrants to the labour market tend to be better qualified than retirees, and as adult education participation rises. Thus, for example, the share of persons with a degree or other higher-education qualification in the cultural occupations rose from 50 per cent in 1995 to 53 per cent in 1999 (Table 23.6). Moreover, persons employed in the cultural sector tended to be more qualified than in the economy as a whole. In 1999, 47 per cent of persons employed in the cultural industries held a degree-level qualification and this was true for 53 per cent of those in cultural occupations. This compares to only 24 per cent of all those employed in the UK economy as a whole.

Particular cultural activities show even more marked concentrations of graduates. Almost 80 per cent of librarians, archivists and curators have a degree, as do over 50 per cent of authors, writers and journalists and over 40 per cent of people employed in the publishing/reproduction/recording and 'radio and TV activities' cultural industries.

6 For individual industries or occupations, the LFS samples in particular age groups can be small. Thus for both years covered, the results indicate less than 1,000 people aged 16–24 are employed in the 'librarians, archivists and curators' occupation. This implies only three actual respondents in this particular age group and occupation.

Table 23.5 Employment in the cultural sector, by age band, 1995 and 1999

Per cent

Main job	1995				1999			
	16–24	25–34	35–49	50+	16–24	25–34	35–49	50+
Cultural industries	11.3	32.45	36.7	19.6	12.8	31.6	37.5	18.1
Cultural occupations	12.0	34.2	36.1	17.7	10.5	33.1	38.6	17.7
All sectors	15.1	27.0	36.4	21.5	14.2	25.8	36.6	23.4

Sources: Labour Force Survey, Spring 1995 and 1999.

Self-employment and employment-stability

Self-employed people are defined as those who, in their main employment, work on their own account, whether or not they have employees. Within the LFS the employment-status division between dependent employees and the self-employed is based upon survey respondents' own assessment of their status.

Following rapid growth in self-employment during the 1980s, and a fall in 1991, over the 1990s self-employment was relatively stable as a proportion of total UK employment. Between the 1995 and 1999 spring-quarters, the LFS surveys' self-employment rates fell from over 13 to under 12 per cent (Moralee, 1998; Campbell and Daly, 1992). Self-employment is known to be very unevenly distributed across the economy and it is certainly disproportionately concentrated in the cultural sector.

Table 23.6 Education levels in the cultural sector, 1995 and 1999

Per cent

Main job	1995			1999		
	Higher education	None or below O level	Other education	Higher education	None or below O level	Other education
Cultural industries						
Publishing/reproduction/recording	45.0	8.9	46.2	54.3	5.5	40.2
Films	35.0	10.1	54.8	41.9	6.9	51.3
Radio, TV activities	52.3	3.9	43.8	57.7	3.5	38.8
Artistic/literary creation, etc	50.4	7.1	42.5	48.0	7.5	44.5
Arts facilities	–	–	–	40.1		59.9
Library/archive activities	37.7	11.1	51.5	40.0	5.0	55.0
Museum activities	40.7	59.3		37.7	12.5	49.8
Total	44.6	9.6	45.8	46.9	6.5	46.7
Cultural occupations						
Entertainment and sports managers	32.9	67.1		33.3	66.7	
Librarians/archivists and curators	82.0	1.6	16.4	81.0	2.7	16.3
Authors, writers and journalists	57.9	2.4	39.7	65.7	0.0	34.3
Artists, graphic designers, etc	51.6	6.9	41.4	52.3	6.3	41.4
Actors, stage managers, etc	48.0	7.1	45.0	53.7	7.9	38.4
Musicians	54.2	45.8		55.5	7.6	36.9
Camera, sound, etc equipment operators	28.1	3.5	68.4	30.6	5.1	64.3
Total	49.5	6.2	44.3	53.1	5.1	41.8
All sectors	21.0	22.5	56.5	24.2	17.4	58.4

Sources: Labour Force Survey, Spring 1995 and 1999.

Table 23.7 Self-employment in the cultural sector, 1995 and 1999

Per cent

Main job	Self-employed	
	1995	1999
Cultural industries		
Publishing/reproduction/recording	10.9	17.6
Films	28.9	27.2
Radio, TV activities	18.9	25.2
Artistic/literary creation, etc	73.8	77.5
Arts facilities	4.0	19.6
Library/archive activities	1.4	–
Museum activities	2.9	1.1
Total	27.6	31.6
Cultural occupations		
Entertainment and sports managers	23.1	11.7
Librarians/archivists and curators	–	–
Authors, writers and journalists	35.9	40.0
Artists, graphic designers, etc	49.4	45.6
Actors, stage managers, etc	55.6	61.1
Musicians	71.5	78.9
Camera, sound, etc equipment operators	36.6	49.0
Total	40.4	41.5
All sectors	13.1	11.8

Sources: Labour Force Survey, Spring 1995 and 1999.

As Table 23.7 shows: in 1999, 32 per cent of those employed in the cultural industries considered themselves to be self-employed, and this was true for 42 per cent of those in cultural occupations. For those in the 'artistic, literary creation etc.' industries and musicians the self-employment rates were 78 and 79 per cent respectively. However, the position is highly polarised. Almost all those employed in the 'library, archive activities' and the 'museum activities' sectors, and the corresponding librarians, archivists and curators occupation, are dependent employees, as are 88 per cent of entertainment and sports managers.

According to the LFS, for the UK economy as a whole, part-time employment grew from 6.3 to 6.9 million between spring 1995 and 1999. Moreover, full-time employment grew less rapidly and the share of part-time in total employment rose from 24.4 to 25 per cent by 1999. As shown in Table 23.8, within the cultural sector part-time employment is important, but in the cultural occupations it is noticeably less important than for the economy as a whole, and accounts for 18 per cent of all employment. For the cultural industries as a whole, part-time employment is (marginally) more important than in the overall economy, with 27 per cent of cultural-industry employment being part-time in 1999.

Part-time employment has grown in cultural industries and occupations, and more rapidly than for the overall economy (by 3.8 per cent for cultural industries and 2.1 per cent for cultural occupations, against 0.8 per cent for the economy overall).

Sharp differences are apparent between the specific cultural industries and occupation groups. In 1995 a small majority (55.5 per cent) of employment in 'library, archive activities' was full-time, the lowest proportion for any cultural

Table 23.8 Part-time employment in the cultural sector, 1995 and 1999

Per cent

Main job	Part-time	
	1995	1999
Cultural industries		
Publishing/reproduction/recording	13.8	11.1
Films	24.4	23.9
Radio, TV activities	6.1	11.3
Artistic/literary creation, etc	20.1	25.6
Arts facilities	41.1	41.5
Library/archive activities	44.5	61.0
Museum activities	31.1	26.3
Total	22.9	26.7
Cultural occupations		
Entertainment and sports managers	5.0	13.1
Librarians/archivists and curators	23.4	22.9
Authors, writers and journalists	17.0	17.4
Artists, graphic designers, etc	13.6	16.3
Actors, stage managers, etc	20.2	22.6
Musicians	33.0	29.7
Camera, sound, etc equipment operators	13.1	12.4
Total	16.0	18.1
All sectors	24.4	25.1

Sources: Labour Force Survey, Spring 1995 and 1999.

industry, but by 1999 the share of full-timers had declined to only 39 per cent of total employment. By contrast, in the publishing/reproduction/recording and 'radio, TV activities' industries, well over 80 per cent of employment was on a full-time basis in both 1995 and 1999.

As noted above, across all the cultural occupations, part-time employment is less common than in the economy as a whole. Thus it is not surprising to find that in only one specific occupation – musicians – is the share of part-time employment above the national average (at 30 per cent, against 25 per cent of overall employment in 1999).

The number of public-sector employees in the UK grew by 0.8 per cent (from 6.1 to 6.2 million) between 1995 and 1999, but the 9.9 per cent growth in the private sector over the same period meant that the public sector's share in total

Table 23.9 Cultural employment in public and private sectors, 1995 and 1999

Per cent

Main job	1995		1999		Growth	
	Private sector	Public sector	Private sector	Public sector	Private sector	Public sector
Cultural industries	56.2	42.7	60.6	38.9	+17.9	−0.6
Cultural occupations	73.5	25.7	71.2	28.7	+8.0	+24.3
All sectors	71.8	27.4	73.6	25.8	+9.9	+0.8

Sources: Labour Force Survey, Spring 1995 and 1999.

Note: These figures exclude individuals who did not provide information on their public/private-sector status, and relate to employees only.

Table 23.10 Workplace size (number of people), 1995 and 1999

Per cent

Main job	1995			1999		
	1–10	11–24	25+	1–10	11–24	25+
Cultural industries	22.5	15.2	62.3	20.7	15.8	63.5
Cultural occupations	25.7	13.7	60.6	24.1	14.9	61.0
All sectors	21.1	13.0	66.0	20.0	13.2	67.5

Sources: Labour Force Survey, Spring 1995 and 1999.

employees fell from 27.4 to 25.8 per cent. As shown in Table 23.9, in both the cultural industries and cultural occupations the private sector is predominant, but noticeably less so than in the economy as a whole. Thus, in 1999 61 per cent of those in the cultural industries and 71 per cent of employees in the cultural occupations were in the private sector, whereas this was true for some 74 per cent of overall UK employees.

Once again, at the levels of individual cultural industries and occupations there is a clear polarisation. Thus, in both the publishing/reproduction/recording and film industries, over 95 per cent of employment was in the private sector, while in museum activities 46 per cent of employment was private in 1999, and in 'library, archive activities' the private sector share was only 1 per cent. Taking the LFS employment estimate for private-sector museum activities at face value indicates 150 per cent growth between 1995 and 1999, to reach almost 16,000 persons.

At the specific cultural-occupation level, librarians, archivists and curators are overwhelmingly employed in the public sector, with only one in eight in the private sector. In contrast, well over 80 per cent of 'authors, writers and journalists' and 'artists, graphic designers, etc' work in the private sector.

Given the high incidence of self-employment in the cultural sector, it is reasonable to expect that workplaces will be smaller than for the economy as a whole. In spring 1999 21 per cent of people in the cultural industries worked in workplaces with fewer than 10 people, while 64 per cent worked in workplaces with 25 or more people (Table 23.10). For the economy as a whole, the proportions were 20 per cent and 68 per cent respectively.

Across the cultural occupations, 24 per cent of workers were in workplaces with 10 or fewer persons and 61 per cent were in workplaces with 25 or more persons in 1999. In the 'artistic, literary creation etc' industry, where self-

Table 23.11 Length of employment in the cultural sector, 1995 and 1999

Per cent

Main job	1995				1999			
	<12 mths	1–5 yrs	5–10 yrs	>10 yrs	<12 mths	1–5 yrs	5–10 yrs	>10 yrs
Cultural industries	18.0	30.8	23.4	27.8	20.4	33.0	16.4	30.2
Cultural occupations	18.7	30.1	22.7	28.6	19.1	33.4	18.1	29.5
All sectors	18.6	29.9	21.0	30.5	19.7	32.6	15.4	32.3

Sources: Labour Force Survey, Spring 1995 and 1999.

employment exceeds 75 per cent (in 1999) almost half (49) per cent of the workplaces have fewer than 11 people. By way of contrast, in the 'radio, TV activities' and 'arts facilities' industries, the shares of workplaces with fewer than 11 people were 8 per cent and 5 per cent respectively. Likewise, just over 8 per cent of librarians, archivists and curators worked in workplaces with under 11 people.

Employment stability can be measured using the job-tenure data provided by the LFS. Respondents are asked how long they have been working in their current organisation in the same occupation. Data from the spring 1999 LFS for cultural industries and occupations are summarised in Table 23.11. In 1999, across both cultural-employment groupings, just under 50 per cent of respondents had been in the same job for five years or more, and about 30 per cent for ten years or more. This pattern is broadly similar to that found for all sectors of the economy.

In 1999 the longest job tenures were found in the 'librarians, archivists and curators' occupations and the 'library, archive' industries, where 74 per cent and 62 per cent respectively of people had been in the same job for over five years, and 54 and 50 per cent respectively for over ten years. Conversely, the film industry had a relatively high turnover, with 72 per cent of people employed for less than five years, and 38 per cent for less than one year (almost twice the 20 per cent share across the economy as a whole).

Unemployment

Under the statistical system of the International Labour Organisation (ILO), every LFS respondent aged 16 years and over is either: in employment; ILO unemployed; or economically inactive. People are unemployed according to the ILO definition if they are:

- out of work, want a job, have actively sought work in the last four weeks and are available to start work in the next two weeks; or
- out of work, have found a job and are waiting to start it in the next two weeks.

Anyone who did at least one hour's paid work in a week, or is temporarily away from a job (due to, say, being on holiday), is regarded as being in employment. People who are not working, but are not ILO-unemployed, are economically inactive (ONS, 1998). Unemployment-related benefits are claimed irrespective of a person's ILO labour-force status in the LFS. Nevertheless, in practice the claimant-count of persons receiving unemployment benefits and ILO unemployment overlap substantially.[7]

Self-defined 'unemployment' may pose particular problems in some cultural occupations, as the numerous jokes about 'resting' actors and other performing artists attest. However, even in the UK's largest private household survey, the limited size of such industries and occupations means that robust samples of

7 However, claimants who state that they are not seeking or are not available to start work would not be ILO-unemployed. Similarly, people can sometimes claim benefits while receiving low earnings from part-time work. On the other hand, people can be ILO-unemployed even if they are not entitled to claim unemployment-related benefits.

(self-defined) unemployed are simply not available. In the spring LFS surveys of 1995 and 1999, none of the individual cultural SIC or SOC categories recorded numbers of unemployed people up to the standard LFS 'publication threshold' (a grossed-up estimate of 10,000 or more from an achieved actual sample of 30 or more).

Since the end of the recession of 1990 to 1992, UK aggregate unemployment has fallen almost continuously (on all measures). In spring 1995, the overall ILO-unemployment rate was 8.6 per cent, and by spring 1999 it had declined to 6 per cent. Across the cultural occupations as a group, unemployment rates stood below the overall-economy level in both years – at 5.9 per cent in 1995 and 5.7 per cent in 1999. However, the absolute number of unemployed people who gave the cultural occupations as their last job actually rose over the four-year period under consideration, although it did so much less rapidly than employment in the cultural occupations (and hence the cultural-occupation workforce, and so the unemployment-rate denominator).

The below-national-average rates of ILO-unemployment recorded in the cultural occupations as a whole may, at first sight, appear unlikely in view of the 'traditional' advice of Noel Coward to Mrs Worthington about her daughter's theatrical job prospects. However, while – if taken literally – the 'actors, stage managers, etc' occupation did record 12 per cent unemployment in spring 1999, certain other important public-sector cultural occupations recorded negligible unemployment rates – for example, well under 3 per cent for librarians, archivists and curators, if concerns over actual sample size are relaxed.

The LFS also provides information on duration of ILO-unemployment, although of course this is subject to the usual caveats on sample size. Among the unemployed whose last job was in the cultural occupations in spring 1999, taken as a group, some 65 per cent had been unemployed for less than six months and 74 per cent for under a year. Across the economy as a whole, 70 per cent of ILO-unemployed had been so for under a year, and 54 per cent for under six months. Thus it appears that, as well as recording lower overall unemployment rates, the unemployed in the cultural occupations include a (slightly) higher proportion of people unemployed for less than a year.[8]

Earnings

Between December 1992 (when income questions were first introduced into the LFS) and February 1997, income questions were asked only during a respondent's fifth (and last) interview. Although this provided information on only about 9,000 employees, it was felt that there was a danger than non-response would be increased if income questions were included in earlier interviews. However, from spring 1997 data were collected from respondents in two waves (1 and 5) of the survey. Such combined-waves estimates significantly improve the precision of the

8 The relative duration pattern prevailed even more strongly in spring 1995, when 71 per cent of the unemployed in the cultural occupations had been unemployed for under one year, against 56 per cent for UK unemployed as a whole.

data and estimates of earnings for groups of 30,000 or more are regarded as reliable enough for publication (Denkins, 1998).

The New Earnings Survey (NES) (and its Northern Ireland equivalent) is a sample survey of 1 per cent of employees conducted every April since 1970. Since April 1975 a panel of individuals has been used, selected using National Insurance numbers. Data are provided by employers from their PAYE records covering the selected employees for a pay period covering a specific date. The large achieved sample (of around 150,000 employees) allows detailed analysis of employees covered by the PAYE income tax system.

Average earnings estimates from the LFS are consistently below those derived from the NES. The reasons for these differences include the limited coverage of employees earning less than the weekly PAYE threshold in the NES, the LFS's exclusive focus on earnings in main jobs, and under-reporting of earnings in the proxy responses sometimes used by the LFS.

On balance, the ONS concluded that, given the much larger sample size used in the NES, it should be considered the most appropriate source of data on full-time employees. However, the limited coverage of employees earning less than the PAYE threshold means that part-time employees are under-represented in the NES. Thus the LFS would be a more appropriate data source on the earnings of part-time employees (Wilkinson, 1998). The above-average prevalence of full-time working in the overall cultural industries and occupation groupings – and the limitations on sample size in detailed industrial and occupational categories within the LFS – mean that the NES is the most appropriate data source for considering average earnings of employees in the cultural sector.

However, it must also be remembered that self-employment is much more prevalent within the cultural sector than in the economy as a whole; for example, in spring 1999 only 68 per cent of people employed in cultural industries were employees, whereas employees accounted for 88 per cent of overall UK employment. Furthermore, even for the NES, sample-size limitations for the tightly defined cultural industries and cultural occupations mean that reliable earnings estimates are simply not available for all the individual sub-groups.

An overview of trends in average earnings for all full-time employees between April 1995 and April 1999 is provided in Table 23.12. Over the four years covered, nominal average earnings across the economy as a whole rose by almost 19 per cent. The NES sample sizes allow analyses of three cultural industries and five occupations for one or both of the years considered.

Radio and TV activities recorded the highest average weekly earnings among the (identifiable) cultural industries in both 1995 and 1999. Average earnings grew by almost 11 per cent over the four years considered, noticeably less than the growth found across all industries, while earnings dispersion in the radio and TV sector remained constant. In the public sector dominated (merged) library, archive activities and museums activities industries, average earnings grew by over 22 per cent, and earnings dispersion rose (somewhat) between 1995 and 1999 – although, even by the latter year, average earnings stood at only about 85 per cent of the average for all industries.

Among the cultural occupations, 'actors, stage managers, etc' were the highest-paid group on average in 1995, with the widest dispersion of earnings found in any

£

Table 23.12 Gross weekly earnings of employees in the cultural sector, 1995 and 1999

	1995					1999				
	Average all employees	Ratio to all sectors	Bottom decile	Top decile	Top:bottom ratio	Average all employees	Ratio to all sectors	Bottom decile	Top decile	Top:bottom ratio
Cultural industries										
Publishing	400.2	1.2	188.0	671.8	3.6	457.3	1.1	211.1	777.4	3.7
Radio and television activities (92.2)	531.6	1.6	251.7	836.1	3.3	589.9	1.5	274.7	911.7	3.3
Library, archives, museums and other cultural activities (92.5)	279.4	0.8	172.0	415.7	2.4	341.8	0.9	200.5	511.1	2.5
All industries	336.3	1.0	160.0	542.5	3.4	400.1	1.0	190.0	645.0	3.4
Cultural occupations										
Entertainment and sports managers (176)	361.6	1.1	191.9	575.9	3.0	413.2	1.0	29.8	661.4	2.9
Authors, writers, journalists (380)	466.0	1.4	246.2	798.9	3.2	–	–	–	–	–
Artists, commercial artists, graphic designers (381)	366.2	1.1	191.8	609.1	3.2	412.4	1.0	230.3	658.7	2.9
Actors, entertainers, stage managers, producers, directors (384)	569.8	1.7	245.8	923.5	3.8	–	–	–	–	–
Photographers, camera, sound and video equipment operators (386)	–	–	–	–	–	425.9	1.1	230.0	685.2	3.0
All manual occupations	271.8	0.8	145.5	420.0	2.9	315.0	0.8	174.0	482.2	2.8
All non-manual occupations	371.6	1.1	172.7	604.6	3.5	443.3	1.1	201.5	725.3	3.6
All occupations	336.3	1.0	160.0	542.5	3.4	400.1	1.0	190.0	645.0	3.4

Sources: CSO (1995); ONS (1999).

of the cultural groupings. All the identified cultural occupations had average earnings levels in excess of those for all occupations in both 1995 and 1999, although this was not always true when compared with average earnings for all non-manual occupations.

Volunteering

Between June and August 1997, the National Centre for Volunteering undertook a national survey of the extent and nature of volunteering in the UK on behalf of the (then) Voluntary and Community Division of the Department of National Heritage and the Charities Aid Foundation. This survey enabled trends in volunteering to be tracked over time by drawing comparisons from the national surveys of 1981 and 1991 (Smith, 1998).

The methodology used divided volunteering between formal activity, carried out for, or through, an organisation or group of some kind, and where there was some organisational boundary around the activity, and informal activity, for example, that undertaken outside an organisational context and on an individual basis (for example, a neighbour helping a neighbour).[9] Some 48 per cent of respondents had taken part in some formal voluntary activity in the past year,[10] and these current volunteers spent an average of 4.05 hours per week on formal volunteering. Grossing-up these estimates implies that 21.8 million volunteers were contributing some 88 million hours per week.

The 1997 survey provides information on volunteer activity across 17 'fields of interest', with half of volunteers (53 per cent) indicating they were involved in one field, almost a quarter (23 per cent) in two fields and the final quarter in three or more. None of the 'fields of interest' corresponds fully with the cultural sector but the 'hobbies, recreation, arts' category is the fifth most common, with 18 per cent of respondents interested in the field (compared with 17 per cent in 1991). Some 21 per cent of male volunteers and 15 per cent of females indicated interest in the 'hobbies, recreation, arts' category.[11]

Although the 1997 survey provides a valuable overview, there are no studies of volunteering across the cultural sector as a whole in the late 1990s. However, the National Trust has long maintained detailed records of its volunteers, and data on volunteer numbers and the hours they worked are set out in Table 23.13. Both volunteer numbers and hours worked have risen (almost) continuously throughout the1990s, with each volunteer working for 61 hours on average in 1999. In 1998/99 the National Trust had over 3,300 permanent staff, so that

9 Not surprisingly (given its origins) the 1997 survey report focused primarily on formal activity, with 'current volunteering' relating to all activity carried out in the previous 12 months.

10 Within this total figure the degree of commitment clearly varies substantially. Some 29 per cent of respondents were 'regular' volunteers, involved with one or more organisations on at least a monthly basis, and 21 per cent of volunteers volunteered on a weekly basis.

11 The four most commonly mentioned fields of interest were: 'sports, exercise'; 'children's education'; 'religion'; and 'health and social welfare' – all mentioned by between 19 and 26 per cent of respondents.

Table 23.13 Trends in National Trust volunteering, 1990–99

	Number of volunteers (thousands)	Number of hours worked (millions)
1990	20.0	1.15
1991	23.4	1.24
1992	26.5	1.38
1993	27.6	1.63
1994	30.0	1.70
1995	34.0	1.90
1996	35.2	2.12
1997	37.4	2.25
1998	38.5	2.21
1999	38.9	2.37

Sources: National Trust (1996); direct communication with NT.

volunteers outnumbered staff by over 10 to 1, and provided around 30 per cent of hours worked.[12]

The (then) Museums & Galleries Commission's DOMUS database provided considerable information on staff at registered museums and galleries. In 1998, the 1,188 registered museums which provided information employed a total of 12,590 permanent staff and 2,775 temporary staff (both in full-time-equivalent terms). Their 25,206 volunteers, thus, outnumbered the 15,365 full-time-equivalent staff by more than 3 to 2.

The National Trust's activities spread well beyond the cultural sector to embrace the national environment. However, in 1998 the 60 registered National Trust museums recorded a total of 4,730 volunteers (almost 19 per cent of the total for all registered museums) and these outnumbered the 809 full-time-equivalent employees in National Trust museums by more than 5 to 1 (Carter et al., 1999).[13]

Estimates of employment at the 6,000 tourist attractions in the UK produced for the national tourist boards for the second half of the 1990s are summarised in Table 23.14. Across the attractions for which employment data are available, paid employment grew by 6.7 per cent between 1994 and 1998 to more than 95,000 (52,600 full-time-equivalents), and volunteer workers grew by 25 per cent over the same period to reach 68,800 in total. Historic properties and museums and galleries accounted for over 70 per cent of volunteers.

In 1998, some 88 per cent of attractions employed paid staff and 46 per cent used volunteers. On average, attractions had 18 paid jobs (10 full-time-equivalents) and 25 volunteers (at attractions which used volunteers). As shown in Table 23.15, volunteers were most commonly employed on wildlife sites and at museums, but on average historic properties employed almost twice as many volunteers (20) as did visitor attractions as a whole (11).

12 Assuming that the 3,300 permanent staff worked seven hours per day for 250 days per year.
13 For a discussion of the DOMUS database and its limitations see Creigh-Tyte and Selwood (1998), and Chapter 28.

Table 23.14 Trends in employment and volunteering in visitor attractions, 1994–98

	Paid employment	Total	Volunteers Historic properties	Museums and galleries
1994	89,100	55,000	20,600	17,200
1995	85,900	56,400	23,570	16,339
1996	89,420	60,050	24,600	17,560
1997	92,860	64,800	28,200	17,400
1998	95,100	68,800	29,500	18,900

Sources: Sightseeing Research, 1995–99.

Further detailed insight into the key role of volunteers in the museums sector is provided by the study of the economic contribution of museums to the economy of the South West region in 1998, which was commissioned by the South West Museums Council (South West Museums Council, 2000). A total of 4,832 people worked in museums in the south west region in 1998, but the vast majority of these (3,533 or 73 per cent) were volunteers. Almost all volunteers were working on a part-time basis (compared to 53 per cent of paid museum employees). Just under one-quarter of the total (full-time-equivalent) of 1,271 jobs in the sector were accounted for by volunteers.

However, the data show marked variations between different types of museum (Table 23.16). Thus, voluntary work provided under 5 per cent of total full-time equivalent jobs in local authority museums compared to over 37 per cent in other museums. Most (almost 79 per cent) of the labour input in small museums came from volunteers and these museums attracted almost 61 per cent of all part-time volunteers. In contrast, large museums drew only 7 per cent of their full-time-equivalent workers from the voluntary sector. The reliance of 'small' museums on voluntary labour is underlined by the fact that such museums (defined as having an annual turnover of under £50,000) had, on average, an actual turnover of only £10,700 in 1998, and an average of under 7,000 visitors in that year.

Table 23.15 Employment in tourist attractions, 1998

	Historic properties	Gardens	Museums	Wildlife sites	Other	All
Percentage of attractions employing:						
Paid staff	84	93	81	94	94	88
Volunteers	47	41	57	58	34	46
Average number of:						
Paid jobs per attraction	15	13	15	23	22	18
Full-time equivalents per attraction	7	7	11	13	10	10
Average number of volunteers:						
At all attractions	20	7	11	9	7	11
At attractions employing volunteers	41	17	19	16	20	25

Sources: Sightseeing Research, 1995–99.

Table 23.16 Employment in South West museums, 1998

	All museums	Local authority	Other	Small	Medium	Large
Paid full-time	608	312	296	15	192	401
Paid part-time	692	303	389	70	192	431
Paid full-time equivalents	954	464	490	50	288	616
Voluntary full-time	25	1	24	9	12	4
Voluntary part-time	3,508	277	3,231	2,128	843	537
Voluntary full-time equivalents	317	24	293	186	82	49
Total full-time equivalents	1,271	488	783	236	370	665

Sources: South West Museums Council, 2000 (adapted from Table 2.7, p.16).

Notes: Each part-time paid job is taken as being equivalent to half of a full-time job, and each part-time voluntary job is assumed to be equivalent to one twelfth of a full-time equivalent. Museum size was defined by total turnover, with 'small' museums (102 sites) having an annual turnover below £50,000 in 1998, 'medium'-sized museums (59 sites) a turnover of £50,000 to £250,000, and 'large' museums (36 sites) a turnover in excess of £250,000.

Growth and diversity of cultural industries and occupations

This section comments on a few of the findings presented above, in the light of some of the growing literature on cultural employment. Throughout the presentation of data above, a clear distinction has been made between cultural industries,[14] which are most relevant for the discussion of product markets, and cultural occupations, which are more relevant for labour-market issues. Cultural industries and occupations coincide only partially.[15] Of all workers in the cultural occupations only about one out of every three (35 per cent) works in cultural industries (see Table 23.1). Most work outside: many librarians, for example, work in educational institutions such as universities, and a high proportion of journalists work in the newspaper industry. And, only 43 per cent of workers in the cultural industries are in cultural occupations – the majority have other occupations, such as accountants or secretaries, which can be found throughout the economy.

Policy interest in the cultural sector is sometimes associated with a wider industrial perspective. For instance, much attention has been given recently to the 'creative industries'[16] and there are, of course, also many other industries which are associated with the cultural sector. The manufacture of TV sets, video recorders, and hi-fi equipment, CDs and the sale of cultural products (distribu-

14 The existing SIC, which for historical reasons gives much greater breakdown for manufacturing than service industries, is not well-suited to new kinds of industrial sector such as 'culture', 'tourism', 'leisure', or 'creative industries'. Hence (somewhat arbitrary) groupings of the existing SIC classes have to be made.

15 Some writers have stressed the interdependence of product and labour markets, for example. Pratt (1997a) defines the 'cultural sector' in terms of the 'cultural industries production system (CIPS)' which seeks to embrace the two.

16 The overlap between the 'cultural' and 'creative' groupings is far from complete: libraries and museums, for example, are part of the 'cultural industries' but not the 'creative industries', whereas the opposite is true of design and fashion activities (see Chapter 34).

tive trades) are obvious examples. And the wealth of culture available (heritage, festivals, concerts, etc) has a major influence on activities such as tourism. For some purposes these wider perspectives are appropriate, but attention in this chapter has been confined just to the cultural sector.

It was shown above that over the period 1995–1999 the growth of employment in the cultural sector (14.3 per cent) has been much faster than in the economy as a whole (4.9 per cent). This comparatively rapid growth, which continues a trend of high growth in this sector in the UK, has also been experienced in many other countries (EC, 1998: 2). The growth is partly attributable to the high income-elasticity of demand for leisure, entertainment and cultural services, and to demographic and lifestyle changes. The growing number of over-55-year-olds are more active in cultural life, with their increased leisure time and disposable income. The higher standards of education (higher staying-on rates beyond age 16 directly affect the demand for culture) and growing urbanisation are also relevant.

> *The socio-cultural profile of city dwellers and the inadequacy of supply in the rural areas distort the demand for culture in favour of urban areas, where the major cultural facilities are concentrated.*

(EC, 1998: 4)

The remarkable and growing concentration of cultural occupations and industries in Greater London was shown in Table 23.3. There is no reason to suppose that this comparatively rapid growth of cultural employment will not continue.

Diversity of employment

One of the most striking features of cultural employment, shown in the data above, is its diversity: it is misleading to suppose that there is a homogeneous labour force. Some of this diversity arises from the sequence of events in cultural production. These embrace creativity, which is fundamental to all cultural activities, through the intermediary stages of activities which are aimed at spreading knowledge and appreciation of any artistic works (via teachers, librarians, curators, exhibitions, festivals, etc) to distribution, which entails the dissemination of artistic endeavours (recording of music, film distribution, etc). These give rise to a wide range of occupations.[17]

These occupations have markedly different characteristics, and examples of polarisation were presented above. On an industrial basis, for example, in 'library, archive activities' virtually everyone is an employee in the public sector, and a majority are part-time. This contrasts with, say, 'publishing/reproduction/recording', where almost all are in the private sector and only a small proportion are

17 For examples of the range of occupations within particular cultural industries see Sadler's (1997) account of the music business, and for an outline of the structure of the film, performing arts, publishing, and TV/radio industries, and the range of occupations, see Creative Industries Task Force (1998) and DCMS (2001).

part-time, or with 'artistic, literary creation, etc' where the great majority are self-employed and only a relatively small percentage are part-time. Similarly, on an occupational basis, most 'musicians' are self-employed whereas very few 'entertainment and sports managers' are.

There are, then, some very different labour markets ranging from standard ones such as librarians to non-standard ones such as artists. As part of this diversity it is also worth recalling (see Tables 23.13 to 23.16) that volunteers are widely used in some parts of the cultural sector, especially in heritage and museums.[18] This diversity can pose problems: the fact that

cultural employment is neither uniform nor standard ... is recognised as a source of richness, but also as a source of difficulty regarding the skills and qualifications of people working in the sector.

(Parker, 1999: 24)

Creative occupations and non-standard employment

Given the strong growth and diversity in cultural employment, it is interesting to look more closely at the quality of these jobs. The focus here is on the creative occupations in the cultural sector, for instance, artists broadly defined (painters, singers, actors, authors, choreographers, etc)[19] because these are central to all cultural industries and they display some of the most interesting characteristics. 'Creation is the work of gifted individuals' (EC, 1998: 3) but if such individuals are to make a living via the labour market, then society must attach a value to their activities.

There is, however, non-market work, such as public-sector patronage, and ample evidence that many such workers create art for art's sake, and thus lie outside the normal labour markets. Unlike ordinary workers, who are normally assumed by economists to care more about their pay, working conditions and effort than about the product they produce, the reverse is true of creative workers.[20]

the creator cares vitally about the originality displayed, the technical prowess demonstrated, the resolution and harmony achieved in the creative act ... [and] ... while these concerns with artistic achievement bear some relation to consumers' ultimate reception of the product, the relationship need not be close.

(Caves, 2000: 4)

The preferences of creators thus lead, by narrow market criteria, to an over-supply of artists and to more creative product than if they valued only the incomes they receive.

18 See Thomas (2000) for an analysis of reasons for the implications of using volunteers in this sector.

19 For some of the difficulties in defining artists, see Mitchell and Karttumen (1992).

20 See Frey (2000), especially Chapter 3, for a fascinating discussion of the importance of intrinsic and extrinsic motivation in creative activity.

There are several distinctive characteristics of artists.[21] Many artists believe that their careers should be independent of the influence of employers, patrons or grant-giving bodies, and the high proportion of (self-defined) self-employed workers (shown in Table 23.7) is a manifestation of this desire. Associated characteristics are mobility, which many artists see as a key factor in their ability to maximise earnings from different opportunities, and multi-activity, for instance, the fact that few artists pursue creative careers exclusively. Shaw and Allen (1997), for example, found for a small sample that about half the visual artists in their study said that teaching and work unrelated to their practice was their most important source of income. All this seems to add up to an image of precarious or 'non-standard' employment.[22] There is, indeed, flexibility in work patterns and many artists often work in a series of piecemeal jobs. In the performing arts, for example, actors and writers move from one production to another, and this sometimes entails movement between subsectors such as stage, film and television.

This 'non-standard', precarious nature of the artists' labour market is partly attributable to the fact that the demand for the product is uncertain. Caves (2000: 3) argues that nobody knows about 'how consumers will value a newly produced creative product, short of actually producing the good and placing it before them'. In films, for example, only about one in ten or twenty is successful.[23] Complex creative products (such as films, pop-music albums, opera) are 'experience goods', but the buyer's satisfaction is a subjective reaction.

The characteristics of artists being independent and in precarious employment, often with low pay (see below), have sometimes been built into a picture of the artist being an isolated figure struggling to make a living. But, this picture must not be overdrawn and certainly does not apply to many creative workers. Far from being isolated, many are part of complex production teams.[24] This is clearly the case with workers in films and the performing arts, but is also true of, say, visual artists, who need agents, galleries, and so on.

The fluid work style has several implications. It is, for example, sometimes claimed (for example, EUCLID, 1999) that much conventional art training provides inadequate preparation for artists because it does not typically acknowledge the difficulties artists face in their lifestyle. Moreover, social security systems and employment contracts are often somewhat rigid and not well-suited to artists with a pattern of intermittent and multiple kinds of employment.[25]

21 There are many discussions of the definition of artists (for example, Mitchell and Karttumen, 1992) and of the characteristics of artists (for example, Caves, 2000; Parker, 1999). The description here draws heavily on EUCLID (1999).

22 For a classification of such jobs ranging from structured permanent (for example, fixed part-time) to unstructured temporary (for example, casual labour), and their implications, see Purcell, et al. (1999).

23 Film producers sometimes try to minimise risk by having test screenings which can, for example, result in changed endings. More generally, it is not uncommon to use option contracts which allow producers to proceed or quit at different stages of production.

24 See Caves (2000) for a discussion of this property of multiplicative production functions.

25 Some countries have special arrangements for such workers. In France for example, performing-arts workers have since the 1960s had their own unemployment benefit scheme which is slightly more generous than the general scheme (though in recent years arrangements have been questioned). This obviously raises issues about the extent of, and reasons for, cross-subsidising performing-arts workers in this way.

'Non-standard' employment and job quality

It is not obvious that the 'non-standard' nature of much cultural employment necessarily implies that these are 'bad' jobs. But what are 'bad' jobs? There is a vast literature on the quality of jobs (which can only be hinted at here). Ultimately of course 'it is the workers themselves who judge job quality and they may consider a job bad for many reasons' (Kelleberg, et al., 2000: 261). The most common measure used to characterise bad jobs is low wages and benefits, though sometimes this simple measure is modified in various ways. Champlin (1995), for example, argues that low pay only means a 'bad' job if it entails a lack of opportunity to move to higher-paying jobs. Several writers, for example Gitelman and Howell (1995), add further measures relating to such things as employment status (such as involuntary part-time hours, and unemployment) and to various skill requirements and working conditions. There is much evidence, notably in Clark's (1998) study of OECD countries, that job satisfaction is closely correlated with job-quality measures, but he found that pay per se was less important to workers than job security and whether they found the job interesting. In the light of these remarks, what can be said about job quality in cultural occupations?

So far as the characteristic of low pay is concerned, the limited evidence from the NES presented above suggested that average earnings of employees in cultural occupations were not, on average, low compared with employees in all occupations and industries. Nor was the dispersion in earnings for artistic occupations any greater than for all occupations. It was noted however that this particular evidence was weak because of limitations in the data, and the exclusion of self-employed workers.

Other datasets on artists' earnings show that they tend to have below-average earnings for all occupations, and much greater dispersion. Numerous studies in several countries have shown that low earnings are endemic and that the distribution is markedly skewed to the right (see for example, Towse, 1993; Strobl and Tucker, 1998; Alper and Wassal, 1998). This last feature is the 'superstar' phenomenon of a tiny percentage of artists receiving exceptionally high earnings. Shaw and Allen (1997), for example, found that 1 per cent of visual artists in Britain earned about 30 or 40 times as much as the average for all such artists.

Only a small proportion make it to the top, in terms of international stardom, and this raises the question of why so many people enter these occupations. In terms of standard labour-market analysis and human-capital theory, there often appears to be negative rates of return (on average) to investing in training in creative cultural careers, and in this sense there is over-supply.[26] This situation has sometimes been attributed to people generally over-estimating small probabilities of very large prizes (see Frank and Cooke, 1995), though this is hard to square with the fact that the superstar phenomenon has been evident for many decades, and it would seem odd if artists and those in training did not recognise disparities and adjust their career decisions. Better explanations probably lie in

26 This indicates that on standard analysis the labour market is in disequilibrium, though some argue (for example, Adler, 1998) that this situation is 'optimal' in the sense that the benefits of the superstar system to consumers outweighs the costs to the artists.

the fact that many artists seem to accept a preference for risk (though it is not clear why the arts should disproportionately attract risk-takers), and in the existence of 'psychic income' arising from the 'art-for-arts' sake' phenomenon noted above. These latter explanations suggest that artists do not themselves believe that their jobs are 'bad', despite being non-standard.

Occupational change

The picture of growth in cultural employment between 1995 and 1999, given above, does not fully reveal the extent of the changes in occupational structure. Table 23.2 shows some switch away from employment in 'library, archive activities' to 'arts facilities' and 'museum activities'. But there are also several important continuing changes within some of the industries shown which are masked by the broad SIC classes used in the LFS, as they show up only at the level of particular workplaces or organisations. Parker (1999) shows that in 'publishing/reproduction/recording', for example, there are many new skills in production and editing, and further growth in new professions such as multimedia design (see EC,1998; Creative Industries Task Force, 1998; DCMS, 2001; Sadler, 1997).

This changing occupational structure, resulting from new technology, raises issues of identifying skills gaps and training needs. These have been examined specifically by Parker (1999) and Keep and Mayhew (1999). One of the needs, in a sector where there is precarious employment, is to maintain employability (see Gazier, 1999). This is not the same as job security but is harder to achieve where many workers move through a series of jobs.

This chapter has shown that employment in the cultural sector is a significant source of jobs, and that its growth rate has been considerably faster than in the economy as a whole. There is great diversity in the forms of employment within the cultural sector, and there are continuing changes within occupations as a result of new technology and other factors. It has been argued that although some of the cultural occupations are 'non-standard', they are not necessarily 'bad' jobs, and the sector seems to offer continuing possibilities for employment growth which is faster than average. This favourable picture of employment in the cultural sector is also found in many other countries.

Part IV
Profile

Introduction

Sara Selwood, University of Westminster

This part consists of ten chapters, which profile the main artforms and heritage activities considered in this book. Chapters 24–31, which focus on built heritage, film, libraries, literature, museums and galleries, performing arts, public broadcasting and visual arts, all collate existing data for the 1998/99 financial year. Where possible, they:

- provide headline data on the 'wider' sector – that is, both commercial and subsidised activity pertaining to turnover, employment, and audiences; and
- present existing data on the subsidised sector which, where possible, describe: the number of organisations funded; the number of people active and employed in field; the type and value of funding to the sector including regional distribution of funding; the types and value of income generated, including imports and exports; the size and profile of audiences and/or participants; and, consumer expenditure.

Chapter 32 analyses data on the financial operations of cultural-sector organisations in 1998/99, based on the findings of a survey undertaken specifically for this book. The 1993/94 operations of many of the same organisations were also examined and comparisons are made between the two sets of data.

The final chapter is based on information gathered between 1994/95 and 1998/99 about the organisations funded (regularly and fixed-term) by the Arts Council of England and the regional arts boards. While it provides a smaller sample than that considered in the previous chapter, and focuses on what are arguably the most securely funded arts organisations in England, this analysis has the advantage of providing year-on-year details.

Overview

Public subsidy

The shares of public funding allocated to individual artforms and heritage activities vary enormously. For example, the BBC's licence fee represents almost half the income that can be identified as coming from the major sources of public funding (Table II.1).

Without public broadcasting, the largest single share of funding from those streams of support from the Department for Culture, Media and Sport, the then Scottish, Welsh and Northern Ireland Offices, local authorities and the National Lottery are those for libraries and museums and galleries. Although the performing arts received more than built heritage, other artforms (film, visual arts, literature) each receive a minuscule percentage of the total (Table II.4).

Existing data

By definition, data pertaining to the operations of the various artforms and heritage activities in the subsidised sector are partial and difficult to compare, and there are virtually no data for either the visual arts or literature. Nevertheless, certain observations can be made.

- During the course of research for this book, some 7,900 cultural organisations were found to have received grants in 1998/99 (a figure which excludes non-cultural organisations in receipt of cultural funding, such as schools, community groups, etc). Within this were probably about 3,000 performing-arts organisations.
- The only public service broadcasters (either funded by the licence fee or subsidised by government) are the BBC Home and World Services and S4C.
- Some 568,000 listed buildings, scheduled ancient monuments and conservation areas in the UK were identified as meriting protection.
- There were a total of 35,086 libraries (the nationals, higher education libraries, public libraries, special libraries, school and further education libraries), with 41,577 service points.
- It is conventionally supposed that there are around 2,500 museums in the UK, although there are probably rather less.

Although the Arts Council of England and the regional arts boards annually publish data on attendances at their regularly funded organisations, beyond that little is known about attendances at subsidised activities. Such information is not conventionally disaggregated from cultural-sector data in general.

- In 1999, BBC 1 and BBC 2 accounted for about 40 per cent of terrestrial viewing. The Corporation also accounts for about 50 per cent of radio listeners.
- There were 136.5 million cinema admissions in 1998, and 68.2 million visits to built heritage (80.2 million if you include churches), in 1999.
- In 1998, the national libraries had 70 million registered or regular users; higher education libraries, 2.4 million; and public libraries, 34.4 million.
- Museums and galleries attracted about 80–114 million visits.
- About 10.8 million people said they went to plays; 11.9 million to classical music; 3.1 million to opera; 3 million to ballet; 2 million to contemporary dance; and 2.7 million to jazz performances.

There is, inevitably, some overlap between the audiences for these various activities. The extent of this has not been assessed.

Data on consumer spend at cultural-sector activities are patchy. The best come from the arts councils of England, Scotland and Wales. The performing-arts organisations they support earned around £205 million in 1998/99.

- Private owners of historic buildings are not obliged to disclose details of their visitors' spend, and the public sector tends not to charge. Nevertheless a spend of £338 million was recorded in 1998, against an average admission for properties in England of £2.70.
- While public libraries tend not to charge for lending books, they do charge for the loan of non-book materials (such as records, etc.), fines and some reservations, hire of audio-visual equipment and lettings. In 1998/99, they earned £73 million from such sources.
- About half of all museums charge admission, and the average admission in 1998/99 was somewhere between £2.20 and £2.80. The only figure of visitors' spend across UK museums – of £37 million – is probably an underestimate.
- Feature films generated £2,651 million in 1999 from a combination of cinema box-office, pay-to-view TV, video rental, laser disk and DVD. The average cost of a cinema ticket was £4.58 (1999).

Details of employment in the cultural sector, based on official data, are covered in Chapter 23. However, the various ad hoc studies referred to in the chapters in Part IV provide rather more detail about individual artforms and heritage activities than do the broad-brush official data.

- In 1998, some 18,600 people were employed at historic properties open to the public in the UK (8,670 full-time-equivalents). Nearly half of all such properties employed volunteers, of whom there were about 29,500.
- Libraries had about 65,000 staff, of whom 35 per cent were trained librarians.
- About 37,000 people were employed in museums. Nearly 20 per cent of museums had no paid staff.
- In 1998, the BBC alone employed 23,000 people.

Survey findings

In many respects, the survey of subsidised organisations carried out for this book provides more insight into the sector than do the existing data described above. Its most salient characteristic is that it covered a wide range of subsidised organisations – some (usually the nationals) with annual incomes of millions of pounds, and others with incomes of less than £1,000 and no permanent staff. Some key survey findings are summarised below.

- At least three-quarters of the organisations were located in England. London and the South East accounted for a third of all respondents.
- Grossing-up, the data for 1998/99 suggest that the subsidised sector as a whole accounted for about 98,000 permanent employees, 63,400 freelance or contract staff opportunities, and around 55,400 volunteer opportunities.
- Just over half of all respondents' recorded income came from public sources.
- Half of respondents' expenditure overall was committed to the costs of their programmes. And, they spent around seven times as much on their main programmes as on their education programmes. Half their administration costs were dedicated to staffing.

Comparing the financial operations of a small group of organisations in 1993/94 and 1998/99 shows some changes in patterns of funding and employment.

- The gap between subsidised organisations may well be increasing. The income of museums and galleries and service organisations surveyed had increased notably, whereas that of the libraries and literature organisations had fallen.
- The nature of organisations' expenditure had shifted. In 1998/99 they spent more on their programmes and less on their administration than was previously the case. Spending on education programmes, in particular, was up.
- The number of people employed by organisations had gone up. In 1998/99 a higher percentage employed permanent staff than had been the case five years earlier, and more had volunteers.

Comparing the arts organisations which provided information about their operations in 1998/99 with those regularly funded by the Arts Council of England and the regional arts boards suggested that, on average, the latter were more likely to have larger incomes. The regularly funded organisations also tended:

- to be more likely to receive Lottery grants, and of greater value, than other organisations;
- to be more dependent on their major funders (albeit the Arts Council of England and the regional arts boards) as the main source of their public subsidies; and
- to spend more on their administration, have higher overheads, larger numbers of staff and higher staff costs.

24
Profile of the Built Heritage

Max Hanna, Sightseeing Research

For the purposes of this chapter, the built heritage embraces the human-made historic environment – historic buildings, ancient monuments and archaeological sites, industrial buildings and historic wrecks. The data in this chapter come from several sources. These include agencies funded by central government, including English Heritage, the Historic Royal Palaces Agency (HRPA), Cadw (Welsh Historic Monuments), Historic Scotland, the Environment and Heritage Service, Northern Ireland, and the Heritage Lottery Fund (HLF), the National Trust and the National Trust for Scotland, and many other trusts and charitable organisations.

Aspects of the built heritage overlap with those of the visual arts, crafts, and museums and galleries. For example, statues and sundials can be listed, like buildings, for special protection. As many as two-thirds of the historic properties open to the public, identified by the English Tourism Council (previously the English Tourist Board) report *The Heritage Monitor* (Sightseeing Research, 1999a), include museums, exhibitions or collections of fine paintings or furniture. Indeed, several hundred historic buildings have been included in the Museums & Galleries Commission register of museums.

Varying amounts of information are available about different aspects of the built heritage. Certain categories of the built heritage, for example, receive more funding, have a more highly developed infrastructure and are better represented in existing sources of data than others. This chapter is divided into two sections which consider the wider context, and sources of funding.

The wider context: sites, visits, earnings and employment

This section considers various aspects of the built heritage: details of visits to historic properties and sites; numbers of historic properties and sites; and their earned income and employment.

Table 24.1 Visits to historic properties in Great Britain, 1998

	Number of visits (millions)	Number of historic properties (a)
English Heritage	5.6	138
Historic Scotland	2.9	70
Historic Royal Palaces Agency	3.4	4
Cadw	1.2	35
Subtotal	*13.1*	*247*
National Trust (b)	8.1	208
National Trust for Scotland	0.8	35
Subtotal	*8.9*	*243*
Total	22.0	490

Sources: EH, HRPA, Cadw, NT and NTS response to English Tourism Council enquiries.

Notes
a) Charging properties only included.
b) Includes England, Wales and Northern Ireland.

Visits to historic properties and sites

During 1998 in the UK there were 68.2 million visits to historic properties for which visitor numbers were known (Sightseeing Research, 1999b).[1] The total number of visits to historic properties increases to 80.2 million if churches are included. The majority of visits were to properties in private hands, including those owned by the National Trust, and other trusts and religious bodies. In 1998, these accounted for 69 per cent of visits to historic properties as compared with 21 per cent for those owned by government agencies or departments, and 10 per cent for those owned by local authorities.

In 1998 there were 13.1 million visits to the historic properties managed by HRPA, Cadw, Historic Scotland and English Heritage (Table 24.1). A further 8.9 million visits were made to historic properties owned by the two National Trusts.

The relative popularity of historic buildings amongst overseas visitors is shown by the fact that the report *Sightseeing in the UK 1998* (Sightseeing Research, 1999b) estimated that 35 per cent of visitors to historic buildings in the UK, in 1998, were foreign. This compares with estimates of 22 per cent for museums and art galleries and 13 per cent for gardens. The earlier British Tourist Authority *Survey of Overseas Visitors* (BTA, 1996) carried out in 1995 found that as many as 73 per cent of foreign tourists had visited historic buildings during their stay, and 67 per cent had visited churches or cathedrals. This compared with 62 per cent visiting museums, 56 per cent visiting gardens open to the public and 34 per cent visiting art galleries. No other activity was mentioned by more than a fifth of the respondents. The 1996 survey found that 37 per cent of overseas visitors mentioned visiting heritage sites as being of particular importance in influencing their decision to visit Britain, as compared with 29 per cent citing visits to

1 This includes properties for which visitor numbers had been estimated for that year or in previous years.

Table 24.2 Number of classified architectural resources in the UK, 1998/99

	England	Scotland	Wales	Northern Ireland	Total (percentage)	
Listed buildings	453,111	44,401	22,308	8,563	528,383	(93.0)
Scheduled ancient monuments	17,759	6,989	3,145	1,466	29,359	(5.2)
Conservation areas	8,819	813	502	53	10,187	(1.8)
Total	479,689	52,203	25,955	10,082	567,929	(100.0)
Percentage	*84.4*	*9.2*	*4.6*	*1.8*	*100.0*	

Sources: Sightseeing Research (1999a); HS (1999), Cadw (1999), and Environment and Heritage Service, Northern Ireland (1999).

museums, art galleries and heritage centres. Again, no other activity was mentioned by more than a fifth of the respondents.

Mintel (1998) commissioned the British Market Bureau to carry out a survey of 'days out' in February 1998, the results of which were published in *Leisure Intelligence*. This survey found that 27 per cent of the adult population had visited historic buildings in the previous 12 months. Demographic variations were analysed and, for example, it was found that the peak age group for visiting historic buildings was 35 to 44, with a proportion of 32 per cent visiting, and that by socio-economic class the proportion for ABs was as high as 49 per cent visiting.

The number of historic properties and sites

Information about the number of historic properties and sites in the UK comes from a variety of sources. Sites and properties are conventionally described in two ways: either by what the ETC refers to as 'classified architectural resources' or by the number of historic buildings open to the public. Classified architectural resources are those that have been identified, as described below, for protection. They include listed buildings, scheduled ancient monuments and conservation areas.

Statutory controls exist to protect historic buildings and monuments where this is deemed to be in the wider public interest. The relevant government departments in England, Northern Ireland, Scotland and Wales are responsible for listing buildings of special architectural or historic significance, including ecclesiastical buildings in use and inhabited buildings. This is to ensure that particular care is taken about decisions affecting their future. In England, for example, between December 1997 and December 1998, 2,178 buildings were added to the listings, 95 new conservation areas identified and 408 ancient monuments scheduled. These numbers have to be considered against the demolition of such buildings. In the year to March 1999 in England, listed-building consent was given for the demolition of 50 buildings, and the Ancient Monuments Society received notification of applications to demolish 169 listed buildings in England in 1998 (Sightseeing Research, 1999a). As Table 24.2 shows, in 1998 there were about 568,000 entries in the listings for the UK.

The relevant government departments are also responsible for compiling and maintaining a schedule of ancient monuments, a system of protection parallel to that of listing. By the end of 1998 there were over 29,000 scheduled ancient

monuments in the UK. In England, 17,759 ancient monuments had been scheduled by the end of 1998 as compared with 13,740 at December 1993. Given that the schedule entries can cover several structures, the 17,759 monuments scheduled in England are estimated to represent about 30,000 individual monuments.

Local planning authorities (and, in Northern Ireland, the Environment and Heritage Service) are required by law to designate areas – as distinct from individual buildings – of special architectural or historic interest as 'conservation areas'. The intention is to preserve and enhance the character or appearance of such areas. At the end of 1998, there were 10,187 conservation areas in the UK.

The English Tourism Council (1999b) calculates that in 1998 there were 1,509 historic properties open to the public in the UK, for which the number of visits were known or had been estimated. The number of properties rises to over 2,000 if properties for which visitor numbers are not known or estimated are included. The same organisation identified 1,989 historic buildings and monuments as being open to the public in England in 1999 (Sightseeing Research, 1999a). This figure does not include cathedrals, listed churches, historic buildings open as a consequence of their economic or social function, or the 200 or more historic properties which open only by appointment.

Earned income of historic properties and heritage sites

There is a lack of comprehensive data about the earnings of the built heritage sector, not least because the private owners of historic properties are not obliged to disclose financial information. It is estimated, however, that historic properties in Britain attracted about £338 million in revenue from visitors in 1998, of which £270 million (80 per cent) would have been accounted for by properties in England (Sightseeing Research, 1999a).

In the year to February 1999, the gross revenue from visitors to National Trust properties in England, Northern Ireland and Wales amounted to £41.3 million. This was divided between £8.6 million from admission fees, £18.1 million from shop trading, and £14.6 million from restaurants and tea-rooms. In addition, £55.7 million was received in membership subscriptions, which permits free entry to all Trust properties, and this is the largest single source of revenue for the National Trust (National Trust, 1999). Admission receipts at the Historic Royal Palaces amounted to £22.7 million in the year to March 1999 and sales receipts came to £8.8 million (Historic Royal Palaces, 1999). The equivalent figures for English Heritage properties (calendar year) were £7.9 million and £5.4 million (English Heritage, 1999).

The 1998 Survey of Visits to Tourist Attractions (Sightseeing Research, 1999a) included a question on the proportions of gross revenue from visitors distributed between admissions, catering and retailing. At historic properties the average proportion of revenue received from admission charges or donations was 64 per cent, from catering 10 per cent, and retailing 26 per cent. The proportion for retailing rose by 1 per cent between 1996 and 1998. For properties charging admission the proportions were 68 per cent (from admission charges), 9 per cent (catering) and 23 per cent (retailing), and for properties offering free admission

Table 24.3 Historic properties in England: adult admission charges relative to 1993 values, 1993–1998

	Government properties	Local authority properties	National Trust properties	Private properties	All	Retail price index
1993	100	100	100	100	100	100
1994	105	103	105	107	106	102
1995	116	113	106	112	111	106
1996	126	122	111	117	117	109
1997	133	127	116	124	122	112
1998	142	138	121	131	129	116

Source: Sightseeing Research 1998a.

they were 29 per cent (from donations), 16 per cent (catering) and 55 per cent (retailing). The proportion for catering is likely to be understated, as some properties sub-contract their catering operation. At the 338 properties where a catering service was offered, the average proportion of gross revenue received from catering was 24 per cent as compared with 53 per cent for admissions and 23 per cent for retailing. Of the 837 historic properties answering the question, 95 per cent derived some revenue from admissions, 40 per cent from catering and 84 per cent from retailing.

Historic properties are increasingly being promoted as venues for conferences and product launches, weddings, film and television locations, receptions and corporate entertainment, and as hotels and other forms of accommodation. The 1999 edition of *Hudson's Historic Houses and Gardens* directory listed 301 historic properties in the UK which are able to accommodate corporate functions and wedding receptions, and the number has risen over the past five years (Hudson, 1999).

Historic properties in the public sector (those owned by local authorities, government departments or government agencies) tend not to charge admission. Of the 1,989 historic properties open to the public in England, as many as 38 per cent admit visitors free of charge. These tend to be in areas where there is a high density of publicly-owned properties. In Leicestershire, for example, admission to 63 per cent of properties is free (Sightseeing Research, 1999a), and 12 of the 24 properties open in this county are owned by local authorities.

The average summer-season adult admission charge at historic properties in England in 1999 was £2.84, compared with £2.71 in 1998 (an increase of 5 per cent). This varied from £1.88 in Humberside to £4.52 in Berkshire. The average charge at local-authority properties was £1.79 compared with an average of £2.81 for government properties, £3.05 for private properties, and £3.42 for National Trust properties. As can be seen in Table 24.3, admission charges to historic buildings have risen substantially above the increase in retail-price inflation since 1993. Charges at government and local-authority properties have risen significantly faster than at National Trust or private properties.

Visitors to historic properties may be offered a range of facilities including guided tours and other forms of interpretation, catering, museums, gardens and parks. Two-thirds of historic properties in England have collections of fine paintings or furniture or exhibitions, 39 per cent give public access to a garden and 18

Table 24.4 Earned income of historic properties: admissions, memberships and services, 1998/99

£ million

	EH	HS	Cadw	HRPA	NT	NTS	Total
Admissions	9.0	8.4	1.7	22.7	8.6	1.8	52.2
Services	6.5	5.0	1.0	8.8	32.7	4.4	58.4
Membership	5.9	–	0.3	–	55.7	4.1	66.0
Total	21.4	13.4	3.0	31.5	97.0	10.3	176.6
As a percentage of total income	*16.2*	*27.9*	*23.1*	*87.0*	*53.2*	*46.9*	*40.7*

Sources: EH, HS, Cadw, HRPA, NT, NTS annual reports 1998/99.

per cent to a park, 29 per cent provide guided tours and a third provide 'teas'. In recent years, special events such as historical re-enactments, concerts and motor-car rallies have also contributed to the income generated by historic properties. Thirty per cent organised such events in 1999. English Heritage staged 747 events in 1998/99 and attracted 788,000 visitors.

Table 24.4 provides a breakdown of the £177 million earned income of bodies which manage the built heritage in the public and trust sectors, and illustrates the main differences between them. English Heritage, Historic Scotland and Cadw each earned less than 30 per cent of their total income, whereas the HRPA is expected to generate over 80 per cent of its operating income. The two National Trusts earned about half of their income, a much higher proportion of which came from membership subscriptions as compared with the public bodies.

The *Day Visits in Great Britain 1991/92* Survey (DNH, 1993), carried out for the Department of National Heritage, included separate results for stately homes, castles and ancient monuments, and churches and cathedrals. The survey covered all leisure day visits of three hours or more in Great Britain, excluding those from a holiday base. It was found, for example, that expenditure on day-trip outings to stately homes amounted to £101 million, of which 36 per cent went on food and drink, 21 per cent on fuel, 20 per cent on admission charges, 9 per cent on gifts, 5 per cent on fares, and 10 per cent on other items.

In 1996 English Heritage published a literature review of the economic and social value of the built heritage entitled *The Value of Conservation?* (EH, 1996). This marked the third stage of research jointly sponsored by the Royal Institution of Chartered Surveyors (RICS) and English Heritage. In 1991 the Investment Property Databank was commissioned to provide a study of the investment performance of listed commercial buildings, and the results are now updated each year. In 1998, the study found that the overall returns from investing in commercial listed buildings – the yield from the rent plus any increase in the capital value – was 11.9 per cent compared with 11.4 per cent for unlisted buildings (IPD, 1999). The Department for Culture, Media and Sport (DCMS) joined in for the second stage of the research, in which the Department of Land Economy at the University of Cambridge considered the effect of listing on the value of buildings.

Employment in built heritage

It is estimated that nearly 18,600 people were employed in historic properties open to the public in the UK in 1998 (Sightseeing Research, 1999b). This number reduces to 8,670 full-time-equivalent posts, as the average number of 14.6 paid jobs per property includes 6.1 part-time seasonal staff, 1.6 full-time seasonal staff, and 2.4 part-time permanent staff as well as 4.5 full-time permanent staff. As many as 59 per cent of properties employ part-time seasonal staff. Nearly half employed volunteers in 1998, whose numbers amounted to 29,500. Numerous volunteers are employed at cathedrals and National Trust properties. These statistics cover only tourism-related activities.

Sources of funding

Apart from the revenue which the built heritage earns through commercial activities, support for this sector is largely channelled through:

- central government departments (directly or through their funding of executive agencies and other bodies);
- local authorities;
- grant-making trusts and foundations, and business sponsorship.

The built heritage received a total of £212 million from central government departments and local authorities and sponsors in the UK in 1998/99, as shown in Table 24.5.

Central government funding

Several central government departments fund the built heritage. DCMS, the Scottish Office (SO), the Welsh Office and the Northern Ireland Office combined provided one third of the public support to the built heritage shown in Table 24.5. As mentioned above, the DCMS, Scottish Office and Welsh Office support agencies and non-departmental public bodies with statutory roles relating to the recording and conservation of the built heritage. These include English Heritage, Historic Scotland, Cadw and, in Northern Ireland, the Environment and Heritage Service. The DCMS also supports the National Heritage Memorial Fund and the Churches Conservation Trust.

English Heritage, Historic Scotland, Cadw and the Environment and Heritage Service (Northern Ireland Office) not only work towards the conservation of the built heritage but, together with National Heritage Memorial Fund and the Heritage Lottery Fund, they also distribute £157.3 million in grants to other bodies (Table 24.6).

In 1980 the government established the National Heritage Memorial Fund to replace the National Land Fund. This fund is administered by trustees, is independent of government, and is able to give grants, loans, and endowments to

Table 24.5 Funding of heritage in the UK, 1993/94–1998/99

£ million

	1993/94	1994/95	1995/96	1996/97	1997/98	1998/99
Central government DCMS (a)						
Historic Royal Palaces Agency	6.700	9.118	4.232	6.687	7.510	3.806
Royal Parks Agency	22.800	23.949	24.701	23.171	21.871	21.065
English Heritage	100.200	104.400	109.674	107.629	105.183	102.214
RCHME	14.800	14.000	11.908	11.313	11.073	10.900
NHMF	12.000	8.700	8.805	8.005	5.000	2.000
Occupied Royal Palaces, other historic buildings and state ceremonial	27.200	24.000	24.789	24.069	22.073	20.689
Other bodies	3.700	4.000	4.585	4.392	4.681	4.730
Subtotal	*187.400*	*188.167*	*188.694*	*185.266*	*177.391*	*165.404*
Scottish Office						
Historic Scotland	51.000	48.000	40.000	33.000	33.000	32.000
Welsh Office						
Cadw	10.000	11.000	11.000	10.000	9.800	10.500
Northern Ireland Office (b)	–	–	–	4.666	4.091	4.217
National Lottery						
Heritage Lottery Fund & Millennium Commission	n/a	39.973	104.583	121.738	82.175	348.470
Local authorities						
England (c)	–	–	–	50.308	42.257	41.031
Wales (c)	–	–	–	1.879	1.939	1.563
Scotland (d)	1.290	2.149	1.524	0.184	0.692	0.982
Northern Ireland (e)	–	–	–	–	–	–
Recorded subtotal	*1.290*	*2.149*	*1.524*	*52.371*	*44.888*	*43.576*
Business sponsorship (f)	0.994	1.429	2.006	2.232	1.946	6.723
Recorded total	250.684	290.719	347.807	409.273	353.291	610.890
Higher education institutions	–	–	–	–	–	2.288

Sources

DNH annual reports 1995–1997; DCMS annual reports 1998–1999; Department of the Secretary of State for Scotland and the Forestry Commission, *The Government's Expenditure Plans* (various years);

The Government's Expenditure Plans: Department report by the Welsh Office, various years;

Expenditure plans and priorities, Northern Ireland: The Government's Expenditure Plans, various years;

HLF; Scottish Local Government Financial Statistics, various years, Government Statistical Service;

Business Support for the Arts, ABSA, various years.

Notes

a) This does not include funding for the built heritage via the National Heritage Memorial Fund, which covers land, buildings, museums and galleries; industrial, transport and maritime heritage; manuscripts and archives, but which could not be disaggregated.

b) The Environment and Heritage Service only came into being in April 1996. Comparable data for built heritage are not available before that date.

c) These figures represent net local authority expenditure on conservation of the historic environment. CIPFA first produced these statistics for the year 1996/97.

d) These figures represent local authority net expenditure on historic houses in Scotland. The figures for 1998/99 are not yet available.

e) No data on local authority expenditure on heritage in Northern Ireland were available.

f) Figures from the annual ABSA/Arts & Business *Business Support for the Arts/Business Investment in the Arts*. May overlap with matching funding for the DCMS-sponsored Pairing Scheme. For the sake of accuracy, separate figures for the Pairing Scheme have therefore been excluded from this table.

Table 24.6 Value of grants distributed by dedicated heritage bodies, 1998/99

Source of funding	Redistributing bodies	Value of grants (£m)	Percentage
DCMS	EH	35.5	22.6
DCMS	NHMF	1.1 (a)	0.7
DCMS	HLF	99.7 (b)	63.4
WO	Cadw	4.5	2.9
SO	HS	13.9	8.8
NIO	E&HS	2.6	1.6
Total		157.3	100.0

Sources: EH, Cadw, HS, NIO and HLF annual reports, 1998/99.

Notes
a) This relates to grants for historic properties and excludes grants to other types of recipient.
b) The figure relates to grants awarded to historic buildings, and industrial, maritime and transport structures.

a wide range of bodies such as the National Trust, building preservation trusts, and museums. The Fund has powers to provide financial assistance towards the acquisition, maintenance and preservation of buildings, land, works of art and other objects or structures of importance to the national heritage. The major part of the money remaining from the National Land Fund was handed over for administration by a body of independent trustees. This amounted to £12.4 million, the remaining sum being allocated to finance the system of acceptance of items of importance to the national heritage in lieu of capital taxation. In addition, the government is committed to paying an annual grant to the Fund at the beginning of each financial year: £2 million was allocated for the year 1998/99 as compared with £5 million for 1997/98 and £12 million for 1993/94 (HLF and NHMF, 1999). The grant-in-aid from the DCMS will rise to £2.5 million in 1999/2000, £3 million in 2000/01, and £5 million in 2001/02. In its nineteenth year to March 1999 the Trustees of the Fund made grant payments totalling £4,735,000, in respect of 15 items of major national importance (HLF and NHMF, 1999). Grants for historic properties amounted to £1.1 million and included two grants totalling £961,000 which were made to the Historic Dockyard, Chatham, for the acquisition and long-term preservation of HMS *Cavalier*, the last surviving destroyer to have seen active service during World War II. The Fund is intended as a safety net to be used only when all other avenues have been exhausted.

From January 1995 the National Heritage Memorial Fund, through the Heritage Lottery Fund, has been the distributor of money destined for the heritage raised by the National Lottery, and by October 1999 £1,329 million had been awarded to 3,009 projects from the Heritage Lottery Fund. This included £540 million awarded to 569 museums or galleries, £367 million to 1,391 historic buildings, £150 million to 252 historic parks, and £92 million to 183 industrial, maritime or transport structures. About 38 per cent of the value of the grants has gone to charities, 27 per cent to local authorities, 20 per cent to central government, 7 per cent to other public-sector bodies, 6 per cent to church organisations, and 2 per cent to private-sector organisations (HLF and NHMF, 1999).

In 1998/99 the Heritage Lottery Fund received £310.2 million in proceeds from the National Lottery as compared with £365.7 million in 1997/98 and

£316.6 million in 1996/97. A large amount of money has been siphoned off from the Heritage Lottery Fund to pay for the New Opportunities Fund which will take a 33 per cent share of the Lottery receipts by 2001. The Heritage Lottery Fund share of Lottery money will continue at 16.7 per cent after the watershed year of 2001, when the original Camelot licence expires.

In the year from April 1998 to March 1999 the Heritage Lottery Fund awarded 1,051 Lottery grants (an increase of 8 per cent on the previous year) to a total value of £292 million (a decrease of 18 per cent). £80.4 million of this was awarded to historic buildings and townscapes, and £19.3 million to industrial, maritime and transport structures. Urban regeneration received a boost through the first awards in the Heritage Lottery Fund's Townscape Heritage Initiative, which was launched in April 1998. This major UK-wide programme is designed to create new opportunities for economic, social and cultural regeneration through the repair and restoration of the urban built fabric. In 1998/99, 35 awards totalling £17.8 million gave priority to towns in Northern Ireland, Scotland and Wales since these had not benefited from the Fund's earlier support for Conservation Area Partnership Schemes for towns in England (HLF and NHMF, 1999). The Civic Amenities Act 1967 made provision for the protection of areas (as distinct from individual buildings) of cities, towns or villages, by requiring planning authorities to designate areas of special architectural or historic interest as conservation areas. The object of designation is the preservation and enhancement of the character or appearance of such areas.

To ensure that local priorities are taken into account for grants of regional and national importance, decision-taking committees were set up in Scotland, Wales and Northern Ireland, and for the English regions, dealing with grants of up to £1 million. In March 1998 the National Heritage Act 1997 came into force, and extended the powers of the Fund to distribute Lottery monies to a wider range of projects and applicants within the heritage field. In particular, it removed the restrictions on eligibility for funding so that Lottery cash can be made available for any project of heritage importance and public benefit, irrespective of ownership. Private individuals have become eligible, therefore, where there is a clear public benefit, although Heritage Lottery Fund trustees have attached a very low priority to such applicants at present (see Chapter 16). Lottery funds are now available to support access, education and youth initiatives in the heritage field. These might include providing or improving facilities for visitors, or using new technology to improve presentation and interpretation. In the spring of 1999, it was announced that the Fund would give increased support for local heritage and greater emphasis on education and access (HLF and NHMF, 1999).

The private sector has responsibility for the majority of heritage properties in the UK. It receives some funds from central government. As Table 24.7 shows, 72 per cent of the amount distributed in grants by public bodies in 1998/99 was dedicated to historic buildings and monuments, which include those in private hands. In addition, 9 per cent can be identified as having gone to ecclesiastical buildings.

Other central government departments support the built heritage, largely as a result of their other functions. The Ministry of Defence, for example, is responsible for the conservation of 700 listed buildings on its land. In inner-city areas,

Table 24.7 Heritage grant expenditure, by type of recipient, 1998/99

£ million

	Historic buildings and monuments	Churches and cathedrals	Other	Total	(Percentage)
EH	15.2	13.1	7.2	35.5	(22.7)
CADW	3.4	(b)	1.1	4.5	(2.9)
HS	12.8	(b)	1.1	13.9	(8.9)
NIO (a)	1.3	0.3	1.0	2.6	(1.7)
HLF	80.4	–	19.3	99.7	(63.8)
Recorded total	113.1	13.4	29.7	156.2	(100.0)
Percentage	72.4	8.6	19.0	100.0	

Sources: EH, Cadw, HS, NIO and HLF annual reports, 1998/99.

Notes

a) 'Other' includes grants given to the National Trust.

b) Grants to churches and cathedrals are included within the historic buildings and monuments column for Cadw and Historic Scotland.

government funds for conservation projects are also available via Challenge Funds, English Partnerships and the recently introduced New Deal for Communities, which are the responsibility of the Department of the Environment, Transport and the Regions (DETR). In 1994 the government introduced the Single Regeneration Budget, designed to make support for regeneration more responsive to local priorities. From that date, the regeneration offices of four government departments were integrated in order to improve the delivery of government programmes at local level. The administration of the Single Regeneration Budget was transferred to the Regional Development Agencies in April 1999. Budgets for 1998/99 included £580 million for Challenge Funds (£459 million in 1997/98), £298 million for English Partnerships (£259 million), £9 million for City Challenge (£149 million) and £12.5 million for New Deal for Communities. Just over 3,900 buildings were improved or brought back into use via Challenge Funds in 1997/98 (DETR, 1999).

Local authority funding

Since 1962 local authorities have been empowered to make discretionary grants or loans towards the repair of historic buildings, which do not necessarily have to be listed to qualify for these grants. There is no common policy on how these grants are allocated since each district or county council adopts the system it thinks most suitable. In 1995 the Chartered Institute of Public Finance and Accountancy (CIPFA) introduced in the annual publication *Planning and Development Statistics* (CIPFA, 1999) a section on the Conservation of the Historic Environment. This includes an analysis of the value of grants offered or paid by local authorities to outside bodies for the repair and refurbishment of listed buildings, other historic buildings, ancient monuments or archaeological remains, or the enhancement of conservation areas. For the year 1998/99, 206 authorities spent £10.5 million on these grants, 78 authorities spent nothing, and 104 authorities (27 per cent of all authorities in England) did not respond to the question. The expenditure for

1998/99 increases to £13.6 million if the expenditure for an earlier year of 69 authorities which did not reply for 1998/99 is included. The CIPFA grossed-up estimate was £14,096,000 for 1998/99. Information is also given on the value of conservation grants offered or paid from the funds of other bodies (such as English Heritage), and these amounted to £14.3 million in 1998/99. Figures are also available for staff costs (£26.2 million), hire or contracted services (£2.1 million) and other expenditure (£19 million). Total grossed-up net local-authority expenditure on the conservation of the historic environment in England was recorded as being £41.031 million in 1998/99.

The number of local-authority staff employed in environmental enhancement and conservation was estimated at 2,105 in 1998/99, which was a drop of 3 per cent compared with the previous year. Not all such staff are concerned with the conservation of buildings. The Institute for Historic Building Conservation (formerly the Association of Conservation Officers until April 1997), founded in 1982, had 1,336 paid-up members at April 1999. The majority of members are employed by local authorities.

Private funding

The main channel of private funds for secular buildings is the National Trust, which has responsibility for over 240 historic buildings in England which are open to the public. The Trust's expenditure on capital works and projects at properties rose by 11 per cent in 1998/99 to a total of £37.8 million, and £8.9 million was spent on acquisitions (of which £1 million related to historic buildings). Expenditure on restoration works to historic buildings and collections amounted to £15.7 million (a decrease of 16 per cent). Total expenditure was £151.8 million, and this was funded partly from ordinary income (£136.9 million), partly from capital grants (£9.5 million), and partly from legacies (£33.3 million) and the sale of leases and freeholds. Ordinary income (which increased by 6 per cent) was divided between membership subscription income (up 8 per cent to £55.7 million), investment income (up 4 per cent to £25.2 million), rents (up 9 per cent to £21 million), National Trust Enterprises Net Contribution (down 2 per cent to £11.4 million), admission fees (down 1 per cent to £8.6 million), appeals and gifts (up 41 per cent to £10.2 million), other property income (£1.4 million) and revenue grants and contributions (£3.5 million). The rise in subscription income was partly due to an increase in the number of members from 2.5 million to 2.6 million (NT, 1999).

On a smaller scale there is the Landmark Trust, which preserves many small buildings of minor importance but often of great charm and eccentricity; 166 of these buildings were let out to 32,500 holiday-makers in 1998, compared with 144 let out to 26,000 in 1993. In addition, there is the Monument Trust, the Manifold Trust, the Leche Trust, the Ernest Cooke Trust, and the Pilgrim Trust amongst several grant-aiding charities which take an interest in old buildings. Details of the grants made by some of the larger charitable trusts are given in the *Directory of Grant Making Trusts* published by the Charities Aid Foundation (1999).

At the local level there were 126 building preservation trusts in England, organised on a regional, county or town basis, at March 1999. A major source of working capital for building preservation trusts is the Architectural Heritage Fund (AHF), a company limited by guarantee with charitable status, governed by a Council of Management and run by a small full-time staff. The AHF came into being in 1976, following an initiative in the European Architectural Heritage Year campaign in 1975, and its first million pounds was raised in equal parts from the private sector and from government. The AHF's capital 'revolves', providing low-interest loans to ease the cash-flow of local buildings preservation trusts engaged in acquiring and restoring old buildings. Over the years this revolving capital fund has grown, as a result of further grants, donations and interest earnings, to nearly £12 million. Since 1990, the AHF has also offered grants for feasibility studies carried out by buildings preservation trusts. By March 1999, the Fund had loaned over £28.68 million in support of 368 projects nationwide, of which just over £21.8 million (from 328 projects) had been repaid. In the same year the AHF disbursed almost £95,000 in grants for 26 feasibility studies carried out by buildings preservation trusts.

Details of the business sponsorship of the heritage are provided by the Association for Business Sponsorship of the Arts/Arts & Business. Table 24.8 shows that almost £7 million was identified in 1998/99.

Table 24.8 Business sponsorship of heritage English RAB and home country, 1993/94–1998/99 (a)

£ million

	1993/94	1994/95	1995/96	1996/97	1997/98	1998/99
England (b)						
East	0	0	0.004	0.002	0	0.002
East Midlands	0	0	0.120	0	0.046	0.022
London	0	0.150	1.481	0	0.030	0.210
North West	0	0	0.018	0	0.005	0.020
Northern	0.024	0	0.184	0.006	0	
South East	0.002	0.015	0	0.014	0	0.002
South West	0.015	0.043	0	0.007	0.002	
Southern	0	0	0	0	0	0
West Midlands	0	0.028	0.017	0.010	0	0.050
Yorkshire & Humberside	0.040	0.014	0.193	0.031	0.007	0
Total England	*0.057*	*0.273*	*1.833*	*0.247*	*0.096*	*0.305*
Scotland	0.101	0.117	0.145	0.068	0.136	0.234
Wales	0.024	0.004	0.003	0	0.009	0.001
Northern Ireland	0	0.009	0.025	0	0.103	
National funding/other	0.813	1.027	0	1.916	1.706	6.080
Recorded total	0.994	1.429	2.006	2.232	1.946	6.723

Source: ABSA/Arts & Business *Business Support for the Arts/Business Investment in the Arts*, various years.

Notes
a) This may include figures for the Pairing Scheme. A similar regional breakdown for the Pairing Scheme is not available.
b) Regional arts board regions.

Table 24.9 Expenditure on heritage by region, 1993/94–1998/99

£ million

	1993/94	1994/95	1995/96	1996/97	1997/98	1998/99
England						
DCMS	187.400	188.167	188.694	185.266	177.391	165.404
Lottery (HLF and Millennium Commission)	n/a	n/a	42.498	137.249	108.437	65.755
Local authorities	–	–	–	50.308	42.257	41.031
Business sponsorship	0.057	0.273	1.833	0.247	0.096	0.305
Wales						
Welsh Office	10.000	11.000	11.000	10.000	9.800	10.500
Lottery (HLF and Millennium Commission)	n/a	n/a	1.492	3.706	2.751	8.102
Local authorities	–	–	–	1.879	1.939	1.563
Business sponsorship	0.024	0.004	0.003	0	0.009	0.001
Scotland						
Scottish Office	51.000	48.000	40.000	33.000	33.000	33.000
Lottery (HLF and Millennium Commission)	n/a	0.419	9.786	26.043	26.242	12.835
Local authorities	1.290	2.149	1.524	0.184	0.692	0.982
Business sponsorship	0.101	0.117	0.145	0.068	0.136	0.234
Northern Ireland						
Northern Ireland Office	–	–	–	4.666	4.091	4.217
Lottery (HLF and Millennium Commission)	–	–	2.396	3.521	7.328	14.807
Local authorities	–	–	–	–	–	–
Business sponsorship	0	0.009	0.025	0	0	0.103

Sources: DNH annual reports 1995–1997; DCMS annual reports 1998–1999;
Department of the Secretary of State for Scotland and the Forestry Commission, *The Government's Expenditure Plans*, various years;
The Government's Expenditure Plans: Department report by the Welsh Office, various years;
Expenditure plans and priorities, Northern Ireland: the government's expenditure plans, various years;
Heritage Lottery Fund; CIPFA *Planning and Development Statistics*;
Scottish Local Government Financial Statistics, various years, Government Statistical Service;
ABSA/Arts & Business *Business Support for the Arts/Business Investment in the Arts*, various years.

Regional distribution

The vast majority of public funding for the built heritage in the UK goes to England, as Table 24.9 shows, largely on the basis of the distribution of heritage assets.

England has 87 per cent of the conservation areas, 86 per cent of the listed buildings, and 61 per cent of the scheduled ancient monuments in the UK (see Table 24.2). As Table 24.10 shows, within England itself, the largest concentrations of classified architectural resources and historic properties open to the public are located in four of the ten tourist regions: the Heart of England, the West Country, East of England and the Southern region. They jointly account for 66 per cent of listed buildings, 58 per cent of conservation areas and 67 per cent of scheduled ancient monuments. These regions also have 59 per cent of all historic properties open to the public.

The computerisation of the listed-building records has meant that it is now possible to carry out detailed counts of the listed-building stock. The Royal Commission on the Historical Monuments of England (now part of English

Table 24.10 Distribution of historic properties in the English tourist regions, 1998/99

Percentage

Tourist region	Listed building Dec. 1998	Conservation areas Dec. 1998	Scheduled monuments Dec. 1998	Historic properties open 1999	EH grants 1998/99
Cumbria	2.0	1.1	4.1	5.0	2.5
Northumbria	3.3	3.1	6.6	5.2	4.9
North West	4.8	7.5	2.3	5.4	13.8
Yorkshire	8.5	8.5	12.6	7.9	10.7
Heart of England	18.6	19.9	14.6	17.6	15.5
East of England	17.4	14.4	10.6	15.5	19.7
London	4.7	9.7	0.9	6.1	11.8
West Country	17.7	11.8	28.6	13.2	8.5
Southern	12.5	12.3	13.0	12.7	5.2
South East	10.5	11.8	6.7	11.4	7.4
England	100.0	100.0	100.0	100.0	100.0

Source: Sightseeing Research 1999a.

Heritage) calculated that there were 370,034 listed-building entries for England at the end of December 1998. As the figure relates to entries, it is therefore lower than the number of listed buildings counted by the Department for Culture, Media and Sport (referred to above). One entry may cover more than one listed building. Devon has the largest number of listed-building entries (20,351) followed by Kent (17,759), London (17,548), Essex (14,270) and North Yorkshire (13,777). The top 150 district councils account for 79 per cent of the total number of listed-building entries. This list is headed by Herefordshire (5,905), Cotswold (4,952), South Somerset (4,631), West Dorset (4,293) and Westminster (3,832). By parish, the top five are Westminster (2,269), Bristol (2,149), Huddersfield (1,655), Bath (1,518) and Liverpool (1,481).

The distribution of listed building entries by age and type as at the end of December 1998 is given in Table 24.11 By century, the proportion varies from 0.9 per cent for the thirteenth century (in origin) to 31.4 per cent for the nineteenth century. The proportion of twentieth-century buildings is only 2.9 per cent, but this is likely to grow as more emphasis is given to this period in the listing programme. Domestic buildings account for 64.8 per cent of all listed buildings by main building type, followed by agricultural buildings (20.9 per cent), commercial buildings (13.2 per cent), transport buildings (11.9 per cent) and religious buildings (11.0 per cent). The percentages do not add up to 100 as there are duplicated entries for buildings which have a number of different functions.

England also has the vast majority (78 per cent) of historic properties open to the public (Sightseeing Research, 1999b), and accounted for 85 per cent of all visits to historic properties in the UK (Scotland has 10 per cent of all visits, Wales fewer than 4 per cent, and Northern Ireland fewer than 1 per cent). Nearly 20 per cent of all visits to historic properties in England are made in London. The West Country, Heart of England, South East and Southern regions jointly accounted for 51 per cent of visits.

Taking account of all the various types of grant made by English Heritage in 1998/99, the largest shares went to London (11.8 per cent), Greater Manchester

Table 24.11 Listed buildings in England by age and type, December 1998

Listed buildings by century	Number	Percentage
1000–1099	5,259	1.5
1100–1199	3,387	0.9
1200–1299	3,343	0.9
1300–1399	4,113	1.1
1400–1499	10,838	3.0
1500–1599	28,901	7.9
1600–1699	70,146	19.3
1700–1799	113,343	31.1
1800–1899	114,487	31.4
1900–1998	10,719	2.9
Listed buildings by main building types		
Domestic	239,702	64.8
Agricultural and subsistence	77,294	20.9
Commercial	48,774	13.2
Transport	44,222	11.9
Religion, ritual and funerary	40,816	11.0
Gardens, parks, urban spaces and street furniture	34,582	9.3
Commemorative of events or persons	26,452	7.1
Industrial	14,370	3.9
Recreational	13,313	3.6
Educational	9,557	2.6
Water supply and drainage	8,979	2.4
Health and welfare	5,220	1.4
Civil administration and law enforcement	5,195	1.4
Communications (transmission of information)	4,107	1.1
Defence	2,754	0.7
Maritime	1,700	0.5
Institutional (private, political or professional bodies)	1,495	0.4

Source: Sightseeing Research 1999a.

(6.2 per cent), Suffolk (5.6 per cent), Kent (4.7 per cent), Norfolk (4.0 per cent) Cheshire (3.9 per cent), West Yorkshire (3.9 per cent), Hereford & Worcester (3.6 per cent), Humberside (3.3 per cent) and Lincolnshire (3.2 per cent). These ten counties raised £15.7 million between them, or half of the total English Heritage grant-aid accepted in 1998/99.1

In the 23 years from 1976/77 to 1998/99, English Heritage (and the Historic Buildings Council before 1984/85) made grants of £471 million: £151 million went on the repair of churches (9 per cent in Suffolk), £147 million on outstanding secular historic buildings (7 per cent in Derbyshire), £102 million on Section 77 conservation grants (14 per cent in London), £43 million on Town Schemes (10 per cent in Kent) and £27 million on cathedrals (14 per cent in Wiltshire). Overall, the largest shares of this money have been taken by London (8.9 per cent), Norfolk (4.5 per cent), Suffolk (4.1 per cent), North Yorkshire (4.1 per cent), Kent (3.9 per cent), Merseyside (3.7 per cent), Derbyshire (3.5 per cent), Cambridgeshire (3.2 per cent), West Yorkshire (3.1 per cent), and Devon (3.0 per cent). The grants for outstanding secular buildings have been most evenly spread (the top ten counties accounting for 43 per cent), whilst the grants for cathedrals have been least evenly spread (the top ten counties accounting for 71 per cent). Taking account of all the various types of grant made by English Heritage in 1997/98, the largest shares went to London (6.4 per cent), Cambridgeshire (5.8

per cent), Kent (4.8 per cent), West Yorkshire (4.3 per cent) Devon (4.2 per cent), Norfolk (4.1 per cent), West Sussex (4.1 per cent), Suffolk (3.7 per cent), Merseyside (3.5 per cent) and Wiltshire (3.4 per cent). These ten counties raised £12 million between them, or 44 per cent of the total English Heritage grant-aid accepted in 1997/98.

Conclusion

Over the past five years the most positive factor affecting the built heritage has been the establishment of the Heritage Lottery Fund. As yet, however, it has been of little benefit to the private sector. In addition, the 1997 government has diverted money from the Heritage Lottery Fund to the New Opportunities Fund. English Heritage has had its grant-in-aid cut for five successive years in real terms to 1999/2000, and the ever-widening definition of the built heritage means that it must spread its grants more thinly. The English Tourism Council has been divested of its marketing budget, and so it is no longer able to promote the built heritage, as it did with the successful Industrial Heritage Year campaign in 1993. Repairs to historic buildings are still subject to a 17.5 per cent rate of value added tax, whilst both demolition and new construction are zero-rated. The government has announced a review of policies relating to the historic environment, but the wide range of topics and short time scale suggest that its analysis is likely to be somewhat superficial.

25
Profile of the Film Industry

David Hancock, *Screen Digest*

This chapter collates the existing data on the film industry in the UK, under the following headings: audiences for cinema; audience profiles; consumer expenditure; film production and output; employment in the media; public support; regional dimension of funding and employment; business sponsorship; and balance of trade.

Cinema audiences and consumer expenditure on films

Audiences for cinema in the UK

UK cinema audiences have risen throughout the 1990s, driven mainly by the construction of multiplex cinemas. Whereas in 1988 admissions stood at 84 million, by 1998 this had risen to 136.5 million – a 60 per cent increase in ten years (Table 25.1). The figure for 1999 rose even higher to 140.3 million. In box-office terms, the UK was worth £643 million in 1999, making the UK the third-largest market in the European Union, behind France and Germany.

The UK is still under-screened compared to the European average, although the country as a whole is showing a continuous rise in the number of screens per million population. There are currently around 45 screens per million people. The average person visits the cinema 2.35 times a year. The average ticket price is rising slightly year on year, standing at £4.58 in 1999.

The change in cinema admissions during the 1990s has been dramatic in many other countries around the world. The UK was one of the first markets to

Table 25.1 The UK cinema exhibition sector, 1996–99

	1996	1997	1998	1999
Admissions	125.1	140.52	136.5	140.3
Box office (£m)	450	556	564.6	643
Average ticket price (£)	3.6	3.96	4.14	4.58
Number of screens	2215	2383	2638	
Screens per million population	37.9	40.6	44.8	–
				–

Source: *Screen Digest*.

begin building multiplex theatres in the late 1980s. The boom in this form of cinema continued throughout the 1990s, and multiplexes now constitute the majority of admissions in the country. Since 1993, the number of multiplex screens has jumped from 600 to 1150 in 1998 (Geobusiness AGI Conference speech, 1998). Multiplex sites now account for 57 per cent of screens and 67 per cent of admissions (www.dodona.co.uk). Apart from this growth, the remaining market has remained relatively stable.

Cinema advertising holds a relatively small share of the overall advertising market, but was worth £123 million in 1999 (Advertising Association/CAA, quoted in www.pearlanddean.com). This is an increase of 26 per cent over 1998. Market growth has been rapid, nearly doubling in five years.

Audience profiles

The main source for data on cinema audience profiles is the Cinema and Video Industry Audience Research (CAVIAR) survey, commissioned by the Cinema Advertising Association (CAA) and undertaken by the British Market Research Bureau (BRMB). The CAVIAR survey, now in its seventeenth year, has two sections:

- an annual report, which provides data on cinema consumption and attitudes, based on 3,000 face-to-face interviews; and
- the film monitor, which provides quarterly film profiles on over 120 films a year, enabling forecast audience figures for the cinema-advertising industry.

The most recent CAVIAR survey (BMRB, 1999), which covers 1998, found that, across all cinemas, 67 per cent of cinema-goers are aged 15–24 (40 per cent) and 25–34 (27 per cent). In terms of class, 66 per cent of cinema-goers are ABC1 and 34 per cent are C2DE. Men constitute 52 per cent of the audience, and women 48 per cent.

The data are also available in more detail. For those sites classified as art screens, 55 per cent of the audience is 35 and over, 23 per cent are in the 25–34 age bracket and 22 per cent are younger than 25. This clearly highlights the two faces of cinema exhibition, where multiplex sites attract the young while older visitors prefer the smaller independent cinemas. In class terms, 73 per cent of art-screen visitors are ABC1 and the remainder are C2DE. The gender split for art screens is very similar to the overall split (53 per cent male and 47 per cent female).

A UK-wide survey in 1995 found that 7–14-year-olds were likely to visit the cinema once a month, with 33 per cent in Scotland visiting more often.[1] The equivalent figure for all UK 15–24-year-olds was 18 per cent. Local cinemas were more popular than multiplexes in Scotland, probably because this age group would rather visit the cinema on their own, meaning that it would be more likely to be local.

1 http://www.netcomuk.co.uk/~media/Survey/watch.html

Table 25.2 Cinema attendance, 1986–96

	1986	1993	1994	1995	1996
Percentage of all persons aged 7 and over attending a cinema at least once a year	53	52	55	60	59

Source: ONS, 1997.

According to the Family Expenditure Survey conducted in 1997 (ONS, 1997), presented in Table 25.2, 59 per cent of people aged over 6 visited the cinema at least once in 1996. This compares with 53 per cent in 1986 and 60 per cent in 1995. The proportion of people who never go to the cinema is decreasing, yet as many as 40 per cent of the population apparently never visits a cinema.

Consumer expenditure

Consumer expenditure on films is channelled through several media: cinema, television (in the form of a movie service or expenditure on film packages), video rental and retail, DVD and, in a small but growing sector, other interactive media. Table 25.3 breaks down yearly overall expenditure on films by the British public. In 1998, the latest year for which all figures are available, sales of films on video were the predominant form of watching films, and worth twice as much as rental of videos. It is predicted that DVD will increasingly replace video sales and rental in the future. Box-office revenue accounts for around a quarter of the expenditure on films, with television movie services (pay TV and pay-per-view) accounting for around the same as cinemas. Films exist in a multimedia world and consumers are making daily choices about how they watch them. As DVD and internet technologies become more widespread, the balance will once again alter, with video being the most likely medium to suffer. Digital television and the expansion of pay-per-view services are likely to consolidate the television sector's involvement in viewing films. Cinemas have experienced competition from new media in the past and are unlikely to suffer too much in the medium- to long-term from competing media. However, it is likely that the share of cinema in the overall consumption of films will continue to drop in the short- to medium-term.

Table 25.3 Consumer expenditure on feature films, 1996–98

£ million

	1996	1997	1998
Box office	450	556	564.6
Television expenditure (pay TV services)	621.9	640 (a)	660 (a)
Video retail	803	858	940
Video rental	424	406	480
Laser disc (estimated)	3	3	3
DVD	n/a	n/a	3.5
Total	2301.9	2463	2651.1

Source: *Screen Digest*.

Note: a) estimates.

Film production and output

As yet, there are no official data collected and disseminated on film production and investment levels in the UK. Data are collected by the trade papers, *Screen Digest*, *Screen International* and *Screen Finance*, and the public agency, the British Film Commission (BFC), keeps a record of films made in the UK.

Film-production output is presented in Table 25.4. In 1998, 87 films were produced in the UK for a total investment of £372 million. The average budget for all productions was £4.3 million. However, a large proportion of this investment came from a very few American productions with the average budget for non-US major films being significantly lower (BFC, 2000). Film-production investment rose by 35 per cent between 1998 and 1999 and the average budget rose by over £1 million per production. This shows the changing nature of films being produced in Britain. Whereas the predominant types have traditionally been either smaller UK productions or big-budget US productions, there is a growing class of mid-range movies being made for the international market by international financiers and sales agents.

Film production in the UK is made up of four main types of film: wholly financed UK productions; majority UK productions; minority UK productions; and overseas productions. The most lucrative for the UK are those films produced by the US majors in the UK. Each film can be worth up to £60 million to the local economy. Films such as *Mission: Impossible* (1995) and the Bond series were shot in Britain using local production and post-production facilities. However, the number of big-budget films shot in Britain is falling due to intense competition from other production locations. Germany, Australia and Canada are developing competitive environments, and investment in studios is creating the technical infrastructure needed to service such films. Australia has managed to attract the next two *Star Wars* prequels and *Mission: Impossible II* away from the UK.

Feature films are made by production companies, financed through a combination of investment from distributors, broadcasters, sales agents, banks and other sources. Recent strategic entrants into the film-finance arena include sales agents (traditionally involved only after the film has been completed) and pension funds, the first recent move from the city in the direction of the film industry. After the bankruptcies of Goldcrest and Palace Pictures in the 1980s and early 1990s, it has taken much development in financial models and persuasion on the part of film producers to bring city finance back into the film industry.

The UK has still not managed to rid the film industry of under-capitalisation, in that production companies are unable to grow as they are forced to sell all

Table 25.4 Film production data, 1996–99

£ million

	1996	1997	1998	1999
Number of films produced	111	108	87	92
(of which co-productions)	52	40	24	28
Total production investment	540	467	372	507
Average investment per film	3.8	4.3	4.3	5.5

Source: *Screen Digest*.

rights to the movie just to get it made, thereby cutting off key future revenue streams. This situation is changing slightly for the better, as companies like Winchester, Renaissance, Film Four and others build up a catalogue of movie rights on the back of output and co-financing deals. The days of setting up a new production company for each film produced are not fully gone, but nowadays producers mainly recognise the benefits of trying to grow a single company through acquiring stakes in projects that will produce revenues rather than just working for a production fee.

Broadcasters have a large involvement in film financing in the UK, with the BBC and Channel Four both very active in this area. In 1999, BBC Films and Film Four backed a combined total of 19 films for around £70 million (*Screen Digest*, February 2000). The BBC created BBC Films in the 1990s to invest in theatrical movies, and their investment levels have been rising year on year. Recent moves have also strengthened the BBC's film unit. Films emanating from these two broadcasters usually receive a cinema and video release before airing on television. Channel Four has pioneered attitudes in the British film industry, creating as it has a unified, vertically integrated operation to handle its film activities, ranging from script development to providing product for its pay-TV venture. ITV has been less active in the film industry over recent years, although Granada intervenes in film production through its subsidiary Granada Film. Carlton owns several post-production companies that operate in the film industry.

The satellite broadcaster BSkyB has recently taken a more engaged position towards investing in feature films than previously. Operating through Sky Pictures, it invests in films via output deals with production companies. Originally, it aired the films under the brand Sky Movies Exclusives, although these films were not strictly theatrical, as television transmission occurred before a possible cinema release. This strategy was modified in late 1999, to back theatrically targeted international movies and build up a catalogue of such product. It put aside £25 million for this activity and aims to become a 'studio' rather than a platform.

In terms of economic value to the UK, figures released by the Office for National Statistics (ONS) demonstrate that the economic value added by film and video production and distribution, together with cinema exhibition, was £1.75 billion in 1996, or 0.26 per cent of total gross value added of the UK.

Precise figures for the numbers and types of companies operating in the film production, distribution, exhibition and post-production sectors are not available.

In any one year in the UK, there are around 50 distributors active in the UK theatrical distribution sector (Hancock, 2000). The five major American distributors are very active in the British market and regularly account for over 80 per cent of exhibition revenues. The remaining portion is shared between local distributors, such as Pathé, Entertainment, Film Four and newcomers Icon and Redbus.

Outside the main exhibition chains, around seven players that account for the majority of audience revenues, we can gauge the numbers of independent cinemas from the British Film Institute (BFI) listing of regional film theatres. The BFI (now under the umbrella of the Film Council) has links with 125 independent

cinemas around the country.[2] There are other independent cinemas that do not have links with the BFI's network.

Some production companies are still established on a film-by-film basis. This means that their life expectancy can be short (up to two years) and this makes them difficult to track. At the end of 1998, the numbers of active film production companies was estimated at 221 by *Screen Digest*. Of the 166 companies for which a location was found, 86 per cent were based in and around London. Cardiff accounted for 2.4 per cent and Edinburgh and Glasgow each accounted for 1.8 per cent.

Employment and public funding

Depending on the source referred to, the UK film industry employs between 30,000 and 45,000 people. The ONS estimated that there were 34,500 people employed in the film and video industries. Actors, producers and directors accounted for 21 per cent of the total. Around half the total is employed in 'non-cultural' occupations, such as management or cinema operation.

In terms of ethnic split, 96 per cent of film industry workers are white, and 1 per cent each are Afro-Caribbean, Indian, Pakistani and other Asian (O'Brien and Feist, 1997). These figures also demonstrate that the vast majority of film and video workers are based in and around London. In 1997, production activities accounted for 60 per cent of all workers, with distribution taking only 15 per cent (unpublished DCMS data).

According to the data released on an annual basis by the ONS (Table 25.5), of the total 34,500 people employed overall, 20,200 were men and 14,300 women. Three-quarters of men were in full-time employment while 58 per cent of women were in part-time employment. The majority of men were engaged in film and video production while the majority of women were involved in distribution and projection. The numbers of people employed in the industry fell by 2,100 between June 1998 and June 1999. This was mainly due to consolidation in film post-production and production facilities, and a drop in part-time workers, usually the first to be laid-off due to the flexible nature of their employment contracts.

In figures relating to regional employment breakdowns for 1997 (see Table 25.11 below), the ONS evaluated that 43,410 people were employed in the film and video industries in Great Britain (ONS, 1998; Labour Force Survey).

According to O'Brien and Feist (1997), 61 per cent of film-industry workers were full-time employees. One-fifth of workers were self-employed without employees (freelances) and one-sixth were part-time employees. In terms of age: over 50 per cent of employees were between the ages of 25 and 44. A third each were either side of this age range (20–24 and 45–54) and most of the rest were older. Only 6 per cent were under 20 (Table 25.6).

2 'Regional Independent Cinemas', www.bfi.org.uk

Table 25.5 Employment in film and video industries, 1998 and 1999

Thousands

	Male		Female		Total		Total
	Full-time	Part-time	Full-time	Part-time	Full-time	Part-time	All
June 1999							
Motion picture and video production	9.4	0.2	1.9	2.7	11.3	2.9	14.0
Motion picture and video distribution/projection	5.6	5.0	4.4	5.5	10.0	10.5	20.5
Total	15.0	5.2	6.3	8.2	21.3	13.4	34.5
June 1998							
Motion picture and video production	9.1	0.7	4.0	2.9	13.1	3.6	16.7
Motion picture and video distribution/projection	4.8	5.2	3.9	6.0	8.7	11.2	19.9
Total	13.9	5.9	7.9	8.9	21.8	14.8	36.6

Source: Office for National Statistics, *Screen Digest* analysis.

Public support for the film industry

Over the five years from 1993/94 to 1998/99, the British system for public funding of the film industry has been radically overhauled with the advent of the Lottery and the film franchises. Previously, the only significant public funding agency was the public/private partnership British Screen Finance. Its shareholders were United Artists Screen Entertainment, Channel 4, Rank and Granada. The government granted the organisation around £2 million a year, and further finance was raised from loan repayments. British Screen was probably the most successful public funder of films in the world in terms of the amounts repaid by producers after a film's release, averaging above 50 per cent of the amount granted. Many public film funds do not prioritise the repayment of amounts granted and those film funds that offer loans and not grants recoup only a small

Table 25.6 Employment in the UK film production, distribution and exhibition sectors by status and age, 1998

	Percentage
Employment status	
Full-time employees	61
Self-employed without employees	19
Part-time employees	16
Self-employed with employees	4
Age band	
16–19	6
20–24	14
25–34	30
35–44	23
45–54	16
55–59	5
60–64	4
65 and over	2

Source: O'Brien and Feist, 1997

Table 25.7 Public expenditure on the film industry, 1997/98

£ million

Department for Culture, Media and Sport	
British Film Institute	16.000
British Screen	2.000
European Co-production Fund	2.000
British Film Commission	0.850
National Film and Television School	2.100
Sector Challenge	0.138
Other support	0.484
Subtotal	*23.572*
National Lottery	
Arts Council of England	14.149
Scottish Arts Council	5.246
Arts Council of Wales	1.065
Arts Council of Northern Ireland	0.831
Lottery franchises	
DNA Film (a)	n/a
The Film Consortium	3.776
Pathe Productions	2.323
Subtotal	*27.390*
Total support for the film industry	50.962

Sources
BFI Handbook; DCMS Annual Report, 1999;
Lottery data provided directly by the Arts Councils of England and Wales; Scottish Arts Council Annual Reports;
Northern Ireland Arts Council, *Annual Lottery Reports*.

Notes: a) DNA was late starting.

percentage of the total amounts they invest. In 1997/98 British Screen granted around £5–6 million a year to selected films. However, this is a relatively small amount compared to other European countries, notably France, where public funding amounts to over one fifth of overall investment in film production.

In 1996, the British government put forward a plan to invest Lottery funds into the film-production sector. The proposal asked for film-production, distribution and sales companies to form integrated consortia to bid for a guaranteed pot of fast-tracked funding for a five-year period. Three consortia shared over £90 million for a slate of projects to be produced over five years. The Lottery money represented about 20 per cent of the films' budgets, which totalled £450 million. The three winners were Pathé Productions (£33 million), The Film Consortium (£30.25 million) and DNA Film Ltd (£29 million). This system was originally administered by the four national arts councils, and the English and Welsh systems are now housed within the new unified film agency, the Film Council.

The total figures for government support are presented in Tables 25.7 and 25.8. Table 25.7 shows the situation in 1997/98, and Table 25.8 presents departmental budgets and public support up to 1998/99. Total expenditure is planned to remain relatively stable over the period, although the Film Council received extra funding in 2000, the first year of its operations.

Central government funding for film comes mainly through the BFI and (until recently) the four national arts councils that administered Lottery funding, including both the Lottery franchise system and one-off grants to individual films. The

Table 25.8 Government support for the film industry, 1997/98 and 1998/99

£ million

	1997/98	1998/99
Film Council		
British Film Institute	16.000	15.100
British Screen Finance	2.000	2.000
European Co-production Fund	2.000	2.000
British Film Commission	0.850	0.850
Subtotal	*20.850*	*19.950*
National Film and TV School	2.100	2.100
Eureka AV and European Audiovisual Observatory	0.247	0.263
Sector Challenge	0.138	0.405
Other support	0.237	0.162
Total	23.572	22.880

Source: DCMS, Annual Report 1999.

BFI is responsible for encouraging the development of awareness about the cinema, and for this receives around £17 million a year. Other organisations in receipt of public funds to assist the film industry are British Screen Finance, a film production funding agency that also controls the European Co-production Fund; the National Film and Television School; and the BFC and its regional offshoots. Central government also channels a small amount of funding into European agencies, notably the European Audiovisual Observatory based in Strasbourg.

Department for Culture, Media and Sport (DCMS) funding for the film industry has dropped significantly since the mid-1990s (Table 25.9), despite having risen slightly from 1997/98 to 1999/2000. Excluding Lottery funding, DCMS funding to the film industry rose by 5.7 per cent between 1997 and 1999. The largest increases came in the BFI budget between 1998 and 1999.

The UK is also the beneficiary of European funding for the film industry. It is a member of the European Commission's MEDIA II programme, which replaced MEDIA I in 1996, when the previous system was scrapped (see also Chapter 13). Whereas MEDIA I had consisted of 20 programmes, for political reasons of representation in each country, MEDIA II replaced these with only three strands: development, distribution and training. MEDIA II is still primarily concerned with encouraging the industry to co-operate at a European level.

One of the MEDIA II funding organisations, EMDA (European Media Development Agency), which was responsible for handing out scriptwriting support, is based in London, although this programme ceased operating in February 2000 after its application for extra funds was rejected by the European Commission. The agency distributed around £12.5 million a year to European producers seeking development funding, on top of smaller funding amounts for company development. There is no explicit film-production support mechanism within the MEDIA programme, but there is a distribution operation, from which UK producers and distributors can benefit from the funds available (£12.5 million in 1996, and rising to about £25 million in 1998). MEDIA II will be replaced by MEDIA Plus from 2001–05. Media Plus is likely to have significantly more money available, as Europe recognises the importance of audio-visual creation and exploitation.

Table 25.9 Funding for film in the UK, 1993/94–1998/99

£ million

	1993/94	1994/95	1995/96	1996/97	1997/98	1998/99
Direct spending by central government						
DCMS						
Assistance to films	24.340	26.144	26.422	23.590	23.572	22.880
Scottish Office						
Film industry	1.000	1.000	2.000	2.000	2.000	2.000
Welsh Office	–	–	–	–	–	–
Northern Ireland Office (a)	–	–	–	–	–	–
National Lottery						
Arts Council of England	n/a	n/a	3.847	25.491	14.149	3.471
Scottish Arts Council	n/a	n/a	6.253	8.239	5.246	3.920
Arts Council of Wales	n/a	n/a	0.932	0.659	1.065	1.698
Arts Council of Northern Ireland	n/a	n/a	0.717	0.653	0.831	0.663
Subtotal	n/a	n/a	11.749	35.044	21.290	9.753
Local authorities (b)	–	–	–	–	–	–
Business sponsorship (c)	4.732	3.469	4.249	3.847	5.875	5.399
Recorded total	30.072	30.613	44.420	64.481	52.737	40.032

Sources

DNH, Annual Reports 1995–1997; DCMS annual reports 1998–1999;

Department of the Secretary of State for Scotland and the Forestry Commission, *The Government's Expenditure Plans*, various years;

The Government's Expenditure Plans: Department report by the Welsh Office, various years;

Expenditure Plans and Priorities, Northern Ireland: the government's expenditure plans, various years;

Lottery data supplied directly by the Arts Councils of England and of Wales; Arts Council of Northern Ireland, Annual Lottery Report, various years, Scottish Arts Council, annual reports, various years (lottery data);

ABSA/Arts & Business *Business Support for the Arts/Business Investment in the Arts*, ABSA, various years.

Notes

a) No dedicated spending on film was identified. There was, however, funding for the NIFC in later years which could not be identified.

b) No dedicated spending on film by local authorities was identified.

c) Figures from the annual ABSA/Arts & Business survey of companies. May overlap with matching funding for the DCMS-sponsored Pairing Scheme. For the sake of accuracy, separate figures for the Pairing Scheme have therefore been excluded from this table.

Until 1995, when it withdrew, the UK was a member of Eurimages, the pan-European co-production fund. Up until this point, UK producers benefited by up to £3 million a year in production funding

Regional dimension of funding and employment

The UK has a system of regional film commissions under the aegis of the BFC in London. The Commission exists to encourage overseas and local film producers to come to the UK for the shooting and post-production process. Regional Commissions serve the same purpose for their given region. The creation of a unifying body, the London Film Commission, in November 1996 (although it operated unofficially for a year prior to this), has alleviated the administrative problems and delays that discouraged producers from coming to London.

Table 25.10 Expenditure on film by region, 1993/94–1998/99

£ million

	1993/94	1994/95	1995/96	1996/97	1997/98	1998/99
England						
DCMS	24.340	26.144	26.422	23.590	23.593	22.880
Lottery – Arts Council of England	n/a	n/a	3.847	25.491	14.149	3.471
Business sponsorship (a)	4.002	2.174	3.929	3.698	4.997	4.095
Subtotal	*28.342*	*28.318*	*34.198*	*52.780*	*42.738*	*30.446*
Wales						
Welsh Office	–	–	–	–	–	–
Lottery – Arts Council of Wales	n/a	n/a	0.932	0.659	1.065	1.698
Business sponsorship	0.000	0.000	0.000	0.000	0.060	0.095
Subtotal	*0.000*	*0.000*	*0.932*	*0.659*	*1.125*	*1.793*
Scotland						
Scottish Office	1.000	1.000	2.000	2.000	2.000	2.000
Lottery – Scottish Arts Council	n/a	n/a	6.253	8.239	5.246	3.920
Business sponsorship	0.013	0.276	0.121	0.145	0.237	0.499
Subtotal	*1.013*	*1.276*	*8.373*	*10.384*	*7.483*	*6.419*
Northern Ireland						
Northern Ireland Office	–	–	–	–	–	–
Lottery – Arts Council of Northern Ireland	n/a	n/a	0.717	0.653	0.831	0.663
Business sponsorship	0.067	0.066	0.199	0.004	0.003	0.060
Recorded subtotal	*0.067*	*0.066*	*0.916*	*0.658*	*0.834*	*0.723*
Recorded total	29.422	29.660	44.420	64.481	52.179	39.382

Sources

DNH, Annual Reports 1995–1997; DCMS annual reports 1998–1999;

Department of the Secretary of State for Scotland and the Forestry Commission, *The Government's Expenditure Plans*, various years;

The Government's Expenditure Plans: Department report by the Welsh Office, various years;

Expenditure Plans and Priorities, Northern Ireland: the government's expenditure plans, various years;

Lottery data supplied directly by the Arts Councils of England and of Wales; Arts Council of Northern Ireland, Annual Lottery Report, various years, Scottish Arts Council, annual reports, various years (lottery data);

ABSA/Arts & Business *Business Support for the Arts/Business Investment in the Arts*, various years.

Notes

a) Excluding national and non-regional funding of £650,000 in 1993/94, £953,000 in 1995/96, £579,000 in 1997/98 and £650,000 in 1998/99.

The arts funding system is determined by the four national arts councils operating in England, Wales, Scotland and Northern Ireland (Table 25.10). However, with the advent of the Film Council in April 2000, the funding operations of the Arts Councils of England and Wales were folded into this. The process of devolution has served to strengthen Scotland's independence from the English-based system. Scottish Screen is primarily responsible for developing the film business in Scotland.

There is a strong concentration of the medium in the South East, notably in London. Research undertaken for *Screen Digest* in 1999 found that just over 86 per cent of film producers were based in or around London, while the figures for Edinburgh, Cardiff and Glasgow did not exceed 2.5 per cent each (Hancock, 1999a). This percentage for London is on a par with Paris, which also has a strongly centralised film industry.

	Production	Distribution	Projection	Total
South East	5,642	800	1,400	7,842
Eastern	800	200	1,100	2,100
London	15,416	3,700	3,100	22,216
South West	1,331	200	900	2,431
West Midlands	730	300	700	1,730
East Midlands (a)	200	–	500	700
Yorkshire & Humber (a)	300	–	1,000	1,300
North West and Merseyside	500	777	900	2,177
North East (a)	486	–	–	486
Wales (a)	200	–	400	600
Scotland	628	200	1,000	1,828
Recorded total for Great Britain	25,781	6,477	11,700	43,410

Source: ONS, Annual Employment Survey and Labour Force Survey.

Note: a) data not available and estimated.

Employment in the industry is similarly concentrated in the South East. The figures for September 1997 released by the ONS in its Annual Employment Survey (Table 25.11) show that in the motion-picture fields (production, distribution and projection), London accounted for 51 per cent of all those employed. Within film and video production, London accounted for 60 per cent of employment.

This high level of centralisation may be necessary if the UK is to compete for international projects. Non-national producers like to stick to a central area where they can be assured of finding the necessary level of support services for a film production. However, this should not prevent the development of other film-making areas within the UK, such as Scotland.

It is difficult to say with any degree of certainty where public funds are geographically spent in the film industry as grants for development, production, distribution, education and training cover the whole country. However, with the preponderance of film producers based in London and the South East it seems clear that most public production and distribution funding will stay within this region. In addition, London is the shooting location most favoured by producers. In 1998, London was the favoured location for around half of all films produced and three-quarters of all films specifying a shoot location in the UK (Hancock, 1999a). Location shooting within the UK will generate local revenues while the shoot is going on, although most post-production is carried out in London.

Business sponsorship and balance of trade

Business sponsorship

Very few individual films are part-funded by business sponsorship. However, business is involved in the sponsoring of film festivals and films on television and also has a role to play in regional promotional schemes. Film festivals are particularly dependent on sponsorship, mainly from major corporations and banks. Both Barclays and National Westminster Banks are sponsors of the film industry.

Table 25.12 UK balance of trade in the film and television industries, 1997 and 1998

£ million

	Film	Television	Total
1998			
Exports	581	444	1,286
Imports	437	692	1,300
Balance of trade	144	−248	−14
1997			
Exports	650	313	1,188
Imports	525	606	1,331
Balance of trade	125	−293	−143

Source: Office for National Statistics.

Barclays Bank, in particular its branch in Soho Square near the historic centre of the film industry, is an active funder of film and television projects. It also contributes to campaigns and initiatives to promote film. In 1997, the bank partnered with All Industry Marketing for Cinema in a £10 million cinema-promotion scheme. Kodak and FujiFilm, dominant players in film stocks and processing, are both also very active in film sponsorship on an international level. This filters down into the UK, particularly into festivals and one-off film literature.

Until spring 2000, funding for the London Film Commission came via a grant from the government's DCMS, and industry sponsorship from organisations such as UIP (United International Pictures), which donated £100,000 over a three-year period. The organisation is now funded by a grant from the Film Council.[3]

UK balance of trade

Over the past five years, the UK's balance of trade in the audio-visual sector has worsened, dropping from a credit of £158 million in 1994 to a £14 million deficit in 1998, via a deficit of £143 million in 1997 (ONS, 1999c). The film industry is generally a net contributor to the balance-of-payments figures, whereas television regularly posts a net deficit. Whilst the trade balance for film was positive for both 1997 and 1998, the television sector posted significant deficits in both years (Tables 25.12 and 25.13).

In 1998, the US was the dominant market for UK film companies' exports. According to data released by the ONS (1999c), the US accounted for 36 per cent of the UK's total exports but supplied 60 per cent of total imports. The European Union accounts for 34 per cent of total exports and 24 per cent of total imports into the UK, emphasising the UK's closer links with the US in the fields of film production, distribution and exhibition.

Since the UK government withdrew from the European co-production fund Eurimages in 1995, government emphasis has been largely aimed at attracting

3 Arts & Business estimates sponsorship for 1998/99 to have been in the region of £5.4 million. Given that this is based on a survey of arts organisations, it is unlikely to present a comprehensive overview of industry's sponsorship income.

Table 25.13 UK balance of trade in the audio-visual industry, 1994–98

£ million

	1994	1995	1996	1997	1998	1999 (a)
Exports	1,091	1,200	1,314	1,188	1,286	1,424
Imports	933	1,175	1,282	1,331	1,300	1,435
Balance of trade	158	25	32	–143	–14	–11

Source: ONS 1999.

Notes
The audio-visual industry consists of film and televsion sectors.
a) Provisional figures: actuals for 1999 were due for publication in late 2000 but not available at the time of writing.

producers from the US and other countries. To this end, the government produced a promotional tool for the UK as a film shoot and post-production location. The BFC has also engaged in a series of meetings with American producers with a view to persuading them to shoot in the UK.

26
Profile of Libraries

Claire Creaser, Library and Information Statistics Unit, Loughborough University

Information on libraries

The wider context

Public libraries have a relatively high profile within the UK, and are a statutory responsibility of local government. They are run, and largely funded, by county councils, unitary authorities, metropolitan districts and London boroughs in Great Britain, and by the five Education and Library Boards in Northern Ireland. They are a relatively small part of the overall library and information sector, however. In its broadest sense, this encompasses a wide range of institutions – school libraries, information units in the workplace, learning resources centres in colleges and universities, the British Library and the National Libraries of Wales and Scotland, and special libraries of all kinds. Also included are the unique British Library Document Supply Centre, and archives held by many different institutions, both public and private.

To place public libraries within this wider context, it is necessary to quantify the different parts of this diverse sector, whether in terms of collections, staff, expenditure or some other factor, and this is where problems lie. Even a simple question such as 'how many libraries are there in the UK?' has no simple answer.

In general terms, information on the existence, and data on the operations, of libraries and information units in the UK are available in proportion to the degree of public funding and public accountability of the libraries' parent organisations. Thus a great deal is known about public libraries, and only a little less about libraries in higher education institutions. The three national libraries each publish annual reports and accounts. Less is known about the operation of libraries and learning resources centres in schools and colleges of further education, although recent survey work (Library Association, 1997; Wallace and Marsden, 1999) carried out on behalf of the Library Association[1] has gone some way to shed light on this important area.

1 The Library Association is the leading professional body for librarians and information managers, with members throughout the UK and in more than 100 countries overseas. See http://www.la-hq.org.uk/ for further information.

The problem is most acute, however, within the 'special library' group. This covers:

- libraries and information units in industrial and commercial companies, whose prime role is usually to provide information to their parent organisations' employees;
- libraries within government departments and other governmental organisations, both central and local, which may have the dual function of supplying information to the departments' own Civil Servants, as well as to members of the public with enquiries;
- libraries within the National Health Service and the private health sector;
- media libraries, both in broadcasting and print media;
- libraries within professional and trade organisations, primarily engaged in providing specialist materials to the organisations' members;
- other libraries which do not fit any of the other definitions, for example libraries within museums and galleries and private-subscription libraries.

At its most extreme, and particularly in many commercial organisations, it may be impossible to define 'library': a collection of books is not sufficient, given the increasing range of information and other resources available electronically; sound and film libraries and archives may hold no printed material at all. The presence of suitably qualified staff cannot be used as a criterion – this would exclude hundreds of school libraries, which are run by a teacher with clerical assistance, but which are still clearly libraries.

In recent years, LISU (the Library and Information Statistics Unit at Loughborough University) has made a number of attempts to quantify the size of the special-library sector (Berridge and Sumsion, 1994; Creaser and Spiller, 1997) and, more recently, to gather some meaningful statistics on some of the more important aspects of its activity (Spiller et al., 1998). Whereas some areas are well served with statistics – the National Health Service (Murphy, 1998) and government departments (Ryan, 1999), for example – others are not. In particular, any organisation which can be considered to have commercial interests may be unable or unwilling to disclose details even of the existence of a library or information centre, for fear of giving away too much to competitors.

Another problem area for regular, reliable, sector-wide statistics is libraries within schools and further education colleges. Here the gaps are beginning to be addressed by the Library Association, with biennial surveys of libraries in secondary schools and, in alternate years, learning resources centres in further education colleges, referred to above. Higher up the academic ladder, colleges of higher education and universities are well served, with comprehensive annual data collection by the HE Colleges Learning Resources Group (HCLRG, 1999), and Standing Conference of National and University Librarians (SCONUL, 1999) respectively.

In this context, public libraries are particularly fortunate. Data on a wide range of measures pertaining to all aspects of library activity have been collected and published for many years by the Chartered Institute of Public Finance and Accountancy (CIPFA, 1999a; 1999b), and recent initiatives have widened the

Table 26.1 Estimates of the library and information sector in the UK, 1998/99

	National libraries	HE libraries	Public libraries	Special libraries	School and FE libraries	Total
Administrative units	3	175	208	5,000	29,700	35,086
Service points	17	770	4,890	5,000	30,900	41,577
Total staff	2,900	13,000	25,829	18,000	5,200	64,929
of which, professional librarians (%)	41	28	25	49	56	35
Registered/ regular users (thousands)	70,000	2,357	34,356	–	–	–
Recorded total expenditure (£m)	150.4	398.3	819.7	800	194.7	2,363
of which, on materials (%)	8	33	15	27	28	23
Approximate public funding (%)	75	83	91	35	98	70

Source: LISU, Loughborough University.

scope of the statistics presented within these important publications. Table 26.1 summarises the latest available estimates of the library and information sector in the UK. The data were initially compiled for the UK return to the LibEcon 2000[2] project and are drawn from a variety of sources. The degree of approximation is considerable in some areas.

Library funding

Library funding is obtained from two main sources – commercial and government. National, public and academic (including school) libraries are largely government-funded, either directly from central or local government, or indirectly through funding for their parent institutions. Some special libraries – those in government organisations and the health service, for example – are also funded in this way. All may receive some commercial funding through sponsorship, charges for services or commercial trading activities. Libraries in industrial and commercial organisations are commercially funded, generally via their parent company. The remainder of the special-library sector could obtain funding in either way, depending on the source of funding of the parent institution. For some of these libraries, it would be very difficult to estimate the proportion of government funding, and statistics on funding sources are not collated across the sector.

Table 26.1 gave broad estimates of the total expenditure of the UK library and information sector (excluding archives). Government funding in this sector is considerable. The table also shows estimates of the proportion of library funding which is obtained, either directly or indirectly, from government subsidy. This is lowest in the special-library sector, and highest for school libraries which have little opportunity for raising money from other sources. See Tables 27.12 and 27.13 for more details of subsidy to libraries, by source and by home country.

2 The LibEcon 2000 project is funded by the European Commission to collect national data on all library sectors from 29 European countries. See http://www.libecon2000.org for more information.

For discussion of the cultural sector, however, it is reasonable to exclude academic and workplace libraries from further consideration – although it is arguable that media libraries and libraries within the museums sector should be included. Such libraries form a relatively small component of the whole, however, and little is known about their activity. These are included, albeit implicitly, in the chapters on museums and the media. The majority of this chapter is concerned with UK public libraries, for which considerable statistical detail is available, going back over a number of years. A brief section at the end considers the British Library and the National Libraries of Wales and Scotland, drawing information from those bodies' annual reports.

Public libraries

This section is concerned solely with public libraries in the UK, run and primarily funded by local authorities. Agency services provided by the public library service on behalf of other local government departments (for example, support services for school libraries, prison libraries, hospital-patient libraries) are not included in these figures.[3] The primary source of many of the statistics given is the CIPFA *Public Library Statistics 1998–99: Actuals* (CIPFA, 1999a), these are supplemented with information from the *LISU Annual Library Statistics* (Creaser and Murphy, 1999). All data relate to the financial year 1998/99, or the position on 31 March 1999 as appropriate, unless otherwise stated.

Number of libraries and opening hours

Public libraries are provided at local authority level in Great Britain – by the London boroughs, metropolitan districts, unitary authorities and counties in England, and by Scottish and Welsh unitary authorities. In Northern Ireland, the public library service is provided by the five regional Education and Library Boards. Following the round of local government reorganisation which was completed on 1 April 1998, there was a total of 208 public library authorities in the UK. Statistics are generally presented separately by authority type, rather than region, within England, and this convention has been followed for the tables in this section.

Services are provided to the public through a range of different service points – central and branch libraries of varying sizes, mobile libraries and service points within institutions such as old people's homes and hospitals. Services are also provided to special-interest groups such as the housebound, and special facilities may be offered to organisations such as playgroups and schools. The public library is required to provide a service to all those who live, work or study within the authority, and in broad terms it is free at the point of use (but see below for information on funding).

3 Limited information on agency services is available in CIPFA (1999a).

Table 26.2 Number of libraries, by region and home country, 1999

	No. of authorities	No. of libraries open for (hours per week):				Mobile libraries	Total service points	Service points in institutions
		45+	30–45	10–30	<10			
London boroughs	33	110	175	86	0	34	405	1,876
Metropolitan districts	36	111	343	250	28	71	803	2,157
English unitary authorities	46	57	214	228	31	69	599	1,833
English counties	34	170	510	783	91	293	1,847	9,349
Total England	149	448	1,242	1,347	150	467	3,654	15,215
Wales	22	45	95	135	45	70	390	322
Scotland	32	187	157	185	65	93	687	680
Northern Ireland	5	24	52	50	0	33	159	805
Total UK	208	704	1,546	1,717	260	993	4,890	17,022

Source: CIPFA (1999a).

Table 26.2 gives details of the number of library authorities in the UK in 1998/99, and the number of library service points they operate, broken down according to their usual weekly opening hours. Libraries open for 45 hours per week or more are the larger branches and central libraries in areas of population concentration, with a larger stock and wider range of facilities than smaller libraries with more restricted opening hours. At the other extreme are libraries open for less than ten hours per week – perhaps restricted to one or two days – with small stocks and sometimes staffed by volunteers rather than library-authority employees.

The total number of service points is dominated by those in institutions. These are generally not staffed, and have small book stocks, with a restricted range of titles, but which are exchanged at regular intervals. They will be further supplemented by individually tailored services for housebound readers, which are not included in these statistics.

Much of the change in service-point numbers over the 1990s was in the number of institutions served. If we discount these and concentrate on the more familiar branch network, including the mobile fleet and smallest service points open for ten hours per week or less, in 1998/99 there were a total of 4,890 in the UK, a fall of 484, or 9 per cent over the previous ten years. Much of the decline occurred between 1993/94 and 1998/99 – 301 service points closed in this period, a fall of 6 per cent. The fall was concentrated in the largest and smallest branches – the number open for 60 hours per week or more fell from 61 in 1988/89 to 45 in 1993/94 and was just 16 in 1998/99. At the other end of the scale, the number of service points open for less than 10 hours per week fell from 604 in 1988/89 to 424 in 1993/94 and 260 in 1998/99. These statistics do not mean that the larger branches and central libraries have been closed, but that opening hours have been progressively reduced, moving the larger libraries down the table. The recently issued draft standards for public libraries may do something to reverse this trend, however, stating that each authority should have at least one library open for 60 hours per week or more (DCMS, 2000).

Table 26.3 Total staff in public libraries, 1999

	Professional	Non-manual	Manual	Total staff	Resident population per: professional staff	total staff
London boroughs	1,239	2,533	155	3,927	5,799	1,830
Metropolitan districts	1,166	3,840	292	5,297	9,562	2,104
English unitary authorities	827	2,320	118	3,266	10,018	2,537
English counties	2,067	6,241	194	8,502	11,066	2,690
Total England	5,299	14,934	759	20,992	9,340	2,358
Wales	284	817	42	1,143	10,337	2,566
Scotland	621	2,114	205	2,940	8,244	1,741
Northern Ireland	138	542	73	753	12,236	2,242
Total UK	6,342	18,408	1,079	25,829	9,340	2,293

Source: CIPFA (1999a).

Overall, total weekly opening hours fell by 4 per cent from 1988/89 to 1993/94, and by 8 per cent in the following five years, from 153,800 in 1993/94 to 141,900 in 1998/99. The reasons are not difficult to see – closing libraries completely is politically unacceptable to local councillors of all parties except as a last resort, whereas the savings in staff and premises costs which can be made by reducing opening hours are very attractive to library managers under pressure to make savings.

Staff

Public libraries in the UK employed a total of 6,342 professional librarians, 18,408 other, non-manual staff (for example, library assistants, clerical staff) and 1,079 manual staff on 31 March 1999 (all figures are full-time equivalent). Relative to the resident population, professional staffing levels are most generous in inner London, where there are 5,531 residents for each member of staff, and least generous in Northern Ireland, where there are 12,236 residents per staff member.

Staff numbers fell considerably since 1988/89, most notably among the number of manual staff employed. This is primarily a result of changes in the organisation and management of local government – for example the introduction of compulsory competitive tendering and consequent contracting out of services such as building maintenance and cleaning – rather than any change in the service provided. However, falls in the numbers of professionally qualified librarians of 11 per cent over the five years from 1993/94, and 10 per cent during the previous five years, will have had much more impact on the level and quality of service. Table 26.3 shows the total number of staff (FTE) employed in each sector on 31 March 1999, together with the ratios of population to staff overall, and for professional staff only.

In addition, there were around 1,000 FTE vacant posts on 31 March 1999 – 286 professional librarians, 682 library assistant and clerical posts, and 74 manual posts. In most authorities, such vacancies are a natural consequence of staff turnover; in some instances posts may be frozen pending the outcome of restructuring or simply as a cost-cutting measure.

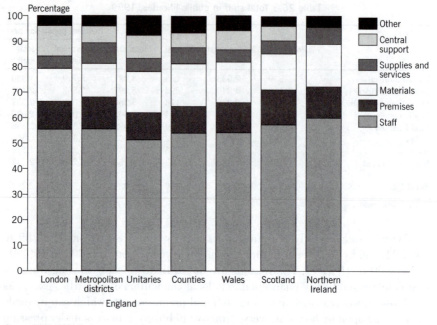

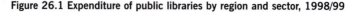

Source: CIPFA (1999a).

Figure 26.1 Expenditure of public libraries by region and sector, 1998/99

Expenditure

In 1998/99, public libraries spent a total of £820 million, equivalent to £13.84 per person. A further £31.2 million was spent on capital projects, 58p per person. Over half of the total revenue expenditure was on staff, 12 per cent on the costs of maintaining premises, and 15 per cent on books and other materials for public use. Figure 26.1 shows the breakdown of library expenditure into its main components, by sector.

Levels of expenditure also vary between sectors. Expenditure was highest in London, at £20.55 per resident, followed by Scotland (£16.66), the metropolitan districts (£14.26) and the English unitary authorities (£12.85). The lowest levels of spending were in Wales (£11.64), the English counties (£11.69) and Northern Ireland (£11.81).

Owing to changes in accounting practice, it is difficult to make exact comparisons of expenditure levels with the position five and ten years prior to 1998/99. It can be estimated, however, that public library expenditure per capita rose by 7 per cent since 1993/94 and by 44 per cent since 1988/89, taking these changes into account. This appears encouraging, until we consider the rate of inflation. The retail price index rose by 16 and 52 per cent respectively over the same periods. In real terms, public library expenditure therefore fell by 8 per cent from 1993/94 and by 5 per cent in the ten years from 1988/89.

For public libraries, the area of spending which generates most interest is that of spending on books and other materials for public use. It is also the area in

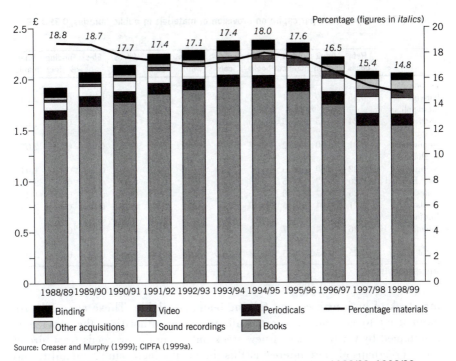

Source: Creaser and Murphy (1999); CIPFA (1999a).

Figure 26.2 Trends in materials expenditure in public libraries, 1988/89–1998/99

which cuts are most easily made when budgets are restricted, and has suffered as a consequence in recent years, as shown in Figure 26.2. In the UK as a whole, £122.3 million was spent acquiring 12.4 million books and other items in 1998/99, compared to £138.9 million five years earlier and £110.1 million in 1988/89. These figures are not encouraging even as they are, and become even worse when book-price inflation is taken into account. Over the same five- and ten-year periods, the average price of all books increased by 6 and 46 per cent respectively. Put another way, in 1998/99, only 14.8 per cent of total library expenditure was devoted to the acquisition of materials, compared to 16.8 per cent in 1993/94 and 18.8 per cent in 1988/89.

Note that these figures relate to all materials, not just books. Cuts in book expenditure alone have been even more dramatic, as provision is made for new media – spoken-word and music recordings (now on CD rather than vinyl), videos and electronic media including CD-ROM and internet provision. Many of these new media are charged for, but few, if any, such services operate on an entirely self-funding basis.

Table 26.4 gives a detailed breakdown of materials expenditure by sector for 1998/99. It is clear that books still form the major element of public library business, although provision of other materials and services has increased dramatically over recent years and will continue to do so as technology advances.

Public libraries have been providing loans of materials other than books for many years – first records, then cassettes, now CDs and videos supplement

317

Table 26.4 Expenditure per capita on provision of materials in public libraries, 1998/99

£

	Ref. books	Adult fiction	Adult non-fict.	Child's books	Period-icals	Spoken word	Music rec's	Videos	Elec .	Binding & other	Total mat'ls
London boroughs	0.35	0.59	0.61	0.37	0.19	0.09	0.13	0.13	0.08	0.10	2.64
Metropolitan districts	0.24	0.55	0.35	0.25	0.14	0.06	0.07	0.05	0.04	0.13	1.87
Unitary authorities	0.31	0.50	0.42	0.27	0.11	0.09	0.07	0.07	0.04	0.18	2.07
English counties	0.22	0.50	0.46	0.27	0.09	0.08	0.07	0.10	0.04	0.11	1.94
Total England	0.26	0.52	0.45	0.28	0.12	0.08	0.08	0.09	0.04	0.13	2.05
Wales	0.23	0.57	0.38	0.30	0.07	0.09	0.03	0.03	0.04	0.11	1.85
Scotland	0.21	0.84	0.46	0.29	0.11	0.09	0.12	0.09	0.04	0.12	2.36
Northern Ireland	0.26	0.44	0.47	0.32	0.13	0.05	0.06	0.08	0.09	0.08	1.97
Total UK	0.25	0.55	0.45	0.28	0.12	0.08	0.08	0.09	0.04	0.12	2.06

Source: CIPFA (1999a).

the stock of both printed and talking books available. These materials are often used to generate income, and, in some authorities, the service is maintained by the purchase of new stock only from the proceeds from hire of the old. Perhaps of more interest at this time is the increasing availability and range of electronic resources available. Growth in this area has been encouraged by the recommendations in *New Library: the People's Network* (LIC, 1997). Developments have been monitored for some years by Chris Batt, in his biennial surveys of information technology, both in library administrations and for public use (Batt, 1997).

In 1998/99, 3,079 main service points – two thirds of the total – were 'computerised'. This is defined as being 'connected for book issuing/library circulation to automatic systems'. Whilst having such a connection does not indicate provision of electronic resources for public use, the lack of such a system is a pointer to the more general lack of computer facilities, particularly in smaller branches.

On 31 March 1999, 2,997 service points had a total of 10,639 computer terminals available for use by the public. These fall into four broad categories – those with access to the online public access catalogue (OPAC); those with facilities for CD-ROM (which may or may not be networked); those with access to the internet; and stand-alone workstations for use with their own software suites. The first three of these categories are not mutually exclusive, and the same workstation may fulfil all three functions in any branch. In the UK as a whole, there were 5,396 terminals in 2,335 libraries with access to the OPAC; 4,841 terminals in 1,911 libraries with facilities for CD-ROM; and 2,769 terminals in 1,209 libraries offering public access to the internet. In many authorities they will be found only in the larger branches at present, although this will change if provision grows as expected in the next few years.

Income

There is, as yet, no charge made in UK public libraries for entering the library to use reference books, read newspapers or borrow books for a limited time. Charges may be made to members of the public for borrowing non-book materials such as music recordings or videotapes, for use of the internet and other electronic facilities, and for reserving items not immediately available. Charges may also be made when borrowed items are not returned on the due date. Such fines and other charges vary considerably between authorities, and concessions are frequently offered to specific groups of users such as children or the disabled. Details are published annually for each authority in England and Wales (Robertson, 1999) and Scotland (Martin, 1999).

Other sources of income in the public library service are charges for photocopying, lettings, grants and sponsorship, and miscellaneous income from the public and from businesses. The relative importance of these sources is shown in Figure 26.3. The increase in the importance of income from the hire of audio-visual materials is immediately apparent. Income-generation accounts for a very small proportion of total library expenditure, however – just 9 per cent in 1998/99. The total value of all income generated by public library services in the UK in 1998/99 was £76.6 million – the balance of expenditure is met by the local authority, funded from central government and local taxes.

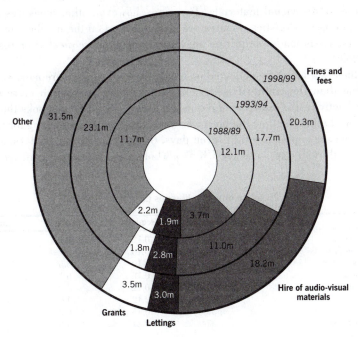

Source: Creaser and Murphy (1999); CIPFA (1999a).

Figure 26.3 Sources of income in public libraries, 1988/89–1998/99

Table 26.5 Books and audio-visual stock per capita in public libraries, 1998/99

	Books			Audio-visual		
	Stock	Acquisitions	Issues	Stock	Acquisitions	Issues
London boroughs	2.5	0.23	7.3	0.22	0.034	0.93
Metropolitan districts	2.1	0.16	6.8	0.12	0.017	0.55
Unitary authorities	1.9	0.17	7.4	0.12	0.021	0.53
English counties	1.8	0.18	8.7	0.12	0.024	0.64
Total England	2.0	0.18	7.9	0.13	0.023	0.64
Wales	2.5	0.20	7.1	0.12	0.013	0.32
Scotland	2.7	0.23	8.0	0.20	0.028	0.81
Northern Ireland	2.4	0.15	5.6	0.14	0.019	0.36
Total UK	2.1	0.19	7.8	0.14	0.023	0.63

Source: CIPFA (1999a).

Provision and use of materials

This section concentrates on books and audio-visual materials, as other materials play a relatively minor role in public libraries at the present time. Table 26.5 summarises levels of provision and use, and there are considerable differences between the sectors. The highest levels of stock are in Scotland and London, which also have the highest rates of acquisitions, for both books and audio-visual materials. The highest levels of use are in the English counties for books, and London for audio-visual materials. There are, however, other measures of use than simple issue statistics. Figures are also collected on the numbers of active borrowers, visits made, enquiries answered and items requested or reserved (Table 26.6).

All these statistics are collected on a sample basis, and so are more variable over time than the count of issues, but they encompass much more of the libraries' activity. For example, of requested items – for instance books that were not on the shelf at the time the borrower went into the library looking for them – 43 per cent are supplied within seven days, 63 per cent within 15 days, and 80 per cent within 30 days, over the UK as a whole. Less than 4 per cent are never supplied.

Table 26.6 Use of public libraries per capita, 1998/99

	Active borrowers (%)	Requests	Visits	Enquiries
London boroughs	38	0.12	7.1	1.4
Metropolitan districts	34	0.10	5.1	1.1
Unitary authorities	33	0.10	5.5	1.0
English counties	40	0.15	6.1	0.9
Total England	37	0.12	5.9	1.1
Wales	38	0.12	4.6	0.9
Scotland	32	0.15	6.2	0.7
Northern Ireland	37	0.21	4.0	1.1
Total UK	37	0.13	5.8	1.0

Source: CIPFA (1999a).

Library users

There are two primary sources of information on library users. A recent survey by Book Marketing Ltd (1998) has given a detailed profile of library users – and non-users. An estimated 34.9 million people, 59 per cent of the UK population, hold a public library ticket, and these represent 72 per cent of all UK house-holds. There are few surprises in the demographic profile obtained from this survey:

- 60 per cent are women (compared to 53 per cent of women in the population as a whole);
- 17 per cent are aged 65 or over (versus 16 per cent in the population as a whole), accounting for 19 per cent of all books borrowed; and
- 49 per cent are from social groups ABC1 (versus 44 per cent in the population as a whole).

It is commonly accepted that the public is, in general, very satisfied with the services it receives from public libraries. The degree of protest at local level which greets any proposal to close libraries or reduce opening hours is clear evidence of that. However, in recent years there has been growth in formal user surveys and a national standard, CIPFA PLUS, has been developed. This gives a standard methodology and questionnaire to be used within the library by individual library authorities, from which they can ascertain information about their own users, and by contributing data to the national archive, compare their ratings with those in other areas. As well as providing some demographic information on library users, this has two key elements on the satisfaction of users. The first is a series of questions concerning whether users found what they were looking for when visiting the library, and the second is a set of satisfaction ratings based on the level of agreement with a series of statements about the library. Table 26.7 summarises a selection of these satisfaction ratings from the CIPFA PLUS archive for 1997 – the most recent year for which nationally aggregated data have been made available (Bohme and Spiller, 1999).

Given the extensive cuts in materials budgets and opening hours, it is only to be expected that lower satisfaction was expressed with the range of materials available and opening hours. It is also noteworthy that less than 1 per cent of respondents rated any of these aspects of the service as 'very poor'.

Table 26.7 Public libraries: survey results on user satisfaction, 1997

	Very good	Good
Opening hours	37.1	40.4
Staff helpfulness	62.7	31.8
Staff expertise	49.2	42.4
Waiting time	41.6	43.3
Range of materials	28.9	39.9
Information provision	34.9	44.0
Children's services	43.0	42.5

Source: Bohme and Spiller (1999).

This survey also gives the most comprehensive picture available of adult public library users and what they do when they visit the library (there is a separate series of surveys of children, from which no national results are yet available). As might be expected, the majority of library visitors (78 per cent) went to borrow or return books. This leaves a significant proportion who went for some other purpose, and many visitors who engaged in more than one activity. Seven per cent borrowed or returned cassettes, 5 per cent videos, and 4 per cent CDs. Outside the traditional lending activity, 22 per cent of visitors came seeking information, 13 per cent read newspapers or magazines, 7 per cent came to study, and 6 per cent used the photocopier.

Of those who borrowed books, 25 per cent took home five or more volumes. More than half of those who were looking for a specific book when they came to the library found what they were looking for, and 87 per cent of those who were not found something to borrow. Of those seeking information, 56 per cent consulted library staff, and 86 per cent found the information they needed, at least in part.

National libraries

The UK is relatively unusual in having three National Libraries; the British Library in London, the National Library of Wales in Aberystwyth, and the National Library of Scotland in Edinburgh. All three function as copyright-deposit libraries, and all are primarily publicly funded institutions. Information on their activities is available in their annual reports, and, in the case of the British Library Document Supply Centre (BLDSC), in its annual *Facts and Figures* pamphlet. The degree of detail available in the annual reports varies, as does the format of the financial data they contain.

The British Library

The size and scope of the operations of the British Library make it the most important library in the UK. Its reference services are now centred on the new building at St Pancras (formally opened by Her Majesty the Queen on 25 June 1998), and the extensive lending functions operate from the BLDSC in Yorkshire. In 1998/99, the British Library total incoming resources were reported at £119 million (excluding capital costs), of which 67 per cent was received as grant-in-aid from central government. Some 39 per cent of total expenditure was accounted for by the salaries of approximately 2,400 staff, and 9 per cent was spent on acquisitions.

The extensive collections are housed in 260 miles of shelving in London, with a further 97 miles at BLDSC. The holdings cover not only books and periodicals, manuscripts and maps, but also include audio-visual items, prints and photographs, stamps, patents and theses. In 1998/99, over four million items were supplied by BLDSC to users all over the world, and a quarter of a million visitors came to use the London reading rooms.

The National Library of Wales

The National Library of Wales holds over four million manuscripts and records, and a further five million printed books. It also has holdings of pictures, maps and audio-visual items. In 1998/99 it purchased 10,000 monographs, and acquired a further 71,000 by legal deposit. There were 37,000 visits to the library, and 232,000 items were consulted. A total of 223 staff were employed.

The National Library of Scotland

The National Library of Scotland is the world's leading source for printed material about Scotland and the Scots. It is Scotland's foremost general research library, and only legal deposit library. It received resources of £12 million in 1998/99, of which almost 98 per cent was received as grant-in-aid from the Scottish Office Education and Industry Department.

The National Library of Scotland acquired 318,247 items in 1998/99, 2 per cent less than in the previous year. Approximately 16 per cent of these acquisitions were purchased, at a total cost of £709,000. There were 46,219 reader visits to the library, consulting 180,479 items not including microforms (both figures were lower than normal, due to the impact of building works). A total of 16,174 enquiries were received, two-thirds by telephone, and 40 per cent from overseas.

Conclusion

There can be no doubt that the public library service is an essential part of both the cultural and educational life of the UK. It is equally clear that, whatever is said about the advances and advantages of electronic information sources and digital technology, the book is here to stay, as a source of both pleasure and information. Public libraries have been in decline over the last decade and more – they face increasing competition from other sources of information and entertainment, and increasing pressures on the leisure time of their customers, the general public. Their resources have been cut again and again, and levels of bureaucracy increased, with many initiatives from central government, which affect all areas of local authority services. Increased accountability has come with the advent of annual public library plans for each authority, and new technologies have been seen as an opportunity, rather than a threat, in most cases. Shortly after taking up his new post as chief executive of the Library Association, Bob McKee said in an interview in *The Bookseller* (1999): 'There is no better random access portable information device than a book, and no better way of communicating works of creativity. A library twenty years from now will have a load of technology, but it will also have a load of books.'

27
Profile of Literature

Debbie Hicks, Freelance arts consultant

This chapter focuses on the UK literature sector in all its diversity. It provides an overview of headline data relating to book publishing and an analysis of existing data pertaining to the subsidised sector.

In the context of the subsidised sector, literature is taken to encompass the full range of imaginative work, including poetry, fiction (short stories and novels) and imaginative prose such as travel writing and some forms of biography. The definition used here in relation to the commercial sector is necessarily broader, taking into account the book as a cultural product. In both contexts the emphasis is upon literature in relation to the reader or consumer.

The book publishing sector: commercial and subsidised

The book publishing economy is characterised by a complex mix of commercial and subsidised activity. The economics of the two sectors are very different, with commercial publishing assuming a clearly dominant role in terms of the size and value of its market. It is important, however, not to underestimate the significance of the subsidised publishing sector and the value of its relationship with commercial publishing.

Whilst it is difficult to provide hard data to quantify the nature of this relationship, there is general acceptance of the fact that publishing subsidy plays an important role in product and market development for the sector. Publishing subsidy supports the emergence of new writers and 'grows' the market for new writing. It means that writers considered a commercial risk achieve publication and, thereby, gain a readership. It is not unusual for writers developed by the subsidised sector to move on to publication in the commercial sector on the strength of their existing market. For example, the poet Simon Armitage was originally published by Smith Doorstop, a small independent press in the north of England. Having established himself as a promising writer with a growing readership, he was published by Bloodaxe, a national press subsidised by the Arts Council of England, followed by a move to Faber and Faber and the commercial publishing sector. Similarly, Jackie Kay moved from being a successful Bloodaxe poet, gaining a publishing contract for a novel with Picador.

Subsidy is also sometimes injected into a commercial publisher to support publishing output that might not be commercially viable in market terms, but which nevertheless represents an important element of a healthy and diverse literary culture. In this context, the commercial industry provides the marketing expertise and the distribution networks whilst the public sector underwrites the commercial risk. Literature in translation is a good example of the type of work that has been supported by this mutually beneficial partnership between the private and public sectors.

It is, however, difficult to draw direct comparisons between the commercial and subsidised arms of book publishing. Whilst there is no lack of headline information on the commercial side, there are considerable gaps in the information available from the subsidised sector. This is not surprising considering the individual and diverse nature of subsidised publishing, the demands on often low-paid or unpaid staff, the complexity of publishing funding and the absence of clearly defined requirements and procedures for collecting data from the sector.

The commercial sector

It is estimated that, in 1998, the value of the UK book market was £3,062 million, with consumer sales representing approximately two-thirds of the value of the market and a much higher share of volume sales. In terms of output, the number of titles published by the commercial sector has continued to grow. In 1998, 104,634 titles were published, the majority of which were new. Employment in printing and publishing has also followed an upward trend, with 362,000 people employed in the industry in 1998.

Value of the book market

The Publishers' Association's figures for 1998 indicate that the total value of the UK book trade/market, based on grossing-up publishers' UK sales to retail value, is £3,062 million. This compares to £2,860 million in 1997, £2,701 million in 1996, £2,756 million in 1995, £2,645 million in 1994 and £2,545 million in 1993. In real terms (and based on the Retail Price Index) the market increased by 1.4 per cent in 1994 and by 0.8 per cent in 1995. It decreased by 4.3 per cent in 1996 but then increased by 2.7 per cent in 1997 and 3.5 per cent in 1998 (Book Marketing Ltd, 1999).

These figures are based upon the segmentation of the market into: consumer books, academic and professional books, and school and English-language-teaching books. In 1998, consumer books accounted for 68 per cent of the total value of the market, a slight increase on the 1997 figure of 67 per cent. Considered over the period 1993–98, there was a slight increase in the percentage of the market by value held by consumer books. In 1993, consumer books accounted for nearly 66 per cent of the total market. In real terms, sales of consumer books showed the greatest increase in 1997 and 1998 with growth rates of 4.0 and 4.2 per cent respectively. This followed a decrease in 1996 of 6.7 per cent (Book Marketing Ltd, 1999).

The growth of consumer sales in 1997 and 1998 coincided with the growth in consumer expenditure, with both showing an 8 per cent increase at current prices. Previous to 1996, the two trends were not compatible. Consumer book sales appeared to rise in 1991 and 1995, while consumer expenditure appeared to fall. This contradiction in trends may be partly because the figures for consumer spending and consumer book sales are not strictly compatible. Books defined by publishers as consumer books can be bought by other sectors as well as by consumers. Whilst this difference may not completely explain the inconsistency, it is nevertheless safe to assume a continued growth in the sales of consumer books (Book Marketing Ltd, 1999).

Unit sales

Whilst consumer books represent approximately two-thirds of the value of the market, they have by far the highest share in the number of volumes sold. Figures from the Publishers' Association indicate that in 1998 consumer sales held 86 per cent of the market by volume, compared to 68 per cent by value (cited in Book Marketing Ltd, 1999: 10). This is partly because they retail at a lower price than, for example, professional and academic titles. Nevertheless, their domination of the market in this context is a significant indicator of the general interest in books and reading in the UK and the size of the 'consumer' reading audience. Publishers' unit sales over the period are illustrated in Table 27.1.

Consumer book sales increased from 352 million in 1993 to 432 million in 1998. This upward trend has played a significant part in the general increase in book sales over the period, from 425 million to 504 million. The growth in the market has not, however, been consistent. Unit-sales figures for 1994 and 1996 fell in relation to the previous years.

Whilst unit-sales figures are a useful indicator of the health of the market, they should be used with care because of the diversity of the book product and the differing proportions in which product types sell each year. The evidence does, however, suggest a general stability in the market during the period from 1993 to 1998.

The large uplift in unit sales shown in 1995 can be partly accounted for by the success of the Penguin '60s' and other low-price series during the period (Bohme and Spiller, 1999: 267).

In terms of volume, adult fiction accounted for just under a quarter of all books bought in 1997/98 although only one fifth of the expenditure.[1] Adult non-fiction and reference in both paperback and other formats were the two largest single categories by value. Each accounted for 27 per cent of expenditure in 1998 and were worth about £1 billion together.

Overall, the combined children's and adult market was split relatively evenly between fiction and non-fiction (51:53 per cent). Non-fiction and reference, however, took a larger 64 per cent share of the market by value (Book Marketing Ltd, 1999).

1 Book Marketing Ltd (1999) uses data from *Books and the Consumer* for 1997/98. There do not appear to be any data available for 1998/99.

Table 27.1 Publishers' sales in units, by sector, 1993–98

Million

	Consumer	School & English language teaching	Academic and professional	Total
1993	352	37	36	425
1994	348	36	35	419
1995	384	33	36	454
1996	381	34	36	451
1997	398	35	36	469
1998	432	35	36	504
Percentage change (a)				
1993–1994	−1.3	−2.1	−2.8	−1.5
1994–1995	+10.5	−7.0	+2.3	+8.3
1995–1996	−0.8	+0.3	+0.0	−0.7
1996–1997	+4.5	+3.6	+0.4	+4.1
1997–1998	+8.7	+1.4	−0.4	+7.4

Source: Book Marketing Ltd, 1999.

Note: a) Based on unrounded figures.

Publishers' sales

The value of publishers' sales is measured by invoiced prices. The figures given below represent the amount of money that publishers received from their sales. There are two main sources of data detailing publishers' sales in the UK: estimates provided by the Publishers' Association, and government estimates based on returns from publishers responding to its Products of the European Community Survey (PRODCOM). Due to differences in data-collection methodology and variances in the definition of books, these two sets of data are not necessarily compatible. They do, however, indicate a similar trend in the overall growth in publishers' sales.

PRODCOM is based on information from publishers who account for about 90 per cent of industry turnover, making it a more accurate portrayal of sales than the Publishers' Association data in terms of sample size. It also, however, includes within its definition of books items that are not normally used in book-publishing data such as books in single sheets, leaflets, brochures and pamphlets. This means that it is difficult to distinguish which data are being shown and that the two sets of data are not directly comparable. The Publishers' Association data are based on a survey of its members, grossing-up sales from responding publishers who account for about 50 per cent of industry turnover. These are used to show the market-size estimates at retail prices (Book Marketing Ltd, 1999).

The Publishers' Association data indicate an increase in sales of 7 per cent in 1996 over 1995 and of 23 per cent in 1996 over 1993. PRODCOM shows 10 and 25 per cent increases for the same years. Both sets of data include exports (Bohme and Spiller, 1999).

The Publishers' Association figures indicate that publishers' sales in 1998 were £2,992 million, 73 per cent or £2,170 million of which represented home sales, with exports worth £822 million. Whilst sales of exports fell in 1998 for the second year running, home sales showed an increase of 4.6 and 8.5 per cent

respectively, at current prices. This represents real increases in each year. Further, growth was most significant at 6.9 per cent in 1998 in consumer sales. Considered over the period 1993/94–1998/99, however, the pattern of sales over the three categories of consumer, school and English-language-teaching, and academic and professional books, has remained relatively constant (Book Marketing Ltd, 1999).

Book titles published

The total number of book titles has continued to grow over the period with the exception of 1997 when there was a decline of 1.5 per cent in the number of titles published. There has, in fact, been a 71 per cent increase in the number of book titles published annually from 1988/89 to 1998/99. The latest figures show that 104,634 titles were published in 1998, representing an increase of 4.6 per cent over the previous year. The majority of these titles, 76 per cent, were new, an increase of 4.7 per cent over the previous year. The number of new editions shows a similar level of increase over the two years (Book Marketing Ltd, 1999).

A comparison with bookselling

It is relevant to consider the value of the bookselling sector alongside the publishing market as the two co-exist in an interdependent relationship. Bookshop chains saw their total sales increase in 1997/98 although only three chains enjoyed a growth rate in excess of 10 per cent. This compares to seven in the two previous years. Considered as a whole, the major bookselling chains (the only outlet for which headline data are available) show sales in excess of £950 million for 1997/98 (Book Marketing Ltd, 1999).

Employment in printing and publishing

Employment in printing and publishing increased by 9.4 per cent between 1993 and 1998. This upward trend is particularly evident towards the end of the period. There was an increase in employment of 4.4 per cent in 1998 over 1997 compared to 1.1 per cent growth in the previous year. Table 27.2 details the figures for full-time employment in printing and publishing.

Figures from the 1998 Publishing Industry Employment Survey published by Book House Training Centre (cited by Book Marketing Ltd, 1999: 21) indicate that in 1997 31,615 employees (approximately 9 per cent) worked in publishing itself, as opposed to the wider context of printing. This figure represents a decrease of 12 per cent on the previous year, suggesting that the upward trend in employment may be in the printing side of the industry (Book Marketing Ltd, 1999).

The subsidised publishing sector

In 1998/99, this sector was estimated to be worth between £2 and £3 million, but without the full regional arts board figures this is only approximate. The lack of

Table 27.2 Full-time employment in printing and publishing, 1993–98

	Thousands employed			Index (1990=100)
	Males	**Females**	**Total**	
1993	197.6	133.0	330.6	93.2
1994	198.7	132.0	330.8	93.2
1995	205.7	132.6	338.4	95.4
1996	199.6	143.3	342.9	96.6
1997	201.7	144.9	346.6	97.7
1998	209.4	152.6	362.0	102.0

Source: Book Marketing Ltd, 1999.

UK data pertaining to the subsidised publishing sector leaves a case-study approach as the best method of indicating the level and the type of funding injected into independent publishing over the period. Headline data are thus given for the publishing spend of the Arts Council of England and two English Regional Arts Boards – East Midlands Arts and Yorkshire and Humberside Arts (Yorkshire Arts since 1999). These data, combined with the publishing spend of the other UK arts councils, are not intended to provide a comprehensive overview of the national picture, but rather to give an indication of the funding picture over the period.

These two arts boards have been used here as a matter of expediency. They are not presumed to be representative of the regional arts boards overall. The East Midlands and the then Yorkshire and Humberside areas are very different. One is a bigger region, with large metropolitan areas including Leeds and Sheffield. The East Midlands region, until the recent acquisition of Lincolnshire, was one of the smaller regional art board areas. It has large rural areas and fewer large cities.

Between 1993 and 1999, the Arts Council of Great Britain and the Arts Council of England subsidised 13 regularly funded presses, literary magazines and organisations supporting independent publishing. It also created a Magazine Development Scheme to encourage the publication of literary magazines. Three-year development funding was granted from this scheme to magazines based in England that were revenue-funded by regional arts boards. In addition, they offered subsidy to support the marketing and promotion of literature by small and independent presses and to commercial publishers to publish work in translation where it would not normally be commercially viable. This period was marked by a clear emphasis on publishing spend, with policy emerging over the period was represented by the initiatives cited.

Analyses of the Arts Council's publishing spend (Table 27.3) show an overall increase of 9.7 per cent over the period. This is despite a decrease in spending in 1994/95, the result of a one-off budget uplift in the previous year. This decrease was to some extent offset by a 10.7 per cent increase in publishing subsidy in 1995/96. Additional money secured for publishing in 1993/94 was invested in the support of poetry publishing, the funding of a national network of magazines and publishing work in translation. In 1995/96, some of the uplift was used to create a marketing fund for small presses.

Even though the Arts Council of England's regularly funded client base of publishers remained on standstill funding since 1996/97, the level of funding increased by 3.6 per cent in 1995/96 and 1996/97, making a total increase of

Table 27.3 Arts Council publishing subsidy, 1993/94–1998/99

£

	1993/94	1994/95	1995/96	1996/97	1997/98	1998/99
Regularly funded clients	563,530	549,600	569,600	590,048	590,048	590,048
Magazine Development Scheme	59,720	41,039	31,339	33,250	37,000	31,750
Small presses	7,237	4,284	77,129	63,364	64,493	75,000
Translations	101,325	113,553	106,561	119,795	109,244	106,100
Total	731,812	708,476	784,629	806,457	800,785	802,898

Source: Arts Council of England.

over 7 per cent for the two years. Between 1993/94 and 1998/99, publishing clients received an increase of 4.7 per cent in subsidy. Although in real terms the uplift is to some extent undermined by rising costs for revenue clients, new monies invested in publishing reflect a continuing commitment to the area.

Publishing subsidy over the period represented approximately 50 per cent of the Arts Council's total literature budget. The Arts Council of Northern Ireland invested approximately the same percentage of its literature spend in publishing subsidy. The publishing allocation of the Welsh Arts Council/Arts Council of Wales totalled over 60 per cent of the literature budget, with most of the strategic literature spending having been in strengthening the publishing infrastructure. On the basis of available figures, the Scottish Arts Council's publishing spend at 34 per cent of the total budget for 1998/99 is slightly lower than the trend set by the other arts councils. Based on these percentage spends, we can estimate that the UK arts councils invested somewhere in the region of £2 million in publishing in the year 1998/99.

Regional spending is also an important factor in the public funding of publishing. At the smaller end of the scale, East Midlands Arts Board invested £11,000 (less than 10 per cent of its literature budget) in regional publishing in 1998/99. It supported five small presses, one magazine, three community publishing ventures and one workshop anthology. Yorkshire and Humberside Arts, on the other hand, spent a base allocation of £79,405 on publishing plus an additional sum of £8,710 raised for this purpose. This allocation represents 44 per cent of the total literature budget. These two sets of figures give an indication of the variance in publishing budgets in the English regions.

Employment in the subsidised publishing sector

There are no available data to suggest employment levels in the subsidised publishing sector. It is likely, however, that the percentage of employees in full-time paid employment in this sector will be slight. Much independent publishing is undertaken on very limited resources and it is quite common for editors and small-press publishers to receive little or no payment for their services.

Audiences

Readers represent the audience for publishing output across the sector. The unit

sales already discussed can thus be used to give some indication of readership. There are, however, other indicators that should be considered in this context.

Research shows that over the period considered here, reading was more popular than many other cultural and leisure pursuits. Various pieces of evidence suggest that imaginative literature is a popular source of reading material. Reading fiction or story books (imaginative literature) is the most common reading-related activity amongst individuals (65 per cent of those surveyed), closely followed by reading newspapers and magazines (63 per cent) (Book Marketing Ltd and The Reading Partnership, 2000). It is also the case that fiction accounts for a quarter of books bought (Book Marketing Ltd, 1999) and that in 1997 in relation to consumer book-buying, general fiction was the most popular category of genre bought by men, women, girls and boys (Bohme and Spiller, 1999: 286). Of the 480 million books which libraries lend per year, 250 million or 52 per cent are adult fiction (Creaser and Murphy, 1999, cited by the Reading Partnership, 1999). Reading engages 71 per cent of women and 58 per cent of men, 65 per cent of the population as a whole, compared to the 54 per cent of the population who visited the cinema and the 23 per cent who visited theatres, museums and galleries. It is relevant that this percentage has not decreased over the period in the face of competition for leisure time from TV, video, computer games and multimedia (Social Trends 30).[2]

Evidence from *Books and the Consumer* indicates that, in 1996, approximately 80 per cent of adults had bought a book in the last 12 months (Book Marketing Ltd, 1996 cited by Bohme and Spiller, 1999).[3] Consumers bought 320 million books in 1997, 110 million for children and 210 million for adults (Bohme and Spiller, 1999).

The type and value of literature subsidy

The individual focus of much literature activity, combined with a relatively high level of project and scheme funding, makes it difficult to achieve a complete picture of the subsidised literature sector. Taking into account the limitations of available data, the following analysis employs a case-study approach to fill gaps in the evidence regarding the type and value of funding available to the artform over the period.

The majority of literature subsidy derives from government and is distributed through the UK arts councils. The largest proportion of this funding is allocated

2 Book Marketing Ltd and the Reading Partnership (2000) provided the most recent data at the time of writing. It found that adults were more likely than average to think that their book reading had not changed over five years, although those feeling that they read more books exceeded those who felt that they read fewer (36:21 per cent). Very few heavy or medium-heavy readers claimed to be reading less than before, and as many as 20 per cent of non-light readers claimed to be reading more. Time-series data cited in Bohme and Spiller (1999) indicate a rise in book-reading from 1977 to 1996 from 54 to 65 per cent, making it more popular than gardening or DIY.

3 After 1996, Book Marketing Ltd's method of collecting data changed and areas of information provided were different.

Table 27.4 Arts Council literature grants, 1993/94–1998/99

	Grant allocation (£ thousand)	Percentage of total grant-in-aid
1993/94	1,488	1.0
1994/95	1,467	1.2
1995/96	1,554	1.3
1996/97	1,565	1.3
1997/98	1,427	1.2
1998/99	1,551	1.2

Source: Arts Council of England.

via the Department for Culture, Media and Sport to the Arts Council of England. An analysis of how this funding is allocated presents a model that is, on the whole, replicated by the rest of the country.

Table 27.4 suggests that, over the period considered, literature received a very slim share of national arts funding. The Arts Council's literature budget represented just over 1 per cent of artform grant-in-aid. This level of funding is unlikely to change in the immediate future. A similarly slim share of artform spend was allocated to literature by the other UK arts councils.

Between 1993 and 1999, the Arts Council's literature budget supported 15 organisations – 13 revenue-funded organisations plus the Arvon Foundation (a writers' retreat with centres in the north and south of England offering people the opportunity to develop their writing with a professional writer, usually over a period of five days) and the Federation of Worker Writers. It also funded a raft of production and distribution budget heads including broadcasting, touring, live literature and writers' residencies. In addition, development funding was available for education, disability and cultural diversity, work with libraries, a network of literature-development workers, writers in prisons and writers' awards. Quite differently from the trend in performing arts, the budget breakdown was weighted towards these streams of project and development funding rather than towards a client base of revenue-funded organisations.

The literature spend for the Arts Councils of Wales, Scotland and Northern Ireland is detailed in Table 27.5. The allocation within these budgets follows a similar pattern to that of the Arts Council of England. Welsh figures for 1998/99 are not comparable to other Welsh Arts Council figures because of the restructuring of literature funding. Changes in the client base also account for the cut between 1993/94 and 1994/95. The subsequent uplift in 1995/96 was a result of Swansea hosting the National Year of Literature.

Table 27.5 Literature spend for the Arts Councils of Wales, Scotland and Northern Ireland, 1993/94–1998/99

£ million

	1993/94	1994/95	1995/96	1996/97	1997/98	1998/99
Wales	0.984	0.896	0.950	1.008	0.964	0.426
Scotland	0.890	0.869	1.109	0.965	1.078	1.064
Northern Ireland	0.261	0.320	0.256	0.286	0.238	0.326

Source: Arts Councils of Wales, Scotland and Northern Ireland.

There are no national data presenting an overview of the level of regional investment for the period. Table 27.6 presents what can be constructed as to the regional arts boards' spend on literature. In general, regional arts board literature budgets broadly repeat the percentage share of artform spend established as a national pattern by the arts councils. This is because the national arts councils set national policy with which regional policy aligns itself; consequently the regional arts boards' spend is likely to be similar with some slight variations.

Levels of regional arts board literature funding available have never been consistent across the ten English regional arts board areas, the budgets having been shaped by a combination of historical factors relating to the size of the region, the size of the client base and the policies of the individual arts boards. East Midlands Arts' literature budget for 1998/99, for example, was £126,000. This figure consisted of a base level of almost £93,000 with additional funding making up the remainder. The budget was predominately project- and scheme-based, although it also supported five small presses funded on an annual basis and five posts for literature development workers. The budget allocation matches the activity found at arts council level although obviously it has a regional rather than national focus. Although the East Midlands budget is typical in the range of activity it supports, unlike the other regional arts boards it does not fund any major revenue clients. By comparison, for the same year, the base budget for Yorkshire and Humberside Arts was £232,569 (information provided by Yorkshire Arts). Using these two indicators as a base point, grossing up to a maximum and a minimum suggests that the English regional arts boards spend somewhere between £1.3 million and £2.5 million per year on literature.

Support from local government represents a further significant source of funding to the sector. Often this funding is in partnership with the regional arts boards to support literature-development-worker posts, events, residencies, writers' workshops and local publishing. Arts budgets provide one common source of literature funding, and public libraries the other. The trend has been for libraries to focus increasingly upon the reading experience and the support of readers' groups, readers in residence and other reader-development strategies. Although it is difficult to arrive at a total figure for library spend, in one defined area of activity it has, over the period, certainly matched the Arts Council of England's annual £65,000 library fund. Libraries' focus on the reading experience impacts on literature because it includes the support of reading and thereby the development of a healthy writing culture. Established reader development theory supports reading as an artistic activity in its own right, resulting in the creation of a personalised artistic product.

Other local government partners in the funding of literature include: the education sector, particularly through the support of visiting writers in schools; the health service through hospice, reminiscence and therapy work; and social services and youth services for projects with their respective client groups. There are no data available to indicate spend in these respective areas.

Table 27.6 Regional arts boards' expenditure on literature, 1993/94–1998/99

£ million

	1993/94	1994/95	1995/96	1996/97	1997/98	1998/99
Eastern	–	–	–	–	–	–
South East	0.105	0.128	0.101	0.113	0.126	0.137
North West	0.219	0.196	0.177	0.201	0.221	0.200
West Midlands	0.104	0.065	0.079	0.066	0.098	0.092
East Midlands	0.075	0.111	0.136	0.139	0.097	0.126
South West	0.195	0.188	0.206	0.238	0.248	0.261
Southern	0.106	0.099	0.120	0.132	0.127	0.125
Yorkshire & Humberside	0.208	0.221	0.189	0.197	0.196	0.233
Northern	0.282	0.267	0.287	0.321	0.308	0.293
London	0.437	0.398	0.427	0.433	0.406	0.471
Recorded total	1.730	1.672	1.723	1.840	1.826	1.938

Sources: RAB reports and accounts.

The National Lottery

Given its lack of capital assets and building-based infrastructure, literature has effectively been excluded from Lottery funding's focus on capital development. This is clearly shown by the number of awards made by the Arts Council of England in 1995 and 1996. In 1995/96, the first year of the Capital Lottery Programme, literature received only seven awards, to the total value of £531,000 (Table 27.7). The largest award for that year was £297,375 to the Arvon Foundation (Table 27.7). Compare this to the £124 million allocated to 134 drama projects and the £42 million given to 148 music projects in 1995/96.

The advent of Arts for Everyone (A4E), with its focus on non-capital projects and its aims of increasing participation and including the voluntary sector, was much more suited to literature needs. A4E accounts for the increase in number and value of awards in 1997. In 1997/98, literature grants from A4E came to £2 million out of £28 million, with a further £1 million coming from the £21 million Express Scheme (Motion, 2000). Over the period 1996/97 and 1998, seven A4E grants were allocated of £200,000 or more; three of these were for over £300,000. Whilst literature was still receiving substantially less funding than the performing arts, A4E nevertheless represented a substantial boost to literature resources.

Table 27.7 Arts Council of England Lottery awards, 1995/96–1998/99

	Number of awards	Value (£ million)
1995/96	7	0.531
1996/97	137	1.652
1997/98	190	2.881
1998/99	31	2.200
Total	365	7.264

Source: Arts Council of England.

Table 27.8 Public Lending Right payments, 1993/94–1998/99

Year	Amount distributed (£ million)	Number of authors in receipt	Amount per loan (pence)
1993/94	4.337	19,388	2.00
1994/95	4.329	20,097	2.00
1995/96	4.346	21,055	2.07
1996/97	4.251	17,512	2.07
1997/98	4.159	17,192	2.07
1998/99	4.206	17,470	2.18

Source: Public Lending Right.

Public Lending Right

DCMS support for the Public Lending Right Scheme, which started in 1982, represents another significant source of financial aid to the sector. The Public Lending Right is a UK scheme that pays published authors each time one of their books is borrowed from a public library.

In 1993/4, Public Lending Right distributed £4.3 million to 19,388 authors at the rate of 2 pence per loan (Table 27.8). Although the total figure distributed decreased by 3 per cent, and the number of authors benefiting by 10 per cent, between 1993/94 and 1998/99, Public Lending Right still represents an important source of income for authors, particularly writers of popular fiction.

The National Year of Reading

The National Year of Reading, launched on 1 September 1998 as part of the Department for Education and Employment's National Literacy Strategy, had a significant impact on the literature sector both through its own funding programme and through its success in levering funding to support reading and reader-development.

The National Year of Reading injected over £750,000 into reading-related activity. Whilst some of this money was invested in literacy, which falls outside the scope of this chapter, a large proportion of funding directly supported reader-development work. Public libraries, with their skills in reader development and reading promotion, played a major role in delivering many National Year of Reading initiatives.

The boost that the National Year of Reading gave to work with readers in terms of both direct funding and profile was significant.

- The response the funding scheme evoked also indicates the prominence of reader development activity in the sector. The first funding round in April 1998 resulted in bids totalling just under £7 million.
- The National Year of Reading also succeeded in securing new money for literature via the sort of high-profile sponsorship that has largely eluded the literature sector. Sainsbury's contributed £6 million to the Bookstart programme, resulting in over 100 projects bringing free books and reading-information packs to the parents of nine-month-old babies. Other sponsors included ASDA, which

supported work with libraries, and Walkers Crisps, which supported the free books for schools scheme. Launchpad, a development agency supporting libraries and their work with children, used a £25,000 Year of Reading grant to generate a £500,000 funding package from the commercial sector.

- The National Year of Reading also generated a large amount of partnership funding from within the arts funding system itself. A partnership between the National Year of Reading and the Arts Council of England worth £200,000 was used to support writers in schools and reading-promotion initiatives in libraries.

- The profile that the National Year of Reading gave to reading development, combined with the developing relationship between the arts funding system and the public library service, also provided the right context for government consideration of direct reader-development funding. The result has been a refocusing of the DCMS/Wolfson Public Libraries Challenge Fund. Previously an IT funding stream, it is now a £2 million reader-development programme aiming to build on the achievements of the National Year of Reading and to take reader-development work into its next phase (DfEE, 1999).

Income, employment and audiences

Income other than subsidy

The sector attracts three types of income other than subsidy from national and regional funding bodies; earned income from box office or sales; sponsorship or other forms of contributed income; and, local authority and other public funding.

Whilst it is not possible to give a comprehensive overview of income into the UK literature sector, we can, however, identify certain trends in the type and value of income generated by analysing available data from regularly funded organisations. Table 27.9 gives a summary of income for Arts Council of England literature clients. Percentages are also shown, as the figures are not directly comparable due to differences in the numbers of organisations providing data. In

Table 27.9 Summary of income for regularly funded literature organisations, 1993/94–1998/99

£ thousand (percentage of total)

	1993/94	1994/95	1995/96	1996/97	1997/98	1998/99
Earned income and box office	1,068 (58)	2,774 (58)	2,795 (59)	2,749 (60)	2,504 (63)	3,099 (46)
Contributed income inc. sponsorship	159 (9)	694 (15)	720 (15)	661 (15)	534 (13)	1,617 (24)
Local authority and other public funding	23 (1)	134 (3)	138 (3)	154 (3)	186 (5)	328 (5)
Subsidy	588 (32)	1,139 (24)	1092 (23)	1,027 (22)	757 (19)	1,681 (25)
Total	1,838 (100)	4,741 (100)	4,745 (100)	4,591 (100)	3,981 (100)	6,725 (100)
Base	–	–	22	21	20	26

Source: Arts Council of England.

Table 27.10 Business support for literature by English RAB and home country, 1993/94–1998/99

£ million

	1993/94	1994/95	1995/96	1996/97	1997/98	1998/99
England (a)						
East	0.003	0.013	0.005	0.002	0.053	0.000
East Midlands	0.000	0.001	0.000	0.000	0.000	0.000
London	0.312	0.354	0.466	0.184	0.207	0.518
North West	0.010	0.000	0.000	0.000	0.000	0.000
Northern	0.001	0.000	0.000	0.000	0.000	0.010
South East	0.000	0.000	0.000	0.025	0.000	0.001
South West	0.000	0.003	0.004	0.000	0.070	0.088
Southern	0.004	0.120	0.000	0.171	0.072	0.007
West Midlands	0.000	0.007	0.000	0.000	0.001	0.005
Yorkshire & Humberside	0.001	0.010	0.000	0.000	0.000	0.007
Total England	*0.330*	*0.508*	*0.475*	*0.382*	*0.404*	*0.634*
Scotland	0.126	0.045	0.022	0.039	0.113	0.151
Wales	0.024	0.001	0.019	0.001	0.000	0.008
Northern Ireland	0.002	0.003	0	0.003	0	0
National funding / other	0.057	0.496	0.000	0.000	0.000	0.000
Total United Kingdom	0.538	1.053	0.516	0.424	0.517	0.793

Source: ABSA/Arts & Business *Business Support for the Arts/Business Investment in the Arts*, various years.

Note: a) Regional arts board regions.

1993/94 the data refer to clients funded by the Arts Council of Great Britain and from 1994/95 by the Arts Council of England. From 1996/97 onwards, the data also include literature clients funded by the regional arts boards.

The available figures indicate a steady decrease in the proportion of income as subsidy from the arts funding system up to 1997/98, offset by a rise in the value of earned income (also up to 1997/98) and a small increase in subsidy from other public sources including local government. Data from another source show varying levels of sponsorship over the period 1993/94–1998/99 (Table 27.10).

What these figures do not indicate is the inventiveness of literature activists in seeking a variety of funding partners from the private and public sectors to support their work. Complex and diverse funding mixes are characteristic of literature subsidy and are both a symptom of slim resources and also a means of enriching the literature sector with a range of expertise and skills from other sectors. It is not possible to indicate levels of imports and exports in the income generated.

Employment in the subsidised literature sector

There is little evidence on which to base an estimate of the level of employment in the subsidised literature sector. The collection of such data is made difficult by a number of factors. These include the individualised nature of the artform, its lack of a directly funded building-based infrastructure and the transient nature of project-based activity. The employment picture is further complicated by the fact that there are a large number of people active in the field, particularly writers,

who do not make a living wage from literature activity. Terms such as amateur and professional are difficult to apply, as even relatively established writers do not always support themselves by writing. Finally, there is a wide variety of forms of activity to take into account. These include people working as literature-development workers, small-press editors, live-literature promoters and writers. Estimates of literature employment based only on writers and authors are, thus, incomplete.

There are, however, a number of indicators that can be used to gauge the level of employment and active participation in certain areas of the literature sector. They by no means give the complete picture but, in the absence of more comprehensive data, they do at least provide some sort of measure.

In 1998/99, the Public Lending Right Scheme had a total of 24,326 published authors on its register. The Authors' Licensing and Collecting Society, which collects and distributes secondary royalties, had 35,000 writers registered in the same year. These royalties pertain to reprography, certain lending rights, and private and off-air recording and simultaneous cabling. Both these figures, however, include writers' estates. The Society of Authors, the professional writers' trade union, probably represents a better measure with its membership of 6,500 (information from the Public Lending Right Scheme; the Authors' Licensing and Collecting Society; and the Society of Authors).

Measuring activity in other areas of the sector, there were approximately 72 literature-development workers/animateurs employed in England in 1998/99 and 182 active literature promoters (unpublished data from the National Association of Literature Development; ACE, 1998).

1998/99 snapshot figures for one English regional arts board area provide a further indicator of the level and diversity of activity. On the basis of available data, in the East Midlands, there were: 5 literature-development workers, 1 writer in residence, 3 writers in receipt of an annual writer's bursary, 9 people employed in literature activity in a professional capacity, 120 amateur writers, 12 literature promoters and 12 small-press editors. This gives a total figure of 162 individuals involved in some form of sustained, but not always paid, literature activity. It would probably be inaccurate to gross up this figure to reflect literature activity within the ten English regional arts board areas because of the distortions created by the large metropolitan area covered by the London regional arts board. The East Midlands figure does, at least, give an indication of the level, type and diversity of sustained activity in the sector.

Literature audiences

Whilst there is a body of evidence suggesting participation levels in reading across the board, there are no comprehensive data regarding attendance levels at UK literature events. Collection of such data is again made difficult by the limited literature client base and the project basis of much activity. Also whilst Arts Council of Great Britain and Arts Council of England annual reports for 1993/94–1998/99 include data for attendance at arts events, this is performing- and visual-arts biased and does not cover literature.

Table 27.11 Audience figures for ACE regularly funded literature clients, 1994/95–1998/99

	1994/95	1995/96	1996/97	1997/98	1998/99
Performance	38,448	11,648	9,119	17,000	20,000
Workshops	10,086	19,040	17,394	17,000	14,000
Published/broadcast	876,622	905,764	801,426	1,065,000	1,037
Total	925,156	936,452	827,939	1,099,000	1,071,000
Additional estimated attendance (a)	44,800	16,065,850	15,032,000	24,000	2,908,000
Base number	22	21	20	20	26

Sources: Hacon et al., 1997; 1998; 2000.

Note: a) This includes radio and television audiences.

Audience figures for organisations regularly funded by the Arts Council of England and the regional arts boards, nevertheless, indicate levels of attendance for literature under three headings: performance; workshops and participatory events; and published and broadcast arts including sales of books. These are shown in Table 27.11.

These figures should be treated with some caution as an indicator of literature audience levels. The limited nature of the client base is not representative of the large amount of literature activity happening in the sector. Also, any small changes in this limited sample would have a marked effect on the data for that year. Fluctuations in attendance shown should also be considered in the context of the other artforms surveyed, the majority of which also indicated a general downward trend. This trend was in direct contrast to the increase in attendance indicated by the Target Group Index figures over the period. This inconsistency could be a result of the reducing value of artform subsidy impacting upon programming in directly funded clients.

Available attendance figures for other areas of the UK similarly contradict this downward trend. Audience figures for live literature in Wales indicate that in 1998/99, 90,000 people attended 1,300 events, approximately 45 per cent of which were in Welsh. This figure had risen from an approximate attendance of 50,000 in 1994/95. The biennial Edinburgh International Book Festival has also seen a general increase in attendance. In 1993, the Festival attracted 65,000 visitors, in 1995, 67,000, in 1997, 68,000 and in 1999, 70,000 (Welsh Academy and the Edinburgh Festival).

Finally, to add a regional indicator to the equation, snapshot figures from the East Midlands for 1998/99 estimate attendance figures for live literature events at 2,220. It should be noted that the East Midlands has no major literature festival or large-scale literature programme. These figures also do not account for participation in IT-based literature activity, an increasingly significant area, but one for which no figures have been collected.

There are no data available relating to UK consumer expenditure in the subsidised literature sector, in terms of either attendance at events or the purchase of books.

Given the relationship between literature and libraries described in this chapter, and the paucity of data for both, Tables 27.12 and 27.13 present an overview of funding to the two sectors by source and by home country.

Table 27.12 Funding for libraries and literature in the UK, 1993/94–1998/99

£ million

	1993/94	1994/95	1995/96	1996/97	1997/98	1998/99
Central government						
DCMS	114.528	146.000	171.399	114.372	106.792	90.816
Scottish Office	19.000	12.000	12.000	11.000	12.000	12.000
Welsh Office	6.000	8.900	12.400	6.000	6.000	6.000
Northern Ireland Office (a)	–	–	–	–	–	–
Recorded subtotal	*139.528*	*166.900*	*195.799*	*131.372*	*124.792*	*108.816*
Arts councils' grants						
Arts Council of England	1.489	1.467	1.554	1.565	1.427	1.551
Scottish Arts Council	0.890	0.869	1.109	0.965	1.078	1.064
Arts Council of Wales	0.984	0.896	0.950	1.008	0.964	0.426
Arts Council of Northern Ireland	0.238	0.317	0.249	0.284	0.238	0.340
Subtotal	*3.601*	*3.549*	*3.861*	*3.822*	*3.707*	*3.381*
National Lottery						
Arts Council of England	n/a	n/a	0.531	1.652	2.881	2.200
Scottish Arts Council	n/a	n/a	0.550	0.141	0.290	0.739
Arts Council of Wales	n/a	n/a	0.155	0.152	0.106	1.079
Arts Council of Northern Ireland	n/a	n/a	0.008	0.003	0.095	0.095
Heritage Lottery Fund (b)	n/a	13.254	7.844	23.175	11.691	21.836
Millennium Commission	n/a	n/a	0.000	0.000	0.000	0.000
Subtotal	*n/a*	*13.254*	*9.088*	*25.122*	*15.064*	*25.949*
Local authorities (c)						
England	623.695	639.279	642.411	651.724	660.808	680.471
Wales	31.163	30.821	33.119	32.177	32.751	34.098
Scotland	81.750	86.346	88.540	88.030	85.208	85.303
Northern Ireland	17.623	17.672	18.347	18.571	18.412	19.936
Subtotal	*754.231*	*774.118*	*782.417*	*790.502*	*797.179*	*819.808*
Business sponsorship (d)	0.538	1.053	0.516	0.424	0.517	0.793
Recorded total	897.898	958.874	991.681	951.243	941.259	958.748

Sources

DNH, annual reports 1995–1997; DCMS, annual reports 1998–1999.

Department of the Secretary of State for Scotland and the Forestry Commission, *The Government's Expenditure Plans*, various years.

The Government's Expenditure Plans: Department report by the Welsh Office, various years;

Arts Council of Great Britain/Arts Council of England, annual report, various years;

Scottish Arts Council, annual report, various years; Welsh Arts Council/Arts Council of Wales, Annual Report, various years; Arts Council of Northern Ireland, Annual Report, various years; annual reports and accounts of the ten regional arts boards; Lottery data supplied directly by the Arts Councils of England and of Wales; Arts Council of Northern Ireland, *Annual Lottery Report*, various years.

Information supplied directly by the Heritage Lottery Fund; www.lottery.culture.gov.uk;

LISU Annual Library Statistics 1999, 1999; *Public Library Statistics 1998–99 Actuals*, CIPFA, 1999.

ABSA/Arts & Business *Business Support for the Arts/Business Investment in the Arts*, various years.

Notes

a) No funding for libraries or literature identified, other than that channelled through the Arts Council for Northern Ireland.

b) Grants for manuscripts and archives. There may also have been grants for libraries under the HLF funding category of Museums and Collections, but this could not be separately identified.

c) Figures for 1993/94 to 1997/98 from *LISU Annual Library Statistics 1999*. Figures for 1998/99 from *Public Library Statistics 1998–99 Actuals*, CIPFA, 1999.

d) Figures for literature only taken from the annual ABSA/Arts for Business survey of companies. May overlap with matching funding for the DCMS sponsored Pairing Scheme.

Table 27.13 Expenditure on libraries and literature in the UK by home country, 1993/94–1998/99

£ million

	1993/94	1994/95	1995/96	1996/97	1997/98	1998/99
England						
DCMS	114.528	146.000	171.399	114.372	106.792	90.816
ACGB/ACE	1.489	1.467	1.554	1.565	1.427	1.551
Lottery (ACE and HLF)	n/a	13.254	8.309	23.831	14.227	16.674
Local authorities	623.695	639.279	642.411	651.724	660.808	680.471
Business sponsorship (a)	0.330	0.508	0.475	0.382	0.404	0.634
Wales						
Welsh Office	6.000	8.900	12.400	6.000	6.000	6.000
WAC/ACW	0.984	0.896	0.950	1.008	0.964	0.426
Lottery (ACW and HLF)	n/a	n/a	0.155	0.152	0.205	1.275
Local authorities	31.163	30.821	33.119	32.177	32.751	34.098
Business sponsorship (a)	0.024	0.001	0.019	0.001	0	0.008
Scotland						
Scottish Office	19.000	12.000	12.000	11.000	12.000	12.000
Scottish Arts Council	0.890	0.869	1.109	0.965	1.078	1.064
Lottery (SAC and HLF)	n/a	n/a	0.615	0.158	0.358	5.572
Local authorities	81.750	86.346	88.540	88.030	85.208	85.303
Business sponsorship (a)	0.126	0.045	0.022	0.039	0.113	0.151
Northern Ireland						
Northern Ireland Office	–	–	–	–	–	–
Arts Council of Northern Ireland	0.238	0.317	0.249	0.284	0.238	0.340
Lottery (ACNI and HLF)	n/a	n/a	0.008	0.982	0.273	2.428
Local authorities	17.623	17.672	18.347	18.571	18.412	19.936
Business sponsorship (a)	0.002	0.003	0	0.003	0	0

Source: Table 27.12.

Note: a) Not including national funding of £0.057 million in 1993/94 and £0.496 million in 1994/95.

Conclusions

Literature has long been overshadowed by the performing and visual arts, largely because of its lowly status as a subsidised artform. There is no doubt that in terms of funding it is a relatively minor player, which probably accounts for the lack of national data available regarding its role in the cultural sector. It is, however, a healthy and energetic artform that has been forced through necessity to be inventive in seeking partnership and support. Its focus on the individual writer and reader rather than the capital asset has also proved a strength in a period of declining public subsidy and shifting emphasis away from the building to the artform. There are many who believe that literature is poised to assume centre-stage in the next decade.

28
Profile of Museums and Galleries

Sara Selwood, University of Westminster

The majority of museums and galleries in the UK are subsidised. Even museums classified as 'independent' often receive support in the form of core funding or Lottery grants. Consequently, it is enormously difficult to distinguish between the subsidised and commercial museums sectors, and so this chapter does not attempt to do so. The chapter collates existing data on museums and galleries in the UK. It describes and compares: the data sources; number of museums; their turnover, including consumer spend; employment; and visitors. It contextualises this information with comments from museum funders and administrators. The chapter focuses on museums and galleries with permanent collections. Galleries without collections, showing temporary exhibitions, are considered elsewhere under 'visual arts' (Chapter 31).

Determining the number of UK museums and galleries

Data sources

Over the past five years, various forces have conspired to encourage the production of better statistics across the museums sector – including the government, as a way of measuring efficiency (Selwood, 2000), and the area museum councils, as a way of mapping their sectors in advance of strategic planning (West Midlands Area Museums Service, 1996; South West Museums Council, 1999). Local authorities are now collecting data for the national league tables and Best Value reviews. And, while most of it remains unpublished, individual museums have also been gathering data for their own purposes. Twenty-two museum services contribute to the Group for Large Local Authority Museums' (GLLAM) annual benchmarking exercise, and 22 individual museums to the Association of Independent Museums (AIM) Comparative Trading Survey. But despite all those efforts, data on the museums sector as a whole remain fundamentally scarce:

> It is widely acknowledged that there are serious gaps in information on all the important criteria that measure the role of museums in society and their use of public funding. Apart from the obvious difficulty with quantifying just how

many 'museums' there are, the gaps include accurate estimates of the number of visitors, understanding different visitor types, the motivation for visiting or not visiting by different sectors of the population, financial comparisons, staffing comparisons, and the use and effectiveness of marketing. Although the museums world is awash with reports on just about every aspect of their work, it is a knowledge deficit that defeats strategic thinking about museums.

(Middleton, 1998: 8).

In addition to the data on the museums and galleries sponsored by DCMS, which appear in the Department's annual reports, there are two sources of national museum statistics which pertain to the period up to 1998/99, both of which were updated annually:

- *Sightseeing in the UK*, which is produced for the four home-country tourist boards and has collected data from UK tourist attractions since 1978; and
- DOMUS (the Digest of Museum Statistics), administered by the Museums & Galleries Commission (MGC) between 1993 and 2000, when responsibility for it passed to Resource, the new Council for Museums, Archives and Libraries. DOMUS collected data from the museums and galleries included in the MGC's Registration Scheme. Its most recent data are for 1998.

Although both surveys were indirectly funded by the DCMS, there was no co-ordination between the two, and numerous discrepancies exist between them (Selwood and Muir, 1997). From 1993 to 1998, the period examined in this chapter, the number of museums and galleries making returns to *Sightseeing in the UK* changed very little – staying around the 1,700 mark. The number of returns to DOMUS varied by about 450.

Various other ad hoc surveys of the museums sector were published between 1993/94 and 1998/99, including those produced at a regional level, such as: an investigation into the impact of the Lottery (Davies, 1997); the market for museums (East Midlands Museums Service, 1996); and the management of university collections (for example, Arnold-Forster, 1999). At a national level, research has focused on various aspects of the museums sector including: audiences (MORI, 1999); employment (HOST Consultancy, 1999); economic impact (Brand et al., 2000); museums' public-service provision (Coles et al., 1998); conservation provision and collection types (Carter et al., 1998).

The number of museums and galleries

According to conventional wisdom, there are about 2,500 museums in the UK (Carter et al., 1999), although estimates of the size of the museum population ultimately depend on what is understood to constitute a museum. The Museums Association's yearbook contains the most comprehensive listing of museums and related organisations in the UK. In 1999 it had around 2,800 entries, not all of which complied with the Association's own definition of a museum. Stripping out museum services, arts centres, contemporary art galleries (without permanent

collections), country parks, heritage centres, railways, archives, etc. leaves around 2,300 entries.

The DOMUS surveys cover registered museums which, by definition, comply with the Museums Association's definition of a museum (see Chapter 6) as well as the MGC's minimum standards. In 1998 there were 1,719 registered museums, of which 1,389 (81 per cent) returned information to DOMUS (Carter et al., 1999). *Sightseeing in the UK* focuses on organisations for which visitor numbers are known or can be reliably collected. In 1998, it covered 1,746 bodies which described themselves as museums or galleries (Hanna, 1999), including those with no permanent collection and which display only temporary exhibitions, such as the Hayward Gallery. Needless to say, there is inevitably some overlap in the make-up of the three listings described above. Indeed, 54 per cent of the 2,300 museums on the Museums Association's database were registered.

A rather more contentious way of estimating the size of the museums population in the UK is on the basis of standards – the quality of the visitor experience they offer, the degree to which they meet standards of efficiency and effectiveness, and satisfy the government's efforts to increase access and encourage lifelong learning (Middleton, 1999: 16). On the basis of this logic, Middleton reckons there are between 1,250 and 1,500 museums in the UK 'in the sense that both government and the target audience would immediately recognise them'. He classifies one third of these as representing the leading edge of good practice; one third as competent, but not leading-edge; and one third as meeting the basic requirements of registration.

Despite museums' expenditure on improving their facilities,[1] as Middleton observes, a sizeable proportion of the sector has a long way to go to satisfy the requirements of visitor care:

- one in five has no labels and one in four no interpretation panels;
- over one in two has no member of staff with specific responsibility for education;
- two out of three don't produce a plan of the museum;
- two out of three have no café;
- one in three has no temporary exhibition space;
- one in five has no toilet facilities, and four out of five have no baby-change facilities;
- only one in five has a marketing policy;
- over half carried out no visitor research in the past five years; and
- less than half train staff in visitor care, and two out of three don't have a member of staff specifically responsible for visitor care (Coles et al., 1998).

Moreover, there is some evidence to suggest that more museums were opening for less time in 1998 than in 1997 (Carter et al., 1999).

1 *Sightseeing in the UK* found that nearly a third of the museums and galleries it surveyed had spent at least £1,000 on developments intended to increase the attractions or facilities during 1998. The majority (52 per cent) had spent up to £5,000, and 4 per cent had spent over £250,000 (Hanna, 1999).

The tension between the number of museums and the quality of what they do is a key issue in the museums sector. As a spokesman for one of the funding bodies interviewed for this chapter put it:

In recent years the prevailing professional view has been that there are too many museums in the UK and new ones should be discouraged because they may put even more pressure on the limited public funds available and supply will outstrip visiting demand. More recently, it has been suggested that too many poor quality museums are diluting the strength of the brand and these should, in some way, be distanced from the 'better' ones. Unfortunately, this does not square well with the pressure from communities to create their own museums.

The museums population in the UK is far from static. One estimate suggests that new museums have been opening at the rate of nearly one a week on average between the early 1980s and the late 1990s. These are generally volunteer-run and attract fewer than 10,000 visits a year (Middleton, 1998). Another, more cautious estimate, proposes that between 1993 and 1998 inclusive, 162 museums and galleries are known to have opened and 97 to have closed (Hanna, unpublished data).

Table 28.1 provides a breakdown of museums in the UK by type and location. Local authorities own about 40 per cent; about 55 per cent are the responsibility of the private sector, charities, universities and government-funded bodies; and, the government is responsible for the remainder. *Sightseeing in the UK* and DOMUS data agree fairly closely on this.

Table 28.1 Number, type and location of registered museums in the UK, 1998

	Number	Percentage
Type of museum		
Armed services	93	7
English Heritage	9	1
Independent	547	39
Local authority	563	41
National	37	3
National Trust	67	5
University	73	5
Total UK	1,389	100
Location (area museums council region)		
East Midlands	84	6
North West	114	8
North East	50	4
South East	448	32
South West	164	12
West Midlands	99	7
Yorkshire & Humberside	114	8
Total England	1073	77
Scotland	237	17
Wales	58	4
NI	21	2
Total UK	1,389	100

Source: Carter et al., 1999.

Income, expenditure and employment

There are, theoretically, two ways of looking at museums' turnover from a national perspective: examining the amount of subsidy to the sector plus, where possible, the amount of income generated by the sector; and analysing museums' own reports of their income and expenditure. Examining funding is generally taken to be the more accurate of the two.

Levels of subsidy to the sector

Government expenditure passes to museums through various routes: the Department for Culture, Media and Sport (DCMS) for England; the Scottish Executive, the National Assembly for Wales and the Northern Ireland Assembly (formerly the Scottish Office, Welsh Office and the Education Department, Northern Ireland Office respectively); the Ministry of Defence (which funds six museums of national status and about 40 regimental museums). In England, the Department for Education and Employment (DfEE) funds pass to museums via the Arts and Humanities Research Board (previously via the Higher Education Funding Council for England) which supports museums in higher education institutions.

Table 28.2 shows the value of funding to the sector between 1993/94 and 1995/96. DCMS's funding for the sector in 1998/99 was almost £9 million less than in 1993/94, although it is set to rise from 1999/2000 with additional funding being earmarked to meet government objectives (DCMS, 1998a; 1998b).

As in other areas of activity, the biggest change to the finances of the museums sector has been the advent of Lottery funding. The HLF alone has accounted for injections of capital ranging from just over half a million to over £200 million per year (Table 28.3). In total, the HLF, the arts councils and the Millennium Commission had provided over £645 million to the sector by the end of 1998/99. Table 28.4 shows the relative importance of HLF and other sources of capital income utilised by members of the GLLAM group in 1998/99.

It has been suggested that, by the end of 1999, HLF capital projects had already created somewhere in the region of £30 million additional operating costs for UK museums. The expectation that museums would generate more earned income against the reality of a static if not diminishing visitor market (see below) suggests that many will find themselves financially over-committed. Rather than remedying the problems of the historic under-funding of museums, there is some risk that Lottery money is actually creating problems for the future (Babbidge, 2001). As an academic observer interviewed for this chapter noted:

Lottery funding has provided an incredible opportunity to review and develop museums. It's still too early to assess its long term impact on museums and it's difficult to predict, because investment has been intuitive rather than planned. In years to come, we may look back and wonder how so much could have been spent without any discernible strategic framework.

Table 28.2 Funding for museums and galleries in the UK, 1993/94–1998/99

£ million

	1993/94	1994/95	1995/96	1996/97	1997/98	1998/99
Central government						
DCMS (a)	221.315	231.900	235.619	223.492	221.018	212.366
Scottish Office	25.000	28.000	27.000	29.000	32.000	30.000
Welsh Office	14.500	12.800	12.500	12.300	12.300	12.700
Northern Ireland Office	8.931	10.103	9.580	9.361	9.428	9.120
Subtotal	*269.746*	*282.803*	*284.699*	*274.153*	*274.746*	*264.186*
National Lottery						
Heritage Lottery Fund	n/a	0.650	120.984	215.045	113.035	93.261
Millennium Commission	n/a	0.000	95.650	0.000	1.176	0.000
ACE	n/a	n/a	1.856	2.978	0.196	0.300
SAC	n/a	n/a	0.536	0.014	0.198	0.013
ACW	n/a	n/a	0.070	0.000	0.001	0.000
ACNI	n/a	n/a	0.000	0.000	0.004	0.000
Subtotal	*n/a*	*0.650*	*219.096*	*218.037*	*114.610*	*93.574*
Local authorities						
England (b)	141.948	154.360	154.009	157.113	166.724	186.709
Wales	5.681	8.299	7.955	6.858	7.989	6.080
Scotland	35.979	38.063	44.975	41.756	33.322	34.061
Northern Ireland (c)	1.714	–	–	–	2.553	–
Recorded subtotal	*185.322*	*200.722*	*206.939*	*205.727*	*210.588*	*226.850*
Business sponsorship (d)	9.040	17.170	9.204	12.759	18.313	31.790
Total	464.108	501.345	719.938	710.677	618.258	616.400
Other central government departments (e)						
Ministry of Defence (f)	–	–	–	–	–	11.779
DETR (g)	–	–	–	–	–	1.800
DfEE (h)	–	–	–	–	–	8.889
Foreign & Commonwealth Office (i)	–	–	–	–	–	0.660
Subtotal	–	–	–	–	–	*22.468*

Sources: Annual reports of DNH and DCMS; Scottish Office; Welsh Office; Northern Ireland Office; HLF; DETR; Welsh Office survey of local authority expenditure; Scottish Office, *Scottish Local Government Financial Statistics*; ABSA/Arts & Business, *Business Support for the Arts/Business Investment in the Arts*; *The Forum for Local Government and the Arts, 1993/94*.

Notes
a) These figures include revenue funding for the sponsored museums including the Royal Armouries, the MGC and Acceptance in Lieu of Tax. The 1998/99 data for MGC are not directly comparable to previous years, because of changes in the presentation of the accounts. There are considerable difficulties in calculating this figure since the published accounts of actual spending in the plans and estimates issued by DNH/DCMS vary considerably, as shown below.

£million	1993/94	1994/95	1996/97	1996/97	1997/98	1998/99
Cash Plans: DNH annual report, March 1997	215	225	228	214*	211*	207*
Cash plans: DCMS annual report, April 1998	215	225	228	214	227*	208*
Cash plans: DCMS annual report, March 1999	212	223	228	214	211	204*
Cash plans: DCMS annual report, April 2000	–	217	219	212	205	203*
DCMS news release 167/98, 24 July 98	–	–	–	–	–	209*
DCMS news release 309/98, 14 December 98	–	–	–	–	212*	203.7*

* Plans and estimates
b) It is doubted that Section 48 bodies are included in these figures, which were supplied by DETR.
c) 1993/94 figure from *The Forum for Local Government and the Arts, 1993/94*; 1997/98 figure provided by the Arts Council of Northern Ireland.
d) Figures from the annual ABSA/Arts & Business survey of companies. May overlap with matching funding for the DCMS sponsored Pairing Scheme. For the sake of accuracy, separate figures for the Pairing Scheme have therefore been excluded from this table.
e) Due to the difficulty in obtaining these data, figures were only collected for 1998/99.
f) Babbidge, 2001. These figures include the MOD spend on major museums as well as the spend on regimental and corps museums based on army estimates.
g) London Transport Museum.
h) This refers to AHRB funding plus £140,000 Study Support.
i) Commonwealth Institute.

Table 28.3 Capital funding for musuems and galleries in the UK, 1993/94–1998/99

£ million

	1993/94	1994/95	1995/96	1996/97	1997/98	1998/99
Central government						
DNH/ Wolfson: Museums & Galleries Improvement Fund (a)	4.000	4.000	4.000	n/a	n/a	n/a
DCMS: Assets accepted in lieu of tax	3.115	6.160	7.407	2.171	6.785	25.299
Subtotal	*7.115*	*10.16*	*11.407*	*2.171*	*6.785*	*25.299*
Government agencies						
MGC: purchase grant funds	1.705	1.965	1.402	1.243	1.243	1.187
MGC: capital grants	0.415	0.401	0.372	n/a	n/a	n/a
National Fund for Acquisitions	0.266	0.270	0.307	0.225	0.286	0.182
Subtotal	*2.386*	*2.636*	*2.081*	*1.468*	*1.529*	*1.369*
SO: capital grant Burrell	0	–	–	–	–	–
Lottery						
Heritage Lottery Fund	n/a	65	120.984	215.045	113.035	90.984
Millennium Commisison	n/a	95.650	0	1.176	0	96.826
ACE	n/a	n/a	1.856	2.970	0.191	0.100
SAC (a)	n/a	n/a	0.536	0.014	0.085	0
ACW (a)	n/a	n/a	0.070	0	0.001	0
ACNI (a)	n/a	n/a	0	0	0.004	0.021
Subtotal	*n/a*	*160.650*	*123.446*	*219.205*	*113.316*	*187.931*
Local authorities						
England	23.467	27.536	22.767	23.465	29.051	62.324
Scotland	4.500	5.108	5.019	5.293	3.526	–
Wales	0.875	3.308	2.368	1.097	2.116	0.604
Northern Ireland	–	–	–	–	–	–
Recorded subtotal	*28.842*	*35.952*	*30.154*	*29.855*	*34.693*	*62.928*
Other (b)						
Business sponsorship for capital projects	–	8.444	1.255	2.643	4.361	17.991
Recorded subtotal	*–*	*8.444*	*1.255*	*2.643*	*4.361*	*17.991*
Recorded total	38.343	217.842	168.343	255.342	160.684	295.518

Source: Table 16.1.

Notes:
a) Details for 1998/99 from DCMS.
b) NHMF expenditure on museums and galleries could not be disaggregated.

The regional distribution of funding

As in the case of other areas of activity considered elsewhere in the present volume, funding for museums and galleries is distributed unevenly throughout both the UK (Tables 28.5 and 28.6) and England (Table 28.7), with London and the South East taking the lion's share. Substantial amounts of public funding to the museums sector also go to the North West and Yorkshire, locations of national museums' headquarters outside London.

Area museum councils (AMCs) are the main channels for government support to the regions. They provide regionally determined packages of advice, information, services and project grants. In recent years, their role has expanded to

Table 28.4 Group for Large Local Authority Museums: capital income by source, 1998/99

	percentage of capital income
HLF	57.2
ACE Lottery	11.9
SAC Lottery	0
EU	0
Sponsorship	0
Private donations	0
Local authority	28.0
Grants and trusts	0
SRB	0
Other	2.4
Total	99.5

Source: GLLAM.

include the provision of advice for funding sources such as the HLF and European Structural Funds, and they now work with the new regional cultural consortia. These increased administrative responsibilities are manifest in an overall decrease in their grant funding against an increase in their administrative spend. In short, they are becoming less and less able to meet the demands of their constituencies as the real value of their grant aid is reduced. The inevitable consequence of this is that they will provide fewer services – evidenced, for example, by the closure of their conservation services (Winsor, 1999) – and become more strategic (Babbidge, 2001).

Museums' income and expenditure

There are considerable difficulties in extracting information about their income and expenditure from many museums and galleries. Despite having to construct accounts for registration and funding applications, many museums and galleries have difficulties providing exact financial data. These institutions include those run by local authorities, universities, the National Trust, English Heritage and the armed forces. Their accounts tend not to stand alone, they don't necessarily pay overheads, and are reliant on central services (see Chapters 17 and 32). This problem is highlighted by DOMUS's attempts to extract financial data from museums.

DOMUS's questions on museums' finances have always generated a low response rate. It was only in 1999 that DOMUS published financial data for the first time, and it did so on the basis of figures being submitted by less than 60 per cent of all registered museums. Those museums were reported to have had a gross revenue income of £505 million for 1998 against an expenditure of £448 million – figures which would have referred to the 1997/98 financial year.[2]

2 The DOMUS questionnaires were sent out in June, so the survey was unable to recover audited financial information from the most recent financial year. The financial information received was, therefore, at best likely to relate to the financial year before last.

Table 28.5 Expenditure on museums and galleries by home country, 1993/94–1998/99

£ millions

	1993/94	1994/95	1995/96	1996/97	1997/98	1998/99
National						
Millennium Commission	n/a	n/a	–	1.176	–	–
England						
DCMS	221.200	231.900	237.619	223.492	221.018	212.366
HLF	n/a	0.650	106.941	197.373	98.913	89.858
Millennium Commission	n/a	n/a	95.650	–	–	–
Local authorities	141.948	154.360	154.009	157.113	166.724	186.709
Business sponsorship (a)	8.234	15.984	8.413	10.827	15.990	28.869
HEFCE/AHRB	–	–	1.956	–	–	8.749
Recorded total	*371.382*	*402.894*	*604.588*	*588.805*	*502.646*	*526.551*
Wales						
Welsh Office	14.500	12.800	12.500	12.300	12.300	12.700
Heritage Lottery Fund	n/a	n/a	0.626	2.436	0.624	2.696
Local authorities	5.681	8.299	7.955	6.858	7.989	6.080
Business sponsorship	–	0.004	0.084	0.175	0.150	0.155
Recorded total	*20.181*	*21.103*	*21.165*	*21.769*	*21.063*	*21.631*
Scotland						
Scottish Offce	25.000	28.000	27.000	29.000	32.000	25.000
Heritage Lottery Fund	n/a	n/a	13.276	14.917	12.729	0.461
Local authorities	35.979	38.063	44.975	41.756	33.322	34.061
Business sponsorship	0.643	1.084	0.610	1.713	1.970	2.732
SHEFC	–	–	–	–	–	0.700
Recorded total	*61.622*	*67.147*	*85.861*	*87.386*	*80.021*	*62.954*
Northern Ireland						
Northern Ireland Office	8.931	10.103	9.580	9.361	9.428	9.120
HLF	n/a	n/a	0.141	0.319	0.768	0.247
Local authorities	1.714	–	–	–	2.553	–
Business sponsorship	0.059	0.081	0.098	0.044	0.203	0.035
Recorded total	*10.704*	*10.184*	*9.819*	*9.724*	*12.952*	*9.402*

Sources
Department for National Heritage annual reports 1995–1997; Department for Culture, Media and Sport, Annual Reports 1998–1999;
Department of the Secretary of State for Scotland and the Forestry Commision, *The Government's Expenditure Plans*, various years;
The Government's Expenditure Plans: Department report by the Welsh Office, various years;
Expenditure Plans and Priorities, Northern Ireland: The government's expenditure plans, various years;
Heritage Lottery Fund; DETR; Welsh Office survey of local authority expenditure;
Scottish Local Government Financial Statistics, various years, Government Statistical Service; *Partnership in Practice*, The Forum for Local Government and the Arts, 1993/94; ABSA/Arts & Business *Business Support for the Arts/Business Investment in the Arts*, various years; Table 12.2.

Note: a) Excluding national and non-regional funding of £105,000 in 1993/94 and £15,500 in 1995/96.

Consumer spend

Throughout the 1990s, self-generated income has become increasingly important for museums – not least in local-authority museums as a response to budget cuts. Between 1989 and 1998, museums' income from consumers' spending increased by 86 per cent (Hanna, 1999: 29). In 1998, over 90 per cent of museums and galleries relied on this form of revenue: 70 per cent generated income from admissions and donations; 22 per cent from catering; and 91 per cent from retailing. But, it is unclear precisely how much income is generated this way.

Table 28.6 Business support for museums and galleries, by English RAB and home country, 1993/94–1998/99 (a)

£ millions

	1993/94	1994/95	1995/96	1996/97	1997/98	1998/99
England						
East	0.196	0.092	0.055	0.116	0.022	0.190
East Midlands	0.006	0.096	0.029	0.089	0.061	0.119
London	6.618	13.461	6.098	8.774	10.076	22.005
North West	0.463	0.218	0.812	0.659	0.698	0.615
Northern	0.197	0.450	0.293	0.261	0.075	0.190
South East	0.251	0.139	0.064	0.058	0.009	0.069
South West	0.096	0.042	0.039	0.156	0.114	0.077
Southern	0.016	0.255	0.352	0.137	0.148	1.378
West Midlands	0.088	0.196	0.387	0.151	3.645	2.721
Yorkshire & Humberside	0.302	1.034	0.285	0.427	1.142	1.505
Total England	*8.234*	*15.984*	*8.413*	*10.827*	*15.990*	*28.869*
Scotland	0.643	1.084	0.610	1.713	1.970	2.732
Wales	0	0.004	0.084	0.175	0.150	0.155
Northern Ireland	0.059	0.081	0.098	0.044	0.203	0.035
National funding/other	0.105	0.016	0	0	0	0
Total United Kingdom	9.040	17.170	9.204	12.759	18.313	31.790

Source: ABSA/Arts & Business *Business Support for the Arts/Business Investment in the Arts*, various years.

Note: a) This may include figures for the Pairing Scheme. A similar regional breakdown for the Pairing Scheme is not available.

Sightseeing in the UK does not collect data on the amount of revenue received from visitors, although DOMUS identified museums and galleries as generating £37 million, 7 per cent of their income (Carter et al., 1999). This is probably a gross underestimate. The AIM comparative-trading survey for 1998 found that the 22 museums in its constant sample alone attracted £22.8 million from admissions and £14.4 million from retail.

An ad hoc survey of the museums and galleries sponsored by DCMS suggested that changes in the amounts of self-generated income (covering admissions, catering, retailing including reproductions and conferences) attracted by individual institutions between 1993/94 and 1998/99 varied enormously. One was found to have achieved a 283 per cent increase since 1994/95, whereas another saw its self-generated income fall by 28 per cent compared with 1993/94.

Admissions

Accounts of the national-average adult admission charge in 1998 range from £2.18 to £2.80 (Hanna, 1999; Museums Association, 1999). A sizeable proportion of museums charged considerably less than the average. (According to *Sightseeing in the UK*, nearly half of all museums charged £1.50 or less, whereas the Museums Association database suggests that this was true of 30 per cent.) The cost of admission may be determined by type of museum, with independents charging some of the highest prices and universities the lowest. But, there are enormous variations in the amounts charged even by the same type of museum (Bailey et al., 1998).

Table 28.7 Selected sources of funding for museums and galleries in the English regions, 1998/99

A. Ministry of Defence, Area Museum Council, Arts and Humanities Research Board and Area Museum Council funding, by area museum council region

£ thousand

	MOD	DCMS	AHRB	AMC
East Midlands	40	–	0	260
North East	35	975	218	332
North West	66	15,874	1,816	758
South East	10,420	178,473	6,512	1,324
South West	868	1,381	59	467
West Midlands	310	0	121	403
Yorkshire & Humberside	40	7,700	23	804
Total England	11,779	204,403 (a)	8,749	4,348

Sources: Babbidge, 2001; Table 12.2; area museum council annual reports.

Note: a) See Table 28.2, note a.

B. Local authority and Heritage Lottery Fund, by Government Office Region

£ thousand

	Local authority	HLF £
East	17,539	10.091
East Midlands	16,934	1.634
London	12,867	26.316
North East	11,303	1.568
North West	26,848	26.614
South East	32,247	5.643
South West	13,465	15.727
West Midlands	34,727	8.144
Yorkshire	20,779	3.494
Total England	186,709	99.231

Sources: DETR, HLF.

Around 50 per cent of museums charge for admission to their core collections.[3] DOMUS puts this at 49 per cent for 1998, and both the Museums Association and *Sightseeing in the UK* specify 51 per cent.[4] It is unclear whether this changed between 1993 and 1998: *Sightseeing in the UK* data show the percentage of museums charging as fluctuating by 2 per cent; DOMUS suggests it rose by 6 per cent, and the DOMUS constant sample showed a 1 per cent decline between 1997 and 1998.

Employment

Estimates of the number of jobs in the museums sector vary considerably. The most consistent measure of employment in the sector is produced by the Labour

3 See Chapters 6 and 15 for a discussion of VAT as related to museum changes.
4 This does not include those that charge for special exhibitions, unless, as in the case of the Royal Academy, these are the only forms of display.

Table 28.8 Employment in museums and galleries in the UK, 1993-98

	Sightseeing in the UK	DOMUS	DOMUS constant sample
1993			
No of paid jobs	20,700	n/a	n/a
FTEs	15,500	13,045	n/a
volunteers	16,000	7,877	n/a
1994			
No of paid jobs	19,671	n/a	n/a
FTEs	14,900	11,047	n/a
volunteers	17,200	11,649	n/a
1995			
No of paid jobs	20,067	n/a	n/a
FTEs	15,100	11,854	n/a
volunteers	16,339	15,608	n/a
1996			
No of paid jobs	19,210	n/a	n/a
FTEs	14,550	–	n/a
volunteers	17,560	–	n/a
1997			
No of paid jobs	19,740	n/a	n/a
FTEs	14,940	13,603	5,576
volunteers	17,400	20,120	4,624
1998			
No of paid jobs	21,061	n/a	n/a
FTEs	16,030	15,365	5,461
volunteers	18,900	25,206	5,545
% change 1993-98			
FTEs	3	18	n/a
volunteers	18	220	n/a

Sources: Hanna, 1999; Selwood and Muir, 1997; Coles et al., 1998; Carter et al., 1999.

Force Survey, which reported 37,075 people being employed in museums in 1999 (see Chapter 23 above).

It is estimated that nearly 20 per cent of museums do not employ paid staff (Hanna, unpublished data for 1999). Nevertheless, returns to DOMUS and *Sightseeing in the UK* suggest that in 1998 there were between 15,365 and 16,300 paid full-time equivalents (FTEs) in the sector, and somewhere between 18,900 and 25,206 volunteers.[5] These FTE estimates may be too low. GLLAM data for 1998/99 found that the 22 museum services contributing to its survey employed 1,884 FTEs.

While both DOMUS and *Sightseeing in the UK* suggest that the numbers of paid FTEs and volunteers has increased since 1993/94, the way they quantify that change is quite different (Table 28.8). The DOMUS constant sample, however, discerned a small fall in the number of paid FTEs (down 2 per cent) between 1997 and 1998, against a 20 per cent rise in the number of volunteers.

In addition to official data sets (see Chapter 23 above), a variety of sources provide information on the characteristics of the museums workforce, in particu-

5 The *Sightseeing in the UK* employment data cover all staff except those solely concerned with conservation.

lar reports by MTI (Museums Training Institute, subsequently Cultural Heritage NTO) whose data embrace a range of associated heritage activities[6] (HOST Consultancy, 1999; MTI, 1997; PIEDA plc, 1996).

- Security and support staff (front of house and security, technical and maintenance) outnumber professional staff (those concerned with care and interpretation of collections, marketing, PR and fundraising) by about 2:1 (HOST Consultancy, 1999).
- In general, the workforce is heavily reliant on part-time workers (44 per cent of total employment). Indeed, growth in the sector between 1994 and 1998 (5,000 new employees) is largely accounted for by part-time workers, who accounted for 71 per cent of the estimated expansion.
- Evidence also suggests that pay for museums jobs has lagged behind increases in earnings in other public-sector occupations. There are no trainee posts for non-graduates and so the financial prospects for new entrants are limited (Babbidge, 2001)
- While the workforce is relatively highly qualified (with just under a third having first or higher degrees), it is ageing (with 60 per cent of workers being over 40 years). It is also characterised by a large proportion of women (57 per cent) and relatively few people from ethnic minorities (4 per cent) (HOST Consultancy, 1999). It is difficult to obtain any reliable trend data, but a general impression is that there is insufficient new blood coming into museums as a result of too few incentives, posts being cut, and established staff being reluctant to move on (Babbidge, 2001).
- Museums with a national remit employ the largest number of permanent staff – 43 per cent of the total (Carter et al., 1999).
- In many respects the nature of the workforce has changed because of tighter core funding and the demands being made of the sector. Recent ad hoc surveys have, for example, identified increases in freelance staff (Hasted, 1996), and decreases in conservation staff (Winsor, 1999).

Audiences for museums and galleries

There are between 80 million and 114 million visits to museums in the UK. DOMUS and *Sightseeing in the UK* respectively cite between 79.6 and 77.7 million visits for 1998. The 2,300 museums on the Museums Association's database suggest 113.7 million visits; GLLAM identified 11.6 million visits to the 22 museums represented by the group; and AIM, 6.1 million.

6 This covers built heritage (ancient monuments; archaeological sites; designed landcapes and parks; botanical and historic gardens; historic buildings; preserved railways; historic ships; industrial heritage organisations); zoos, wildlife parks and aquaria; places of worship; museums and arts galleries; venues for touring exhibitions; historic libraries and archives; conservation organisations; heritage theme parks; science centres; consultants/ freelancers and support organisations.

Table 28.9 Numbers of visitors to the museums and galleries sponsored by DCMS, 1993/94–1998/99

million

	1993/94	1994/95	1995/96	1996/97	1997/98	1998/99
British Museum (a)	6.0	6.2	6.1	6.5	6.1	5.5
Geffrye Museum	0.04	0.05	0.05	0.06	0.06	0.09
Horniman Museum & Gardens	0.2	0.2	0.2	0.2	0.2	0.2
Imperial War Museum (b)	1.2	1.3	1.3	1.3	1.4	1.4
Museum of London	0.3	0.3	0.3	0.3	0.3	0.3
Museum of Science & Industry in Manchester	0.3	0.3	0.3	0.3	0.2	0.3
National Gallery (c)	3.9	4.2	4.5	5.0	5.8	4.8
Natural History Museum	1.7	1.6	1.5	1.8	1.8	1.9
National Maritime Museum	0.6	0.6	0.4	0.5	0.5	0.8
National Museums & Galleries on Merseyside (d)	1.4	1.4	1.2	1.2/0.8	0.6	0.7
National Portrait Gallery	0.8	0.9	0.8	0.9	1.0	1.0
National Museum of Science & Industry (e)	2.7	2.5	2.7	2.5	2.4	2.2
Sir John Soane's Museum	0.5	0.1	0.1	0.1	0.1	0.1
Tate Gallery (f)	2.7	2.8	3.0	2.5	2.2	3.0
Wallace Collection	0.2	0.2	0.2	0.2	0.2	0.2
Victoria and Albert Museum (g)	1.6	1.6	1.5	1.6	1.5	1.5
Total	24.2	24.2	24.1	25.0/24.6	24.3	24.0

Sources: DCMS annual reports; National Gallery.

Notes

a) Visitor figures for 1998/99 reflect the closure of the Museum of Mankind, the departure of the British Library and restricted access during major building works.

b) The figures for the Imperial War Museum include: Duxford Airfield, the Cabinet War Rooms, and HMS Belfast.

c) Figures shown from 1992/93 are figures supplied by Gallery for calendar year 1992 onwards.

d) 1996/97 numbers reported as 1.21 but adjusted to 0.75 for new counting base; 1997/98 figures onwards based on till sales count.

e) The figures for the Science Museum include: the National Railway Museum, the National Museum of Photography, Film and Television, and The Wroughton outstation. National Museum of Photography, Film and Television closed all year, 1998/99.

f) The figures for the Tate include: Tate Gallery Liverpool and Tate Gallery St Ives. Tate Gallery Liverpool closed for redevelopment, 1997/98.

g) The figures for the V&A include: the Theatre Museum, the National Museum of Childhood and the Wellington Museum. Visitor figures for the Royal Armouries not available.

Accuracy of information

There are, however, doubts as to the accuracy of all these data. Visits are counted in a number of ways, with some methods being more accurate than others. Museums which charge admission to their core collections and record admission numbers through their box offices are assumed to produce relatively accurate figures. The figures for museums with free entry, where visits are counted manually, are far less likely to be accurate. Table 28.9 shows that before the introduction of charges, the number of visits to the National Museums and Galleries on Merseyside were overestimated by 400,000 – as much as a third. Indeed, the accuracy of counting after charges are introduced has been cited as accounting for the fall in numbers. A fire count at the British Museum in 1993 also found the museum's figures to be out – also by a third – although no adjustments were subsequently made to its data (Creigh Tyte and Selwood, 1998). However, the assumption that manual counting always produces higher attendance figures is not necessarily true. Comparisons made at Bristol Museums and

Art Gallery found that electronic counting devices provided higher figures than manual counts (correspondence with Stephen Price). It has been suggested that the only accurate method of counting manually is by video (Thomas et al., undated). As one civil servant put it: 'Unless the museums world can crack this issue of validating its basic usage data, I don't see how we can ever say anything sensible about how popular or otherwise museums are.'

No effective checks are made of the accuracy of data submitted by museums to the national surveys. *Sightseeing in the UK* rings museums and galleries known to have over 50,000 visitors which have not completed their questionnaire. If DOMUS receives no data in any one year, it reverts to the previous year's values.

Trends

The number of visits to museums and galleries is set to rise as a result of the number of museums opening, and the number of Lottery-funded capital developments coming on-stream. This expectation might have prompted certain requirements for the accuracy of data and the establishment of baseline figures but, in the event, little has changed. In fact, far from rising, the number of visits is variously described as reaching a plateau, or as 'static and falling' (Middleton, 1998; Davies, 2000).

- Both DOMUS and *Sightseeing in the UK* indicate a fall in visitor numbers for the period, 1993/94 to 1998/99, although this may be indicative of smaller numbers of returns. Nevertheless, the DOMUS constant sample (1997 and 1998) also shows a fall of 4 per cent.
- The number of visits to the museums and galleries funded by DCMS shows a slight fall (see Table 28.9).
- Data collected on the basis of interviews with the public also show a falling-off from 12.7 million visits in 1992/93 to 11.9 million in 1996/97 (BMRB/TGI data cited in Middleton, 1998: 18).

Only the indices used by *Sightseeing in the UK* show an increase in visits (Table 28.10).

Over the past few years, increasing emphasis has been placed by funding and other bodies on the importance of museum visitors (see Chapter 6). While the data cited above are indicative of the number of visits, they reveal nothing about the number or nature of visitors across the UK.

Frequency of attendance

Twenty-two per cent of visitors to museums and galleries are reported to be from overseas, and another 32 per cent are children (Hanna, 1999), which means that the remaining 46 per cent of visitors are British adults.

Estimates based on population surveys suggest that between 22 and 35 per cent of the adult population visits museums (Leisure Tracking Survey,

Table 28.10 Visits to UK museums, 1993/94 and 1998/99

		1993/94 (million)	base	1998/99 (million)	base	% change in visit numbers
DOMUS	UK	69.5	1569	65.5 (a)	1252	−5.8
Sightseeing in the UK	UK	78.6	1789	77.7	1747	−1.1
DCMS-sponsored museums and galleries	England	24.2	16	24	16	−0.8
Indices:						
Sightseeing in the UK constant sample (b)	UK	115		119		
Sightseeing in the UK including new museums and closures (b)	UK	125		130		

Sources: Selwood and Muir, 1997; Coles et al, 1998; Hanna, 1999; DCMS annual reports; National Gallery.

Notes:
a) Combined with previous DOMUS survey results for non-responding museums, plus nationals not included in DOMUS, brings this figure up to 79.7m.
b) 1976 = 100.

1997–1998, cited in ONS, 1999; and MORI, 1999, respectively). The latter source suggests that visiting museums and galleries is surpassed in popularity only by going to the cinema (59 per cent) and going to a well-known park or garden (36 per cent), and that it is more popular than attending live sporting events (26 per cent). Moreover, those who visit museums and galleries are likely to do so frequently. MORI (1999) found that people visited museums an average of three times in the year of their survey (see also Davies, 1994); and that 8 per cent of the population visited five times or more.

Rather less is known about non-visiting. Non-visiting is often associated with museums and galleries' perceived élitism. However, MORI (1999) found that as few as one in a hundred respondents were intimidated by museums. Non-visitors' main reason for not attending was that there was 'nothing they wanted to see'. Minority ethnic origins are sometimes also regarded as inhibiting people from visiting. Research found that the proportion of members of ethnic minorities visiting was similar to that amongst the general public (MORI, 1999), and that the profile of such visitors mirrored that of the general population (Desai and Thomas, 1998).

Profile of attenders

An issue considered in Part I of this book is the desire by government and various other agencies for museums and other forms of cultural provision to be 'for the many and not just the few'. Indeed, since the mid-1990s various initiatives have been directed towards achieving broader access and encouraging lifelong learning. However, there are no comparative data which would enable any changes in the visitor profile to be measured.

Although the percentage of visitors from particular social classes may vary on a regional basis, in general the frequency of visiting is associated with educa-

Table 28.11 Socio-economic group of visitors to selected museums and galleries sponsored by DCMS, 1997

Percentage

	AB	C1	C2DE	Total
V&A	89	(a)	11	100
British Museum	41	50	9	100
National Museum of Science and Industry	52	34	14	100
Imperial War Museum	47	33	17	97
National Gallery (b)	49	31	9	89
National Maritime Museum	34	45	21	100
Natural History Museum	41	38	21	100
Tate Gallery	91	0	8	99
Average (mean)	55.5	33	13.75	

Source: *Hansard*, Written Answers 14 January 1998.

Notes

Totals may not sum to 100 per cent because of rounding.

a) Figures for AB include C1.

b) 10 per cent not specified.

tional levels and social class (see, for example, Henley Centre's Leisure Tracking Survey, cited in ONS, 1999). The most frequent visitors identified by MORI (1999) were likely to be over 45, to have been through higher education, work full-time, live in or around Greater London and have no children.

Social group and educational level also influence the type of museums most visited. People with no formal qualifications have been found to be more likely to go to natural history museums, whereas those with high educational qualifications were more likely to go to the national and archaeological museums. Both groups included frequent attenders of social/local-history museums (MORI, 1999).

An ad hoc survey of the museums and galleries sponsored by DCMS produced data from four more institutions than are shown in Table 28.11. Those that had carried out any visitor research provided a useful comparison with those museums shown in the table in that none were based in central London. On average, a lower percentage of their visitors were from social groups ABC1 (70 per cent, as opposed to 84 per cent for the London-based institutions in the table); and more were from social groups C2DE (29 per cent as opposed to 14 per cent) (see also Creigh-Tyte and Selwood, 1998). This suggests that the profile of museum visitors is rather more complex than is generally supposed. As a museums consultant interviewed for this chapter confirms:

The perception, among journalists and other commentators, is that museums and galleries can be lumped with opera, ballet, etc. as a high-brow activity pursued by a relatively small élite social group. Research allegedly supports this view. In fact, the picture is much more complicated that this suggests. Perhaps the better educated visit more often, but they certainly don't have a monopoly on visiting. Nevertheless there is room for improvement. We need more relevant and contemporary exhibitions with are pitched at attracting a more educationally and culturally diverse audience.

Summary

In the period 1993/94 to 1998/99 the museums sector was subject to increased pressure from government to demonstrate levels of efficiency and quality standards. As a result of this, local-authority museum services are, for the first time, becoming nationally accountable. This may well encourage the production of more and better statistics, but for the time being hard data on museums remain very partial. Their analysis is complicated by the fact that the primary data are collected according to four different systems of regional accounting (area museum council regions; regional tourist boards; regional arts boards and government office regions: see Appendix 3).

Levels of funding from central government barely diminished, but are set to rise. Local authority funding has risen, although much of this is accounted for by capital funding which carried no guarantees for the future. While Lottery funding has changed the financial landscape of the sector, it has created more demands for revenue funding at a time when this is unlikely to be forthcoming in the form of core funding or admissions income. Although the political will exists for museums to attract more visitors, attendances have plateaued, if not declined. The expansion of employment in the sector is largely due to the recruitment of part-time workers and volunteers.

29
Profile of the Performing Arts

Kate Manton, Freelance researcher

This chapter provides a statistical overview of the performing arts in the UK, covering finance (public and private), employment, performances and audiences. The definition of the performing arts used here is broad and covers drama, dance, opera and music, as well as combined arts – which for the arts funding system covers multi-purpose buildings, such as arts centres, and multi-disciplinary events, such as festivals.

With the exception of music, recently the subject of a major economic study (Dane et al., 1999), statistics on the performing arts as a whole are partial, sometimes out-of-date and quite often appear self-contradictory. While it is undoubtedly true that there is now more statistical information in this area available than was the case ten years ago, this has not necessarily made the task of mapping the field any easier. Central government expenditure, with programmes spread over different ministries and under different definitions, remains difficult to define accurately. Data on local government expenditure are patchy, to say the least, and in the case of Northern Ireland, accessible information is apparently non-existent. Each arts council collects and publishes statistics in different ways, if they are published at all. Every regional arts board presents its accounts in a different way. Attempts to rectify the situation may lead to different approaches to data being tried out every few years, thus making it impossible to produce consistent year-on-year comparisons.

If these problems inhibit any attempt to construct a statistical overview of the arts in general, they are multiplied when one tries to distinguish any artform or group of art forms from the whole. It is probable that public expenditure on the performing arts has, in this chapter, been underestimated simply because it is impossible to identify precisely from annual reports what is, and is not, performing arts expenditure. Merely arriving at an accurate assessment of local government expenditure on the arts seems impossible, let alone breaking this down by individual artform. Therefore, throughout this chapter, data are presented with caution, and 'health warnings' are applied where appropriate.

The chapter begins with such details as are available on the sector as a whole, covering buildings and companies, performances and audiences, turnover and employment. The subsidised sector is then examined. Finally, the conclusion

brings together and compares, where possible, the performing arts sector as a whole with the subsidised sector in general.

The performing arts sector as a whole

Number of venues and companies

The *British and International Music Yearbook 1999* (Rhinegold, 1999) lists 228 symphony and chamber orchestras. Numbers of groups performing other types of music are unknown. According to Quine (2000) there are 486 producing companies of which 127 are drama companies; 137, community theatre; 77, dance; 59, puppets; 27, opera; and 58, mixed media/entertainment.

Live performances take place in a huge variety of venues. The *British Performing Arts Yearbook* (Rhinegold, 1999) lists 1,184 performance venues in the United Kingdom: 217 arts centres; 141 producing theatres; 142 concert halls; 101 national touring houses; and 583 others, including leisure centres, civic halls, studio and educational venues.

Inclusion in these listings does not, of course, inform the reader about how active these venues are or what types of performance they promote.

Performances and audiences

Overall attendance figures for performing arts may be collected in two ways – most accurately by actual audience counts by venues and also by use of market research, as conducted on an annual basis through TGI (Target Group Index). This survey asks a sample of about 25,000 adults, selected by standard market research criteria to represent the British population, whether they 'currently' attend arts events of various types. Results for 1998/99, the most recent figures available for publication, are shown in Table 29.1. Unlike actual counts of tickets sold, these figures reflect the numbers of people who say they attend events of various types. Most will attend more than once in a year.

While the market-research approach has obvious drawbacks in terms of accuracy, it is at least all-inclusive, covering subsidised, commercial and amateur sectors. Information on numbers of concerts (of any type) and audiences for live music is almost entirely lacking. Dane et al. (1999) produced no figures for classical music attendance.

Table 29.1 Adult population of Britain who 'currently' attend arts events, 1998/99

	Percentage of GB adults	Equivalent to (millions)
Plays	22.2	8.9
Opera	6.3	2.5
Ballet	6.2	2.5
Contemporary dance	4.3	1.7
Classical music	11.6	4.6
Jazz	6.0	2.4

Source: TGI quoted in ACE, 1999.

Table 29.2 Performing arts: performances and tickets sold, 1998

	Performances	Tickets sold
West End	16,000	11,925,000
TMA	24,000	9,326,000
ITC	25,000	5,068,000
Apollo Leisure	–	3,000,000
Recorded totals	65,000	29,319,000

Source: Quine, 2000.

The state of knowledge in the field of theatre is better. Annual figures collected by members of SOLT (Society of London Theatres) and TMA (Theatrical Management Association) cover the West End theatre (including publicly subsidised venues such as the Royal Opera House and National Theatre) and most of the larger theatre venues outside London, respectively. All forms of performance are covered by these figures – drama, musicals, opera and dance. They are shown in Table 29.2. To these figures may be added those supplied by ITC (Independent Theatre Council, which has in membership small independent touring companies) and the Apollo Leisure Group, which owns some larger theatres which are not amongst the TMA membership.

The annual TGI surveys offer some clues as to who the audience for the performing arts is, in terms of social grade and age group. Table 29.3 confirms other market research findings, that theatre-goers tend to be older and more affluent than the population in general. Again, this table shows the most recent data which can be cited.

Table 29.3 Attendance at theatres, by age and social group, 1996/97

Percentage

	GB adult population	Adult population attending any performance in a theatre
Age		
15–24	13.5	15.3
25–34	19.5	19.6
35–44	19.1	17.1
45–54	19.0	16.1
55–64	13.4	12.2
65+	15.6	19.7
All	100.0	100.0
Social grade		
AB	21.3	33.9
C1	27.6	32.5
C2	22.5	17.8
DE	28.5	15.9
All	100.0	100.0

Source: TGI, quoted in ACE, 2000.

Turnover and consumer expenditure

Little is known for sure about the economic value of the performing arts sector as a whole. Difficulties arise in defining the extent of the 'industry', and obtaining the necessary information from the many companies involved. Dane et al. (1999) attempted to assess the value of the music industry as a whole and estimated that total consumer spending on live performance (including opera and musical theatre) in 1997/98 was £604.3 million. Value added (defined as the sum of employment costs, self-employment income and company profits) was calculated at £571.3 million. Overseas earnings were put at £139.4 million and overseas payments at £69.8 million, giving a surplus of earnings over payments for the year of £69.6 million.

No other part of the performing arts sector has been subjected to this type of analysis in recent years. A report on the economic impact of London's West End theatre (Travers, 1998) cited West End companies' expenditure in 1997 as £282 million. Consumer spending (ticket sales only) was quoted as £246 million, while West End theatres were responsible for exports of £266–286 million in 1997. Imports were estimated at about £50 million, giving a surplus of exports over imports of over £200 million. Theatres in membership of TMA were responsible for ticket sales of £109.5 million and companies in ITC sold tickets worth about £13 million, both in 1998.

Another method of determining consumer expenditure on tickets for live performance is to turn to the government's regular Family Expenditure Survey which asks a sample of the adult population about their spending in the two weeks before interview. The weakness of this survey is that it is relatively unreliable at covering infrequent purchases such as tickets for live events. In 1997/98 (the latest year in which information was sought in this form) the Office for National Statistics (1999) reckoned that the 'average family' spent £0.60 per week on purchase of tickets for theatres, concerts, etc. If this is grossed up on the basis of known households, it can be estimated that total household spending was £733 million in 1997/98 (Feist, 1998). If this is put alongside known and estimated ticket sales from a variety of sources, given in Table 29.4, then an estimate of

Table 29.4 Consumer expenditure on tickets for performing arts, 1997 and 1998

£ million

Source or sector	Expenditure
SOLT (1998)	258
TMA (1998)	109
ITC (1998 estimate)	13
Concert Promoters Association (a)	227
Other popular concerts (a)	76
Classical musical performance (a)	60
Amateur opera (a)	25
Amateur drama (a)	22
Total	790

Source: Dane et el., 1999.

Note: a) Quoted in Dane et al., 1999. All figures refer to 1997; all estimated.

consumer expenditure on tickets for the performing arts of between £700 and £800 million looks reasonable.

Employment

The ten-yearly census is recognised as the most authoritative source of employment statistics in the UK. Data from the 1991 census were analysed and published by O'Brien and Feist (1995). In 1991, there were 53,400 'actors, entertainers, stage managers, producers and directors' and 21,700 musicians. These simple figures disguise the complexity of the industries. As Myerscough (1988) noted, 'The difficulties of measuring irregular and part-time work and self employment, which characterises many sectors of the arts, are virtually insurmountable.' To these difficulties may be added the problem of assessing numbers of jobs contributing to or dependent upon the creative work of actors, musicians, etc. Table 29.5, derived from Dane et al. (1999), illustrates the variety of trades and occupations that may be said to be dependent upon the making of music.

The number of performers is almost double that recorded by the census. This is probably because of the nature of the census, which asks about the individual's employment status in the week before census night. Thus, those who work casually or intermittently as performers, being otherwise unemployed or having another job, may well not be included. Dane et al. (1999) estimated that 35,000 full-time-equivalent musicians were employed in pop, rock, etc.

Equivalent figures for theatre are not available, although Dane et al. (1999) quote full-time-equivalent employment in opera companies at 653, with 430 full-time equivalent actors and 425 full-time-equivalent pit musicians employed in music theatre. The most recent study to estimate actors' and dancers' employment goes back some years. Jackson et al. (1994) estimated that in 1993 the numbers employed in dance as performers at any one time was about 1,000 to 1,500, with a total workforce – including teachers of dance – of about 20,000 to 25,000. It estimated the numbers involved in all forms of drama at any one time, excluding teachers and others not directly employed in a performance-related occupation, at about 25,000.

Table 29.5 Employment in music industries, 1997/98

	Number employed
Live performance of which:	54,351
Performers	40,453
Ancillary employment	13,898
Education and training	31,353
Retailing and distribution of recordings	18,668
Recording companies	11,538
Musical instruments: production, retailing and distribution	9,600
Managers, agents, promoters	1,126
Composition of musical works and music publishing	3,688
Total	130,324

Source: Dane et al., 1999.

Employment is also provided within venues devoted exclusively or largely to the performing arts. Many of these venues are owned and run by local authorities, and Chartered Institute of Public Finance and Accountancy (CIPFA) conducts annual surveys of local authorities which request staff numbers. In 1998/99, the number of full-time-equivalent employees in English and Welsh venues was quoted as 2,162 employed in theatres, 568 employed in concert halls and 655 employed in arts centres.

No figures are available for other types of venue, nor for employment in trades and occupations which depend upon the performing arts for their existence. This is an area which is in need of attention from the arts world – there is little point in advocating the performing arts as job creators when no reliable figures can be produced to back up this statement.

The subsidised sector

Organisations supported

Broadly, the performing-arts clients of the four arts councils and the regional arts boards in England may be divided into those supported on an annual basis for a programme of work (in other words, regularly funded clients) and those receiving project grants of various types. The numbers of project grants and their recipients will vary from year to year, while the list of regular clients is more stable, although changes in status will occur from time to time. Difficulties of definition within the arts councils' annual reports make comparisons over time unreliable, and the devolution of the Arts Council of England (ACE) revenue clients to the regional arts boards has compounded this difficulty. A simple comparison of ACE's performing-arts revenue-client list (defined here as combined arts, dance, drama, music and touring) in 1993/94 and 1998/99 reveals a reduction in numbers from 150 to 109. In Scotland, a comparison of the same years shows an increase from 39 to 53.

In terms of total grants given and total numbers of organisations supported, a simple count of grants in 1998/99 annual reports revealed that more than 3,400 grants would have been distributed by the arts funding system. This included 867 grants by the ACE; 1,925 grants by regional arts boards; 388 grants by the Scottish Arts Council, and 218 by the Arts Council of Wales. This count excludes grants to individuals, and grants which could not easily be identified as referring to the performing arts. It is not uncommon for an organisation to receive grants under more than one heading, or to receive a grant for one purpose from ACE and another purpose from a regional arts board. To compensate for the element of double-counting, if the total number of grants is reduced by 15 per cent, this would give a total of about 3,000 performing arts organisations supported by arts councils and regional arts boards in 1998/99.

Performances and audiences

The four arts councils collect data on regularly funded organisations, but each

Table 29.6 British performance-indicator data, 1998/99 (a)

Thousand

	Performances	Attendance
England	65	13,635
Scotland (b)	22	2,535
Wales (c)	21	1,643
Total	108	17,813

Sources: Hacon et al., 2000; SAC annual report and accounts, 1998/99; ACW unpublished data.

Notes
a) Categories are: combined arts, music, drama and dance.
b) Includes Edinburgh Festival Fringe.
c) Includes workshops.

body adopts its own approach to the collection and publication of data. The ACE (formerly the Arts Council of Great Britain) and the Scottish Arts Council have both collected information on performances and audiences for their major performing-arts clients over many years, thus providing a valuable source of trend data. In 1996/97, ACE began publication of performance-indicator data, covering basic information on the activities, attendances and financial matters of regularly funded ACE and regional arts board clients. The difficulty of using performance-indicator data as an indicator of trends is that the 'basket' of companies used in each year varies slightly due to a company's change of status or unwillingness to provide the required information. The figures in Tables 29.6 and 29.7, acknowledging this difficulty, use only the latest performance-indicator data available, while attempting to discover longer-term trends by using more detailed data avail-

Table 29.7 Orchestras: concerts and attendance, 1994/95–1998/99

Thousand

	1994/95		1995/96		1996/97		1997/98		1998/99	
	Concerts	Attd ('000)	Concerts	Attd ('000)	Concerts	Attd ('000)	Concerts	Attd ('000)	Concerts	Attd ('000)
London orchestras (a) (own promotions)	189	335	185	318	174	290	175	298	185	332
English regional orchestras (b) (own promotions)	339	405	400	467	411	478	415	503	–	–
Scottish orchestras (c) (own promotions)	162	174	158	149	130	134	162	176	162	146
National Orchestra of Wales	65	48	63	88	71	74	–	–	–	–
Ulster Orchestra	84	66	165	110	197	120	171	110	–	–
Recorded total	839	1028	971	1132	983	1096	–	–	–	–

Sources: ACE, 2000; unpublished data.

Notes
The missing data have not been made available to the Finance and Business Service Department, ACE.
a) London Philharmonic, London Symphony, Philharmonia, Royal Philharmonic.
b) Bournemouth orchestras, City of Birmingham Symphony, Halle, Royal Liverpool Philharmonic.
c) Royal Scottish National Orchestra and Scottish Chamber Orchestra.

Table 29.8 Drama, opera and dance performances and attendances, 1993/94–1998/99

	1993/94	1994/95	1995/96	1996/97	1997/98	1998/99
National drama companies (a)						
Performances	564	523	517	543	548	488
Attendance (thousand)	693	697	715	734	725	683
Average attendance per performance	1,229	1,333	1,383	1,352	1,323	1,402
Royal Opera						
Performances	155	151	138	143	–	–
Attendance (thousand)	284	291	256	277	–	–
Average attendance per performance	1,832	1,927	1,855	1,937	–	–
Other opera companies (b)						
Performances	563	523	517	538	539	488
Attendance (thousand)	693	697	705	724	725	684
Average attendance per performance	1,231	1,333	1,364	1,346	1,345	1,402
Royal Ballet						
Performances	107	106	109	111	–	–
Attendance (thousand)	200	193	196	207	–	–
Average attendance per performance	1,869	1,821	1,798	1,865	–	–
Other dance companies (c)						
Performances	804	774	702	662	594	682
Attendance (thousand)	603	809	678	663	610	678
Average attendance per performance	750	1,045	966	1,002	1,027	994

Source: ACE and SAC unpublished data.

Notes
The missing data have not been made available to the Finance and Business Service Department, ACE.
a) Companies are: Royal National Theatre and Royal Shakespeare Company.
b) Companies are English National Opera, Opera North, Glyndebourne Touring Opera, Scottish Opera and Welsh National Opera.
c) Companies are English National Ballet, Birmingham Royal Ballet, Northern Ballet, Rambert, Richard Alston, Scottish Ballet.

able from individual companies. (However, the first time-series analysis of a constant sample of the ACE and regional arts boards' performance data has been used for this volume – see Chapter 33.)

Table 29.6 shows performance indicator data for England, Scotland and Wales for 1998/99. In total, the regularly funded companies included gave 108,000 performances (including workshops in Wales only) for an audience of nearly 18 million. No performance-indicator data exist for companies in Northern Ireland. Nonetheless, the four major theatres there gave 1,286 performances in 1997/98, with attendances of 483,000.

Information available on music is frustratingly incomplete, even for the major orchestras, due to the fact that most orchestras record information on audiences for only their own promotions, ignoring their hired engagements. Table 29.7 gives the only data available, from 1994/95 to 1998/99. This shows some decline in the number of concerts by London orchestras, with a slight corresponding decline in audience numbers, up to 1997/98, with an increase in 1998/99 to earlier levels. Concert numbers and audience numbers for English regional orchestras both

Table 29.9 Income of regularly funded performing arts organisations in Britain, 1998/99

	England	Scotland	Wales	Total
Earned income (£ m)	178	13.2	14	205.2
Column %	46	32	34	43
Arts Councils/RABs (£ m)	150.8	19.4	9.5	179.7
Column %	39	47	23	38
Local authorities/other grants (£ m)	34.1	5.1	13.9	53.1
Column %	9	12	34	11
Sponsorship & contributions (£ m)	27.4	3.8	3.3	34.5
Column %	7	9	8	7
Total	390.3	41.5	40.7	472.5

Sources: ACE, SAC, ACW.

increased to 1997/98. Concert numbers and audiences for the Scottish orchestras remained approximately the same through this period, while the numbers of concerts by the Ulster Orchestra doubled from 1994/95 to 1997/98, with a consequent increase in audience.

Table 29.8 summarises data for major opera, dance and drama companies from 1993/94 to 1998/99. For the national drama companies, this shows an overall decline in numbers of performances over the period. Due to the unavailability of data for the Royal Opera and Royal Ballet in 1997/98, these companies are shown separately. Numbers of performances for the Royal Opera fell in 1996/97. For other opera companies, attendance and average attendance per performance increased in 1994/95 and maintained this increased level for the next three years. There was a sharp decline in the number of performances in 1998/99. For dance companies other than the Royal Ballet, the number of performances declined over the period, but increased again in 1998/99, while the average attendance per performance was variable.

Income of subsidised performing arts companies

Table 29.9 is based on performance-indicator data supplied by the arts councils of England, Scotland and Wales, and summarises the income of performing arts organisations. Such summaries conceal wide disparities between different artforms; there are also wide variations between individual companies. In general, however, the English companies were most successful at raising earned income. Scottish and Welsh companies raised more funding from local authorities. Sponsorship and contributions were evenly distributed. Overall, the performing arts companies managed to raise half of their total income from earnings and private contributions.

Central government, the four national arts councils and the Lottery

Public expenditure on the performing arts may be directed through the national

Table 29.10 Funding for the performing arts in the UK, 1993/94–1998/99

£ million

	1993/94	1994/95	1995/96	1996/97	1997/98	1998/99
Central government via the arts councils (a)						
ACGB/ACE	125.176	110.115	114.384	114.799	114.966	116.800
Regional Arts Boards (b)	27.077	40.693	42.356	42.646	43.178	42.879
Scottish Arts Council	17.100	18.400	18.800	20.200	21.400	21.200
WAC/ACW	8.300	8.600	9.300	10.700	9.400	10.300
Arts Council of Northern Ireland	4.300	4.300	4.600	4.700	4.900	5.299
Subtotal	*181.953*	*182.108*	*189.440*	*193.045*	*193.844*	*196.478*
National Lottery						
Arts Council of England (c)	–	–	301.766	264.946	201.534	66.942
Scottish Arts Council (d)	–	–	18.060	14.774	32.362	16.498
Arts Council of Wales (e)	–	–	7.905	10.938	23.462	9.223
Arts Council of Northern Ireland (f)	–	–	5.110	5.849	3.885	8.288
Millennium Commission (g)	–	–	7.474	–	4.780	–
Recorded subtotal	–	–	*340.316*	*296.507*	*266.024*	*100.951*
Local authorities						
England (h)	147.300	128.600	130.600	153.100	152.400	155.700
Wales (i)	–	–	–	–	–	9.745
Scotland (j)	–	47.7	–	35.4	37.2	–
Northern Ireland (k)	4.09	4.00	–	–	7.85	–
Recorded subtotal	*151.393*	*180.301*	*130.600*	*188.500*	*197.446*	*165.445*
Business sponsorship (l)	42.738	47.185	41.119	50.532	53.573	58.597
BBC (m)	15.000	16.000	18.000	18.000	15.000	15.000
Subtotal	*376.085*	*409.593*	*701.475*	*728.584*	*725.887*	*536.471*
Other (o)						
Higher education institutions (n)	–	–	–	–	–	4.925
Ministry of Defence (p)	–	–	–	–	–	8.430
Recorded subtotal	–	–	–	–	–	13.355

Sources
Arts Council of Great Britain/Arts Council of England, annual report, various years; Scottish Arts Council, annual report, various years; Welsh Arts Council/Arts Council of Wales, annual report, various years; Arts Council of Northern Ireland, annual report, various years; annual reports and accounts of the ten regional arts boards;
Lottery data supplied directly by the Arts Councils of England and of Wales; Arts Council of Northern Ireland, Annual Lottery Report, various years; Marsh and White (1995); O'Brien and Feist (1996); Joy and O'Brien (1998) and Joy and Jermyn (1999); Scottish Arts Council, *COSLA / SAC* survey of arts expenditure in Scotland, 1994/95, 1996/97 and 1997/98; National Assembly for Wales *Partnership in Practice*, The Forum for Local Government and the Arts, 1993/94, and 1994/95; BBC, annual reports; ABSA/Arts & Business *Business Support for the Arts/Business Investment in the Arts*.

Notes
a) Representing grants made to the performing arts by the arts councils. They all cover slightly different activities. For example, ACGB/ACE data cover combined arts, dance, mime, drama, music including opera, new audiences; SAC data, combined arts, dance, mime, drama, music inc opera; WAC/ACW, dance, music, drama plus performing arts headings from regional sections; ACNI, drama and dance, Grand Opera House allocation, music and opera, Ulster Orchestra, community arts, Belfast Festival plus identifiable elements of traditional arts, education and regional projects.
b) The regional arts boards have been put 'below the line' to avoid double counting. The figures for local authority expenditure in England are likely to include subscriptions to the RABs. The figures for ACE, however, do not include its grants to the RABs, so there is no overlap there.
c) Representing grants made for circus, combined arts, dance, drama, mime, music and opera.
d) Representing grants made for combined arts, dance, drama, music and opera.
e) Representing grants made for circus, dance, drama, multi-arts, music, opera, amateur dramatic and operatic societies.
f) Representing grants made for combined arts, community arts, dance, drama, music and opera.
g) Representing grants made for combined arts and drama.
h) These figures represent local authority revenue spending on 'arts', excluding specific expenditure for museums and galleries and for libraries. This figure is likely to contain some spending on arts other than the performing arts, such as grants to visual artists and support for general arts venues. However, the data available cannot be further disaggregated, so this figure is offered as a best estimate of spending on the performing arts.
i) Covers revenue expenditure on arts venues, arts-related staff, arts promotion and revenue grants and support in kind to arts organizations. It is likely, therefore, that a proportion of this expenditure will be on areas other than the performing arts (see also note g, above).
j) Including arts centres, arts festivals, community arts, dance, drama, music and opera.
k) Figure for 1997/98 supplied by the Arts Council of Northern Ireland. These figures represent spending on 'arts and culture' rather than the performing arts per se.
l) Figures from the annual ABSA / Arts for Business survey of companies. May overlap with matching funding for the DCMS sponsored Pairing Scheme. For the sake of accuracy, separate figures for the Pairing Scheme have therefore been excluded from this table.
m) Covers house orchestras.
n) Table 12.3. This includes universities' spend on arts centres, theatre/drama and music.
o) Due to the difficulty in obtaining these data, figures were collected only for 1998/99.
p) Represents spending on military bands and music schools. Information supplied directly by the Ministry of Defence.

Table 29.11 Lottery awards to the performing arts, 1995/96–1998/99

£ million

	1995/96	1996/97	1997/98	1998/99
ACE (a)	301.8	264.9	201.5	66.9
SAC (b)	18.1	14.8	32.4	16.5
ACW (c)	7.9	10.9	23.5	9.2
ACNI (d)	5.1	5.8	3.9	8.3
Total	332.8	296.5	261.2	101.0
At real (1998/99) prices	*364.8*	*314.8*	*269.8*	*101.0*
Percentage change year-on-year	n/a	–13.7	–14.3	–62.6

Sources:
Arts Councils of England, Wales and Scotland; annual reports; Arts Council of Northern Ireland, *Annual Lottery Reports*.

Notes
a) Circus, combined arts, dance, drama, mime, music, opera.
b) Combined arts, dance, drama, music, opera.
c) Circus, dance, drama, multi-arts, music including opera.
d) Combined arts, community arts, dance, drama, music, opera.

arts councils, the English regional arts boards and local authorities. There is also some expenditure by central government via other departments.[1] Table 29.10 tracks funding for the performing arts from 1993/94–1998/99. The table includes details of expenditure by the arts councils and regional arts boards from 1993/94 to 1998/99. While these figures should be treated with caution, the table suggests that spending by the arts funding system on the performing arts remained essentially static in cash terms. Between 1993/94 and 1994/95, regional arts boards' expenditure rose by about £14 million, while ACE expenditure fell by approximately the same amount – the result of devolution of major clients. Although 1995/96 showed a 3.6 per cent increase on 1994/95, the two following years showed only negligible increases.

The Lottery has also become a major component of public expenditure on the performing arts. Although originally designed only for capital projects, the rules have since been broadened. In 1997 and 1998, revenue funding was provided through the Arts for Everyone (A4E) programme of small grants, the stabilisation of larger companies with substantial deficits, and dance and drama students. From 1999/2000, £10 million per annum has been allocated to the new government-created Youth Music Trust.

Lottery expenditure by the four arts councils amounted to more than £250 million in 1997/98, exceeding ordinary grant aid, but fell sharply in 1998/99 to £101 million (Table 29.11). ACE and Arts Council of Wales Lottery expenditure fell by over a half in 1998/99, compared to the previous year. In 1999/2000, £6.5 million per annum will be devolved to the regional arts boards for capital projects of less than £100,000 in value.

1 Casey et al. (1996) estimated that spending on performing and combined arts in England in 1993/94 was £34.8 million, of which £19.6 million came from the Department of Education. This is the last year for which such information is available.

Table 29.12 Local authority grants and contributions to professional arts organisations, 1996/97 (a)

	England		Scotland		Wales	
	£000s	(%)	£000s	(%)	£000s	(%)
Dance	2,786	(6)	363	(4)	17	(1)
Drama	23,628	(53)	3,987	(40)	84	(7)
Music	6,752	(15)	2,793	(28)	3	(c)
Opera	1,693	(4)	322	(3)	15	(1)
Festivals	1,868	(4)	2,512	(25)	217	(18)
Arts centres not directly funded through local authority	7,842	(18)	(b)	n/a	874	(72)
Total	44,569		9,977		1,210	

Source: ACE, 2000.

Notes
a) CIPFA ceased to collect data to this level of detail after 1996/97.
b) Included in categories above.
c) Less than half the final digit shown.

Local authorities

The value of local authority expenditure on the performing arts has traditionally been difficult to assess. The main source of information for England and Wales – the CIPFA annual *Leisure and Recreation Statistics Estimates* – is considered unreliable because it is based on questionnaires to local authorities asking for estimates for the coming year, rather than out-turn figures. The ACE has produced its own surveys (England only), based on out-turn figures, but these have failed to ask specifically for information on grants by artform. The only source in Scotland is the survey conducted by COSLA and SAC (Scottish Arts Council/COSLA, 1999). No information is available for Northern Ireland, although the limited responsibilities of the local authorities mean that expenditure is probably small.

No source of data is entirely compatible with any other source, and, because all the data are based on surveys which never receive a 100 per cent response rate, year-on-year comparisons may be misleading. Therefore the following data are based on the latest available year, and no attempt is made to discern trends.

Local authority expenditure may be of two types – grants to performing arts organisations, and direct provision. Table 29.12 shows grants to arts organisations in England, Scotland and Wales in 1996/97. This was the last year for which CIPFA collected data by artform for England and Wales. The Scottish figures include grants to amateur groups, while the English and Welsh figures refer only to professional organisations. The table suggests that local authorities in the three countries spent a total of over £55 million on grants to the performing arts. In addition, English and Welsh local authorities spent £21.3 million in 1996/97 in supporting amateur performing arts organisations (ACE, 2000). The latest figures for Scotland (1997/98) show grants expenditure to have increased to £10.2 million.

Direct provision is made by local authorities through the many performing arts venues which are owned and maintained by them, and in which many local authorities undertake their own promotions of arts events. In 1998/99 in England,

Table 29.13 Expenditure on the performing arts by home countries, 1993/94–1998/99

£ million

	1993/94	1994/95	1995/96	1996/97	1997/98	1998/99
England						
ACGB/ACE	125.176	110.115	114.384	114.799	114.966	116.800
Lottery (ACE)	n/a	n/a	301.766	264.946	201.534	66.942
Local authorities	147.300	128.600	130.600	153.100	152.400	155.700
Business sponsorship	34.185	39.520	33.677	43.464	44.099	49.105
Regional arts boards (a)						
Eastern	2.249	3.063	2.747	2.880	2.349	2.650
South East	1.612	1.720	1.673	1.845	2.199	2.169
North West	2.729	5.261	5.339	5.404	5.859	5.408
West Midlands	2.419	4.137	4.484	4.241	4.385	4.277
East Midlands	1.608	3.008	3.218	3.163	3.153	3.116
South West	1.792	3.105	3.679	3.656	3.868	3.850
Southern	1.230	2.256	2.482	2.415	2.342	2.698
Yorkshire & Humberside	3.146	4.969	5.349	5.271	5.148	5.232
Northern	3.841	3.980	4.274	4.195	4.458	4.155
London	6.451	9.193	9.111	9.576	9.418	9.323
Subtotal	*333.739*	*318.927*	*622.783*	*618.955*	*556.177*	*431.425*
Scotland						
Scottish Arts Council	17.100	18.400	18.800	20.200	21.400	21.200
Lottery (Scottish Arts Council and Millennium Commission)	n/a	n/a	25.534	14.774	32.362	16.498
Local authorities	–	47.7	–	35.4	37.2	–
Business sponsorship	5.542	4.642	4.394	3.841	6.719	5.839
Recorded subtotal	*22.642*	*70.742*	*48.728*	*74.215*	*97.681*	*43.537*
Wales						
WAC/ACW	8.300	8.600	9.300	10.700	9.400	10.300
Lottery (ACW)	n/a	n/a	7.905	10.938	23.462	9.223
Local authorities	9.745	–	–	–	–	9.745
Business sponsorship	1.795	2.007	2.462	2.303	2.347	2.788
Recorded subtotal	*10.095*	*10.607*	*19.667*	*23.941*	*35.209*	*32.056*
Northern Ireland						
Arts Council of Northern Ireland	4.300	4.300	4.600	4.700	4.900	5.299
Lottery (Arts Council of Northern Ireland and Millennium Commission)	n/a	n/a	5.110	5.849	8.665	8.288
Local authorities	4.093	4.001	–	–	7.846	–
Business sponsorship	0.750	0.750	0.586	0.724	0.408	0.865
Recorded subtotal	*9.143*	*9.051*	*10.296*	*11.273*	*21.819*	*14.452*
Recorded total (b)	375.619	409.327	701.474	728.384	710.886	521.471

Source: Table 29.10.

Notes

a) There may be some element of double-counting here. See note b, Table 29.10.

b) The total here is not the same as in Table 29.10 due to the omission of national projects.

local authorities spent a net £100.7 million on their own venues, defined as theatres, concert halls, arts centres, and other halls catering primarily for arts events (Joy and O'Brien, 1998). This figure also includes expenditure on venues used for temporary exhibitions, although museums and libraries are excluded. Net expenditure in Scotland on similarly defined venues was £23.7 million.

If these figures are totalled – and they exclude Welsh local authorities' spending on their own venues and all local authority spending in Northern Ireland – then local authority expenditure on the performing arts is shown to be in excess of £180 million a year, matching the total revenue expenditure of the four arts councils and the regional arts boards.

Details of the regional distribution of public expenditure on the performing arts in England are shown in Table 29.13.

Business sponsorship

Figures for business sponsorship do not distinguish between support for subsidised and unsubsidised organisations, although it is probably the case that the vast majority of sponsorships support the subsidised sector, hence the inclusion of the topic here.

Table 29.14 shows business sponsorship of the performing arts from 1993/94 to 1998/99, as reported to Arts & Business and formerly the Association for Business Sponsorship of the Arts in their annual surveys. Year-on-year comparisons should be treated with caution, as totals are based on those responding to surveys rather than on a constant sample.

It is possible to distinguish between the sponsorship of capital projects and general business sponsorship from 1994/95 to 1998/99. (Prior to 1994/95, capital and general sponsorship were not distinguished.) As Table 29.15 shows, sponsorship of capital projects increased from 5 per cent in 1995/96 to 25 per cent in

Table 29.14 Business support for the performing arts by English RAB and home country, 1993/94–1998/99 (a)

£ million

	1993/94	1994/95	1995/96	1996/97	1997/98	1998/99
England (b)						
East	0.670	1.090	0.796	0.765	0.623	1.012
East Midlands	0.540	0.666	0.555	0.659	0.731	1.274
London	17.702	20.947	20.436	29.938	29.799	32.198
North West	2.723	2.475	1.698	2.277	2.015	2.415
Northern	0.510	0.873	0.744	0.683	0.626	0.614
South East	5.040	6.160	2.957	2.740	2.449	2.804
South West	1.565	1.142	1.247	1.281	1.461	1.874
Southern	1.228	2.222	1.466	1.522	2.009	1.846
West Midlands	2.099	2.022	2.216	2.136	3.000	3.378
Yorkshire & Humberside	2.109	1.921	1.562	1.463	1.386	1.689
Total England	*34.185*	*39.520*	*33.677*	*43.464*	*44.099*	*49.105*
Scotland	5.542	4.642	4.394	3.841	6.719	5.839
Wales	1.795	2.007	2.462	2.303	2.347	2.788
Northern Ireland	0.750	0.750	0.586	0.724	0.408	0.865
National funding/other	0.466	0.266	0.000	0.200	0.000	0.000
Total United Kingdom	42.738	47.185	41.119	50.532	53.573	58.597

Source: ABSA/Arts & Business *Business Support for the Arts/Business Investment in the Arts*, various years.

Notes
a) This may include figures for the Pairing Scheme. A similar regional breakdown for the Pairing Scheme is not available.
b) Art board regions.

1996/97, suggesting the impact of the Lottery. Beside this growth in capital projects, other categories of sponsorship remained relatively static.

Table 29.16 shows all business sponsorship by artform, from 1993/94 to 1998/99. Again, year-on-year comparisons must be treated with caution. However, the percentages show consistently small amounts of support for arts centres and community arts in comparison with other categories. Festivals, despite their lack of capital projects, remain relatively attractive to sponsors.

1996/97 marks a large increase in the levels of sponsorship for drama, because of a tenfold increase in capital sponsorship, from £0.8 million in 1995/96 to £7.9 million in 1996/97. In total, sponsors produced nearly £60 million for the performing arts in 1998/99. However, a quarter of this was devoted to capital projects and was therefore not available for the day-to-day running costs of organisations.

Income from trusts and foundations

Little information is available on income from trusts and foundations. The performance-indicator data collected by the ACE do not distinguish between sponsorship and other forms of private contributions. However, a special analysis of this data revealed that in 1996/97, 424 clients (across all artforms) received a total of £16.7 million from trusts and foundations. Based on this, it can be estimated that £10 million went to the performing arts. Fifty-six per cent of this total (£9.4 million) was received by the Royal Opera House, other major opera companies and orchestras (ACE, 2000).

Self-generated income

In addition to attracting income from outside sources, performing arts organisations also generate a certain level of income themselves. Consumer expenditure

Table 29.15 Business sponsorship of the performing arts, 1993/94–1998/99 (a)

	1993/94		1994/95		1995/96		1996/97		1997/98		1998/99	
	£ million	(%)	£million	(%)	£ million	(%)	£ million	(%)	£ million	(%)	£ million	(%)
General business sponsorship	29.9	70	29.5	62	26.4	64	25	50	29.7	55	29.5	50
Sponsorship of capital projects	n/a	n/a	4.7	10	2.1	5	12.8	25	11.9	22	13.5	23
Corporate membership	6.3	15	7.9	17	7.4	18	7.4	15	6.9	13	5.7	10
Total cash sponsorship	36.2	85	42.1	89	35.9	87	45.2	90	48.5	90	48.7	83
Sponsorship in kind	2.7	6	2.9	6	3.5	9	3.4	7	3.8	7	4.5	8
Corporate donations	3.8	9	2.2	5	1.7	4	1.9	4	1.4	3	5.5	9
Total business support	42.7	100	47.2	100	41.1	100	50.5	101	53.7	100	58.7	100

Source: ABSA/Arts & Business annual surveys.

Note: a) Categories are: arts centres, community arts, dance, drama, festivals, music and opera.

Table 29.16 Business sponsorship of the performing arts by artform, 1993/94–1998/99

£ million

	1993/94	1994/95	1995/96	1996/97	1997/98	1998/99
Arts centres	1.799	3.800	1.187	1.302	1.177	1.634
Arts festivals	6.491	7.396	8.029	8.119	10.418	9.752
Community arts	–	0.671	0.451	0.752	1.382	1.651
Dance	2.661	2.252	2.962	3.006	1.752	3.012
Drama/theatre	9.191	8.824	9.295	16.549	19.919	17.177
Music	11.907	11.674	11.051	11.095	10.870	12.336
Opera	10.690	12.568	8.144	9.708	8.055	13.036
Total	42.738	47.185	41.119	50.532	53.573	58.597
At real (1998/99) prices	*48.877*	*53.203*	*45.061*	*53.649*	*55.322*	*58.597*
Percentage change year-on-year	n/a	8.9	–15.3	19.1	3.1	5.9

Source: ABSA/Arts & Business *Business Support for the Arts/Business Investment in the Arts*, various years.

on performing-arts tickets of all types is estimated to have been £790 million in 1997/98 (see Table 29.4). The earned income of performing arts companies regularly funded by the arts councils of England, Scotland and Wales totalled £205 million in 1998/99 (see Table 29.9).

Employment in the subsidised sector

Little information is available on employment within the subsidised sector. This is largely because of the high mobility of performers and other contracted employees both within the sector and between subsidised companies and commercial employment. The ACE performance indicators offer some data on permanent staff working within the sector – people likely to be employed in some sort of administrative capacity. Figures are shown in Table 29.17.

Dane et al. (1999) give figures for employment in orchestras and opera companies in 1997/98, as follows:

- regional contract orchestras – 540 players and 252 in administration, etc;
- London orchestras – 382 players and 93 in administration;
- BBC orchestras – 400 players and 43 in administration;
- the major opera companies employed 653 in all.

Conclusion

Any attempt to map the total extent of the performing arts sector, and the place of the subsidised sector within the whole, is inevitably frustrated by the lack of up-to-date and reliable data. The following summary of the main points can only indicate the gaps in our knowledge. No summary material on employment is presented, for reasons that will be apparent from the above.

For the sector as a whole, theatres presented in excess of 65,000 performances of all types in 1998. Attendance at these performances totalled 29.3 million

Table 29.17 Permanent staff employed in regularly funded companies in England, 1998/99

Type of company	Staff employed
Combined arts	1,437
Dance	991
Drama & mime	3,893
Music	2,051
Total	8,372

Source: Hacon et al., 2000.

(Table 29.2). The total number of classical concerts is unknown, as is attendance. In the subsidised sector, regularly funded clients of the Arts Council of England, Arts Council of Wales and Scottish Arts Council presented 108,000 performances and concerts in 1998/99. Attendance at these events totalled 17.8 million (Table 29.6).

Total subsidy to the performing arts in 1998/99 (including sponsorship) was in the region of £530 million (Table 29.10). Trusts and charities may have provided another £10 million. Consumer expenditure on performing arts is estimated at £790 million for 1997/98 (Table 29.4), and the performing arts clients of the Arts Council of England, Scottish Arts Council and Arts Council of Wales earned another £205 million in 1998/99 (Table 29.9).

30
Profile of Public Broadcasting

Robert King, Institute of Public Policy Research

This chapter profiles broadcast media in the UK. The first section looks at trends in general, with specific reference to funding, audiences and employment. The second section primarily focuses on the subsidised sector – the BBC and S4C (Welsh Channel 4).

Broadcasting in the UK: funding, audiences and employment

Broadcasting in Britain now consists of an ever expanding group of organisations competing for success on a variety of platforms. Television broadcasts by the BBC are mostly on Channels 1 and 2. Channel 3 – ITV – is split into 14 regions, covered by 15 franchises (Carlton TV and LWT broadcast jointly to London). GMTV is licensed to provide Channel 3 breakfast services. The final two national television services are Channels 4 and 5. Sky transmits over 200 channels from its Astra satellite, and there are well over 150 channels now broadcast through cable.

There are six digital terrestrial television multiplexes: three are allocated to the commercial sector; one to the BBC; one to minority-language programming; and one for text and other services. In addition, Sky Digital provides digital television through its satellite, and a number of cable operators also run digital services. The BBC is held accountable to Parliament through its board of governors, who are appointed by the Department for Culture, Media and Sport (DCMS). Regulation of the commercial sector is carried out by the Independent Television Commission, which, like the Broadcasting Standards Commission, monitors standards and quality.

The BBC operates five national radio stations, as well as a number of local and regional services. The UK has four national commercial stations broadcasting on either the FM or AM frequency, Virgin Radio, Atlantic Radio, Classic FM and Talk Radio, and over 220 local and regional stations. Seven multiplexes, which effectively bundle together different broadcasters in one digital signal, have been allocated to digital radio: one for BBC national radio; one for national commercial radio; and the rest for various levels of local radio. The Radio Authority regulates the commercial sector.

The headline data on broadcasting have changed somewhat since the publication of *Culture as Commodity?* (Casey et al., 1996). The expansion of satellite, cable and now digital television and radio has led to a plethora of new services. Casey et al. (1996) identified broadcasters according to three models of funding:

- public service broadcasting – either funded by the licence fee (the BBC Home Service) or subsidised by the government (the BBC World Service and S4C);
- commercial TV (Channels 3, 4 and 5) and radio – free-to-air and paid for by advertising revenue; and
- cable and satellite television – with mixed funding from subscription, pay-per view and advertising revenue.

The distinctions between the different types of funding are now becoming increasingly blurred. The BBC currently generates additional revenue, albeit at arm's length, from its Worldwide division; and free-to-air Channel 3 companies, such as Carlton, have interests in pay-TV.

Turnover

For funding purposes, the BBC is divided in two: the Home Service and the World Service. Figure 30.1 shows the BBC's total annual turnover; it is by far the largest of any broadcaster in Britain. Until recently, the licence fee accounted for virtually all of this income (in 1998 it was £2.2 billion). Yet, quite a significant proportion of revenue now comes from the BBC Worldwide division, which manages the sale of BBC products both in Britain and overseas. For 1998/1999, BBC 1 received £752 million, whilst BBC 2 received £406 million (BBC, 1999).

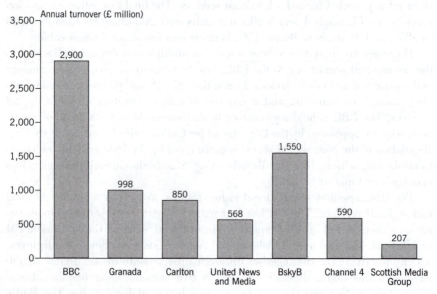

Source: Keynote, 1999.

Figure 30.1 Turnover of major players in broadcasting in the UK, 1998

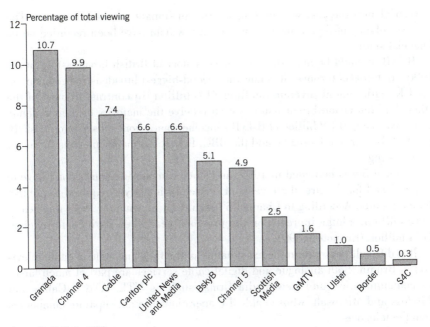

Source: Zenith Media, 2000.

Figure 30.2 UK commercial broadcasters' share of total viewing in the UK, June 1999

The other publicly owned broadcasters, Channel 4 and S4C, are much smaller. Channel 4 had a turnover of nearly £600 million for 1998/99, which was mainly programme sponsorship and advertising revenue. £24 million was raised from programme and film sales (Channel 4, 1999). Since *Culture as Commodity?* (Casey et al., 1996) the C4 funding formula, which drained some advertising revenue away from the station and towards ITV, has ended. S4C's turnover was £86 million in 1998: £74 million raised in grants from the DCMS and £12 million in revenue from advertising and programme sales.

Of the 15 regional Channel 3 franchises, until 1999 only three were owned by 'independents', Channel, Ulster and Border TV, whilst the rest were owned either by Carlton, United News and Media, Granada, or by the much smaller Scottish Media Group which in 1998 had a turnover of nearly £300 million.

In 1999 in terms of turnover and audience, and apart from the BBC and Channel 4, television broadcasting in the UK had four 'big players': BSkyB, Carlton TV, UN&M Broadcasting, and Granada Media. Their shares of total viewing are shown in Figure 30.2. All are powerful companies in the commercial sector in their own right. All four also happen to be part of much bigger cross-media empires: BSkyB is predominantly a subsidiary of News International; Carlton TV is part of the much bigger Carlton plc; UN&M Media is part of the UN&M group (until recently, owners of the Express newspapers); and Granada Media is part of the Granada Leisure Group – which raises the issue of how their ownership relates to the public interest.

Both Carlton plc and Granada are at the forefront of the new digital age. Their joint ownership of OnDigital (launched in 1998), which controls three of the six

terrestrial multiplexes, will certainly have an impact on their turnover. The relative infancy of digital means that as yet few data have been recorded on its financial status.

BskyB, it could be argued, is the success story of British broadcasting in the 1990s. In terms of turnover it is now the second-biggest broadcasting company in the UK, with annual revenue totalling £1.6 billion. In contrast to most of the other 'big' television broadcasters which receive the majority of their revenue from advertising, £1.2 billion of BskyB's income comes from subscription (BskyB, 1999). Like Carlton, Granada, and the BBC, BskyB has major interests in digital broadcasting.

Channel 5 was launched in 1997, and since company accounts don't have to be published for the first three years of service, it is not yet required to publish annual reports. According to Channel 5's own data, revenue for 1999 was nearly £415 million, a huge increase on the previous year when its income reached £144 million (Keynote, 1999).

It is difficult to ascertain the exact nature of the financial state of cable television in Britain. Both analogue and digital cable services are part of much larger telecommunication and new-media firms, such as NTL, AT&T, Cable and Wireless and Microsoft, whose cable TV operations are not separate companies from the telecoms.

British radio attracts much lower revenues than television. The BBC funds its national, regional and local services to the tune of £434 million a year. In addition, the Foreign and Commonwealth Office (FCO) funds the BBC World Service, with the 1998 subsidy reaching £161 million (BBC, 1999).

Total commercial radio revenues for 1999 were £464.4 million (Radio Advertising Bureau, 1999). While this may sound very small in comparison to the television sector, it must be noted that since the Broadcasting Act 1990, independent radio has seen a 239 per cent growth in revenue. Three major players dominate the commercial sector: GWR, Capital Radio and EMAP (part of the much larger publishing group) between them control well over 50 per cent of independent radio in the country.

Overall revenue has increased in all areas of the UK broadcast industry. Yet, much of that success has been generated at home. Britain last operated a broadcasting trade surplus in 1985, and now runs a substantial trade deficit with the rest of the world, importing nearly double its exports. Surplus in 1985 was £24 million; in 1996, the deficit was £282 million (DCMS, 1998) And, despite having a language advantage over the rest of Europe, the UK exports only 1 per cent more programmes than Germany and France. Its biggest export market is the European Union, and most imports are from North America.

Audience

Table 30.1 shows total audience share for British television in 1999. Combined, the BBC terrestrial television channels still captured the greatest share (40 per cent), closely followed by ITV (33 per cent). Channel 5's share (under 5 per cent) was very small in comparison. But, whereas Table 30.1 shows the still quite

Table 30.1 Total audience share for British television, 1999

	Percentage
BBC 1 and 2	40.2
ITV (Channel 3)	32.9
Channel 4	9.9
Cable	7.4
Sky	5.0
Channel 5	4.6
Total	100.0

Source: *Guardian*, 2000.

substantial share of both BBC and ITV audiences, Figure 30.3 suggests that this is declining. Given that BBC 1's share of audience was nearly 40 per cent in 1989, its 30 per cent share in 1999 represented a substantial drop for the Corporation's flagship service. Both Channel 4's and BBC 2's shares have remained remarkably constant by contrast. Channel 5 saw some growth in its first two years, but was able to attract only around 5 per cent of all viewers in 1999.

There has also been a quite substantial rise in viewing figures for satellite and cable services, which combined have doubled their audience share in the last five years. BskyB accounts for much of that success, and now has 7.2 million subscribers, including 1.2 million on Sky Digital. However, it hasn't quite lived up to predictions that it would command a much higher percentage of total audience share. Three million homes were connected to cable television services in 1999. Amongst these households, satellite and cable channels were the most

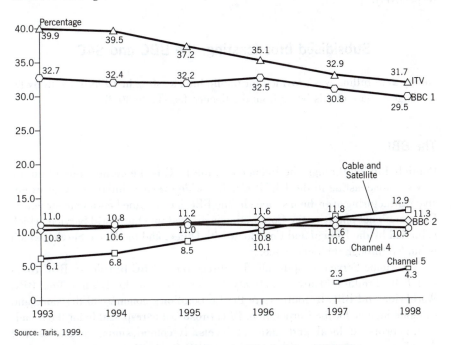

Source: Taris, 1999.

Figure 30.3 Audience share for UK television, 1993–98

popular television services, accounting for 38 per cent of total share (Taris, 1999). ITV was second, with 24 per cent, followed by the BBC with 21 per cent.

Listener share in radio tends to be split in terms of national and local figures. Overall, the BBC and the commercial sector have roughly a 50/50 split. At a national level, though, the BBC can claim to be the most successful broadcaster, with over 30 per cent of the overall share compared to national independent radio's 10 per cent. At a local and regional level, the picture is somewhat reversed: local independent radio accounts for over 40 per cent of all radio listeners, whilst BBC local and regional services account for only 9 per cent. The long-term trend suggests that it is the local sector that will experience the most growth at the expense of the BBC (*Guardian*, 2000).

Employment

The *Creative Industries Mapping Document* (DCMS, 1998) showed 63,453 people working in the broadcast sector. That figure is based on 1996 data, and doesn't cover the quite substantial expansion in staffing at the BBC, BskyB and Channel 5. The true figure is probably well over 70,000. This excludes freelance personnel working for ITV, who in 1996 numbered nearly 5,000.

The BBC is the largest broadcast employer, with 23,000 staff for the year 1998/99. BskyB employs over 8,000 staff, nearly double the level of the previous year (BSkyB, 1999). UN&M and SMG respectively have 2,000 and 1,500 staff. Channel 4 and S4C, both commissioners of programmes, have 700 and 160 respectively.

Subsidised broadcasting: the BBC and S4C

Nearly £2.5 billion was provided for public broadcasting in 1998/99, with by far the largest share of this being from the licence fee (Table 30.2).

The BBC

Publicly funded through the licence fee, the BBC is the cornerstone of public service broadcasting in the UK. It also has wide overseas interests. After extensive restructuring over the last decade, the BBC has a refined corporate structure. For operational purposes the Corporation is divided into the World Service, which is funded by the Foreign and Commonwealth Office, and the Home Service which is funded through the licence fee.

The Home Service is split into five directorates: BBC Broadcast, BBC News and BBC Production are effectively funded through the licence fee; BBC Worldwide and BBC Resources are the Corporation's commercial divisions and generate income for the Corporation. BBC Broadcast is responsible for the broadcast network at local and national levels. It commissions, schedules and distributes programmes, either made by BBC Production, or by independent

Table 30.2 UK funding for broadcasting, 1993/94–1998/99

£ million

	1993/94	1994/95	1995/96	1996/97	1997/98	1998/99
Direct spending by central government DCMS						
S4C	58.000	63.776	68.486	72.223	18.414	75.127
Other broadcasting (a)	2.000	4.818	3.920	1.971	1.971	1.971
Subtotal	*60.000*	*68.594*	*72.406*	*74.194*	*20.385*	*77.098*
Other central government departments						
FCO (BBC World Service)	175.700	174.900	180.600	174.600	156.800	161.500
BBC licence-fee income	1,684.000	1,751.000	1,820.000	1,915.000	2,009.700	2,179.500
Total	1,919.700	1,994.494	2,073.006	2,163.794	2,186.885	2,418.098

Sources: DNH, annual reports 1995–1997; DCMS, 1998–1999; BBC annual reports various years.

Note: a) This includes funding to the Broadcasting Standards Commission and the Broadcasting Complaints Commission (which were merged to form the Broadcasting Standards Commission); payments to ITC; Radio Communication Agency; and compensation payments for the concessionary television licence scheme.

producers. BBC Education, a sub-division of BBC Broadcast, plays an important role in developing national educational resources in tandem with national learning policy. BBC News manages news operations, including BBC News 24. In commissioning and broadcasting bi-media (radio and TV) programmes at a global level, the BBC has become the world's biggest news-gatherer. BBC News broadcasts on both BBC World television and BBC World Service radio, and now competes with global news operators such as CNN, and Reuters News. World Service radio broadcasts programmes in 43 languages.

Licence fee

Figure 30.4 shows how the licence fee was distributed throughout the Corporation in 1998. Flagship television channels BBC 1 and 2 receive £1.2 billion, whilst £285 million was distributed between national radio services. The two most popular stations, Radios 1 and 2, receive the least amount of funding (£37 million and £42 million respectively) whereas Radio 3, despite a very small listenership, receives the second highest share – £62 million. Radio 4 has the highest income at £89 million. The BBC World Service received £162 million from the FCO in 1998, plus a further £20 million from subscription services.

As mentioned in Chapter 8 above, the Corporation has faced criticism over spending licence-fee revenue on services not universally accessible. This criticism was re-visited in the recent furore over the increase in the fee to pay for greater digital expansion. The political cost of increased public spending seemed too great for the government. But, as an innovator and a provider of quality information, the BBC needs to be at the forefront of the digital future.

In providing a public service, the BBC must take into account regional and local dimensions in broadcasting. As a result of devolution, the Corporation has had to extend its programming within each home country. Figure 30.5 shows its per capita spend on television and radio programmes made and broadcast in each

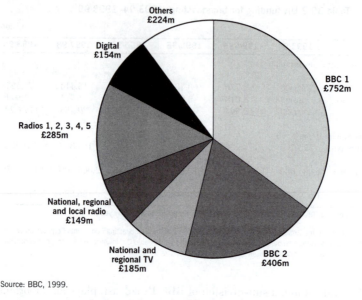

Source: BBC, 1999.

Figure 30.4 How the BBC licence fee was spent, 1998

country. Of the total £185 million spent on television and £149 million spent on radio, Northern Ireland receives the greatest spending per head in both media. Spend per capita in England is extremely low. London is not included in the BBC's analysis of regional variations, summarised as part of the UK-wide spending assessment. Local London programming is counted as part of the national programming budget.

Programming costs

As a public service broadcaster, the BBC has to cater for diverse tastes. Effectively, this means commissioning programmes across a broad range of genres. From the licence fee, the BBC funds a number of formats at differing costs. Comparisons across different channels show, for instance, that average programming on BBC 1 costs £123,000 per hour to make, whereas programmes on the Parliament Channel cost just £500 per hour (BBC, 1999). By genre, the most expensive type of programme is drama, which on average costs the BBC some £487,000 per hour. The contrasting cost of sport, only £77,000 per hour, explains why, in some instances, sports programming is so popular.

Self-generated income

The BBC's commercial activities are becoming ever more lucrative. Both BBC Worldwide and BBC Resources generate money that can be channelled back into the Corporation, and used to aid licence-fee activity. BBC Worldwide sells programmes to overseas broadcasters, operates with commercial channels in joint ventures and publishes books, videos, magazines, tapes and CDs. BBC Resources provides facilities and other resources to the BBC and also operates in the exter-

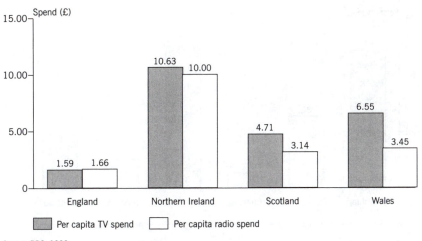

Source: BBC, 1999.

Figure 30.5 Spending on national, regional and local television and radio in the UK, per capita, 1998/99

nal facilities markets. Their relationship with the Corporation is complex, in that they have to operate 'at arm's length' and in that they are both constituted as separate limited companies, but are still part of the publicly owned Corporation as a whole. Both companies are subject to the BBC's Fair Trading Commitment, which requires them to compete fairly in all markets. For example, BBC Worldwide pays the Corporation at market rates for the right to extract the commercial value of BBC programmes – regulated and administered by the BBC rights agency, an internal organisation.

Since its inception in 1994, BBC Worldwide has increased its turnover from £239 million to £420 million (BBC Worldwide, 1999). The value of Worldwide within the BBC is becoming ever more important, pumping money back into the public side of the Corporation. Between 1994 and 1999, the Worldwide division channelled nearly £220 million back into the Corporation for purely programme purposes. Money is also directed back into other divisions within the BBC such as the extensive archive service. Figure 30.6 shows how that money is generated, by type of activity and by area. Publishing is the most lucrative activity, and the UK is the biggest market.

Beeb.com is BBC Worldwide's website. Like Worldwide in general, Beeb.com has proved successful in its own right and is now the fifth most popular commercial website in the UK. Its primary aim is to ensure that BBC products are accessible to the new brand of internet shopper. Its success has led to a number of banner advertising deals with Amazon and Waterstone's books, and Expedia shopping.

Less successful in terms of generating resources to the BBC are the partnership arrangements between the BBC and other broadcasters. The agreement with Flexitech, managing the UKTV family of commercial subscription channels including UK Gold, has led to little in the way of turnover, and in some instances has resulted in net loss. BBC Worldwide has also gone into partnership with the

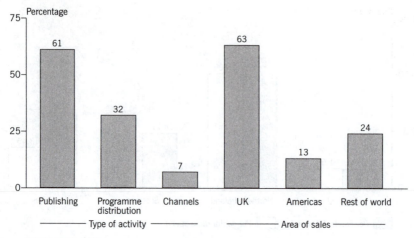

Source: BBC Worldwide, 1999.

Figure 30.6 BBC Worldwide sales, 1999

Discovery channel, to provide documentaries for the worldwide market.

Compared to BBC Worldwide, BBC Resources has not proved as robust. The BBC annual report suggests that the income it generates for the corporation as a whole has reduced, because of effective work practices across other areas of the Corporation. BBC Resources' turnover for 1998 was £30 million.

Finally, the Corporation provides programming for the Open University, as well as supporting its in-house orchestras to the tune of £13 million.

Employment

The BBC is the largest broadcast-employer in the UK. In 1998 23,119 people worked for the Corporation at a cost of £823 million in wages and other expenses. This figure includes both full- and part-time workers. The BBC also had 1,175 staff working on a casual basis. Employment is spread across the organisation. The Home Service is the largest division, accounting for 69 per cent of all BBC staff, followed by BBC Worldwide (18 per cent); BBC Resources (7 per cent); and the World Service (6 per cent).

As an equal-opportunities employer, the BBC has set itself targets for the number of people from ethnic minorities in its workforce, as well as the proportion of women in management. The Corporation has exceeded its target of 30 per cent for women as senior executives, but has not made the target for senior- or middle-management.

Within the Corporation as a whole, the proportion of ethnic-minority staff is 8.1 per cent, slightly exceeding its own target of 8 per cent. Departmentally, as well as regionally, the picture is slightly different: London Home Services and the World Service both exceed the target of 8 per cent, whilst regional services just fail to meet theirs.

Audiences

The decline in the BBC's audience share has already been highlighted. In 1985, the BBC held an average 46 per cent share of total audience (The Advertising Association, 1998). That had fallen to 41 per cent by 1998. The biggest drop was in BBC 1's audiences, which saw a 5 per cent reduction over that 13-year period. BBC 2 has been more consistent, maintaining between 10 and 11 per cent share of total audience.

In comparison to the ITV network, the BBC has held up remarkably well. It seems that ITV, which has seen a 14 per cent drop in its total audience, has been hit most by the introduction of new broadcasting services such as satellite and cable. At a regional level BBC 1 has high ratings in the South West, whereas in Ulster its popularity is limited. BBC 2 is not very popular in Central Scotland, as opposed to London, where its share is higher than that of the UK average. The Corporation's broadcasts generally attract more women viewers, although BBC 2 seems more popular amongst men than women.

BBC Online is proving immensely successful and is now one of the most popular websites in the world, outside the US. During April 1999, 40 million page impressions were made.

Sianel Pedwar Cymru

Sianel Pedwar Cymru, S4C, the Welsh Channel 4, is a public service broadcaster, regulated by the S4C Authority, whose members are appointed by the DCMS. The channel is funded mostly through the public service grant provided by the DCMS. Its central aim is to provide peak-time programming in Welsh, in part to ensure the preservation of the language. Both S4C and Channel 4 originated from the Broadcasting Act of 1980, and many regard S4C's inception as a response to nationalist demands evident throughout the UK during the 1970s. It is specifically scheduled to provide programmes to: children of pre-school age, 4–15s, young people and Welsh-language learners. S4C commissions and buys off-the-shelf programmes from independent producers, as well as using Channel 4 services. It also broadcasts on digital Multiplex One. For such a small channel, S4C has performed extremely well. The station has been nominated for three Oscars, for: *Hedd Wyn* and *Famous Fred* in 1994 and *Canterbury Tales* in 1999. It is also the only channel in Britain to produce and broadcast a soap (*Pobol Y Cwm*) in the same week.

As a relatively small organisation, S4C does not have the same sort of large-scale bureaucratic structure as the BBC. But like the Corporation, it has its own commercial arm enabled under the 1996 Broadcasting Act. S4C Masnachol is the umbrella company that oversees airtime and programme sales, S4C International, S4C multimedia and S4C Digital Network Ltd. The latter now works in partnership with United News and Media and telecommunications giant NTL to create the channel SDN, which is broadcast on Multiplex One.

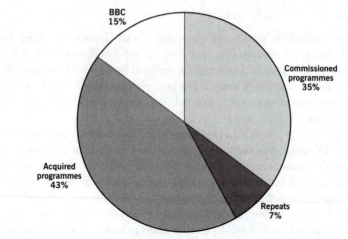

Source: BBC Worldwide, 1999.

Figure 30.7 S4C split of programme sources, 1998

Turnover

S4C's turnover for 1998 was £86 million, which included a grant from the DCMS of £74 million. The additional £12 million was raised through S4C Masnachol's activities, of which £3.2 million was ploughed back into the 'public fund' – the money used to fund the station's public service activities. The rest was used for investment. The majority of that £12 million was generated from the UK, although nearly a million pounds originated from the US and Europe. The Oscar nomination has led to S4C developing its interests in the global market, and it has set up a number of joint ventures with overseas broadcasters to build on its success.

Programming costs

In programming terms, income is spent in a variety of ways. In 1998 £60 million was spent on programmes, not all of which are Welsh-language. On average 37.2 hours per week (21.3 during peak time) of Welsh-language programmes were broadcast on S4C during the year. The rest (114.5 per week), broadcast in English, were provided free of charge by Channel 4, under the 1990 Broadcasting Act. And the majority of that is rescheduled around S4C's commitment to peak-

Table 30.3 Composition of the S4C workforce, 1999

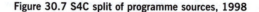

	Number of employees	
Area of activity	Male	Female
Programme commissioning and presentation	23	27
Finance and administration	14	23
Marketing, press and publicity	10	11
Engineering	24	14
Commercial	4	11

Source: S4C, 1999.

Source: BBC Worldwide, 1999.

Figure 30.8 S4C share of Welsh-speaking audience in peak hours, 1998/99

time broadcasting in Welsh. The cost for Welsh programming varies (on average) from between £37,000 per hour to £43,000 per hour.

Welsh programmes are either commissioned in-house or acquired off-the-shelf from a number of independent producers including HTV and BBC Wales, which on average provides 10 hours of Welsh programmes per week. Figure 30.7 shows the ratio between the different commissioning sources. Welsh news services dominate programmes provided by the BBC, although *Pobol Y Cym*, the most popular Welsh-language programme, is provided by the Corporation. Much of the in-house commissions cater for children and the youth market. S4C also provides text and subtitling services, including Welsh subtitling for English programmes.

Employment

S4C employs a core staff of 161 people. Unlike the BBC (but, like Channel 4) the channel does not make its own programmes, hence the small size of its staff. It employs more women than men, and the ratio is the same across most areas in the organisation (Table 30.3). Data for gender equality by level are not available. Because the channel relies on independent production, S4C provides funds for Cyfle, a scheme organised in partnership with Welsh training agencies to encourage the development of broadcasting skills amongst young people.

Audiences

Whilst S4C has only an 8.5 per cent share in all viewing hours, compared to C4's UK average of 10 per cent, amongst Welsh speakers the picture is slightly different. During peak hours, when the commitment to Welsh programming is evident, S4C is far more popular. Its share of audience during peak hours is 19 per cent,

but that popularity is not consistent throughout Wales. Figure 30.8 shows the variations amongst Welsh speakers in different parts of Wales. S4C is far more popular in the rural North than in the much more urban South.

Between 1993 and 1998 the nature of public broadcasting in the UK changed substantially. Technological advance, coupled with regulatory changes, presents a very different environment from that represented in Casey et al. (1996). Policy-makers, concerned to reassess the role of public service broadcasting, are increasingly having to contend with the speed of change and expansion, as well as the emergence of powerful multimedia corporations.

31
Profile of the Visual Arts

Sara Selwood, University of Westminster

Introduction

During the second half of the 1990s, when Brit Art hit the headlines with unerring regularity, it appeared that there was much to celebrate about contemporary visual art in the UK. Its influence seemed boundless. At the same time as British artists in the Royal Academy's *Sensation* exhibition were scandalising the taxpayers of Brooklyn, they were also being credited with spearheading regeneration back home. The galleries and exhibitions in which their work is exhibited have been cast in the role of urban catalysts and as central to the allure of cultural tourism (Allthorpe-Guyton, 1997; TMS, 1997) – Tate Modern being the most obvious example. But, even if the presence of the visual arts has been regarded as benefiting local and regional economies (see Chapter 20, above), it doesn't necessarily follow that the financial health of the sector itself is buoyant, or that the majority of artists are bathing in reflected financial glory (DTZ PIEDA Consulting, 2000).While the YBAs (Young British Artists) may be renowned for the prices for which their work sells, artists' average earnings are only marginally more than what a full-time worker paid the minimum wage might expect to take home.

This chapter collates existing statistical information on arts and crafts, focusing in particular on: the turnover of the subsidised visual arts sector; the number of people working in it; their employment status; their earnings; and the size of their audiences. It primarily focuses on England.

There are, however, a number of caveats that have to be applied to this exercise, not least that there are so few sources of hard data available on the visual arts in the UK. Moreover, where data exist, there tend to be problems in harmonising them. Some aspects of the sector are covered by national data, and others only by ad hoc surveys which present snapshots of various years or particular geographical areas. This paucity of data means that the visual arts are not covered by the quarterly statistical journal, *Cultural Trends*. The sector also tends to receive scant attention in overviews of the cultural sector as a whole – Casey et al. (1996) being no exception.

This lack of data can probably be put down to the pervasive influence of modernism, which has informed attitudes towards the visual arts throughout the

twentieth century (see Chapter 34, below). As a result, the majority of artists have traditionally been regarded as functioning beyond the marketplace, and even the bureaucracy of the arts funding system has largely mitigated against its being subject to various forms of accountability. The visual arts are effectively the only artform still not charging for access, and recent studies have pointed to its practitioners' lack of business acumen (Honey el al., 1997; La Valle et al., 1997). Bodies as varied as the Creative Industries Task Force (Anderson, 2000) and the Fine Art Trade Guild and the Society of London Dealers (SLAD/FATG, 1996) have attempted to rectify this 'skills mismatch'. Other research has drawn attention to the fact that many artists regard the need to earn their living as a necessary evil rather than a positive force (Douglas and Wegner, 1996). Paradoxically, their lack of commercialism is reinforced by the rhetoric of the creative industries, which places artists at its very core (DCMS,1998). The fact that their practice is regarded as involving 'innovative or difficult or new or esoteric work' and, as such, falls outside the interests of the market, is precisely what justifies its public subsidy (Smith, 1998:18).

Much of the data drawn on in this chapter derive from1996 to 1998 – a period when arts-funding bodies' attention was drawn to the economic situation of the visual artist. According to the London Arts Board, changing patterns of funding were having a detrimental impact on artists' incomes. These changes included: cuts in Treasury and local authority funding for the arts and a fall in sponsorship monies which resulted in an increase of visual arts organisations in serious financial crisis; the fact that Lottery capital schemes and Arts for Everyone programmes were directed at formally constituted arts organisations, rather than individuals; the market having become reliant on artists' receiving low fees; unsympathetic tax and social security rules; and the introduction of the New Deal for the young, long-term unemployed, which threatened artists' reliance on the benefits system (LAB, 1998).

The wider sector: turnover, employment and earnings

The wider sector for the visual arts constitutes design (as in 'art and design'); crafts; and, the art trade. However, certain caveats apply to the data about those activities. What passes for headline data is, at best, approximate.

Turnover

Table 31.1 summarises estimates of the turnover of parts of the art, craft and design sector. In 1997, approximately 750 businesses traded in twentieth century art, with sales of £250 million (MTI, 1997). The UK's trade in contemporary art is substantially smaller – worth about £35 million in 1995/96.[1]

1 The market is disadvantaged by VAT on contemporary works which the government applies at full rate (17.5 per cent), in comparison to reduced rates elsewhere – notably in France and Germany (at 5.5 and 7 per cent respectively). It has been suggested that the threat of Droit de Suite may also have financial implications for the contemporary art market (Selwood and Thomas, 1998). See Chapter 22.

Table 31.1 Information on the turnover of the wider visual arts sector

£ million

Activity	Estimate of turnover	At 1998/99 prices
Turnover of craftspeople	400 (a)	458
Expenditure on design in the UK economy	12,000 (b)	12,700
Overseas earnings of design consultancies	358 (b)	380
Turnover of contemporary art trade	35 (c)	40

Source: Based on Selwood and Dunlop, 1998.

Notes
a) Knott, 1994 based on1993 research.
b) Sentance and Clarke, 1997.
c) Butlar Research, 1994.

Employment

It is estimated that about half a million people work in art, craft and design: about 123,500 in arts – of whom around 34,000 are visual artists (O'Brien, 1997); 25,000 people in crafts (Crafts Council, 1995); and 299,000 in design (Sentance and Clarke, 1997).

Earnings

Individuals working in the arts, crafts and design earned just over £3 billion in 1996 – a sum arrived at by multiplying the average earnings by the number of people working in the sector (Selwood and Dunlop, 1998). Research published in 1997 found that visual artists earned an average of £7,590 in 1994/95 – a sum which includes non-artistic sources (Shaw and Allen, 1997). Craftspeople earned £11,101 in 1992–93 (Knott, 1994), and designers, anything from £10,250 – for a junior in furniture design – to £42,000 – for a creative director in product design (Design Week and Major Players, 1997).

The relationship between subsidised and private visual arts sectors

The relationship between the commercial and subsidised sectors is symbiotic. It is common for artists to be discovered and shown by dealers before graduating to exhibitions in the subsidised sector, say at the Serpentine Gallery; or for subsidised galleries and dealers to collaborate. There are also examples of commercial galleries receiving subsidy. No attempt has been made to explore the effects of the relationship between the subsidised and commercial sectors on artists' careers and earnings since Willi Bongard's listings of artists' prices, published in the journal *Kunst Compass* in the 1980s.

The subsidised sector: turnover, earnings and audiences

Turnover

The amount of subsidy from central government increased year-on-year since 1993/94 (Tables 31.2 and 31.3). The arts councils provide a relatively small percentage of the revenue funding to the sector. Between 1993/94 and 1998/99 the English regional arts boards (Table 31.4) annually provided around twice as much funding to the sector as the Arts Council of England (ACE). At the time of writing the arts boards' funding was set to increase in the future as a result of the devolution of the ACE's major clients in 1999.

Since 1997/98 business sponsorship has also provided a larger share of visual arts funding than the combined arts councils (Table 31.5). Little is known about the amount of funding available to the sector through private sector prizes and awards, but in 1997 the amount of such funding available to UK artists and photographers represented over 80 per cent of central government funding to the sector.

Lottery funding has also added considerably to the sector's turnover. Between 1995/96 and the end of 1998/99, visual arts and crafts had been awarded £184 million by the four arts councils (Table 31.2) – over twice as much as the value of revenue funding from government sources (£88 million).

The largest Lottery awards to have been distributed by ACE to date were towards the creation of the New Art Gallery, Walsall; Baltic Flour Mill, Gateshead; the National Glass Centre, Sunderland; Tate Modern; and, the Lowry Centre, Salford – an arts centre which includes several galleries. Over half (54 per cent) of all ACE's capital funding for the visual arts went on the first four of these projects alone (Table 31.6).

In addition to these projects, the visual artists have benefited by the Lottery in three ways, through its funding of: artists' film and video; Arts for Everyone; and artists' commissions.

- According to the ACE, the publication of film production guidelines in 1997 specifically for artists' film and video represented the first 'real possibility for works of substance' to be commissioned from artists outside broadcasting. Given its failure to realise proposals for a Lottery-funded arts programme agency to take responsibility for the former film and video department's range of collaborative schemes with broadcasters, this is the only mechanism supporting innovative work for broadcast.
- Arts for Everyone provided one-off grants to small groups and established organisations for a range of projects, encouraging access to the arts, particularly amongst young people.
- One of the criteria for the ACE's capital programme required applicants to address 'the contribution of artists, craftspeople and film and video makers to their building projects' – a concept which built on 'percent for art' developed in the UK in the late 1980s (Selwood, 1995).

Table 31.2 Funding for the visual arts and crafts in the UK, 1993/94–1998/99

£ million

	1993/94	1994/95	1995/96	1996/97	1997/98	1998/99
Central government via the arts councils (a)						
ACGB/ACE	3.880	4.238	4.707	4.661	5.161	5.148
Scottish Arts Council	1.845	1.943	1.996	1.930	2.054	2.093
WAC/ACW	1.011	0.991	1.361	1.415	1.425	1.237
Arts Council of Northern Ireland	0.808	0.829	0.856	0.806	0.573	0.611
Crafts Council (b)	n/a	n/a	3.520	3.632	3.696	3.844
Regional arts boards (c)	7.893	8.323	8.928	9.346	9.667	10.311
Subtotal	*15.436*	*16.324*	*21.368*	*21.791*	*22.576*	*23.244*
National Lottery (d)						
Arts Council of England	n/a	n/a	21.240	47.951	67.652	20.278
Scottish Arts Council	n/a	n/a	1.822	8.930	3.134	1.688
Arts Council of Wales	n/a	n/a	2.287	2.324	1.942	2.237
Arts Council of Northern Ireland	n/a	n/a	0.026	0.283	0.711	0.653
Millennium Commission	n/a	n/a	0.000	1.599	0.000	0.000
Subtotal (e)	*n/a*	*n/a*	*25.376*	*61.086*	*73.439*	*24.856*
Local authorities (f)	n/a	n/a	n/a	n/a	n/a	n/a
Business sponsorship (g, h)	3.133	4.649	7.855	5.165	9.654	9.347
Total	18.570	20.973	54.599	88.042	105.669	57.446

Sources

ACGB/ACE annual report, various years; SAC annual report, various years; WAC/ACW annual report, various years; ACNI annual report, various years; RABs' annual reports and accounts; Lottery data supplied directly by the Arts Councils of England and of Wales; ACNI, *Annual Lottery Report,* various years; ABSA/Arts & Business *Business Support for the Arts/Business Investment in the Arts,* various years.

Notes

a) Expenditure on grants and guarantees for the visual arts, crafts, artists' film and video.

b) The Crafts Council changed its method of accounting in 1995/96. Previous figures for operational costs other than staff are not strictly comparable. The figures given in this table include grants as well as the Craft Council's own direct spending on exhibitions, library and photo store, craft development, etc.

c) Not including grants made by the Eastern Arts Board, which could not be identified by artform. These figures do not overlap with ACE funding.

d) These figures largely refer to capital funding. However, these include revenue funding which in the case of ACE is identified in the following table:

£ million

1993/94	1994/95	1995/96	1996/97	1997/98	1998/99
n/a	n/a	n/a	1.659	7.035	4.536

e) Of which the following amounts represent revenue funding: 1996/97, £1.659m; 1997/98, £7.035m; 1998/99, £4.536m.

f) Local authority expenditure on the visual arts and crafts could not be disaggregated from existing data.

g) Figures from the annual ABSA/Arts & Business survey. May overlap with matching funding for the DCMS sponsored Pairing Scheme.

h) Component of business sponsorship for arts and crafts capital projects:

£ million

1993/94	1994/95	1995/96	1996/97	1997/98	1998/99
–	0.165	0.442	0.088	0.107	1.161

By the close of the original ACE capital programme (see Chapter 16), a total of 2,021 projects had been funded on the basis of awards worth approximately £1 billion, excluding partnership funding (Annabel Jackson Associates, 1999). Although not all the projects funded are expected to be complete until 2004/05,

Table 31.3 Expenditure on visual arts and crafts by home country, 1993/94–1998/99

£ million

	1993/94	1994/95	1995/96	1996/97	1997/98	1998/99
England						
ACGB/ACE	3.880	4.238	4.707	4.661	5.161	5.148
Lottery (ACE and MC)	n/a	n/a	21.240	49.550	67.652	20.278
Local authorities	–	–	–	–	–	–
Business sponsorship	2.543	3.765	7.284	4.740	9.303	8.742
Regional arts boards	7.893	8.323	8.928	9.346	9.667	10.311
Wales						
WAC/ACW	1.011	0.991	1.361	1.415	1.425	1.237
Lottery (Arts Council of Wales)	n/a	n/a	2.287	2.324	1.942	2.237
Local authorities	–	–	–	–	–	–
Business sponsorship	0.087	0.129	0.046	0.008	0.301	0.279
Scotland						
Scottish Arts Council	1.845	1.943	1.996	1.930	2.054	2.093
Lottery (Scottish Arts Council)	n/a	n/a	1.822	8.930	3.134	1.688
Local authorities	–	–	–	–	–	–
Business sponsorship	0.202	0.217	0.268	0.166	0.045	0.260
Northern Ireland						
Arts Council of Northern Ireland	0.808	0.829	0.856	0.806	0.573	0.712
Lottery (Arts Council of Northern Ireland)	n/a	n/a	0.026	0.283	0.711	0.653
Local authorities	–	–	–	–	–	–
Business sponsorship	3.133	4.649	7.856	5.165	9.654	9.347
National/non-regional funding						
Business sponsorship	0.279	0.506	0.258	0.251	0.005	0.067

Source: Table 31.1.

it is estimated that the total value of artists' commissions they will have generated (both integral and stand-alone projects) will be around £70 million, including partnership funding. Thus, the visual arts will have received substantially more from the ACE's capital funds than Table 31.2 shows directly.

Table 31.4 Regional arts boards: expenditure on the visual arts, crafts, film and video, 1993/94–1998/99

£ million

	1993/94	1994/95	1995/96	1996/97	1997/98	1998/99
Eastern	n/a	n/a	n/a	n/a	n/a	n/a
South East	0.446	0.468	0.567	0.637	0.676	0.739
North West	1.251	1.231	1.200	1.256	1.342	1.398
West Midlands	0.729	0.710	0.637	0.709	0.760	0.600
East Midlands	0.468	0.521	0.551	0.528	0.529	0.566
South West	0.586	0.593	0.674	0.719	0.820	0.834
Southern	0.517	0.522	0.547	0.599	0.617	0.626
Yorkshire & Humberside	0.972	1.009	1.076	0.986	1.155	1.267
Northern	1.523	1.504	1.916	2.123	1.905	2.358
London	1.401	1.765	1.761	1.789	1.862	1.925
Total	7.893	8.323	8.928	9.346	9.667	10.311

Source: RABs annual reports.

Table 31.5 Business sponsorship of visual the arts by English RAB area and home country, 1993/94–1998/99 (a)

£ million

	1993/94	1994/95	1995/96	1996/97	1997/98	1998/99
England						
East	0.072	0.048	0.030	0.007	0.000	0.003
East Midlands	0.023	0.016	0.001	0.009	0.016	0.018
London	1.976	3.057	5.799	4.310	7.053	6.590
North West	0.081	0.172	0.074	0.012	0.136	0.059
Northern	0.039	0.018	0.699	0.125	0.014	0.026
South East	0.034	0.015	0.005	0.036	0.022	0.243
South West	0.047	0.157	0.045	0.039	0.089	0.090
Southern	0.064	0.090	0.031	0.018	0.050	0.017
West Midlands	0.132	0.060	0.432	0.041	1.417	0.059
Yorkshire & Humberside	0.075	0.131	0.170	0.142	0.506	1.639
Total England	*2.543*	*3.765*	*7.284*	*4.740*	*9.303*	*8.742*
Scotland	0.202	0.217	0.268	0.166	0.045	0.260
Wales	0.087	0.129	0.046	0.008	0.301	0.279
Northern Ireland	0.022	0.032	0.0002	0.000	0.000	0.000
National funding/other	0.279	0.506	0.258	0.251	0.005	0.067
Total United Kingdom	3.133	4.649	7.856	5.165	9.654	9.347

Source: ABSA/Arts & Business *Business Support for the Arts/Business Investment in the Arts*, various years.

Note: a) This may include figures for the Pairing Scheme. A similar regional breakdown for the Pairing Scheme is not available.

Artists' earnings

Research carried out into artists' career paths, earnings and employment and tax status indicates: multiple job-holding; an imbalance between artistic and non-artistic work; relatively low levels of income from artistic practice; and a paucity of commissions, awards, bursaries and residencies. While this multifaceted nature of artists' work patterns has conventionally been perceived as problematic, Summerton (undated) has suggested that there is evidence of preference within the constituency for 'a kaleidoscopic portfolio' of work.

Unfortunately, national statistics on employment and earnings are of little use in assessing how much fine artists earn. Information about this group is aggregated with that about other kinds of practitioners and in practical terms cannot be disaggregated because the sample would be too small and unreliable.

According to the standard occupational classification, in 1995 artists, commercial artists and graphic designers in full-time employment earned an average of £366.2 per week, £19,042 per year (see Chapter 23). Those who were self-employed and worked full-time earned less than half that (Selwood and Dunlop, 1998). According to ad hoc studies of visual artists, they earned even less.

By comparison with the official statistics, the data produced by one-off studies tend to be less accurate. They are typically based on smaller samples, usually focus on artists who have some relationship with the funding system and only refer to particular geographical areas. Much of the data available (published since Casey et al., 1996) refers to the mid-90s. However, the advantage of such studies is that they provide more focused data.

Table 31.6 Largest capital visual arts awards made by the Arts Council of England, 1994/95–1998/99

	ACE award (£ million) funding	Partnership (£ million)	Total (£ million)	ACE award (a) visual arts capital 1995–1999
New Gallery, Walsall	15.75	9.48	25.23	12.33
Gateshead MBC: Baltic Flour Mill	40.905	18.16	59.065	32.02
National Glass Centre, Sunderland	5.951	5.48	11.431	4.66
Tate Modern (b)	6.2	6.579	12.779	4.85
Total				53.86

Source: ACE, annual review: National Lottery Report, 1999.

Note:
a) as % of its visual arts capital spend of £127.761 million.
b) Tate's accounts provide a total of £134.5m, made up as follows: Millennium Commission, £50m; ACE £6.2m; English Partnerships, £12m; donations, £47.85m; finance and other benefits £18.45m.

The reports by Shaw and Allen (1997) and Baker Tilly (1997) on behalf of the National Artists Association are the most detailed investigations into artists' economic circumstances since the Brighton and Pearson report of 1985. They suggest that little has changed in the intervening decade. Artists have continued to earn substantially less than the average wage from all their sources of income; they hold one or more other jobs usually unconnected to their artistic practice; and are likely to be financially supported by, if not dependent upon, a partner.

Shaw and Allen's (1997) findings are based on responses from 523 individual artists and 69 exhibition organisers and refer to the 1994/95 financial year. They found that the average artist's annual income was £7,590 – a sum which refers to artists' total earnings, including income from non-artistic sources. The average for manual workers in Britain at that time was £17,148 (New Earnings Survey, April 1995, cited by O'Brien, 1997). Around two-thirds of artists earned less than £10,000, and over one third earned less than £5,000. Moreover, artists can expect to see only a gradual increase in their earnings the longer they remain in the labour force. A year and a half after graduation, a third earned less than £5,000, whereas for those who had graduated between two and a half and three and a half years previously, only a quarter earned less than £5,000.

Most artists are self-employed and finance periods of production themselves (Honey et al., 1997, based on 1996 research). Fewer than half (47 per cent) work full-time at their principal artistic activity. Only about 10 per cent derive all their income from artistic work; about 60 per cent earned less than half their income from it; and nearly 39 per cent earned nothing from it (O'Brien, 1997; Scottish Arts Council, 1995). On average, the amount that artists earn from their artistic practice is very low – around £1,746 (O'Brien, 1997).

Artists' two most important sources of income are teaching and work unrelated to their practice, even though they tend to regard exhibitions, sales and commissions as vital to their professional status. Yet, despite the arts funding system's rhetoric that by funding galleries they are benefiting artists, this tends not to be manifest in fees – 'the market has become reliant on low fees and payments to

Table 31.7 Sources of artists' income, 1994/95

	1 (highest)	2	3	4	5	6	7	8	9	10 (lowest)	Total	Rank
	Degree of importance attributed to each source of income by number of respondents											
Private sales	40	58	71	50	21	12	4	5	7	10	278	1
Sales at exhibitions	38	67	54	41	16	14	7	11	6	11	265	2
Teaching	108	35	36	21	8	9	8	7	6	8	246	3
Private commission	32	41	51	28	16	12	7	2	1	11	201	4
Workshops/residencies/ community arts projects	36	50	22	26	20	7	8	7	1	10	187	5
Commissions for public places	38	24	12	9	7	5	6	3	60	16	180	6
Work unrelated to artistic practice	83	30	12	22	12	6	2	2	1	9	179	7
Grants/awards	29	29	20	18	19	7	7	4	2	9	144	8
Fees for exhibitions	5	6	19	17	23	8	3	6	6	23	116	9
Management of exhibitions/comm- issions/events	7	8	5	4	8	8	2	5	0	16	63	10
Gallery stipends/ retainers	4	4	5	5	3	1	0	0	3	21	46	11

Source: Shaw and Allen, 1997.

Base: 523 artists and 69 exhibition organisers.

artists' (LAB, 1998). Between 1993 and 1996, 72 per cent of artists had never received a fee from a publicly funded space. The average gross income from an exhibition in a public space was £143 (excluding Exhibition Payment Rights, which had effectively ceased operation as a national scheme by 1997, materials and expenses). In terms of commissions: the median fee was £500 (with the lowest being £70 and the highest being £75,000). Only 26 per cent of artists received a design or concept fee for a public-sector commission and just under half had received a designated budget for materials and expenses. On average, artists received £250 from sales in commercial galleries (Shaw and Allen, 1997). Grants and awards for artistic work, also indicators of esteem, rank about eighth in terms of the importance of the contribution they make to artists' income (Table 31.7).

Artists' incomes from Lottery projects should have improved through recommended professional rates of fees and payments advocated by the National Artists Association and ACE and which are required by the Lottery as part of the application procedure. However, as yet, no data are available on the amounts artists have received in fees. Although the large-scale, stand-alone commissions (such as Anthony Gormley's *Angel of the North*) have tended to receive the most publicity, the majority of funding has gone to the crafts sector —benefiting 'makers' rather than 'fine artists' (Ben Heywood, ACE, correspondence with the author).

For their part, artists' descriptions of their careers point to the fact that making money is not the driving force behind making work. Nor is the amount of money earned as a result of artistic practice necessarily seen as signifying success (Baker Tilly, 1997; Douglas and Wegner, 1996; Honey et al., 1997; Shaw and Allen, 1997).

A significant proportion of the artists surveyed had a relatively low level of interest in, or awareness of, the business side of their profession. In many ways, this is compounded by their relative poverty and desperation to have their work shown, which in turn reduced their bargaining power and self-confidence. Many artists indicated that they are prepared to work 'for little, nothing, or at a loss', to have their work seen.

(La Valle et al., 1997)

A standard reflex is for visual arts funders to argue the case for more money for artists. But whereas funding from foundations, like the Paul Hamlyn Foundation's Awards for Artists, has few if any conditions attached to it, support from public funding bodies is more accountable. The ACE and the regional arts boards are currently working on a visual artists action plan. In 1998, the London Arts Board consulted artists about a proposed artists' initiative scheme (Etches, 1998), characterised by key grants being tied to the development of secure, affordable and accessible studio space and an information service for London artists.

Given its inability to supplement artists' incomes directly, much of the ACE's efforts in the late 1990s were dedicated to lobbying to protect artists' social security benefits. The New Deal announced in 1997 affected artists up to the age of 24 (a group which includes young graduates) who support their creative work by signing on. As the most vociferous objectors to the government's Welfare to Work programme suggest, the New Deal potentially cuts off the 'life-blood' of our creative future (Alan McGee cited by O'Rorke, 1998). It becomes an option after claimants have been on full benefits for six months. At this point, they are offered various options – subsidised employment, voluntary placement, a position with the Environmental Task Force, full-time training and education – which the ACE argued 'would do nothing for their career development and prevent them from creating work' (Donagh, 1998). It was not until 2001 that DCMS proposed extending the New Deal for Musicians to other creative careers (DCMS, 2001: 27).

Audiences

There are virtually no data on audiences for the visual arts. ACE data taken from the Target Group Index Survey conflate attendances at art galleries and art exhibitions. It suggests that 8.3 million people (21 per cent of the population) attended art galleries and exhibitions in 1998/99. However, this figure duplicates much of what is covered by the museums and galleries data (see Chapter 28). But, in effect, no figure is attributable to what the arts funding system supports, namely the contemporary visual arts.

Data on visual arts audiences are even more complicated by the fact that visual arts venues tend to be free. The figures for visits to non-charging venues are generally inflated and notoriously inaccurate (Chapter 28). Consequently, it is unclear how much credibility to attach to the increases in audiences reported by ACE and the regional arts boards' regularly funded organisations (Chapter 33).

Over the period considered in this chapter, the ACE had at least two initiatives which were intended to consider the development of visual arts audiences: its research into public attitudes to the Year of Visual Arts in the North of

England, and New Audiences. Unfortunately, neither throws any light on the national picture. New Audiences was a £5 million programme, launched by the Secretary of State for Culture, Media and Sport in September 1998, intended to help to deliver access for all and 'bring new art to new people'. The evaluation of the Year of Visual Arts (Harris Research Centre, 1998) specifically identified awareness of the year of visual arts rather than producing any overview of the size of the visual arts audience or its profile.

32
Survey Findings

Sara Selwood, University of Westminster

This chapter comprises three sections. The first presents an overview of the 1998/99 returns of a survey of organisations in the cultural sector carried out specifically for this volume. It describes: the number of respondents; their location; their total income, including the value of their public subsidies; and their expenditure. The second section analyses the survey results by artform and heritage area, and the final section compares a constant sample or organisations responding both to this survey and to another covering the same data from five years before.

Overview

Respondents' characteristics

The population identified for the survey consisted of a core of 7,920 organisations, of which just under one third (2,429) were surveyed (see Appendix 2 for the survey methodology). A further 61 organisations which had made returns to Casey et al's 1996 survey but which were not found listed among funders' grant schedules were also added. Data were received for 1,272 organisations (51 per cent of the sample). The number of sites and venues included among the returns is, however, actually higher than this suggests because in some cases, particularly the national museums and galleries, the annual accounts from which data were collected cover several institutions.[1]

Tables 32.1 and 32.2 provide breakdowns of these returns by artform and heritage activity, and by region. The detailed activity categories were collapsed to provide larger samples (as in Casey et al., 1996). The relationship between the original and the collapsed categories is shown in Table 32.1. At least three-quarters of respondents were based in England (Table 32.2). London and the South East accounted for nearly a third of all respondents.

1 For example, the return from the National Galleries of Scotland covers the National Gallery of Scotland, the Scottish National Portrait Gallery, the National Gallery of Modern Art and the Dean Gallery, as well as its outstations at Paxton House, Berwickshire, and Duff House, Banff.

Table 32.1 Returns by artform and heritage activity, 1998/99

Returns by original category	Number	(%)	Collapsed categories	Number	(%)
Visual arts			Visual arts	131	(10)
Architecture	2	(*)			
Multimedia	8	(1)			
Visual arts	121	(10)			
Combined arts			Combined arts	260	(20)
Arts centres	38	(3)			
Festivals	35	(3)			
Combined	187	(15)			
Built heritage	76	(6)	Built heritage	76	(6)
Performing arts			Performing arts	507	(40)
Ballet	6	(0)	Dance	69	(5)
Other dance	63	(5)			
Drama	219	(17)	Drama	219	(17)
Opera	32	(3)			
Music	219	(17)	Music	219	(17)
Orchestra	52	(4)			
Other music	135	(11)			
Libraries and literature			Libraries and literature	64	(5)
Library	16	(1)			
Literature	48	(4)	Literature	48	(4)
Film and video (a)	40	(3)	Film and video (a)	40	(3)
Museums and galleries	165	(13)	Museums and galleries	165	(13)
Services	29	(2)	Services	29	(2)
Total	1,272	(100)		1,272	(100)

Base: 1,272 responses drawn from annual accounts, short questionnaire and ACE/RAB data.

Note: a) ACE/RAB data also include broadcasting.

Income and expenditure

Respondents' combined turnover was £1,746 million (Table 32.3), just over half the total funding to the sector identified above in Table II.1 (minus the BBC licence fee).

Over half (55 per cent) of respondents' combined income (£951.8 million) consisted of public subsidies – funding from central government, the arts funding system (the arts councils and the regional arts boards), local authorities and Europe, the Lottery and various 'specialist' funders (such as English Heritage, the British Film Institute and the Museums & Galleries Commission). Respondents generated the remaining 45 per cent of their income (£794.3 million) from earnings and unearned and private-sector sources.

Whereas a third of funding to the sector was capital (see Table II.6 above), capital income accounted for only one-tenth of survey respondents' turnover. Overall, respondents' income exceeded their expenditure by £76 million. However, this is not a long-term surplus.

Table 32.2 Returns by home country and government office region, 1998/99

	Number	(%)
England		
East of England	103	8
East Midlands	57	4
London	249	20
North East	50	4
North West	100	8
South East	151	12
South West	127	10
West Midlands	69	5
Yorkshire & the Humber	98	8
Total England	*1,004*	*79*
Northern Ireland	20	2
Scotland	129	10
Wales	118	9
Total	1,271	100

Base: 1,272 responses drawn from annual accounts, short questionnaire and ACE/RAB data.

A breakdown of the income and expenditure data collected from 1,034 organisations (81 per cent of the respondents) provides a rather more elaborate picture of the relationship between the different components of the sector's income and expenditure (Table 32.4). The overall picture shown in Table 32.4 concurs with that of the larger group of respondents shown in Table 32.3. However, the percentage of Lottery income shown in 32.4 is about twice that shown in Table 32.3. This suggests that Lottery funding was most likely to go to organisations with larger incomes which is a characteristic of the organisation whose accounts were used in Table 32.4.

The organisations in Table 32.4 committed half their combined expenditure on direct costs associated with their public programmes (their main programmes and education programmes). They spent seven times as much on their main

Table 32.3 Headline income and expenditure figures for all respondents, 1998/99

	£ thousand
Public subsidy	
Arts councils and RAB subsidy	194,380
Local authority	72,690
Lottery	121,104
Central government	62,032
Specialist funder	5,536
European funding	7,275
Other public subsidy	38,965
Subtotal	*951,748*
Total income	1,746,055
of which total capital income	174,359
Total expenditure	1,669,913

Base: 1,272 organisations drawn from annual accounts, short questionnaire and ACE/RAB data.

Note

Subtotals and totals may not always appear to add up to the sum of their constituent parts. This reflects missing values within sub-categories of funding.

Table 32.4 Breakdown of respondents' income and expenditure, 1998/99

£ thousand

	Income
Earned income	483,601
Public subsidy	
Arts councils and RAB	185,139
Local authority	66,095
Lottery	211,996
Central government	11,930
Specialist funder	5,228
European funding	7,033
Other public subsidy	33,414
Subtotal	*908,358*
Private and unearned income	
Sponsorship	23,403
Trusts, donations etc	66,261
Memberships	7,866
Investments	74,770
Subtotal	*219,767*
Total income	1,634,176
of which, total capital income	124,056

	Expenditure
Programme of activities	
Main programme costs	528,628
Education programme costs	72,298
Subtotal	*707,042*
Administrative costs	
Marketing costs	38,454
Staff costs	222,506
Overheads	142,441
Subtotal	*438,377*
Capital costs	194,212
Any other expenditure	81,659
Total expenditure	1,555,773
Deficit (a)	105,911
Surplus (a)	184,216

Base: 1,034 organisations drawn from annual accounts and ACE/RAB data.

Notes
a) Surpluses were recorded by 541 organisations, and deficits by 474. Subtotals and totals may not always appear to add up to the sum of their constituent parts. This reflects missing values within sub-categories of funding.

programmes as on their education programmes. Half their administrative costs were accounted for by staff costs, and a third by overheads.

The size of survey respondents' annual incomes varied enormously, ranging from those with over £1 million to those with less than £1,000. The majority (60 per cent) had incomes of £100,000 or more (Table 32.5); about 25 per cent had incomes over £500,000. At the other extreme, 29 per cent operated on less than £50,000 per year.

Table 32.5 Number of survey respondents, by size of income, 1998/99

Income (£)	Number	(%)
1m+	206	(16)
500,000–999,999	107	(8)
100,000–499,999	457	(36)
50,000–99,999	148	(12)
25,000–49,999	99	(8)
10,000–24,999	84	(7)
5,000–9,999	77	(6)
1,000–4,999	83	(7)
under 1,000	11	(1)
Total	1,272	(100)

Base: 1,272 organisations drawn from annual accounts, short questionnaire and ACE/RAB data.

Only a relatively small percentage of respondents' income has been identified as capital. The figures shown in Table 32.6 provide a breakdown of different public sources of capital funding, which is almost exclusively associated with Lottery funding from the arts councils and the Heritage Lottery Fund.

A common assumption about the Lottery is that the distribution of Lottery funding (capital funding in particular) was concentrated in London and the South East. This was certainly the case amongst survey respondents, with London and

Table 32.6 Breakdown of capital income from public sources, 1998/99

	£ thousand
Central government:	
DCMS, WO, SO, NIO	10,668
Other government departments	19,603
Arts councils	864
Specialist funders (a)	379
RABs	1
Local authorities	975
Lottery distributors (b)	
Arts councils	100,213
Heritage Lottery Fund	23,091
Subtotal	138,571
Lottery partnership funding (c)	15,267
European funders	114
Other public subsidy	3,184
Total capital income	174,359

Base: 1,272 organisations drawn from annual accounts, short questionnaire and ACE/RAB data.

Notes
a) The only returns pertained to heritage and collections funders.
b) No income was recorded from the Millennium Commission or the National Lottery Charities Fund.
c) This category refers only to the 425 returns from the ACE/RAB survey. The inclusion of this category assumes that partnership funding is from public sources.
Subtotals and totals may not always appear to add up to the sum of their constituent parts.
This reflects missing values within sub-categories of funding.

Table 32.7 Breakdown of capital income from public sources by region and home country, 1998/99

	East of England	England (%) London	North East	North West	South East	South West	West Midlands	Yorkshire & Humberside	Northern Ireland (%)	Scotland (%)	Wales (%)	Total (£ thousand)
Central government:												
DCMS, WO, SO, NIO	0	75	8	3	0	0	7	1	0	3	2	10,668
Other govt depts	0	54	0	0	0	0	0	0	0	46	0	19,603
Arts councils	0	80	0	0	14	0	0	2	0	0	4	864
Specialist funders (a)												
Heritage	0	0	0	88	0	0	0	0	0	12	0	351
Collections	0	0	0	50	0	7	2	36	0	7	0	28
RABs	0	0	0	0	100	0	0	0	0	0	0	1
Local authorities	0	69	0	1	1	20	0	0	0	8	0	975
Lottery distributors: (b)												
Arts councils	4	66	0	16	1	1	12	0	0	0	0	100,213
Lottery partnership (c)	5	22	0	32	1	2	35	3	0	0	0	15,267
Heritage Lottery Fund	0	52	0	0	6	4	0	1	0	37	0	23,091
Subtotal	*3*	*5*	*0*	*15*	*2*	*1*	*12*	*1*	*0*	*6*	*0*	*138,571*
European funders	0	0	0	38	0	0	0	54	0	0	9	114
Other public subsidy	3	18	3	1	27	1	2	14	0	20	11	3,184
Total capital income (%)	3	59	1	13	2	1	10	1	0	11	0	174,359
No of organisations	103	249	50	100	151	127	69	98	20	129	119	1,272

Base: 1,272 organisations drawn from annual accounts, short questionnaire and ACE/RAB data.

Note
a) These include, for example, English Heritage, BFI, Museums & Galleries Commission etc.
b) No income was recorded from the MC/NLCF.
c) This applies only to the 425 responses from the ACE/RAB survey.

Table 32.8 Types and sizes of employment categories, 1998/99

	Permanent	Freelance	Volunteer
Number	26,035	8,757	7,609
Mean	25.18	8.47	7.36

Base: 1,034 organisations drawn from annual accounts and ACE/RAB data.

the South East accounting for nearly 60 per cent of capital income from public sources (Table 32.7).

Employment

Grossing up the data available on the number of people employed in respondents' organisations in 1998/99 (Table 32.8) to the total population of the subsidised sector identified for the survey (7,920 organisations) suggests around 198,000 permanent employees, 63,360 freelance or contract staff, and 55,440 volunteers. Comparisons cannot be drawn with the findings in Chapter 23 above on employment in the cultural sector, given the differences in the definitions used and the fields covered.

Comparisons between regularly funded and other funded organisations

Comparing the organisations regularly funded by the Arts Council of England and the regional arts boards (ACE/RABs) with other arts organisations which were captured by the survey not only extends our knowledge about the subsidised sector beyond the confines of arts funding system, but also serves to contextualise the data presented in Chapter 33 below.

ACE/RAB regularly-funded organisations have larger incomes than the other organisations surveyed (as a comparison between Table 32.9, and Table 32.5 suggests). The vast majority (84 per cent) have annual incomes of over £100,000. Just over 2 per cent attract less than £25,000. The sector as a whole is much more diverse.

Table 32.9 Arts Council of England and regional arts boards' respondents, by size of income, 1998/99

Income (£)	Number	(%)
1m+	84	(20)
500,000–999,999	49	(12)
100,000–499,999	215	(51)
50,000–99,999	50	(12)
25,000–49,999	19	(4)
10,000–24,999	8	(2)
5,000–9,999	0	(0)
1,000–4,999	0	(0)
under 1,000	0	(0)
Total	425	(100)

Table 32.10 Comparison between regularly funded and other funded arts organisations: income and expenditure, 1998/99

£ thousand (mean)

	ACE/RAB regularly funded organisations	Other funded organisations
Income		
Earned income	472	465
Public subsidy		
Arts councils and RABs	359	54
Local authority	75	56
Lottery	264	164
Central government (a)	–	20
Specialist funder (a)	–	9
European funding (a)	–	12
Other public subsidy (a)	17	43
Recorded subtotal	*714*	*993*
Private and unearned income		
Sponsorship	39	12
Trusts, donations etc	34	85
Memberships	–	13
Investments	39	96
Recorded subtotal	*111*	*284*
Total recorded income	1,297	1,778
Expenditure		
Programme of activities		
Main programme costs	424	572
Education programme costs	51	83
Recorded subtotal	*474*	*830*
Administrative costs		
Marketing costs	51	28
Staff costs	363	112
Overheads	157	124
Recorded subtotal	*571*	*321*
Capital costs	429	19
Any other expenditure	–	134
Total recorded expenditure	1,474	1,526
Surplus/deficit (b)	51.14/(331)	100/(472)
Number of respondents	425	609

Base: 1,034 literature, film and video, visual arts, combined and perfoming arts organizations.

Notes

a) ACE/RAB data do not disaggregate details of income from central government, specialist funders or Europe. These are shown uner 'other public subsidy'.

b) For the ACE/RAB-funded organisations, surpluses were recorded by 169 organisations and deficits by 254. For the other funded organisations, surpluses were recorded by 220 respondents and deficits by 372.

Subtotals and totals may not always appear to add up to the sum of their constituent parts. This reflects missing values within sub-categories of funding.

Table 32.10 provides a rather better basis for comparison, in that both columns refer specifically to arts organisations – combined arts, performing arts, literature, visual arts, film and video companies. As suggested above, only a relatively small percentage of respondents' income overall was identified as capital. Within this context the comparison between the ACE/RAB regularly funded organisations and other funded organisations is, nevertheless, striking. ACE/RAB organisations were likely to receive two-thirds more Lottery income, most of which would have been capital funding, than other organisations. Table 32.10, thus, supports the common assumption that the non-strategic policies which characterised the first years of the arts-capital programme meant that organisations already supported by the arts funding system were the most likely to receive funding from the arts councils (see Chapter 16 above).

There are other differences between these two groups of organisations.

- ACE/RAB clients are more likely to be dependent on their primary funder (in this case the ACE or the RAB) for the majority of public subsidy. Non-ACE/RAB organisations show evidence of attracting a larger percentage of their support from a variety of funders.
- ACE/RAB-funded companies appear to be more successful at raising sponsorship (which accounts for over a third of all their income from private and unearned sources). This may reflect the fact that the sample contains high-profile national companies, such as the Royal Opera House, the Royal Ballet and the Royal National Theatre. The other group of organisations appears better at raising support from trusts and foundations.
- ACE/RAB organisations' administrative costs account for a larger percentage of their expenditure than their programme costs. Their average staff costs are over three times those of other organisations. Non-ACE/RAB-funded organisations are more likely to spend more on their programmes of activity.
- In terms of employment, ACE/RAB arts organisations appear to involve far more people than other organisations. They are far more likely to employ freelance staff and volunteers, in particular (Table 32.11).

Table 32.11 Comparison between regularly funded and other funded arts organisations: employment, 1998/99

			Number of employees
	Permanent	Freelance	Volunteer
ACE/RAB organisations (425)			
Number	9,290	8,211	4,496
Mean (including 0s)	22	19	11
Other organisations (609)			
Number	16,745	546	3,113
Mean (including 0s)	28	1	5

Base: 1,034 literature, film and video, visual arts, combined and perfoming arts organisations.

Table 32.12 Returns by region and home country, by type of activity, 1998/99

Percentages

Government office region	Visual arts	Comb arts	Built herit	Perf arts	Lit/ Lib	Film	Mus & gal	Services
England								
East of England	8	10	8	7	13	8	6	7
East Midlands	5	5	3	4	0	5	7	3
London	22	14	12	25	26	20	14	17
North East	5	3	5	5	3	3	1	7
North West	8	11	8	7	10	8	7	0
South East	12	14	20	11	11	5	10	17
South West	10	11	14	9	5	13	11	3
West Midlands	6	5	1	5	2	15	7	10
Yorkshire & the Humber	8	5	4	8	10	5	12	10
Total England	*83*	*78*	*75*	*81*	*78*	*80*	*76*	*75*
Northern Ireland	1	3	3	1	2	3	1	10
Scotland	5	9	16	9	11	15	15	14
Wales	12	9	7	10	11	3	8	3
Total	101	99	101	101	102	101	1	102
Number of respondents	131	260	76	507	64	40	165	29

Base: 1,272 responses drawn from annual accounts, short questionnaire and ACE/RAB data.

Note: Figures may not add up to 100 because of rounding.

Survey results by artform and heritage activity

Geographical distribution

London and the South East fairly consistently boast the highest percentage of returns in any area of activity (Table 32.12). However, a relatively large percentage of responding museums and galleries are based in Yorkshire and the Humber, and Scotland, and a relatively large percentage of built heritage organisations are based in Scotland. A combination of the scale of funding available in those locations, and the sheer number of classified sites and buildings in Scotland, is likely to account for this. (See, for example, Table 28.5 and Babbidge (2001) for museum funding; Table 24.5 on built heritage.)

Income and expenditure

Table 32.13 compares various artforms and heritage activities' share of the total income and expenditure identified. Performing and combined arts companies jointly account for over 40 per cent of all the public subsidy and income accounted for by survey respondents. They also account for nearly 50 per cent of the expenditure. Drama companies have the largest single share of income and expenditure.

The size of organisations' incomes varied considerably, even within individual arts and heritage categories. This is indicative of the wide-ranging nature of the survey (see Appendix 2). As many as 20 per cent of performing arts organisations and nearly 25 per cent of museums and galleries had turnovers of over £1 million (Table 32.14). At the other end of the scale, the turnovers of nearly 25 per cent of

Table 32.13 Headline income and expenditure figures for all respondents, by type of activity, 1998/99

	Visual arts	Comb arts	Built herit	Perf arts	Lib/ Lit	Film	Mus & gals	Services	Total (%)	Total (£ thousand)
	Activity (percentage)									
Public subsidy	3	7	6	32	11	1	39	0	100	1,001,850
Total income	4	8	7	35	10	1	35	0	100	1,746,055
Total capital income	8	6	18	53	0	0	14	0	100	174,359
Lottery capital income	10	7	8	66	0	0	9	0	100	138,571
Total expenditure	4	9	6	40	10	1	30	0	100	1,669,913
Number of respondents	131	260	76	507	64	40	165	29	1,272	

Percentage

	Performing arts		
	Dance	Drama	Music
Public subsidy	7	14	11
Total income	6	17	12
Total capital income	21	18	14
Lottery capital income	27	23	16
Total expenditure	7	17	16
Number of respondents	69	219	219

Base: 1,272 responses drawn from annual accounts, short questionnaire and ACE/RAB data.

visual arts, performing arts and literature organisations were under £25,000. Across the board, respondents were most likely to have incomes of between £100,000 and £499,999.

A breakdown of respondents' income and expenditure (Table 32.15) illustrates the complexities of subsidised performing arts organisations (as referred to in Chapter 19). These companies not only account for the largest percentage of income earned by respondents, but also for the vast majority of public subsidies from the arts councils and the regional arts boards, local authorities and the Lottery and sponsorships. They also account for the most capital expenditure.

Table 32.15 implies that built heritage account for a very small share of the cultural sector's income and expenditure. This is misleading. Responses from the

Table 32.14 Respondents by size of income and type of activity, 1998/99

Percentage

	Visual arts	Comb arts	Built heritage	Perf arts	Lib/ Lit	Film	Mus & gals	Services
1m+	10	12	17	20	14	3	24	3
500,000– 999,999	10	10	12	7	6	15	8	3
100,000–499,999	37	45	30	33	34	58	24	55
50,000– 99,999	15	13	13	9	14	3	14	10
25,000– 49,999	8	6	14	7	9	5	11	10
10,000– 24,999	5	5	8	8	3	3	7	10
5,000–9,999	5	5	3	7	3	8	9	3
1,000–4,999 (a)	10	3	3	8	11	8	4	3
Under 1,000 (a)	3	0	0	1	5	0	0	0
Total	100	100	100	100	100	100	100	100
Number of respondents	131	260	76	507	64	40	165	29

Base: 1,272 organisations drawn from annual accounts and ACE/RAB data.

Table 32.15 Breakdown of respondents' income and expenditure, 1998/99

	Visual arts	Comb arts	Built herit	Perf arts	Literature	Film	Mus & gals	Services	Dance	Drama	Music	Total (%)	Total (£ thousand)
Income													
Earned income	5	9	9	49	8	1	19	0	5	28	16	100	483,601
Public subsidy													
Arts councils and RABs	7	13	0	78	1	1	1	0	17	28	33	100	185,139
Local authority	5	23	4	52	1	1	14	1	5	32	15	100	66,095
Lottery	6	6	3	44	1	0	40	0	18	13	13	100	211,996
Central government	0	2	28	2	2	0	65	2	0	2	0	100	11,930
Specialist funder	2	8	27	9	3	10	37	4	0	9	0	100	5,228
European funding	10	62	4	2	0	4	15	3	0	1	1	100	7,033
Other public subsidy	5	22	9	23	2	4	34	0	1	12	10	100	33,414
Subtotal	*3*	*7*	*3*	*34*	*13*	*1*	*38*	*0*	*8*	*15*	*11*	*100*	*908,358*
Private and unearned income													
Sponsorship	5	14	1	71	3	1	4	0	8	26	37	100	23,403
Trusts, donations etc	7	8	9	21	16	0	39	0	2	8	11	100	66,261
Memberships	35	27	3	12	2	0	9	13	0	5	6	100	7,866
Investments	9	6	12	19	4	0	50	1	1	15	3	100	74,770
Subtotal	*7*	*7*	*7*	*22*	*6*	*0*	*49*	*1*	*2*	*10*	*10*	*100*	*219,767*
Total income	4	8	5	37	10	1	34	0	6	18	12	100	1,634,176
of which, total capital income	11	8	2	75	0	0	2	0	30	26	19	100	124,056
Expenditure													
Programme of activities													
Main programme costs	5	9	3	40	4	1	38	1	4	21	14	100	528,628
Education programme costs	3	5	23	28	1	1	39	0	4	12	12	100	72,298
Subtotal	*4*	*9*	*7*	*35*	*3*	*1*	*40*	*1*	*4*	*19*	*13*	*100*	*707,042*

Table 32.15 *continued*

Activity (percentage)	Visual arts	Comb arts	Built herit	Perf arts	Literature	Film	Mus & gals	Services	Dance	Drama	Music	Total (%)	Total (£ thousand)
Administrative costs													
Marketing costs	7	14	4	50	4	1	17	1	8	26	16	100	384,454
Staff costs	9	12	2	59	6	1	10	0	10	26	23	100	222,506
Overheads	5	11	7	43	4	2	27	1	7	21	15	100	142,441
Subtotal	*7*	*12*	*5*	*50*	*5*	*1*	*20*	*1*	*8*	*23*	*18*	*100*	*438,377*
Capital costs	7	5	0	81	0	0	6	0	25	17	39	100	194,212
Any other expenditure	0	4	2	3	0	0	90	0	0	2	2	100	81,659
Total expenditure	5	8	5	41	11	1	29	0	7	17	17	100	1,555,773
Number of respondents	104	206	70	411	52	34	130	27	61	185	165	1034	1,034

Base: 1,034 organisations drawn from annual accounts and ACE/RAB data.

Table 32.16 Value of capital income from public sources, by type of activity, 1998/99

	Activity (percentage)								
	Visual arts	Comb arts	Built herit	Perf arts	Lit/Lib	Film	Mus & gals	Services	Total (£ thousand)
Central government									
DCMS, WO, SO, NIO	0	3	88	0	2	0	7	0	10,668
Other govt depts	0	0	54	0	0	0	46	0	19,603
Arts councils	0	41	0	57	0	0	2	0	864
Specialist funders	0	0	95	0	0	0	8	0	369
RABs	0	0	0	100	0	0	0	0	1
Local authorities	0	8	9	63	0	0	21	0	975
Lottery distributors									
Arts councils	0	44	0	53	0	0	3	0	249
Heritage Lottery Fund	0	0	47	0	0	0	53	0	23,091
MC/NLCB	0	0	0	0	0	0	0	0	0
Subtotal	*0*	*0*	*0*	*0*	*0*	*0*	*0*	*0*	*23,340*
European funders	0	0	38	0	0	0	54	9	114
Other public subsidy	0	3	10	19	1	0	66	0	2,832
Total capital income	0	953	31,590	1,814	196	10	24,203	10	58,776
Capital income as % of total income	0	2	54	3	0	0	41	0	100
Number of organisations	71	152	76	291	38	25	165	29	847

Base: 847 organisations drawn from annual accounts and short questionnaire.

National Trust and the National Trust for Scotland were deliberately excluded from the analysis, because neither organisation disaggregates built heritage and natural heritage in their accounts, and any attempt to do so on our part would be inaccurate. The National Trust's income was £182.4 million and its expenditure, £151.8 million; the National Trust for Scotland's income was £25 million and its expenditure £22.3 million. Neither organisation would commit to a detailed breakdown, but the National Trust's estimate is that around two-thirds of its finances can be attributed to the built heritage. The National Trust for Scotland puts it at more like 50 per cent (personal communications).

Museums and galleries and the built heritage were the main recipients of capital funding amongst survey respondents. Table 32.16 demonstrates that explicitly, with the former accounting for over 40 per cent and the latter for over 50 per cent of the total amount identified. The only other activities amongst survey respondents with significant capital income were combined and performing arts. Visual arts respondents recorded no capital income whatsoever.

The rest of this section considers survey findings on the distribution of various sources of:

- income – public subsidy, earned income (box office, merchandising and trading), private-sector income (from membership, donations, investment, other income and sponsorships); and
- expenditure – programme costs, administration costs (staff, marketing and other overheads), staff costs and capital spend.

Table 32.17 Public subsidy as percentage of respondents' total income by type of activity, 1998/99

Percentage	Visual arts	Comb arts	Built herit	Perf arts	Lib/ Lit	Film	Mus & gals	Services
Less than 1	10	3	18	9	9	13	16	3
1-9	4	3	8	5	5	0	8	0
10-19	9	7	11	9	2	10	8	10
20-39	11	20	13	18	23	18	14	21
40-59	13	20	11	22	17	15	16	14
60 to 79	24	26	13	22	19	23	20	21
80 plus	29	21	26	15	22	23	17	31
Total	100	100	100	100	97	100	100	100
No. of respondents	131	260	76	507	64	40	165	29

Percentage	Performing arts		
	Dance	**Drama**	**Music**
Less than 1	3	5	16
1-9	0	5	7
10-19	3	5	15
20-39	4	16	23
40-59	23	27	16
60 to 79	41	27	11
80 plus	26	14	12
Total	100	99	100
No. of respondents	69	219	219

Base: 1,272 organisations drawn from annual accounts and ACE/RAB data.

Note: Figures may not add up to 100 because of rounding.

Public subsidy

All the organisations surveyed were in receipt of public subsidy. Table 32.17 compares the percentage of income made up by public subsidy in terms of each area of cultural activity considered. Dance companies emerge as the most likely to be dependent on public subsidy. For nearly 70 per cent, public subsidy accounts for upwards of 60 per cent of their income. Over half the visual arts and service organisations, and nearly half the film organisations, were in receipt of this level of public funding.

By comparison with arts organisations, heritage bodies were far less likely to attract much in the way of public funding. Around 25 per cent of built heritage organisations and museums received less than 10 per cent of their income from public sources. This applied to only 3 per cent of service organisations and dance companies

Earned income

Organisations concerned with film and music – the most popular activities, after cinema, which attracts 56 per cent of the population (Office for National Statistics, 1999) – were also the most likely to generate earned income (Table 32.18). Nearly 25 per cent of respondents in both categories earned 60 per cent or more of their income.

Table 32.18 Earned income as percentage of respondents' total income by type of activity, 1998/99

Percentage	Visual arts	Comb arts	Built herit	Perf arts	Lib/ Lit	Film	Mus & gals	Services
Less than 1	16	6	30	6	17	15	8	26
1-9	19	15	16	8	13	9	24	19
10-19	17	17	7	13	21	9	20	11
20-39	21	30	24	31	17	24	13	11
40-59	9	18	9	24	15	21	15	15
60 to 79	8	11	10	12	10	0	12	19
80 plus	10	2	4	7	6	24	8	0
Total	100	100	100	100	100	100	100	100
No. of respondents	104	206	70	411	52	34	130	27

Percentage	Performing arts		
	Dance	Drama	Music
Less than 1	2	5	7
1-9	18	5	7
10-19	23	11	11
20-39	44	31	26
40-59	10	28	25
60 to 79	2	13	14
80 plus	2	6	9
Total	100	100	100
No. of respondents	61	185	165

Base: 1,034 organisations drawn from annual accounts and ACE/RAB data.

A large percentage of organisations earned relatively small percentages of their incomes. Over 50 per cent of organisations in the categories of visual arts, built heritage, library and literature, services and museums and galleries, and over 40 per cent of dance organisations, generated less than 20 per cent of their incomes. In some respects (as in the case of visual arts and libraries) this may be related to not charging admission. In others, as in the case of service organisations, it may be associated with providing free or very cheap education and access services. In terms of dance, it may simply reflect low attendance and a lack of interest on the part of potential audiences. The ACE's *Facts and Figures about the Arts* (ACE, 1999) cites contemporary dance as attracting the lowest percentage of adult attenders of any artform covered. As Table 32.17 implies, this reveals the arts funding system is particularly concerned to support and maintain less popular artforms.

Private-sector and unearned income

For more than 70 per cent of dance organisations, and 50 per cent of visual arts and service organisations, the private sector and unearned monies provide upwards of 60 per cent of their income (Table 32.19). However, this is not necessarily indicative of those art forms' success in raising sponsorship (Table 32.20). For the vast majority of organisations, sponsorship had little impact on their finances – it rarely made up as much as 10 per cent of their income.

Table 32.19 Private and unearned income as percentage of respondents' total income, 1998/99

Percentage	Visual arts	Comb arts	Built herit	Perf arts	Lib/ Lit	Film	Mus & gals	Services
Less than 1	9	3	19	8	8	15	19	4
1–9	4	1	9	5	4	0	6	0
10–19	10	6	10	8	2	12	5	11
20–39	10	18	13	16	21	15	15	22
40–59	13	22	11	25	17	15	19	11
60 to 79	29	29	14	23	23	26	21	19
80 plus	26	20	24	14	25	18	15	33
Total	100	100	100	100	100	100	100	100
No. of respondents	104	206	70	411	52	34	130	27

Percentage		Performing arts	
	Dance	Drama	Music
Less than 1	2	4	16
1–9	0	4	8
10–19	2	4	15
20–39	2	17	21
40–59	25	30	21
60 to 79	41	29	11
80 plus	30	12	9
Total	100	100	100
No. of respondents	61	185	165

Base: 1,034 organisations drawn from annual accounts and ACE/RAB data.

Table 32.20 Sponsorship as percentage of respondents' total income, 1998/99

Percentage	Visual arts	Comb arts	Built herit	Perf arts	Lib/ Lit	Film	Mus & gals	Services
Less than 1	73	63	94	59	85	74	89	89
1–9	20	28	3	32	13	12	9	4
10–19	5	7	1	5	0	12	1	4
20–39	2	3	1	3	0	3	1	4
40–59	0	0	0	0	0	0	0	0
60 to 79	0	0	0	0	2	0	0	0
80 plus	0	0	0	0	0	0	0	
Total	100	100	100	100	100	100	100	100
No. of respondents	104	206	70	411	52	34	130	27

Percentage		Performing arts	
	Dance	Drama	Music
Less than 1	66	58	58
1–9	26	38	27
10–19	7	2	8
20–39	2	2	6
40–59	0	0	0
60 to 79	0	0	1
80 plus	0	0	0
Total	100	100	100
No. of respondents	61	185	165

Base: 1,034 organisations drawn from annual accounts and ACE/RAB data.

Programmes of activity

The percentage of expenditure that organisations dedicated to their programmes – such as their main programmes and their education programmes – varies enormously (Table 32.21). Music, museums and galleries and built heritage were the only activities in which a quarter of respondents committed over 80 per cent of their expenditure to this.

Nevertheless, comparatively large percentages of museums and galleries and built heritage organisations also spent relatively little on these core activities – suggesting considerable diversity with these constituencies. This was particularly true of heritage organisations. Around 30 per cent of museums and galleries and built heritage organisations devoted less than 20 per cent of their expenditure to programme activities.

Administration

The percentage of spend on administration depends on the type of organisation, the nature of its income portfolio, popularity, and so on. Many charities use 80:20 as a guiding ratio – 80 per cent direct charitable spend: 20 per cent fundraising, management and administration. Administration costs obviously vary depending on the nature of the organisation, and service providers are likely to have a relatively high spend. Arts Council of England Lottery applications usually look for a 10–15 per cent spend on administration.

Table 32.21 Programme of activities as percentage of respondents' total expenditure, 1998/99

Percentage	Visual arts	Comb arts	Built herit	Perf arts	Lib/ Lit	Film	Mus & gals	Services
Less than 1	7	6	19	2	6	3	15	4
1–9	6	6	3	2	4	12	5	4
10–19	8	9	6	4	8	6	12	4
20–39	29	33	10	18	19	29	17	19
40–59	19	16	10	31	29	15	4	15
60–79	18	17	23	24	21	12	20	33
80 plus	13	13	30	18	13	24	28	22
Total	99	100	100	100	100	100	100	100
No. of respondents	104	206	70	411	52	34	130	27

Percentage		Performing arts	
	Dance	Drama	Music
Less than 1	2	2	4
1–9	3	3	1
10–19	7	5	3
20–39	28	17	14
40–59	46	38	18
60 to 79	13	23	29
80 plus	2	12	32
Total	100	100	100
No. of respondents	61	185	165

Base: 1,034 organisations drawn from annual accounts and ACE/RAB data.

Note: Figures may not add up to 100 because of rounding.

Table 32.22 Administration as percentage of respondents' total expenditure, 1998/99

Percentage	Visual arts	Comb arts	Built herit	Perf arts	Lib/ Lit	Film	Mus & gals	Services
Less than 1	5	1	7	6	10	3	3	0
1–9	8	5	19	6	2	15	22	11
10–19	4	11	20	11	8	6	18	7
20–39	19	17	21	24	23	21	12	37
40–59	25	21	9	33	29	18	9	15
60 to 79	23	30	9	14	19	21	12	15
80 plus	15	14	16	6	10	18	23	15
Total	99	100	100	100	100	100	100	100
No. of respondents	104	206	70	411	52	34	130	27

Percentage	Performing arts		
	Dance	Drama	Music
Less than 1	0	3	12
1–9	3	4	9
10–19	2	8	18
20–39	15	26	25
40–59	46	39	21
60 to 79	23	14	10
80 plus	11	5	6
Total	100	100	100
No. of respondents	61	185	165

Base: 1,034 organisations drawn from annual accounts and ACE/RAB data.

Note: Figures may not add up to 100 because of rounding.

Levels of spending on administration amongst respondents vary enormously. Table 32.15 suggests an approximate 60:30 ratio across the board – 60 per cent plus on direct spend: 30 per cent administration and overheads. In practice, the percentage spent on administration varies considerably (Table 32.22). Between 40 and 50 per cent of built heritage organisations and museums and galleries committed less than 20 per cent of their expenditure to administration, whereas nearly 25 per cent of museums and galleries spent 80 per cent plus.

Spend on administration in performing arts organisations varies enormously. Whereas only 5 per cent of dance organisations kept these costs to under 20 per cent of their expenditure, this was true of 39 per cent of music organisations. Over a third of dance organisations spent 60 per cent or more of their expenditure on administration.

Staff costs

Very few responding organisations spent over 60 per cent of their expenditure on staff (Table 32.23). Those most likely to were library, literature and film organisations. At the other end of the scale, a great many organisations recorded spending less than 1 per cent on staff. This applies to over half the built heritage organisations and museums and galleries, and a sizeable percentage (25–50 per cent) of visual arts, performing arts, film, services and music organisations. This indicates a reliance on volunteers. Built heritage and museums and gallery

Table 32.23 Staff costs as percentage of respondents' total expenditure, 1998/99

Percentage	Visual arts	Comb arts	Built herit	Perf arts	Lib/ Lit	Film	Mus & gals	Services
Less than 1	25	22	54	28	21	26	54	33
1–9	6	8	16	9	12	9	8	7
10–19	4	8	6	15	12	6	6	22
20–39	32	30	10	31	33	35	11	19
40–59	28	24	13	14	12	12	18	15
60 to 79	5	7	1	3	12	12	3	4
80 plus	3	2	0	0	0	0	0	0
Total	103	101	100	100	100	100	100	100
No. of respondents	104	206	70	411	52	34	130	27

Percentage		Performing arts	
	Dance	Drama	Music
Less than 1	7	22	42
1–9	3	8	13
10–19	8	16	16
20–39	41	39	18
40–59	34	13	8
60 to 79	7	3	3
80 plus	0	0	0
Total	100	100	100
No. of respondents	61	185	165

Base: 1,034 organisations drawn from annual accounts and ACE/RAB data.

Note: Percentages may not add up to 100 because of rounding.

respondents, in particular, tended to keep their staff costs low relative to the rest of their expenditure. Over 60 per cent of both groups spent under 10 per cent of their expenditure on staff.

Employment

On the basis of responses, combined and performing arts organisations appear to be the most likely to employ volunteers (Table 32.24). Activities with the largest numbers of permanent staff are museums and galleries, libraries and literature and drama. The sample appears not to support the notion that museums and galleries are attracting more volunteers than paid employees (see also Table 28.8).

Constant sample

The 127 organisations in the constant sample responded to the survey carried out by Casey et al. (1996), as well as that undertaken for the present volume. (They represent 37 per cent of all the organisations that responded to Casey et al., 1996.) Their returns provide a basis for comparing data from 1993/94 and 1998/99.

Table 32.24 Number and type of employees, 1998/99

	Volunteers		Freelance/contractual		Permanent		Number of respondents
	Number	Mean	Number	Mean	Number	Mean	
Built heritage	20	0	10	0	1,574	22	70
Combined arts	2,147	10	1,598	8	2,166	10	206
Film	149	4	207	6	273	8	34
Literature & libraries	106	2	118	2	2,975	57	52
Museums & galleries	11	0	124	1	9,571	74	130
Services	0	0	0	0	54	2	27
Visual arts	622	6	507	5	865	8	104
Performing arts, of which:	4,554	11	6,193	15	8,607	21	411
Dance	132	2	1,008	17	991	16	61
Drama	1,033	6	2,105	11	5,186	28	185
Music	3,389	21	3,080	19	2,430	15	165
Total	7,609		8,757		26,085		1,034

Base: 1,034 organisations drawn from annual accounts and ACE/RAB data.

Characteristics of the constant sample

The profile of the constant sample differs slightly from that of the 1998/99 respondents as a whole in relation to the distribution of artforms and heritage activities, organisations' geographical locations, and size of income. The constant sample includes slightly higher percentages of combined arts organisations and museums and galleries, and a lower percentage of performing arts companies (Table 32.25, compared with Table 32.1). It has a lower percentage of organisations from England and a higher percentage from Scotland (Table 32.26, compared with Table 32.2). And, it contains a higher percentage of organisations with annual incomes of £500,000 and over, and a lower percentage of those under £50,000. The last characteristic is more exaggerated in the group of 64 respondents which provided full details for both 1993/94 and 1998/99 (Table 32.27, compared with Table 32.5).

Despite comprising only a tenth of all the 1998/99 respondents, the constant sample accounts for just over a third (36 per cent) of public subsidy received; just under a third of the total income and the same proportion of expenditure (Table 32.28, and see Table 32.3). While the constant sample may not precisely

Table 32.25 Constant sample by collapsed artform and heritage activity

	Number	(%)
Visual arts	9	(7)
Combined arts	33	(26)
Built heritage	2	(2)
Performing arts	38	(30)
Libraries and literature	6	(5)
Film	5	(4)
Museums and galleries	28	(22)
Services	6	(5)
Total	127	(100)

Base: 127 constant sample responses drawn from annual accounts, short questionnaire and ACE/RAB data.

Table 32.26 Constant sample by region and home country

	Number	(%)
England		
East of England	2	(2)
East Midlands	6	(5)
London	32	(25)
North East	4	(3)
North West	9	(7)
South East	13	(10)
South West	9	(7)
West Midlands	4	(3)
Yorkshire & Humberside	9	(7)
Total England	*88*	*(69)*
Northern Ireland	5	(4)
Scotland	26	(20)
Wales	8	(6)
Total	127	(100)

Base: 127 constant sample responses drawn from annual accounts, short questionnaire and ACE/RAB data.

represent the sector as a whole, the amount of public subsidy it attracted means that it is highly likely to reflect the impact of public policy and the impact of funding strategies.

The constant sample received £19.5 million of capital income (about 11 per cent of the respondents' capital income as a whole). Of that, about half (£9.8 million) was from the arts councils, Lottery units and the Heritage Lottery Fund.

Comparisons across the various artforms and heritage activities, 1998/99

Between 1993/94 and 1998/99, the total income of constant-sample respondents increased by over 20 per cent, and their expenditure by 3 per cent (see Table

Table 32.27 Constant-sample respondents by size of income, 1993/94 and 1998/99

	All respondents				Those providing detailed information			
	1993/94		1998/99		1993/94		1998/99	
Income (£)	Number	(%)	Number	(%)	Number	(%)	Number	(%)
1m+	33	(26)	40	(31)	28	(44)	34	(53)
500,000–999,999	11	(9)	11	(9)	8	(13)	7	(11)
100,000–499,999	43	(34)	51	(40)	18	(28)	18	(28)
50,000–99,999	18	(14)	15	(12)	3	(5)	3	(5)
25,000–49,999	12	(9)	4	(3)	3	(5)	0	(0)
10,000–24,999	5	(4)	5	(4)	1	(2)	1	(2)
5,000–9,999	2	(2)	1	(1)	1	(2)	1	(2)
1,000–4,999	1	(1)	0	(0)	0	(0)	0	(0)
under 1,000	2	(2)	0	(0)	2	(3)	0	(0)
Total	127	(100)	127	(100)	64	(100)	64	(100)

Bases
127 constant-sample responses drawn from annual accounts, short questionnaire and ACE/RAB data.
64 constant-sample responses drawn from annual accounts and ACE/RAB data.

Table 32.28 Headline income and expenditure of constant-sample respondents, 1993/94 and 1998/99

£ thousand

	1993/94 prices	1998/99 prices	1998/99	Percentage change
Public subsidy				
Arrts councils and RABs	14,004	16,016	15,853	−1.01
Local authority	12,544	14,346	12,886	−10.18
Lottery	n/a	n/a	33,977	n/a
Central government (a)	245,480	280,741	19,772	−92.96
Specialist funder (a)	1,361	1,556	1,693	8.77
European funding (a)	–	–	325	–
Other public subsidy (a)	589	674	7,516	91.04
Recorded subtotal (b)	*273,978*	*313,333*	*342,007*	*9.15*
Total income	372,214	425,679	548,939	22.45
Total expenditure	387,840	443,549	488,227	2.95

Base: 127 constant-sample responses drawn from annual accounts, short questionnaire and ACE/RAB data.

Notes
a) ACE/RAB data do not provide details of income from central government, specialist funders or Europe.
These are shown under 'other public subsidy'.
b) The 1993/94 figure is calculated rather than recorded.

32.28). As Table 32.29 reveals, the rate of change in the incomes of various artforms and heritage activities covered is very different. At one extreme, the average income of service organisations and museums and galleries has increased by over half, whereas, at the other, libraries and literature organisations' has diminished by almost one third.

In general terms, income from private-sector sources had almost doubled, particularly in the visual arts, libraries and museums (Table 32.30). The Arts Council of England and regional arts board data in Chapter 33 show a decline in the value of their funding from the private sector and unearned income. This trend is also evident in the Arts Council of England and regional arts boards data presented below in Chapter 33.

Table 32.31 shows a 5 per cent rise overall in organisations' average expenditure from 1993/94 to 1998/99. Visual arts and service organisations show marked increases in expenditure of nearly two-thirds, whereas libraries and literature show the sharpest decline. However, the nature of organisations' expenditure has changed radically, shifting from administration (and employee) costs to spending on programmes of activities. On average, programme costs have increased fourfold, whereas administration costs fell by about three-quarters. Again, data in Chapter 33 show a similar, although less extreme, trend – with a marked increase in education-programme spending.

Employment

As far as it is possible to compare the 1993/94 and 1998/99 data, it would appear that the number of people employed in organisations in the constant sample

Table 32.29 Average income and expenditure of constant-sample respondents, by type of activity, 1993/94 and 1998/99

Means (£ thousand)

	Visual arts	Combined	Built heritage	Perf arts	Lit/ Lib	Film	Mus & gal	Services	Overall
Income									
Public subsidy									
Arts councils and RABs									
1993/94	99.6	54.8	0	280.3	18.5	4.6	13.4	22.8	110.3
at 1998/99 prices	*113.9*	*62.7*	*0*	*320.6*	*21.2*	*5.3*	*15.3*	*26.1*	*126.1*
1998/99	105.2	78.4	0	302.9	18.8	7.0	17.7	27.0	124.8
Local authority									
1993/94	47.7	68.5	23.5	122.0	24.7	22.6	173.9	6.8	98.8
at 1998/99 prices	*54.6*	*78.3*	*26.9*	*139.5*	*28.2*	*25.8*	*198.9*	*7.8*	*113.0*
1998/99	25.7	86.0	12.5	126.3	29.2	27.4	164.9	10.0	101.5
Lottery									
1993/94	n/a	n/a	n/a	n/a	n/a	n/a	n/a	n/a	n/a
at 1998/99 prices	*n/a*	*n/a*	*n/a*	*n/a*	*n/a*	*n/a*	*n/a*	*n/a*	*n/a*
1998/99	7.9	23.5	75.0	25.9	0.2	21.8	1,136.2	12.0	267.5
Central government									
1993/94	0	1.3	1,079.0	0.1	15,289.3	0	5,410.9	6.2	1,932.9
at 1998/99 prices	*0*	*1.5*	*1,234.0*	*0.1*	*17,485.5*	*0*	*6,188.1*	*7.1*	*2,210.5*
1998/99	0	0	0	0.2	0	0	705.9	0	155.7
Specialist funder									
1993/94	0	1.8	4.0	0.9	0	33.6	39.0	0	10.7
at 1998/99 prices	*0*	*2.1*	*4.6*	*1.0*	*0*	*38.4*	*44.6*	*0*	*12.2*
1998/99	0	0.5	0	12.9	0	21.2	38.3	1.0	13.3
European funding									
1993/94	–	–	–	–	–	–	–	–	–
at 1998/99 prices	*–*	*–*	*–*	*–*	*–*	*–*	*–*	*–*	*–*
1998/99	7.1	0	0	0	4.2	2.4	8.0	0	2.6

Table 32.29 continued

Means (£ thousand)

	Visual arts	Combined	Built heritage	Perf arts	Lit/ Lib	Film	Mus & gal	Services	Overall
Other public subsidy									
1993/94	3.4	5.5	0	2.5	3.0	4.6	8.3	0.8	4.6
at 1998/99 prices	*3.9*	*6.3*	*0*	*2.9*	*3.4*	*5.3*	*9.5*	*0.9*	*5.3*
1998/99	15.8	23.8	603.0	10.1	6.2	23.2	172.5	2.5	59.2
Recorded subtotal									
1993/94 (a)	150.7	131.9	1,106.5	405.8	15,335.5	65.4	5,645.5	36.6	2,157.3
at 1998/99 prices	*172.3*	*150.8*	*1,265.4*	*464.0*	*17,538.3*	*74.8*	*6,456.4*	*41.9*	*2,467.2*
1998/99	162.9	212.1	1,930.0	482.0	15,430.5	106.8	7,770.7	111.0	2,693.0
Total recorded income									
1993/94	203.8	404.6	1,786.0	935.1	27,919.5	233.2	6,926.6	99.0	3,287.5
at 1998/99 prices	*233.1*	*462.7*	*2,042.5*	*1,069.4*	*31,929.9*	*266.7*	*7,921.5*	*113.2*	*3,759.7*
1998/99	339.2	512.6	2,462.0	1,082.6	22,460.3	365.8	12,329.4	181.7	4,322.4
Expenditure									
1993/94	183.2	415.2	1,859.5	1,002.2	20,206.7	266.0	7,385.3	98.5	3,053.9
at 1998/99 prices	*209.5*	*474.8*	*2,126.6*	*1,146.2*	*23,109.2*	*304.2*	*8,446.1*	*112.6*	*3,759.7*
1998/99	349.7	547.8	2,152.5	1,086.6	22,421.2	383.6	10,138.6	180.0	3,844.3
Number in the constant sample	9	33	2	38	6	5	28	6	127

Base: 127 constant sample responses drawn from annual accounts, short questionnaire and ACE/RAB data.

Notes
a) Calculated rather than recorded.

Table 32.30 Breakdown of average income of constant-sample respondents, by type of activity, 1993/94 and 1998/99

Means (£ thousand)

	Visual arts	Combined	Built heritage	Perf arts	Lit/Lib	Film	Mus & gal	Services	Overall
Earned income									
1993/94	50.5	369.0	124.5	669.6	9,263.0	8.0	1,544.4	2.0	1,503.9
at 1998/99 prices	*57.8*	*422.0*	*142.4*	*765.8*	*10,593.5*	*9.1*	*1,766.2*	*2.3*	*1,719.9*
1998/99	104.0	375.6	107.0	806.9	10,381.7	5.0	2,109.1	3.0	1,552.7
Public subsidy									
Arts councils and RABs									
1993/94	194.3	177.4	0	398.3	17.7	0	17.1	35.5	182.5
at 1998/99 prices	*222.2*	*202.9*	*0*	*455.5*	*20.2*	*0.0*	*19.6*	*40.6*	*208.7*
1998/99	217.8	256.9	0	458.3	16.3	10.0	22.6	7.0	215.3
Local authority									
1993/94	91.8	112.3	23.5	159.3	49.0	5.0	202.1	7.5	148.1
at 1998/99 prices	*105.0*	*128.4*	*26.9*	*182.2*	*56.0*	*5.7*	*231.1*	*8.6*	*169.3*
1998/99	47.0	104.4	12.5	176.4	57.7	45.0	209.9	0.5	153.7
Lottery									
1993/94	n/a	n/a	n/a	n/a	n/a	n/a	n/a	n/a	n/a
at 1998/99 prices	*n/a*	*n/a*	*n/a*	*n/a*	*n/a*	*n/a*	*n/a*	*n/a*	*n/a*
1998/99	17.7	0	75.0	32.3	0	0	1,142.6	14.0	408.3
Central government									
1993/94	0	6.0	1,079.0	0	30,578.7	0	6,403.4	18.5	3,669.5
at 1998/99 prices	*0.0*	*6.9*	*1,234.0*	*0.0*	*34,971.1*	*0.0*	*7,323.2*	*21.2*	*4,196.6*
1998/99	0	0	0	0	0	0	0.4	0	0.1
Specialist funder									
1993/94	0	8.4	4.0	1.2	0	0	48.3	0	18.1
at 1998/99 prices	*0.0*	*9.6*	*4.6*	*1.4*	*0.0*	*0.0*	*55.2*	*0.0*	*20.7*
1998/99	0	2.6	0	20.0	0	0	48.3	0	24.1
European funding									
1993/94	–	–	–	–	–	–	–	–	–
at 1998/99 prices	*–*	*–*	*–*	*–*	*–*	*–*	*–*	*–*	*–*
1998/99	8.5	0	0	0	8.3	0	10.2	0	4.4

Table 32.30 continued

Means (£ thousand)

	Visual arts	Combined	Built heritage	Perf arts	Lit/ Lib	Film	Mus & gal	Services	Overall
Other public subsidy									
1993/94	0	0	0	2.4	6.0	23.0	10.1	0	5.0
at 1998/99 prices	*0.0*	*0.0*	*0.0*	*2.7*	*6.9*	*26.3*	*11.6*	*0.0*	*5.7*
1998/99	6.5	77.9	603.0	11.5	11.7	5.0	146.9	2.0	83.1
Subtotal public subsidy (a)									
1993/94	286	304.1	1,106.5	561.1	30,651.3	28.0	6,680.5	61.5	4,023.2
at 1998/99 prices	*327.1*	*347.8*	*1,265.4*	*641.7*	*35,054.1*	*32.0*	*7,640.1*	*70.3*	*4,601.0*
1998/99	297.3	440.3	1,930.0	702.9	30,838.0	60.0	8,612.5	169.5	8,890.0
Private and unearned income									
Sponsorship/ memberships/ donations									
1993/94	36.5	67.0	508.0	94.2	399.0	22.0	419.8	30.0	197.1
at 1998/99 prices	*41.7*	*76.6*	*581.0*	*107.7*	*456.3*	*25.2*	*480.1*	*34.3*	*225.4*
1998/99 (a)	133	61	257.5	97.6	2872	28	232.5	0	273.1
Investment and other income									
1993/94	0.8	25.0	47.0	8.3	174.3	1.0	491.5	1.0	272.8
at 1998/99 prices	*0.9*	*28.6*	*53.8*	*9.5*	*199.3*	*1.1*	*562.1*	*1.1*	*312.0*
1998/99	55.8	24.3	167.5	28.5	192.8	1.0	443.8	9.0	183.5
Subtotal private and unearned income									
1993/94	37.3	92.0	555.0	102.5	573.3	23.0	911.3	31.0	575.8
at 1998/99 prices	*42.6*	*105.2*	*634.7*	*117.2*	*655.6*	*26.3*	*1,042.2*	*35.5*	*658.5*
1998/99	216.3	85.3	425.0	121.6	3,064.7	29.0	2,368.2	9.0	1,038.3
Total income									
1993/94	373.3	711.6	1,786.0	1,333.1	40,487.7	59.0	8,260.1	94.5	6,102.9
at 1998/99 prices	*426.9*	*813.8*	*2,042.5*	*1,524.6*	*46,303.4*	*67.5*	*9,446.6*	*108.1*	*6,979.4*
1998/99	617.8	901.0	2,462.0	1,635.6	44,284.3	94.0	13,793.1	181.5	3,480.0
Number in the constant sample	4	7	6	23	3	1	22	2	64

Base: 64 constant-sample responses drawn from annual accounts and ACE/RAB data.

Note
a) Calculated rather than recorded.

Table 32.31 Breakdown of average expenditure of constant-sample respondents, by type of activity, 1993/94 and 1998/99

Means (£ thousand)

	Visual arts	Combinded	Built heritage	Perf arts	Lit/ Lib	Film	Mus & gal	Services	Overall
Artistic costs									
1993/94	90.3	298	1,462.5	599.5	790	8	743.3	17	592.6
at 1998/99 prices	*103.3*	*340.8*	*1,672.6*	*685.6*	*903.5*	*9.1*	*850.1*	*19.4*	*677.7*
1998/99	279.0	716.0	1,978.5	1,234.0	2,675.3	84.0	8,012.4	8.5	3,482.4
Administration									
Employee costs									
1993/94	139.0	222.3	216.0	571.9	16,755.3	27.0	4,349.6	49.0	2,527.8
at 1998/99 prices	*159.0*	*254.2*	*247.0*	*654.0*	*19,162.1*	*30.9*	*4,974.4*	*56.0*	*2,890.9*
1998/99	152.8	66.9	68.0	121.7	7.3	0	562.6	29.0	257.4
Subtotal admin									
1993/94	319.0	702.3	1,798.0	1,387.0	40,386.3	57.0	8,394.3	88.5	5,433.7
at 1998/99 prices	*364.8*	*803.2*	*2,056.3*	*1,586.2*	*46,187.4*	*65.2*	*9,600.1*	*101.2*	*6,214.2*
1998/99	261.5	149.3	166.0	374.8	1,016.3	1.0	1,769.7	154.0	833.4
Total expenditure (a)									
1993/94	319.0	710.6	1,859.5	1,412.4	40,386.3	57.0	8,848.6	88.5	5,601.8
at 1998/99 prices	*364.8*	*812.7*	*2,126.6*	*1,615.3*	*46,187.4*	*65.2*	*10,119.6*	*101.2*	*6,406.5*
1998/99	617.8	894.3	2,152.5	1,640.7	44,082.3	85.0	11,212.9	162.5	6,720.4
Surplus									
1993/94	265.0	18.5	0	27.2	162.2	2.0	466.8	6.0	224.2
at 1998/99 prices	*303.1*	*21.2*	*0*	*31.1*	*185.5*	*2.3*	*533.9*	*6.9*	*256.4*
1998/99	71.0	38.0	309.0	62.1	659.5	0	3,793.3	19.0	1,485.7
Deficit									
1993/94	16.0	22.3	73.5	217.6	21.0	-0	785.6	0	266.1
at 1998/99 prices	*18.3*	*25.5*	*84.1*	*248.9*	*24.0*	*0*	*898.4*	*0*	*304.4*
1998/99	24.0	35.0	0	159.0	713.0	1.0	687.0	0	292.0

Table 32.31 continued

Means (£ thousand)

	Visual arts	Combinded	Built heritage	Perf arts	Lit/ Lib	Film	Mus & gal	Services	Overall
Number in the constant sample	4	7	6	23	3	1	22	2	64
Number recording surplus, 1993/94	1	4	0	13	2	1	17	2	40
Number recording surplus, 1998/99	1	4	2	16	2	0	16	2	43
Number recording deficit, 1998/94	3	3	2	10	1	0	5	0	24
Number recording deficit, 1998/99	3	3	0	7	1	1	6	0	21

Base: 64 constant-sample responses drawn from annual accounts, short questionnaire and ACE/RAB data.

Note: a) Calculated rather than recorded.

Table 32.32 Number of and type of employees in the constant sample, 1993/94 and 1998/99

Percentage

| | 1993/94 | | 1998/99 | | |
	Permanent	Volunteer	Permanent	Freelance	Volunteer
None	47	98	31	84	92
1–4	6	0	8	3	3
5–9	5	0	6	2	0
10–14	3	0	3	2	2
15–19	3	0	5	3	0
20–29	3	0	9	3	0
30 plus	33	0	38	3	3
Total	100	100	100	100	100

Base: 64 organisations drawn from annual accounts and ACE/RAB data.

increased and that a higher percentage of organisations employed permanent staff and more had volunteer workers (Table 32.32).

33

The Arts Council of England and Regional Arts Boards' Constant Sample, 1994/95–1998/99

Paul Dwinfour, Arts Council of England, and
Sara Selwood, University of Westminster

This chapter provides an analysis of five years' worth of data from organisations which receive regular and fixed-term funding[1] from the Arts Council of England (ACE) and the regional arts boards (RABs). The data cover the period 1994/95 to 1998/99.

The Arts Council of Great Britain first considered using indicators to assess the effects and effectiveness of public expenditure in 1992. This led to the collection of performance-indicator data intended to inform both the Office of Arts and Libraries and the arts funding system. A pilot survey was conducted by ACE and the RABs in 1993/94 and full surveys have been carried out each year since. The overall sample for each year consists of around 400 organisations.

Table 33.1 ACE/RAB constant sample by artform activity, 1994/95–1998/99

Artform activity	Number of organisations	Percentage of 1998/99 turnover
Combined arts	19	7
Dance organisations	21	17
Drama	41	32
Film, video and broadcasting	4	0
Literature	14	2
Music	22	37
Visual arts	17	5
Total	138	100

1 The ACE uses 'fixed-term funding' to denote an annual or three-year funding agreement. Organisations with such funding are considered to be: of key strategic importance; covered by the appraisal system; and/or in receipt of grant of £20,000 or more per annum. The funding period for 'regularly funded' organisations, by comparison, is not set, although the organisations are reviewed annually. The regional arts boards do not use the same terminology. Although fixed-term-funded organisations have always been included in the annual surveys (Hacon et al., 1997; 1998), the title of those surveys has only recently been changed to reflect this (Hacon et al., 2000).

Table 33.2 ACE/RAB constant sample: income and expenditure, 1994/95–1998/99

	1994/95 £ thousand	(%)	1995/96 £ thousand	(%)	1996/97 £ thousand	(%)	1997/98 £ thousand	(%)	1998/99 £ thousand	(%)	Percentage change 1995/96– 1998/99
Earned income	130,624	(49)	126,748	(47)	127,778	(48)	128,766	(46)	126,015	(45)	–4
ACE/RAB subsidy of which:	100,188	(37)	103,039	(39)	104,006	(39)	116,820	(42)	118,179	(43)	18
Lottery A4E (b)	n/a		n/a		n/a		726		3,491		n/a
Lottery Stabilisation (b)	n/a		n/a		n/a		1,575		5,096		n/a
Local authority subsidy	11,847	(4)	11,541	(4)	15,442	(6)	13,946	(5)	12,605	(5)	6
Other public subsidy	1,746	(1)	4,816	(2)	1,414	(1)	1,647	(1)	2,003	(1)	15
Sponsorship	11,654	(4)	9,355	(4)	8,515	(3)	9,614	(3)	10,435	(4)	–10
Trusts/donations etc.	12,319	(5)	11,488	(4)	10,703	(4)	8,545	(3)	8,405	(3)	–32
Total income	*268,378*		*266,987*		*267,703*		*279,337*		*277,642*		*3*
Artistic programme costs (a)	137,196	(51)	112,630	(41)	116,570	(43)	110,411	(39)	113,842	(40)	1
Education programme costs (a)	n/a		3,895	(1)	4,376	(2)	5,559	(2)	5,845	(2)	50
Marketing costs (a)	n/a		13,439	(5)	14,412	(5)	14,126	(5)	13,871	(5)	3
Staff costs (a)	n/a		103,472	(38)	103,002	(38)	112,462	(40)	103,696	(37)	0
Overheads (a)	131,728	(49)	38,139	(14)	34,599	(13)	39,566	(14)	43,925	(16)	15
Total expenditure	*268,924*		*271,575*		*272,959*		*282,124*		*281,180*		*5*
Deficit/surplus	–546		–4,588		–5,256		–2,787,123		–3,537,690		–3,538
Total reported attendance (incl. estimated attendance)	13,377,287		14,096,205		14,159,274		15,909,706		16,835,247		26

Base: 138 organisations.

Notes

a) Full expenditure breakdown not available for 1994/95. Percentage change in last column refers to 1995/6–1998/99.

b) ACE/RAB data include only these sources of Lottery income. Capital funding is excluded.

The annual publication of these data conventionally refers to a constant sample of organisations which made returns for the current and previous years (Hacon et al, 2000; 1998; 1997). This chapter, by comparison, refers to a constant sample of organisations which have consistently made returns since 1994/95. Although not strictly comparable with the data collected by Casey et al. (1996) and the present volume (Chapter 32), they provide another indicator of changes within the workings of the subsidised arts sector over recent years.

The constant sample: income, expenditure and audiences

The constant sample consists of 138 combined art, dance, drama, film video and broadcasting, literature, music and visual arts organisations, which are listed by name in Appendix 5. Table 33.1 shows a classification of these organisations by activity and their share of the total 1998/99 turnover.

Table 33.3 ACE/RAB constant sample: income and expenditure, excluding Royal Opera and Royal Ballet, 1994/95–1998/99

	1994/95 £ thousand	(%)	1995/96 £ thousand	(%)	1996/97 £ thousand	(%)	1997/98 £ thousand	(%)	1998/99 £ thousand	(%)	Percentage change 1995/96–1998/99
Earned income	105,837	(49)	103,343	(47)	105,566	(48)	108,867	(46)	114363	(45)	8
ACE/RAB subsidy (a)	85,614	(37)	88,215	(39)	89,457	(39)	93,719	(42)	96,918	(43)	13
Local authority subsidy	11,847	(4)	11,541	(4)	15,442	(6)	13,946	(5)	12,605	(5)	6
Other public subsidy	1,746	(1)	4,816	(2)	1,414	(1)	1,647	(1)	2,003	(1)	15
Sponsorship	8,537	(4)	9,355	(4)	8,515	(3)	9,614	(1)	9,840	(4)	15
Trusts/donations etc.	7,487	(5)	6,281	(4)	5,637	(4)	5,980	(3)	7,595	(3)	1
Total income	*221,068*		*223,551*		*226,031*		*233,773*		*243,324*		*10*
Artistic programme costs (b)	119,812	(51)	97,886	(41)	102,601	(43)	93,798	(39)	104,728	(40)	7
Education programme costs (b/c)	–	–	3,404	(1)	3,941	(2)	5,150	(2)	5,554	(2)	63
Marketing costs (b/c)	–	–	11,766	(5)	12,784	(5)	12,267	(5)	12,742	(5)	8
Staff costs (b/c)	–	–	81,201	(38)	80,956	(38)	90,211	(40)	85,067	(37)	5
Overheads (b/c)	101,855	(49)	31,457	(14)	29,334	(13)	32,042	(14)	34,247	(16)	9
Total recorded expenditure	*221,667*		*225,714*		*229,616*		*233,469*		*242,339*		*9*
Deficit/surplus	–599		–2,163		–3,585		304		985		
Total reported attendance (incl. estimated attendance)	12,889,337		13,617,278		13,633,847		15,302,295		16,437,708		28

Base: 136 organisations

Notes
a) ACE/RAB subsidy for 1997/98 and 1998/99 includes Lottery A4E and Lottery stabilisation awards.
b) Percentage change calculated only for 1995/96 to1998/99.
c) Full expenditure breakdown not available for 1994/95.

The constant sample includes a higher proportion of large organisations than the overall sample. Amongst them are: the six 'national' companies (the Royal Opera House, English National Opera, Birmingham Royal Ballet, South Bank Centre, Royal National Theatre and Royal Shakespeare Company); two other major ballet companies (English National Ballet and the Northern Ballet Theatre); one other large-scale opera company (Glyndebourne Touring Opera); and ten major funded orchestras (six 'regional' orchestras – Bournemouth Orchestras, City of Birmingham Symphony, Hallé Concerts Society, Royal Liverpool Philharmonic, Royal Philharmonic Orchestra, Northern Sinfonia; and the four London-based orchestras – London Philharmonic Orchestra, Sinfonietta Productions, London Symphony Orchestra and the Philharmonia).

The particular circumstances of any of the largest organisations can have a significant impact on the overall figures for a particular year, as comparisons of Tables 33.2 and 33.3 show. Table 33.2 shows the constant sample including the Royal Opera and Royal Ballet, and Table 33.3 excludes those two companies. A

Table 33.4 ACE/RAB constant sample: income and expenditure, by main funder, 1994/95–1998/99

	Main funder 1994/95 £ thousand		Main funder 1995/96 £ thousand		Main funder 1996/97 £ thousand		Main funder 1997/98 £ thousand		Main funder 1998/99 £ thousand		Percentage change 1994/95–1998/99	
	ACE	RAB	ACE	RAB	ACE	RAB	ACE	RAB	ACE	RAB	ACE	RAB
Earned income	112,925	17,699	108,309	18,439	111,017	16,761	112,575	16,191	106,777	19,239	5	9
ACE/RAB subsidy (a)	89,287	10,901	90,738	12,301	91,765	12,241	104,424	12,396	105,787	12,392	18	14
Local authority subsidy	7,240	4,607	5,923	5,618	9,899	5,543	7,983	5,963	7,287	5,319	1	15
Other public subsidy	926	820	4,233	583	620	794	673	974	1,295	708	40	14
Sponsorship	10,779	875	8,251	1,104	7,610	905	8,558	1,056	9,444	991	12	13
Trusts/donations etc.	11,143	1,176	10,511	977	9,557	1,146	7,021	1,523	6,792	1,613	39	37
Total income	232,300	36,078	227,965	39,022	230,468	37,235	241,234	38,103	237,381	40,261	2	12
Artistic programme costs	118,202	18,994	97,215	15,415	101,125	15,445	95,587	14,824	97,228	16,615	18	13
Education programme costs (b)	–	–	2,746	1,149	2,936	1,440	4,478	1,081	4,730	1,115	2	3
Marketing costs (b)	–	–	11,173	2,266	12,303	2,109	11,847	2,279	11,617	2,254	16	1
Staff costs (b)	–	–	89,759	13,713	89,806	13,196	99,988	12,474	90,714	12,982	9	5
Overheads (b)	114,482	17,246	30,541	7,598	28,473	6,126	33,357	6,209	36,666	7,259	7	4
Total recorded expenditure	232,684	36,240	231,434	40,141	234,643	38,316	245,257	36,867	240,956	40,224	4	11
Deficit/surplus	–384	–162	–3,469	–1,119	–4,175	–1,081	–4,023	1,236	–3,575	37	n/a	n/a
Total reported attendance (incl. estimated attendance)	9,375,450	4,001,837	9,945,296	4,150,909	10,763,730	3,395,544	13,285,137	2,624,569	12,512,681	4,322,566	33	8

Base: 138, of which 77 have ACE as main funder, and 61 have RAB as main funder.

Source: ACE unpublished performance indicator data.

Notes

a) ACE/RAB subsidy for 1997/98 and 1998/99 includes lottery A4E and lottery stabilisation awards.
b) Full expenditure breakdown not available for 1994/95. Percentage change in last columns refer to 1995/6–1998/99.

Table 33.5 ACE/RAB constant sample: income and expenditure of literature organisations, 1994/95–1998/99

	1994/95 £ thousand	(%)	1995/96 £ thousand	(%)	1996/97 £ thousand	(%)	1997/98 £ thousand	(%)	1998/99 £ thousand	(%)	Percentage change 1995/96– 1998/99
Earned income	1,944	(61)	2,103	(61)	2,266	(63)	2,422	(66)	2,354	(50)	21
ACE/RAB subsidy (a)	607	(19)	629	(18)	655	(18)	658	(18)	724	(16)	19
Local authority subsidy	0	(0)	13	(0)	4	(0)	2	(0)	2	(0)	0
Other public subsidy	7	(0)	42	(1)	41	(1)	101	(3)	140	(3)	1,902
Sponsorship	117	(4)	156	(5)	457	(13)	2	(0)	726	(16)	521
Trusts/donations etc.	503	(16)	502	(15)	146	(4)	508	(14)	720	(15)	43
Total income	*3,178*		*3,445*		*3,569*		*3,693*		*4,665*		*47*
Artistic programme costs (a)	1,431	(46)	1,309	(38)	1,614	(45)	1,374	(37)	1,921	(42)	47
Education programme costs (b)	n/a	n/a	30	(1)	12	(0)	45	(1)	40	(1)	32
Marketing costs (b)	n/a	n/a	369	(11)	396	(11)	387	(11)	601	(13)	63
Staff costs (b)	n/a	n/a	847	(25)	1,078	(30)	1,145	(31)	1,321	(29)	56
Overheads (b)	1,655	(54)	882	(26)	501	(14)	722	(20)	704	(15)	–20
Total recorded expenditure	*3,086*		*3,437*		*3,601*		*3,673*		*4,587*		*49*
Deficit/surplus	92		8		–32		20		78		
Total reported attendance	3,027		10,938		2,800		3,394		5,045		67

Base: 14 organisations.

Notes
a) ACE/RAB subsidy for 1997/98 and 1998/99 includes Lottery A4E and Lottery stabilisation awards.
b) Full expenditure breakdown not available for 1994/95. Percentage change in last column refers to 1995/96–1998/99.

comparison of the tables reveals the extent to which the figures are skewed by the reduced activity and increased income of Royal Opera and Royal Ballet, whilst the Royal Opera House was closed for rebuilding.

Income

Although Lottery revenue funding is considered here, capital funding is not. Discounting the Royal Opera House companies, the combined total income of organisations in the constant sample overall was at its highest in 1998/99, having increased by 10 per cent in current terms since 1994/95 (Table 33.3).

The greatest overall increases were in sponsorship and 'other' public subsidy (income from other public bodies such as the British Film Institute, the Single Regeneration Budget and the European Regional Development Funds, etc). The increase in Arts Council and regional arts board subsidies for 1997/98 and 1998/99 is largely due to Lottery revenue funding. These include the Lottery revenue 'closure costs' awarded to the Royal Opera House for the period of refurbishment, to cover additional revenue costs incurred, affecting figures for 1997/98 and 1998/99. This amounted to a total of £23 million, or around £9 million of ACE/RAB subsidy for each of the above years (Table 33.2).

Table 33.6 ACE/RAB constant sample: income and expenditure of film, video and broadcasting organisations, 1994/95–1998/99

	1994/95	(%)	1995/96	(%)	1996/97	(%)	1997/98	(%)	1998/99	(%)	Percentage change 1994/95– 1998/99
Earned income	470	(44)	538	(50)	594	(52)	506	(40)	523	(42)	11
ACE/RAB subsidy (a)	371	(35)	407	(38)	396	(35)	404	(32)	435	(35)	17
Local authority subsidy	78	(7)	74	(7)	67	(6)	60	(5)	51	(4)	−35
Other public subsidy	35	(3)	18	(2)	53	(5)	271	(21)	193	(15)	451
Sponsorship	21	(2)	24	(2)	24	(2)	18	(1)	41	(3)	97
Trusts/donations etc.	93	(9)	5	(0)	2	(0)	9	(1)	7	(1)	−92
Total income	*1,068*		*1,066*		*1,136*		*1,269*		*1,249*		*17*
Artistic programme costs (a)	527	(49)	231	(20)	327	(26)	250	(19)	330	(25)	43
Education programme costs (b)	n/a	n/a	111	(10)	118	(9)	133	(10)	47	(4)	−58
Marketing costs (b)	n/a	n/a	71	(6)	71	(6)	123	(9)	102	(8)	44
Staff costs (b)	n/a	n/a	471	(41)	509	(40)	516	(40)	548	(42)	16
Overheads (b)	545	(51)	262	(23)	250	(20)	282	(22)	290	(22)	11
Total recorded expenditure	*1,072*		*1,146*		*1,275*		*1,303*		*1,317*		*23*
Deficit/surplus	−4		−80		−139		−34		−68		
Total reported attendance	112,000		141,869		135,118		132,815		562,566		402

Base: 4 organisations.

Notes
a) ACE/RAB subsidy for 1997/98 and 1998/99 includes Lottery A4E and Lottery stabilisation awards.
b) Full expenditure breakdown not available for 1994/95. Percentage change in last column refers to 1995/96–1998/99.

Expenditure

As the tables suggest, expenditure figures for 1994/95 were not collected in a format which allows direct comparisons of artistic programme costs, or any other costs, with other years. The expenditure displayed as 'artistic programme costs' for 1994/95 includes elements of education and possibly marketing.

Whereas the expenditure of the constant-sample organisations (including the Royal Opera House companies) appears to have been consistently greater than its income, taking the Royal Opera House companies out of the calculation reduces this.

The only category of spending which appears to have been cut across the board is the cost of artistic programmes. Whereas education spending for the constant sample including the Royal Opera House companies increased by 50 per cent from 1995/96, without the Royal Opera House companies it increased by only 2 per cent.

Deficits

Despite the arts funding system's concern to wipe out deficits (not least, as a criterion for Lottery capital grants and the introduction of the Stabilisation

Table 33.7 ACE/RAB constant sample: income and expenditure of combined arts organisations, 1994/95–1998/99

	1994/95	(%)	1995/96	(%)	1996/97	(%)	1997/98	(%)	1998/99	(%)	Percentage change 1994/95–1998/99
Earned income	5,894	(34)	6,317	(35)	6,319	(35)	7,122	(36)	7,378	(39)	25
ACE/RAB subsidy (a)	9,511	(55)	9,823	(55)	9,928	(56)	10,012	(51)	9,952	(52)	5
Local authority subsidy	773	(4)	814	(5)	794	(4)	1,089	(6)	801	(4)	4
Other public subsidy	212	(1)	148	(1)	209	(1)	488	(2)	170	(1)	–20
Sponsorship	751	(4)	636	(4)	436	(2)	571	(3)	241	(1)	–68
Trusts/donations etc.	295	(2)	166	(1)	181	(1)	373	(2)	427	(2)	44
Total income	*17,436*		*17,904*		*17,867*		*19,656*		*18,969*		9
Artistic programme costs (a)	5,189	(30)	3,411	(19)	3,814	(22)	4,654	(25)	4,168	(22)	22
Education programme costs (b)	n/a	n/a	13	(0)	36	(0)	258	(1)	286	(2)	2,103
Marketing costs (b)	n/a	n/a	1,560	(9)	1,724	(10)	1,465	(8)	1,521	(8)	–2
Staff costs (b)	n/a	n/a	7,621	(42)	7,383	(42)	7,293	(39)	7,531	(40)	–1
Overheads (b)	12,321	(70)	5,480	(30)	4,680	(27)	5,212	(28)	5,142	(28)	–6
Total recorded expenditure	*17,510*		*18,085*		*17,637*		*18,882*		*18,649*		7
Deficit/surplus	–74		–181		230		773		320		
Total reported attendance	3,646,666		2,820,663		2,922,123		1,687,311		2,165,203		–41

Base: 19 organisations.

Notes

a) ACE/RAB subsidy for 1997/98 and 1998/99 includes Lottery A4E and lottery stabilisation awards.

b) Full expenditure breakdown not available for 1994/95. Percentage change in last column refers to 1995/96–1998/99.

Programme), the total value of the 1998/99 deficit for organisations in the constant sample including the Royal Opera House companies was five times what it had been in 1994/95. Without the Royal Opera House companies, the organisations showed a surplus.

Attendances

Audiences (including estimated figures) have risen by a quarter in the sample that includes the Royal Opera House companies, and marginally more in the sample without them. Much of the substantial increase in reported attendance is due to visual arts organisations which rely most heavily on estimated attendances as opposed to recorded actuals.

Changes over five years

Changes in income, expenditure and audiences by main funder

The majority of organisations within the constant sample (56 per cent) are funded mainly by the ACE (Table 33.4). These organisations generate some 86 per cent

Table 33.8 ACE/RAB constant sample: income and expenditure of dance organisations, 1994/95–1998/99

	1994/95	(%)	1995/96	(%)	1996/97	(%)	1997/98	(%)	1998/99	(%)	Percentage change 1994/95–1998/99
Earned income	20,318	(40)	18,170	(39)	17,379	(37)	20,305	(39)	15,037	(33)	–26
ACE/RAB subsidy (a)	21,680	(43)	22,163	(48)	22,134	(48)	26,163	(51)	25,906	(56)	19
Local authority subsidy	1,799	(4)	1,849	(4)	1,834	(4)	1,891	(4)	1,859	(4)	3
Other public subsidy	266	(1)	102	(0)	188	(0)	72	(0)	280	(1)	5
Sponsorship	2,038	(4)	1,193	(3)	972	(2)	1,309	(3)	1,687	(4)	–17
Trusts/donations etc.	4,445	(9)	3,154	(7)	4,001	(9)	1,953	(4)	1,267	(3)	–71
Total income	*50,546*		*46,631*		*46,353*		*51,694*		*46,038*		*–9*
Artistic programme costs (a)	26,162	(51)	17,859	(36)	17,628	(37)	19,730	(37)	15,895	(33)	–11
Education programme costs (b)	n/a	n/a	941	(2)	899	(2)	895	(2)	805	(2)	–14
Marketing costs (b)	n/a	n/a	2,756	(6)	2,624	(6)	3,125	(6)	2,727	(6)	–1
)Staff costs (b)	n/a	n/a	20,450	(41)	20,931	(44)	21,881	(42)	19,783	(42)	–3
Overheads (b)	24,773	(49)	7,307	(15)	5,330	(11)	7,090	(13)	8,397	(18)	15
Total recorded expenditure	*50,935*		*49,313*		*47,412*		*52,720*		*47,607*		*–7*
Deficit/surplus	–389		–2,682		–1,059		–1,026		–1,569		
Total reported attendance	1,733,598		1,419,043		1,361,410		1,325,806		1,831,016		6

Base: 21 organisations.

Notes

a) ACE/RAB subsidy for 1997/98 and 1998/99 includes Lottery A4E and Lottery stabilisation awards.

b) Full expenditure breakdown not available for 1994/95. Percentage change in last column refers to 1995/96–1998/99.

of the turnover of the constant sample, and account for around 74 per cent of the reported attendance.

As Table 33.4 demonstrates, there are some noticeable differences in the income and expenditure of ACE- and RAB-funded organisations over the years between 1994/95 and 1998/99. Those mainly supported by RABs have, for example, increased the levels of income they attract from local authorities, sponsors and trusts and donations. Arts Council clients, by comparison, have increased their levels of 'other' public subsidy – but lost income from sponsors, trusts and donations and, to a lesser extent, earned income. Their increased spend on marketing may well be reflected in their 33 per cent increase in audiences. Both ACE and RAB clients have cut spending on artististic programmes.

Changes in income, expenditure and audiences by artform activity

This general picture of the constant sample belies the differences in the perform-ances of individual artforms within the sample. Tables 33.5 to 33.13 track the income, expenditure and audiences of these organisations. As Table 33.1 demon-strates, the percentage changes referred to below are relative given the considerable differences in the numbers of organisations by art form activity and

Table 33.9 ACE/RAB constant sample: income and expenditure of dance organisations excluding the Royal Ballet, 1994/95–1998/99

	1994/95	(%)	1995/96	(%)	1996/97	(%)	1997/98	(%)	1998/99	(%)	Percentage change 1994/95–1998/99
Earned income	12,636	(40)	10,958	(39)	10,300	(37)	11,350	(39)	10,531	(33)	—17
ACE/RAB subsidy (a)	14,870	(43)	15,453	(48)	15,579	(48)	15,760	(51)	16,368	(56)	10
Local authority subsidy	1,799	(4)	1,849	(4)	1,834	(4)	1,891	(4)	1,859	(4)	3
Other public subsidy	266	(1)	102	(0)	188	(0)	72	(0)	280	(1)	5
Sponsorship	1,247	(4)	1,193	(3)	972	(2)	1,309	(3)	1,329	(4)	7
Trusts/donations etc.	1,856	(9)	985	(7)	401	(9)	799	(4)	903	(3)	–51
Total income	*32,674*		*30,540*		*29,274*		*31,182*		*31,272*		*–4*
Artistic programme costs (b)	20,144	(51)	13,194	(36)	12,792	(37)	12,254	(37)	12,838	(33)	–3
Education programme costs (b/c)	–	n/a	649	(2)	682	(2)	711	(2)	674	(2)	4
Marketing costs (b/c)	–	n/a	2,021	(642)	1,875	(637)	2,288	(6)	2,219	(42)	10
Staff costs (b/c)	–	n/a	11,224	(41)	10,969	(44)	11,868	(42)	11,403	(42)	2
Overheads (b/c)	11,931	(49)	4,386	(15)	3,102	(11)	3,704	(13)	4,042	(13)	–8
Total recorded expenditure	*32,075*		*31,474*		*29,420*		*30,825*		*31,176*		*–3*
Deficit/surplus	599		–934		–146		357		96		
Total reported attendance	1,529,248		1,195,960		1,112,825		1,136,233		1,617,335		6

Base: 20 organisations.

Notes

a) ACE/RAB subsidy for 1997/98 and 1998/99 includes Lottery A4E and Lottery stabilisation awards.

b) Percentage change calculated only for 1995/96 to 1998/99.

c) Full expenditure breakdown not available for 1994/95.

their share of the turnover of the sample as a whole. Tables 33.8 and 33.9 include data for dance organisations with and without the Royal Ballet, and Tables 33.11 and 33.12 show data for music organisations with and without the Royal Opera.

As expected, the two smallest groups within the sample – literature and film, video and broadcasting (Tables 33.5 and 33.6) show the most extreme changes. Film, for example, shows the largest percentage falls across the board in income from trusts and donations, and on expenditure on education. It also boasts the greatest increase in surplus as well as a fourfold increase in audiences. Literature shows the largest rises in income (derived from local authorities, other public subsidy and sponsorship) as well as the largest rises in expenditure, including artistic programme costs, staffing and marketing.

Changes across the other art activities vary enormously (Tables 33.7 onwards). The five-year period covered by the data shows extreme variations. In terms of income: visual arts organisations increased their earned income by 28 per cent whereas the income of dance organisations (excluding the Royal Ballet) fell 17 per cent. Levels of 'other' public subsidy rose by 176 per cent amongst the music sample (minus the Royal Opera) and fell by 56 per cent for drama. However, drama organisations gained in other categories of income, with their levels of sponsorship up 118 per cent and their income from trusts/donations up 429 per

Table 33.10 ACE/RAB constant sample: income and expenditure of drama organisations, 1994/95–1998/99

	1994/95	(%)	1995/96	(%)	1996/97	(%)	1997/98	(%)	1998/99	(%)	Percentage change 1994/95– 1998/99
Earned income	44,011	(54)	39,383	(48)	41,907	(49)	41,493	(48)	46,342	(51)	5
ACE/RAB subsidy (a)	29,670	(36)	30,523	(37)	31,487	(37)	33,347	(39)	32,534	(36)	10
Local authority subsidy	4,772	(6)	4,118	(5)	7,899	(9)	5,829	(7)	5,001	(6)	5
Other public subsidy	780	(1)	4,075	(5)	544	(1)	497	(1)	345	(0)	−56
Sponsorship	1,625	(2)	2,326	(3)	2,427	(3)	3,203	(4)	3,545	(4)	118
Trusts/donations etc.	438	(1)	1,230	(2)	1,921	(2)	1,721	(2)	2,316	(3)	429
Total income	*81,296*		*81,655*		*86,185*		*86,090*		*90,082*		*11*
Artistic programme costs (a)	40,539	(51)	36,079	(44)	37,436	(42)	32,926	(38)	37,191	(41)	3
Education programme costs (b)	–	n/a	1,420	(2)	1,760	(2)	2,088	(2)	2,088	(3)	63
Marketing costs (b)	–	n/a	3,761	(5)	4,502	(5)	4,141	(5)	4,100	(5)	9
Staff costs (b)	–	n/a	31,410	(38)	33,991	(38)	36,055	(42)	34,779	(39)	11
Overheads (b)	39,414	(49)	10,220	(12)	11,232	(13)	10,620	(12)	11,853	(13)	16
Total recorded expenditure	*79,953*		*82,890*		*88,921*		*85,830*		*90,237*		*13*
Deficit/surplus	1,343		−1,235		−2,736		259		−156		
Total reported attendance	4,227,756		4,674,552		4,825,905		5,219,384		4,413,587		4

Base: 41 organisations.

Notes
a) ACE/RAB subsidy for 1997/98 and 1998/99 includes Lottery A4E and Lottery stabilisation awards.
b) Full expenditure breakdown not available for 1994/95. Percentage change in last column refers to 1995/96–1998/99.

cent. At the other end of the scale, sponsorship fell 77 per cent in visual arts, and income from trusts/donations fell by 51 per cent amongst the dance sample (without the Royal Ballet).

There were similarly extreme changes on the expenditure side. Combined arts organisations increased their spend on education by 2,103 per cent from 1995/96, whereas spending on education by dance (without the Royal Ballet) increased by only 4 per cent during the same period.

Dance experienced the largest percentage fall in income (4 per cent, without the Royal Ballet). A major factor was the fall in its funding from trusts and donations of 51 per cent. Drama organisations recorded the highest increases in sponsorship, and income from trusts and donations. Their income rose 11 per cent over the period. However, drama showed the highest rise in overheads (16 per cent) and expenditure generally (13 per cent). By comparison, music attracted the highest percentage increase in local authority income (13 per cent) as well as a large increase in 'other' public subsidy (mentioned above).

Visual arts organisations' increased earning (28 per cent) has to be set against their falls in support from local authorities, sponsors and 'other public funders'. The visual arts organisations in the constant sample increased their spending on artistic programmes and education, at the same time as having the highest increase in staff costs (16 per cent). This sample also reported the largest rise in

Table 33.11 ACE/RAB constant sample: income and expenditure of music organisations, 1994/95–1998/99

	1994/95	(%)	1995/96	(%)	1996/97	(%)	1997/98	(%)	1998/99	(%)	Percentage change 1994/95–1998/99
Earned income	54,105	(53)	55,722	(54)	55,480	(55)	52,688	(50)	49,415	(48)	–9
ACE/RAB subsidy (a)	31,621	(31)	32,726	(32)	32,715	(32)	39,559	(38)	41,684	(40)	32
Local authority subsidy	3,981	(4)	4,193	(4)	4,385	(4)	4,652	(4)	4,518	(4)	13
Other public subsidy	273	(0)	114	(0)	235	(0)	128	(0)	754	(1)	176
Sponsorship	6,587	(6)	4,693	(5)	3,888	(4)	4,192	(4)	4,078	(4)	–38
Trusts/donations etc.	6,089	(6)	6,039	(6)	4,020	(4)	3,556	(3)	3,018	(3)	–50
Total income	*102,656*		*103,487*		*100,723*		*104,774*		*103,467*		*1*
Artistic programme costs (a)	59,197	(57)	49,257	(47)	51,812	(51)	47,467	(44)	49,762	(47)	1
Education programme costs (b)	–	n/a	1,159	(1)	1,377	(1)	1,784	(2)	1,928	(2)	66
Marketing costs (b)	–	n/a	3,974	(4)	4,152	(4)	4,113	(4)	3,899	(4)	–2
Staff costs (b, c)	–	n/a	38,695	(37)	35,013	(34)	41,362	(38)	35,107	(33)	–9
Overheads (b)	44,715	(43)	11,136	(11)	10,211	(10)	12,971	(12)	14,911	(14)	34
Total recorded expenditure	*103,912*		*104,221*		*102,565*		*107,698*		*105,607*		*2*
Deficit/surplus	–1,256		–734		–1,842		–2,923		–2,140		
Total reported attendance	2,179,704		2,622,242		2,637,047		3,508,841		2,678,880		23

Base: 22 organisations.

Notes

a) ACE/RAB subsidy for 1997/98 and 1998/99 includes Lottery A4E and Lottery stabilisation awards.

b) Full expenditure breakdown not available for 1994/95. Percentage change in last column refers to 1995/96–1998/99.

c) For 1997/98, two orchestras reported musicians costs as staff costs whilst including those costs as artistic programme costs for each other year.

audiences (251 per cent). However, visual arts attendance figures are notoriously inaccurate. Given that admission tends to be free, there are no box-office systems which are normally used to count attendances.

Table 33.12 ACE/RAB constant sample: income and expenditure of music organisations excluding the Royal Opera, 1994/95–1998/99

	1994/95	(%)	1995/96	(%)	1996/97	(%)	1997/98	(%)	1998/99	(%)	Percentage change 1994/95– 1998/99
Earned income	37,000	(53)	39,529	(54)	40,347	(55)	41,744	(50)	42,269	(48)	14
ACE/RAB subsidy (a)	23,857	(31)	24,612	(32)	24,721	(32)	26,861	(38)	29,961	(40)	26
Local authority subsidy	3,981	(4)	4,193	(4)	4,385	(4)	4,652	(4)	4,518	(4)	13
Other public subsidy	273	(0)	114	(0)	235	(0)	1,282	(0)	754	(1)	176
Sponsorship	4,261	(6)	4,693	(5)	3,888	(4)	4,192	(4)	3,841	(4)	–10
Trusts/donations etc.	3,846	(6)	3,001	(6)	2,554	(4)	21,452	(3)	2,571	(3)	–33
Total income	*73,218*		*76,142*		*76,130*		*79,722*		*83,915*		*15*
Artistic programme costs (b)	47,831	(57)	39,178	(47)	42,679	(51)	38,330	(44)	43,705	(47)	12
Education programme costs (b)	–	n/a	960	(1)	1,159	(1)	1,560	(2)	1,768	(2)	84
Marketing costs (b/c)	–	n/a	3,036	(4)	3,273	(4)	3,091	(4)	3,278	(4)	8
Staff costs (b/c/d)	–	n/a	25,650	(37)	22,929	(34)	29,124	(38)	24,858	(33)	–3
Overheads (b/c)	27,684	(43)	7,375	(11)	7,174	(10)	8,833	(12)	9,588	(14)	30
Total recorded expenditure	*75,515*		*76,199*		*77,214*		*80,938*		*83,197*		*10*
Deficit/surplus	–2,297		–57		–1,084		–1,216		718		
Total reported attendance	1,896,104		2,366,398		2,360,205		3,091,141		2,495,022		32

Base: 21 organisations.

Notes
a) ACE/RAB subsidy for 1997/98 and 1998/99 includes Lottery A4E and Lottery stabilisation awards.
b) Percentage change calculated only for 1995/96 to 1998/99.
c) Full expenditure breakdown not available for 1994/95.
d) For 1997/98, two orchestras reported musicians costs as staff costs whilst including those costs as artistic programme costs for each other year.

Table 33.13 ACE/RAB constant sample: income and expenditure of visual arts organisations, 1994/95–1998/99

	1994/95	(%)	1995/96	(%)	1996/97	(%)	1997/98	(%)	1998/99	(%)	Percentage change 1994/95– 1998/99
Earned income	3,882	(32)	4,515	(35)	3,833	(32)	4,230	(35)	4,966	(38)	28
ACE/RAB subsidy (a)	6,728	(55)	6,768	(53)	6,691	(56)	6,675	(55)	6,945	(53)	3
Local authority subsidy	444	(4)	480	(4)	459	(4)	422	(3)	374	(3)	−16
Other public subsidy	173	(1)	317	(2)	144	(1)	89	(1)	121	(1)	−30
Sponsorship	515	(4)	327	(3)	311	(3)	319	(3)	117	(1)	−77
Trusts/donations etc.	456	(4)	392	(3)	432	(4)	425	(3)	650	(5)	43
Total income	*12,198*		*12,799*		*11,870*		*12,161*		*13,173*		*8*
Artistic programme costs (a)	4,151	(33)	4,484	(36)	3,939	(34)	4,009	(33)	4,576	(35)	2
Education programme costs (b)	–	n/a	221	(2)	174	(2)	356	(3)	425	(3)	92
Marketing costs (b)	–	n/a	948	(8)	943	(8)	773	(6)	921	(7)	−3
Staff costs (b)	–	n/a	3,978	(32)	4,097	(35)	4,210	(35)	4,210	(35)	16
Overheads (b)	8,305	(67)	2,852	(23)	2,395	(21)	2,669	(22)	2,628	(20)	−8
Total recorded expenditure	*12,456*		*12,483*		*11,548*		*12,017*		*13,177*		*6*
Deficit/surplus	−258		316		322		144		−4		
Total reported attendance	1,474,536		2,406,898		2,274,871		4,032,017		5,178,950		251

Base: 17 organisations.

Notes

a) ACE/RAB subsidy for 1997/98 and 1998/99 includes Lottery A4E and Lottery stabilisation awards.

b) Full expenditure breakdown not available for 1994/95. Percentage change in last column refers to 1995/96–1998/99.

34
Afterword: The Cultural Commodity and Cultural Policy

Nicholas Garnham, University of Westminster

From the arts to the creative industries: anatomy of a confusion

The UK Cultural Sector aims to chart empirically the structure of the publicly supported cultural sector and the changes that have taken place since *Culture as Commodity?* (Casey et al., 1996), not least as a result of Lottery funding. But such a data collection exercise does not take place in a policy vacuum. It takes place within a context where the search for 'value for money' governs government expenditure and where, under its contract with the Treasury, the Department for Culture, Media and Sport (DCMS) is expected to demonstrate, by developing performance indicators, a clear relationship between spending inputs (now re-termed 'investment') and measurable policy outputs. It also takes place within a broader context of policy thinking that has shifted focus from 'the arts' to 'the creative industries'. Its purpose, therefore, is to be of value in the determination and monitoring of cultural policy.

This chapter, consequently, analyses the policy context within which public support for culture now takes place. It does so for two reasons. In order to decide what should be measured and why, it is necessary to clarify two arguments within the current policy discourse. The first concerns the reasons why certain types of cultural production and consumption receive public support and others do not – the problem of definition, the thorny question of what is meant by art or culture. The second, given that choice, is concerned with what objectives public support is designed to achieve and, thus, how the success or failure of policy might be monitored – the problem of assessment or accountability. The second argument is particularly crucial precisely because arts funding now takes place within the general Treasury remit of value for money judged against other possible uses of scarce public resources.

The case for the public support of the arts has to be made against a social and political background in which it is assumed that the majority of goods and services should be provided under competitive market conditions. Moreover, the

tendency over the last three decades has been to move as much as possible non-market state provision out of the public sector and into the market and to bring what remains of public provision under quasi-market disciplines (as, for instance, in health and education).

It is in this context that current cultural policy operates. It is, therefore, hardly surprising that current cultural policy discourse is couched in the language of economics. DCMS's *A New Cultural Framework* (DCMS, 1998) talks not of subsidy but of 'investment in culture', and of publicly funded arts organisations as 'sponsored bodies'. The aims of cultural policy are 'the delivery of appropriate outputs', 'improved efficiency', 'providing the public with the widest choice of high quality services provided in the most efficient way', 'putting a new emphasis on the public rather than the producer', and all within the general policy envelope of 'resource accounting'.

This position has been marked by the change of title of the responsible ministry from National Heritage to Culture, Media and Sport and by the focus on 'creative industries' which has marked a range of the 1997 Labour administration's policy initiatives.

The mobilisation of this concept and the choice, as one of the four key themes of cultural policy, of 'the fostering of the creative industries' gives to current policy a look of radicalism, coherence and hard-headedness, which a closer examination belies. The purpose of this chapter is not to criticise this shift, but to uncover its often contradictory logics. For the mobilisation of the terms culture and creative industries, and the more general economic rhetoric used to justify them, are more complicated and contradictory than they at first sight appear. In deciding what or who needs support, and thus needs measuring, and what detailed policy outcomes are sought, and thus how they might be monitored for the purposes of resource accounting, it is necessary to unpick the different strands of policy thinking, and the different and sometimes contradictory rationales that stem from them. In that process, terms such as creative industries, as is the way with concepts used as slogans, do as much to disguise as to reveal. It is also important to stress that current policy is much less radical than its presentation might lead one to believe; it is still faced with long-standing problems in public cultural policy, and, indeed, the current proposals are very familiar responses.

The key themes of current policy, as described elsewhere in this book, are:

- the promotion of access for the many, not just the few;
- the pursuit of excellence and innovation;
- the nurturing of educational opportunity;
- the fostering of the creative industries (DCMS, 1998).

The first three of these, and the tension between them (what the Arts Council in the past has referred to as the clash of priorities between 'raising' and 'spreading', have been the staples of cultural policy since the foundation of the Arts Council of Great Britain in 1946. The question that needs to be asked is, how does a focus on creative industries and on culture from an economic perspective change the ways in which we go about pursuing these goals and our judgements as to the resulting success or failure? In particular, what relationship is there

446

between 'fostering the creative industries' and the other aims of cultural policy – access, excellence and education?

Economic justification of public support in the cultural sector

Broadly, it is possible to identify the following justifications from an economic perspective for public support for culture. Some arguments are general arguments about types of market failure and some are specific to the symbolic, media or knowledge economy.

General market failures derive from public-good, externalities, merit-good and information-cost arguments. Public goods are distinguished by 'non-rivalry' and 'non-exclusivity'. The problem is that it is difficult to get people to pay for goods where they do not have exclusive rights to consume the good in question – for example, a museum or art gallery – or where their consumption of the good does not effect the good in question – for example, a concert performance, looking at a painting or reading a book. Externalities refer to those cases where the social costs and benefits of an economic activity spill over to those not directly involved in the economic transaction, and thus producers and consumers are either not paying the full costs or not receiving the full benefits of the activity in question. A classic case in the cultural field is land and buildings, hence the need for planning controls and protection of the heritage. The merit goods are those the consumption of which is deemed intrinsically desirable either for individuals or society as a whole, for example public health, but which consumers tend to under-consume for reasons of cost or lack of information, for example, in risk assessment (QUEST, 2000). The provision of compulsory education is a classic case.

In addition to these general cases of market failure, there are special arguments in relation to symbolic, as opposed to material, goods. In the cases of mechanically reproducible forms of art, the non-rival nature and low-to-zero marginal costs of consumption mean that any price barrier to consumption produces an overall welfare loss. This is one of the arguments for the licence-fee financing of public broadcasting. The non-homogeneous and essentially innovatory nature of cultural products – a key quality of cultural products and services is that each product or experience is new and unique – undermines two assumptions of market theory and the fully rational utility-maximising consumer upon which such theory is based. First, in the cultural case, the competitive goods and services are non-substitutable. Consumers can make a reasonable comparative assessment of the relative quality and cost of different cars or packets of soap powder, but not of two films or books. Second, there is an inherently high level of uncertainty in the act of consumption. It is simply impossible for us to know adequately in advance whether the product or service is going to match our expectations of it. This has three consequences.

1 It works against innovation.
2 It leads to a very loose fit between supply and demand, such that even within the commercial cultural industries sector, with the aid of the most sophisti-

cated forms of market research, a high proportion of products fail. This means that, even under conditions of profit maximisation, cultural production is inherently risky and the extent of audience satisfaction can only be judged in the aggregate and over a relatively large range of product and long-run time scale.

3 It leads to the argument that the utility derived from cultural consumption is endogenously rather than exogenously determined. Put crudely, cultural consumption feeds upon itself – we learn the pleasures and rewards of cultural consumption from within the process itself. Hence, the arguments for support of arts education. This is, of course, a special case of the merit-good argument.

There is also the possibility of labour-market failure. It can be argued that artists, or 'creative workers', require support because the necessary training period is long and the benefits of such human-capital enhancement go as much to society as to the individual and, therefore, the incentives to enter the profession are inadequate. This is the classic economic defence of the public provision of education and training. Here the very existence of intellectual property protection designed as a solution to the special incentive and market-entry problems of symbolic or knowledge production is the classic example of public support. Indeed, some would make the very definition of 'creative industries' as those which are based on trading intellectual property rights.

Finally there are the research and development (R&D) spin-off and infrastructure arguments. The arts, it can be argued, are the research and development arm of downstream commercial activities and, as in other industries, for instance high technology, public support for this R & D is justified in the same way as support for the so-called science base. It provides national competitive advantage. The same argument is mobilised around the University for Industry in relation to the UK's multimedia educational publishing industry. It is also argued that, as with roads, hospitals and schools, the provision of cultural institutions and activities increases the attractions of a country and encourages tourism or inward investment.

These arguments were summed up by the former Secretary of State for Culture, Media and Sport, Chris Smith, as

> *five principal reasons for state subsidy of the arts in the modern world: to ensure excellence; to protect innovation; to assist access for as many people as possible, both to create and appreciate; to help provide the seedbed for the creative economy; to assist in the regeneration of areas of deprivation.*
>
> (Smith, 1998: 19)

If these are the key reasons for public support in the cultural sector, then how does a cultural/creative-industries approach affect the logic or justification for subsidy? What does it say about excellence, access, innovation or regeneration?

The sources of the 'creative-industries' perspective

As so often, the use of a common term can lead to a false sense of unity. In fact, three distinct streams of policy thinking can be seen as feeding into the current focus on the creative industries. Each derives from a distinct analysis of the problem posed by public support for the arts, and arrives at a distinct set of policy objectives which it is important to disentangle.

One source of thinking has been the analysis of cultural-industries strategy by the Greater London Council (GLC) in the early 1980s, the results of which were published as *The State of the Art or the Art of the State* (GLC, 1985). Indeed the Labour Party's pre-election policy document *Create the Future* (Labour Party, 1997) talked about the arts and cultural industries and the creative economy. But, this shift from cultural to creative industries is not just a question of nomenclature. It also represents an important shift in the analysis.

In GLC thinking, the term cultural industries was mobilised for two distinct purposes. The first was a critique of the then dominant model of public support for the arts, in particular through the Arts Council. This critique focused on the model of arts support which supported the producers of a limited range of cultural artefacts or performances traditionally defined as high art. The cultural-industries focus argued for a shift of attention away from producers of art to its consumers – the audience – and away from high art towards the commercially produced art that, in fact, most people consumed. As the author of the present chapter and one of the proponents of this policy wrote at the time:

> *To mobilise the concept of the cultural industries as central to an analysis of cultural activity and of public cultural support is to take a stand against a whole tradition of idealist cultural analysis.... This is important because in general public cultural policies have evolved from within that tradition. Public intervention, in the form of subsidy, is justified on the grounds (1) that culture possesses inherent values, of life enhancement or whatever, which are fundamentally opposed to and in danger of damage by commercial forces; (2) that the need for these values is universal, uncontaminated by questions of class, gender and ethnic origin, and (3) that the market cannot satisfy this need.*
>
> *A further crucial component of this ideology is the special and central status attributed to the 'creative artist' whose aspirations and values, seen as stemming from some unfathomable and unquestioned source of genius, inspiration or talent, are the source of cultural values. The result of placing artists at the centre of the cultural universe has not been to shower them with gold, for artistic poverty is itself an ideologically potent element in this view of culture, but to define the policy problem as one of finding audiences for their work, rather than vice-versa. When audiences cannot be found, at least at a price and in a quantity which will support the creative activity, the market is blamed and the gap is filled by subsidy....*
>
> *One result of this cultural policy making tradition has been to marginalise public intervention in the cultural sphere and to make it purely reactive to processes which it cannot grasp or attempt to control. For while this tradition*

has been rejecting the market, most people's cultural needs and aspirations are being, for better or worse, supplied by the market as goods and services.

(Garnham, 1990: 154–5)

Thus, from this perspective the mobilisation of the term cultural industries shifted attention from artists to audiences and from high art to commercially produced and distributed culture. This is important, because the term creative industries and current policy statements attempt to combine a central focus on the artist – now renamed as the 'creative core' of the creative industries matrix – with an apparent rejection, in the name of democracy, of any hierarchy or distinction between high art and popular art or culture. However, this distinction is in fact smuggled back in under the name of excellence. At the same time, it both sees access as a central problem and policy aim while at the same time wishing to justify support for commercial cultural activities on the grounds that they are so successful and dynamic economically and thus presumably do not suffer from an access problem. (An example is the contradiction within Smith's *Creative Britain* (1998) of claiming publishing as a leading economic growth sector, while at the same time wishing to justify its continuing exemption from VAT – a cultural subsidy that could be redirected.)

Employment creation and economic development

The second focus of cultural industries thinking within GLC policy, and one with no necessary connection to the first, was the problem of economic development and employment. It is important to note that it was specifically directed at London, which for historical reasons had experienced heavy but hidden de-industrialisation (for instance, in the dock industry) while being at the same time a centre for cultural industries of both national and international scope. That being said, the arguments for public cultural support were now very different. They took patterns of consumption for granted; indeed it was growing cultural consumption that was driving the relevant changes in market structure. And, it was argued, within a more general framework of the macro-economic analysis of the shift to the service sector within developed industrial economies and the specific economic characteristics of the cultural industries, for public investment in the infrastructure of cultural distribution, support for training, venture capital, etc. One branch of this argument then developed as part of a local economic development strategy in which the employment-creation thrust became confused with an argument that cultural facilities contributed to local economic growth by creating an environment that was attractive to inward investment (the 'making the world comfortable for executives and their families' argument, where culture is part of a wider package of good schools, transport links, golf courses, etc.) and by contributing to tourist income.

This part of the argument has been folded into branding of Britain – the 'Cool Britannia' part of recent policy. In *Creating the Future* the cultural industries are seen as 'central to the task of re-establishing a sense of community, of identity, of civic pride' (Labour Party, 1997: 13). In *Creative Britain* Smith talks of 'culture

and art as the things that help to shape our shared identity' (Smith, 1998: 16) and argues that creativity and cultural activity help develop civil society in five ways, through 'fulfilment, identity, inclusion, challenge and useful beauty' (Smith, 1998: 24). The same line of thinking is evident in the inclusion among the five reasons for state subsidy of the arts 'to assist in the regeneration of areas of deprivation' (Smith, 1998: 19). This refers quite explicitly to Keynes's original argument for the Arts Council. Indeed he is quoted by Chris Smith as follows:

> *The purpose of the Arts Council of Great Britain is to create an environment, to breathe a spirit, to cultivate an opinion, to offer a stimulus to such purpose that the artist and the public can sustain and live on each other in that union that has occasionally existed in the past at the great ages of communal civilized life.*
>
> (Smith, 1998:18)

In stressing the continuity of this approach to cultural policy it is also possible to quote Peter Palumbo in the introduction to the 1990/91 Arts Council of Great Britain annual report, where he talks of the arts

> *as a precious national asset, as the means by which we are perceived as a nation in the eyes of the rest of the world, as a means of transforming inner city blight or reviving the economic fortunes of towns and cities throughout the country which have lost their traditional industries, as an earner of soft currency and as a civilizing influence that enhances the quality of life.*
>
> (ACGB, 1991)

It was this focus on the multiplier effects of the cultural sector that lay behind Myerscough's influential study (Myerscough et al., 1988). Here the crucial point is the need to separate out the economic arguments for the cultural sector or creative industries as employment generators in their own right – which may, in fact, not need subsidy to produce the necessary effects – from the creative industries or cultural sector as a recipient of public investment as a form of development aid, on the same grounds as infrastructure investment, to be judged and monitored in terms of its multiplier effects. Here, given scarce resources, it is perfectly proper, indeed unavoidable, to ask whether other investment, for instance in public transport, might not be more efficient.

The information society

These arguments for public intervention in the cultural industry sector came from the interventionist left of the political spectrum. However, they chimed with the third strand of policy thinking lying behind the creative industries, a strand that came from the neo-liberal right. A key policy document here was the Cabinet Office report of 1983, *Making a Business of Information* (Cabinet Office, 1983), itself part of a wider government initiative around information and communication technology led by the Department of Trade and Industry (DTI). Indeed, one

aspect of policy debates on the arts and culture, of which current initiatives are a part, can be seen as a continuing turf war at the heart of government throughout the 1980s and 1990s between the DTI, what is now the DCMS, and the Treasury, which was about managing economic and industrial policy in the information society. Indeed the DCMS's predecessor was itself the creation of this war's focus on control over broadcasting.

Making a Business of Information was the expression at the heart of the UK government of the post-industrial, information-society policy argument from which the focus on dependence on the exploitation of intellectual property as the defining characteristic of the creative industries and on the key role of the creative core ultimately derives. The argument is by now familiar and lies increasingly at the heart not just of UK government policy formation but of that of the European Commission and the US government. It is argued that the developed world is moving into a new economic paradigm on a global scale, centred on digitally based information and communication technologies. Within this, the key growth sectors of the economy and sources of added value are the so-called knowledge industries, where the product is no longer physical objects but information. We are moving from an economy of atoms to an economy of bits (or a weightless economy), within which knowledge workers are the key competitive resource.

This line of argument was then linked to more general work on the competitiveness of the UK economy and, inspired by the work of management gurus such as Michael Porter, fed into statistical work on the export earnings and potential of the cultural industries (British Invisibles, 1991). This in its turn fed into both Myerscough's study for PSI and the report by Gorham and Partners for the British Council, *Export Potential of the Cultural Industries* (Gorham and Partners, 1996). It is from this strand of policy analysis that derives:

- the measurement of the creative industries in the Mapping Document and the associated claims that they now represent the fastest sector of economic growth;
- the stress on the training of creative workers; and
- the stress on the protection of intellectual property.

This is the source of the view expressed in *Creating the Future* that the cultural industries 'are vital to the creation of jobs and the growth of our economy. The creative and media industries world wide are growing rapidly – we must grasp the opportunities presented' (Labour Party, 1997). It is also the source of Chris Smith's claim in *Creative Britain* that

> given the levels of growth already experienced in these fields, given the flow of changing technology and digitisation, given our continuing ability to develop talented people, these creative areas are surely where many of the jobs and much of the wealth of the next century are going to come from.
>
> (Smith, 1998: 25)

This whole line of argument is open to serious objection (Garnham, 2000), particularly when linked to arguments that Britain is especially 'creative' as a nation. But, let us assume that the argument is broadly correct. It still needs to be stressed that the focus on knowledge and intellectual property within this general economic analysis does not single out the creative industries for special attention or status since the centrality of knowledge runs throughout all economic activity. Indeed, in the source of much of this thinking (Bell, 1973) it is specifically organised science that is the core of the knowledge industries. In fact, the fastest-growing areas of employment in the US economy are not in the creative industries but in health care, to which exactly the same arguments apply. In the communication sphere it is functional business-to-business communication that dominates, not the 'artistic' media as normally defined.

However, the key question for cultural-policy purposes is about what contribution, if any, might public support for the cultural sector make to the economic growth, and therefore the generation of wealth and employment, of the creative-industries sector.

Human capital, skills and training

First, support for the training of creative workers is required, it is argued, to ensure international competitiveness in the provision of suitable human capital. In brief, the argument is that without suitably targeted public support there will be an inadequate supply of core creative workers. If that is the case, monitoring should focus on this problem. It is vital to know whether or not the UK supply of trained creatives really is, in comparison with our competitors, deficient in some way and whether targeted public support leads to an enhancement in either quantity or quality. There must, however, be doubts as to whether this really is a problem.

In the media-studies field it is constantly said that higher education is producing an over-supply. And, indeed, the Gorham report (1996) argues for an export push in part to mop up above-average levels of unemployment in the sector. Is the reason for US global dominance in knowledge sectors really due to their training and education sector? If, however, such a human-capital/skill-base approach to education is appropriate education policy here, this may clash with other current policy imperatives. It is, for instance, striking that just as UK education policy is heading back towards a less 'child-centred' approach, our competitors, for instance France and Japan, for just the reasons adumbrated above, are trying to move toward what was seen as the UK approach precisely because it fosters the 'creativity' seen as essential to the new 'creative' industries (NACCCE, 1999).

Thus, it is necessary to distinguish, within the theme of education in current policy, a policy directed at training creative workers (a human-capital, skill-shortage argument) from education to educate the audience, an argument about barriers to access. One simply bears no relation to the other. And, the measures of their success will necessarily be very different. It is also important to distinguish the human-capital argument from that which argues that the arts are

potentially valuable employment generators, not because they are globally competitive creative industries, but precisely because they are inherently labour-intensive and local and, therefore, not subject to the technologically based productivity, and thus labour-shedding, pressures of global competition.

Innovation and synergy

It is further argued that: the subsidised sector acts as the R & D arm of the commercial creative industries; the support of fine arts feeds through into excellence in design; the competitive market for knowledge is inherently conservative; and only publicly supported work will favour innovation (one of the arguments for the licence-fee support of the BBC).

A central theme of cultural policy discourse has been the source of the value of art in the necessarily unpredictable and, thus, unplannable and uncontrollable creativity of the artist. The community must support artists because they provide us with new and challenging insights. The market is notoriously bad at providing for this, hence the general economic arguments for the public support for basic science and R & D. This argument then links to that which derives from the information-economy tradition concerning the centrality of human-capital formation in international competitivity and comparative advantage, and to an argument concerning the subsidised arts sector as the testbed for the commercial sector's R & D arm. This then needs serious analysis as to whether there is in fact the transfer supposed and, if there is, why the profitable commercial undertakings in the creative industries cannot support it directly, for instance by a training levy or licensing agreements. It certainly seems to be a very questionable proposition that the US dominance in the film and TV industries is based upon a thriving publicly funded theatre sector or that the success of British graphic design in some way depends upon the training and support of fine artists. Of course, another view of the market would say that, on the contrary, the market is the best way to encourage innovation and that subsidy always tends to favour the established, the conservative, the past. Indeed one of the attractions of the creative-industries rhetoric is clearly the wish of the 1997 government to appear to be future-oriented and trendy. Hence the title of its pre-election strategy document on the cultural sector, *Creating the Future*.

The problem with this artist-centred approach is twofold. First, if we reject the market test, which many would hold is the only and most rigorous test of excellence, how do we identify which artists or creatives to support? (Classically, with the Arts Council, this was to be left to peer review.) Secondly, how do we reconcile this with access if audiences fail to appreciate this creativity. It is striking that there is a clear contradiction at the heart of current policy, which on the one hand stresses access and education while on the other emphasising excellence and the creative core. The key problem is that if we wish to place an emphasis on excellence and wish to reject the simple test of popularity, we are left with the difficult problem of defining and perhaps measuring excellence (Selwood, 2000). In fact, we are left with the unavoidable conclusion that the term excellence within cultural-policy discourse can only be a code for exclusiv-

ity, for the hierarchy of forms or activities (where excellence is found) as opposed to the normal everyday cultural products produced by the cultural/creative industries and consumed by their paying publics. It is a debate with which those involved with broadcasting are familiar under the term 'quality'.

But, perhaps more fundamentally, the development of performance indicators linking government investment to measurable outputs faces a problem common to all economic sectors dealing in intangibles, whether those intangibles are defined as services or knowledge. The problem, whether outputs are defined as excellence (the quality of the product) or access (the size and social composition of the audience), is to find hard, stable, coherent measures for either inputs or outputs so that in thinking about the relationship between the two, the economic concepts of efficiency or productivity are of any use. This is emphatically not to retreat into a mystical defence of the unmeasurable and unassessable nature of art, but to underline the real difficulty of the search for useful performance indicators and thus of the data required for their construction.

Access, excellence and accountability

However, the key policy problems, and therefore monitoring problems, raised by the creative-industries focus relate to deep-seated policy dilemmas. Should support be focused on producers or consumers? Is there a restricted range of cultural forms or activities that merit public subsidy and, if so, why? This question of a hierarchy of cultural forms and practices which merit public support, and of judgements of quality, other than those of popularity, is hidden in current policy discourse under the notoriously fluid term 'excellence'. The claim is made that current policy is focused on democratising culture by widening access or lowering barriers to the widest possible range of cultural experiences. This is for two reasons: on the consumption side, for audiences; and on the production side, by allowing the maximum number of people to fulfil their creative potential (this is based in turn on the unexamined and on the face of it unlikely notion that the population of the UK is uniquely creative, whatever that might mean).

From one perspective, the success of the creative industries might lead us to assume that the problem of democratisation was on the way to solution, for such industries, driven by market imperatives, wish to attract, and do in fact attract, the widest possible range of consumers and precisely for that reason do not sustain a hierarchy of artistic forms or practices. Indeed, their opponents in part criticise their cultural effects precisely for that reason. It has become known in popular journalistic parlance as 'dumbing down'. The desire not to give up on either the traditional support for the artist or a hierarchy of quality is covered by the terms 'creative' and 'excellence'. Indeed, the shift in nomenclature from cultural industries to creative industries above all signals a shift back to a focus on the artist and on the supply of culture rather than on the audience and the consumption of culture.

Current creative-industries policy is presented as a break with the past in two senses. The renaming of the Department of National Heritage as the Department

for Culture, Media and Sport is intended, on the one hand, to signal a shift of focus away from support for the 'traditional' high arts, with their association with the protection of the values of some golden age, and towards the creatively new (often associated with young, trendy and 'cool'). On the other hand, the idea is to signify a shift of focus from the marginality of the Ministry of Fun to a serious concern with the central business of economic policy – a shift from circuses to bread.

In fact, this shift has been taking place over a long period in response to the manifest problems raised by previous policies. Traditionally, public support for the arts was based upon a model of patronage in which it was the responsibility of a 'civilised' community to support artists on the grounds of the contribution they made to fostering higher spiritual values. Policy was artist-centred. As Keynes put it in justification of the Arts Council's creation in 1946:

> *The artist walks where the breath of the spirit blows him. He cannot be told his direction: he does not know it himself, but he leads the rest of us into fresh pastures and he teaches us to love and enjoy what we often begin by rejecting, enlarging our sensibilities and purifying our instincts.*

This original founding position, however, raised two problems with which cultural policy still grapples – accountability and access.

This necessarily free and unpredictable nature of artistic creation was the justification for the arm's-length principle of accountability whereby only the artistic community itself could decide who was worthy of support and who was not. Just as children should not decide education policy, so, it could be argued, neither the potential consumers of culture nor their political representatives were competent to judge either the distribution of arts funding or its outcomes.

The problem was that this position was in practice unsustainable. First, the appropriate recipients of support were steadily widened. The remit of the Arts Council was widened from fine arts to the arts in 1967, and in 1971 a Crafts Advisory Committee was created. Throughout the 1970s and early 1980s a battle raged around the Arts Council over whether, and if so how, to include so-called community arts and ethnic arts within the funding remit. This is a continuing argument. In effect, this debate was about excellence and its definition. That this problem has not gone away is illustrated by the fact that the four key themes of current creative industries policy are, according to Chris Smith, 'access', 'excellence', 'education' and 'economic value'. The problem of excellence has continued to raise two policy problems. On the one hand, who is to decide what is excellent, which in turn has been closely associated with the question of whether certain forms or genres, labelled art, are ipso facto excellent and therefore worthy of support, while others, labelled culture or perhaps popular culture, are not.

The second problem is the relation between excellence and access. Or, to put it another way, to what extent should the audience be the measure of excellence? In Arts Council reports this has been expressed as a tension between the policy objectives of 'raising' and 'spreading'. This is important because it relates closely to the market-failure arguments for arts support and to the stress on education as a solution to the problem of the narrow access or the absent audience. In short,

having set up the core justification of public arts support as the creation of a civilised community through the educational effect of art, if the community resolutely fails to be educated, whose fault is it – artist or audience – and what should be the response? The shift in current policy discourse from cultural industry, the term used in the Labour Party's pre-election document *Create the Future*, to creative industries marks in part a shift back to an artist-centred definition of excellence (properly trained artists, no doubt) and a search for the solution to lack of access through education of the consumer. But such an approach does not fit easily with the parallel stress on immediate audience-widening criteria (or access) for arts funding. Here the clear identification of what are seen as the barriers to access, how they might be removed, and whether any arts organisation has much if any control over such mechanisms, is crucial in judging the efficacy and value for money of any policy.

There are here two distinct ways of thinking about the policy problem. On the one hand, there is the model whereby a particular cultural output is deemed excellent and a merit good which would not survive without public subsidy of production, for example, Covent Garden. The problem is to distribute this scarce good fairly and to avoid the clearly undemocratic situation whereby poor taxpayers subsidise the cultural pleasures of the better-off. In this model, the main barrier to access is seen as cost and in principle could be solved by some type of means-tested rationing system. But, this model also covers the very real policy problem of the physical availability of cultural institutions and events and, thus, the geographical spread of arts funding. In the first case it is necessary to assess the relationship between funding of Covent Garden, the cost of seats and the socio-economic composition of its audience. In the second case it will be necessary to measure at the macro-level the relationship between regional funding and audience catchment areas and composition. But, the crucial point is whether this would lead to a redistribution of existing funds and, thus, the possible removal of support for existing excellence in one place in favour of the inherently risky enterprise of creating possible excellence where it does not yet exist, and where an audience may not, as yet, exist either. The question here is in part whether the availability of certain types of cultural goods and services is in some sense a democratic citizens' right, to be guaranteed by the state.

On the other hand, the access problem is folded into a wider concept of social exclusion. Here, the barriers to access are likely to be much more complex, and may require a much deeper analysis than they have been given before appropriate policies and performance indicators can be designed. But two things are clear. Education may be a solution to this, as to so many other problems of social exclusion. It is also a necessarily long-term solution. And, we first have to solve what has proved to be the deep-seated problem of social exclusion from the benefits of education itself before this burden can reasonably be passed on to already hard-pressed arts organisations. But, on the basis of the available evidence it is also likely to be the case that a key element in social exclusion is the existing hierarchy of cultural forms and experiences and the very definition of excellence itself. Many, if not all, of those who are now deemed to be socially excluded, are existing and enthusiastic customers of the creative industries. For some analysts the creative industries are part of the problem and not its solution. The very nature of

the involvement of the socially excluded in a commercially driven media culture is itself both a mark of and a reinforcement of their social exclusion. Thus, at the very least there is likely to be a lack of fit, if not direct opposition, between policies designed to support 'excellence' and policies designed to combat social exclusion. Certainly there are no short-term solutions.

Thus, the stress on access, and the monitoring for accountability purposes of the achievement of wider access, fits very uneasily with that strand in creative-industry thinking which wishes to reject a hierarchical division of cultural forms and practices and which, in order to sustain its argument for the economic importance of the sector, has to claim how successful they are and how large and growing their audience is. But of course in that case there is no justification for public subsidy to remedy problems of access or under-supply.

In *Creative Britain*, former Secretary of State Chris Smith states that 'Access will be the corner stone of our cultural policy. Experience of the highest quality must be available to the widest public audience' (Smith, 1998). But, the problem here is the linking of access to highest quality or excellence. How are we to define excellence? From a creative-industries economic perspective, quality and excellence are open to the market test of consumer preference. And access is by definition not a problem, since a successful creative industry has solved the access problem through the market. If it is successful, why does it need public support? If it is unsuccessful, why does it merit public support?

References

Introduction and Observations

ACE (2000) *Artstat: Digest of arts statistics and trends in the UK, 1986/87–1997/98*. London: Art Council of England

ACGB (1988a) *Better Business in the Arts*. London: Arts Council of Great Britain

ACGB (1988b) *An Urban Renaissance: the role of the arts in urban regeneration. The case for increased public and private sector co-operation*. London: Arts Council of Great Britain

ACGB (1993) *A Creative Future. The way forward for the arts, crafts and media in England*. London: HMSO

Casey, B, Dunlop, R and Selwood, S (1996) *Culture as Commodity? The economics of the arts and built heritage in the UK*. London: Policy Studies Institute

DCMS (1997) *Chris Smith welcomes new name for his department*. DCMS press release 178/97. London: Department for Culture, Media and Sport

DCMS (1998a) *Creative Industries Mapping Document 1998*. London: Department for Culture, Media and Sport

DCMS (1998b) *A New Cultural Framework*. London: Department for Culture, Media and Sport

DCMS (2001a) *Creative Industries Mapping Document 2001*. London: Department for Culture, Media and Sport

DCMS (2001b) *Annual Report 2001*. London: The Stationery Office

Robinson, G (1998) *An Arts Council for the Future*. The Arts Council of England Annual Lecture. London: Arts Council of England

Selwood, S (2000) 'Access, Efficiency and Excellence: measuring non-economic performance in the English subsidised cultural sector', *Cultural Trends* 35: 87–137

Smith, C (1998) *Creative Britain*. London: Faber & Faber

Introduction to Part I

ACGB (1984) *The Glory of the Garden. The development of the arts in England. A strategy for a decade*. London: Arts Council of Great Britain

ACGB (1993) *A Creative Future. The way forward for the arts, crafts and media in England*. London: HMSO

Anderson, D (1997) *A Common Wealth. Museums and Learning in the United Kingdom*. London: Department of National Heritage

Anderson, D (1999) *A Common Wealth. Museums in the Learning Age*. London: Department for Culture, Media and Sport

DCMS (1998a) *The Comprehensive Spending Review: A new approach to investment in culture*. London: Department for Culture, Media and Sport

DCMS (1998b) *A New Cultural Framework*. London: Department for Culture, Media and Sport

DCMS (1999) *Public Service Agreement*. London: Department for Culture, Media and Sport (mimeo)

DCMS (2001) *Culture and Creativity: the next ten years*. London: Department for Culture, Media and Sport

DoE/DNH (1994) *PPG15 Planning Policy Guidance: Planning and the historic environment*. London: HMSO

DNH (1996a) *Setting the Scene. The arts and young people*. London: Department of National Heritage

DNH (1996b) *Treasures in Trust*. London: Department of National Heritage

DNH (1997) *Reading the Future*. London: Department of National Heritage

EH (undated) *Strategic Plan, 1999–2002*. London: English Heritage

EH (2000) *Power of Place. The future of the historic environment*. London: English Heritage

Harland, J, Kinder, K, Hartley, K and Wilkin, A (undated) *Attitudes to Participation in the Arts, Heritage, Broadcasting and Sport: A review of recent research*. London: Department of National Heritage (mimeo)

Moody, D (1997) 'A fair share? Support for cultural activities in the English regions', *Cultural Trends* 27: 1–25

Pieda (undated) *Access Case Studies*. London: Department of National Heritage (mimeo)

QUEST (2000) *Modernising the Relationship. Part two. Developing risk management in DCMS sponsored bodies*. London: Quality, Efficiency and Standards Team

Robinson, G (1998) *An Arts Council for the Future*. The Arts Council of England Annual Lecture 1998, organised with the RSA. London: Arts Council of England

Selwood, S (2000) 'Access, Efficiency and Excellence: measuring non-economic performance in the English subsidised cultural sector', *Cultural Trends* 35: 87–137

Chapter 2, The Built Environment

DCMS (1998) *A New Cultural Framework*. London: Department for Culture, Media and Sport

DoE (1990) *PPG 16 Planning Policy Guidance: Archaeology and planning*. London: HMSO

DoE (1995) *Quality in Town and Country: Urban design campaign*. London: Department of the Environment

DoE/DNH (1994) *PPG 15 Planning Policy Guidance: Planning and the historic environment*. London: HMSO

English Heritage (1997) *Sustaining the Historic Environment: New perspectives on the future. An English Heritage discussion document*. London: English Heritage

English Heritage (1998) *Conservation-led Regeneration*. London: English Heritage

English Heritage (1999) *The Heritage Dividend. Measuring the results of English Heritage regeneration*. London: English Heritage

English Heritage (2000) 'Response from English Heritage on the Urban White Paper'. Press Release, 16 November. London: English Heritage

House of Commons (1999) *The House of Commons Select Committee on Culture, Media and Sport. Sixth report*. London: The Stationery Office

House of Commons (2000) *The House of Commons Environment, Transport and Regional Affairs Committee. Eleventh report. 'Proposed urban White Paper' vol. 1*. London: The Stationery Office

Howarth, A (2000) Letter from the Minister to English Heritage, announcing the review of policies relating to the historic environment, 31 January.

Independent on Sunday (1998) '"Backward looking" English Heritage to be scrapped', 18 October, p. 4

Urban Task Force (1999) *Towards an Urban Renaissance*. London: E & FN Spon.

References to Chapter 3, The Film Industry

BFC (2000) 'UK Production Activity Nears All-time High in '99'. Press Release, January. London: British Film Commission

DCMS Film Policy Review Group (1998) *The Bigger Picture*. London: Department for Culture, Media and Sport

Hancock, D (1999) 'Film production/distribution: year of mixed fortunes', *Screen Digest*, June

Chapter 4, Libraries

Aslib (1995) *Review of the Public Library Service in England and Wales for the Department of National Heritage: Final report*. London: Association for Information Management

Audit Commission (1997) *Due for Renewal: a Report on the Public Library Service*. London: Audit Commission Publications

British Library (1999) *Strategic Plan 1999–2002: The outcome of the Library's 1998 strategic review*. London: British Library Board

British Library (2000) *Annual Report 1998/99*. London: British Library Board

COI (1998) *Our Information Age: The government's vision*. London: Central Office of Information

Creaser, C and Scott, J (1998) *LISU Annual Library Statistics 1998*. Loughborough: Library and Information Statistics Unit

DCMS (1998a) *New Library: The people's network – the government's response*. London: The Stationery Office (Cm 3887)

DCMS (1998b) *New Links for the Lottery: Proposals for the New Opportunities Fund*. London: The Stationery Office

DCMS (1999) *A New Cultural Framework*. London: Department for Culture, Media and Sport

DCMS (2000) *Comprehensive and Efficient*. London: Department for Culture, Media and Sport

DNH (1997) *Reading the Future: Public libraries review*. London: Department of National Heritage

IPF Ltd (1999) *Appraisal of Annual Library Plans 1998*. London: Institute of Public Finance

KPMG (1995) *DNH Study: Contracting out in public libraries*. London: KPMG (Ref: 20271 RPT)

Library Association (1995) *Model Statement of Standards for Public Library Services*. London: The Library Association

LIC (1997) *New Library: the People's Network*. London: Library and Information Commission
LIC (1998) B*uilding the New Library Network*. London: Library and Information Commission
Public Libraries and Museums Act 1964 (1964) London: HMSO (Chapter 75)

Chapter 5, Literature

ACE (1998a) *The Arts Council of England Annual Report*. London: Arts Council of England
ACE (1998b) *Reading for Life. The Arts Council's National Conference for the Promotion of Literature in Public Libraries*. London: Arts Council of England
ACE (1999) *Annual Review. National Lottery Report 1999*. London: Arts Council of England
ACGB (1984) *The Glory of the Garden: The development of the arts in England: the strategy for a decade*. London: The Arts Council of Great Britain
Davidson, J, Hicks, D and McKearney, M (1998) *The Next Issue, Reading Partnerships for Libraries*. London: Arts Council of England
de Botton, A (1998) *How Much do you Think a Writer Needs to Live on? The Cost of Letters*. Middlesex: Waterstone's
Hicks, D (1995) *Research Project to Develop and Implement a Proposal for an Accredited Literature Module for Librarian Courses*. (mimeo)
Hinton, B (ed) (1990) *Marshalled Arts: A handbook for arts in libraries*. Newcastle under Lyme: AAL Publishing
McKearney, M and Baverstock, A (1990) *Well Worth Reading: An experiment in fiction promotion*.Winchester: Well Worth Reading
McKeone, G (1998) 'Afterword, the writer, the state and a question of attitude'. In de Botton, A (ed) *How Much do you Think a Writer Needs to Live on? The Cost of Letters*. Middlesex: Waterstone's
The Reading Partnership (1999) *Public Libraries and Readers: Building a creative nation*. London: The Reading Partnership
Stewart, I (ed) (undated) *Shelf Talk: A handbook promoting literature in public libraries*. London: Arts Council of England
van Riel, R (ed) (1992) *Reading the Future: A place for literature in public libraries*. London: The Arts Council of England and The Library Association

Chapter 6, Museums and Galleries

Anderson, D (1997) *A Common Wealth. Museums in the Learning Age* (1st edn January 1997; 2nd edn July 1999). London: Department of National Heritage
Audit Commission (1991) *The Road to Wigan Pier? Managing Local Authority Museums and Art Galleries*. London: HMSO
Babbidge, A (2001) 'UK museums – safe and sound?', *Cultural Trends* 37: 1–35
Bailey, S J, Falconer, P, Foley, M, McPherson, G and Graham, M, for Glasgow Caledonian University (1998) *To Charge or Not to Charge?* London: Museums & Galleries Commission
DCMS (undated) *The Establishment of a Museums, Libraries and Archives Council. Report of the Design Group*. London: Department for Culture, Media and Sport

DCMS (1998) *A New Cultural Framework*. London: Department for Culture, Media and Sport

DCMS (1999a) *Efficiency and Effectiveness of Government Sponsored Museums and Galleries*. London: Department for Culture, Media and Sport

DCMS (1999b) *Museums for the Many. Standards for museums and galleries to use when developing access policies*. London: Department for Culture, Media and Sport

DCMS (2000) *Centres for Social Change: Museums, galleries and archives for all. Policy guidance on social inclusion for DCMS funded and local authority museums, galleries and archives in England*. London: Department for Culture, Media and Sport

DCMS (2001) Budget 2001 'Final obstacle to universal free admission to national museums and galleries is now removed', Press Release DCMS 61/2001. London: Department for Culture, Media and Sport

DCMS and DfEE (2000) *The Learning Power Of Museums – A vision for museum education*. London: Department for Culture, Media and Sport and Department for Education and Employment

DNH (1996a) *People Taking Part*. London: Department of National Heritage

DNH (1996b) *Setting the Scene. The arts and young people*. London: Department of National Heritage

DNH (1996c) *Treasures in Trust. A review of museum policy*. London: Department of National Heritage

Dodd, J and Sandell, R (1998) *Building Bridges: Guidance for museums and galleries on developing new audiences*. London: Museums & Galleries Commission

House of Lords (1997) 'Museums and galleries. Free access', *Hansard* 18 December, p. 804ff

Kawashima, N (1997) *Museum Management in a Time of Change. Impacts of cultural policy on museums in Britain 1979–1997*. Coventry: Centre for the Study of Cultural Policy, University of Warwick

Labour Party (1997) *Create the Future. A strategy for cultural policy, arts and the creative economy*. London: Labour Party

Lord, B and Lord, G D (1997) *The Manual of Museum Management*. London: HMSO

Mathers, K (1996) *Museums, Galleries & New Audiences*. London: Art & Society

MGC (undated) *Museums and Best Value. A guidance note*. London: Museums & Galleries Commission

Mullins, S (2000) 'Free admission and the independent museum', *AIM*, June 2000: 1–2

Museums Association (1990) *Policy Statement on Admission Charges*. London: Museums Association

NACF (1997) 'The price of admission charges'. News Release, 18 November. National Art Collection Fund

National Assembly for Wales (2000) *Policy Review: Arts and culture – meeting of the Post-16 Education and Training Committee* (28 June)

National Audit Office (1993) *Department of National Heritage, National Museums and Galleries: Quality of Service to the Public*. London: HMSO

National Audit Office (1995) *Scotland's National Museums and Galleries: Quality of Service and Safeguarding the Collections*. London: HMSO

Northern Ireland Department of Culture, Arts and Leisure (1999) Press Release 9912071-cal

Resource (2000) *Resource manifesto*. London: Resource

Runyard, S (1994) *The Museum Marketing Handbook*. London: HMSO

Scottish Office (1998) 'New money to improve public access to the National Galleries of Scotland' News Release 0561/98, 19 March

Scottish Museums Council (1999) *A National Strategy for Scotland's Museums*. Edinburgh: Scottish Museums Council

Selwood, S (1999) 'The applied art museum's commercial role: intervening in the creative economy', unpublished paper delivered to the conference, *Museums of Applied Art Re-Appraised*. London: V&A

Selwood, S (2000) 'Access, efficiency and excellence: measuring non-economic perform-ance in the English subsidised cultural sector', *Cultural Trends* 35: 87–137

Vergo, P (ed) (1989) *The New Museology*. London: Routledge

Wilson, A (1995) *A Time for Change: A review of major museums in Northern Ireland*. Belfast: Department for Education in Northern Ireland

Chapter 7, The Performing Arts

ACE (2000) *The Next Stage: Towards a national policy for theatre in England*. London: Arts Council of England

ACE/BBC (1994) *Review of National Orchestral Provision*. London: Arts Council of England

ACE/DCMS (1997) *Agreement between the Department for Culture, Media and Sport and the Arts Council of England*. London: Arts Council of England

DCMS (2001) *Culture and Creativity: the Next Ten Years*. London: Department for Culture, Media and Sport

Peter Boyden Associates (2000) *Roles and Functions of the English Regional Producing Theatres*. London: Arts Council of England

Stevenson, D and McIntosh, J (1995) *Lyric Theatre Review*. London: Arts Council of England

Chapter 8, Public Broadcasting

Davies, G (1999) *The Future Funding of the BBC*. London: BBC

Guardian (1998) *Media Copybook 1998*. London: Guardian Media Group

Chapter 9, The Visual Arts

ACE (undated a) *Visual Arts Department Plan 1998–2002*. London: Arts Council of England (mimeo)

ACE (undated b) *Visual Arts Department Plan 2000–2002*. London: Arts Council of England (mimeo)

ACE (undated c) *Visual Arts. A policy for the art funding system in England*. London: Arts Council of England

ACE (1996a) *Creating New Notes. A policy for the support of new music in England*. London: Arts Council of England

ACE (1996b) *Jazz. A policy for the support of jazz in England*. London: Arts Council of England

ACE (1996c) *The Policy for Dance of the English Arts Funding System*. London: Arts Council of England

ACE (1996d) *The Policy for Drama of the English Arts Funding System.* London: Arts Council of England

ACE (1997a) *Leading through Learning. The English art funding system's policy for education and training.* London: Arts Council of England

ACE (1997b) *South Asian Music. A policy for the support of South Asian Music in England.* London: Arts Council of England

ACGB (1984) *The Glory of the Garden. The development of the arts in England: the strategy for a decade.* London: Arts Council of Great Britain

Boyden Southwood (1996) *Research into the Application of New Technologies and the Arts.* London: Arts Council of England (mimeo)

DCMS (1998) *A New Cultural Framework.* London: Department for Culture, Media and Sport

Haskell, L (1996) *Plugged In. Multimedia and the Arts in London.* London: London Arts Board

Honey, S, Heron, P and Jackson, C, for the Institute of Employment Studies (1997) *Career Paths of Visual Artists.* London: Arts Council of England

Moody, D (1997) 'A fair share? Support for cultural activities in the English regions', *Cultural Trends* 27: 1–25

Chapter 10, Funding from Central Government

DCMS (1998) *A New Cultural Framework.* London: Department for Culture, Media and Sport

Casey, B, Dunlop, R and Selwood, S (1996) *Culture as Commodity? The economics of the arts and built heritage in the UK.* London: Policy Studies Institute

Dane, C, Feist, A, Manton, K (1999) *A Sound Performance. The economic value of music to the United Kingdom.* London: National Music Council

Forrester, S (1996) *The Arts Funding Guide 1997/98 Edition.* London: Directory of Social Change

Scottish Executive (2000) *Investing in You: The annual expenditure report of the Scottish Executive.* Edinburgh: Scottish Executive

Chapter 11, Urban Regeneration Programmes

Bennett, A (2000) *Popular Music and Youth Culture: Music, identity and place.* Basingstoke: Macmillan

Casey, B, Dunlop, R and Selwood, S (1996) *Culture as Commodity? The economics of the arts and built heritage in the UK.* London: Policy Studies Institute

Chelliah, R (1999) *Arts and Regeneration.* London: Local Government Information Unit

DETR (2000) *DETR Annual Report 2000.* London: Department of the Environment, Transport and the Regions

English Heritage (1999) *The Heritage Dividend. Measuring the results of English Heritage regeneration.* London: English Heritage

Garfinkel, S and Brindle, D (2000) 'Art and soul', *Guardian,* 26 July

Hall, S (1999) 'Continuity and change: a review of English regeneration policy in the 1990s', *Regional Studies* 33 (5): 477–491

Hall, S (2000) 'The way forward for regeneration? Lessons from the Single Regeneration Budget Challenge Fund', *Local Government Studies* 26 (1): 1–14

LGA (2000) *Culture and Tourism in the Learning Age: A discussion paper*. London: Local Government Association

Loftman, P and Beazley, M (1998) *Race and Regeneration: A review of the Single Regeneration Budget Challenge Fund*. London: Local Government Information Unit

Matarasso, F (1997) *Use or Ornament? The social impact of participation in the arts*. Stroud: Comedia

Noon, D, Smith-Canham, J and Eagland, M (2000) 'Economic regeneration and funding', in P Roberts and H Sykes (eds), *Urban Regeneration: A handbook*. London: Sage, pp. 61–85

Oatley, N (1998a) 'Cities, economic competition and urban policy', in N Oatley (ed.), *Cities, Economic Competition and Urban Policy*. London: Paul Chapman, pp. 3–20

Oatley, N (1998b) 'Restructuring urban policy: the Single Regeneration Budget and the Challenge Fund', in N Oatley (ed.), *Cities, Economic Competition and Urban Policy*. London: Paul Chapman, pp. 146–62

Oatley, N and Lambert, C (1998) 'Catalyst for change: the City Challenge initiative', in N Oatley (ed.), *Cities, Economic Competition and Urban Policy*. London: Paul Chapman, pp. 109–26

PA Consulting Group (1999) *Interim Evaluation of English Partnerships: Final report*. London: Department of the Environment, Transport and the Regions

Policy Action Team 10 (1999) *Arts and Sport. A report to the Social Exclusion Unit*. London: Department for Culture, Media and Sport

Roberts, P (2000) 'The evolution, definition and purpose of urban regeneration', in P Roberts and H Sykes (eds), *Urban Regeneration: A handbook*. London: Sage, pp. 9–36

Symon, P and Verhoeff, R (1999) 'The New Arts in Birmingham', paper presented at International Conference on Cultural Policy Research, 10–12 November, Bergen

Chapter 12, Funding from Institutions of Higher Education

AHRB (2000) *Funding for University Museums, Galleries and Collections Consultation Paper*. London: Arts and Humanities Research Board (mimeo)

Bennett, O, Shaw, P and Allen, K (1999) *Partners and Providers. The role of HEIs in the provision of cultural and sports facilities to the wider public*. Bristol: Higher Education Funding Council for England

Carter, S, Hurst, B, Kerr, RH, Taylor, E and Winsor, P (1999) *Museum Focus. Facts and figures on museums in the UK, Issue 2*. London: Museums & Galleries Commission

Coles, A, Hurst, B and Winsor, P (1998) *Museum Focus. Facts and figures on museums in the UK, Issue 1*. London: Museums & Galleries Commission

HEFCE (1993a) (Circular 5/93) *Non-formula Funding*. Bristol: Higher Education Funding Council for England

HEFCE (1993b) (Circular 46/93) *Museums, Galleries and Collections: Review of non-formula funding*. Bristol: Higher Education Funding Council for England

HEFCE (1995) (Circular 9/95) *Museums, Galleries and Collections: The outcome of the review of non-formula funding*. Bristol: Higher Education Funding Council for England

HEFCE (1998) *Libraries Review: Research Support Libraries Programme (RSLP)*. Last updated 2 March 1999 (http://www.hefce.ac.uk/Initiat/)

HEFCE (1999) *Libraries Review: Specialised Research Collections in the Humanities*. Last updated 28 May 1998 (http://www.hefce.ac.uk/Initiat/)

Milne, R and Davenport, G (1999) 'The Research Support Libraries Programme Access Survey', *The New Review of Academic Librarianship* 5: 23–39

SHEFC (1994) *(*Circular 70/94) *Review of the Minor Recurrent Grant for Museums, Galleries and Collections.* Edinburgh: Scottish Higher Education Funding Council

Weeks, J (2000) 'The loneliness of the university museum curator', *Museum International* (UNESCO Blackwell Publishers) no. 206, vol. 52, no. 2

Chapter 13, European Funding

Bates and Wacker, SC (1993*) Community Support for Culture: A study carried out for the European Commission (DG X).* Brussels (mimeo)

EC (1993) *Growth, Competitiveness and Employment* (White Paper. COM (93)700). Brussels: European Commission

EC (1995) *The Role of the Union in the Field of Tourism* (Green Paper. COM (95) 97). Brussels: European Commission

EC (1997) *Guide to Programmes in Education, Training and Youth.* Brussels: European Commission

EC (1998) *Investing in Culture: An asset for all regions.* Luxembourg: EUR-OP

Evans, G and Foorde, J (2000) 'European funding of culture: promoting common culture or regional growth?', *Cultural Trends* 36: 52–87

Evans, G L, Shaw, P, White, J et al. (1997) *Digest of Arts and Cultural Trends 1987–1996* (unpublished draft). London: Arts Councils of England, Wales and Scotland (cited in Evans and Foorde, 2000)

Chapter 14, Local Authorities: New Opportunities and Reduced Capacity

ACE (2000) *Artstat: Digest of arts, statistics and trends in the UK, 1986/87–1997/98.* London: Arts Council of England

Audit Commission (1991a) *Local Authorities, Entertainment and the Arts.* London: HMSO

Audit Commission (1991b) *The Road to Wigan Pier? Managing local authority museums and art galleries.* London: HMSO

Audit Commission (1997) *Due for Renewal: A report on the library service.* London: TSO

Audit Commission (1998) *Consultation on the Local Authority Performance Indicators.* London: Audit Commission

Carter, S, Hurst, B, Kerr, RH, Taylor, E and Winsor, P (1999) *Museums Focus: Facts and figures on museums in the UK.* Issue 2. London: Museums & Galleries Commission

Davies, S and O'Mara, J (1997) *Retrenchment in Local Authority Museums.* Leeds: University of Leeds (unpublished research paper)

Davies, S and Selwood, S (1998) 'English Cultural Services: government policy and local authority strategies', *Cultural Trends* 30: 69–110

DCMS (2000) *Local Authority Museums and Galleries – A Review.* Unpublished departmental paper

DETR (1997) *Modernising Local Government: Improving local services through Best Value (Green Paper).* London: Department of the Environment, Transport and the Regions

GLLAM (2000) *Museums and Social Inclusion.* Newcastle: The Group for Large Local Authority Museums

Hasted, R (1996) *Consultants and Freelance Workers in Museums*. London: Museums Association (mimeo)

Jackson, P (1993) 'Performance indicators: promises and pitfalls' in S Pearce (ed.), *Museums, Economics and the Community*. London: Athlone Press

Lister, D (2000) 'Museums being left to "wither", says Serota of the Tate'. *The Independent*, 22 November

Middleton, VTC (1998) *New Visions for Museums in the 21st Century*. London: Association of Independent Museums

Proctor, R (1998) 'Survey reveals scale of library cuts and closures', *British Library Research and Innovation Centre Research Bulletin* 21: 9–10

Proctor, R, Lee, H and Reilly, R (1998) *Access to Public Libraries: The impact of opening hours reductions and closures 1986–1997*. Sheffield: Centre for the Public Library in the Information Society, University of Sheffield

Resource (2000) *Regional Collections: Towards a sustainable future*. London: Resource: The Council for Museums, Archives and Libraries (mimeo)

Rutherford, J (2000) Personal communication

Selwood, S (2000) 'Access, efficiency and excellence: measuring non-economic performance in the English subsidised cultural sector', *Cultural Trends* 35: 87–137

Winsor, P (1999) 'Conservation in the UK', *Cultural Trends* 33: 3–34

Chapter 15, Taxation

ACE (1997) *New and Alternative Mechanisms for Financing the Arts. A Report by London Economics for the Arts Council of England and the English Regional Arts Board*. ACE Research Report No. 12, London: Arts Council of England

Advisory Committee on Film Finance (Chair: Sir Peter Middleton) (1996), *Report to the Secretary of State for National Heritage, July 1996*. London: Department of National Heritage

Banks, J and Tanner, S (1997) 'The state of donation: household gifts to charity, 1974–96', *Institute for Fiscal Studies, Commentary 62*, London: Institute for Fiscal Studies

Banks, J and Tanner, S (1998) 'Taxing charitable giving', *Institute for Fiscal Studies, Commentary 75*, London: Institute for Fiscal Studies

BTA (1997) *The Economic Effects of Changing VAT Rates on the British Tourism and Leisure Industry. Phase two report*. London: British Tourist Authority

CAF and ACE (2000) *Increasing Donations to Arts Charities: an introduction of the new tax incentives for giving*. London: Charities Aid Foundation and Arts Council of England

Creigh-Tyte, SW (1997) 'The development of British policy on built heritage preservation', Chapter 8 in Hutter, M and Rizzo, I (eds), *Economic Perspectives on Cultural Heritage*. London: Macmillan, pp.133–154

Creigh-Tyte, SW and Farrell, L (1998) *The Economics of the National Lottery*, Working Paper No. 190. Durham: Department of Economics, University of Durham

Creigh-Tyte, SW and Gallimore, J (1998) 'The built heritage in England: the history and development of government policy', *Cultural Trends* 32: 25–36

Creigh-Tyte, SW and Selwood, S (1998) 'Museums in the UK: Some evidence on scale and activities', *Journal of Cultural Economics*, 22, (2–3): 151–165

DCMS (1997) 'Review of Access to National Museums and Galleries'. News Release 115/1997 (8 December). London: Department for Culture, Media and Sport

DCMS(1998a) *The Comprehensive Spending Review: A new approach to investment in culture*. London: Department for Culture, Media and Sport

DCMS(1998b) *A New Cultural Framework*. London: Department for Culture, Media and Sport

DCMS(1999a) *Annual Report 1999* (CM4213, March). London: Department for Culture, Media and Sport

DCMS (1999b) *Government Reforms the Way 'British Films' are Defined*. Media release 186/99 (8 July). London: Department for Culture, Media and Sport

DCMS (2000a) *Getting Britain Giving to Culture*. London: Department for Culture, Media and Sport

DCMS (2000b) 'Chris Smith Announces, 'Quids In' Policy for Charges at England's national museums and galleries', News Release 69/20000 (3 April). London: Department for Culture, Media and Sport

Deloitte and Touche (1998) *The Economic Impact of Air Passenger Duty*, Report prepared for the Council for Travel and Tourism. London: Council for Travel and Tourism

Department of National Heritage (1995) *The British Film Industry*, (Cm 2884). London: HMSO

Dyer, V (2000) 'Admission charges: why museums must hold their breath', *Arts News* Spring: 7

Dyja, E (ed.) (2000) *BFI Film and Television Handbook 2000*. London: British Film Institute

Eckstein, J (2000) *The Impact of VAT on Church Properties: Summary of main findings and related tables*. London: Church House Publishing

Film Policy Review Group (1998) *A Bigger Picture. The report of the Film Policy Review Group*. London: DCMS

Gale, W (1997) 'What can America learn from the British tax system?', *Fiscal Studies*, 18: 341–370

Hanna, M (1998a), 'The built heritage in England: grants, earnings and employment', *Cultural Trends* 32: 5–24

Hanna, M (1998b) 'The built heritage in England: properties open to the public, visitors and visitor trends', *Cultural Trends* 32: 37–53

Hansard (2000a) 31 January, column 779

Hansard (2000b) 29 March, columns 847–879

Historic Environment Review Steering Group (2000) *Power of Place: The future of the historic environment*. London: English Heritage

HM Treasury (1997) *Charity Taxation Reviewed*. Budget press release No. 5. London: HM Treasury

HM Treasury (1998) *Modern Public Services for Britain: Investing in reform* (Cm 4011). London: The Stationery Office

House of Commons National Heritage Committee (1995) *The British Film Industry*, Vol 1, Session 1993–94. London: HMSO

Inland Revenue (2000) *Getting Britain Giving: Inland Revenue guidance note for charities*. London: Inland Revenue

JCNAS (1999) *The Impact of VAT on Repairs and Alterations to Listed Properties*. London: Joint Committee of the National Amenity Societies

Jenkins, J (1999) 'VAT and the built heritage: findings of the recent study' *Context*, Issue 64 (December). London: Institute of Historic Building Conservation

Labour Party (1997) *Create the Future: A strategy for cultural policy, arts and the creative economy*. London: Labour Party

McAndrew, C and O'Hagan, J (2000) 'Export restricting, tax incentives and the national artistic patrimony', *Cultural Trends* 37: 41–63

Middleton Committee (1996) *see* Advisory Committee on Film Finance (1996)

MGC (1998) *To Charge or not to Charge?* (Full Report). London: Museums & Galleries Commission

MGC (1999) *MGC Calls for Reduced VAT on Museum Admission Charges*. Press Release 10 September. London: MGC

Musgrave, R A (1959) *The Theory of Public Finance: A study in public economy*. New York: McGraw-Hill

Nevin, M (1999) 'Are high taxes damaging British tourism?', *Journal of Vocation Marketing* 5 (January): 94–104

Potts, J (1999) *VAT and Historic Buildings*. London: The Society for the Protection of Ancient Buildings

Smith, C (2000) 'Arts get charity boost with budget tax concessions', *Arts News* 53 (Spring): 5

Thomas, B and Townsend, A (forthcoming), 'New trends in the growth of tourism employment in Britain in the 1990s', *Tourism Economics*

Tunstall, J and Machin, D (1999) *The Anglo-American Media Connection*. Oxford: Oxford University Press

Chapter 16, The National Lottery

This chapter draws on research by *Lottery Monitor* and other periodicals, including: *Arts Digest*, *HLF News*, HLF's *Lottery Update*, *Arts Council News* and *The National Lottery Yearbook*. It also refers to the distributors' annual reports and reviews, the DCMS annual reports, and those of the Foundation for Sport and the Arts.

ABSA (1995) *Bulletin (*Spring Edition). London: Association for Business Sponsorship for the Arts

ACE (undated) *The Arts Council of England. National Lottery Report 1996/97*. London: Arts Council of England

ACE (1994) *National Lottery Application Pack*. London: Arts Council of England

ACE (1997) *National Lottery Funding. Capital programme application pack*. London: Arts Council of England

ACE (1998) *Arts Council Warns of Crisis on Capital Projects*. Press release, 25 August

ACE (1999a) *Lottery Strategic Plan*. London: Arts Council of England

ACE (1999b) *National Lottery Review*. London: Arts Council of England

ACE (2000a) *Artstat. Digest of arts statistics and trends in the UK 1986/87–1997/98*. London: Arts Council of England

ACE (2000b) *Whose Heritage? The impact of cultural diversity on Britain's living heritage*. A report of national conference at G-Mex, Manchester, 1999. London: Arts Council of England

Annabel Jackson Associates (1999*) Evaluation of the Arts for Everyone Main Scheme. Final report to the Arts Council*. London: Arts Council of England

Babbidge, A (2001) 'UK museums – safe and sound?', *Cultural Trends* 37: 1–35

Booth, P and Bloye, R (1993) 'See Glasgow, see Culture' in Bianchini, F and Parkinson, M (eds), *Cultural Policy and Urban Regeneration: The West European experience*. Manchester: Manchester University Press

DCMS (1998) *Coalfields Lottery Conference Report*. London: Department for Culture, Media and Sport

DCMS, (1999) *Arts & Sport. A report to the Social Exclusion Unit.* Policy Action Team 10. London: Department for Culture, Media and Sport

DCMS website, www.lottery.culture.gov.uk

DNH (1996) The *National Lottery. A first report on the distribution of proceeds.* London: Department of National Heritage

DNH (1997) *A New Good Cause for the National Lottery. The Millennium Information and Communication Technology Fund.* London: Department of National Heritage

Evans, G (1998) *The Employment Effects of the Arts Lottery in England: A report by CELTS for the Arts Council of England.* ACE Research Report No. 14. London: Arts Council of England

Evans, G and White, J (1996) *The Economic and Social Impact of the National Lottery. A literature review.* Prepared for the Department for Culture, Media and Sport. London: Centre for Tourism and Leisure Studies, University of North London

Evans, G, White, J and Bohrer, J (1997) *The Economic and Social Impact of the National Lottery. Research Digest – Volume 1, 1997.* Prepared for the Department for Culture, Media and Sport. London: Centre for Tourism and Leisure Studies, University of North London

The Factary (1994) *Capital Grants for the Arts. A Report for the Arts Councils of England, Scotland, Wales and Northern Ireland.* London: Arts Council of England

FitzHerbert, L, Giussani, C and Hurd, H (1996) *The National Lottery Yearbook. 1996 edition.* London: Directory of Social Change

FitzHerbert, L, Rahman, F and Harvey, S (1999) *The National Lottery Yearbook. 1999 edition.* London: Directory of Social Change

FitzHerbert, L and Rhoades, L (1997) *The National Lottery Yearbook & Grant Seekers Guide. 1997 edition.* London: Directory of Social Change

FitzHerbert, L and Peterson, M (1998) *The National Lottery Yearbook. 1998 edition.* London: Directory of Social Change

Gore, T, Dabinett, G and Breeze, J (2000) *Improving Lottery Funding, Access and Delivery in the British Coalfields.* London: Department for Culture, Media and Sport, National Lottery Division

Gummer, P (1996) 'Peter Gummer in Conversation', in FitzHerbert et al., 1996: 28–29

Harding, S (2000) 'Towards a renaissance in urban parks', *Cultural Trends* 35: 1–20

Hewitt, P and Dixon, A (1996) *New Lottery Directions.* Winchester: English Regional Arts Boards

HLF (1995) *Guidance for Applicants to the Heritage Lottery Fund.* London: Heritage Lottery Fund

HLF (1999) *Strategic Plan 1999–2002.* London: Heritage Lottery Fund

HLF/NHMF (1997) *Heritage Lottery Fund and the National Heritage Memorial Fund. Annual Report and Accounts 1996/97.* London: Heritage Lottery Fund and the National Heritage Memorial Fund

HLF/NHMF (2000) *2000 Corporate Plan.* London: Heritage Lottery Fund and the National Heritage Memorial Fund

House of Commons (1996) House of Commons National Heritage Committee. *The National Lottery. Report and Minutes of Proceedings.* London: The Stationery Office

House of Commons (2000) House of Commons Public Accounts Committee. *Arts Council of England: Monitoring Major Capital Projects Funded by the National Lottery. Minutes of evidence.* 21 June 1999. London: The Stationery Office

Johnson, P and Thomas, B (1997) *The Use of Employment–Sales Ratios to Estimate Employment from Lottery-Financed Capital Expenditure in the Arts.* Durham: Department of Economics, University of Durham

KMPG (1996) *Delivering National Lottery Projects: Effective arrangements for Lottery partners*. London: KPMG

Labour Party (1996) *The National Lottery. Initiatives and recommendations*. London: The Labour Party

Larter, F (1999) *Employment Research Report: To identify new employment created through Arts 4 Everyone Express projects*. London: Arts Council of England

Leisure Futures and CELTS (1996) *The London Pride Lottery Study*. London: Association of London Government, London Arts Board, The Sports Council (London Region), London First, Government Office for London and BT

LGIU (1996) *Everyone a Winner? Local government and the Lottery*. London: Local Government Information Unit

Loftman, P and Nevin, B (1992) *Urban Regeneration and Social Equality: A case study of Birmingham, 1986–1992*. Research Paper No. 8. Birmingham: Faculty of the Built Environment, University of Central England at Birmingham

McAndrew, C and O'Hagan, J (2000) 'Export restrictions, tax incentives and the national artistic patrimony', *Cultural Tends* 37: 41–63

National Audit Office (1999) *Arts Council of England: Monitoring major capital projects funded by the National Lottery*. London: The Stationery Office

National Lottery Distribution Fund (various years) *Accounts*. London: The Stationery Office

NCA/NMC (1996) *The National Lottery. Whatever next?* NCA and NMC seminar. London: National Campaign for the Arts and National Music Council

Selwood, S (1997) 'Museums, galleries and the Lottery,' *Cultural Trends* 28: 1–27

Selwood, S (2000) 'Access, efficiency and excellence: measuring non-economic performance in the English subsidised cultural sector', *Cultural Trends* 35: 87–137

Tomkins, A (ed.) (1994) *London and the Lottery: Samples of capital need in Greater London*. London: The London Arts Conference

Tomkins, A (ed.) (1996) *London and the Lottery: The experience of smaller arts organisations*. London: The London Arts Conference

Which? (1997) 'The National Lottery: Who wins? who loses?' January, pp. 7–8.

White, J, Evans, G with Bohrer, J (1998) *The Economic and Social Impact of the National Lottery. Research digest – Volume 2, 1998*. Prepared for the Department for Culture, Media and Sport. London: Centre for Tourism and Leisure Studies, University of North London

Chapter 17, Funding from the Private Sector

This chapter draws on the annual reports by ABSA (Association for Business Sponsorship of the Arts), subsequently Arts & Business, *Business Support for the Arts. National research survey*, subsequently *Business Investment in the Arts. National research survey*, 1993/94–1998/99.

ABSA (various years, 1993/94 to 1996/97) *Business Support for the Arts. National research survey* 1997/98. London: Association for Business Sponsorship of the Arts

ABSA/DNH (undated) *National Heritage Arts Sponsorship Scheme. Applying to the Pairing Scheme 1997/98*. London: Association for Business Sponsorship of the Arts

Arts & Business (various years) *Business Investment in the Arts. National research survey 1997/98–1998/99*. London: Arts & Business

CAF (1999) *Directory of Grant Making Trusts 1998*. London: Charities Aid Foundation

Casey, B, Dunlop, R and Selwood, S (1996) *Culture as Commodity? The Economics of the Arts and the Built Heritage in the UK*. London: Policy Studies Institute

The Factary (1994) *Capital Grants for the Arts: A report for the Arts Councils of England, Scotland, Wales and Northern Ireland*. London: Arts Council of England

Fitzherbert, L, Addison, D and Rahman, F (1999) *A Guide to the Major Trusts. Volume 1, 1999*. London: Directory of Social Change

Forrester, S (1996) *The Arts Funding Guide 1997/98 Edition*. London: Directory of Social Change (Reprinted in1998)

Forrester, S and Casson, D (1998) *The Environmental Funding Guide (3rd edn)*. London: Directory of Social Change

Forrester, S and Manuel, G (2000) *The Arts Funding Guide (5th edn)*. London: Directory of Social Change

Chapter 18, Why Does Government Fund the Cultural Sector?

Akerlof, GA (1970) ' "The market of lemons": quality, uncertainty and the market mechanism', *Quarterly Journal of Economics*, 84: 488–500

Allison, G, Ball, S, Cheshire, P, Evans, A and Stabler, M (1996) *The Value of Conservation*. London: Department of National Heritage, English Heritage, Royal Institution of Chartered Surveyors

Baumol,W J and Bowen, W G (1965) 'On the performing arts: the anatomy of their economic problems', *American Economic Review*, 55(2): 495–502

Baumol, W J and Bowen, W G (1966) *Performing Arts – the Economic Dilemma*. New York: Twentieth Century Fund

Creigh-Tyte, S W (1997) 'The development of British policy on built heritage preservation' in Hutter, M and Rizzo, I (eds), *Economic Perspectives of Cultural Heritage*. London: Macmillan, pp. 133–154

Creigh-Tyte, S W (1998) 'Mixed economy and culture: Britain's experience' in Boorsma, P B, Van Hemel, A and van der Wielen, N (eds), *Privatization and Culture: Experiences in the arts, heritage and cultural industries in Europe*. Dordrecht: Kluwer, pp. 183–195

Creigh-Tyte, S W (2000) 'The built heritage; some British experience', *Louvain Economic Review*, 66(2): 213–229

Creigh-Tyte, S W and Gallimore, J (2000) 'The UK National Lottery and the arts; reflections on the Lottery's impact and development', *International Journal of Arts Management*, 3(1): 9–31

Creigh-Tyte, SW and Thomas, B (2000) 'Valuing the historic environment: Some British experience', paper presented at Session F2, Preserving Cultural Heritage: Economics and Beyond, Association for Cultural Economics International Conference, Minneapolis

Davies, G (1999) *see* IRP (Independent Review Panel) (1999)

DCMS (1999a) DCMS *Efficiency and Effectiveness of Government-Sponsored Museums and Galleries*. London: Department for Culture, Media and Sport

DCMS (July 1999b) *Policy Action Team 10: A report to the Social Exclusion Unit*. London: Department for Culture, Media and Sport

DCMS (2000a) *Annual Report 2000* (Cm 4613). London: The Stationery Office

DCMS (2000b) *A Sporting Future for All*. London: Department for Culture, Media and Sport

DCMS (2001) *Resource Accounts 1999–2000*, HC181. London: The Stationery Office

Feist, A, Fisher, R, Gordon, C, Morgan, C and O'Brien, J (1998) *International Data on Public Spending in the Arts in Eleven Countries*. ACE Research Report 13. London: Arts Council of England

Fullerton, D (1991) 'On justifications for public support of the arts', *Journal of Cultural Economics*, 15(2): 67–82

Gore, T, Dabinett, G and Breeze, J (2000) *Improving Lottery Funding Access and Delivery in the British Coal Fields*. London: Department for Culture, Media and Sport, National Lottery Division

Grampp, WD (1989) *Pricing the Priceless: Art, artists and economics*. New York: Basic Books

HM Treasury (1995) *A Framework for the Evaluation of Regeneration Projects and Programmes*. London: HM Treasury

HM Treasury (1998a) *Modern Public Services for Britain: Investing in reform. Comprehensive spending review: new public spending plans 1999–2002* (Cm 4011). London: The Stationery Office

HM Treasury (1998b) *Public Services for the Future: Modernisation, reform, accountability* (Cm 4181). London: The Stationery Office

HM Treasury (1999) *The Government's Measures of Success. Output and performance analyses*. London: HM Treasury

HM Treasury (2000) *Prudence for A Purpose: Building opportunity and security for all. 2000 spending review: new public spending plans 2001–2004* (Cm 4807). London: The Stationery Office

Hochman, H and Rodgers, J (1986) 'The optimal tax treatment of charitable contributions' in Rose-Ackerman, S (ed.), *The Nonprofit Sector*. New Haven: Yale University Press

Independent Review Panel (Chairman Gavyn Davies) (1999) *The Future Funding of the BBC*. London: Department for Culture, Media and Sport

McCain, R A (1980) 'A market for works of art and markets for lemons' in Hendon, W S et al. (eds), *Economic Policy for the Arts*. Cambridge, Mass: Abt Books

Musgrave, RA (1958) *The Theory of Public Finance*. New York: McGraw-Hill

NACCCE (National Advisory Committee on Creativity and Cultural Education) (Chairman Ken Robinson) (1999) *All Our Futures: Creativity, culture and education*. London: Department for Education and Employment

Netzer, D (1978) *The Subsidized Muse: Public support for the arts in the United States*. Cambridge: Cambridge University Press

O'Hagan, J W (1998) *The State and the Arts: An analysis of key economic policy issues in Europe and the United States*. Cheltenham: Edward Elgar

Ozdemiroglu, E and Mourato, S (2001) 'Valuing our recorded Heritage' paper presented at The Economic Valuation of Cultural Heritage Seminar, 2 February, Centre for Cultural Economics and Management, University College London

Peacock, A (1995) 'A future for the past: the political economy of heritage', *Proceedings of The British Academy*, 87: 189–243

Peacock, A (2000) 'Public Financing of the Arts in England', *Fiscal Studies*, 21(2): 171–205

Samuelson, P A (1954) 'The pure theory of public expenditure', *Review of Economics and Statistics*, November: 387–389

Sawers, D (1993) 'Should the taxpayer support the arts?', *Current Controversies No. 7*. London: Institute of Economic Affairs

Scitovsky, T (1983) 'Subsidies for the arts: the economic argument' in Hendon, W S and Shanahan, J L (eds), *Economics of Cultural Decisions*. Cambridge, Mass: Abt Books

Towse, R (1997) *Baumol's Cost Disease: The arts and other victims*. Cheltenham: Edward Elgar

Willis, K, Beale, N, Calder, N and Freer, D (1993) *Paying for Heritage: What price Durham Cathedral?* Working Paper 43. Reading: Countryside Change Unit

Chapter 19, The Relationship between the Subsidised and the Wider Cultural Sector

ACE (2000a) *ACE Statistics Report No. 4 – A statistical survey of regularly and fixed term funded organisations based on performance indicators for 1999/2000*. London: Arts Council of England

ACE (2000b) *Artstat: Digest of arts statistics and trends in the UK, 1986/87–1997/98*. London: Arts Council of England

ACE (2000c) 'The creativity imperative – investing in the arts in the 21st century' speech by Gerry Robinson, *New Statesman* Arts Lecture 2000, Banqueting House, Whitehall, London, 27 June

ACGB (1986) *Theatre is for All – Report of the enquiry into the professional theatre in England ('The Cork Report')*. London: Arts Council of Great Britain

ACGB (1994) *Response to the Broadcasting Green Paper*. London: Arts Council of Great Britain

ACW (2000) *Annual Report and Accounts, 1999/2000*. Cardiff: Arts Council of Wales

Barnard, S (1989) *On the Radio: Music radio in Britain*. Milton Keynes: Open University Press

BBC/ACE (1994) *Orchestral Review*. London: BBC/Arts Council of England

Bennett, O (1991) 'British cultural policies 1970–1990', *Boekmancahier* 9: 61–72

Blamires, C (1992), 'What price entertainment?', *Journal of the Market Research Society*, 34(4): 31–42

Casey, B, Dunlop, R, Selwood, S (1996) *Culture as Commodity? The economics of the arts and built heritage in the UK*. London: Policy Studies Institute

Dane, C, Feist, A and Manton, K (1999), *A Sound Performance – The economic value of music in the United Kingdom*. London: KPMG/National Music Council

DCMS (1998) *Creative Industries Mapping Document*. London: Department for Culture, Media and Sport

Dickinson, M and Street, S (1985), *Cinema and State – The film industry and the British government 1927–1984*. London: British Film Institute

Feist, A (1997). 'Consumption in the arts and cultural industries: recent trends in the UK' in Fitzgibbon, M and Kelly, A (eds), *From Maestro to Manager – Critical issues in arts and cultural management*. Dublin: Oaktree Press

Feist, A (2000) *Cultural Employment in Europe* (Policy Note 8). Strasbourg: Council of Europe

Feist, A and Hutchison, R (1990a) 'Television', *Cultural Trends* 6: 45–66

Feist, A and Hutchison, R (1990b) 'Music', *Cultural Trends* 7: 20–45

Girard, A (1981) *Cultural Industries: A challenge for the future of culture*. Paris: UNESCO

Hughes, G (1989) 'Measuring the economic value of the arts', *Policy Studies* 9(3): 33–45

Hutchison, R and Feist, A (1992) *Amateur Arts in the UK*. London: Policy Studies Institute

Jackson, C, Honey, S, Hillage, J and Stock, J (1994) *Careers and Training in Dance and Drama*. Brighton: Institute for Employment Studies

Langsted, J (1990) 'Double strategies in a modern cultural policy', *Journal of Arts, Management and Law*, 19(4): 53–71

London Economics (1997) *New and Alternative Funding Mechanisms for Financing the Arts*. London: Arts Council of England

McLaughlin, C (1986) *The Art of Television – Arts programming and its audience*. London: The Independent Broadcasting Authority

MBI (1991) *Pricing the Arts 1990*. Warwick: Millward Brown International

Mulgan, G and Worpole, K (1986) *Saturday Night or Sunday Morning? From arts to industry – new forms of cultural policy making*. London: Comedia

Myerscough, J (1988) *The Economic Importance of the Arts in the UK*. London: Policy Studies Institute

National Music Council (1996) *The Value of Music*. London: National Music Council/The University of Westminster

O'Brien, J and Feist, A (1995) *Employment in the Arts and Cultural Industries: An analysis of the 1991 census* (ACE Research Report 2). London: The Arts Council of England

Peacock, A (2000) 'Public financing of the arts in England'. Unpublished paper presented to the Institute of Fiscal Studies

Chapter 20, Assessing the Economic Impact of the Arts

Alliance for the Arts (1993) *The Economic Impact of Major Exhibitions at the Metropolitan Museum of Art, the Museum of Modern Art, the Solomon R. Guggenheim Museum*. New York: Alliance for the Arts

Alliance for the Arts (1997) *The Economic Impact of the Arts on New York City and New York State*. New York: Alliance for the Arts

DCMS (1998) *Creative Industries Mapping Document*. London: Department for Culture, Media and Sport

DiNoto, MJ and Merk, LH (1993) 'Small economy impacts of the arts', *Journal of Cultural Economics*, 17(3): pp.41–53

Casey, B, Dunlop, R and Selwood, S (1996) *Culture as Commodity? The economics of the arts and built heritage in the UK*. London: Policy Studies Institute

Caves, RE (2000) *Creative Industries*. Cambridge, Mass: Harvard University Press

Cwi, D and Moore, S (1977) *Economic Impact of Arts and Cultural Institutions: A model for assessment and a case study in Baltimore*. Washington: US National Endowment for the Arts

Frey, BS (1997) 'The evaluation of cultural heritage: some critical issues', pp. 31–49 in Hutter, M and Rizzo, I (eds) *Economic Perspectives on Cultural Heritage*. Basingstoke: Macmillan

Frey, BS (2000) *Arts and Economics: Analysis and cultural policy*. Berlin: Springer-Verlag

Frey, BS and Pommerehne, WW (1989) *Muses and Markets*. Oxford: Blackwell

Gazel, RC and Schwer, RK (1997) 'Beyond rock and roll: the economic impact of the grateful dead on a local economy', *Journal of Cultural Economics*, 21(1): 41–55

Heilbrun, J and Gray, CM (1993) *The Economics of Art and Culture: An American Perspective*. Cambridge: Cambridge University Press

Hughes, G (1989) 'Measuring the economic value of the arts', *Policy Studies*, 9(3): 33–45

Johnson, P S and Thomas, R B (1992) *Tourism, Museums and the Local Economy*. Aldershot: Edward Elgar

McConnell, K E (1985) 'The economics of outdoor recreation', pp. 677–722 in Kneese, A V and Sweeney, J L (eds), *Handbook of Natural Resource and Energy Economics* (volume II). Amsterdam: Elsevier Science Publishers

Mitchell, C J A (1993) 'Economic impact of the arts: theatre festivals in small Ontario communities', *Journal of Cultural Economics*, 17(2): 55–69

Myerscough, J (1988a) *The Economic Importance of the Arts in Britain*. London: Policy Studies Institute

Myerscough, J (1988b) *The Economic Importance of the Arts in Glasgow*. London: Policy Studies Institute

Myerscough, J (1988c) *The Economic Importance of the Arts in Ipswich*. London: Policy Studies Institute

Myerscough, J (1988d) *The Economic Importance of the Arts in Merseyside*. London: Policy Studies Institute

Myerscough, J (1996) *The Arts and the Northern Ireland Economy*. Belfast: Northern Ireland Development Office

O'Hagan, J (1992) 'The Wexford Opera Festival: a case for public funding?', pp. 61–66 in Towse, R and Khakee, A (eds), *Cultural Economics*. Berlin: Springer-Verlag

Port Authority of New York and New Jersey and the Cultural Assistance Center (1983) *The Arts as an Industry: Their economic importance to the New York–New Jersey metropolitan region*. New York: Cultural Assistance Center

Port Authority of New York and New Jersey, Alliance for the Arts, New York City Partnership, Partnership for New Jersey (1993) *The Arts as an Industry: Their economic importance to the New York–New Jersey metropolitan region*. Part 1 of *Tourism and the arts in the New York–New Jersey Region*. New York: Port Authority of New York and New Jersey

Robinson, G (2000) 'The Creative Imperative'. *New Statesman* Arts Lecture, 2000. (www.artscouncil.org.uk./press/2000/jun)

Seaman, B (1986) 'Arts impact studies: a fashionable excess', pp. 43–76 in Radich, A J and Schwoch, S (eds), *Economic Impact of the Arts: A sourcebook*. Denver: National Conference of State Legislatures

South West Museums Council (2000) *The Economic Contribution of Museums in the South West*. Taunton: South West Museums Council

Thompson, EC (1998) 'Contingent valuation in arts impact studies', *The Journal of Arts Management, Law and Society*, 28(3): 206–210

Throsby, D (1994) 'Production and consumption of the arts; a view of cultural economics', *Journal of Economic Literature*, XXXII(1): 1–29

Towse, R (1997) *Cultural Economics: The arts, the heritage and the media industries* (2 volumes). Cheltenham: Edward Elgar

van Puffelen, F (1996) 'Abuses of conventional impact studies in the arts', *Cultural Policy*, 2(2): 241–254

Vaughan, D R (1976) *The Economic Impact of the Edinburgh Festival*. Edinburgh: Scottish Tourist Board

Welsh Economy Research Unit (1998) *The Economic Impact of the Arts and Cultural Industries in Wales*. Cardiff: Welsh Economy Research Unit, Business School

West Country Tourist Board (1996) *Tate Gallery St Ives 1994/5. Visitor survey*. Exeter: West Country Tourist Board

Chapter 21, Innovation and Diversity in Repertoire in Grant-aided and Commercial Theatre

ACE (various years) *ACE Playlists England*. London: Arts Council of England

ACE (1995/96) *Annual Report*. London: Arts Council of England

ACE (1996) *The Policy for Drama of the English Arts Funding System*. London: Arts Council of England

ACE (2000a) *The Next Stage. Towards a national policy for theatre in England* (www.artscouncil.org.uk/nextstage/nextstage.html, May 2000)

ACE (2000b) 'Arts to receive £100 million a year more by 2003/04', (www.artscouncil.org.uk/press/2000/july/jul25.html, 10 November 2000)

ACE (2001) *A Living Theatre. Delivering the national policy for theatre in England* (www.artscouncil.org.uk/nextstage/living-theatre.html, 8 March 2001)

Austen-Smith, D (1980) 'On the impact of revenue subsidies on repertory theatre policy', *Journal of Cultural Economics* 4: 9–17

Boyden Associates (2000a) *A Report for the ACE on the Roles and Functions of the English Regional Producing Theatres. Stage one*. (Summary). Bristol: Boyden Associates

Boyden Associates (2000b) *The Roles and Functions of the English Regional Producing Theatres. Final report* (www.artscouncil.org.uk/nextstage/boyden.html, May 2000)

Castañer, X (2000) 'The determinants of artistic innovation by cultural organisations: a review and extension', conference paper. Minneapolis: ACEI International Conference on Cultural Economics

Caves, R (2000) *Creative Industries: Contracts between art and commerce*. Cambridge, Mass: Harvard University Press

Cloake, M (1997) 'Management, the arts and innovation' in Fitzgibbon, M and Kelly, A (eds), *From Maestro to Manager. Critical issues in arts & cultural management*. Dublin: Oak Tree Press

Cogo-Fawcett, R (2000) Personal communication, March 2000

Cork, K (1986) *Theatre is for All*. London: Arts Council of Great Britain

DiMaggio, P and Stenberg, K (1985a) 'Conformity and diversity in American resident theatres', *Arts, Ideology and Politics*. New York: Praeger

DiMaggio, P and Stenberg, K (1985b) 'Why do some theatres innovate more than others? an empirical analysis', *Poetics* 14: 107–22

Evans, G (2000) 'Measures for measure: evaluating performance and the arts organisations', Conference paper. Vienna: FOKUS-ACEI Joint Symposium

Federal Cultural Policy Review Committee (1982) *Report*. Ottawa: Government of Canada

Feist, A (1998) 'Comparing the performing arts in Britain, the US and Germany: making the most of secondary data'. *Cultural Trends* 10(31): 25–48

Feist, A, Hacon, D, Davidson, A and Benn, S (1996) *The Professional Drama Sector in England – A statistical profile. An appendix to the drama White Paper*. London: Arts Council of England

Gardiner, C (1997) *Box Office Data Report 1996*. London: Society of London Theatre

Gardiner, C (1998) *Box Office Data Report 1997*. London: Society of London Theatre

Gardiner, C (1999) *Box Office Data Report 1998*. London: Society of London Theatre

Hacon, D, Dwinfour, P and Greig, P (1997) *A Statistical Survey of Regularly Funded Organisations based on the Performance Indicators for 1996/97*. ACE Statistics Report No. 1. London: Arts Council of England

Hacon, D, Dwinfour, P and Jermyn, H (1998) *A Statistical Survey of Regularly Funded*

Organisations based on the Performance Indicators for 1997/98. ACE Statistics Report No. 2. London: Arts Council of England

Hacon, D, Dwinfour, P, Jermyn, H and Joy, A (2000) *A Statistical Survey of Regularly and Fixed Term Funded Organisations based on the Performance Indicators for 1998/99.* ACE Statistics Report No. 3. London: Arts Council of England

Lidstone, G and Stewart-David, M (2000) *Box Office Data Report 1999.* London: Society of London Theatre

Mackintosh, C (1995/96) 'No public subsidy, no west end', in ACE (1995/96)

Martorella, R (1977) 'The relationship between box office and repertoire: a case study of opera', *The Sociological Quarterly* 18: 354–66

National Campaign for the Arts (1998) 'Theatre in crisis: the plight of regional theatre. a national campaign for the arts briefing' (www.ecna.org.uk/nca/theatreincrisis.htm, 1 August 2000)

O'Hagan, J W (1998) *The State and the Arts: An analysis of key economic policy issues in Europe and in the United States.* Cheltenham: Edward Elgar

Pierce Lamar, J (2000) 'Programmatic risk-taking by American opera companies', *Journal of Cultural Economics* 24(1): 45–63

Quine, M (1998) 'The theatre system of the United Kingdom' in Van Maanen, H and Wilmer S E (eds), *Theatre Worlds in Motion. Structures, politics and developments in the countries of Western Europe.* Amsterdam/Atlanta: Rodopi BV

Quine, M (1999) 'Audiences for live theatre in Britain: the present situation and some implications', *Cultural Trends* 34: 2–29

Ruhe, P (2000) 'Anything goes in New Music, so long as it's not atonal', *Financial Times,* 27 January: 14

Tait, S (2000) 'West End Winners', *Livewire,* August/September: 10–14

Theatrenet (1996) 'Theatre investment fund', (www.theatrenet.com/investment/invest-ment.shtm, 15 August 2000)

Theatrenet (2000) 'News archive. backstage whisper overheard by Richard Andrews' (showsavers.co.uk/archives/190500.htm, 19 May 2000)

Thorncroft, A (1998): 'Star-struck and stimulating', *Financial Times,* 19/20 September

Thorncroft, A (1999): 'Curtain up on a New Era for London', *Financial Times,* 17 September: 7

Travers, T (1998) *The Wyndham Report: The economic impact of London's West End theatre.* London: Society of London Theatre

Weil, S (1995) *A Cabinet of Curiosities: Inquiries into museums and their prospects.* Washington DC: Smithsonian Institution

West, R (2000) Personal communication, March 2000

Chapter 22, Art Trade and Government Policy

Art Sales Index (2000) *CD ROM 1992–2000.* London: Art Sales Index

Biondi, A (1997) 'The merchant, the thief, and the citizen: the circulation of works of art within the European Union', *Common Market Law Review* 34: 1173–1195

Browne, A (2000) 'The European Union and the art market: current concerns', *Christies Bulletin for Professional Advisers* 5(1): 13–16

Capital Taxes Office (1999) *Capital Taxes – Relief for heritage assets.* London: Inland Revenue

Casey, B, Dunlop, R and Selwood, S (1996) *Culture as Commodity? The economics of the arts and built heritage in the UK.* London: Policy Studies Institute

Christie's (1998) *Guide de la Droit de l'Art*. Geneva: Christies Publications

Creigh-Tyte, S (1998) 'The built heritage in England: the history and development of government policy', *Cultural Trends* 32: 25–33

DCMS (1999) *Annual Report of the Department for Culture, Media and Sport 1999* (www.culture.gov.uk/DCMSANN.HTM)

DNH (1998) *Export Licensing for Cultural Goods: Procedures and guidance for exporters of works of art and other cultural goods*. London: Department of National Heritage

European Commission (1999) *Report from the Commission to the Council on the Examination of the Impact of the Relevant Provisions of the Council Directive 94/5/EC on the Competitiveness of Community Art Market Compared to Third Countries Art Markets*. Brussels: European Commission

Eurostat (2000) *CD ROM 2000*. Luxembourg: Eurostat

Frey, B and Pommerehne, W (1989) *Muses and Markets*. Oxford: Basil Blackwell

Goetzmann, W (1993) 'Accounting for taste: art and the financial markets over three centuries', *American Economic Review* 83(5): 1370–1376

Greenfield, J (1995) *The Return of Cultural Treasures* (2nd edn). Cambridge: Cambridge University Press

Inland Revenue (1986) *Capital Taxation and National Heritage*. London: Board of the Inland Revenue

Inland Revenue (1990–1998) *Inland Revenue Statistics*. London: HMSO/TSO

Manisty, E (1996) 'Negotiated sales of heritage chattels: the law, practice, and procedures with some comments on funding – part I', *Art, Antiquity and Law* 3: 353–363

Manisty, E (1997) 'In situ offers of heritage property in lieu of capital taxation', *Private Client Business*, 6: 36–35

McAndrew, C (2000) *Collection and distribution of visual artists reproduction and resale rights: preliminary research – section c: examination of Droit de Suite in Germany, Finland, France, Denmark, Belgium, and California*. London: Arts Council of England.

McAndrew, C and O'Hagan, J (2000) 'Export restrictions, tax incentives, and the national artistic patrimony', *Cultural Trends*. 37: 40–63

MTIC (2000) *The European Art Market 2000*. London: TEFAF

O'Hagan, J and McAndrew, C (2001) 'Restricting international trade in the national artistic patrimony: economic rationale and policy instruments', *International Journal of Cultural Property* 10(1): 32–54

RCEWA (Reviewing Committee on the Export of Works of Art) (1993/94 and 1997/98) *Annual Report*. London: HMSO/TSO

Schulze, G and McAndrew, C (forthcoming) *Cultural Autonomy versus Free Trade in the European Union*.

World Bank (2000) (www.worldbank.org)

Chapter 23, Employment

Adler, M (1998) 'Psychic income and subsidies for artists', *Proceedings of the Tenth International Conference on Cultural Economics*. Barcelona: Association for Cultural Economics International

Alper, N and Wassall, G (1998) 'Earnings of American artists 1940–1990', *Proceedings of the Tenth International Conference on Cultural Economics*. Barcelona: Association for Cultural Economics International

CSO (1995) *New Earnings Survey 1995: Parts C and D*. London: HMSO

Carter, S, Hurst, B, Kerr, RH, Taylor, E and Winsor, P (1999) 'The 1998 DOMUS Survey', *Museums Focus. Facts and figures on museums in the UK*, Issue 2. London: Museums & Galleries Commission

Casey, B, Dunlop, R and Selwood, S (1996) *Culture as Commodity? The economics of the arts and built heritage in the UK*. London: Policy Studies Institute

Caves, RE (2000) *Creative Industries. Contract between art and commerce*. Cambridge: Harvard University Press

Champlin, D (1995) 'Understanding job quality in an era of structural change – what can economics learn from industrial relations', *Journal of Economic Issues*, 29(3): 829–841

Clark, AE (1998) 'Measures of job satisfaction. What makes a good job? Evidence from OECD countries', *Labour Market and Social Policy*, Occasional Paper No. 34. Paris: OECD

Creative Industries Task Force (1998) *Creative Industries Mapping Document*. London: Department for Culture, Media and Sport

Creigh-Tyte, SW and Selwood, S (1998) 'Museums in the UK: some evidence on scale and activities', *Journal of Cultural Economics*, 22(2–3): 151–165

Campbell, M and Daly, M (1992) 'Self-employment in the 1980s', *Employment Gazette*, 100(6): 269–292

Denkins, J (1998) 'Expanding the coverage of earnings data in the LFS' *Labour Market Trends*, 106(4): 157–162

DCMS (2001) *Creative Industries Mapping Document 2001*. London: DCMS

EUCLID (1999) 'A working culture – culture, creativity and employment', *Eureka Briefing* 2.5 (February)

EC (1998) *Culture, the Cultural Industries and Employment*. Commission Staff Working Paper, 14.5.98. Brussels: European Commission

Frank, RH and Cooke, PJ (1995) *The Winner-Take-All Society*. New York: Free Press

Frey, BS (2000) *Arts and Economics. Analysis and cultural policy*. Berlin: Springer-Verlag

Gazier, B (ed.) (1999) *Employability, Concepts and Policies. Report on behalf of the European Commission, DG V*. Berlin: IAS

Gitleman, MB, Howell, DR (1995) 'Changes in the structure and quality of jobs in the United States – effects by race and gender, 1973–1990', *Industrial and Labour Relations Review*, 48(3): 420–440

Kalleberg, AL, Reskin, BF and Hudson, K (2000) 'Bad jobs in America: Standard and nonstandard employment relations and job quality in the United States', *American Sociological Review*, 65(2): 256–278

Keep, E and Mayhew, K (1999) 'The leisure sector', *Skills Task Force Research Paper 6*. London: Department for Education and Employment

Laux, R (1998) 'Monthly publication of up-to-date quarterly data from the Labour Force Survey', *Labour Market Trends*, 106(2): 59–63

Mitchell, R and Karttumen, S (1992) 'Why and how to define an artist: different types of definitions and their implications for empirical research results', in Towse and Khakee (1992)

Moralee, L (1998) 'Self-employment in the 1990s', *Labour Market Trends*, 106(3): 121–130

National Trust (1996) *Annual Report and Accounts 1995/96*. London: National Trust

O'Brien, J and Feist, A (1997) *Employment in the Arts and Cultural Industries: An analysis of the Labour Force Survey and other sources*. ACE Research Report No. 9, London: Arts Council of England

ONS (1997) 'Comparisons of sources of employment data', *Labour Market Trends*, 105(12): 511–519

ONS (1998) *How Exactly is Unemployment Measured?* (3rd edn, April). London: Office for National Statistics

ONS (1999) *New Earnings Survey: Parts C and D*. London: Office for National Statistics

ONS (2000) *Guide to Labour Market Statistics Releases* (2nd edn, April). London: Office for National Statistics

Parker, M (1999) *Skill Requirements in the Creative Industries*. Skills Task Force Research Paper 12. London: Department for Education and Employment

Pratt, AC (1997a) 'The cultural industries production system: a case study of employment change in Britain, 1984–91', *Environment and Planning* A 29(11): 1953–1974

Pratt, AC (1997b) 'Production values: from cultural industries to the governance of culture', *Environment and Planning* A 29(11): 1911–1917

Purcell, K, Hogarth, T and Simm, C (1999) *Whose Flexibility? The costs and benefits of non-standard working arrangements and contractual relations*. York: YPS for the Joseph Rowntree Foundation

Sadler, D (1997) 'The global music business as an information industry: reinterpreting economies of culture', *Environment and Planning* A 29(11): 1919–1936

Shaw, P and Allen, K (1997) *Artists' Rights Programme: a review of artists' earnings from exhibitions and commissions*. London: National Artists Association

Sightseeing Research (1995–99) *Sightseeing in the UK 1994; 1995; 1996; 1997; 1998*. London: English Tourism Council

Smith, JD (1998), *The 1997 National Survey of Volunteering*. London: National Centre for Volunteering

South West Museums Council (2000) *The Economic Contribution of Museums in the South West* (prepared by S. Brand, P. Gripaios and E. McVittie), May. Taunton: South West Museums Council

Strobl, E and Tucker, C (1998) 'The distribution of gross earnings of artists generated by album sales in the UK pre-recorded popular music industry', *Proceedings of the Tenth International Conference on Cultural Economics*. Barcelona: Association for Cultural Economics International.

Stuttard, N, Tiwana, H and Partington, J (1998) 'Industry comparisons of employment estimates', *Labour Market Trends*, 106(10): 519–526

Thomas, B (2000) 'Volunteer labour: allocation issues and intrinsic motivation', *University of Durham, Department of Economics and Finance Working Paper* No. 2002

Towse, R (1993) *Singers in the Marketplace: the economics of the singing profession*. Oxford: Clarendon Press

Towse, R and Khakee, A (eds.), (1992) *Cultural Economics*. Berlin: Springer-Verlag

Wilkinson, D (1998) 'Towards reconciliation of NES and LFS earnings data', *Labour Market Trends* 106(5): 223–231

Chapter 24, Profile of the Built Heritage

This chapter draws on various annual reports, including those of the DNH/ DCMS; Department of the Secretary of State for Scotland and the Forestry Commission, the Welsh Office, the Northern Ireland Office; and the HLF as well as the local authority figures published in Scotland by the Government Statistical Service and those for England and Wales published by CIPFA; and ABSA/A&B's *Business Support for the Arts/Business Investment in the Arts*.

BTA (1996) *Survey of Overseas Visitors 1995*. London: British Tourist Authority

BTA (1997) *Survey of Overseas Visitors 1996*. London: British Tourist Authority

Cadw (1999) *Annual Report and Accounts 1998/99*. Cardiff: HMSO

Charities Aid Foundation (1999) *Directory of Grant Making Trusts*. London: Directory of Social Change

CIPFA (1999) *Planning and Development Statistics 1998*. London: Chartered Institute of Public Finance and Accountancy

DCMS (1999) *Annual Report: the government's expenditure plans 1999/2000*. London: The Stationery Office

DETR (1999) *DETR Annual Report 1999*. Norwich: The Stationery Office

DNH (1993) *Day Visits in Great Britain 1991/92*. London: The Stationery Office

DoE NI (1998) *Northern Ireland: expenditure plans and priorities 1998/99*. Belfast: The Stationery Office

English Heritage (1996) *The Value of Conservation?* London: English Heritage

English Heritage (1999) *Annual Report 1998/99*. London: English Heritage

HLF and NHMF (1999) *Annual Report and Accounts 1998/99*. London: Heritage Lottery Fund and the National Heritage Memorial Fund

HRP (1999) *Annual Report 1998/99*. London: The Stationery Office

Historic Scotland (1999) *Annual Report and Accounts 1998/99*. Edinburgh: The Stationery Office

Hudson, N (ed) (1999) *Hudson's Historic Houses and Gardens*. Banbury: Norman Hudson and Co.

IPD (1999) *The Investment Performance of Listed Office Buildings*. London: Royal Institution of Chartered Surveyors

Mintel (1998) *Leisure Intelligence*. London: Mintel (May)

National Trust (1999) *Annual Report and Accounts 1998/99*. London: National Trust

NTS (1999) *Annual Report and Accounts 1997/98*. Edinburgh: National Trust for Scotland

Sightseeing Research (1999a) *The Heritage Monitor 1999*. London: English Tourism Council

Sightseeing Research (1999b) *Sightseeing in the UK 1998*. London: English Tourism Council

Chapter 25, Profile of the Film Industry

This chapter draws on regular publications: the monthly journal, *Screen Digest*; the Labour Force Survey; cinema box-office data for UK collected by ACNielsenEDI on a weekly basis; the National Readership Survey (www.nrs.co.uk) used by the cinema advertising industry to obtain the profile of the cinema audience; and the annual *BFI Handbook*.

Other annual publications referred to include; DNH/DCMS annual reports; the Government Expenditure Plans published by the Department for the Secretary of State for Scotland and the Forestry Commission, the Welsh Office, and the Northern Ireland Office; the annual reports and reviews containing Lottery data issued by the Arts Councils of England, Scotland, Wales and Northern Ireland; and, the findings of the ABSA/Arts & Business annual survey of *Business Support for the Arts/Business Investment in the Arts*.

Websites used include: British Film Institute (BFI): www.bfi.org.uk; Donoda Research: www.donoda.co.uk; Geobusiness: www.geobusiness.co.uk/Information/CaseStudies/cases-tudies.htm; Pearl and Dean: www.pearlanddean.com

Other references

BFC (2000) 'UK Production Activity Nears All-time High in '99'. Press Release (January) London: British Film Commission

BFI (1999) *BFI Handbook 1999*. London: British Film Institute

BMRB (1999) CAVIAR survey. London: BRMB

DCMS Film Policy Review Group (1998) *The Bigger Picture*. London: DCMS

Hancock, D (ed.) (1995) *Mirrors of Our Own*. Strasbourg: Council of Europe Publishing

Hancock, D (1999a) 'Film Production and Distribution: year of mixed fortunes', *Screen Digest* (June)

Hancock, D (1999b) 'Towards a Single European Market in Film', *Screen Digest* (October)

Hancock, D (2000) 'Film Production and Distribution Trends', *Screen Digest* (June)

ONS (1997) *Family Expenditure Survey*. London: Office for National Statistics

ONS (1998) *Annual Employment Survey*. London: Office for National Statistics

ONS (1999a) *Annual Employment Survey*. London: Office for National Statistics

ONS (1999b) *Overseas Transactions in the Film and Television Industries*. London: Office for National Statistics

ONS (1999c) *Overseas Transactions of the Film and Television Industry*, News release. London: Office for National Statistics. See http://www.statsbase.gov.uk/statbase/Product.asp?vlnk=734

O'Brien, J and Feist, A (1997) *Employment in the Arts and Cultural Industries: an analysis of the Labour Force Survey and other sources*. London: Arts Council of England

Chapter 26, Profile of Libraries

Batt, C (1997) *Information Technology in Public Libraries* (6th edn). London: Library Association

Berridge, P and Sumsion, J (1994) *UK Special Library Statistics*. Loughborough: Library and Information Statistics Unit

Bohme, S and Spiller, D (1999) *Perspectives of Public Library Use 2: A compendium of survey information*. Loughborough: LISU and London: Book Marketing Ltd, pp52–59

Book Marketing Ltd (1998) *Household Library Use Survey 1998*. London: Book Marketing Ltd

The Bookseller (1999), 5 November, p25

CIPFA (1999a) *Public Library Statistics 1998–99 Actuals*. London: Institute of Public Finance

CIPFA (1999b) *Public Library Statistics 1999–2000 Estimates*. London: Institute of Public Finance

Creaser, C and Murphy, A (1999) *LISU Annual Library Statistics 1999*. Loughborough: Library and Information Statistics Unit

Creaser, C and Spiller, D (1997) *TFPL Survey of UK Special Library Statistics*. Loughborough: Library and Information Statistics Unit

DCMS (2000) *Comprehensive and Efficient – Standards for Modern Public Libraries: a consultation paper.* London: The Stationery Office. Full text available at (www.culture.gov.uk/heritage/library_standards.html)

HCLRG (1999) *Statistics 1997–98.* Canterbury: Higher Education Colleges Learning Resources Group

LIC (1997) *New Library: The people's network.* London: The Stationery Office. Full text available at (www.ukoln.ac.uk/services/lic/newlibrary/)

Library Association (1997) *Survey of Secondary School Libraries in the UK.* London: Library Association (November). Full text available at (www.lahq.org.uk/)

Martin, J (1999) *Libraries in Scotland: Loan periods and charges 1999/2000.* Ardrossan: North Ayrshire Library Services

Murphy, A (1998) *A Survey of NHS Libraries 1997–98.* Loughborough: Library and Information Statistics Unit

Robertson, S (1999) *Fines and Charges in Public Libraries in England and Wales* (12th edn). Sheffield: SINTO (The Sheffield Information Organisation)

Ryan, P (1999) *Government Libraries Statistics 1997/98.* London: Committee of Departmental Librarians

SCONUL (1999) *Annual Statistics 1997–98.* London: Standing Conference of National and University Librarians

Spiller, D Creaser, C and Murphy, A (1998) *Libraries in the Workplace.* Loughborough: Library and Information Statistics Unit,

Wallace, W and Marsden, D (1999) *Library and Learning Resources Services in Further Education: The report of the1996/97 survey.* London: Library Association. Full text available at (www.la-hq.org.uk/directory/prof_issues/linfe.html)

Chapter 27, Profile of Literature

This chapter draws on unpublished data provided by the East Midlands Arts Board and Yorkshire Arts Board; the National Association of Literature Development (NALD); the Target Group Index, published by British Market Research Bureau; the Welsh Academy; and the Edinburgh Festival. Published sources include Arts Council of England annual reports and those listed below.

ACE (1998) *Live Literature.* London: The Arts Council of England

Bohme, S and Spiller, D (1999) *Perspectives on Public Library Use 2. Compendium of survey information.* Loughborough: Library and Information Statistics Unit and London: Book Marketing Ltd

Book Marketing Ltd (1996) *Books and the Consumer Survey.* London: Books Marketing Ltd

Book Marketing Ltd (1999) *Book Facts 1999: An annual compendium.* London: Book Marketing Ltd

Book Marketing Ltd and The Reading Partnership (2000) *Reading the Situation.* London: Book Marketing Ltd

Creaser, C and Murphy, A (1999) *LISU Annual Library Statistics 1999.* Loughborough: Library and Information Statistics Unit

Creaser, C and Scott, J (1998) *LISU Annual Library Statistics 1998.* Loughborough, Library and Information Statistics Unit

DfEE (1999) *Turn on to Reading. Celebrating the National Year of Reading.* London: Department for Education and Employment

Hacon, D, Dwinfour, P and Greig, P with O'Brien, J (1997) *A Statistical Survey of Regularly Funded Organisations based on Performance Indicators for 1996/97.* London: Arts Council of England

Hacon, D, Dwinfour, P and Jermyn, H (1998) *A Statistical Survey of Regularly Funded Organisations based on Performance Indicators for 1997/98.* London: Arts Council of England

Hacon, D, Dwinfour, P, Jermyn, H and Joy, A (2000) *A Statistical Survey of Regularly and Fixed Term Funded Organisations based on Performance Indicators for 1998/99.* London: Arts Council of England

Motion, A (2000) *Poetry in Public. The Arts Council of England annual lecture organised with the RSA.* London: Arts Council of England

NLT (2000*) Building a Nation of Readers: A review of the National Year of Reading.* London: The National Literacy Trust

The Reading Partnership (1999) *Public Libraries and Readers.* Winchester: The Reading Partnership

Social Trends 30 (2000) London: The Stationery Office

Chapter 28, Profile of Museums and Galleries

This chapter draws on various regular publications, including: the annual reports for DHH/DCMS, the Scottish Office, the Welsh Office and the Northern Ireland Office, HLF, NACF, National Fund for Acquisitions, the MGC and the AMCs. It also draws on the annual ABSA/Arts & Business, *Business Support for the Arts/Business Investment in the Arts*; Scottish Office, *Scottish Local Government Financial Statistics*; and unpublished data collected by GLLAM and AIM.

Arnold-Forster, K (1999) *Beyond the Ark: Museums and collections of higher-education institutions in southern England.* London: South East Museums Service

Babbidge, A (2001) 'UK museums – safe and sound?', *Cultural Trends* 37: 3–39

Bailey, S, Faconer, P, Foley, M, McPherson, G and Graham, M (1998) *To Charge or not to charge?* Full report. London: Museums and Galleries Commission

Brand, S, Gripaios, P and McVittie, E, for the South West Economy Centre (2000) *The Economic Contribution of Museums in the South West.* Taunton: South West Museums Council

Carter, S, Hurst, B, Kerr RH, Taylor, E and Winsor, P (1999) *Museum Focus. Facts and figures on museums in the UK.* Issue 2. London: Museums & Galleries Commission

Coles, A, Hurst, B and Winsor, P (1998) *Museum Focus. Facts and figures on museums in the UK.* Issue 1. London: Museums & Galleries Commission

Creigh-Tyte, SW and Selwood, S (1998) 'Museums in the UK: some evidence on scale and activities', *Journal of Cultural Economics*, 22(2–3): 151–165

Davies, S (1994) *By Popular Demand. A strategic analysis of the market potential for museums and art galleries in the UK.* London: Museums & Galleries Commission

Davies, S (1997) *Walls and Whispers. Factors affecting the success and failure rates of museum lottery application bids in the West Midlands.* Leeds: University of Leeds DPM Associates

Davies, S (2000) 'Those who do and those who don't', *Visiting Rights?* Conference London: Tate Modern (mimeo)

DCMS (1998a) 'Chris Smith details biggest ever increase in cultural funding' News Release 167/98, 24 July. London: Department for Culture, Media and Sport

DCMS (1998b) 'Chris Smith unveils biggest ever reform of cultural funding and organisation' News Release 309/98, 14 December. London: Department for Culture, Media and Sport

Desai, P and Thomas, A (1998) *Cultural Diversity: Attitudes of ethnic minority populations towards museums and galleries* (prepared for the Museums & Galleries Commission). London: BMRB International

DNH (1996) *Treasures in Trust.* London: Department of National Heritage

East Midlands Museums Service (1996) *Knowing our Visitors. Market survey 1994/96.* Nottingham: East Midlands Museum Service

Hanna, M (1999) *Sightseeing in the UK: A survey of the usage and capacity of the United Kingdom's attractions for visitors.* London, Belfast, Edinburgh and Cardiff: English Tourism Council, Northern Ireland Tourist Board, Scottish Tourist Board and the Wales Tourist Board

Hasted, R (1996) *Consultants and Freelance Workers in Museums.* London: Museums Association (mimeo)

HOST Consultancy (1999) *UK Cultural Heritage Labour Market Information Report 1999.* Bradford: Cultural Heritage NTO

Middleton, VTC (1998) *New Visions for Museums in the 21st Century.* London: Association of Independent Museums

MORI (1999) *Visitors to Museums & Galleries in the UK. Research findings.* London: Museums & Galleries Commission

MTI (1997) *Review of Management Training and Developments in the Museums, Galleries and Heritage Sector.* Bradford: Museums Training Institute

Museums Association (1999) *Museums Yearbook 1999.* London: Museums Association

ONS (1999) *Social Trends 1999.* London: The Stationery Office

Selwood, S (2000) 'Access, efficiency and excellence: measuring non-economic performance in the English subsidised cultural sector', *Cultural Trends* 35: 87–137

Selwood, S and Muir, A (1997) 'Museums and gallery statistics: the DOMUS database', *Cultural Trends* 28: 29–48

South West Museums Council (1999) *Mapping Project 1999.* Taunton: South West Museums Council

Thomas, R, Purdon, S, McGarry, T and Donagher, P (undated) *Counting Visitors to the British Museum.* London: Social and Community Planning Research

West Midlands Area Museums Service (1996) *First Principles. A framework for museum development in the West Midlands.* Bromsgrove: West Midlands Area Museums Service

Winsor, P (1999) 'Conservation in the UK', *Cultural Trends* 33: 3–34

Chapter 29, Profile of the Performing Arts

This chapter draws on several regular publications, including: the annual reports and Lottery reports of the Arts Council of Great Britain and its successor body, the Arts Council of England (London); the Arts Council of Northern Ireland (Belfast); and the Scottish Arts Council (Edinburgh); the Welsh Arts Council, and its successor body, Arts Council of Wales (Cardiff); the annual reports and review of the regional arts boards; the annual national surveys of *Business Support for the Arts/Business Investment in the Arts*) published by Arts & Business (formerly the Association of Business Sponsorship for the Arts; and the BBC. Local authority data have been drawn from various sources including the SAC/COSLA surveys of arts expenditure in Scotland; the National Assembly for Wales and two reports published by The Forum for Local Government and the Arts, Northern Ireland.

ACE (1999) *Facts and Figures about the Arts*. London: Arts Council of England

ACE (2000). *Artstat: Digest of arts, statistics and trends in the UK 1986/87–1997/98*. London: Arts Council of England

British Performing Arts Yearbook 1999/2000 (1999) London: Rhinegold

British and International Music Yearbook 1999 (1999) London: Rhinegold

Casey, B, Selwood, S and Dunlop, R (1996) *Culture as Commodity? The economics of the arts and built heritage in the UK*. London: Policy Studies Institute

Dane, C, Feist, A and Manton, K (1999), *A Sound Performance*. London: National Music Council

Feist, A (1998) 'Comparing the performing arts in Britain, the US and Germany: making the most of secondary data', *Cultural Trends* 31: 29–47

Feist, A and O'Brien, J (1996) *Local Authority Expenditure on the Arts in England, 1995/96*. London: Arts Council of England

Hacon, D, Dwinfour, P, Jermyn, H and Joy, A (2000) *A Statistical Survey of Regularly and Fixed Term Funded Organisations based on Performance Indicators for 1998/99*. London: Arts Council of England

Jackson, C, Honey, S, Hillage, J and Stock, J (1994) *Careers and Training in Dance and Drama*. Brighton: Institute of Manpower Studies

Joy, A and Jermyn, H (1999) *Local Authority Expenditure on the Arts in England, 1998/99*. Research report 18. London: Arts Council of England

Joy, A and O'Brien, J (1998) *Local Authority Expenditure on the Arts in England, 1997/98*. London: Arts Council of England

Marsh, A and White, J (1995) *Local Authority Expenditure on the Arts in England, 1993/94*. London: Arts Council of England

Myerscough, J (1988) *The Economic Importance of the Arts in Britain*. London: Policy Studies Institute

O'Brien, J and Feist, A (1995) *Employment in the Arts and Cultural Industries: An analysis of the 1991 census*. London: Arts Council of England

ONS (1999) *Family Spending. A report on the 1998–99 Family Expenditure Survey*. London: The Stationery Office

O'Brien, J and Feist, A (1996) *Local Authority Expenditure on the Arts in England 1995/96*. Research report 6. London: Arts Council of England

Quine, M (2000) 'Audiences for live theatre in Britain: the present situation and some implications'. *Cultural Trends* 34: 1–24

Scottish Arts Council/COSLA (1999) *Arts Expenditure in Scotland 1997/98: COSLA/SAC Survey*. Edinburgh: Convention of Scottish Local Authorities

Travers, T (1998) *The Wyndham Report. The economic impact of London's West End theatre*. London: Society of London Theatre

Chapter 30, Profile of Public Broadcasting

This chapter draws on various annual reports by DNH, DCMS and the BBC, and the following websites: BBC Worldwide (www.Beeb.com) and BBC Online (www.bbc.co.uk).

BBC (1999) *Annual Report 1998/99*. London: BBC

BBC Worldwide (1999) *Annual Report 1998/1999*. London: BBC Worldwide

BskyB (1999) *Annual Report*. London: BskyB

Casey, B, Dunlop, R and Selwood, S (1996) *Culture as Commodity? The economics of the arts and built heritage in the UK*. London: Policy Studies Institute

Channel 4 (1999) *Annual Reports and Accounts, 1998/1999*. London: Channel Four
DCMS (1998) *Creative Industries Mapping Document*. London: Department for Culture, Media and Sport
Guardian (2000) *The Media Guide, 2000*. London: *The Guardian*
Keynote (1999) *Keynote Market Trends*. London: Keynote
Radio Advertising Bureau (1999) *Radio Report, 1999*. London: Radio Advertising Bureau
S4C (1999) *Annual Report and Accounts 1998/1999*. Cardiff: Sianel Pedwar Cymru
Taris (1999) *The Taris UK Television and Video Yearbook, 1999*. London: Taris
The Advertising Association (1998) *Media Pocket Book*. Henley on Thames: The Advertising Association in association with NTC Publications Ltd
Zenith Media (2000) *UK Media Yearbook*. London: Zenith Media

Chapter 31, Profile of the Visual Arts

This chapter largely draws on two sources in particular: Selwood and Dunlop (1998) (as detailed below), and Selwood, S (2000) '"I do it because I want to": fine artists, self-sufficiency and the arts economy' in Furlong, W, Gould, P and Hetherington, P (eds), (2000) *Issues in Art and Education: The dynamics of now*. London: Wimbledon School of Art in Association with Tate Publishing (pp 167–172). It also refers to the annual reports and accounts of: ACGB/ACE, SAC, WAC/ACW, ACNI and the RABs, as well as Lottery data provided by ACE and ACW, the ACNI Annual Lottery Report, and Arts & Business/ABSA's review of *Business Support for the Arts/Business Investment in the Arts*.

Allthorpe-Guyton, M (1997) 'Points of view' in 'Culture as business', *Times Higher Education Supplement*, 7 September.
Anderson, J (2000) 'The current state of play', in Dumelow, I, MacLennan, M and Stanley, N (eds), *Planning the Future: Career employment patterns among British graduates in art, craft & design*. Corsham: NSEAD
Annabel Jackson Associates (1999) *Evaluation of Public Art Projects Funded under the Lottery. Final report to the Arts Council of England*. London: Arts Council of England
Baker Tilly (1997) *Artists' Rights Programme: Taxation and employment status of visual artists*. London: National Artists' Association
Brighton, A and Pearson, N (1985) *The Economic Situation of the Visual Artist*. London: Calouste Gulbenkian Foundation (mimeo)
Butlar Research (1994) *The Final Report on the Fine Art and Antiques Trade for the Department of Trade and Industry* (mimeo)
Casey, B, Dunlop, R and Selwood, S (1996) *Culture as Commodity? The economics of the arts and built heritage in the UK*. London: Policy Studies Institute
Crafts Council (1995) *The Crafts and the Economy*. London: Crafts Council
DCMS (1998) *Creative Industries Mapping Document*. London: Department for Culture, Media and Sport
DCMS (2001) *Culture and Creativity: the next ten years*. London: Department for Culture, Media and Sport
Design Week and Major Players (1997) 'Reeling it in. Salary survey', *Design Week*, 3 October
Donagh, H (1998) *Artists and the New Deal*. London: Arts Council of England (unpublished briefing note)
Douglas, A and Wegner, N (eds) (1996) *Artists' Stories*. Sunderland: AN Publications
DTZ Pieda Consulting (2000) *Evaluation of Glasgow 1999: UK City of Architecture and Design*. Edinburgh: DTZ Pieda Consulting

Etches, S (1998) *Artists' Initiative Consultation. Final Report.* London: London Arts Board, Visual Arts Department (mimeo)

Harris Research Centre (1998) *Visual Arts UK: Public attitudes towards and awareness of the Year of Visual Arts in the North of England (Summary).* ACE Research Report No. 15. London: Arts Council of England

Honey, S, Heron, P and Jackson, C, for the Institute of Employment Studies (1997) *Career Paths of Visual Artists.* London: Arts Council of England

Knott, CA (1994) *Crafts in the 1990s: A summary of the independent socio-economic study of craftspeople in England, Scotland and Wales.* London: Crafts Council

LAB (1998) *London Arts Board Artists' Initiative. Draft paper.* London: London Arts Board (unpublished)

La Valle, I, O'Regan, S and Jackson, C, for the Institute of Employment Studies (1997) *The Art of Getting Started: Graduate skills in a fragmented labour market.* London: The London Institute

MTI (1997) *The British Art Market 1997.* London: British Art Market Federation

O'Brien, J (1997) *Professional Status as a Means of Improving Visual Artists' Incomes.* London: Arts Council of England (working paper)

O'Rorke, I (1998) 'How the dole made Britain swing... and how Labour is about to destroy all that', *Guardian* (6 January)

Scottish Arts Council (1995) *A Socio-Economic Study of Artists in Scotland.* Edinburgh: Scottish Arts Council

Selwood, S (1995) *The Benefits of Public Art. The polemics of permanent art in public places.* London: Policy Studies Institute

Selwood, S (2000) 'Museums, galleries and the business of consulting with young people', in Horlock, N (ed.) *Testing the Water: Young People and Galleries.* Liverpool: Liverpool University Press, Tate Gallery Liverpool

Selwood, S and Dunlop, R (1998) *Arts, Crafts and Design in the National Economy – A handbook* (prepared for the CHEAD Links Group). London: Policy Studies Institute (unpublished)

Selwood, S and Thomas, A (1998) 'The art and antiques trade', *Cultural Trends* 29: 37–65

Sentance, A and Clarke, J (1997) *The Contribution of Design to the UK Economy.* Working paper. London: Design Council

Shaw, P and Allen, K (1997) *Artists' Rights Programme: A review of artists' earnings from exhibitions and commissions.* London: National Artists Association

SLAD/FATG (1996) *Artists & Galleries. A profitable relationship.* London: Society of London Art Dealers and The Fine Art Trade Guild,

Smith, C (1998) *Creative Britain.* London: Faber & Faber

Summerton, J (undated) *Synopsis of Artists at Work 1999. A study of patterns and conditions of work.* Winchester: Southern Arts Board (mimeo)

TMS (1997) *Glasgow 1996 Festival of Visual Arts. Monitoring study. Final report.* Edinburgh: TMS

Chapter 32, Survey Findings

ACE (1999) *Facts and Figures about the Arts.* London: Arts Council of England

Babbidge, A (2001) 'UK museums – safe and sound?', *Cultural Trends* 37: 1–35

Casey, B, Dunlop, R and Selwood, S (1996) *Culture as Commodity? The economics of the arts and built heritage in the UK.* London: Policy Studies Institute

Office for National Statistics (1999) *Social Trends 29. 1999 edition.* London: The Stationery Office

Chapter 33, The Arts Council of England and Regional Arts Boards' Constant Sample, 1994/95–1998/99

Casey, B, Dunlop, R and Selwood, S (1996) *Culture as Commodity? The economics of the arts and built heritage in the UK*. London: Policy Studies Institute

Hacon, D, Dwinfour, P and Greig, P with O'Brien, J (1997) *A Statistical Survey of Regularly Funded Organisations based on Performance Indicators for 1996/97*. London: Arts Council of England

Hacon, D, Dwinfour, P and Jermyn, H (1998) *A Statistical Survey of Regularly Funded Organisations based on Performance Indicators for 1997/98*. London: Arts Council of England

Hacon, D, Dwinfour, P and Jermyn, H and Joy, A (2000) *A Statistical Survey of Regularly and Fixed Term Funded Organisations based on Performance Indicators for 1998/99*. London: Arts Council of England

Chapter 34, Afterword: The Cultural Commodity and Cultural Policy

ACGB (1991) *Annual Report*. London, Arts Council of Great Britain

Bell, D (1973) *The Coming of Post-Industrial Society: A venture in social forecasting*. New York: Basic Books

British Invisibles (1991) *Overseas Earnings of the Arts 1988/89. A report for the Cultural Sector Working Party*. London: British Invisibles

Cabinet Office (1983) *Making a Business of Information*. London: HMSO

Casey, B, Dunlop, R and Selwood, S (1996) *Culture as Commodity? The economics of the arts and built heritage in the UK*. London: Policy Studies Institute

DCMS (1998) *A New Cultural Framework*. London: Department for Culture, Media and Sport

GLC (1985) *The State of the Art or the Art of the State: Strategies for the cultural industries in London*. London: Industry and Employment Branch, Department of Recreation and the Arts, Greater London Council

Garnham, N (1990) *Capitalism and Communication*. London: Sage

Garnham, N (2000) 'Information Society as Theory or Ideology', *Information, Communication and Society (iCS)* 3(2): 139–152

Gorham and Partners (1996) *Export Potential of the Cultural Industries*. London: The British Council

Labour Party (1997) *Creating the Future: A strategy for cultural policy, arts and the creative economy*. London: Labour Party

Myerscough, J (1988) *The Economic Importance of the Arts in Great Britain*. London: Policy Studies Institute

NACCCE (1999) *All our Futures. Creativity, Culture & Education*. London: Department for Culture, Media and Sport and Department for Education and Employment

QUEST (2000) *Modernising the Relationship. Part Two. Developing risk management in DCMS sponsored bodies*. London: Quality, Efficiency and Standards Team

Selwood, S (2000) 'Access, efficiency and excellence: measuring non-economic performance in the English subsidised cultural sector', *Cultural Trends* 35: 87–137

Smith, C (1998) *Creative Britain*. London: Faber and Faber

Appendix 1
Identifying and Interpreting Funding

Identifying funding for the cultural sector, 1998/99

One of the aims of this study was to identify the level of support going into the cultural sector over the period 1993/94 to 1998/99, specifically non-commercial income such as grants and guarantees, sponsorship and donations.

Funding for the sector was identified as coming from various sources:

- public sources: the Department for Culture, Media and Sport (DCMS) and other central government departments; regeneration sources; higher education funding; Europe; and local authorities;
- taxation forgone;
- the National Lottery;
- private sources (trusts and charitable foundations);
- business sponsorship and donations.

Funded cultural projects include those intended to support various social objectives, such as drama projects used to promote particular health messages, or community projects concerned with the production of a play or public artwork. This appendix describes how details of funding were collected from each of these sources, where double-counting might be an issue, and how it was avoided, and other difficulties encountered.

The amounts given in the funding tables in the book may not necessarily appear to comply with the artform or heritage activity lines in funders' reports and accounts. This is because, wherever possible, sums have been added which pertain to specific art form and heritage activities from general headings.

Public sources

Department for Culture, Media and Sport and the Welsh, Scottish and Northern Ireland Offices

The main sources of funding from central government were tracked through the DCMS, and the former Welsh, Scottish and Northern Ireland Offices. Their

support includes direct grant-in-aid to the national museums and galleries, libraries, and the four arts councils in England, Wales, Scotland and Northern Ireland. Other support that these departments provide to the sector is detailed in the relevant chapters of this report. Data were collected from the annual reports and accounts of each department for the years in question.

Other central government departments

Central government departments other than those with a specific cultural remit can, and do, contribute to the sector. For example, the Department of Environment, Transport and the Regions (DETR) directly funds the London Transport Museum, and the Ministry of Defence supports museums and funds music schools for military bands. Other funding is indirect, for example: the Department for Education and Employment's support for museums, galleries and special collections in higher education institutions via the Higher Education Funding Councils and the Arts and Humanities Research Board; DETR's support for cultural projects via its regeneration funding; and DTI (Department of Trade and Industry) support of British Trade International which supports trade missions by cultural organisations.

Because these activities are incidental to the central remit of these departments, it is often difficult to identify specific cultural funding. It was decided, therefore, to attempt to identify such funding for 1998/99 only.

Regeneration funding

The focus of research on regeneration funding was the Single Regeneration Budget (SRB) – the main form of support from central government for urban regeneration. Given that no records are kept of funding to the cultural sector, the principal method used to estimate this contribution was a survey of SRB programmes which distributed funding in 1998/99.

Higher education funding

The amount of funding channelled to the cultural sector through higher education institutions has been identified in two ways:

- the amount spent on university museums, galleries and collections by the Higher Education Funding Councils for England and Scotland, and the Arts and Humanities Research Board. There is no equivalent scheme in Northern Ireland, and a scheme was only introduced in Wales in 1998/99 (details of this funding appear in Tables 12.1, 12.2 and 18.8).
- a survey of higher education institutions' own direct funding of cultural venues and events, which was carried out for the present volume.

European Commission

Research sources include existing reports, studies, funding schedules, statistics and raw data (published and unpublished) from a variety of sources. These include: the European Union itself (the European Commission's Regional Policy Directorate General (DG); the Culture Unit and other DGs; the European Parliament, etc.); their European agencies (including research institutes and consultancies); and UK sources (including government offices, regional arts boards and independent researchers). The information and data were accessed from library and internet searches, visits to EC offices, meetings and interviews (in person and by phone) and from other bodies such as those outlined above. The research is concentrated on 1995–1999, as this was the last major complete period of funding, but where there are gaps for this period, data from the previous period have been noted.

Local authority funding

Local government across the UK provides support for the cultural sector in a number of ways:

- funding and managing local museums and galleries and cultural venues such as arts centres and theatres;
- making grants and guarantees directly to organisations and individuals working in the cultural sector; and
- in England, providing financial support to the regional arts boards.

Identifying the value of this support is far from straightforward. There are a number of sources of information on local authority expenditure, but not all can be reconciled. The sources used in this report are as follows.

- CIPFA (Chartered Institute of Public Finance and Accountancy) *Leisure and Recreation Statistics* derive from annual surveys of Leisure and Recreation Departments in English and Welsh local authorities. The survey relies on grossing-up to compensate for non-respondents. Data, based on a mixture of actuals and estimates, are not always disaggregated to show clearly expenditure on various artforms and cultural activities. This survey also excludes potential spending on the cultural sector by departments other than Leisure and Recreation.
- CIPFA *Planning and Development Statistics* are also based on annual surveys. These contain data based on estimates pertaining to the conservation of the historic environment in England and Wales. Grossed-up estimates are only available from 1996/97 onwards.
- The annual *Scottish Local Government Financial Statistics* (published by the Scottish Executive) contain data on expenditure on the arts, museums and galleries by Scottish local authorities. As with CIPFA, the data are not always presented in a way that allows cultural spending to be readily identified. This publication also includes expenditure on historic houses.

- The Arts Council of England's annual *Survey of Local Authority Expenditure on the Arts in England* has been published since 1993/94.
- DETR data on local authority expenditure cover museums, galleries, libraries and (since 1998/99) arts activities and facilities in England. It is published in the Department for Culture, Media and Sport's annual reports.
- The Scottish Arts Council and the Convention of Scottish Local Authorities survey, *Arts Expenditure by Scottish Local Authorities*, has results available for 1994/95, 1996/97 and 1997/98.
- *The Annual Library Statistics* of LISU (Library and Information Statistics Unit, Loughborough University) re-analyses CIPFA data on local authority expenditure on public libraries and provides a detailed breakdown of this spending. It also includes other library expenditure, such as that in higher and further education.

In those cases where regular published statistics were not available, other information was obtained, where possible, from the National Assembly for Wales and the Northern Ireland Assembly.

The various sources of data listed above were used to calculate local authority expenditure on the cultural sector. The report makes clear which source is being used when. Where a particular part of the cultural sector was covered by more than one source, double counting was avoided by selecting only one of these sources to provide an estimate for that part of the sector.

It should be noted that the variety of sources, and the variation in the bases used, means that any figure for the overall value of local authority expenditure on the cultural sector is, at best, a general estimate.

Tax forgone

The sources used to assess the value of tax forgone are inevitably selective, but cover the major published independent research reports and papers and official policy statements. Primarily the publications used are those which have appeared since the May 1997 election, although, necessarily, some of the material used reflects ongoing policies embodied in earlier legislation – notably the Value Added Tax Act of 1994. Likewise, where possible, recent policy data are set in the context of general trends across the 1990s.

National Lottery

The national arts councils

National Lottery funding for the arts is distributed by the four national arts councils in England, Northern Ireland, Scotland and Wales. Details of such funding were available directly from the Arts Councils themselves and from their annual reports.

Heritage Lottery Fund

The Heritage Lottery Fund (HLF) distributes National Lottery funding to the heritage sector. It provided details of the grants and guarantees it had made since the inception of the National Lottery.

Millennium Commission

The Millennium Commission has funded a number of arts-based projects. These include large-scale projects, such as the Tate Modern at Bankside and the renovation of the British Museum, as well as smaller-scale projects.

Funding for the cultural sector from the Millennium Commission was identified from the list of grants and guarantees detailed in its annual reports. Those projects with a major cultural element were identified and included in the totals for the sector.

National Lottery Charities Board

Funding for the cultural sector also comes through the National Lottery Charities Board, but this is much harder to identify than other Lottery funding. The cultural sector benefits from grants made by the Board in a number of ways. For example, grants may be given: to groups that use the arts to help people with stress-related problems; to buy musical instruments for performances in hospitals and nursing homes; or, to support theatrical performance by people with disabilities.

The National Lottery Charities Board categorises these grants according to the social need that they address, and not any incidental cultural element. As the Board has made over 33,500 grants as of the beginning of September 2000, it was not possible to go through details of each one to identify those with a major cultural component.

To arrive at some sort of estimate of the value of support coming from this sector, the official National Lottery website (http://www.culture.gov.uk/lottery) was used to review approximately 5,000 grants over various years. From this, estimates were made of the number of projects that had a major cultural component, and their approximate value in each year.

Private sector

Charitable trusts and foundations

The most comprehensive picture of charitable trusts' giving to the cultural sector is provided by the Directory of Social Change's series of arts funding guides (see, for example, Forrester and Manuel, 2000). A survey of charitable trusts' 1998/99 giving was also undertaken for the present volume. In an attempt to compare changes in the value of charitable trusts' funding over time (which the Directory of Social Change does not provide) a constant sample of 53 charitable trusts was drawn up which provided data for both 1993/94 and 1998/99.

Sponsorship

Data on business sponsorship of the cultural sector can be found in the annual survey of the business sector carried out by Arts & Business (formerly the Association for Business Sponsorship of the Arts). The survey of over 1,000 organisations provides an analysis of business sponsorship broken down by artform (including heritage and museums and galleries) and by geographical region. Although Arts & Business provides grossed-up estimates for the headline figures, the detailed analyses are not grossed up, and no grossed figures have been reproduced in the present report. This means that the figures given here are minimum estimates of the amount of support going to the cultural sector.

Arts & Business also provides data on the Pairing Scheme, which it administers and which provided business sponsorship with matching funding from the DCMS. However, as some of that sponsorship might be included in the annual survey mentioned above, and the whole of the DCMS element is included in its annual figures, the Pairing Scheme has not been added to the overall estimates of support given here. A pilot Heritage Pairing Scheme in the North of England produced no data.

Problems of data comparison

Year-on-year series

With some types of data it is more or less impossible to attempt year-on-year comparisons. European funding (see Chapter 13) typifies a range of difficulties, none of which are unique to it.

- No single agency is concerned with how much European Union funding is dedicated to cultural projects in the UK. Consequently, however systematically carried out, searches are ultimately ad hoc in that you only know what you've managed to access.
- While the most easily accessible data refer to the value of awards or allocations, these may not be the same as the amounts drawn down, or received by cultural sector organisations.
- Funding for cultural projects often comes from sources which are not dedicated to cultural funding. Judgements about what might or might not qualify as a cultural project, or what proportion of project funding might be attributable to a cultural component of a project, are often subjective. Although investment in tourism or visitor attraction are sometimes used as proxies for cultural funding (Evans and Foorde, 2000), this has not been the case here.
- Funding may not be attributable to specific years, since programmes last five years, and there may be time lags between announcements and grant allocations, and between allocations and actual spend. It has been reported that post-completion audits may be delayed for five years or more.

Two major difficulties were encountered during the process of preparing tables: interpreting data over time and comparing data between organisations.

Interpreting data over time

Comparisons over time across certain sets of data might be expected to be easy. However, even these may be subject to changes in the way accounts are presented, which means that it can be impossible to produce a time-series table where headings in the annual report and accounts have changed, as a result of being either aggregated or disaggregated.

Other changes may involve accounting practices. While figures may appear under the same heading, they may not refer to the same things. Although this should appear somewhere in notes to the accounts, it may not always be picked up, and cannot be reconfigured.

Comparing data between organisations

The form of organisations' accounts, and how they present those accounts, may appear similar, but may in fact be very different. For example, take two organisations that fund the arts. They present spending under artform headings, and then the rest of their expenditure under other, operational costs. One organisation might include only grant expenditure under the artform, and all other expenditure, such as staff costs, research, etc, under 'other' expenditure. Another organisation might include all sorts of things under the artform heading – grant expenditure, a pro rata allocation of staff and overhead costs, research and training.

References

Casey, B, Dunlop, R and Selwood, S (1996) *Culture as Commodity? The economics of the arts and built heritage in the UK*. London: Policy Studies Institute

Evans, G and Foorde, J (2000) 'European Funding of Culture: promoting common culture or regional growth', *Cultural Trends* 36: 53–87

Forrester, S and Manuel, G (2000) *The Arts Funding Guide* (5th edn). London: Directory of Social Change

Appendix 2
Survey of Organisations and Individuals in Receipt of Support, 1998/99

Survey methods

The survey of organisations and individuals in receipt of support in 1998/99, carried out for this book, was intended to:

- provide a financial profile of those organisations receiving support in 1998/99;
- enable comparisons to be made with the profile drawn from the 1993/94 data collected by Casey et al. (1996); and
- complement the annual surveys of those organisations which are regularly funded or receive fixed-term funding from the Arts Council of England and the regional arts boards (indeed, the 1998/99 returns from that survey have been integrated to produce the most comprehensive set of data in existence on cultural organisations in the UK).

The survey was based on the same methods as used for *Culture as Commodity?* (Casey et al., 1996). The survey population consisted of organisations and individuals in the cultural sector in receipt of some form of financial support in 1998/99. Each was sent a letter requesting a copy of their annual report and accounts for 1998/99, or the nearest financial year to which they kept their accounts. Two reminders followed. These reports were then transcribed on to a standard proforma (as included below) and the data transferred to computer.

This method was favoured over the more conventional route of sending out questionnaires for the respondents to fill in themselves. It was anticipated that the approach used would achieve a better response rate as it required less effort on the part of respondents. It would also allow the various accounting conventions that might be used by respondents to be standardised before the data were entered on to computer for SPSS analysis.

Although the original request to all organisations and individuals asked for their report and accounts, the two subsequent reminders varied according to how much organisations and individuals were identified as having received in 1998/99. Those receiving grants identified as totalling less than £25,000 were sent a short questionnaire as an alternative (also included at the end of this

appendix). This requested basic information, which it was hoped that even the smallest of operations, or self-employed individuals, would be able to provide.

The survey was supplemented by data provided by the Arts Council of England (ACE). Each year, ACE surveys organisations that receive regular and fixed-term funding from the regional arts boards and the Arts Council itself. This survey covers details of income and expenditure and the number of performances and attendances. From this ACE is able to calculate subsidy per performance; subsidy per attendance and earned income per attendance. ACE made these data available for the year 1998/99. The proforma used for the survey for this book was adapted from that used in Casey et al. (1996) to match up with the ACE data. As a result, all the data received by ACE (from 425 organisations – 76 per cent of the 560 population of regularly funded and fixed-term funded organisations) were included in this data set (Appendix 7). An analysis of organisations which have made returns to the ACE since 1994/95 is included in Chapter 33, and these organisations are listed in Appendix 8.

Identifying the survey population

The aim of the survey was to examine the financial operations of organisations and individuals in the UK cultural sector in receipt of some form of financial support in 1998/99. To identify this population, lists of grant recipients were taken from annual reports or schedules of grants provided by the funding bodies listed below:

Central government

- Department for Culture, Media and Sport
- National Assembly for Wales for Welsh Office
- Northern Ireland Assembly for Northern Ireland Office
- Scottish Executive for Scottish Office

- Department for Education and Employment
- Department of Health
- Department of the Environment, Transport and the Regions
- Foreign and Commonwealth Office
- Lord Chancellor's Department
- Ministry of Defence

Museums funding bodies

- Museums & Galleries Commission
- National Fund for Acquisitions

Area museum councils

- Council of Museums in Wales

- East Midlands Museums Service
- North East Museums Service
- North West Museums Service
- Northern Ireland Museums Council
- Scottish Museum Council
- South Eastern Museums Service
- South West Museums Council
- West Midlands Regional Museums Council
- Yorkshire and Humberside Museums Council

Built heritage and archaeology funding bodies

- Cadw
- Environment and Heritage Service, Department of the Environment, Northern Ireland
- English Heritage
- Historic Scotland

- Council for British Archaeology
- Council for the Care of Churches
- Historic Churches Preservation Trust
- National Heritage Memorial Fund
- Royal Archaeological Institute
- Royal Commission on the Ancient and Historical Monuments of Wales
- Royal Commission on the Historic Monuments of Scotland

Arts funding bodies

- Arts Council of England for Arts Council of Great Britain and ACE
- Arts Council of Northern Ireland
- Arts Council of Wales for Welsh Arts Council and ACW
- Scottish Arts Council
- Crafts Council

Regional arts boards

- East Midlands Arts Board
- Eastern Arts Board
- London Arts Board
- North West Arts Board
- Northern Arts Board
- South East Arts Board
- South West Arts Board
- Southern Arts Board
- West Midlands Arts Board
- Yorkshire Arts for Yorkshire and Humberside Arts Board

Lottery distributors

- Arts Council of England
- Arts Council of Northern Ireland
- Arts Council of Wales
- Heritage Lottery Fund
- Millennium Commission
- National Lottery Charities Board
- Scottish Arts Council

Libraries

- British Library
- Library and Information Commission

Film and media

- British Film Institute
- British Screen
- Northern Ireland Film Commission
- Scottish Screen
- Sgrin

- Croydon Film and Video Awards
- National Disability Film and Video Project
- South West Media Development Agency

Local authorities

Local authorities throughout the UK – various departments concerned with economic development, arts and leisure, leisure and recreation, education, libraries, museums, tourism and heritage

Metropolitan area grant schemes

- Association of Greater Manchester Authorities
- London Borough Grants Committee
- West Yorkshire Grants

Other funding bodies

- Arts & Business for ABSA and Arts & Business
- Northern Ireland Community Relations Council
- Further Education Funding Council
- International Fund for Ireland
- National Council for Voluntary Youth Services

Higher education funding bodies

- Arts and Humanities Research Board

- Higher Education Funding Council for England
- Higher Education Funding Council for Scotland

Charitable trusts and foundations (see Appendix 9)

Higher education institutions (see Appendix 10)

Regeneration funding bodies

- Highlands & Islands Arts
- Merseyside Music Development Agency
- Single Regeneration Bid Programmes (see Appendix 11)

While this was the best method of collecting these data, the data are only as good as the information provided by the funding bodies. Some funders provided no data or incomplete data. In some cases this was intentional to protect the confidentiality of their clients; in others, it was due to poor record-keeping.

Over 10,000 organisations and individuals were identified, including the recipients of 3,000 awards made by Heritage Lottery Fund and the arts councils' Lottery units. However, as described below, not all these organisations or individuals were ultimately included in the survey population.

Criteria for inclusion in the survey

Two criteria applied to the inclusion of organisations and individuals in the database: geographical location and the nature of their business. The geographical area covered by the study was the whole of the UK, with the exception of the Channel Islands. Any grant recipients based overseas (such as many of those supported by Visiting Arts, for example) were excluded.

The aim of the survey, as stated above, was to collect information on the financial operations of the cultural sector. However, some of the organisations in receipt of funding operate largely outside the cultural sector (for example, community groups, village halls and schools). These organisations were excluded from the survey population as their accounts would not have been pertinent to the aims of the study. Community groups specifically dedicated to arts or cultural activities were, however, included.

Also excluded were organisations which operated only partly within the cultural sector and were unlikely to be able to provide separate accounts for their cultural activities. Organisations such as local authorities and higher education institutions were excluded on this basis. However, where discrete accounts could be provided, cultural organisations run by local authorities and higher education institutions were included.

In the built heritage sector, privately owned properties were excluded, as were organisations not solely dedicated to the preservation of the built heritage, such as the Civic Trust and the Scottish Civic Trust. Individual buildings and sites

were included only if funding they received was intended for a dedicated centre (such as The Early Music Centre, St Margaret's Church), or if they were run by building preservation trusts, or discrete bodies. Examples of the latter include historic ships, canals and railways run by trusts. Again, these decisions were taken on the basis of which organisations would be able to provide a pertinent response to the survey.

Festivals that were not specifically arts festivals were excluded. Thus the Edinburgh Fringe Festival was excluded, but the Edinburgh International Festival was included. Zoos and botanical gardens were excluded from the survey on the basis that they could not (according to the requirements of the Museums & Galleries Commission registration criteria) be considered to be museums, although they were included in Casey et al. (1996). Toy and leisure libraries and local authority and higher and further education libraries were exempted.

Universities, schools and specialist art colleges were excluded on the basis that they are part of the education sector, which is again not strictly part of the cultural sector. The only exceptions to this were some 'private' schools such as the Poetry School, or the Irish Dancing School, which were deemed to be operating in the cultural sector. Organisations in receipt of grants for literacy and language development (such as the Year of Reading project) were also deemed to be part of the education sector, and were thus excluded from the survey, as distinct from grants given for literature, which were included. There is, it should be said, some ambiguity around the relationship between encouragement of literacy and literature. Indeed, Chapter 27 above does refer to the Year of Reading.

Constant sample

Every effort was made to include those organisations and individuals which had responded to the original survey by Casey et al. (1996). The aim was to create a constant sample of those organisations which had responded to both surveys, and provided data for both 1993/94 and 1998/99 (see Appendix 6).

Sampling the survey population

Constructing the database

A database of grant recipients in 1998/99 was constructed from funding bodies' data. For each organisations and individual in receipt of a grant, the following details were logged.

- The name of organisation or individual.
- A serial number. If a grant recipient had responded to the survey by Casey et al. (1996), they were allocated the same number for the present survey. This enabled them to be included in the constant sample. Organisations in the ACE data set were also allocated specific serial numbers. Where neither of these cases applied, the organisation or individual was given a new serial number.

- Amount of grant received. A running total was kept for each organisation and individual, as some received grants from more than one source. This figure was used later to band the survey population according to the amount of support they had been identified as receiving in 1998/99.
- Main area of cultural operation. Each organisation was assigned a code according to the area of the cultural sector in which it primarily operated, corresponding to those used in the proforma. Further details of how this categorisation was carried out can be found below.

Categorisation by cultural activity

Each organisation and individual was categorised according to the type of cultural activity it was primarily involved with. These categories were as follows:

- architecture;
- art centre;
- ballet;
- other dance;
- built heritage – including historic buildings, and sites, parks, public monuments, industrial heritage, archaeology;
- combined/cross/live arts – including community arts with an unspecified art form or venue;
- drama;
- festivals – for combined/cross arts festivals only (where a festival was specific to a particular artform, it was included under that artform rather than under 'festivals' per se. For example Huddersfield Contemporary Music Festival was categorised as 'music', whereas the Edinburgh International Festival was included under 'festivals');
- film/video;
- library – including archives;
- literature;
- multimedia/computer arts;
- museum/gallery;
- opera/music theatre;
- orchestra/orchestral music;
- other music;
- radio/television/broadcasting;
- services to the cultural sector – including education and training; if services were dedicated to a particular artform (such as Engage, which supports visual arts education) they were included under that artform. Thus, theatre-in-education companies were included under 'drama', and so on;
- visual arts/crafts/photography/contemporary sculpture.

Table A1 Sampling frame

Band	Estimated grant income (£)	Total database population	Sample as % of total	Number in sample	Constant sample	ACE sample minus constant sample	New inclusions	Total
1	1m+	82	100	82	34	8	40	42
2	500,000–999,999	85	100	85	19	13	53	32
3	100,000–499,999	480	90	432	88	77	273	432
4	50,000–99,999	433	60	260	38	74	148	112
5	25,000–49,999	581	40	232	32	53	148	85
6	10,000–24,999	852	30	256	27	46	184	72
7	5,000–9,999	763	20	153	11	16	126	27
8	1,000–4,999	2,126	20	425	14	12	396	26
9	under 1,000	2,518	20	504	5	7	492	12
Total		7,920		2,429	268	305	1,860	840

Organisations which made returns to Casey et al., 1996, but were not identified in 1998/99

	pop. unknown	61		61				61

The sample

The survey population was too large to survey in its entirety, so a sampling system was set up in much the same way as it had been in Casey et al. (1996). The survey population was organised in bands according to the total value of support that each organisation or individual was identified as having received in 1998/99. Table A1 shows: these bands, and also the number of organisations and individuals which fell into each band, the sampling ratios applied and the final numbers surveyed in each band.

Responses and non-responses

Data were collected from 1,272 organisations, 51 per cent of the total number of 2,490 organisations sampled. There were 847 responses to the mailing (listed in Appendix 5) plus data for the 425 organisations provided by ACE. In the event, no individuals provided usable returns.

About 130 organisations (5 per cent of the sample) wrote to say that they would not be participating in the survey. Around half were simply unwilling to participate – they 'had no time', or regarded their accounts as confidential. Some described themselves as too small or as not fitting into the criteria used. About a fifth were no longer at the address written to, and no forwarding address could be found. Other organisations had no accounts because they were part of a larger body, or had recently been amalgamated. Some organisations declined to participate because they had either just closed or were closing; whereas others had not yet started operating in 1998/99. Some were dormant. Several sent accounts that were inadequate for this analysis, including those who denied being in receipt of subsidies.

Analysing the data

As explained above, three types of information were collected for 1998/99:

- data from organisations which returned annual (audited) accounts, of which there were 609 which were transcribed to the proformas;
- data from organisations, primarily those with small incomes and which could not provide detailed annual accounts, which completed short questionnaires. There were 238 of these, and they provided rather less detail than those providing annual accounts; and,
- ACE data, which provided 425 returns (see Hacon et al., 2000; 1998; 1997 and Chapter 33).

These three sets of data have been used in various combinations to provide the analysis presented in this volume.

- All three are used to provide headline data for each artform and heritage activity: the number of organisations; their geographical distribution; their overall income and expenditure and the amount of income received from public subsidies.
- Data from the annual accounts and the ACE data have been combined to provide more detailed analysis of various elements of organisations' incomes and expenditures.
- The constant sample is drawn across all three data sets, along the same lines, for comparison between 1993/94 and 1998/99.

Only data from the annual accounts are compared with ACE 1998/99.

Although every effort was made to ensure the compatibility of the proforma and ACE data, by definition the short questionnaire could not provide the same level of detail. Consequently, as is evident from the analysis of the survey returns, the base numbers change according to the contents of the table. In some instances, details (as for surpluses and deficits) have had to be calculated on the basis of information provided in the short questionnaire. This is, however, always indicated.

References

Casey, B, Dunlop, R and Selwood, S (1996) *Culture as Commodity? The economics of the arts and built heritage in the UK*. London: Policy Studies Institute

Hacon, D, Dwinfour, P and Greig, P with O'Brien, J (1997) *A Statistical Survey of Regularly Funded Organisations based on Performance Indicators for 1996/97*. London: Arts Council of England

Hacon, D, Dwinfour, P and Jermyn, H (1998) *A Statistical Survey of Regularly Funded Organisations based on Performance Indicators for 1997/98*. London: Arts Council of England

Hacon, D, Dwinfour, P Jermyn, H and Joy, A (2000) *A Statistical Survey of Regularly Funded Organisations based on Performance Indicators for 1998/99*. London: Arts Council of England

Questionnaire proforma used to survey organisations in receipt of subsidy, 1998/99

Proforma

		Serial No.		Card 1
1.a	**Serial Number**	☐	(1–4)	(5)

| 1.b | **Constant Sample** | Yes ☐ 1 | No ☐ 2 | (6) |

2. Location (by Government Office Region)

Eastern	☐	1
East Midlands	☐	2
London	☐	3
North East	☐	4
North West	☐	5
South East	☐	6
South West	☐	7
West Midlands	☐	8
Yorkshire & the Humber	☐	9
Northern Ireland	☐	10
Scotland	☐	11
Wales	☐	12 (7–8)

3. Art/heritage activity

Architecture	☐	1
Art Centre	☐	2
Ballet	☐	3
Other dances	☐	4
Built Heritage	☐	5
Combined/cross/live	☐	6
Drama	☐	7
Festival	☐	8
Film/video	☐	9
Library	☐	10
Literature	☐	11

Multimedia/computer arts ☐ 12

Museum/gallery ☐ 13

Opera/music theatre ☐ 14

Orchestra/orchestral music ☐ 15

Other music ☐ 16

Radio/television ☐ 17

Services, etc ☐ 18

Visual arts (including ☐ 19

Crafts & photography ☐ (9–10)

4. **Income (£000)**
4.a *Earned income*
4.a.1 Box office ☐☐☐☐☐ (11–15)
4.a.2 Merchandising/Trading ☐☐☐☐☐ (16–20)
4.a.3 Other ☐☐☐☐☐ (21–25)
4.a.4 SUBTOTAL EARNED INCOME ☐☐☐☐☐ (26–30)

4.b *Unearned income other than subsidy*
4.b.1 Sponsorship ☐☐☐☐☐ (31–35)
4.b.2 Memberships ☐☐☐☐☐ (36–40)
4.b.3 Donations ☐☐☐☐☐ (41–45)
4.b.4 Investment and other income ☐☐☐☐☐ (46–50)
4.b.5 SUBTOTAL ☐☐☐☐☐ (51–55)

4.c *Public subsidy*

4.c.1 *DCMS/WO/SO/NIO*
revenue ☐☐☐☐☐ (56–60)
capital ☐☐☐☐☐ (61–65)
project/other ☐☐☐☐☐ (66–70)
SUBTOTAL ☐☐☐☐☐ (71–75) Card 2

4.c.2 *Other central government dpts* (1–4) (5)
revenue ☐☐☐☐☐ (6–10)
capital ☐☐☐☐☐ (11–15)
project/other ☐☐☐☐☐ (16–20)
SUBTOTAL ☐☐☐☐☐ (21–25) Card 2

4.c.3 *Arts councils*
revenue ☐☐☐☐☐ (26–30)
capital ☐☐☐☐☐ (31–35)
project/other ☐☐☐☐☐ (36–40)
SUBTOTAL ☐☐☐☐☐ (41–45)

4.c.4 *Heritage funder (EH,etc)*

revenue ☐☐☐☐☐ (46–50)

capital ☐☐☐☐☐ (51–55)

project/other ☐☐☐☐☐ (56–60)

SUBTOTAL ☐☐☐☐☐ (61–65)

Card 3

4.c.5 *Media funder (BFI, etc)* (1–4) (5)

revenue ☐☐☐☐☐ (6–10)

capital ☐☐☐☐☐ (11–15)

project/other ☐☐☐☐☐ (16–20)

SUBTOTAL ☐☐☐☐☐ (21–25) Card 2

4.c.6 *Collections funder (MGC,etc)*

revenue ☐☐☐☐☐ (26–30)

capital ☐☐☐☐☐ (31–35)

project/other ☐☐☐☐☐ (36–40)

SUBTOTAL ☐☐☐☐☐ (41–45)

4.c.7 *Performing arts funder*

revenue ☐☐☐☐☐ (46–50)

capital ☐☐☐☐☐ (51–55)

project/other ☐☐☐☐☐ (56–60)

SUBTOTAL ☐☐☐☐☐ (61–65)

Card 4

4.c.8 *Regional arts board* (1–4) (5)

revenue ☐☐☐☐☐ (6–10)

capital ☐☐☐☐☐ (11–15)

project/other ☐☐☐☐☐ (16–20)

SUBTOTAL ☐☐☐☐☐ (21–25)

4.c.9 *Local authority*

revenue ☐☐☐☐☐ (26–30)

capital ☐☐☐☐☐ (31–35)

project/other ☐☐☐☐☐ (36–40)

SUBTOTAL ☐☐☐☐☐ (41–45)

4.c.10 *Lottery – arts councils*

revenue ☐☐☐☐☐ (46–50)

capital ☐☐☐☐☐ (51–55)

project/other ☐☐☐☐☐ (56–60)

SUBTOTAL ☐☐☐☐☐ (61–65) Card 2

4.c.11 *Lottery – HLF* Card 5

revenue ☐☐☐☐☐ (6–10)

capital ☐☐☐☐☐ (11–15)

project/other ☐☐☐☐☐ (16–20)

SUBTOTAL ☐☐☐☐☐ (21–25)

4.c.12 *Lottery – MC*

revenue	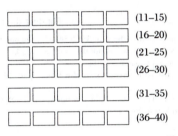	(26–30)
capital		(31–35)
project/other		(36–40)
SUBTOTAL		(41–45)

4.c.13 *Lottery – NLCB*

revenue		(46–50)
capital		(51–55)
project/other		(56–60)
SUBTOTAL		(61–65)

4.c.14 *European funding*

revenue		(66–70)
capital		(71–75)
project/other		(76–80)
SUBTOTAL		(6–10) Card 6

4.c.15 *Any other public subsidy*

revenue		(11–15)
capital		(16–20)
project/other		(21–25)
SUBTOTAL		(26–30)

4.c.16 SUBTOTAL PUBLIC SUBSIDY — (31–35)

4.d TOTAL INCOME — (36–40)

5. Expenditure (£000)

5.a Artistic costs

5.a.1 Artistic programme		(41–45)
5.a.2 Education programme		(46–50)
5.a.3 SUBTOTAL ARTISTIC		(51–55)

5.b Administrative costs

5.b.1 Staff costs		(56–60)
5.b.2 Marketing costs		(61–65)
5.b.3 Other overheads		(66–70)
5.b.4 SUBTOTAL ADMIN		(71–75) Card 7

5.c *Capital costs*		(6–10) (1–4) (5)
5.d *Any other expenditure*		(11–15)
5.e TOTAL EXPENDITURE		(16–20)

6. Financial out-turn

6.a Operating surplus/deficit +/–		(21)
6.b *Total surplus or deficit (£000)*		(22–26)

7.	**Avg no permanent employees**	(27–31)
8.	**Avg no contractual/freelance staff**	(32–36)
9.	**Avg no volunteers**	(37–41)

Short questionnaire

(1–4)

Serial no	

(5–6)

Location	

Please return this questionnaire to
Sara Selwood, PSI, 100 Park Village East
London NW1 3SR

Funding the Cultural Sector

All questions refer to the year 1998/99 (the financial year from 1 April 1998 to 31 March 1999 inclusive) or the nearest twelve months to which you keep accounts. If your financial year corresponds to the calendar year, please use 1998.

Please write your answers in the boxes provided and follow the instructions given carefully.

Question 1 In which sector did you operate in 1998/99?
Please tick one box only

Architecture	1	Literature		11
Art centre	2	Multimedia/computer arts		12
Ballet	3	Museum/gallery		13
Other dances	4	Opera/music theatre		14
Built heritage	5	Orchestra/orchestral music		15
Combined/cross	6	Other music		16
Drama	7	Radio/television		17
Festival	8	Services, etc[*]		18
Film/video	9	Visual arts/crafts/photography		19
Library	10			
(7–8)				(7–8)

Note: * For example, marketing, training, business services for one of these sectors, etc.

Question 2 List any grants, donations and sponsorships (not any other type of payment) received in 1998/99 and the amount. Please name the funding body or bodies and fill in the amount under the type of grant received. (These should include grants from the government, arts or heritage funding bodies, local authorities, the business sector and from charities, foundations or individual patrons). Continue on another page if necessary.

Answer to the nearest £

Name of Funder		Revenue Grant	Capital Grant	Project Grant/other
		(11–15)	(16–20)	(21–25)
	(9–10)			
		(28–32)	(33–37)	(38–42)
	(26–27)			
		(45–49)	(50–54)	(55–59)
	(43–44)			
		(62–66)	(67–71)	(72–76)
	(60–61)			

Card 1
1 (80)

If you did not receive any grant, donation or sponsorship in 1998/99: please tick here and return the form in the envelope provided. You do not need to fill in the rest of the questionnaire.

Card 2
(1–4)

☐ 1
(5)

Question 3 In 1998/99, were you as the recipient of these grants either:
Please tick one box only, either A or B

A. An organisation ☐ 1
or

B. An individual working as freelance or self-employed?* ☐ 2
(6)

***If you answered B, please make sure that you answer the following questions ONLY in relation to your activities as an arts professional.**

Question 4 What was the total income of your organisation or yourself (in relation to your activities as an arts professional) in 1998/99?

Please answer to the nearest £ of your total income.

Total income £ []
(7–12)

Question 5 What was the total expenditure of your organisation or yourself (in relation to your activities as an arts professional) in 1998/99?
For individuals, include any wages you paid yourself plus any tax-deductible costs in relation to your arts activities. (This refers to **pre-tax** income)

Please answer to the nearest £ of your total expenditure

Total income £ []
(13–18)
Card 2 (80)

THANK YOU FOR COMPLETING THIS QUESTIONNAIRE

Appendix 3
English Regions

Five different administrative systems of dividing England impact on the reporting of cultural activities in the present volume: government office regions, regional arts boards areas, area museum council regions, tourist board regions and European Union beneficiary regions.

The area museums councils' boundaries are coterminous with government office regions, although the area covered by the South East Museums Service covers three government office regions. Only some regional arts board areas are the same as government office regions: Yorkshire (with Yorkshire and the Humber), West Midlands, the Eastern region and London. No attempt has been made to impose a single system in the reporting in the present volume.

The following lists and maps are based on bodies' own descriptions of their geographical remits.

Area museum council regions (Map 1)

- East Midlands: Derbyshire, Leicestershire, Nottinghamshire, Lincolnshire, Northamptonshire;
- North: Durham, Northumberland, Tyne and Wear, Cleveland;
- North West: Cumbria, Cheshire, Greater Manchester, Merseyside, Lancashire;
- South East: Hampshire, Isle of Wight, West Sussex, East Sussex, Kent, Greater London, Surrey, Berkshire, Oxfordshire, Buckinghamshire, Bedfordshire, Hertfordshire, Essex, Suffolk, Norfolk, Cambridgeshire;
- South West: Cornwall, Devon, Somerset, Dorset, Wiltshire, Avon, Gloucestershire;
- West Midlands: Hereford & Worcester, Warwickshire, West Midlands, Stoke, Staffordshire;
- Yorkshire & Humberside: South Yorkshire, West Yorkshire, Humberside, North Yorkshire.

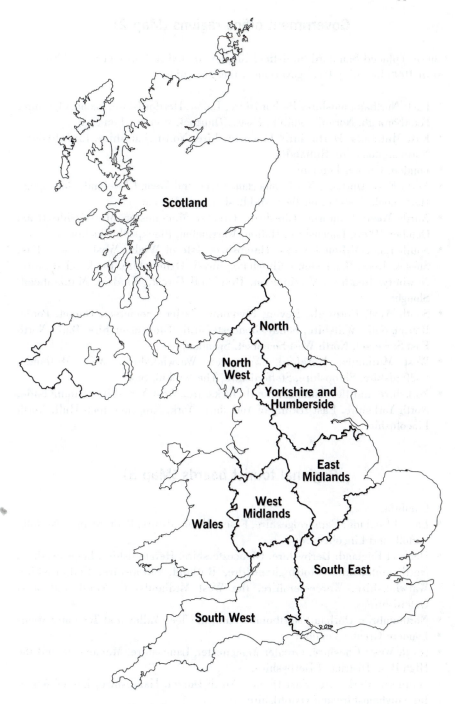

Scotland

North

North
West

Yorkshire and
Humberside

East
Midlands

West
Midlands

Wales

South East

South West

Map 1 Area museum council regions

Government office regions (Map 2)

These replaced Standard Statistical Regions (noted in Casey et al., 1996) on 1 April 1996 following local government reorganisation.

- East: Northamptonshire, Bedfordshire, Luton, Hertfordshire, Cambridgeshire, Peterborough, Norfolk, Suffolk, Essex, Thurrock, Southend on Sea;
- East Midlands: Derbyshire, Leicestershire, Nottinghamshire, Lincolnshire, Northamptonshire, Rutland;
- London: Greater London;
- North East: Durham, Northumberland, Tyne and Wear, Cleveland, Darlington, Hartlepool, Stockton-on-Tees, Middlesborough, Redcar;
- North West: Cumbria, Cheshire, Greater Manchester, Merseyside (from October 1998), Lancashire, Halton, Warrington, Blackpool, Blackburn;
- South East: Milton Keynes, Hampshire, Isle of Wight, West Sussex, East Sussex, Kent, Rochester, Gillingham, Surrey, Oxfordshire, Buckinghamshire, Newbury, Reading, Wokingham, Bracknell Forest, Windsor, Maidenhead, Slough;
- South West: Cornwall, Devon, Plymouth, Torbay, Somerset, Dorset, Poole, Bournmouth, Wiltshire, South Gloucestershire, Gloucestershire, Bath, North East Somerset, North West Somerset, Swindon;
- West Midlands: Hereford, Worcester, Warwickshire, West Midlands, Staffordshire, Shropshire, Staffordshire, The Wrekin, Stoke;
- Yorkshire and the Humber: South Yorkshire, West Yorkshire, Humberside, North Yorkshire, East Riding of Yorkshire, York, Kingston upon Hull, North Lincolnshire.

Regional tourist boards (Map 3)

- Cumbria;
- East of England: Cambridgeshire, Essex, Hertfordshire, Bedfordshire, Norfolk, Suffolk and Lincolnshire;
- Heart of England: Derbyshire, Gloucestershire, Herefordshire, Leicestershire, Northamptonshire, Nottinghamshire, Rutland, Shropshire, Staffordshire, Warwickshire, Worcestershire, the West Midlands, Cherwell and West Oxfordshire;
- Northumbria: Durham, Northumberland, the Tees Valley and Tyne and Wear;
- London: Greater London;
- North West: Cheshire, Greater Manchester, Lancashire, Merseyside and the High Peak District of Derbyshire;
- Southern: Berkshire, East Dorset, North Dorset, Hampshire, Isle of Wight, Buckinghamshire and Oxfordshire;
- South East: East Sussex, West Sussex, Kent and Surrey;
- South West: Bath, Bristol, Cornwall and the Isles of Scilly, Devon, Dorset, Somerset and Wiltshire;
- Yorkshire: Yorkshire and North East Lincolnshire.

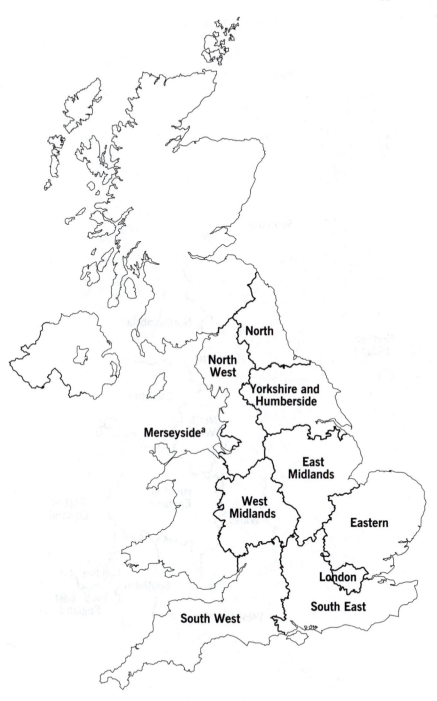

North

North
West

Yorkshire and
Humberside

Merseyside[a]

East
Midlands

West
Midlands

Eastern

London

South East

South West

Note: a) From October 1998 Merseyside was included in the North West

Map 2 Government Office Regions

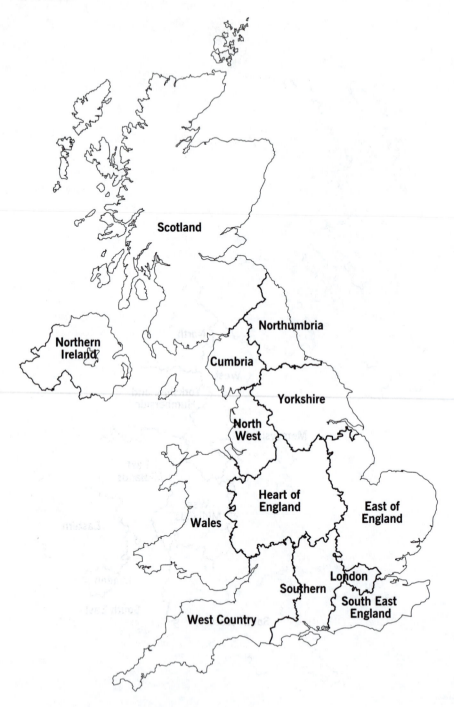

Map 3 Regional tourist boards

Regional arts boards (Map 4)

- Eastern: Bedfordshire, Cambridgeshire, Essex, Hertfordshire, Norfolk, Suffolk; the unitary authorities of Luton, Peterborough, Southend on Sea, Thurrock;
- East Midlands: Derbyshire (excluding High Peak District), Leicestershire, Lincolnshire, Northamptonshire, Nottinghamshire; the unitary authorities of Derby, Leicester, Nottingham, Rutland.
- London: the 32 London boroughs and the Corporation of the City of London.
- Northern: Cumbria, Durham, Northumberland, the unitary authorities of Darlington, Hartlepool, Middlesbrough, Redcar and Cleveland, Stockton; the metropolitan districts of Gateshead, Newcastle upon Tyne, North Tyneside, Sunderland and South Tyneside;
- North West: Cheshire, Lancashire; High Peak District of Derbyshire; the unitary authorities of Blackburn with Darwen, Blackpool, Halton and Warrington; the metropolitan districts of Bolton, Bury, Knowsley, Liverpool, Manchester, Oldham, Rochdale, St Helens, Salford, Sefton, Stockport, Tameside, Trafford, Wigan and the Wirral;
- Southern: Buckinghamshire, Hampshire, Oxfordshire, Wiltshire; the unitary authorities of Bournemouth, Bracknell Forest, Isle of Wight, Milton Keynes, Poole, Portsmouth, Reading, Slough, Southampton, Swindon, West Berkshire, Windsor and Maidenhead, Wokingham; Borough of Christchurch;
- South East: East Sussex, Kent, Surrey and West Sussex; the unitary authorities of Brighton and Hove and Medway;
- South West: Cornwall, Devon, Dorset (excluding Borough of Christchurch), Gloucestershire and Somerset; the unitary authorities of Bath and North East Somerset, Bristol, North Somerset, Plymouth, South Gloucestershire and Torbay;
- West Midlands: Shropshire, Staffordshire, Warwickshire and Worcester; the unitary authorities of Herefordshire, Stoke-on-Trent, Telford and Wrekin; the metropolitan districts of Birmingham, Coventry, Dudley, Sandwell, Solihull, Walsall and Wolverhampton;
- Yorkshire: North Yorkshire; the unitary authorities of East Riding, Kingston upon Hull, North Lincolnshire, North East Lincolnshire, York; the metropolitan districts of Barnsley, Bradford, Calderdale, Doncaster, Kirklees, Leeds, Rotherham, Sheffield and Wakefield.

European Union beneficiary regions, 1994–99 (Map 5)

- Objective 1 (regions whose development is lagging behind): Northern Ireland, Merseyside, and the Highlands and Islands;
- Objective 2 (industrial areas in decline): East London & Lee Valley, East Midlands, Greater Manchester, North East England, Plymouth, Thanet, West Cumbria, West Midlands, Yorkshire & Humberside, East Scotland, West Scotland, industrial South Wales (and Gibraltar);

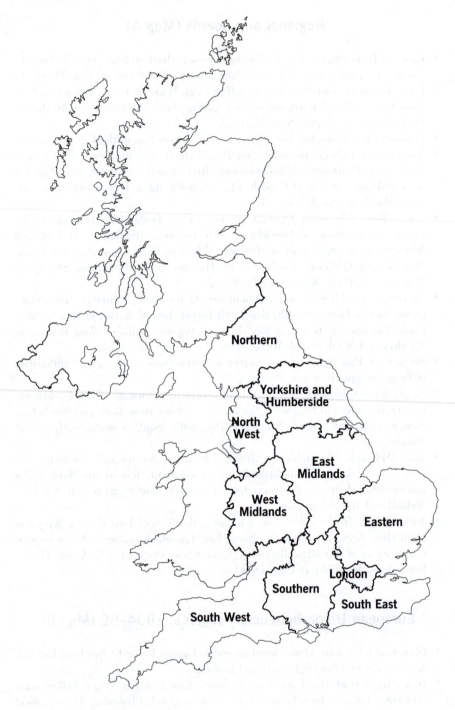

Map 4 Regional arts boards

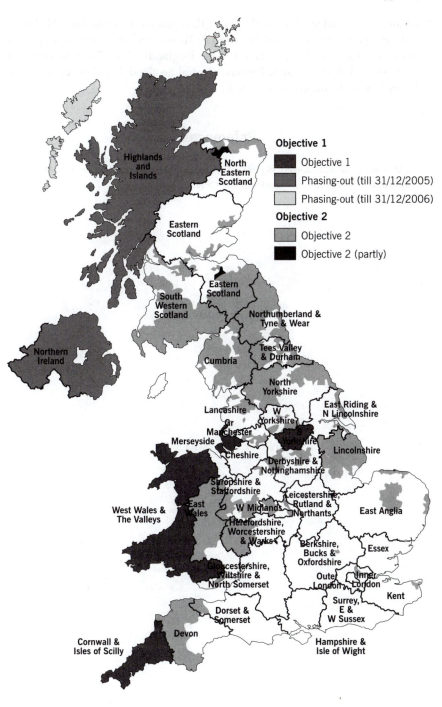

Objective 1

Objective 1

Phasing-out (till 31/12/2005)

Phasing-out (till 31/12/2006)

Objective 2

Objective 2

Objective 2 (partly)

Highlands and Islands

North Eastern Scotland

Eastern Scotland

South Western Scotland

Eastern Scotland

Northumberland & Tyne & Wear

Northern Ireland

Cumbria

Tees Valley & Durham

North Yorkshire

Lancashire

W Yorkshire

East Riding & N Lincolnshire

Gr Manchester

Merseyside

S Yorkshire

Cheshire

Lincolnshire

Derbyshire & Nottinghamshire

Shropshire & Staffordshire

Leicestershire, Rutland & Northants

East Anglia

West Wales & The Valleys

East Wales

W Midlands

Herefordshire, Worcestershire & Warks

Berkshire, Bucks & Oxfordshire

Essex

Gloucestershire, Wiltshire & North Somerset

Outer London

Inner London

Kent

Surrey, E & W Sussex

Dorset & Somerset

Devon

Cornwall & Isles of Scilly

Hampshire & Isle of Wight

Map 5 European Union beneficiary regions, 1994–99

- Objective 5b (vulnerable rural areas): East Anglia, Lincolnshire, Midlands uplands (parts of Salop, and Hereford & Worcestershire), Northern uplands (parts of North Yorkshire, South West England), The Marches (parts of Derbyshire & Staffordshire), Borders, Central Scotland, Dumfries & Galloway, North & West Grampian and rural Wales.

References

Casey, B, Dunlop, R and Selwood, S (1996) *Culture as Commodity? The economics of the arts and built heritage in the UK*. London: Policy Studies Institute

Appendix 4
Survey of Single Regeneration Budget Partnerships

Survey methods and responses

A postal survey of Single Regeneration Budget (SRB) local partnerships was used to collect the information reported in Chapter 11 because no reliable secondary data on SRB cultural expenditure were available. Monitoring forms returned annually to Regional Development Agencies (RDAs) by local partnerships provide information about 'quantified outputs', rather than expenditure, of SRB Challenge Fund (SRBCF) programmes. These forms provide data on outputs which purport to measure performance in relation to economic objectives. Four potentially useful measures of 'cultural' outputs recorded using these forms are:

- number of new cultural facilities (Output 7A(vi));
- number of community cultural facilities improved (7B(vi));
- number of people given access to new cultural facilities/opportunities (7A(iii));
- numbers using improved cultural facilities (7B(iii)).

However, the Department of the Environment, Transport and the Regions (DETR) does not provide guidance on the definition of these four indicators nor on their measurement. Definitions of 'cultural facilities' are likely to vary between local partnerships depending, for example, on whether education resource centres or community halls are regarded as 'cultural facilities'.

An SRB programme will typically consist of many projects: some have over 100 projects (in the survey reported in Chapter 11, one programme had 95 projects). Responsibility for selecting and managing projects is devolved to the local partnerships. RDAs – and before 1999, Government Offices for the Regions (GORs) – do not hold full data on individual projects. Such data are kept by the local partnerships, but these do not include data on cultural expenditure. Within the time and financial constraints of the project, it was not possible to survey SRB projects directly. Such data would have to be constructed by programme lead officers in local partnerships who would, if necessary, consult individual project records.

The questionnaire was piloted in June 2000 in six SRB programmes in the West Midlands. The pilot questionnaire was accompanied by an information note specifying activities defined as cultural expenditure for the purposes of the survey,

including expenditure on the arts, heritage and media sectors. Expenditure on youth, community, adult education and health promotion and other projects that use cultural activity as a means of delivering their objectives, was defined as 'cultural'.

After the pilot survey, the information note was revised in order to specify more clearly the range of activities which should, for the purposes of the survey, be considered by respondents as 'cultural activities'. Respondents in the pilot survey were likely, for example, to consider a youth-empowerment project, which had been delivered as a video-making project by a youth arts group, 'youth work' and not a 'cultural' project. The main-stage questionnaire and the information note which accompanied it are included at the end of this appendix.

For any project with cultural expenditure in 1998/99, the pilot questionnaire requested information about the project's total budget and the amount of expenditure on culture. However, data on amounts of cultural expenditure in projects were not readily available to programme lead officers, who would have to estimate the amounts. Therefore, in the main-stage questionnaire, respondents were asked to provide only basic details: for example, start and end years, total project spend in 1998/99 and over the lifetime of the project (see main survey questionnaire below) about each project they considered either 'partly' or 'mainly' cultural. 'Partly' cultural projects were defined as those with less than half of their lifetime expenditure estimated to be allocated to cultural activity. Mainly cultural projects were those with half or more of their lifetime expenditure estimated to be allocated to cultural activity. For each project, only the total amount committed was requested, rather than that share which was taken by 'cultural expenditure'.

In July 2000, the first wave of the main-stage postal survey was launched in three English regions. The regions selected were London and Eastern – the regions awarded the most and least SRB Challenge Fund monies in 1998/99 respectively – and the North West, the northern region with the most SRBCF monies. RDAs in these three regions provided a complete list of the 363 SRB programmes which were in receipt of SRB funding from rounds one through four in 1998/99.

Questionnaires were sent to lead officers in SRB programmes operated by local partnerships in the three regions. These lead officers were asked to complete the questionnaires using information obtained from projects, rather than circulating the questionnaire to be completed by representatives of individual projects. Due to the summer vacation period, the pressure of time on SRB programme officers and the difficult data-assembly exercise which was required in order to complete the survey, initial response was low. Second and third waves of questionnaires and reminder letters were sent during August 2000. A final response rate of 18 per cent was achieved (Table A2). The response rate was lowest in London and highest in the North West. In total, 66 usable questionnaires were returned. The low response rate highlights the difficulty of doing quantitative research on data which are not generally held in a form appropriate for the purposes of the survey. Due to the low response rate, the analysis which is presented in Chapter 11 of this book concentrates mainly on the level of the sample as a whole, with some regional analysis.

Table A2 SRB partnerships: survey response rate

Region	SRB programmes in receipt of funding (1998/99)	Number of questionnaires returned	Response rate (%)
London	194	27	13.9
Eastern	44	9	20.5
North West	125	30	24.0
Total	363	66	18.2

At the data-analysis stage, to take account of notional amounts of 'non-cultural' spending in 'partly cultural' and 'mainly cultural' projects, the total amount spent in 1998/99 and the projected total amount spent over the lifetime of the project were adjusted by a factor of 0.67 for 'mainly cultural' projects and by a factor of 0.33 for 'partly cultural' projects. These calculations produced an estimated notional amount for cultural expenditure per project.

The questionnaire sought details of the amounts of funding contributed to the SRB programme (in 1998/99 and over the lifetime of the programme) from seven potential sources: SRBCF, local authority, other public sector, European Union, private sector, voluntary sector and National Lottery. The total amount of programme funding was also requested. More responses were obtained for the total funding amounts than for the sub-totals. Fifty-nine SRB programmes provided details of their total income for 1998/99 and for the lifetime of the programme. The amounts for total programme income in 1998/99 ranged from £14,000 to £33.2 million.

Apart from contributing directly to projects, SRB programmes could indirectly fund cultural activities from a 'community chest' or a fund which allocates small grants to community groups. Where it is created, the community chest is usually managed by a local voluntary committee. Grants from the community chest may be used to support small-scale cultural activity at a neighbourhood level. However, the survey found that the contribution of the community chest to cultural support was insignificant. Only 17 SRB programmes (around one in every four in the survey) had allocated funds to a community chest in 1998/99. Of those 17 community-chest allocations, amounts ranged from £3,000 to £152,000 with a median amount of £20,000. Community-chest funding was more prevalent in the North West than in the other two regions. No information was sought in the survey about the allocation of community-chest money to cultural activities.

Serial no

Card 1
(1–4) 1 (5)

THE UNIVERSITY
OF BIRMINGHAM

Centre for Urban and Regional Studies

Policy Studies Institute

Single Regeneration Budget Cultural Expenditure in 1998/99

- Please refer to the attached sheet headed, 'Activities Defined as SRB Cultural Expenditure'. This lists the activities that are covered by this survey.
- Where a question refers to the year 1998/99, it means 01.04.98 to 31.03.99.
- Please write your answers only in the boxes provided, and attach additional sheets if necessary.

SECTION A: ABOUT THE SRB PROGRAMME

(A1) Region:	(6)		(A2) SRB Round:	(7)	
London		1	SRB Round 1		1
Eastern		2	SRB Round 2		2
North West		3	SRB Round 3		3
			SRB Round 4		4

(A3) Duration of SRB Programme in years
(e.g. 7 years) (8)

(A4) In how many local authority areas does the Programme operate? (9–11)

(A5) How much was allocated to Community Chest in 1998/99
(to the nearest £100)? (12–18)
If none, please enter '0'

(A6) How many projects completed or underway in 1998/99 received
funding in that year as part of the SRB Programme? (19–21)

(A7) Sources and amounts of SRB Programme funding, to nearest £100:
(Please note that the year 1998/99 refers to the period, 1.4.98–31.3.99)

Source of funding	1998/99 (to the nearest £100)	Lifetime (to the nearest £100)	
SRB			(22–30) (31–39)
Local authority			(40–48) (49–57)
Other public sector			(58–66) (67–75)
European Union			Card 2 (1–4) 2 (5) (6–14) (15–23)
Private sector			(24–32) (33–41)
Voluntary sector			(42–50) (51–59)
National Lottery			(60–68) (69–77)
Total programme funding			Card 3 (1–4) 3 (5) (6–15) (16–25)

SECTION B: PROJECT INFORMATION

(B1) Please enter the number of SRB Programme funded projects underway or completed in 1998/99 which you judge to fall into each of the following three categories. Given that it may be difficult to make an accurate assessment, please give us your best estimate.

Please see the enclosed information note for a definition of 'cultural'.

(a) Mainly cultural projects *(at least half of the project's expenditure in 1998/99 was cultural expenditure)* (26–27)

(b) Partly cultural projects *(less than half of the project's expenditure in 1998/99 was cultural expenditure)* (28–29)

(c) Non-cultural projects *(none of the project's expenditure in 1998/99 was cultural expenditure)* (30–31)

(d) Projects about which you *could not make an estimate* as to how much of their expenditure was cultural in 1998/99 (32–33)

Section C, below, is for projects which you've described as 'mainly cultural' (B1a).
Section D is for projects which you've described as 'partly cultural' (B1b).
Please complete one box for each project, photocopying the form if necessary.

If you have no projects that you'd describe as either 'mainly cultural' or 'partly cultural' then you have completed the questionnaire. Thank you for your time and effort. Please return the questionnaire in the enclosed pre-paid envelope to Sara Selwood at PSI at the address at the end of the questionnaire.

SECTION C: 'MAINLY CULTURAL' PROJECTS IN 1998/99

Please answer questions C1–C5 for each project identified in B1(a) as having 'mainly cultural' expenditure. Please see the enclosed information note for a definition of 'cultural'.

(C1) Title of project: ⬚

Card 4
(1–4) 4 (5)
(6–7)

(C2) SRB Programme funding to nearest £100: 1998/99 ⬚ Lifetime ⬚

(8–16) (17–25)

(C3) First financial year of project's SRB Programme funding:

95/96 ⬚ 1 96/97 ⬚ 2 97/98 ⬚ 3 98/99 ⬚ 4 (26)

(C4) Last financial year of project's SRB Programme funding:

98/99 ⬚ 1 01/02 ⬚ 4 04/05 ⬚ 7

99/00 ⬚ 2 02/03 ⬚ 5 05/06 ⬚ 8 (27)

00/01 ⬚ 3 03/04 ⬚ 6

(28)

(C5) In 1998/99, was there *any* involvement in the project – in a leadership capacity or otherwise – of cultural, media or arts organisations?

Yes ⬚ 1

No ⬚ 2

(C1) Title of project: ⬚ (29–30)

(C2) SRB Programme funding to nearest £100: 1998/99 ⬚ Lifetime ⬚

(31–39) (40–48)

(C3) First financial year of project's SRB Programme funding:

95/96 ⬚ 1 96/97 ⬚ 2 97/98 ⬚ 3 98/99 ⬚ 4 (49)

(C4) Last financial year of project's SRB Programme funding:

98/99 ⬚ 1 01/02 ⬚ 4 04/05 ⬚ 7

99/00 ⬚ 2 02/03 ⬚ 5 05/06 ⬚ 8 (50)

00/01 ⬚ 3 03/04 ⬚ 6

(51)

(C5) In 1998/99, was there *any* involvement in the project – in a leadership capacity or otherwise – of cultural, media or arts organisations?

Yes ⬚ 1

No ⬚ 2

Please repeat questions C1–C5 for each project identified in B1(a) as having 'mainly cultural' expenditure, copying this page if necessary.

SECTION D: 'PARTLY CULTURAL' PROJECTS IN 1998/99

Please answer questions D1–D4 for each project identified in B1(b) as having 'partly cultural' expenditure. Please see the enclosed information note for a definition of 'cultural'.

(D1) Title of project:

Card 5
(1–4) 5 (5)
(6–7)

(D2) SRB Programme funding to nearest £100: 1998/99 Lifetime

(8–16) (17–25)

(D3) First financial year of project's SRB Programme funding:

95/96 [] 1 96/97 [] 2 97/98 [] 3 98/99 [] 4 (26)

(D4) Last financial year of project's SRB Programme funding:

98/99 [] 1 01/02 [] 4 04/05 [] 7

99/00 [] 2 02/03 [] 5 05/06 [] 8 (27)

00/01 [] 3 03/04 [] 6

(D1) Title of project:

(28–29)

(D2) SRB Programme funding to nearest £100: 1998/99 Lifetime

(30–38) (39–47)

(D3) First financial year of project's SRB Programme funding:

95/96 [] 1 96/97 [] 2 97/98 [] 3 98/99 [] 4 (48)

(D4) Last financial year of project's SRB Programme funding:

98/99 [] 1 01/02 [] 4 04/05 [] 7

99/00 [] 2 02/03 [] 5 05/06 [] 8 (49)

00/01 [] 3 03/04 [] 6

Please repeat questions D1–D4 for each project identified in B1(b) as having 'partly cultural' expenditure, copying this page if necessary.

Thank you for your time and effort. Please return the questionnaire in the enclosed pre-paid envelope provided to Sara Selwood, PSI, 100 Park Village East, London, NW1 3SR.

ACTIVITIES DEFINED AS SRB CULTURAL EXPENDITURE
INFORMATION NOTE

This information note is intended to help you fill in the questionnaire by defining cultural expenditure for the purpose of this research. References to the cultural sector should be interpreted as being inclusive of the arts, heritage and media sectors.

Please note that you will not be asked to distinguish *between* activities in the following areas. The questionnaire is intended to cover *all* forms of cultural activity, but not to classify that activity by art form or type of service. The headings below are intended to be indicative of activity within our remit.

Please include any building, facility or service that includes elements of the activities below. Youth, community, adult education and health-promotion projects, for example, which use cultural activity as a means of delivering their objectives, should also be included. Any of the activities below should be included, even if they are delivered by a non-cultural organisation.

Community arts

Social and educational uses of culture, such as reminiscence work or community theatre. Other examples would include community groups using artists as animateurs, or a craftsperson or designer as a tutor or facilitator.

Arts centres

Please include community resource centres intended to house cultural activity as well as to fulfil general community functions.

Performing arts

Music, dance, theatre, drama, opera and music theatre of all genres, whether classical or popular, workshop or public performance.

Festivals or carnivals

Please include festivals – but only those which are form focused, or include forms of 'combined' or 'live' arts such as street theatre and busking.

Multimedia/computer arts

Within this area we are interested in projects which use IT for *creative purposes*; please do not include general IT training courses, or community IT facilities without a creative element.

Media

Film, video, radio and television.

Literature, archives and writing

Libraries, archives, literature-related projects and creative writing.

Visual arts

Museums and galleries. Visual arts including crafts, public art, design and photography.

Architecture and built heritage

Preservation, repair and maintenance of structures and sites of particular architectural or historical interest. This might include historic 'quarter' restorations, for example, but *not* usually large-scale residential renewal. Please also include building projects which are not of special architectural merit or historic interest but contain public art elements – for example, sculpted railings or murals.

Cultural services

Initiatives to promote cultural tourism or training or education in any of the above areas, for example.

Please do not include sporting activities in your responses.

Any questions about the research are most welcome and should be directed to Adele Williams on 0121 414 2293, or by email at axw829@bham.ac.uk.

Appendix 5
Lists of Survey Respondents

Survey of organisations and individuals in receipt of support, 1998/99

1st Queen's Dragoon Grants Regimental
 Museum
2000 Voices
Abbot Hall
Abbots Langley Arts Societies
Abbotsbury Music Festival
Aberdeen Alternative Festival
Aberdeen Arts Centre
Aberdeen Chamber Music Club
Aberdeen Chamber Orchestra
Aberdeen International Youth Festival
Aberdeen Opera Company
Aberglasney Restoration Trust
Aberystwyth Music Club
Academy of Live and Recorded Arts
Accessible Arts Club
Actors of Dionysus
Adam Smith Theatre
African and Caribbean Music Circuit
Almond Valley Heritage Trust
Alnwick and District Arts Association
Alnwick District Choral Society
Alternative Theatre Company (Bush
 Theatre)
Ambache Chamber Orchestra and
 Ensemble
American Museum in Britain
Ammanford Town Band
An Comunn Gaidhealach
Antonine Films
Anvil
ARC Theatre Ensemble
Archimedes Concerts for All
Argyll and Sutherland Highlanders
 Regimental Museum
Ark-T Centre
Arnolfini Gallery

Artangel
Artists Collective Gallery
Artlink, Edinburgh and Lothians
Artram
Arts Alive (formerly Shropshire Live)
Arts Centre, Ards
Arts Cinema Trust
Arts Disability Wales
Arts Factory
Arts Training Central
Artsway
Arty Folks
Arundel Festival Society
Ashby de la Zouch Museum
Ashington Jazz Club
Ashmolean Museum
Aspex Visual Arts Trust
Avoncroft Museum of Historic Buildings
Ballyclare Musical Festival
Banbury Jazz Club
Band on the Wall
Bangor Choral Festival
Banner Theatre Company
Barbican Theatre
Barefoot Doctors
Barnet Borough Arts Council
Barracudas
Basildon Operatic Society
Bath Preservation Trust
Battersea Arts Centre
Bedford Community Arts
Belfast Buildings Preservation Trust
Belfast Community Circus
Bennie Museum, Bathgate
Berern Arts
Berwick-upon-Tweed Preservation Trust
Bethel Arts and Community Centre

Beverley Folk Festival
Birmingham Arts Marketing
Birmingham Hippodrome Theatre
Black Country Living Museum
Black Cultural Archives
Blackheath Halls
Blackpool Grand Theatre
Boat Museum, Ellesmere Port
Bodleian Library
Boilerhouse Theatre Company
Borde Hill
Border Regiment and The King's Own
 Royal Border Regiment Museum
Borderland Voices
Boston Playgoers
Bournemouth Friends Literary Society
Bradford Industrial Museum
Brangwyn Hall
Brecon Town Concert Band
Brentham Ladies Choir
Bressingham Steam Preservation
Bridewell Theatre
Bridgwater Arts Centre
Bright Ideas (North Essex Scrap Scheme)
Bright Light Arts
Brighton West Pier Trust
British Architectural Library
British Chinese Artists' Association
British Federation of Young Choirs
British Library
British Museum
British Museum (Natural History)
British Records Association
British Trust for Conservation Volunteers
British Youth Opera
Britten-Pears Library
Brontë Parsonage Museum
Brooklands Museum
Broughton's Brass Band
Bruvvers
Burry Port Town Band
Bury St Edmunds Art Gallery
Bushey Museum
Buxton Arts Festival
Byre Theatre
CADMAD (Cardiff and District
 Multicultural Arts Development)
Café Gallery
Cambridge and County Folk Museum
Cambridgeshire Jazz Festival
Camden Arts Centre
Campaign for Museums

Canolfan y plase, y bala
Canterbury Cathederal Archives
Canterbury Conservation Advisory
 Committee
Cantorion Pontarddulais
Captain Cook Memorial Museum
Cardiff Arts Marketing
Cardiff Old Library Trust
Carliol Choir
Carlisle & District Music & Drama
 Festival
Carmarthen Sketch Club
Caryl Jenner Productions (Unicorn
 Theatre for Children)
Cascade TiE
Castle, Wellingborough
Castlefield Gallery
Castlemilk Partnership Arts & Social
 Development
Castleward Opera
Cawthorne Museum Society
Celtica
Centerprise Trust
Centre for Contemporary Arts
Channel Arts Association
Channel Theatre
Chapelfields Photo Project
Chapter, Cardiff
Charleston Trust
Charnwood Arts
Chatham Historic Dockyard Trust
Chats Palace
Chelsea Physic Garden Company
Cheltenham Arts Festivals
Chester Summer Music Festival
Chesterfield Arts Centre
Chetham's Library
Chichester City Film Society
Chichester Festival Theatre Productions
Chicken Shed Theatre Company
Chipping Barnet Heritage Trust
CHNTO (Cultural Heritage National
 Training Organisation)
Chris Chapman
Churches Conservation Trust
Churchill Archives Centre
Citizens' Theatre, Glasgow
Claire Russ Ensemble
Clan Munro Heritage
Clarbeston Road Players
Cleveland Arts
Clwb Cerdd Dwyfor Music Club

Clwyd Theatr Cmyru
Colchester Arts Forum
Colchester Choral Society
Colchester New Music
Colne Valley Museum
Colour Museum
Colwyn Bay Library
Comhairle Nan Sgoiltean Araich
Communicado Theatre Company
Community Arts Forum
Community Dance Wales
Community Media Association
Community Music
Connections Communications Centre
Constitution Hill
Contemporary Popular Music
Continuum Ensemble
Converse Theatre
Cookworthy Museum
Cor Mihangel
Corn Exchange
Cornwall County Music Festival
Cornwall Drama Assocation
Cornwall Media Resource
Cornwall New Music Group
Corstorphine Trust
Council for Music in Hospitals
Coventry Community Circus
Craigmillar Festival Society
Cranleigh Arts Centre
Craven Museum
Crawford Arts Centre
Crewe & Nantwich Folk Festival
Cross Border Arts
Crucible Theatre
Cuckoo Farm Studios
Cumbernauld Theatre Trust
Cwmaman Institute Amateur Operatic
 Society
Cwmni Dawns Werin Caerdydd
Cymdeithas Gymraeg Treorci a'r Cylch
Cynon Valley Writers Association
Cywaith Cymru Artworks Wales
Dacorum Heritage Trust
Dalston Handbell Ringers
Dane Coppice Craft Group
Daneside Theatre
David Glass New Mime Ensemble
Dawns Tan Tan Dance
De La Warr Pavilion
Derry Media Access
Derwent Arts Workshop

Design Museum
Directors' Guild of Great Britain
Disability Arts Agency
Diss Museum
Dolgellau Music Club
Doreen Bird College of Performing Arts
Dorset Philharmonic Society
Dorset Triumph
Douglas Heritage Museum Trust
Dover Bronze Age Boat Trust
Downpatrick & Ardglass Railway
 Company
Drama Association of Wales
Duchy Opera
Dukes
Dulwich Picture Gallery
Dumfries & Galloway Arts Assocation
Dumfries & Galloway Arts Festival
Dumfries & Galloway Guild of Spinners,
 Weavers and Dyers
Dumfries Town Band
Dunbartonshire Concert Band
Dunblane Cathedral Museum
Dundee Heritage Trust
Dundee Repertory Theatre
Durham County Brass Band
Dyson Perrins Museum Trust
East Finchley Arts Festival
East Grinstead Town Museum
Eastbourne Community Dance Festival
Eastbourne Symphony Orchestra
Eastern Touring Agency
Eden Court Theatre
Edgmond Video Project
Edinburgh Audience Development
 Initiative
Edinburgh Festival Society
Edinburgh Printmakers Workshop and
 Gallery
Edinburgh Puppet & Animation Festival
Educational Theatre Services
Eisteddfod Gadeiriol Mynydd y Cilgwyn
Elgin Museum
Ellerton Church Preservation Trust
Emery Theatre
Engage
English Sinfonia
Estover Percussion Project
Eyam Museum
Faceless Company
Falkland Heritage Trust
Farmland Museum

Festival City Theatres
Film & Television Commission (North West)
Filmhouse
Finchley Society – Stephens Collection
Fleet Air Arm Museum
Flitwick Arts Festival
Flowerfield Arts Centre
Football Museum
Forest Arts Centre
Foyle Film Projects
Friends of Highgate Cemetery
Friends of Lancashire Student Symphony Orchestras
Furness Railway Trust
Fusion
Gaelic Arts Agency
Gairloch Museum
Gallery Arts Trust
Game Productions
Garsington Opera
Gateway Theatre
Geese Theatre Company
Geffrye Museum
Georgian Theatre Royal, Richmond
Gibberd Garden Trust
Ginger Dance Theatre
GLAM (Gay and Lesbian Arts and Media)
Glasgay
Glasgow 1999 Festival Company
Glasgow Building Preservation Trust
Glasgow Film Theatre
Glasgow Gaelic Drama Association
Glasgow Royal Concert Hall
Glen Singers
Glenholme Theatre Club
Godalming Museum Trust
Golfal Celf/Arts Care
Gravesham Arts Council
Greater Pilton Print Resource
Greenfield Valley Trust
Greenock Camera Club
Greenock Writers Club
Greenwich Foundation for the Royal Naval College
Grey Coast Theatre Company
Groam House Museum
Grosvenor Museum, Chester
Gwyl Plant Cymru
Gwyl Werin y Cnapan
Hackney New Variety
Half Moon Young People's Theatre

Hampshire Archives Trust
Harrogate International Festival
Harrow Arts Council
Haslemere Educational Museum
Havant Arts Centre
Havant Orchestras
Haymarket Theatre, Basingstoke
Hebridean Trust
Hereford Cider Museum
Herefordshire Music, Speech and Drama Festival
Herefordshire Photography Festival
Heritage Ceramics
Heritage of London Trust Operations
Heritage Trust of Lincolnshire
Hestercombe Gardens Trust
High Salvington Mill Trust
Hijinx Theatre
His Majesty's Theatre, Aberdeen
Historic Chapels Trust
Historic Royal Palaces
HMS Trincomalee Trust
Horniman Museum and Gardens
Horsham Arts Centre
Hoxton Hall
Hull Truck Theatre
Hungerford and District Community Arts Festival
Imperial War Museum
Impossible Theatre
Insight Arts Trust
Inter-Action (Milton Keynes)
Ipswich Building Preservation Trust
Ironbridge Gorge Museum Trust
Isle of Wight Symphony Orchestra
Isles of Scilly Museum
Jazz East
Jean Napier
Jenner Museum
Jewish Music Heritage Trust
John Creasey Museum
Jolyon Symonds Productions
Kala Chethena Kathakali Troupe
Kegworth Museum
Keighley Bus Museum
Kelmscott Manor
Kennet Opera
Kent Music School
Kew Bridge Engines Trust
Kilmacolm Dramatic Society
Kilmartin House Trust
Kings Head Theatre

Kingsgate Workshops
Kirklees Media Centre
Kneehigh Theatre
Komedia Productions
L'Ouverture
Lambeth Orchestra
Lancashire and Yorkshire Railway Trust
Lauderdale House Society
Learig Orchestra
Leighton Buzzard Music Club
Lemon Tree
Leominster Folk Museum
Lichfield District Arts Association
LIFT (London International Festival of
 Theatre)
Lighthouse Arts & Training
Lincolnshire Artists' Society
Lincolnshire Cinema Exhibitors
 Consortium
Lincolnshire Rural and Community
 Touring Scheme
Linen Hall Library
Liverpool Architecture and Design Trust
Living Archive Project
Llanbrynmair Brass Band
Llanelli Arts Society
Llanelli District Music & Drama Club
Llanfair Caereinion Male Voice Choir
Llanidloes Music and Arts Club
Llantarnam Grange Arts Centre
Llwchwr Art Group
London Disability Arts Forum
London Festival of Literature
London Film and Video Development
 Agency
London Independent Arts Digest
London Transport Museum
Long Shop Project Trust
Long Shop Steam Museum
Longridge Band
Loop Dance Company
Lostwithiel Museum
Louth Museum
Louth Navigation Trust
Lowfield Heath Windmill Trust
Lymington Choral Society
Macclesfield Museums Trust
Machynlleth and District Music Club
Machynlleth Tabernacle Trust
MacRobert Arts Centre
Maddermarket Theatre
Maelor Music Society

Magic Me
Maidenhead Heritage Trust
Malton Museum
Manchester International Arts
Mansfield Music & Drama Festival
Mantolen Seindorf Deiniolen
Maritime Museum, Lancaster
Maritime Museum, Swansea
Maritime Trust
Mary Rose Trust
Media Trust
Melincryddan Male Voice Choir
Melton Mowbray Toy Soldiers Marching
 Display Band
Mendelssohn on Mull Festival
Menter Mon
Metier
Metropole Arts Centre
Mid Pennine Arts
Mid Wales Entertainment Circuit
Mid Wales Jazz Society
Mikron Theatre Company
Milford Jazz Workshop
Mill Community Education & Arts Centre
Milton Cottage Trust
Milton Keynes Arts Association
Milton Keynes Chorale
Mind the Gap
Miners Museum
Miracle Theatre Trust
Mission Gallery (formerly Swansea Arts
 Workshop Gallery)
Montgomeryshire Youth Theatre
Montrose Air Station Museum
Moonstone International
Moravian Museum
Morts Astley Heritage Trust
Morven Singers
Mount Edgcumbe House & Country Park
Museum of Abernethy Trust
Museum of Antiquities, Newcastle upon
 Tyne
Museum of Bath at Work
Museum of British Road Transport
Museum of Kent Life
Museum of Lincolnshire Life, Lincoln
Museum of London
Museum of North Devon
Museum of Worcester Porcelain
Museum, Newton Stewart
Museums Association
Music at Alfreton Hall

Music Village (Cultural Co-operation)
Narrow Gauge Railway Museum
National Army Museum
National Artists Association
National Association of Gaelic Arts Youth Tuition Festivals
National Coal Mining Museum for England
National Federation of Music Societies
National Gallery
National Library for the Blind
National Library of Scotland
National Library of Wales
National Maritime Museum
National Museum and Gallery, Cardiff
National Museum of Labour History
National Museum of Science and Industry
National Museums and Galleries on Merseyside
National Museums of Scotland
National Portrait Gallery
National Railway Museum
National Society for Education in Art and Design
National Tramway Museum
National Trust for Scotland
National Youth Choir of Scotland
National Youth Orchestra of Scotland
NCT Touring Theatre Company
Neath Arts Club
Nelson Opera
Nettlefold Festival Trust
New Ashgate Gallery
New Perspectives Theatre Company
New Wind Symphony Orchestra
Newbridge and District Ladies Choir
Newbury Choral Society
Newbury Festival of Choirs
Newbury Nomads
Newbury Operatic Society
Newbury Youth Theatre
Newcastle International Concert Series
Newcastle International Dance Festival
Newlyn Art Gallery
Norfolk Contemporary Art Society
Norfolk and Norwich Community Dance
Norfolk and Norwich Music Club
North Devon Festival of Choirs
North East Theatre Trust
North End Trust
North Kensington Video/Drama Project
North Pennines Heritage Trust

North Wales Bluegrass Festival
North West Film Archive
North West Musicians Collective
Northampton Museum and Art Gallery
Northern Lights
Northern Regional Brass Band Trust
Norwich Theatre Royal
Nottingham Media Centre
Nottingham Playhouse
Nuffield Theatre, Southampton
Oakdale Silver Band
Ocean Music Trust
Oglander Roman Trust
Old Bull Arts Association
Old House Museum, Bakewell
Old Kiln Museum Trust
Old Museum Arts Centre
Oldham Coliseum Theatre
One in a Hundred Theatre Company
Open Hand Open Space
Opera Brava
Opera South East
Opportunities Without Limits
Orange Tree Theatre
Orchard Centre Pottery Group
Orchestra of the Age of Enlightenment
Oriel 31
Oriel Myrddin
Oriental Arts
Orleans House Gallery
Orwell Players
Out of Joint
Overtones
Oxford Bach Choir
Oxford Festival of Contemporary Music
Oxford Playhouse
PACE
Painshill Park Trust
Palace Theatre, Watford
Pan Project
Pangbourne and District Silver Band
Pathé Distribution
Pearoom
Pegasus Theatre
Pendle Arts Gallery
Pentabus Arts
People's Theatre Arts Group
Performing Arts Laboratories
Permanent Waves (Women's Arts Association)
Perth Museum and Art Gallery
Phoenix Theatre Company

Photoarts 2000
Pied Piper Theatre Company/ Yvonne
 Arnoad Theatre
Pier Arts Centre
Pilton Barn Trust
Pitlochry Festival Theatre
Pitshanger Poets
Plas Tan yr Allt Arts Venture
Plymouth Chamber Music Group
PM Music Ensemble
Poetry Business
Poetry School
Pontardawe Art Club
Poole Arts Trust
Port Talbot Society of Arts
Powysland Museum
Prescap (Preston Community Arts Project)
Preservation Jazz Society
Presteigne Festival of Music and the Arts
Presteigne Film Society
Priest's House Museum and Garden
Princess Royal Class Locomotive Trust
Prism Arts
Proiseact Nan Ealan (The Gaelic Arts
 Agency)
Project Ability
Quay Theatre
Queen's Hall (Edinburgh)
Queen's Theatre, Hornchurch
Queens Park Arts Centre
Radstock Museum
Ragged School Museum (Holiday Club)
Ratby Co-operative Band
Raw Material Music & Media Education
Red Gallery
Red House Museum
Replay Productions
Rhondda Players
Rhyl Music Club
Ribchester Museum Trust
Richmondshire Museum
Rio Cinema
Riverside Theatre, Coleraine
Robin Hood Theatre
Rochdale Canal Trust
Rosehill Theatre
Roses Theatre
Ross & District Festival of the Arts
Rosslyn Chapel
Royal Academy of Arts
Royal Air Force Museum
Royal Commission on the Ancient and

Historical Monuments of Scotland
Royal Hampshire Regiment Museum
Royal Lyceum Theatre
Royal Naval Museum
Royal School of Needlework, Hampton
 Court Palace
Royal Scottish Academy
Royal Society for the Encouragement of
 Arts, Manufactures & Commerce
Rural Arts East
Rural History Centre incorporating the
 Museum of English Rural LIfe
Ruskin Museum
Rydale Folk Museum
Rye Castle Museum
Sainsbury Centre for the Visual Arts
Salisbury & South Wiltshire Museum
Scarborough Festival of Youth Arts
Scarlet Theatre Company
Scottish Amateur Music Association
Scottish Ballet
Scottish Book Trust
Scottish Borders Council Museum
Scottish Chamber Orchestra
Scottish Fisheries Museum
Scottish Maritime Museum
Scottish Mining Museum
Scottish Music Information Centre
Scottish National Gallery
Scottish Opera
Scottish Poetry Library
Scottish Publishers Association
Scottish Storytelling Forum
Scottish Theatres Technical Training
 Trust, Edinburgh
Scottish Youth Theatre
SCRAN (Scottish Cultural Resources
 Access Network)
Search Project
Second Wave: Centre for Youth Art
Seindorf Beaumaris Band
Serious
Sgript Cymru
Shaftesbury Arts Centre
Shakespeare Birthplace Trust
Shakespeare Globe Trust
Shape London
Sharing Stories
Sheffield Independent Film
Sheffield Industrial Museums
Sheffield Museums & Galleries Trust
Sheffield Town Trust

Sheringham Museum
Sherman Theatre
Shetland Arts Trust
Showroom Gallery
Shropshire Dance
Shropshire Heritage Trust
Shropshire Live
Shropshire Music Trust
Shropshire Youth Arts Network
Sinfonietta Productions
Sir John Soane's Museum
Six Towns Poetry Festival
Skyline Productions
Slough Arts Festival
Slough Philharmonic Society
Small Scale Theatre
Smalley Art Group
Sobriefly Project
Society for the Protection of Ancient
 Buildings (SPAB)
Soldiers of Gloucestershire Museum,
 Gloucester
Somerset Art Week
Somerset Building Preservation Trust
 Company
Somerset Dance Connections
Somerset House Trust
Sound Lincs
Sounds Fine
South and West Concerts Board
South Wales Borders and Monmouthshire
 Regimental Museum
South Wales Miners Eisteddfod
South West Film Commission
Southwark Playhouse
Southway Mature Arts Workshop
Speakeasy
Special Connection (National Drama
 Special Needs)
Spectacle Theatre Company
Spitalfields Festival
SS Great Britain Project
St Alban's Cathedral Music Trust
St George's Music Trust
Stable Theatre
Stafford Jazz Society
Staffordshire Regiment: Regimental
 Museum
Stagecoach Youth Theatre York
Stained Glass Museum
Stamford Arts Centre
Stanhope Choral Society

Stanley Spencer Gallery
Stantonbury Campus Theatre
Starmaker Theatre Company
Stills Gallery
Stirling Writers Group
Stirling Youth Theatre
Stoke on Trent Bedford Singers
Stone Choral Society
StopGaP – Dance Gateways
Stowe Landscape Gardens
Strange Cargo Arts
Stranraer Drama Club
Street Gallery
Strode Theatre
Stromness Museum
Surrey Heath Archaeological and
 Heritage Trust
Surrey Heath Arts Council
Surrey Opera
Suspect Culture
Sussex Arts Marketing
Sussex Counterpoint (formerly Hastings
 Arts)
Swansea and District Writers' Circle
Symphonic Wind Orchestra of North
 London
TAG Theatre Company
Tain and District Museum Trust
Talbot Rice Gallery
Taliesen Arts Centre
Talkin Singers
Tarbat Historic Trust
Tate Gallery
Tavistock and West Dartmoor Writers
Tees Archaeology
Tenby Arts Festival
Tenby Museum
Thaxted Festival Foundation
The Clitheroe Great Days of Folk
The Theatre
Theatr Bara Caws
Theatr Fforwm Cymru
Theatr na n'Og
Theatre Company Blah Blah Blah
Theatre Investment Fund
Theatre of Thelema/ Quicksilver Theatre
 for Children
Theatre Royal (Norwich) Trust
Theatre Royal, Newcastle upon Tyne
Theatre Workshop Company
Theatres Trust
Theatrestorm

Them Wifies
Thirlestane Castle Trust
Thirsk & District Museum Society
Three Rivers Music Society
Three Spires Singers
Tinderbox Theatre Company
Tip Top Productions
TMSA
Toddington Poetry Society
Told by an Idiot
Torch Theatre
Torfaen Museum
Torquay Museum
Traverse Theatre
Tredegar House Folk Festival
Tregynon Community Craft Group
Trevithick Trust
Triangle Arts Trust
Tricycle Theatre Company
Trinity House National Lighthouse Centre
Truro Three Arts
Turner Sims Concert Hall
Tyne and Wear Museums
Ulster Folk and Transport Museum
Ulster Orchestra
Ulster Youth Orchestra
Usher Gallery
Vale Mill Trust
Verbal Arts Centre
Verulamium Museum
Victoria and Albert Museum
Vintage Carriages Trust
Visual Art Projects
Visual Arts North East
Vivid Animations
Vocaleyes
Voluntary Arts Network
Wakefield Concert Society
Wakefield Jazz
Wakefield Music Collective
Wakefield Theatre Royal and Opera
 House
Wales Millennium Centre
Wallace Collection
Walsall Leather Museum
Warehouse Theatre
Warkworth Village Choir
Warminster Preservation Trust

Watermill Theatre
Waterside Arts
Welsh Regiment Museum
Welsh Amateur Music Federation
Welsh National Opera Brass Consort
Welsh Water Elan Trust
Welshpool & Llanfair Light Railway
 Preservation Co.
Welshpool Music Club
West Cliff Theatre
West Highland Museum
West London Disability Arts Group
West London Opera
West Lothian Youth Theatre
West Yorkshire Arts Marketing
Western Association of Ballet Schools
Western Sinfonia
WHALE, the arts agency
Whalley Village Hall Players
White Bear Theatre Club
White Horse Opera
White Mill Folk Museum, Sandwich
Whithorn Photographic Club
Whitley Bay Playhouse
Whitworth Art Gallery
William Cookworthy Museum Society
William Herschel Museum
Willis Museum
Wilson Museum of Narberth
Woking Brass Band
Women in Tune
Woodchester Mansion Trust
Wrexham Arts Centre
Wycombe Swan
Y Gloran
York Citizens' Theatre Trust
York Guildhall Orchestra
Yorkshire Artspace Society
Yorkshire Bach Choir
Young People Speak Out
Yr Academi Gymreig
Ysgol Borth-y-Gest
Ysgol Bryn Golau
Ysgol Gymraeg Coed y Gof
Ystalyfera Public Band
Zap Productions
Zip Theatre

Constant sample of organisations[1]

Abbot Hall
Aberdeen Alternative Festival
Aberdeen International Youth Festival
Action Space London Events
Alternative Theatre Co: Bush Theatre
Arnolfini Gallery
Artists Collective Gallery
Arts Alive (formerly Shropshire Live)
Arts Disability Wales
Band on the Wall
Battersea Arts Centre
Bedford Community Arts
Belfast Community Circus
Bolton Octagon Theatre
Bradford Film Theatre
Bridgwater Arts Centre
British Chinese Artists' Association
British Library
British Museum
British Museum (Natural History)
Bruvvers
Business in the Arts, North West
Byre Theatre
Caryl Jenner Productions (Unicorn Theatre for Children)
Castlemilk Partnership Arts & Social Development
Centerprise Trust
Centre for Contemporary Arts
Charnwood Arts
Chats Palace
Chesterfield Arts Centre
Chichester City Film Society
Churches Conservation Trust
Cinema City
Citizens' Theatre, Glasgow
Crucible Theatre
Derry Media Access
Disability Arts Agency
Dorchester Arts Centre
Drama Association of Wales
Dukes
Eastbourne Symphony Orchestra
Edinburgh Printmakers Workshop and Gallery
Edinburgh Puppet & Animation Festival

Filmhouse
Fleet Air Arm Museum
Flowerfield Arts Centre
Gaelic Arts Agency
Geffrye Museum
Glasgay
Hackney New Variety
Half Moon Young People's Theatre
Haymarket Theatre, Basingstoke
Heritage Ceramics
Hijinx Theatre
His Majesty's Theatre, Aberdeen
Horniman Museum and Gardens
Horsham Arts Centre
Huddersfield Contemporary Music Festival
Imperial War Museum
Impossible Theatre
Insight Arts Trust
Jenner Museum
John Creasey Museum
Kelmscott Manor
Kneehigh Theatre
LIFT (London International Festival of Theatre)
London Independent Arts Digest
London Magazine
London Review of Books
Loop Dance Company
MacRobert Arts Centre
Metier
Museum of London
National Army Museum
National Gallery
National Library of Scotland
National Museum of Labour History
National Museums and Galleries on Merseyside
National Museums of Scotland
National Portrait Gallery
Nettlefold Festival Trust
New Perspectives Theatre Company
Nottingham Playhouse
Newhouse Arts Centre
Orchestra of the Age of Enlightenment
PACE
Painshill Park Trust

1 Organisations in italics are those included in the smaller constant sample (64) drawn from annual accounts and ACE/RAB data.

Pearoom
Pilot Theatre
Pitlochry Festival Theatre
Prescap (Preston Community Arts Project)
Queens Hall Arts Centre
Queenspark Books
Replay Productions
Riverside Theatre, Coleraine
Royal Air Force Museum
Royal Liverpool Philharmonic Society
Royal Naval Museum
Royal Scottish Academy
Salisbury & South Wiltshire Museum
Scottish Ballet
Scottish Chamber Orchestra
Scottish Fisheries Museum
Scottish Mining Museum
Scottish Music Information Centre
Serpentine Gallery
Shobana Jeyasingh Dance Company
Sir John Soane's Museum

Solent Peoples Theatre
Stained Glass Museum
Stills Gallery
Sussex Arts Marketing
Taliesen Arts Centre
The Quay Arts Centre
The Roadmender
Theatre Clwyd Cymru
Theatre Resource
Theatre Royal, Newcastle upon Tyne
Theatre Workshop Company
Torch Theatre
Tricycle Theatre Company
Tyne and Wear Museums
Victoria and Albert Museum
VIVID
Voluntary Arts Network
Welsh Amateur Music Federation
York Citizens' Theatre Trust
Yorkshire Artspace Society

Arts Council of England and regional arts boards' survey, 1998/99

Acme Housing Association
Acta Community Theatre
Action Factory Community Arts
Action Space London Events
Action Transport Theatre Company
Actiontrack Theatre
Actors Touring Company
Adzido Pan African Dance Ensemble
Aldeburgh Poetry Trust
Aldeburgh Productions
Almeida Theatre
Alnwick Playhouse
Ambit
AN Publications
Angel Row Gallery
Angles Theatre & Arts Centre
Anvil Press
Apples and Snakes
Architecture Foundation
Art of Change
Artability
Artezium
Artists Agency
Artlink Exchange
Artlink West Yorkshire

Artreach (NW)
Arts About Manchester
Arts Services Grants Ltd
Arts Training North West
Arts Training South West
Artsadmin
Artshape
Artshare South West
Artsline
Artspace Bristol
Artsreach
Arvon Foundation
Asian Music Circuit
Autograph
AXIS Visual Art Information Service
Badejo Arts
Basingstoke Haymarket Theatre
Bath Festivals Trust
Beaford Arts Centre
Birmingham Contemporary Music Group
Birmingham International Film & TV
 Festival
Birmingham Repertory Theatre
Birmingham Royal Ballet
Blast Theory

Bloodaxe Books
Bluecoat Arts Centre
Bolton Octagon Theatre
Book Trust
Book Works
Bournemouth Orchestras
Bradford Festival
Bradford Film Theatre
Brazilian Contemporary Arts
Brewery Arts (SW)
Brewhouse Arts Centre
Brewhouse Theatre and Arts Centre
Bridport Arts Centre
Brighton Media Centre
Bristol and Bath Dance consortium
Bristol Old Vic
British Association of Steelbands
British Centre for Literary Translations
British Music Information Centre
Britten Sinfonia
Bury St Edmunds Theatre Royal
Business in the Arts North West
Cambridge Darkroom Gallery
Cambridge Drama Centre
Cambridge Modern Jazz Club
CandoCo
Canterbury Festival
Carcanet Press
Carousel
Cartwheel Community Arts
Chard Festival of Women in Music
Charivari
Cheshire Dance Workshop
Chester Gateway Theatre
Chinese Views Arts Association
Chisenhale Dance Space
Chisenhale Gallery
Cholmondeleys & Featherstonehaughs
Cinema City
Circus Space
Citadel Arts Centre
City of Birmingham Symphony Orchestra
City of Birmingham Touring Opera
City of London Sinfonia
Cleveland Theatre Company
Colchester Arts Centre
COMA
Commissions East
Commonword
Community Arts Northwest
Compass Theatre Company
Contact Theatre Company

Contemporary Art Society
Contemporary Dance Trust
Corby Community Arts Centre
Cornerhouse
Cornwall Theatre Umbrella
Coventry Belgrade Theatre
Craftspace Touring
Creative Camara
Creative Jazz Orchestra
Daily Life Ltd
Dance 4
Dance Agency Cornwall
Dance City
Dance Initiative Greater Manchester
Dance Northwest
Dance Services
Dance UK
Dance Umbrella
Darlington Arts Cenre
Dartington Arts
Dedalus Arts
Derby Dance Development
Derby Playhouse
Development of the Arts in Northwich
Devon Guild of Craftsmen
Doncaster Community Arts
Dorchester Arts Centre
Dorset Dance Forum
Dot to Dot
Dr Fosters
Durham City Arts
DV8 Physical Theatre
Early Music Network
East London Dance
East Midlands Shape
East of England Orchestra
Eastern Angles Film Archive
Eastern Orchestral Board
Eden Arts Trust
Education and Training Project
English National Ballet
English National Opera
English Stage Company
English Touring Opera
English Touring Theatre
Essexdance
Exeter Northcott Theatre
FACT
Federation of Worker Writers
Film & Video Umbrella
Firebird Trust
First Movement

First Take Films Ltd
Firstsite
Focal Point Gallery
Folk South West
Folkworks
Forced Entertainment
Forest Forge
Forkbeard Fantasy
Foundation for Community Dance
Freeform
Full Circle Arts
Gainsborough House
Gardner Arts Centre
Gloucester Dance Project
Gloucester Everyman Theatre
Gloucester Three Choirs
Glyndebourne Touring Opera
Graeae
Grand Union
Green Candle Dance Company
Green Room
Grizedale Society
Hackney Empire Ltd
Halle Concerts Society
Hammersmith Lyric Theatre
Hampshire Dance Trust
Hampstead Theatre
Harrogate Theatre (White Rose)
Heart n Soul
High Peak Community Arts
Horse & Bamboo Theatre
Hospital Arts
Hove Museum
Huddersfield Contemporary Music
 Festival
Hull Time Based Arts
I.O.U. Theatre
Ikon Touring
Ilkley Literature Festival
Impressions
Independent Theatre Council
Iniva
Institute of Contemporary Art
Intermedia Film & Video
International Workshop Festival
Interplay
Irie Dance Theatre
ITHACA
Jabadao
Jazz Action
Jazz Moves

Jazz Services
Jazz Umbrella
John Hansard
Jubilee Arts
Kaboodle Productions
Kadam Asian Dance and Music
Kettles Yard Gallery
Kings Lynn Arts Centre
Kokuma Dance Theatre
Kuumba
Lancaster Dukes Playhouse
Leicester Theatre Trust
Light House Media Centre
Live Music Now
Liverpool Dance Initiative
Locus +
London International Jazz Festival
London Magazine
London Mozart Players
London Philharmonic Orchestra
London Review of Books
London Sinfonietta
London Symphony Orchestra
Ludus Dance Agency
LUX (LFM Co-op)
M6 Theatre Company
Maltings Arts Centre
Manchester Camerata
Manchester Royal Exchange
Mansfield Community Arts Centre
Media Arts
Meltdown
Mercury Theatre
Merlin Theatre
Merseyside Dance Initiative
Merseyside Young Peoples Theatre
Method & Madness
Metropolitan Arts Centre
Midland Arts Centre
Mimika Theatre
Modern Music Theatre Troupe
Moti Roti
Motionhouse
Mu-Lan Arts Ltd
Museum of Modern Art, Oxford
Music in the Round
National Opera Studio
National Youth Jazz Orchestra
Natural Theatre Company
New Peckham Varieties
New Writing North

Newbury Watermill
Newcastle-under-Lyme New Victoria
 Theatre
Norfolk and Norwich Festival
Norfolk Arts Marketing
North Cornwall Arts
Northampton Repertory Players
Northern Ballet Theatre
Northern Disability Arts Forum
Northern Freeform
Northern Print Studio
Northern Sinfonia
Northern Stage Company
Northwest Playwrights
Norwich Arts Centre
Norwich Gallery
Norwich Puppet Theatre
Nottingham Theatre Trust
NTC Touring Theatre Company
NWDAF
Oily Cart Company
Old Town Hall Arts Centre
Oldham Coliseum
Open Eye Photography
Opera Circus
Opera North
Orchard Theatre Company
Orchestra St Johns
OTTC
Oxford House Arts Workshop
Oxford Stage Company
Paddington Arts
Paines Plough
Pallant House Gallery
Pavillion
Pentabus Theatre
People Show
Peterborough Museum & Art Gallery
Peterloo Poets
Philharmonia Orchestra
Phoenix Dance
Photofusion
Photographers Gallery
Photoworks
Pilot Theatre
Place Theatre
Plymouth Arts Centre
Plymouth Theatre Royal
Poetry Book Society
Poetry Society
Polka Theatre for Children
Pop Up Theatre

Prema Arts Centre
Proper Job
Proteus
Public Art Development Trust
Public Art Forum
Public Arts
Public Arts South West
Quay at Sudbury
Queens Hall Arts Centre
Queenspark Books
Quicksilver Theatre
Rambert Dance Company
Red Ladder Theatre Company
Red Shift Theatre Company
Rejects Revenge Theatre Company
Restormel Arts
Rialto
Right Size
Rockingham Press
Royal Ballet
Royal Liverpool Philharmonic Society
Royal National Theatre
Royal Opera
Royal Philharmonic Orchestra
Royal Shakespeare Company
Rural Arts North Yorkshire
Rural Media Company
Sadlers Wells Theatre Trust
Salamanda Tandem
Salisbury Arts Centre
Salisbury Playhouse
Salongo
Same Sky
SAMPAD
Scarborough Stephen Joseph Theatre
Serpentine Gallery
Shared Experience
Sheffield Theatres
Sheringham Little Theatre
Shobana Jeyasingh Dance Company
Side Gallery
Signals
Signature
Sinfonia 21
Siobhan Davies Dance Company
Snap Peoples Theatre
Society for Promotion of New Music
Solent Peoples Theatre
Sonic Arts Network
Sound Sense
South Bank Centre (performing)
South Bank Centre (visual arts)

South East Dance Agency
South East Exhibitions Project
South Hill Park
South West Jazz
South West Media Development Agency
Southern Arts Touring Exhibition Service
Southport Arts Centre
Spacex
Sphinx
Suffolk Art Link
Suffolk Dance
Swindon Dance
Take Art!
Tamasha Theatre Company
TAPS
Tara Arts
The Dance Xchange
The Drum
The Gantry
The Junction
The Quay Arts Centre
The Roadmender
Theatre Alibi
Theatre Centre
Theatre Resource
Theatre Royal Stratford East
Tiebreak Touring Theatre
Trading Faces
Travelling Light Young Peoples Theatre
Trestle Theatre
Trinity Arts Centre
Tyneside Cinema
Unicorn Theatre
Union Dance Company

Unity Theatre
University of Surrey
Urban Strawberry Lunch
VIVID
V-Tol Dance Company
Walford Mill Craft Centre
Walsall Museum and Art Gallery
Warwick Arts Centre
Wasafiri
Watershed Arts Trust
Welfare State International
Welsh National Opera
West Yorkshire Playhouse
WFA Media and Culture
Whitechapel Art Gallery
Wigmore Hall Trust
Windows Project
Wingfield Arts
Woking Dance Umbrella
Women in Music
Womens Arts Library
Worcester Arts Workshop
Worcester Swan Theatre
Wren Trust
Yolande Snaith Dance Company
York Early Music Festival
York Theatre Royal
Yorkshire Art Circus
Yorkshire Dance Centre
Yorkshire Sculpture Park
Yorkshire Youth & Music
Young Vic Theatre
Youth and Music

Arts Council of England and regional arts boards' constant performance indicator sample, 1998/99

Combined arts

Alnwick Playhouse
Artshare South West
Artsreach
Beaford Arts Centre
Bridport Arts Centre
Canterbury Festival
Carousel
Cleveland Arts
Dorchester Arts Centre

Durham City Arts
Eden Arts Trust
First Movement
Gardner Arts Centre
Locus +
Northern Disability Arts Forum
Queens Hall Arts Centre
Restormel Arts
South Bank Centre (performing)
Take Art!

Dance

Adzido Pan African Dance Ensemble
Birmingham Royal Ballet
Dance City
Dance UK
Dance Umbrella
DV8 Physical Theatre
English National Ballet
Foundation for Community Dance
Northern Ballet Theatre
Place Theatre
Rambert Dance Company
Royal Ballet
Sadlers Wells Theatre Trust
Shobana Jeyasingh Dance Company
Siobhan Davies Dance Company
Suffolk Dance
Swindon Dance
The Dance Xchange
Union Dance Company
V-Tol Dance Company
Yolande Snaith Dance Company

Drama and mime

Actors Touring Company
Bristol Old Vic
Compass Theatre Company
Derby Playhouse
Eastern Angles Film Archive
English Stage Company
Exeter Northcott Theatre
Forkbeard Fantasy
Graeae
Hampstead Theatre
I.O.U. Theatre
International Workshop Festival
Kaboodle Productions
Leicester Theatre Trust
Mercury Theatre
Method & Madness
Natural Theatre Company
Northampton Repertory Players
Northern Stage Company
Nottingham Theatre Trust
NTC Touring Theatre Company
Oily Cart Company
Oxford Stage Company
Paines Plough
People Show

Polka Theatre for Children
Pop Up Theatre
Red Ladder Theatre Company
Red Shift Theatre Company
Right Size
Royal National Theatre
Royal Shakespeare Company
Shared Experience
Sphinx
Theatre Alibi
Theatre Centre
Theatre de Complicite
Travelling Light Young Peoples Theatre
Trestle Theatre
Unicorn Theatre
West Yorkshire Playhouse

Film, video and broadcasting

Film & Video Umbrella
Intermedia Film & Video
Signals
Film, video and broadcasting

Literature

Ambit
Anvil Press
Bloodaxe Books
Book Trust
British Centre for Literary Translations
Carcanet Press
Federation of Worker Writers
London Magazine
London Review of Books
Peterloo Poets
Poetry Book Society
Queenspark Books
Signature
Wasafiri

Music

Bournemouth Orchestras
Chard Festival of Women in Music
City of Birmingham Symphony Orchestra
City of Birmingham Touring Opera
East of England Orchestra
English National Opera

English Touring Opera
Firebird Trust
Glyndebourne Touring Opera
Halle Concerts Society
Jazz Action
London Philharmonic Orchestra
London Sinfonietta
London Symphony Orchestra
Northern Sinfonia
Philharmonia Orchestra
Royal Liverpool Philharmonic Society
Royal Opera
Royal Philharmonic Orchestra
Society for Promotion of New Music
Sonic Arts Network
South West Jazz

Visual arts and photography

Angel Row Gallery
Artspace Bristol
Book Works
Commissions East
Creative Camara
Freeform
Hove Museum
Ikon Touring
Iniva
Kettles Yard Gallery
Museum of Modern Art, Oxford
Northern Freeform
Northern Print Studio
Photofusion
Side Gallery
South Bank Centre (visual arts)
Whitechapel Art Gallery

Charitable trusts and foundations

Alice Ellen Cooper Dean Charitable
 Foundation
Balney Charitable Trust
Baring Foundation
Bridge House Estates Trust Fund
Britten-Pears Foundation
Bromley Trust
Calouste Gulbenkian Foundation
Carew Pole Charitable Trust
Carlton Television Trust
Carnegie Dunfermline Trust
Carnegie United Kingdom Trust
Charles Wallice India Trust
Charlotte Bonham-Carter Charitable Trust
Chase Charity
Children's Film and Television Foundation
City Parochial Foundation
Clore Foundation
Clothworkers Foundation
Coln Trust
Community Relations Council
Conservation Foundation
Dancers Trust
D'Oyly Carte Charitable Trust
Earl Fitzwilliam Charitable Trust
Earl of March's Trust Company Ltd
Eleanor Rathbone Charitable Trust

Ellis Campbell Charitable Foundation
Elmley Foundation
Esmée Fairbairn Charitable Trust
Foundation for Sport and the Arts
Frank Copplestone Trust
Francis C Scott Charitable Trust
Frieda Scott Charitable Trust
Gannochy Trust
Geoffrey Burton Charitable Trust
Goldsmith's Company Charities
Gordon Fraser Charitable Trust
Great Britain Sasakawa Foundation
Grocers Charity
Hamamelis Trust
Hampton Fuel Allotment Charity
Harold Hyam Wingate Foundation
Hayward Foundation
Henry Moore Foundation
Heritage of London Trust Ltd
Hilden Charitable Fund
Hinrichsen Foundation
Historic Churches Preservation Trust
Holst Foundation
Hon Charles Pearson Charity Trust
Hon HMT Gibson's Charity Trust
Inverforth Charitable Trust
John Ellerman Foundation

John Kobal Foundation
King's Fund
Kirby Laing Foundation
Lady Artists
Langtree Trust
Lankelly Foundation
Lauchentilly Charitable foundation
Leche Trust
Lesley David Trust
Lisa Ullman Travelling Scholarship Fund
MacRobert Trusts
Maritime Trust
Mary Webb Trust
Mathews Wrightson Charity Trust
Maurice Laing Foundation
Mayfield Valley Arts Trust
Michael Tippett Musical Foundation
Milly Apthorp Charitable Trust
Miss KM Harbinson's Charitable Trust
Mr. & Mrs. JA Pye's Charitable Trust
 Settlement
Mrs Waterhouse Charitable Trust
Musician's Union
National Art Collections Fund
Northamptonshire Historic Churches
 Trust
Northern Ireland Voluntary Trust
Northern Rock Foundation
Notgrove Trust
Oakdale Trust
Oppenheimer Charitable Trust
Ouseley Trust
Paragon Concert Society
Paul Hamlyn Foundation
Pilgrim Trust
Railway Heritage Trust
Richmond Parish Lands Charity
RJ Harris Charitable Settlement
Robert Kiln Charitable Trust
Robertson Trust
Robin Howard Foundation
Royal Victoria Hall Foundation
Sainsbury Family Charitable Trusts
Save and Prosper Educational Trust
Schuster Charitable Trust
Simon Gibson Charitable Trust
Society of Authors
St Katherine & Shadwell Trust
Steel Charitable Trust
Stoll Moss Theatres Foundation
Theo Moorman Charitable Trust

Tory Family Foundation
Tudor Trust
Vivien Duffield Foundation
Wates Foundation
Wellcome Trust
Welton Foundation
William Adington Cadbury Charitable
 Trust
Wolfson Foundation

Constant sample of charitable trusts and foundations 1993/94 and 1998/99

Balney Charitable Trust
Bromley Trust
Calouste Gulbenkian Foundation
Carew Pole Charitable Trust
Carlton Television Trust
Carnegie United Kingdom Trust
Charlotte Bonham-Carter Charitable Trust
Chase Charity
Ellis Campbell Charitable Foundation
Esmée Fairbairn Charitable Trust
Foundation for Sport and the Arts
Francis C Scott Charitable Trust
Geoffrey Burton Charitable Trust
Great Britain Sasakawa Foundation
Grocers Charity
Hamamelis Trust
Henry Moore Foundation
Heritage of London Trust Ltd
Hinrichsen Foundation
Historic Churches Preservation Trust
Holst Foundation
Inverforth Charitable Trust
John Ellerman Foundation
King's Fund
Kirby Laing Foundation
Langtree Trust
Lankelly Foundation
Leche Trust
Lisa Ullman Travelling Scholarship Fund
Maritime Trust
Mary Webb Trust
Milly Apthorp Charitable Trust
Northamptonshire Historic Churches
 Trust
Northern Ireland Voluntary Trust

Notgrove Trust
Paragon Concert Society
Paul Hamlyn Foundation
Pilgrim Trust
RJ Harris Charitable Settlement
Robert Kiln Charitable Trust
Robertson Trust
Royal Victoria Hall Foundation
Save and Prosper Educational Trust
Schuster Charitable Trust

Simon Gibson Charitable Trust
Society of Authors
St Katherine & Shadwell Trust
Steel Charitable Trust
Stoll Moss Theatres Foundation
Tory Family Foundation
Wates Foundation
Welton Foundation
William Adington Cadbury Charitable
 Trust

Higher education institutions

University of Aberdeen
Aberystwyth University
Anglia Polytechnic University
Bournmouth University
Bishop Grosseteste College
University of Bradford
Bradford College
University of Brighton
Brunel University
University of Cambridge
University of Central England
University of Central Lancashire
Cheltenham & Gloucester College of
 Higher Education
Cumbria Academy
De Montfort University
University of Derby
University of Dundee
University of Durham
Edge Hill
University of Edinburgh
University of Essex
University of Exeter
University of Glamorgan
University of Glasgow
University of Greenwich
Heriot-Watt University
University of Hertfordshire
University of Huddersfield
University of Hull
Imperial College
University of Keele
University of Kent
Kingston University
Lancaster University
Leeds Metropolitan University

University of Leicester
London Institute
Loughborough University
London School of Economics
University of Manchester
Manchester Metropolitan University
Middlesex University
University of Newcastle
Norwich School of Art & Design
University of Nottingham
Nottingham Trent University
University of Oxford
Oxford Brookes University
University of Paisley
University of Plymouth
Queen's University of Belfast
University of Reading
Royal College of Art
University of Salford
University of Sheffield
Sheffield Hallam University
School of Oriental and African Studies
Southampton University
Southampton Institute
University of St Andrews
St Mary's College, University of Surrey
Staffordshire University
University of Stirling
University of Strathclyde
University of Surrey
University of Sussex
Trinity College, Carmarthen
University College London
University of East Anglia
University of Ulster
University College Chichester

University College Northampton
University of Wales Institute, Cardiff
University of Wales, Lampeter
University of Wales, Swansea

University of Warwick
University of Wolverhampton
Wye College, University of London

Survey of Single Regeneration Budget partnerships

London SRB programmes

with cultural projects

Crystal Palace – Restoring the Vision
Cityside – London Borough of Tower
 Hamlets
FUNK – Fighting Unemployment in North
 Kensington
South Leytonstone Community
 Partnership
Green Corridors: A West London Pilot
Community Resistance Against Substance
 Harm
Upper Lee Valley Partnership
Time for Greenwich (formerly Greenwich
 2000)
West Euston
Building on Excellence
Roding Valley Area Regeneration

without cultural projects

Building a Future in North West London
Business Education Alliance
Challenging Racial Harassment in
 Newham
Education – Business Partnerships in
 West London
Stockley Park Transport Hub
Contributing to a World Class City
Safe in the City
Vauxhall/Lambeth Walk Initiative
Salter's City Foyer
Overcoming Barriers to Access
Raising Participation: Raising
 Achievement
Language Support East London
Education and employability in East
 London
London Accord
Raising the skills base in East London
Camden and Islington Health Authority -

Breaking the Barriers (formerly
Trading Places)

Eastern Region SRB programmes

with cultural projects

Ipswich Wet Dock
Suffolk Prosper
The Kirkley Regeneration Initiative –
 Lowestoft
The Luton Dunstable Partnership

without cultural projects

Four Wards for the Future (Borehamwood)
Access to Education and Business Links
 (Phase 2)
Norwich – A Learning City
Five Links Estate Regeneration, Basildon
Working Communities Partnership -
 Shoeburyness

North West SRB programmes

with cultural projects

Greater Deepdale Regeneration (Preston)
Stockport II
Investing in Tomorrow's Citizens
Lairdside Regeneration Initiative
Lancashire Tourism Partnership Ltd
Working Together in Westwood
Hamilton Quarter SRB
Hattersley Development Trust
North Liverpool Partnership
Blackpool Challenge Partnership
Moss Rose Building People's Potential for
 Today
Oldham/Glodwick People to the Fore

Blackburn Regeneration Partnership
The Wythenshaw Initiative
New Opportunities for Communities
Central Southport Partnership

without cultural projects

Welfare to Work +
New Frontiers Adult Guidance
The Tree Project
Expanding Horizons

The Hyndburn Partnership
Safer Merseyside Partnership
Support for Technology in Education in
 Partnership
IF
River Valley Action
Appleby Heritage Centre
Manchester Foyer
Higher Skills for Business
Bootle Village
Liverpool East Area Partnership

Index

Idaho Arts 205–7
Ikon Gallery 34
impact studies *see* economic impact of the
 arts
Independent Theatre Council (ITC) 362,
 363
Info 2000 99–100
information society, the 451–3
Inner City Task Force 59
Institute for Historic Building
 Conservation 290
Interim Funding Scheme (IFS) 146
International Fund for Ireland 502
International Labour Organization (ILO)
 262
Interreg II initiative 81
Investment Property Databank 284
Ipswich Wet Dock 63
Irish Republic 184
IT for All 15
ITC challenge fund 24
ITV 377, 378, 380, 381

Japan 453
Joint Committee of the National Amenity
 Societies (JCNAS) 122–4, 138
Joint Scheme for Churches and other
 Places of Worship in England 147
Jowell, Tessa (Secretary of State for
 Culture, Media and Sport) xlviii

Kaleidoscope initiative 88–9
King's Head Theatre 230
Kirklees Cultural Services 116
Kirklees Media Centre xliv
Kirklees museums and galleries
 case study 116–17
Kirklees Museums Service 116
Kodak 308
Konver initiative 81–2

Labour Force Survey (LFS) 200, 250,
 252–64, 274, 301, 352–3
Landmark Trust 290
Launchpad 335
Leader II initiative 82
Leche Trust 290
Leicester Haymarket Theatre 229
Leisure Intelligence 281
Leonardo da Vinci programme 95–7
LibEcon 2000 312
libraries

higher education institutions *see*
 funding
public *see* public libraries
Library Association 16, 310, 323
Library Fund 19
Library and Information Commission
 (LIC) 15, 17, 24, 318, 502
Library and Information Statistics Unit
 (LISU), University of Loughborough
 14, 66, 311, 312, 313, 495
library policy 19
listed buildings *see* built heritage
literature
 access to 19
 Ariane programme 89–90
 audiences 338–9
 subsidised publishing sector 330–1
 Bookstart 335
 commercial publishing sector
 book titles published 328
 bookselling compared 328
 employment in 328
 generally 20–1, 324, 325
 publishers' sales 327–8
 unit sales 326–7
 value of book market 325–6
 employment in
 commercial publishing sector 328
 subsidised literature sector 337–8
 subsidised publishing sector 330
 funding 18–20, 41, 42, 53, 331–4, 440
 business sponsorship 335, 341
 income other than subsidy 336–7
 National Lottery 334, 340, 341
 National Year of Reading 335–6, 504
 government policy 18–21
 literary magazines 21, 329
 National Year of Reading 335–6
 Northern Ireland 332, 340, 341
 partnership working 20–1
 Public Lending Right 334–5, 338
 public libraries *see* public libraries
 Scotland 330, 332, 340, 341
 subsidised publishing sector
 audiences 330–1
 employment in 330
 generally 21, 324–5, 328–30
 literary magazines 21
 type and value of subsidy 331–4
 support for writers and readers 18–20
 Wales 330, 332, 340, 341
 writers' bursaries 21